D0583956

FASHION NOW

a global perspective

Prentice Hall
Boston Columbus Indianapolis New York San Francisco Upper Saddle River
Amsterdam Cape Town Dubai London Madrid Milan Munich Paris Montreal Toronto
Delhi Mexico City Sao Paulo Sydney Hong Kong Seoul Singapore Taipei Tokyo

Editorial Director: Vernon Anthony
Acquisitions Editor: Sara Eilert
Editorial Assistant: Doug Greive
Director of Marketing: David Gesell
Development Editor: Christine Buckendahl
Senior Marketing Coordinator: Alicia Wozniak
Marketing Manager: Kara Clark
Marketing Assistant: Les Roberts
Associate Managing Editor: Alexandrina Benedicto Wolf
Project Manager: Alicia Ritchey

Operations Specialist: Deidra Schwartz
Text and Cover Designer: Kathy Mrozek
Cover Art: AP Photo/Chris Young, CP
Lead Media Project Manager: Karen Bretz
Full-Service Project Management: S4Carlisle Publishing Services
Composition: S4Carlisle Publishing Services
Printer/Binder: Courier Kendallville, Inc.
Cover Printer: Lehigh-Phoenix Color
Text Font: 9/15 Helvetica Light

Photos

Chapter 1, p. 4: Getty. **Chapter 2, p.20:** Marie Antoinette BARBIE doll, courtesy of Mattel. 2003 Limited Edition BARBIE Collector Doll. BARBIE and associated trademarks and trade dress are owned by, and used under permission from, Mattel, Inc. © 2009 Mattel, Inc. All Rights Reserved. **Chapter 3, p. 40:** Getty. **Chapter 4, p. 56:** Getty. **Unit 2, p. 84 (blue Dior purse):** Dorling Kindersley. **Chapter 5, p. 86:** Punchstock. **Chapter 7, p. 122:** Punchstock. **Chapter 8, p. 138:** Getty. **Chapter 9, p. 158:** Punchstock. **Unit 3, p. 174 (mannequin on display):** Andy Crawford, Steve Gorton © Dorling Kindersley. **Chapter 10, p. 176:** Photolibrary.com. **Chapter 11, p. 198:** Getty. **Chapter 12, p. 214:** Dorling Kindersley. **Chapter 13, p. 236:** DanitaDelimont. **Chapter 14, p. 252:** Getty. **Chapter 15, p. 276:** Getty.

Illustrations

Appendix Illustrations by Sumi Lee.
Illustrations in chapters 4, 5, 11 (unless otherwise credited) by Irina Ivanova.

Credits and acknowledgments borrowed from other sources and reproduced, with permission, in this textbook appear on appropriate page within text.

Copyright © 2011 Pearson Education, Inc., publishing as Prentice Hall, One Lake Street, Upper Saddle River, NJ 07458. All rights reserved. Manufactured in the United States of America. This publication is protected by Copyright, and permission should be obtained from the publisher prior to any prohibited reproduction, storage in a retrieval system, or transmission in any form or by any means, electronic, mechanical, photocopying, recording, or likewise. To obtain permission(s) to use material from this work, please submit a written request to Pearson Education, Inc., Permissions Department, One Lake Street, Upper Saddle River, NJ 07458.

Many of the designations by manufacturers and seller to distinguish their products are claimed as trademarks. Where those designations appear in this book, and the publisher was aware of a trademark claim, the designations have been printed in initial caps or all caps.

10 9 8 7 6 5 4 3 2 1

Library of Congress Cataloging-in-Publication Data
Stall-Meadows, Celia.
 Fashion now : a global perspective / Celia Stall-Meadows.
 p. cm.
 Includes bibliographical references and index.
 ISBN 978-0-13-159410-4
 1. Fashion merchandising. 2. Fashion design. 3. Clothing trade. 4. Advertising--Fashion. I. Title.
 HD9940.A2S69 2010
 746.9'2--dc22
 2010005113

www.pearsonhighered.com

ISBN 10: 0-13-159410-9
ISBN 13: 978-0-13-159410-4

brief contents

UNIT I: Fashion Then and Now

1 Overview and Global View of the Fashion Industry | 5
2 European Fashion Influences | 21
3 Early American Clothing Influences | 41
4 Fashion Retrospection: 100+ Years of Fashion | 57

UNIT II: The Uniqueness of Fashion

5 Fundamentals of Fashion | 87
6 Fashion Principles, Perspectives, and Theories | 103
7 Marketing Terminology and the 4 Ps of Fashion Marketing | 123
8 Fashion Analysis and Prediction | 139
9 Fashion Branding | 159

UNIT III: Fashion Marketing Supply Chain

10 Textile Producers and Suppliers | 177
11 Designers, Product Developers, and Fashion Manufacturers | 199
12 Fashion Market Centers, Wholesalers, and Intermediaries | 215
13 Textile and Apparel Legislation | 237
14 Fashion Retailing Formats | 253

UNIT IV: Careers and Opportunities

15 Creative Fashion Careers and Enrichment Opportunities | 277

Appendices

A Basic Apparel Styles | 300
B Small Business Fashion Marketing Plan | 328
C Fashion Retail Promotional Plan | 334
D Sample Résumés, Cover Letters, and Interview Questions | 338

GLOSSARY | 345
BIBLIOGRAPHY | 351
INDEX | 358

contents

UNIT I: Fashion Then and Now

1 Overview and Global View of the Fashion Industry | 5

Learning Objectives 5
Dress and Fashion 7
Why Study Fashion? 7
Why Is Fashion Unique? 10

Fashion Has Emotional Appeal 10 • Fashion Is Perishable 11 • Fashion Is Democratic 11 • Fashion Requires Group Acceptance 11

The Supply Chain or Channel of Distribution 11
Domestic and Global Textile and Apparel Production 13
Domestic and Global Fashion Retailing 15
Four Cs of a Career in Fashion 16

Critical Thinking 16 • Creativity 17 • Charisma 17 • Calculating 18

Summary 18
Terminology for Review 19
Questions for Discussion 19
Related Activities 19

2 European Fashion Influences | 21

Learning Objectives 21
Early Cultural Influences 22
Key European Countries 23

France: Fashion Capital 24 • Italy: Fashion Capital Runner-Up 25

Historic Fashion Innovators and Opinion Leaders 27

Louis XIV 27 • Madame de Pompadour 28 • Marie Antoinette 28 • Rose Bertin 28 • Napoleon Bonaparte 28 • Beau Brummell 29 • Count D'Orsay 29 • Empress Eugénie 30 • Charles Frédéric Worth 30 • Coco Chanel 31 • Christian Dior 32 • Giovan Battista Giorgini 33

Historic European Fashion Communicators 36

Fashion Dolls 36 • Fashion Plates and Periodicals 37

Summary 38
Terminology for Review 38
Questions for Discussion 38
Related Activities 39

3 Early American Clothing Influences | 41

Learning Objectives 41
Ethnic Influences 42

European Immigrant Influences 42 • African Immigrant Influences 46 • Native American Influences 46 • Influences on American Western Wear 46

The Industrial Revolution Developments 47

Spinning Wheel 48 • Spinning Jenny 48 • Steam Engine 48 • Spinning Machine 48 • Weaving Machine or Power Loom 49 • Knitting Machine 49 • Cotton Gin 49 • Sewing Machine 50

The Growth of the American Textile and Apparel Industry 50

Textile Mills 50 • Corporate Codes of Conduct 51 • Sweatshops 53

Summary 54
Terminology for Review 55
Questions for Discussion 55
Related Activities 55

4 Fashion Retrospection: 100+ Years of Fashion | 57

Learning Objectives 57
Fashion in Retrospect 58

Fashion Emphasis, 1900–1909: Swirls of Curves 59 • Fashion Emphasis, 1910–1919: The Angular Look 61 • Fashion Emphasis, 1920–1929: The Roaring Twenties! 62 • Fashion Emphasis, 1930–1939: Implausible Elegance 64 • Fashion Emphasis, 1940–1949: Informal to Delicate 66 • Fashion Emphasis, 1950–1959: Suburban Style 67 • Fashion Emphasis, 1960–1969: The Lull and the Storm 69 • Fashion Emphasis, 1970–1979: Dressing for Success 71 • Fashion Emphasis, 1980–1989: Status Symbols and Conspicuous Consumption 74 • Fashion Emphasis, 1990–1999: Sporty and Comfy 75 • Fashion Emphasis, 2000–Present: You Make the Call! 77

Early Influential American Designers 80

Hattie Carnegie (1889–1956) 80 • Gilbert Adrian (1903–1959) 80 • Claire McCardell (1905–1958) 81 • Edith Head (1907–1981) 81

Summary 82
Terminology for Review 82
Questions for Discussion 82
Related Activities 83
Your Fashion IQ: Case Study
 Romancing the Style: Vintage Fashions 83

UNIT II: The Uniqueness of Fashion

5

Fundamentals of Fashion | 87

Learning Objectives 87
Women's Wear 88

Sizing 88 • Wholesale Price Zones 89

Menswear 91

Classifications 91 • Sizing 92

Children's Wear 93

Trends 94 • Sizing 94

Basic Terminology 95

Contemporary Fashion Terminology 96 • General Fashion
Terminology 97

Basic Apparel Styles 99
Summary 100
Terminology for Review 100
Questions for Discussion 100
Related Activities 101
Your Fashion IQ: Case Study
Halston: Faster Than Fast Fashion 101

6

Fashion Principles, Perspectives, and Theories | 103

Learning Objectives 103
Principles of Fashion 104

Fashion Is Not a Price 104 • The Consumer Is King or Queen 105 •
Sales Promotion Cannot Reverse a Fashion's Decline 105 • All Fashions
End in Excess 105 • Fashion Is a Form of Social Imitation 105 •
Fashion Is Cyclical 106 • Fashion Change Is Evolutionary; It Is Rarely
Revolutionary 107 • Fashion Is a Reflection of the Way of Life 108

Fashion Theories and Theorists 109

Trickle-Down Theory 109 • Trickle-Up Theory 112 • Trickle-Across
Theory 112 • Geographic Theory 113 • Collective Selection
Theory 113 • Fashion Systems Theory 114 • Zeitgeist Theory 114 •
Populist Model 114

Other Fashion Perspectives 116

Timeline of Acceptability 116 • Shifting Erogenous Zone 117 • The
Many Purposes of Fashion in Western Civilization 117

Summary 119
Terminology for Review 119
Questions for Discussion 120
Related Activities 120
Your Fashion IQ: Case Study
Much Ado about One-Quarter Inch 121

7

Marketing Terminology and the 4 Ps of Fashion Marketing | 123

Learning Objectives 123
Target Market and Market Segmentation 124

Demographic Segmentation 125 • Psychographic Segmentation 125 •
Behavioral Segmentation 125 • Geographic Segmentation 127 •
Targeting Multiple Segments 127 • Niche Markets 128

The 4 Ps of Fashion Marketing 130

Product 131 • Price 131 • Place 131 • Promotion 132 • Positioning
and Repositioning 133 • Unique Selling Proposition 134 • Integrated
Marketing Communications 134

Summary 135
Terminology for Review 136
Questions for Discussion 136
Related Activities 137
Your Fashion IQ: Case Study
To Buy or Not to Buy 137

8

Fashion Analysis and Prediction | 139

Learning Objectives 139
Fashion Life Cycle and Adopter Groups 140

Introductory Stage and Fashion Innovators 141 • Rise Stage and Early
Adopters 141 • Culmination Stage and Early Majority 141 • Decline
Stage and Late Majority 142 • Obsolescence Stage and Laggards 142

Marketing and the Fashion Life Cycle 142

Marketing Fashions during the Introductory Stage 142 • Marketing
Fashions during the Rise Stage 144 • Marketing Fashions during the
Culmination Stage 145 • Marketing Fashions during the Decline
Stage 146 • Marketing Fashions during the Obsolescence Stage 146

Database Marketing 147
Fashion Forecasting 147

Color Association of the United States 147 • Doneger Group 148 •
Promostyl 148 • Trendstop 149 • World Global Style Network 149

Fashion Research 149

Types of Research and Data 150 • Steps in Conducting Quantitative
Research 151 • Common Research Methods Used in the Fashion
Industry 153

Summary 155
Terminology for Review 155
Questions for Review 156
Related Activities 156
Your Fashion IQ: Case Study
Barneys and Target Coop: Confusing to Customers? 157

9 Fashion Branding | 159

Learning Objectives 159
The Value of Branding 160

Positioning, Repositioning, Rebranding, and Reinventing Brands 160 •
Brand Equity 161

Types of Fashion Brands 162

Private Label Brands 163 • Multinational and Global Brands 164 •
Designer Brands 164 • Luxury Brands 165

Branding and Legal Issues 166

Licensing Agreements 166 • Intellectual Property Rights 166 •
Knockoffs and Style Piracy 167 • Counterfeiting Brands 168

Summary 170
Terminology for Review 170
Questions for Discussion 171
Related Activities 171
Your Fashion IQ: Case Study
Clothing or Fashion: Useful Articles or Works of Art? 172

UNIT III: Fashion Marketing Supply Chain

10 Textile Producers and Suppliers | 177

Learning Objectives 177
Textile Industry: Scope and Trends 179
Raw Materials in the Fashion Industry 179
Textile Fiber Classifications 180

Natural Fibers 180 • Man-made or Manufactured Fibers 186 • Leather
and Fur as Textiles 190 • Yarns 191 • Fabrication 191

Marketing Textiles 191

Trade Shows 192 • Trade Associations 194

Summary 195
Terminology for Review 195
Questions for Discussion 196
Related Activities 196
Your Fashion IQ: Case Study
Buying Green Fashions: Is This Fundamentally Wasteful? 197

11 Designers, Product Developers, and Fashion Manufacturers | 199

Learning Objectives 199
Designing and Developing Fashion 200
Stages in Product Development and Manufacturing 200

Preproduction and Production Steps 202 • Speed-to-Market
Production 206

Apparel Manufacturing in Developing Countries 206

Sourcing 208 • Working Conditions in Developing Countries 209 •
Codes of Conduct in the Apparel Industry 210

Domestic Apparel Manufacturing 210
Summary 211
Terminology for Review 211
Questions for Discussion 212
Related Activities 212
Your Fashion IQ: Case Study
Proximity Pays: The Case for Domestic Production 213

12 Fashion Market Centers, Wholesalers, and Intermediaries | 215

Learning Objectives 215
United States Market Event Locations 216

New York, New York 216 • Los Angeles, California 220 • Las Vegas,
Nevada 220 • Atlanta, Georgia 220 • Chicago, Illinois 221 • Dallas,
Texas 222

Sourcing Worldwide and Labor-Intensive Regions 224

China 225 • Mexico 227 • India 229 • Indonesia 229 • Vietnam 229

Wholesalers and Other Intermediaries 230

Wholesaling 230 • Independent Resident Buying Offices 232 •
Consolidation, Mergers, and Ownership Groups 233

Summary 234
Terminology for Review 234
Questions for Discussion 235
Related Activities 235

13 Textile and Apparel Legislation | 237

Learning Objectives 237
Regulating Organizations 238

Federal Trade Commission 238 • Consumer Products Safety
Commission 238 • Office of Textiles and Apparel 238 • U.S. Customs
and Border Protection 238 • Office of the United States Trade
Representative 239 • World Trade Organization 239

Legislation and Government Involvement 240

Wool Products Labeling Act 241 • Fur Products Labeling Act 242 •
Flammable Fabrics Act 242 • Textile Fiber Products Identification
Act 242 • Care Labeling Rule 243 • Made in the U.S.A. 243 • North
American Free Trade Agreement 243 • Caribbean Basin Trade
Partnership Act 244 • Central American Free Trade Agreement 244 •
African Growth and Opportunity Act 245 • Multifiber Agreement and
Agreement on Clothing and Textiles 245

Contemporary Global Issues 245

Intellectual Property Rights 246 • Dumping 246 • Bilateral and
Multilateral Free Trade Agreements 247 • Fair Labor Standards and
Human Rights Issues 247

Summary 249
Terminology for Review 250
Questions for Discussion 250
Related Activities 251
Your Fashion IQ: Case Study
 Greenwashing in Green Marketing 251

14 Fashion Retailing Formats | 253

Learning Objectives 253
Fashion Retailing Formats 254
Benefits of Retailing 254

 Breaking Bulk 254 • Taking Ownership of Goods 255 • Providing One-Stop Shopping Experiences 255 • Creating Convenience 255 • Offering Services 255 • Guaranteeing the Products 256 • Linking Manufacturers to Consumers 256

Origins of Retailing 256
Department Stores 257
Specialty Stores and Limited Line Specialty Stores 259

 Pop-Up Stores 260

Mass Merchandise or Discount Stores 260
Off-Price Stores 262
Shopping Centers and Malls 263

 Open-Air Centers 265 • Regional Malls 266 • Superregional Malls 267

E-Tailing, E-Commerce, and M-Commerce 267
Direct Marketing and Other Nonstore Retailing 270
Summary 271
Terminology for Review 271
Questions for Discussion 272
Related Activities 272
Your Fashion IQ: Case Study
 Tough Times in 2008 273

UNIT IV: Careers and Opportunities

15 Creative Fashion Careers and Enrichment Opportunities | 277

Learning Objectives 277
Fashion Careers 278

 Fashion Trend Analyst 278 • Textile Specialist 278 • Designer 280 • Patternmaker 280 • Sourcing Specialist 280 • Product Developer 281 • Account Executive 282 • Independent Wholesale Sales Representative 282 • Merchandise Planner 283 • E-Commerce Merchandise Planner 283 • Buyer 284 • Fashion Copywriter 285 • Merchandise Coordinator 285 • Special Events Coordinator 286 • Executive Training Program Trainee 286 • Store Manager 286 • Visual Merchandiser 287

Entrepreneurship 288

 Why Start a Business? 288 • Business Types 289 • Economic Impact of Entrepreneurship 289

College Opportunities 291

 Internship 291 • Job Shadow 292 • Study Abroad 292 • Attend Career Days, Career Fairs, and Enter Competitions 292 • Visit Fashion Market Centers 294 • Join Student and Professional Organizations 294 • Gain Industry Work Experience 295

Summary 298
Terminology for Review 298
Questions for Discussion 298
Related Activities 299

Appendices

A Basic Apparel Styles | 300
B Small Business Fashion Marketing Plan | 328
C Fashion Retail Promotional Plan | 334
D Sample Résumés, Cover Letters, and Interview Questions | 338

GLOSSARY | 345
BIBLIOGRAPHY | 351
INDEX | 358

preface

Fashion Now: A Global Perspective emphasizes fashion *and* marketing by incorporating business concepts commonly used in general marketing with creative fashion concepts used by design and merchandising students. Students will learn that one of the keys to becoming successful in the fashion business is through decision making based on the marketing approach. This entails first finding out what customers want and then providing a product or service to meet these needs or wants. The fashion industry has tremendous financial opportunities for graduating students, and this textbook focuses on learning how to capitalize on global consumer spending for fashion goods.

The content is of value to all fashion students, whether housed in family and consumer sciences or business marketing. The book is geared toward two- and four-year college students taking an introductory fashion course and is designed to be the sole text used for a three-credit course for an entire semester.

Brief Description

Fashion Now: A Global Perspective is divided into four units to meet market needs:

I. Fashion Then and Now
II. The Uniqueness of Fashion
III. Fashion Marketing Supply Chain
IV. Careers and Opportunities

The textbook is logically ordered, beginning with a historical perspective that covers both domestic and international influences. The basic language and principles of fashion are presented early in the text, so that students can apply these to more advanced marketing and merchandising discussions. Chapters are designed to build on concepts introduced in previous chapters, so learning is reinforced. The globalization of fashion is an important topic in the text, presented in many ways including history, international sourcing and trade, and retailing. Finally, students will explore exciting career opportunities in the fashion industry. Students are provided with a template for developing their own résumé to encourage them to apply at fashion businesses while they are still in college.

Differentiating Features

Unlike the competition, this book includes:

- A discussion of marketing as it applies to fashion to help prepare students to enter the industry.
- A section of basic style illustrations in Appendix A, based on feedback from practitioners, thus bringing real-world examples directly to students.
- The strategic placement of Fashion Facts boxes throughout the chapters which profile a particularly noteworthy idea, person, place, or event, including topics such as sustainability and social responsibility. This further engages the students and encourages them to read ahead.
- The Business of Fashion feature boxes throughout the text highlight a significant business or marketing event or concept.
- Fashion Chronicle timelines throughout the chapters provide a snapshot of the important events.
- An eye-catching, four-color design that includes robust photos and illustrations to keep the highly visual student engaged.
- Concepts that have been thoroughly researched and are based on industry literature, thus providing a sound framework.
- A variety of tables that are based on global industry statistics, thus illustrating actual information.
- Small Business Fashion Marketing Plan project (Appendix B). Presented in bite-sized chunks, the project guides students through the process of building a fashion retail business plan. Instructors can easily implement this ready-made plan as a group assignment and the instructors are presented with a sample project in the instructor's guide. Based in part on the Small Business Administration's suggested business plan, Appendix B offers a real world, team-oriented exercise, ideally adapted to an introductory text.
- Fashion Retail Promotional Plan project (Appendix C). Also presented in bite-sized chunks, the Promotional Plan project offers teamwork opportunities and applies the marketing concepts the students have learned to help launch a promotional event. Instructors are also provided a sample promotional campaign in the instructor's guide.
- For instructors who prefer a chapter-by-chapter assignment, Related Activities sections complement the chapters and provide diverse, creative real-world assignments that help students gain confidence and practitioner skills.

Also note that this book does not devote specific chapters to product knowledge (e.g., discussions of accessories, leg wear, inner wear, cosmetics, etc.). Instead, the book has numerous examples that refer to these products from a broader fashion marketing perspective.

Chapter Features

- Learning Objectives to ensure students understand the expected outcomes;
- Your Fashion IQ Case studies for small group discussion and enhanced learning;
- Questions for Discussion provide additional opportunities for review;
- Important terms set in bold with clear in-text definitions and Terminology for Review;
- In-text citations and a complete Glossary and Bibliography for additional research opportunities;
- Related Activities that reinforce student learning;
- Numerous photographs, tables, graphs, illustrations, and charts strengthen the visual appeal of the textbook and provide students with valuable pictures that are worth a thousand words.

Overall Approach

Fashion Now: A Global Perspective provides fashion merchandising and marketing students with a detailed and highly visual study of important introductory fashion concepts and a global view of the fashion industry. Careful structuring of the chapters enables this textbook to remain current in spite of fashion changes. The textbook should remain a viable book choice through several semesters and updated editions are planned.

About the Author

Celia Stall-Meadows' currently teaches apparel merchandising classes at Oklahoma State University in Tulsa, OK. Her previous academic experience encompasses fashion marketing and general marketing classes in the College of Business at Northeastern State University in Tahlequah, OK. Over the past two decades, Stall-Meadows has taught a wide variety of fashion merchandising classes at a total of four different universities: a community college, a regional university, an online university, and a comprehensive university. This is her second textbook in the field of fashion. She welcomes any feedback or suggestions for future revisions from practitioners, students, and faculty.

Instructor's Resource Center

There is an Instructor's Manual (ISBN: 013-159413-3) and PowerPoint (ISBN: 013-5010419-X) associated with this title.

To access supplementary materials online, instructors need to request an instructor access code. Go to www.pearsonhighered.com/irc, where you can register for an instructor access code. Within 48 hours after registering, you will receive a confirming e-mail, including an instructor access code. Once you have received your code, go to the site and log on for full instructions on downloading the materials you wish to use.

Acknowledgments

A special thank-you goes to all my former students who inspired me to authorship and continuing professional development. This book is for you. To Dad, Mom, Kendall, Faye, Kendra, and Elaine—much love and thanks for your abiding support.

We would also like to thank our reviewers:
Courtney Cothren, Stephens College
Julie DeMaggio, Butte College
Mary Ann Eastlick, University of Arizona
Phyllis Fein, SUNY Westchester Community College
Eun Jin Hwang, Indiana University of Pennsylvania
Jim McLaughlin, Florida State University
Diana Saiki, Ball State University
Patricia Stealey, Shepherd University
Nelly Tejeda-Rodriguez, Keiser University

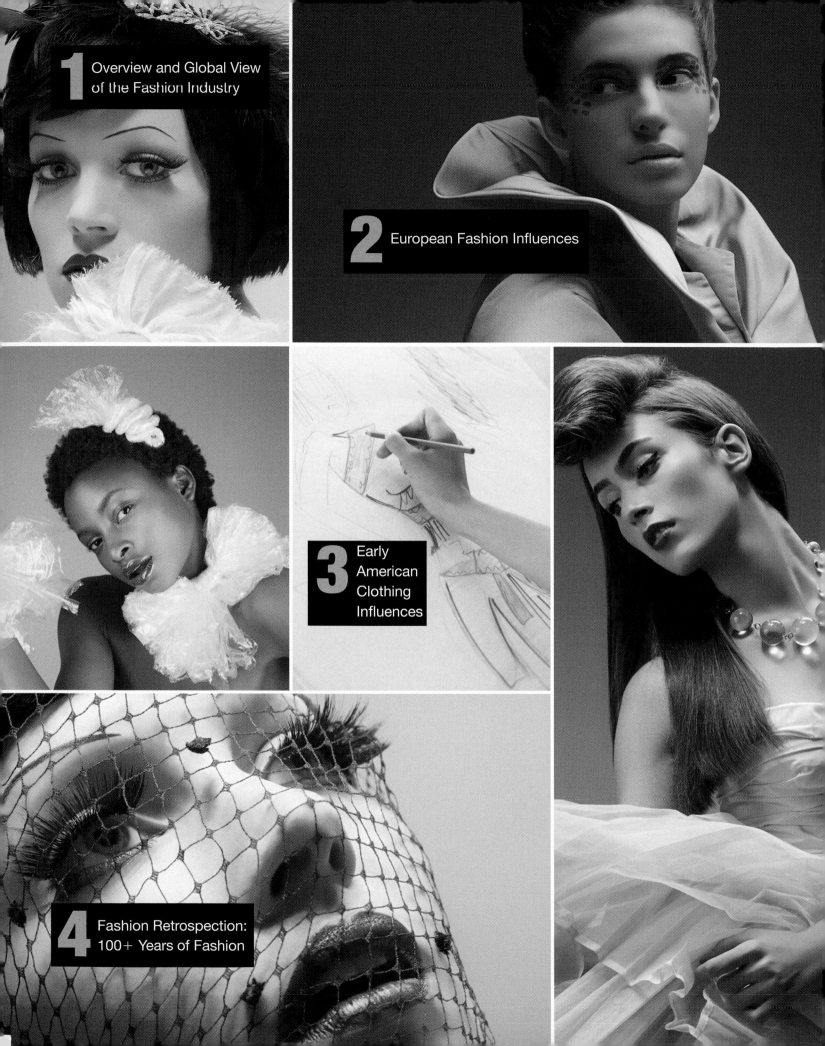

1 Overview and Global View of the Fashion Industry

2 European Fashion Influences

3 Early American Clothing Influences

4 Fashion Retrospection: 100+ Years of Fashion

FASHION
Then and Now

"After all, malls in Dayton, Ohio, and
Singapore all carry the same Ralph Lauren
Polo shirt these days."

THOMAS E. HICKEY, Textile World, Nov./Dec. 2006

OVERVIEW and GLOBAL VIEW of the FASHION INDUSTRY

LEARNING OBJECTIVES

At the end of the chapter, students will be able to:

- Compare fashion in apparel and accessories with fashion in other consumer products.
- Identify different career opportunities given a student's skills and strengths.
- Identify the emotional motives consumers have for buying fashion.
- Discuss the characteristics that make fashion unique.
- Explain the relationship among the levels of the fashion merchandise supply chain.
- Explain the importance of speed to market during production.
- Order the steps in creating and selling fashion merchandise from production through consumption.

Fashion occurs in almost every aspect of life. One of the many definitions of fashion is that fashion is what the majority of a group is wearing. However, apparel and accessories are not the only products subject to fashion influences. Fashion's pervasive nature becomes evident in many products areas, including food, interiors, architecture, automobiles, lifestyles, technology, and many other consumer goods. The red thread that connects these different aspects of fashion is usually a larger, more pervasive trend. For example, as the green movement gains momentum in consumer products and lifestyles, it affects what is fashionable in many consumer products, such as organic foods,

sustainable environments, hybrid automobiles, postconsumer recycling, eco-friendly products, and organic apparel. Another pervasive trend might be the concept of streamlining. Apparel may reflect simple designs, interiors may feature minimalist décor, and automobiles and buildings may become sleeker and less ornate.

Often the fashion first shows up in apparel and accessories, but it seeps into other product areas. Most often, the fashion moves from accessories and apparel to home fashions and then eventually to other consumer products. For example, in the 1950s, the fashionable pink-and-gray color scheme was first visible in women's wear and menswear and soon after became popular in home furnishings and home exteriors. In the second half of the 1960s decade, the futuristic and space age look became all the rage in apparel and accessories (shiny patent leather shoes and ciré and lamé fabrics). Home interiors and office building exteriors mirrored shiny, futuristic details, and automobiles sported bubbles and wings that were reflective of the space age, such as the Batmobile. Television programs such as *The Jetsons, Lost in Space*, and *Get Smart* also reflected the space age optimism and futuristic technology in the 1960s.

More recently, the fashion of a black-and-white color scheme became popular in women's wear, bridal party wear, wedding cakes, china, kitchen appliances, and kitchen and bath interiors. Whether studying the history of clothing, interiors, architecture, or automobiles, definite fashion trends are identifiable and quite often linked to the other products of the era. Figure 1.2 shows the influence of a similar fashion look across several consumer products.

Figure 1.1 Futuristic 1960s fashion.
(Getty Images/Stone Allstock)

Figure 1.2 A similar fashion trend shows up in a variety of products.

Dress and Fashion

The terms *dress* and *fashion* are related, but each considers apparel from a different perspective. According to one of the foremost authorities in the study of clothing, Joanne Eicher, dress is a symbolic communicator of a person's identity. The term *dress,* according to Roach-Higgins and Eicher (1992), includes apparel and accessories as well as body modifications and supplements to the body. On the other hand, the primary consideration for fashion would be that the dress has achieved acceptance by the majority of a group. Fashion is less concerned with a single person's identity and more concerned with group identity. An individual's look and his or her intent to communicate would be important to a behavioral or social scientist. A businessperson or marketer would be interested in the ultimate profitability of interpreting broader classifications of looks into marketable ideas.

Why Study Fashion?

The employment opportunities in fashion encompass dynamic careers at every level of the industry. A career in fashion can be a very rewarding opportunity, and the types of careers are quite varied. Whether students are problem solvers, creative, people-oriented, or skilled with numbers, the fashion industry offers exciting challenges, competitive salaries, and the opportunity to travel globally.

Because students have the most interaction with retail salespeople, it is common for incoming fashion marketing students to assume that a degree in fashion marketing leads to a career as a retail sales position. This is far from the truth! It is true that many students begin their fashion marketing careers in retail stores as part-time sales clerks to help supplement their school expenses. This type of work experience is valuable to employers because it demonstrates an understanding of selling and of providing customers what they want, when they want it. The definition of good **merchandising** is providing the right merchandise, at the right time, in the right sizes and quantities, and at prices consumers are willing to pay. Once students understand the power of the consumer, they can identify the practices leading to profitable merchandising and marketing.

The fashion industry consists of many career paths for students with ambition, creativity, and a love of fashions and fabrics. The best way for a student to find the right path is to remain attentive and ask questions. When shopping, the student of fashion can quiz the salesclerks or store managers about careers in the field of retailing. If professors schedule guest speakers, ambitious students will stay after class and make introductions. If the school has a job-shadowing program with area employers, students should ask to participate. They gain helpful information from talking to recent graduates of the program because alumni are usually quite willing to assist students. They should make every effort to attend career days and enter student competitions sponsored by professional organizations. As one senior apparel design student who won multiple awards for her student fashion design noted, "If you don't enter, you can't win!" Students can look for opportunities to travel domestically and abroad. They should read fashion magazines religiously, learn names of styles, touch fabrics, and read garment labels every time they shop—and they should shop often, even if it is only window-shopping or browsing. The best thing a student can do to learn about the fashion industry is to get a job—any job related to the business of fashion. It will open more employment doors for a student than almost any other source. Students should be assertive and not get discouraged. If a company is not hiring

today, they can check back in a few weeks and again in a few more weeks. The employer is likely to appreciate the student's persistence. Students need to develop professional résumés (see Appendix D for samples) and dress fashionably, but not fussily or seductively (and definitely not in jeans). Job seekers should submit no less than five applications per week (every week) until they get that fashion job. Most importantly, students must be enthusiastic and let the interviewers know they are truly interested in the job. During the interview, the applicants should explain their interest in the company and let the employer know of their desire to pursue a career in fashion upon graduation.

> The fashion industry consists of many career paths for students with ambition, creativity, and a love of fashions and fabrics.

A recent perusal of one issue of the daily trade publication, *Women's Wear Daily*, revealed many advanced level career opportunities. These advertised positions usually require three to five years of direct work experience, so they are not appropriate for entry-level job seekers. However, a list of the vacancies provides some idea of the varied nature of fashion career opportunities. An entry-level position might entail becoming an assistant for any one of these advertised positions. Tables 1.1 a–f show positions in corporate headquarters, fashion production, marketing, and many other fashion-

Table 1.1a Corporate Buying Office Positions

Corporate Buying Office Positions	
Assistant Buyer	Merchandise Planning Manager
Buyer	Store Planner
Brand Manager	Warehouse Manager
Customer Service Allocator	

Table 1.1b Data Analysis Positions

Data Analysis Positions
Replenishment Analyst
Retail Analyst
Merchandise Analyst

Table 1.1c Production Positions

Preproduction and Production Positions	
CAD Artist, CAD Coordinator, CAD Designer	Patternmaker, Technical Designer
Assistant Designer	Product Developer
Designer	Production Coordinator (Bilingual)
Draper	Production Manager
Graphic Artist	Quality Assurance Manager
Graphic Designer	Sample Maker
Fabric Director/Fabric Purchaser	Sourcing Director
Fit Model	Tailor, Seamstress, Fitter
Master Tailor	

Table 1.1d Marketing Positions

Marketing Positions	
Public Relations Director	Vice President of Merchandising
Marketer	Web Designer
Vice President of Marketing	

Table 1.1e Wholesale Sales Positions

Wholesale Sales Positions
Account Manager
Account Executive
Business Manager
Showroom Manager
Wholesale Sales Representative

Table 1.1f Retail Store Positions

Retail Store Positions	
Alterations	Store Manager
District Visual Manager	Visual Merchandiser

related opportunities advertised in one issue of the classified section of the *Women's Wear Daily* periodical. Chapter 15 provides detailed descriptions of various fashion careers.

U.S. Department of Labor data show the average wages for several different fashion-related occupations. Most retail salesperson and unskilled production-type jobs are compensated with hourly wages, whereas those positions requiring advanced education and prior work experience are salaried positions. Table 1.2 shows the fashion occupations wage data obtained from the U.S. Department of Labor and the U.S. Census Bureau.

Table 1.2 Wage Table for Selected Fashion Occupations in the United States

Fashion Industry Occupation	Median Annual Earnings	Mean Annual Earnings	Median Hourly Earnings	Mean Hourly Earnings
Apparel manufacturing supervisor	N/A**	N/A	15.23	N/A
Cloth/fabric designer (27-1021)*	N/A	60,540	27.19	29.11
Clothing store retail salesperson	N/A	N/A	8.53	N/A
Fabric/apparel patternmaker (51-6092)*	N/A	40,900	17.18	19.67
Fashion designer (27-1022)*	71,840	71,170	30.60	34.22
First-line supervisor or manager of retail salespersons (41-1011)*		39,210	16.57	18.85
Interior designer in furniture stores	38,980	N/A	N/A	N/A
Interior designer in specialized design services (27-1025)*	42,000	50,190	21.14	24.13
Marketing manager (11-2021)*	N/A	113,400	50.19	54.52
Retail salesperson (41-2031)*	N/A	23,170	9.69	11.79
Textile mill supervisor	N/A	N/A	19.35	N/A
Visual merchandiser (27-1026)*	N/A	27,370	11.94	13.16
Wholesale or retail buyer (13-1022)*	42,230	49,050	22.58	25.76
Wholesale sales representative (41-4012)*	N/A	60,190	24.40	28.94

SOURCES: *May 2007 National Occupational Employment and Wage Estimates, United States.* U.S. Department of Labor, Bureau of Labor Statistics. Retrieved June 2, 2008, from http://www.bls.gov/oes/current/oes_nat.htm#b41-0000

Occupational Outlook Handbook, 2008-2009 Edition. Bureau of Labor Statistics, U.S. Department of Labor. Retrieved June 2, 2008, from http://www.bls.gov/oes/current/oes412031.htm

*Denotes the Standard Occupational Classification (SOC) numbering system used by U.S. government federal agencies.
**N/A denotes not available.

The salary data supplied in the tables are general and do not reflect regional differences, but they are helpful starting points for information. An advisor or teacher is another good source of salary information because instructors generally have contacts with recent graduates and can provide more specific salary ranges and even exact starting salaries for some companies. Career counselors and placement services subscribe to additional databases and may know beginning salaries offered by employers that interview on campus.

Students armed with degrees in apparel or textiles and directly related work experiences are the most marketable and can command the highest salaries. It is important to know the average starting salaries in a particular industry, so that students can be sure they are being compensated fairly.

FASHION FACTS: The Four Rs of Sustainability

As students begin their college career studying the fashion industry, they will need to keep their eye on the concept of sustainability. Broadly speaking, sustainability means producing and consuming in a way that does not compromise the environment or future generations. It includes reducing, reusing, recycling, and redesigning. The Web site of the U.S. Environmental Protection Agency (EPA) provides a definition of sustainable development. It states: "Sustainable development meets the needs of the present without compromising the ability of future generations to meet their own needs" (Sustainability, 2008).

Students of fashion can view sustainability on many levels of the textile,

apparel, and fashion industries. Sustainability can mean the elimination of harmful herbicides and pesticides used for growing natural fibers. It refers to creating manufactured fibers from renewable resources or recycled materials. Sustainability means eliminating water pollution during the production processes required to tan leather and manufacture and dye textiles. It involves designing products that can be easily recycled or reused after consumers have finished with them. Sustainability means reducing or eliminating the packaging. In general, it involves "using less stuff."

So important is creating a sustainable environment, that the Environmental Protection Agency created a student

sustainability competition called the P3 Program (People, Prosperity, and Planet). The program is open to student-led college teams who conduct research on sustainable issues. Winning teams will "receive support to research, develop, and design solutions to real-world challenges involving sustainability" (Sustainability, 2008). For additional information on the competition, see the EPA's P3 Student Design Competition for Sustainability at http://epa. gov/sustainability/index.htm.

SOURCE: *Sustainability.* (2008). U.S. Environmental Protection Agency Web site. Retrieved Nov. 15, 2008, from http://epa.gov/sustainability/index.htm

Why Is Fashion Unique?

Add *fashion* to almost any consumer product and the company will sell more of its products. Fashion is appealing, fashion is ever-changing, and best of all, fashion is democratic. Fashion apparel and accessories possess unique qualities not found in other consumer products. The fashion industry thrives because of these special qualities. The following sections explain the differences between fashion goods and general consumer products, such as electronics, automobiles, food, and many other nonfashion goods.

Fashion Has Emotional Appeal

Fashions create beautiful visual images. The products of clothing, accessories, and home décor are superficial, without deep meanings, yet marketers may patronize consumers by infus-

ing the fashion promotions with **emotives** (emotional motives) to sell more fashion. Ideally, a fashion marketer creates emotionally charged marketing campaign to sell fashions, but realistically, fashion is a business and should be taken at face value.

Fashion Is Perishable

Fashions quickly go out of fashion. It is perishable by nature and must be available through retailing channels at the precise time the fashion gains acceptance. Speed, from idea conception to product delivery, is the key to ensuring a product is on the shelves soon after customers demand it. If just a couple of weeks too late, the merchandise may lose market attractiveness, and the selling price declines.

The fashion industry is built on the foundation of **planned obsolescence**. Since consumers grow tired of wearing the same apparel and accessories over an extended time, the fashion industry responds with continual introductions of new and different styles, prints, colors, and fabrics. The new introductions are somewhat dissimilar, rendering the former styles, prints, colors and fabrics out-of-date or **out of fashion**. Chapter 6 contains information about a similar concept called *artificial obsolescence.*

Fashion Is Democratic

Fashion is a dichotomous concept that encompasses the notion of conformity and individuality. It coexists as fashions-for-all as well as status symbols for individuals. True fashion is available to everyone because the same fashion look can be available at all price levels, from budget to couture.

A fashion can start anywhere, in any city and in any country. It can begin with an ethnic or mainstream group, with celebrities or common laborers, and with any age group, although teenagers and young adults are the primary fashion innovators.

Fashion Requires Group Acceptance

A fashion only exists with group acceptance. The very term *fashion* implies group acceptance. Without group acceptance, a style is destined to remain a style and never become a fashion. Nonfashion products are still products, whether or not many of the items actually sell. A particular style cannot be a fashion unless the majority of a group accepts it. According to Rishad Tobaccowala, a business management consultant, "Fashion emerges from unexpected places and its content is edited by the wisdom of the crowd" (Kurt Salmon Associates, 2008, p. 9). This means that the whims of the group that adopt the fashion control the direction of fashion, not the fashion editors and companies.

> Apparel and accessories styles do not become fashions until the majority of a given group is wearing them.

The Supply Chain or Channel of Distribution

The fashion industry, regardless of location, is comprised of several levels with each level selling and distributing to the following level. This group of levels is called the **supply chain**. The process of moving fashion merchandise from its conception to the ultimate consumer through

these levels is the **channel of distribution**. Generally, marketers use these two terms interchangeably, although *supply chain* is the more current term. The levels include:

producers → manufacturers → wholesalers → retailers → ultimate consumers.

The goal of marketers is to move the fashion merchandise through the fewest possible levels in the shortest period of time. This is called **speed to market** and is a key to successfully marketing fashions that are hot at the moment and demanded by consumers. Lost sales occur when there are too many participants in the supply chain or wasted time exists in the channel of distribution. Merchandise may go through every level of the supply chain before it reaches the ultimate consumer, whereas other merchandise might bypass a level, such as the wholesaling level. Each time fashion goods pass from one member of the supply chain to another and each time the merchandise changes ownership, the prices are increased. Some companies choose to bypass the middleman or wholesale level to gain greater profits, while passing along savings for the ultimate consumers. Other companies vertically integrate and design, manufacture, and retail their own products. Some variation of the levels still exists, whether they are all conducted under the ownership of the same company or each level is performed by separate companies. Shown following is an expanded version of the supply chain for apparel. Accessories go through similar levels (production, manufacturing, wholesaling, and retailing), but the activities within the levels might be different. For example, if the fashion items were silver jewelry, the production stage would consist of the mining of the silver ore and the processing and melting of the silver to ready it for jewelry manufacture.

- Fiber and yarn production
 - Raw fibers growth or manufacture
 - Yarn spinning (fibers spun into yarns suitable for weaving or knitting)
- Textile production and converting into finished fabrics
 - Fabric weaving
 - Fabric knitting
 - Nonwovens, braids, and other miscellaneous construction processes
 - Dyeing, printing, and so forth
- Fashion manufacturing
 - Apparel
 - Accessories
- Wholesaling
 - Importers
 - Middlemen
 - Jobbers
- Retailing
 - In-store
 - Electronic retailing
 - Direct selling
- Auxiliary services (supporting services that occur at every level)
 - Forecasting services
 - Advertising, publicity, and promotions
 - Buying or merchandising offices
 - Consulting services

Unit III of the textbook is entitled the Fashion Marketing Supply Chain, and it contains separate chapters devoted to the levels of the supply chain, from textile producers and suppliers through the retailing function.

Domestic and Global Textile and Apparel Production

Worldwide, the textile and apparel industry is a $450-billion-dollar market. Together, the United States and the European Union are the largest participants in global trade and are enormous consumers of globally manufactured fashions.

Offshore sourcing of textiles and apparel continues to be a major trend in the fashion industry because the production of textiles and clothing is labor-intensive. As a result, the lowest hourly wage becomes an important factor in determining where the manufacturing of textiles and apparel occurs. Production facilities outside of the United States account for approximately 96 percent of the fashion apparel and accessories sold in the United States. Buyers from developed countries continue to seek out low-cost production countries for sourcing. The retail demand for apparel products has increased in the United States, but the number of textile and apparel manufacturing jobs in the United States has declined 40 percent since 2000. Table 1.3 shows the amount of imports from several countries supplying the United States with apparel and accessories (NAICS Code 315) in both 2000 and 2008. The most significant increases are from China and Vietnam. Table 1.4 shows the top countries supplying the United States with textiles and fabrics (NAICS Code 313) for the years 2005 and 2008. China is the largest supplier with over $1.3 billion in textiles and fabrics supplied to the United States. Table 1.5 shows the U.S. exports of textiles and fabrics (NAICS Code 313) in the years 2005 and 2008. The

Table 1.3 U.S. Imports of NAICS 315

Top countries supplying the United States with apparel and accessories manufactured products (NAICS Code 315) in 2000 and 2008; totals in thousands ($ USD)

Country	2000 Imports into U.S.	2008 Imports into U.S.
China	8,314,815	26,169,885
Vietnam	47,321	5,238,551
Mexico	8,709,783	4,194,751
Indonesia	2,136,050	4,039,704
Bangladesh	2,117,778	3,443,663
India	2,022,050	3,214,415
Honduras	2,417,430	2,675,392
Italy	1,713,609	1,697,842
Thailand	1,839,652	1,693,763
Hong Kong	4,582,654	1,581,077
El Salvador	1,602,095	1,533,968
Sri Lanka	1,481,676	1,497,318
Guatemala	1,500,016	1,401,633
Philippines	1,923,240	1,377,906
Canada	1,912,594	819,286

SOURCE: National Trade Data. TradeStats Express. Provided by the Office of Trade and Industry Information, Manufacturing and Services, International Trade Administration, U.S. Department of Commerce. Retrieved July 15, 2009, from http://tse.export.gov

Table 1.4 U.S. Imports of NAICS 313

Top countries supplying the United States with textiles and fabrics (NAICS Code 313) in 2005 and 2008; totals in thousands ($ USD)

Country	2005 Imports into the U.S. (in thousands $ USD)	2008 Imports into the U.S. (in thousands $ USD)
China	977,360	1,313,093
Canada	1,069,488	763,276
South Korea	635,413	532,564
Italy	574,259	518,088
Mexico	580,800	500,397

SOURCE: National Trade Data. TradeStats Express. Provided by the Office of Trade and Industry Information, Manufacturing and Services, International Trade Administration, U.S. Department of Commerce. Retrieved July 15, 2009, from http://tse.export.gov

Table 1.5 U.S. Exports of NAICS 313

Top countries supplied textiles and fabrics (NAICS Code 313) by the United States in 2005 and 2008

Country	2005 Exports from the U.S. (in thousands of $ USD)	2008 Exports from the U.S. (in thousands of $ USD)
Mexico	3,066,895	2,509,740
Honduras	1,003,187	1,361,656
Canada	1,270,881	1,086,683
Dominican Republic	572,692	474,185
El Salvador	418,973	410,236
China	263,352	389,744

SOURCE: National Trade Data. TradeStats Express. Provided by the Office of Trade and Industry Information, Manufacturing and Services, International Trade Administration, U.S. Department of Commerce. Retrieved July 15, 2009, from http://tse.export.gov

countries involved with the North American Free Trade Agreement (NAFTA) and the Central American Free Trade Agreement-Dominican Republic (CAFTA-DR) receive the most textile shipments. Chapters 11 and 12 contain discussions about the changes over the years and other issues of apparel manufacturing.

The fashion industry is extremely competitive on a global scale because of its low barriers to entry (relative ease of start-up). Countries that are industrializing may begin with textile and apparel factories because these industries do not always require extensive know-how or large capital investments. The workers in most textile and apparel production industries do not require extensive training. These industries may begin as low-technology, cottage industries, or they may be set up with more sophisticated textile and apparel machinery. Due to the low barriers to entry, the vast majority of countries in the world has textile and apparel production industries and trades these products with other countries.

To aid the struggling domestic apparel manufacturing industry with international trade opportunities, the U.S. government established the Office of Textiles and Apparel (OTEXA). This office provides resources to assists domestic textile and apparel companies in competing in the global economy. Domestic companies desiring to export merchandise gain support from

the office's Export Advantage. **Export Advantage** is an informational resource staffed by trade specialists that assist domestic producers and manufacturers with exporting U.S. textiles and apparel products.

Domestic and Global Fashion Retailing

According to the U.S. Census Bureau, the 2005 per capita spending at clothing and clothing accessories stores was $680. Per capita spending at nonstore retailers was $840. Consumers spent about 6.4 percent of this total, or $54, on clothing and clothing accessories bought via the Internet in 2005. This translates into online sales of $12.5 billion for apparel, apparel accessories, and shoes in 2005, which was a 23 percent increase over the previous year (Dodes, R., 2006). In addition, the per capita spending at general merchandise stores was $1,774. General merchandise stores include mass merchandise or discount stores, such as Wal-Mart, Costco, and Target, with large sections of high-margin apparel and accessories.

In-store retailing is highly competitive and requires uniqueness on the part of the retailers. Important trends include niche marketing, shoppertainment, shortened inventory cycles (buy now—wear now approach), loyalty programs, and multichannel retailing by traditional brick-and-mortar stores. **Niche marketing** refers to focusing on a narrow target customer base, such as the specialty store Hot Topic that caters very specifically to concert-going, gothic teenagers. **Shoppertainment** is a merchandising philosophy that combines the shopping experience with entertainment opportunities. For example, a mall may offer fashion retail stores, restaurants, and a movie theater or arcade. A store may feature a Starbucks kiosk or even an entire food court, such as Macy's Herald Square in New York City. The purpose of creating an entertaining atmosphere is to differentiate from competitors and encourage shoppers to stay longer, thereby spending more money. **Shortened inventory cycles** mean retailers stock the floors with merchandise closer to the wearing season and tend to keep the merchandise in the store for shorter periods of time. This keeps the merchandise selection new and fresh and available when customers are actually wearing the fashions. **Loyalty programs** reward a store's best customers—the people who spend the most and shop the most in that store. These programs may take the form of extra discounts, early sale notices, VIP days, or frequent buyer clubs. **Multichannel retailing** is the combination of retailing venues to offer convenience to customers. A common example is when a traditional store enhances its in-store retailing with a Web site and a toll-free telephone number for ordering. Retailers strive to seamlessly integrate the variety of retailing channels so that consumers can shop in a convenient manner. For example, a customer can make a selection online or order via a toll-free number and have the item shipped to his or her home, and if it doesn't fit, he or she can return it to the nearest store without any problem.

Internet retailing offers wide selections, efficiency, and value to online customers. It is especially suitable for consumers who have significant amounts of discretionary income and are time poor. Internet retailers should focus on a well-designed Web site and efficient operations, including quick order fulfillment and ease of merchandise returns.

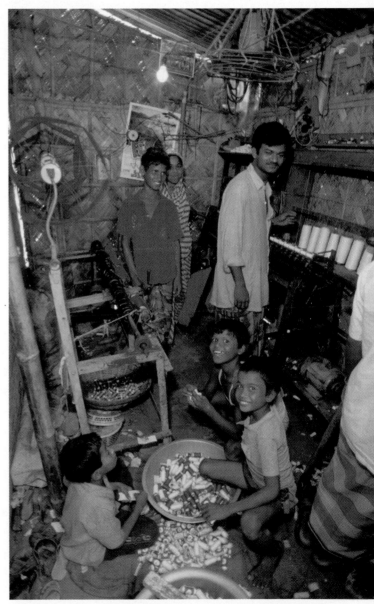

Figure 1.3 Cottage-type manufacturing facility.
(© ADAM BUCHANAN/DanitaDelimont.com)

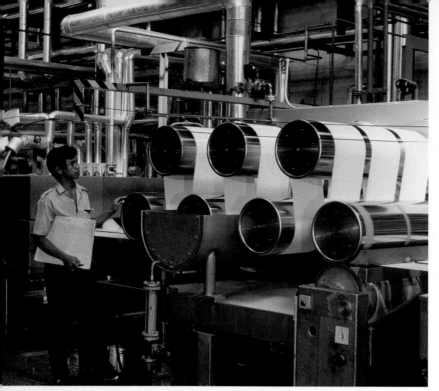

Figure 1.4 High-tech manufacturing facility.
(© Mira.com/Peter/Georgina Bowater)

Globalization is a major trend in retailing, and consumers are becoming increasingly receptive to the trend. Globalization may take the form of retailers opening up stores in foreign countries, such as Wal-Mart opening a store in China. It may take the form of global brand companies offering products in local retail stores all over the world, and it may take the form of global Internet retailing. The widespread availability of the Internet and increased travel opportunities for consumers create familiarity with foreign retailers and brands, regardless of a consumer's home country, and consumers in developing countries are hungry for popular global brands such as Chanel, Ralph Lauren, Louis Vuitton, Nike, and Gap.

Giant domestic retailers expand into foreign countries because of the retail saturation in mature consumer markets such as the United States. In order to grow, companies opt for less-developed consumer markets that have some discretionary income such as India, China, Brazil, or Germany. **Multinational** companies operate in foreign countries and include retailers such as Gap, IKEA, Zara, and Home Depot. Chapter 14 includes a discussion of domestic and global retailing formats.

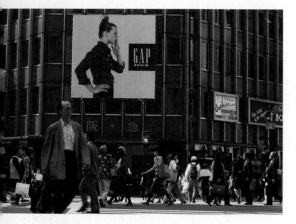

Figure 1.5 GAP stores sell similar merchandise across the world.
(CORBIS)

Four Cs of a Career in Fashion

When evaluating the marketability and quality of a diamond, the gemologist looks for the precise combination of the four Cs of a diamond: cut, clarity, carat, and color. Likewise, in order to be a marketable graduate of a fashion program, the student should possess a combination of four Cs: critical thinking, creativity, charisma, and calculating. The student may be stronger in one of the four Cs than in another, but as a total package, he or she should possess some degree of all of the four Cs. These are general characteristics important for all types of fashion careers; specific careers will be discussed in Chapter 15.

Critical Thinking

A college education is one of the best ways to prepare oneself to think critically. To think critically means to consider a problem, gather information, evaluate the alternatives, and make an informed decision. Postsecondary classes are designed to encourage students to think critically and explore ideas not previously considered. Often, the phrase "thinking outside the box" is used to describe critical thinking. Young professionals are expected to break down a problem into smaller components and determine the best way to resolve each of them. It is like having a goal and determining the objectives required to achieve the goal. For example, a problem might be that sales need to be increased and expenses need to be decreased. What is the best way to do this? A critical thinker will look at many possibilities: revising the staffing during peak or slow times; studying sales data and determining which SKUs (stockkeeping units) are the most/least profitable; remerchandising the selling floor; implementing promotions that increase store traffic and provide a desired return on investment; and many other ideas that might achieve the goal. Asking questions, seeking information, considering alternatives, and choosing the best course of action are elements of critical thinking that a college-degreed professional faces every day.

Students of fashion can get a general idea of the career paths that are available in the textile and apparel industries by studying the *Career Guide to Industries* published by the U.S. Bureau of Labor Statistics. The document explains the outlook for a career position in two broad occupation categories: manufacturing and trade. Within the Manufacturing Industry section, the *Career Guide* lists the subheading Textile, Textile Product, and Apparel Manufacturing. Within the Trade section are two subheadings: Wholesale and Clothing, Accessory, and General Merchandise Stores. The Wholesale section is not specific to the textiles and apparel industry, but it does offer some helpful explanations about wholesaling in general. The Clothing, Accessory, and General Merchandise Stores subheading includes relevant topics such as Nature of the Industry, Working Conditions, Employment, Occupations in the Industry, Training and Advancement, Outlook, and Earnings.

Unfortunately, the broad classifications presented are not representative of specific career paths, and the guide highlights only a limited number of the potential careers that fashion students can pursue. For a closer look at specific occupations, Chapter 15 of this textbook offers a variety of ideas.

SOURCE: *Career Guide to Industries.* United States Bureau of Labor Statistics. Retrieved March 16, 2009, from www.bls.gov/oco/cg

Creativity

Most students who study fashion, apparel, and textiles have some creativity—an eye for color and the ability to effortlessly put together a fashionable outfit. This fashion ability becomes increasingly evident by the time they reach high school. They have known all along that being fashionable does not mean spending a lot of money on clothing, nor does it mean mismatching random articles of clothing. Instead, they realize that creativity and the way certain items are pulled together (via style, colors, prints, and/or fabrications) are what make a fashionable ensemble. This process of acquiring an elevated taste level and aptitude for crafting fashionable looks is defined as **studied creativity**.

Students who are creative and have a flair for fashion might choose a career as a textile or style designer, product developer, advertiser, or visual merchandiser. The career paths offer hands-on experience appealing to many young professionals. For example, designers and product developers excel at the ability to interpret social cues and create marketable apparel and accessories. Another example might be a visual merchandiser for a department store who is responsible for creatively displaying merchandise in the large windows and setting up displays in the interior of the store. The visual merchandiser may also be responsible for designing floor sets and maintaining the signage throughout the store.

Figure 1.6 A career in visual merchandising is for creative individuals.

Charisma

The Merriam-Webster online dictionary defines charisma as "personal magic of leadership arousing special popular loyalty or enthusiasm for a public figure" (www.m-w.com, 2008). The key words in this definition are leadership, loyalty, and enthusiasm. A fashion marketer should be a strong leader and be able to motivate those with whom he or she works. Persuasion skills are needed in just about every type of job in the fashion industry. At all levels, fashion marketers are attempting to persuade others to their line of thinking. Whether it is persuading customers to buy, persuading salespeople to sell with enthusiasm, or persuading colleagues to adopt an

idea or plan, charisma is needed. Fearmongering and browbeating simply do not work for long in a free society and certainly not in business.

Like all the other Cs of fashion marketing, charisma can be developed with practice and application. Those persons who naturally possess high degrees of charisma often choose careers in sales or in sales management. They enjoy the challenge of persuading or encouraging others and the successes of selling. A career in sales is a rewarding opportunity for highly charismatic individuals, and the earning potential can be quite high.

Calculating

Mathematical and computer skills are also important to fashion marketers. Understanding basic mathematical functions (such as multiplication, fractions, and percents), algebra, statistics, and spreadsheet applications are needed for many careers in fashion marketing. Students who excel at calculating might want to consider fashion-related occupations that deal with number crunching and data analysis. For example, a career as a fashion buyer involves working from a budget, calculating open-to-buy amounts, estimating sales figures, and evaluating gross margins and markups. The design field has many applications related to calculating, too. During preproduction and production, efforts are devoted to calculating and applying measurements and creating specification sheets for manufacturers. All levels of the industry are concerned with sales, inventories, and profits, so a basic accounting course is indispensible.

summary

- Fashion may occur in almost every aspect of life, including food, interiors, architecture, automobiles, lifestyles, and technology.
- Fashion usually emerges first in apparel and accessories but trickles into other product areas.
- For the best career preparations, college students are encouraged to gain part-time employment, have strong work ethics, and understand that change will be a constant during their employment.
- The income is rewarding, the hours are sometimes long, and travel opportunities are increasingly available.
- Fashion products appeal to consumers' emotions.
- Fashion is perishable.
- Fashions are available to most income levels of consumers.
- Fashion requires group acceptance.
- Apparel and accessories styles do not become fashions until the majority of a given group is wearing them.

- The fashion industry is comprised of many levels called a supply chain or channel of distribution, and fashion merchandise moves through these levels on the way from the producer to the ultimate consumer.
- The supply chain levels are:
 producers → manufacturers → wholesalers → retailers → ultimate consumers.
- The sourcing of textiles and apparel comes from suppliers all over the world because offshore sourcing is a way to obtain the lowest costs on merchandise.
- Current trends in retailing include niche marketing, shoppertainment, shortened inventory cycles, loyalty programs, and multichannel retailing.
- Fashion retail companies are expanding their presence in the international economy with Internet offerings.
- Personal qualities desired in students who pursue fashion careers include the ability to think critically and solve problems, creativity, charisma, and a calculating mind or business sense.

terminology for review

merchandising 7

emotives 11

planned obsolescence 11

out of fashion 11

supply chain 11

channel of distribution 12

speed to market 12

Export Advantage 15

niche marketing 15

shoppertainment 15

shortened inventory cycles 15

loyalty programs 15

multichannel retailing 15

multinational 16

studied creativity 17

questions for discussion

1. What are some examples of fashion in consumer products other than apparel and accessories?

2. How might a student gain fashion experiences outside of the traditional classroom?

3. What are some careers and benefits for college graduates with a degree in textiles, apparel, and fashion?

4. What makes fashion unique?

5. What is a channel of distribution or a supply chain as it relates to the fashion industry?

6. What is offshore sourcing, and why is it important to the fashion industry?

7. Why is the fashion industry prevalent in many developing countries?

8. What steps has the U.S. government taken to promote the textiles and apparel industries in the United States?

9. What are current trends in retailing?

10. What are the four Cs of a career in fashion?

related activities

1. Choose five nonfashion consumer products and describe ways to impart fashion to these products with the marketing goal of increasing sales. This list can include household products, such as cleaners, facial tissues, cooking utensils, electronics, office supplies, or any other nonfashion goods.

2. Select a career in fashion that is of interest and research the topic using four sources besides this textbook. Create an electronic presentation or type a 500-word essay on this career. Include the following information: What are the benefits and drawbacks of this chosen career? What is the average starting salary in the area? What type of education is required? What technical skills are needed? What personal qualities are good for this position? Is travel or relocation required? Why is this career suitable? Conclude with complete bibliographic citations using the American Psychological Association (APA) format.

3. Create a different alliterative list of four personal qualities needed for a successful career in textile, apparel, or fashion.

Write a paragraph to explain each quality. It can be a list of four Ts, four Ds, or any other letter of the alphabet. Refer to the four Cs near the end of this chapter.

4. Using your library's electronic databases, locate a recent article pertaining to sustainability in the textiles, apparel, or fashion industry. Summarize the article in one paragraph and then use the remainder of the page to evaluate the feasibility of implementing this type of measure. Your evaluation should show evidence of critical thinking by answering questions such as: How feasible is this idea? Why? What problems might occur when implementing this sustainable measure? How will this sustainability measure be received by the various levels of the industry? Which level of the industry might be most affected by implementing this measure? How might this affect customer opinion and sales? Can you offer a better solution for sustainability than the one discussed in the article? Conclude with the complete bibliographic citation using the American Psychological Association (APA) format.

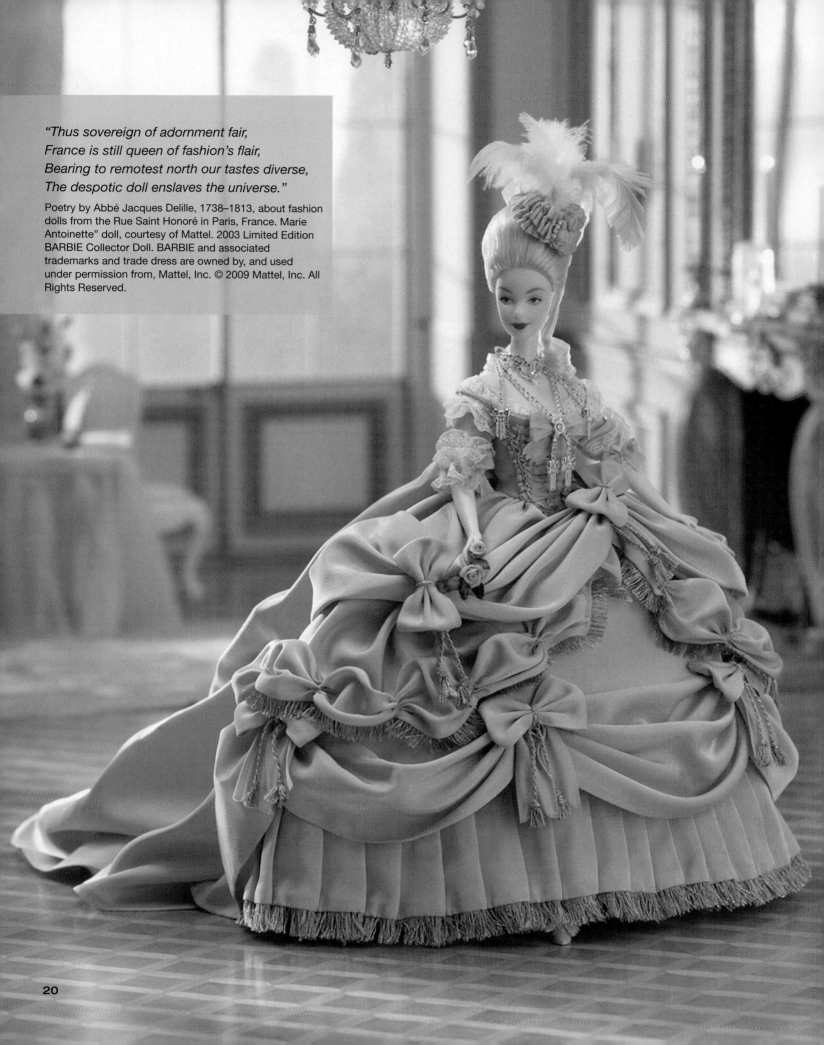

*"Thus sovereign of adornment fair,
France is still queen of fashion's flair,
Bearing to remotest north our tastes diverse,
The despotic doll enslaves the universe."*

Poetry by Abbé Jacques Delille, 1738–1813, about fashion dolls from the Rue Saint Honoré in Paris, France. Marie Antoinette" doll, courtesy of Mattel. 2003 Limited Edition BARBIE Collector Doll. BARBIE and associated trademarks and trade dress are owned by, and used under permission from, Mattel, Inc. © 2009 Mattel, Inc. All Rights Reserved.

EUROPEAN
FASHION
INFLUENCES

LEARNING OBJECTIVES

At the end of the chapter, students will be able to:

- Explain the historic events that spread fashions across the Western world.
- Assess the social implications of sumptuary laws and explain why they cannot be successful in a democratic society.
- Identify the events that made France a fashion capital in the last three centuries.
- Compare and contrast Italy's rise to the fashion forefront with France's power to set fashions.
- Recognize the fashion contributions of European rulers and fashion influencers.
- Explain Worth's contributions to the haute couture.
- Explain the relationship between haute couture and the mass fashion industry.
- Identify historic methods for communicating the latest fashions.

The United States is a melting pot of different cultures, but it is Western Europe that most influenced the domestic fashion industry during America's developmental years. France and later Italy played key roles in shaping the fashion industry in the United States. France was a fashion arbiter (judge) during the early years of the history of the United States, whereas Italian fashion companies grew with the needs of U.S. consumers in the second half of the twentieth century. Both have a valued place in U.S. fashion history.

Early Cultural Influences

The U.S. fashion industry has been influenced by many regions of the world, but most notably by Western Europe. This region was in turn influenced by the oriental fashions from the Byzantine Empire. For almost two thousand years, traders carried sumptuous fabrics and embroideries along the routes of the famous Silk Road stretching from China to Greece. Although called the Silk Road, it was actually a commerce route for all kinds of goods, including plants and precious metals. However, silk may have been the most intriguing good transported over the centuries (see Figure 2.1).

The **Silk Road** was an extensive and established pattern of commercial trade that spanned the entire country of China, Central Asia, and ended in the Mediterranean region. It was not a single road but a series of branches linked by watered oases. Some routes headed in a northeastern direction, and others headed in a southeastern direction. It is believed that the beginning of the route was on the eastern side of China, originating in the capital, Changan (now just ancient ruins). As ships were built better, the Sea Silk Route became an alternative trade route, and the conditions were normally less hostile than the land routes (except for pirates and stormy seas). Merchants who opted to cross the Silk Road on land faced hardships of extreme climate and terrain conditions. Their parties had to survive vast expanses of deserts and negotiate the politics of the indigenous tribes. Figure 2.2 shows both the land and sea routes of the Silk Road.

The Crusades (pseudo-religious military campaigns during the eleventh through thirteenth centuries) also contributed to the spread of silk and the influence of Eastern fashions on the European elite. Europeans traveling to Jerusalem gained knowledge of the Eastern cultures and brought home many valuable textiles from the Middle East. The Romans realized much of the imported silk fabrics were too heavy for the temperate climate in Western Europe. Consequently, weaving centers developed in the Mediterranean region (such as Italy) in which the heavy silk fab-

Figure 2.1 Highly valued silk fabric.

(© Judith Miller/Dorling Kindersley/Sara Covelli)

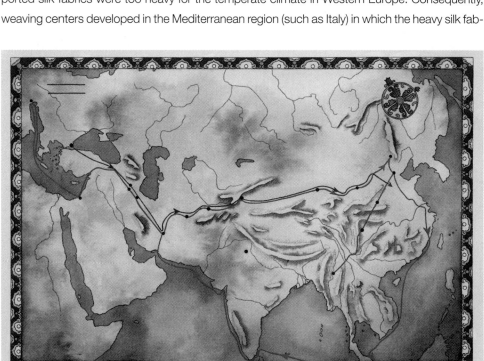

Figure 2.2 The Silk Road and waterway map.

(© Dorling Kindersley)

rics were unraveled and woven into more sheer fabrics that were suitable for the warmer temperatures. These refurbished silks were highly valued commodities, often worth their weight in gold.

As centuries progressed, fashions spread as merchants and travelers moved from one region of Europe to other regions. Fabrics, patterns, prints, colors, silhouettes, styles, and trims reflected the blending of cultures when conquering civilizations interacted with the defeated civilizations and whenever marriage alliances were created to strengthen relationships between countries. Although regional differences did exist in fashions, some fashion trends were so pervasive that they can be identified in paintings from several different countries. For example, remarkable feats of collar pleating are depicted in the artwork from several Western European countries. This pleating evolved into the famous starched ruffs of the late sixteenth and early seventeenth centuries (see Figure 2.3). Examples of sizable ruffs can be found in paintings, statues, and engravings from the countries that would become Spain, Italy, France, England, Germany, Austria, and Holland.

> Although regional differences did exist in fashions, some fashion trends were so pervasive that they can be identified in paintings from several different countries.

Key European Countries

The region with the most fashion influence on American colonial and modern dress has been the area encompassing the Western European countries. England, France, and Italy have been and still are important resources for U.S. fashions, and they have influenced the American Look. Our modern focus on European fashions can be attributed in large part to the numerous immigrants from Western Europe that entered America through its Eastern seaboard. These immigrants continued to wear their native country dress but adapted it to their American resources. A certain amount of snobbishness existed among the early American social elite (and promoted by the European elite), who continued to support the fashion industry in England and believed that there was much more culture and refinement in the long-established countries abroad. It is interesting to note that although many poor immigrants traveled to the American colonies to get away from the oppressive ruling classes of the European countries, the same immigrants found themselves inexplicably drawn to emulate the ostentatious fashions of the European aristocracy.

Similar to English rules, American colonial sumptuary laws of Massachusetts and Connecticut existed to control clothing expenditures and the wearing of certain extravagant items of clothes. A **sumptuary law** is one that restricts or regulates clothing for economic, religious, or political reasons. The American colonial sumptuary laws forbade wearing of certain clothing items or styles based two extremes: a desire to demonstrate social rank and preserve class distinctions and to restrain display on the basis that lavishness and excessive display

Figure 2.3 Fashionable seventeenth century ruff.

(Steve Teague © Dorling Kindersley)

of wealth were wicked and contributed to a decline of moral standards. Economically poor offenders were especially targeted because it was believed that the offender was sacrificing family necessities in order to afford the fashions. Breaking the laws resulted in fines or confiscation of the forbidden garments. The government exempted certain persons from these laws, including the families of magistrates, public officers, military personnel, well-educated persons, the affluent, and those who once had affluence. The government allowed these persons to choose their clothing at their own discretion.

By law, the most offensive fashions included silk garments and silk lace and silver or gold laces and ribbons. For example, a seventeenth-century English fashion that involved multiple slashing of sleeves to display exquisite undergarment fabric was allowed only in moderation. The General Court of Massachusetts forbade the wearing or buying of clothing that had more than one slash per sleeve or one in the back of the garment. A 1651 Massachusetts sumptuary law gave authority to certain townsmen to selectively judge the town's inhabitants who exceeded their social status.

The law stated,

". . . we cannot but to our griefe take notice that intolerable excesse and bravery hath crept in upon us especially amongst people of meane condition, . . . and also declare our dislike that men or women of mean conditions, educations, and callings should take upon them the garbe of gentlemen, by the wearing of gold or silver lace or buttons, or poyntes at theire knees, to walk in great bootes, or women of the same ranke to weare silke or tiffany hoodes or scarfes, which though allowable to persons of greater estates or more liberal education, yet we cannot but judge it intolerable in persons of such like condition. . . ." (Warren, 1927, p. 10)

The lack of success in the declarations and the frequency with which governments enacted and expanded sumptuary laws indicate the laws were a futile attempt, akin to appointing a fashion police. In spite of continuous efforts to enforce sumptuary laws, the laws were usually powerless. A 1910 historian eloquently stated,

"History has proved that all sumptuary laws have been everywhere, after a brief time, abolished, evaded or ignored. Vanity will always invent more ways of distinguishing itself than the laws are able to forbid." (Giraudias, 1910)

France: Fashion Capital

Since the latter seventeenth century and certainly through the developmental years of the United States, France has been considered a world fashion leader. King Louis XIV of France was an important player in influencing early American fashions. His reign occurred from 1643 to 1715, a fruitful 72 years! He is credited with creating the fashion image that France still enjoys today. Historians often point to the 1660s as the turning point in Western world history for the coming together of fashion in a single country—France.

In addition to support from the monarchy, the business of fashion was encouraged by a technological innovation—the printing press. In the winter of 1678, with the advent of the printing press, a newspaper in France decided to cover a fashion show and sent out flyers describing the fashions in great detail. Fashion engravings depicting a style with the most exacting details were made available to the general public. These engravings often diagramed the precise placement of lace, so that all women could follow the fashion rules.

France by far exerted the greatest influence on early American fashions, but specific individuals from a variety of countries have become famous for their own contributions to U.S. fashions. Descriptions of the more noteworthy fashion influencers are described in the next section.

Italy: Fashion Capital Runner-Up

Italy's fashion association with the United States was in the embryonic stages in the early post World War II era, and the growth accelerated in the 1980s. Although France boasts haute couture and fashion creativeness, it was the Italians that contributed the simplicity of design that has been so important in helping define the **American Look** of casual simplicity. Also, the relationship between Italy and the United States has been much different than the relationship between France and the United States. France was historically a dictatorial force on American fashions during the early development of the country in the seventeenth through the mid-twentieth centuries (until World War II). On the other hand, Italy became a partner with the United States after the middle of the twentieth century (post World War II). The United States supported, funded, and encouraged the reconstruction of the Italian textile industry after the damages of the war. It was the Italian companies that most accurately interpreted the increasingly casual design needs of the U.S. fashion industry and offered European clothing at prices that were more affordable and appealing than the fashions available through the French industry. Italy became popular for knitwear, decorated yet simplified cuts, comfortable designs, and a diversity of offerings. Italy's long tradition in the textile craft and the country's discernable Italian style attracted U.S. department stores and their customers.

Even before the famous international collection organized by Giovan Giorgini in 1951, other Italian spokespersons had been criticizing the Italian dependence on French haute couture and advocating Italian fashions. Rosa Genoni, an early twentieth century advocate of creating a national Italian fashion, published articles and became a political activist for the cause as early as 1908. A contemporary of Genoni was Lydia De Liguoro, who also struggled to bring life to the Italian fashion industry after World War I. In 1928, the creation of a national fashion body, the ENM (*Ente Nazionale della Moda*), called for the creation of professional schools and a much-needed unity among the different branches of fashion production, including textile mills, fabric manufacturers, designers, and craftspeople.

In the early 1960s, famous Italian designer Emilio Pucci predicted the decline of the Paris couture and the increase in casual wear (not surprising, since sportswear was his trademark). According to an issue of *Women's Wear Daily* at the beginning of the 1960s, Pucci defined casual as "a woman who perfectly co-ordinates her clothes but still gives the air of great nonchalance"

(White, 2000, p. 118). That simple elegance shows how the role of Italian fashion was intended to support a woman's image, rather than the notion that a woman was to serve as a manikin on which to show a designer's creation.

The first organized international appearance of Italian ready-to-wear fashion was in 1975 in Milan. Italian couture was first offered as early as 1951, but boutique ready-to-wear was a little slower to progress. The Italian boutique ready-to-wear clothing was well received by U.S. buyers. By the 1980s, Milan had wrestled the fashion capital image away from competing Italian cities, such as Florence, Rome, and Turin. Many Italian cities had sectors of craftsmanship and decorative arts industries, but Milan grew in an image of high fashion ready-to-wear and Italian high couture, which was missing or limited in many of the Italian cities.

The nonprofit Italian organization in Milan committed to coordinating and internationally promoting the development of Italian fashions is the *Camera Nazionale della Moda Italiana* (the National Chamber for Italian Fashion). Organized in 1958, the Chamber schedules fashion shows, supports and integrates designers and fashion companies, and acts as the spokesperson for domestic and international activities that promote Italian style and fashion. The 200 companies represented include haute couture houses, prêt à porter companies, furriers and leather goods companies, textile manufacturers, cosmetics, and accessory manufacturers.

Rome, Italy, has its own *alta moda* (high fashion or haute couture) event called the *AltaRomAltaModa*. This semiannual event publicizes couture fashions and "Made in Italy" labels, features new designers, showcases fashion research and designs, and sponsors fashion schools. In addition to fashion shows, the AltaRomAltaModa includes special projects, performances, and themed exhibitions.

During the twentieth century, Paris and Milan saw the rise of another source of strong competition—the U.S. fashion industry. This industry included manufacturers, retailers, and designers with creative talent and easy access to the U.S. public. World War II provided impetus to the U.S. fashion industry, since Italy and France were under siege during the war. Chapter 4 contains a discussion of twentieth-century U.S. designers.

Marketing to Opinion Leaders

Throughout history, opinion leaders have driven the direction of fashion. These persons have influenced the fashions for their social group, whether they belonged to the elite aristocracy or the common people. Approximately fifteen percent of the population is considered opinion leaders. In today's society, it is likely that they are young, hip, and cool, and enjoy social networking, whether on Facebook, Twitter, or MySpace. They are likely to talk a great deal about fashion, and their associates trust and value their fashion leadership.

How do we know about the preferences and activities of opinion leaders? The Word of Mouth Marketing Association (WOMMA) exists to study and disseminate information about opinion leaders and the spread of word-of-mouth marketing. The United States–based organization has nearly 300 members across the world. The association provides webinars to its members and defines a variety of word-of-mouth marketing methods, including buzz and viral marketing, product seeding, and cause marketing. According to the Web site, the goal of word-of-mouth marketing is to provide opinion leaders and their social community with ample opportunities and reasons to positively discuss a company's products and services.

SOURCE: *Word of Mouth Marketing Association* at http://www.womma.org

Historic Fashion Innovators and Opinion Leaders

Numerous individuals played key roles in fashion history. Whether designer or wearer, innovators and opinion leaders wielded great power, influencing the styles that were to become popular. The timeline in the following Fashion Chronicle shows the key European players in promoting fashion over a period of 300 years.

FASHION CHRONICLE

300-Year Timeline of European Fashion Influencers

1640s–1690s Louis XIV	1770s–1790s Marie Antoinette Rose Bertin	1790s–1810s Beau Brummell	1850s–1860s Empress Eugénie	1920s Gabrielle Coco Chanel	1950s Giovan Battista Giorgini
	1740s–1750s Madame Du Pompadour	1800s–1810s Napoleon and Josephine Bonaparte	1830s–1840s Count D'Orsay	1860s–1890s Charles Frédéric Worth	1940s Christian Dior

Louis XIV

The famous French King Louis XIV said that "fashion is a mirror." Louis himself was renowned for his exceptional style, which tended toward extravagant laces and velvets. Most importantly, Louis XIV is credited with the introduction of a new concept—marketing of fashion. As a result of his efforts during the 1660s and 1670s, France became the undisputed leader of fashion.

When the king began his reign at age five in 1643, France had not achieved dominion over the fashion world. But by the end of his reign, King Louis XIV and his French subjects had become accepted as the arbiters of fashion. The economy of France benefited from the country's dominance over much of the commercial luxury trade, from silk fabrics and delicate laces to high fashion designs. For example, King Louis XIV carefully selected the textiles for his sumptuous wardrobe from the French silk manufacturers to help improve the domestic production of luxurious silk fabrics. Under the monarch's image-making direction, boutiques emerged that showed merchandise elegantly displayed. The shop interiors were designed to create a shopping experience by offering an unforgettable store ambiance. Fashions were marketed by seasons, and as the seasons changed, the fashions necessarily changed with them.

Some of Louis XIV's contributions to the fashion industry during his 72-year reign were his emphasis on beautiful things of glitz and glamour, champagne, the popularity of diamonds, the Louis XIV heel (hourglass shape), mules (slide-in shoes), full-length mirrors, and nighttime streetlights that improved after-dark commerce on the streets of Paris. Today, the City of Light is still known for its nightlife experiences, due in part to the forward-thinking King Louis XIV (see Figure 2.5).

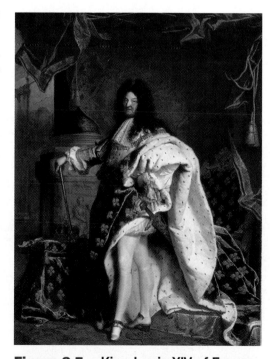

Figure 2.5 King Louis XIV of France.
(Rigaud, Hyacinthe (1659–1743). Louis XIV, King of France (1638–1715). 1701 Oil on Canvas. 277 × 194 cm. Inv.: INV 7492. Photo: Herve Lewandowski. Louvre, Paris, France. Photo Credit: Reunion des Musees Nationaux/Art Resource, NY.)

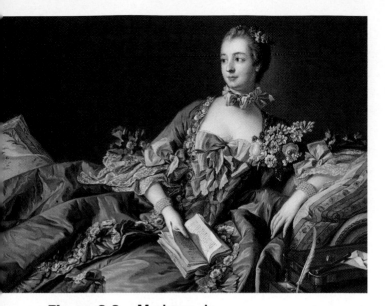

Figure 2.6 Madame de Pompadour of France.
(Picture Desk, Inc./Kobal Collection)

Figure 2.7 Queen Marie Antoinette of France.
(© Dorling Kindersley)

Fine or high sewing, the literal translation of the French term *haute couture,* actually refers to the most exquisite and remarkable high fashion clothing.

Madame de Pompadour

Austrian Jeanne-Antoinette Poisson was born on December 29, 1721, and was educated with impeccable social skills and excellent taste in clothing. She contrived to meet France's King Louis XV and ultimately became his mistress. Although she was only the official king's mistress for a few years, she managed to remain an indispensable lifetime confidante of the king and was involved in state matters until her death in 1764. Her contributions to the fashion industry were not so much a particular item (unless one counts her coiffure), but an elegant, feminine style that pervaded the French court and the palace at Versailles. Many say she reigned as the arbiter of fashion (see Figure 2.6).

Marie Antoinette

The future queen of France, Maria Antonia Josepha Johanna was born in 1755 in Vienna, Austria. She was married to Louis XVI and became queen a few years later, while she was still just a teenager. She loved extravagance and was passionate about fashion (see Figure 2.7). Unfortunately, she reigned at a time in French history in which all of the lavish expenditures of the monarchy so enraged the French peasantry that the French Revolution ensued. Her friendship with dressmaker/milliner Rose Bertin lasted until Marie Antoinette's death by beheading in 1793 at age 38.

Rose Bertin

Rose Bertin began her professional career as an apprentice to the hat designer Pagalle. She opened her exclusive dressmaking and millinery shop in Paris in 1770 and soon became a main supplier of French court clothing. In 1771, Bertin's millinery and couture designs were noticed by the newly arrived Marie Antoinette. As Marie Antoinette prepared for her role as future queen of France, Bertin acted as her consultant, helping the future queen define her own style. Bertin was appreciated by her clients because she considered their likes and dislikes when fashioning clothing for them, rather than imposing her own personal preferences.

Rose Bertin was nicknamed France's minister of fashion by her beloved countrymen and countrywomen. Bertin is widely accepted as the first haute couture fashion designer, although it was Charles Worth who fathered the organized haute couture several decades later.

Napoleon Bonaparte

The Emperor of France reigned from 1804 to 1814. His fashion contribution was a distinct divergence from the prerevolutionary costume. During Napoleon's reign, embroidery and neckwear became important fashions and indicators of rank. The textile and lace-making industries in France received support from Napoleon and flourished. Also during this time, the discovery of the ancient Italian ruins of Herculaneum and Pompeii created a revival of Greek fashions: diaphanous fabrics (filmy fabrics reminiscent of the goddess Diana), empire waistlines (so named because the style was rediscovered during the Napoleonic

Empire), and the color white (many Greek marble statues were pure white). Figure 2.8 depicts Napoleon's wife, Josephine, in Greek revival clothing. As an extra boon to France's reputation as a cultural city, Napoleon's armies amassed a great deal of artwork and artifacts from all over Europe and relocated the items to the Louvre in Paris (see Figure 2.9).

Beau Brummell

George Bryan "Beau" Brummell was England's dandy from 1796 to 1816. As the unofficial ruler of English fashion, he is credited with introducing shoe polish (reputed to polish his boots with champagne), beautifully cut suits, starched and elaborately tied cravats, and fresh linens daily. His impeccable taste in fashion was observed as early as his school years at Oxford. His friendship with the Prince Regent, who later became King George IV, propelled his dressing style to the limelight in the royal courts. He was called a **dandy**, and his style was considered **dandyism**, words describing a man or his characteristic of being overly concerned with his clothing appearance and wearing the latest fashions. Although famous during the height of his fashion career, Beau Brummell escaped to France in 1816 to avoid his debts and died penniless in 1840. Figure 2.10 depicts an early nineteenth-century fashionably dressed man wearing a meticulously wrapped cravat and high starched collar similar to those popularized by Beau Brummell and other dandies.

Count D'Orsay

Alfred Guillaume Gabriel was a handsome and intellectual Frenchman who lived from 1801 to 1852. He was a clever writer and talented painter. As unofficial successor to Brummell, he is credited with a 20-year reign (1830s and 1840s) as fashion arbiter at the English Court in London during Queen Victoria's early reign. The French emperor appointed the count to the position of director of fine arts, and he continued in this capacity until his death.

Figure 2.8 Empress Josephine of France in Greek revival clothing.
(Private Collection/The Bridgeman Art Library)

Figure 2.9 Louvre Museum, Paris, France.
(Rober O'Dea © Dorling Kindersley)

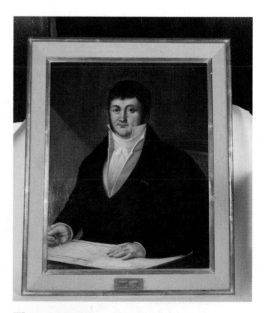

Figure 2.10 Neckwear style made fashionable by Beau Brummell.
(Tina Chambers © Dorling Kindersley)

Figure 2.11 French Empress Eugénie with her ladies-in-waiting, all wearing caged crinolines, 1855.
(Winterhalter, Franz Xaver (1805–1873). Empress Eugenie surrounded by the ladies of her court, 1855. Oil on canvas, 300 x 420 cm. Chateau, Compeigne, France. Reunion des Musees Nationaux/Art Resource. NY)

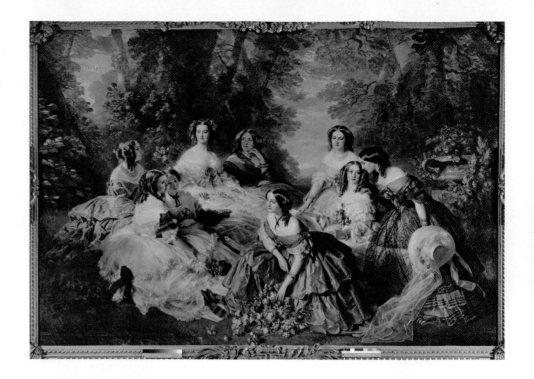

Empress Eugénie

Born in Spain, Eugénie de Montijo became the Empress of France in 1853. She used the couturier services of Charles Frédéric Worth and exerted a great deal of fashion influence over Europe. She is credited with creating the popularity for Worth's caged crinoline in 1855 and the discarding of that fashion for Worth's narrower bustled silhouette a decade later. Figure 2.11 shows the empress and her ladies-in-waiting wearing the enormous caged crinolines and sporting the spaniel-eared hairstyle and sausage curls that were favorites of the era. Their petticoats were supported by a **caged crinoline** made of graduated sizes of lightweight steel hoops held together by narrow cotton tape. Although cumbersome to wear, they allowed for some air circulation since the petticoats did not cling to the legs.

Charles Frédéric Worth

Charles Worth is considered by fashion historians to be the father of haute couture because he was the founder of the association of couture houses and was the first to open his own design house, called the House of Worth. Although a Worth design was typically created with expensive embroidered silks and velvets, he also started a lucrative pattern business that provided an affordable opportunity for a broader base of women to wear his elegant designs. Worth was the first to put his name on the labels of his custom-designed clothing. The House of Worth also made several perfumes, including the still famous *Je Reviens* (French for "I will return") perfume in 1932 (see Figure 2.12).

Worth was born in England in 1826 and began his career working in a fabric shop. After spending time learning the trade, he moved to Paris and was employed in the French shop of Gagelin and Opigez. He began designing dresses for Marie Worth, his model and wife; the admiring attention she received prompted him to branch out into commercial dressmaking. He obtained financial backing from a Swedish investor and opened the first *maison de couture* (couture house) in 1858 under the names Worth and Bobergh, at 7, rue de la Paix in Paris. Worth's novel idea of showing his couture collection on live models, including his wife,

Figure 2.12 Worth perfume *JeReviens*.
(© Judith Miller/Dorling Kindersley/David Rago Auctions)

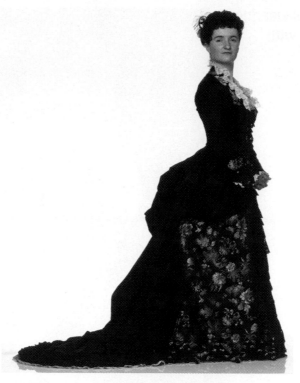

Figure 2.13 The caged crinoline created extra fullness in skirts.
(Andy Crawford © Dorling Kindersley)

Figure 2.14 Bustle design made famous by Charles Frédéric Worth.
(Liz McAulay © Dorling Kindersley)

was well-received by his clients. His client list included notable aristocrats, such as Empress Eugénie and wealthy women as far away as New York. Worth believed he knew what looked best on his clients and provided his own ideas for how they should dress. Worth has been described as a dictator of fashion whose power was so great that his preferences took precedence over his clients' preferences.

His fashion contributions included the first Paris couture house bearing his name (1858) and the first couture collection shown on live models. Worth is also known for the caged crinoline of 1858 (see Figure 2.13) and the demise of the caged crinoline with his new introduction in 1869—the back fullness bustle (see Figure 2.14). The **bustle** was a structural "dress improver" (Byrd, 1994, p. 39) made of stiff horsehair ruffles or wires shaped to create back fullness. Its vast popularity lasted only about seven years, from its introductory date to 1876.

It was Worth who helped cement the reputation of Paris for fine fashion. To protect the French couture industry from the unethical copying of designs, Worth organized an association of couture houses to regulate and protect the couture industry called the *Chambre Syndicale de la Confection et de la Couture pour Dames et Fillettes.* This is loosely translated to "a union for manufacturers and dressmakers of clothing for women and girls." Later, the union was shortened to *Chambre Syndicale de la Haute Couture.* As the pioneer of modern haute couture, Worth reigned supreme in the fashion world from the 1860s to the early 1900s.

Coco Chanel

Gabrielle "Coco" Chanel was a famous French *couturière* who began her career in Paris, France, in 1912. A celebrity and world-renowned designer, Chanel was at the height of her popularity in the roaring 1920s. In 1927, *Vogue* magazine complimented Chanel on her exquisite designs by

Figure 2.15 Coco Chanel wearing her trademark boxy jacket with braid trim.

(Getty Images Inc./Hulton Archive Photos)

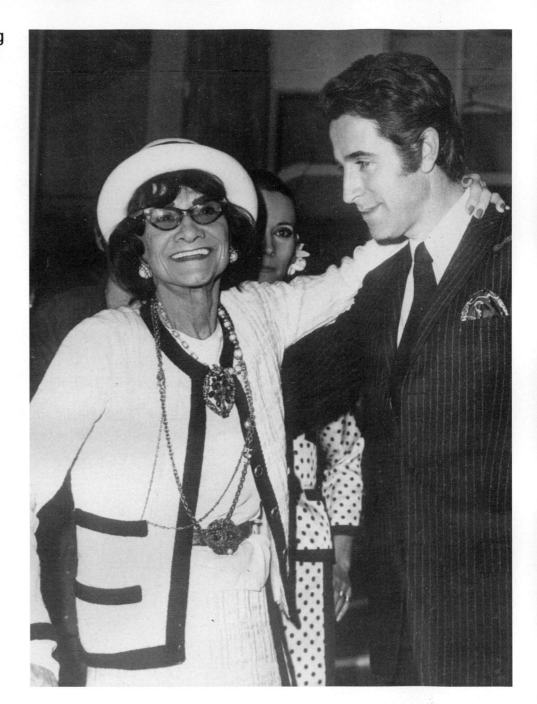

Figure 2.16 Chanel label.

(© Dorling Kindersley)

writing, "Mademoiselle Chanel's dresses are peculiarly free from mistakes, either in taste or execution" (Mulvey & Richards, 1998).

Coco Chanel epitomized the flapper style and was the ideal free spirit. Her contributions to fashion are numerous, including costume jewelry—a la **faux** pearls, jersey fabrics for couture clothing, cloche hats, above-the-knee hemlines (for the first time in recorded history), decorative chains, the boxy Chanel jacket, and the famous quilted Chanel handbag (see Figures 2.15 and 2.16).

Christian Dior

French-born Christian Dior was also a twentieth-century member of the Haute Couture but received notoriety from his 1947 Spring collection, the famous *Corolla* (petal) line, dubbed the New Look by a fashion editor. This post–World War II fashion revolution was almost an overnight sensation according to a quote from fashion model Ernestine Carter. She said his col-

lection made "every woman wish she were naked with a chequebook" (Byrd, 1994, p. 43). The New Look advocated rounded shoulders and longer, fuller skirts flaring from a waspish waist-line. The effect of the fashion was that women resembled flowers, and it was a direct contrast to the shorter skirts and military appearance that had been the "Make Do and Mend" utility scheme of the wartime fashions (see Figures 2.17 and 2.18). Dior died unexpectedly in 1957 and was succeeded by 21-year-old Yves St. Laurent.

Giovan Battista Giorgini

Italian Giovan Battista Giorgini was a *commissionaire* of Italian crafted goods, particularly fashions. He sold the merchandise to buyers for upscale U.S. stores, such as I. Magnin of San Francisco and Bergdorf of New York. Giorgini organized the first international collection fashion show staged at his home in Florence, Italy, on February 12, 1951. It was the turning point for Italian fashions and is referred to as the precise date of the "birth of Italian fashion" (Settembrini, 1994, p. 485). Eight important U.S. buyers were invited to the three-day showing of Italian high fashion ready-to-wear. The show generated such enthusiasm that the second runway show had 300 buyers in attendance, and the media claimed that Italy was posing a challenge to Paris.

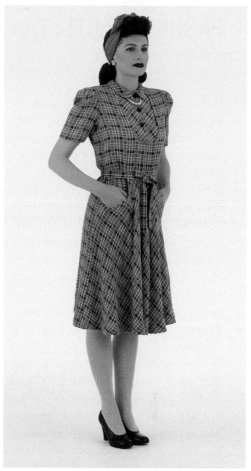

Figure 2.17 WWII era fashions—close-fitting and shorter skirts, rationed fabrics, and small hat styles.
(Liz McAulay © Dorling Kindersley)

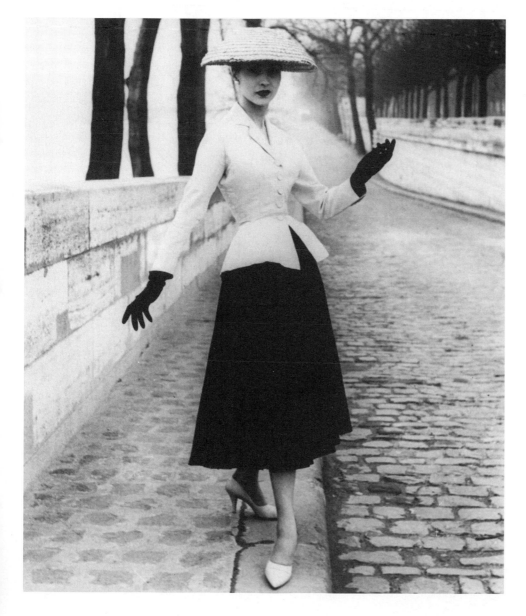

Figure 2.18 Christian Dior's revolutionary New Look from 1947.
(AP Worldwide Photos)

FASHION FACTS: The Haute Couture

Fine or high sewing, the literal translation of the French term **haute couture**, actually refers to the most exquisite and remarkable high fashion clothing. These *crème de la crème* designs of the fashion industry are the pinnacle of the fashion pyramid and are created and custom-made in France. Confusion exists with the phrase "haute couture" because many companies use it to designate their high fashion designer lines. Haute couture, as it was originally intended, refers to made to order clothing by Paris design houses that are members in the **Chambre Syndicale de la Couture Parisienne**.

The *haute couture* boasts only 200 to 300 regular clients and about 2,000 total world customers. Creating these garments may involve the cooperation of several **ateliers** (sewing workrooms) in France. Each value-adding embellishment, whether embroidery, beading, or feathering, is performed in *l'ateliers* or workrooms with master crafters. A single hand-beaded evening dress may sell for over $200,000, but this includes white glove treatment and global travel to the client's home for fittings. The wearer can rest assured that she is the only one in the world with that fashion (at least for awhile, until style piracy results in a knockoff garment).

The *haute couture* organization began as a needles trade union in 1868 started by Charles Frédéric Worth, and it was later refined by his son, Gaston Worth. Today, it is a combination guild and union and is open to exclusive designers on a membership basis. Only members of this organization are allowed to use the *haute couture* label and are protected by legislation. Located in France, the organization is formally called the *Chambre Syndicale de la Haute Couture Parisienne*, but it is often shortened to just the *Chambre*. It is regulated by the French Department of Industry and is the original and most prestigious of the three sections of the executive organization (founded in 1973), referred to as the French Federation

(formally called the *Fédération Française de la Couture, du Prêt-à-Porter des Couturiers et des Créateurs de Mode*). The other two sections of the Federation were begun in 1973 and are the *Chambre Syndicale du Prêt-à-Porter des Couturiers et des Créateurs de Mode* (couture and high-end ready-to-wear organizations) and the *Chambre Syndicale de la Mode Masculine* (menswear organizations).

The rules for membership in the *haute couture Chambre* are stringent and enforced by the Federation. They ensure participation, copyrights or intellectual properties, and contributions to the economy and the craft. The craftsmanship is exquisite; the garments are as beautiful on the inside as they are on the outside! Some of the most important stipulations include:

- The couturiers or couturiere (and their employed team) must create original patterns for private clients.
- Haute couture fashions must be made in the firm's *atelier*.
- Each house must have a minimum staff size of 15 persons.
- The collections are formally shown twice annually in Paris at dates and times determined by the *Chambre*. One collection is for the fall/winter season, and the other is for the spring/summer season.
- Each collection is comprised of at least 35 looks and shown on a minimum of three live models.
- The house must also show the collection 45 other times on its own premise, including private viewings.
- All couture designs must be custom-fitted to a client's exact measurements. No mass production in standardized sizes is allowed.

The 2009 *haute couture* list includes:

- Adeline André
- Giorgio Armani Privé
- Chanel (head designer Karl Lagerfeld)
- Christian Dior (head designer John Galliano)
- Jean-Paul Gaultier
- Givenchy (head designer Riccardo Tisci)
- Rabih Kayrouz
- Christian Lacroix
- Alexis Mabille
- Martin Margiela
- Alexandre Matthieu
- Stephane Rolland
- Elie Saab
- Franck Sorbier
- Valentino (head designer Alessandra Facchinetti)
- Alexandre Vauthier

Some of the most famous haute couture designers since its inception, their nationalities, and contributions to the profession are shown in Table 2.1. Many design houses still bear the name of the original head designer, although he or she is deceased. The table reflects the designer's own tenure over and contributions to his or her couture house while it was part of the Paris haute couture.

The *haute couture* has been called the "laboratory of fashion" and the "locomotive that drives the train." These phrases mean that the **couturiers** and **couturières** (male and female designers) introduce new ideas for original fashions that are tested through the *couture*. It becomes the proving ground for new fashions and a place to perfect the craft. The designers get their inspiration from art, theater, Hollywood and celebrities, a beautiful bolt of fabric, nature, history, and other cultures. Some ideas successfully trickle down to mass fashions, whereas other ideas presented are simply runway fodder. Likened to a locomotive, the *haute couture* collection shows have traditionally been at the forefront—the first sighting of the newest fashions. Because fashion is a form of imitation, fashion-conscious consumers flock to adopt similar fashions,

(continued)

Table 2.1 Important *Haute Couture* Designers Who Established Houses in Paris

Designer	Nationality	Head Designer Tenure	Major Contributions
Andeline André	French	1997–present	Three-sleeve hole; knits and other fluid fabrics
Cristobal Balenciaga (pronounced *ball-en-cee-ah-gah*)	Spanish	1937–1968	Rivaled Vionnet as best couturier in history; bold and exquisite designs; emphasized the figure
Pierre Balmain	French	1946–1982	Sophisticated and feminine fashions
Callot Soeurs (3 sisters)	French	1895–1926	Chinese-inspired; feminine
Coco Chanel	French	1915–1939; 1954–1971	Little black dress; faux pearls; quilted handbag; dropped waistlines/ shorter hemlines
André Courrèges	French	1961–1993	Futuristic, space age; metallics; go-go boots
Christian Dior	French	1947–1957	The New Look; head designers have included Yves Saint Laurent, Marc Bohan, and John Galliano
Jacques Fath	French	1937–1954	Beautiful designs emphasized tiny waist and back flare on skirts
Jean Paul Gaultier	French	1997–present	Dressed Madonna; irreverent creations; sex appeal
Hubert de Givenchy (pronounced *hugh-bear-de-jhee-von-she*)	French	1952–1995	Dressed Audrey Hepburn and Jackie Kennedy; cotton fabrics; head designers included Alexander McQueen and Riccardo Tisci
Madame Alix Grès	French	1942–1987	Sculptured clothing
Karl Lagerfeld	German	1984–present	Also head designer for the house of Chanel and Fendi (furs)
Christian Lacroix (pronounced *la-kwa*)	French	1987–present	Poufs; ethnic colors; unparalleled construction
Jeanne Lanvin	French	1910–1946	Hats; mother/daughter collection; appliqué; embroidery; formality
Lucien LeLong	French	1918–1958	Skilled with beautiful fabrics; waspish waists and pencil skirts
Mainbocher	American	1929–1940	Used luxurious fabrics; designed WWII uniforms for women's organizations
Edward Molyneux	Irish/English	1919–1950	Tailored silk suits; subtlety and elegance; youthfulness
Jeanne Paquin	French	1891–1920	Beautifully designed clothes and lingerie
Jean Patou	French	1919–1936	Rival of Chanel; sportswear; dominant color scheme
Robert Piguet	Swiss	1933–1951	Slenderizing suits and day dresses; romantic and uncluttered
Paul Poiret	French	1904–1914	Empire waistline; simplicity; Asian influence; colorful
Nina Ricci	Italian	1932–1954	Designed on live models; feminine designs
Yves Saint Laurent (pronounced *eves-saint-la-ront*)	French	1961–2002	Head designer for house of Dior after Dior's death; trapeze dress; created themed collections
Elsa Schiaparelli (pronounced *scap-a-rel-ee*)	Italian	1928–1954	Shocking pink colors; futuristic, surrealistic, and avant-garde fashions
Dominique Sirop	French	2004–present	Contemporary tailoring; elegant chic
Emanuel Ungaro	French	1965–2004	Elegance; draped fabrics; voluminous designs
Gianni Versace (pronounced *ver-saw-chee*)	Italian	1989–1997	Street chic fashions; designed for ballet and theater
Madeline Vionnet (pronounced *vee-o-nay*)	French	1912–1939	Bias-cut dresses; superb draping; discarded the corset; rivals Balenciaga as best couturier in history
Charles Frédéric Worth	English	1871–1895	Father of haute couture; big, caged crinoline; bustle silhouette; princess line

(continued)

albeit at a more affordable price. Eventually, the fashion trickles down to the mass merchandise or discount store level (the fashion caboose).

A designer's *haute couture* collection is extremely expensive to produce and may not be a large moneymaking venture. Some couture designers loan clothes to public figures and celebrities to gain exposure for their brand. One only has to watch the red carpet runway at the Emmy Awards and see the elegant dresses on the physically flawless actresses who say "I'm wearing a design by so and so" and give credit to the designer in front of a television broadcast viewed by 18 million households. The prestige of the high-fashion collection helps sell the designer's other products, including perfumes, cosmetics, ready-to-wear clothing, and accessories.

SOURCES: The grand French Haute Couture houses. (2001). *Elegant-Lifestyle.com* Web site. Retrieved Feb. 14, 2006, from http://www .elegant-lifestyle.com/haute_couture.htm

Haute Couture (1928, Aug. 13). *Time Magazine*. Retrieved June 14, 2008, from http://www.time.com/ time/magazine/article/0,9171,928838,00.html

Haute Couture. (2006). *Ministry of Foreign Affairs and Label France* magazine Web site. Retrieved Feb. 20, 2006, from http://www.diplomatie.gouv.fr/label_ France/ENGLISH/DOSSIER/MODE/MOD.html

Onlins, A. (2009, Jan. 27). Haute Couture houses profit from an influx of new money. *The Times* (London), Edition 1, p. 9.

Paris Haute Couture Fall 2009. (2009, July 6). *Women's Wear Daily* online. Retrieved July 14, 2009, from www.wwd.com

Skrebneski, V., & Jacobs, L. (1995). *The Art of Haute Couture*. New York: Abbeville Press.

Socah, M., Mascetta, K., & Foreman, K. (2009, July 6). Couture rides the economic storm. *Women's Wear Daily* online. Retrieved July 14, 2009, from www.wwd.com

Historic European Fashion Communicators

In order for a style to become a fashion, it must have acceptance among the members of a group. Before the advent of mass media, there were limited ways to disseminate fashion information so that women and men might have the opportunity to adopt the latest styles. Fashion trendsetters wearing the latest styles could be seen at chic parties, and copies of these styles were created by talented dressmakers in the local cities and towns. Miniature fashions on scaled-down mannequins or dolls were mailed internationally, but they had limited use as a mass medium. Fashion pictures that could be documented with illustrated details and sketches were the most reasonable answer to the dissemination issue. Since copperplate engravings were also a product of the fifteenth century, fashion plates (engravings) became a useful resource.

Fashion Dolls

Fashion dolls are recorded to have been used as early as 1600, when the French King Henry IV had dolls created for his Italian bride Maria de Medici, so that she would be fashionably dressed when she arrived at his French court. The systematic use of fashion dolls did not occur until the late seventeenth century when the dolls were shipped to international destinations dressed in **chic** (pronounced "sheek") or stylish French fashions. By the turn of the new century, dolls were being shipped on a monthly basis to London and with slightly less frequency to Venice, Vienna, St. Petersburg, Constantinople, and Boston. The most famous fashion dolls were referred to as *The Doll from the Rue Saint-Honoré*. (The *Rue St. Honoré* is one of the main roads or *rue* in Paris on which the Louvre is located.)

The wood-carved, anatomically correct **fashion dolls** (also called **jointed babies** or **mannequins**) ranged in height from one to two feet. Fashion houses dressed the dolls as precise miniature replicas of French couture fashions, complete with necessary accessories and real hair styled in the latest fashion. Eagerly awaited, the dolls featured powdered wigs, scented perfumes, ribbons, laces, crinolines, embroidered silk stockings, and fashionable shoes fit for the court of Versailles (see Figure 2.19).

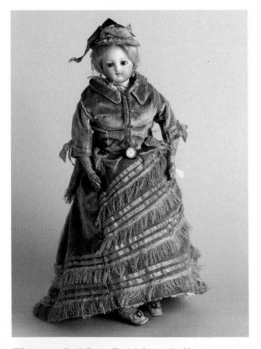

Figure 2.19 Fashion doll.
(© Judith Miller/Dorling Kindersley/Victoriana Dolls)

The exporting of fashion dolls is an early example of international marketing promotions, but foreign governments did not always receive them with open arms. During the reign of Marie Antoinette, the British declared a ban on some French fashions because they competed (a little too successfully) with British commerce. According to British diplomatic agent from the 1780s, Sir James Harris (his actual title was *chargé d'affaires*),

> "Embroideries and furbelows [ruffles or showy ornamentation] are banned. Coiffures are not to exceed two and a half inches in height. The enormous growth in the export of fashion articles from France was the prime reason for this reform in ladies' dress." (Arnaud, J. L., 1996)

Fashion Plates and Periodicals

Limited circulation of French court fashion plates occurred during the late seventeenth century and early eighteenth century, but the popularity of the engraved images—a beautifully illustrated picture is worth a thousand words—flourished after the 1789 French Revolution. Although only two-dimensional, fashion engravings were much easier to transport and reproduce than fashion dolls and consequently had a broader reach. French fashion houses created **fashion plates** in lightweight cardstock. Pictures in black ink or watercolor on white paper could be sent across borders with relative ease (see Figure 2.20). By the latter nineteenth century, coal dyes and chroma lithography had progressed so that coloring (rendering) was vivid. Women eagerly anticipated the fashion news and relished the detailed descriptions and elegant color pictures of the latest fashion from Paris. Fashion plates were replaced by fashion photography in the 1920s.

By the end of the eighteenth century, fashion plates were extensively featured in foreign fashion magazines such as *La Belle Assemblée, Journal des Dames et des Modes, Le Moniteur de la Mode*, *Les Modes Parisiennes,* and *Les Modes Illustrées*. Dozens of these weekly, biweekly, or monthly fashion periodicals with circulations that numbered into the millions were published in the major European cities to feed the voracious appetite of all women, from the fashion elite to the average homemaker. The prolific output of these periodicals created heightened fashion awareness, especially during the nineteenth century. In addition to fashion plates, the periodicals contained society news, fiction, sheet music, poetry, general interest articles, home fashions and household décor, needlework, etiquette, and domestic tips. Although many periodicals existed, descriptions of three follow.

1. **La Belle Assemblée.** Despite its French-sounding name, this fashion magazine was created by British publisher John Bell (living in France) and spanned the decades from 1806 to 1868. As with most fashion magazines of the time, the periodical displayed black-and-white and later colored engravings with corresponding descriptive copy explaining the colors, fashion style and details, accessories, and fashionable hairstyles.

2. **Journal des Dames et des Modes.** This fashion magazine consisted chiefly of illustrated men's and women's fashion plates and descriptive captions. Founded in 1797, it existed for more than four decades. During its life, the influential magazine absorbed eight other fashion periodicals.

3. **Le Moniteur de la Mode.** This was an important Paris women's fashion publication from 1843 to 1913. It featured the current trends in apparel, coiffures, and home fashions. The publication's primary fashion

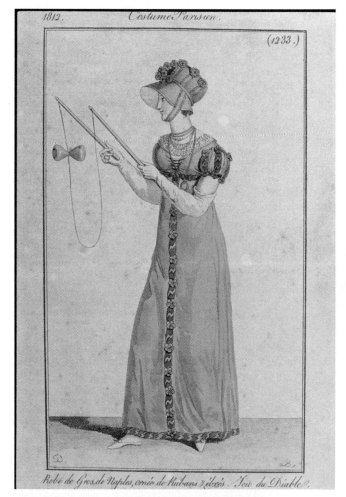

Figure 2.20 Engraved fashion plate.
(Getty Images, Inc./PhotoDisk)

plate illustrator and watercolorist, Jules David, featured common activities of the *bourgeoisie* (upper class) women in naturalistic environments, such as on the ocean beach or in a formal garden. He also depicted the subjects in elegantly furnished parlors. By viewing the fashion in the context of a setting, the fashion follower could better understand the appropriate occasion intended for the clothing. Interested consumers can still purchase these antique fashion plates via the Internet. Information at the lower edge of the plates indicates the date and fashion houses from which the featured items could be purchased.

summary

- Fashion has been influenced by all cultures.
- Because the United States was settled primarily by immigrants, the country's early fashions reflected a blending of indigenous and imported (primarily European) cultures.
- The coming together of commerce, religion, and politics created unique fashions for areas of Europe.
- Important events affecting fashion included trade across the Silk Road, the Crusades, and political alliances of intermarriages across country borders.

- King Louis XIV propelled France into a cultural empire admired by American colonists.
- Other Western European countries, such as Italy and England, were also instrumental in exporting fashion ideas to America.
- Fashion influencers and trendsetters ranged from dressmakers with lowly beginnings to aristocratic rulers, such as King Louis XIV, Rose Bertin, Madame de Pompadour, and Charles Worth.
- Fashion ideas were disseminated by fashion dolls, fashion engravings or plates, and fashion magazines.

terminology for review

Silk Road 22
sumptuary law 23
American Look 25
dandy 29
dandyism 29
caged crinoline 30

bustle 31
faux 32
haute couture 34
Chambre Syndicale de la Couture Parisienne 34
ateliers 34

couturiers 34
couturières 34
chic 36
fashion dolls, jointed babies, or mannequins 36
fashion plates 37

questions for discussion

1. What are some of the major fashion contributions of France and Italy?
2. How did the Silk Road affect the global fashions and fabrics?
3. In what ways did the Crusades affect the global fashions and fabrics?
4. What are sumptuary laws, and why were they difficult to enforce?
5. What were some of France's King Louis XIV contributions to the fashion world?
6. What contributions did Italy make to the U.S. fashion industry?

7. In what ways did the United States strengthen and encourage the Italian fashion industry?
8. Who are some European fashion influences, and what were their major contributions?
9. What is the role of the haute couture in setting global fashions?
10. What are some historic fashion communicators, and how did they help spread fashion information?

related activities

1. Choose a *haute couture* designer from Table 2.1. Research the designer's biography, design philosophy, major contributions, and product offerings. Also include several product illustrations credited to this designer. Create an interesting and informative electronic slide show about the designer and present it to the class. Conclude with the complete bibliographic citation for all sources using the American Psychological Association (APA) format.

2. As a class, brainstorm about important fashions items from the last two or three centuries. Select one of these to research on the Internet. Find illustrations and descriptions of the item. Determine what historical factors (political, economic, social, and religious) contributed to the popularity of the fashion. Create an interesting and informative electronic slide show about this fashion and present it to the class. Conclude with the complete bibliographic citation for all sources using the American Psychological Association (APA) format.

3. Using your library's electronic databases, locate an article that discusses how fashions are influenced by celebrities, political events or personalities, economic factors, the role of women in the workforce, or any other social influence. Begin with a paragraph summary of the article. In the second paragraph, offer a thought-provoking article critique (your opinion). Explain how this information relates to Chapter 2 of the textbook and tell how it might be useful to fashion marketers. Conclude with the complete bibliographic citation using the American Psychological Association (APA) format.

4. Over the centuries, marketing and promoting efforts by fashion businesses have driven the industry. Identify a minimum of five specific marketing and promotional activities mentioned in this chapter and explain how each activity served to encourage fashion usage among consumers. Identify the marketer, marketing message or activity, and intended receivers. Create a chart using the column/row format.

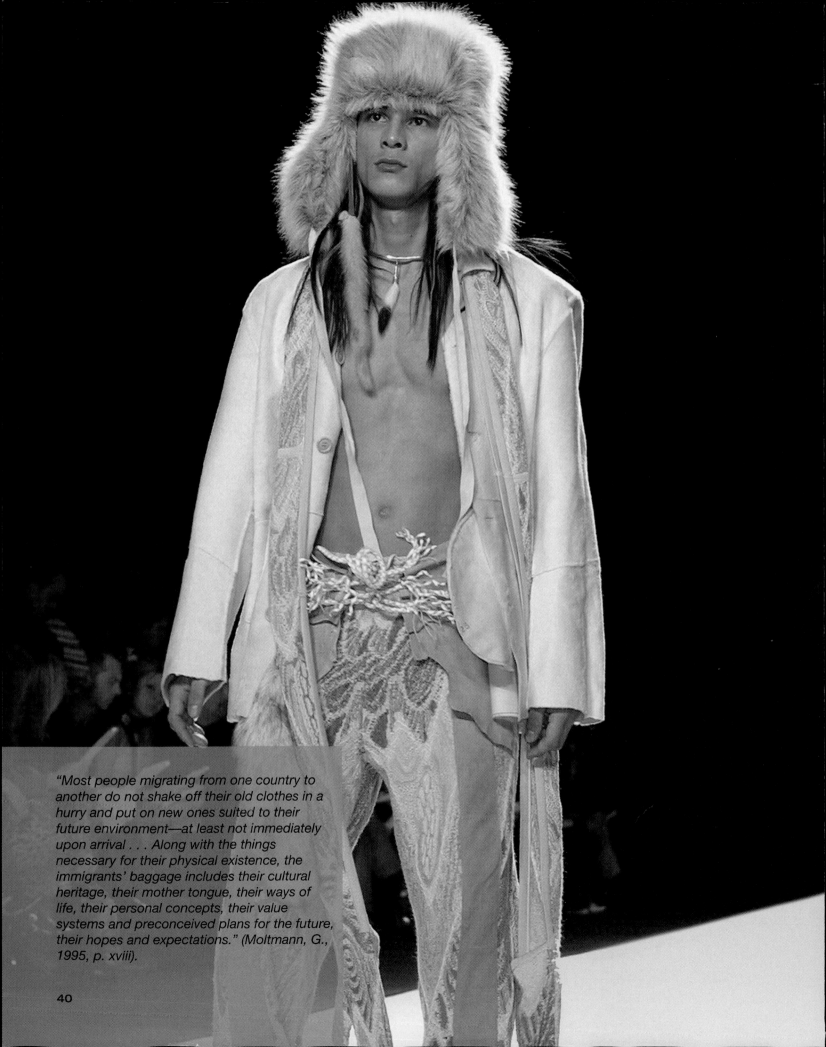

"Most people migrating from one country to another do not shake off their old clothes in a hurry and put on new ones suited to their future environment—at least not immediately upon arrival . . . Along with the things necessary for their physical existence, the immigrants' baggage includes their cultural heritage, their mother tongue, their ways of life, their personal concepts, their value systems and preconceived plans for the future, their hopes and expectations." (Moltmann, G., 1995, p. xviii).

Early
AMERICAN
CLOTHING
Influences

LEARNING OBJECTIVES

At the end of the chapter, students will be able to:

- Distinguish the textile and apparel contributions of various ethnic groups arriving in colonial America.
- Assess the role of fur trappers and traders in promoting the fashion industry while settling early America.
- Explain the impact of the Industrial Revolution on the textile and apparel industries.
- Identify the various textile and apparel industry inventions during the Industrial Revolution.
- Explain how developing countries expand their economy with textile and apparel factories and identify the problems that can occur during development.
- Evaluate the benefits of a code of conduct in the apparel industry.

Historically, many unique cultures contributed to the U.S. fashion industry. Immigrants came from all over the world and left their mark on the clothing that would eventually become the American Look.

The Industrial Revolution profoundly impacted the U.S. textile and apparel industry with the invention of all kinds of power-driven machinery to speed up the production process. Apparel production moved from fireside to factory, creating new jobs and new wealth.

Economic growth is not without its share of hardships. Although the United States has mostly eliminated sweatshop conditions, they still exist in developing countries. Unsafe working conditions contribute to employment catastrophes, but the public outrage after a catastrophe often ensures greater safety in many other factories. Codes of conduct have become business requirements for many major fashion companies.

Ethnic Influences

From 1620 to 1790, an estimated 875,000 people immigrated to the original American colonies (The Peopling of America, 2000). According to the earliest Ellis Island census data from 1790, the immigrants in the largest numbers were from England (300,000), Africa (300,000), Ireland (100,000), Germany (100,000), and Scotland (75,000). The Native American population, excluding Eskimos, was counted during the first census in 1860, and it was estimated they numbered nearly 340,000. The French, British, and Spanish fur traders came from Europe, often via the Missouri River, and the Russian fur traders crossed through Alaska. Their intent was to open fur trading posts in areas populated with beaver and other desired fur-bearing animals. The Spanish soldiers and missionaries settled the southwestern region of North America in settlements such as San Antonio, Santa Fe, Tucson, and San Francisco. Each of these groups of people brought their own culture, behavior, expertise, and most certainly dress. Over time, the dress of these diverse groups merged into a composite culture referred to as the American Look.

European Immigrant Influences

After the Native Americans and fur traders, the European immigrants settled the eastern seaboard of the American colonies. From the time span between 1607 when settlers colonized Jamestown, Virginia, and 1650, approximately 52,000 people, mostly of European and African descent, were living along the East Coast of the colonies. Many of these immigrants were Puritans who landed in Plymouth, Massachusetts, beginning in 1620.

From the beginning, the British provided the majority of textiles to New England until the colonies declared their war for independence. Textiles were in short supply during the American Revolution, so General George Washington appointed a clothier general, Mr. James Meese, to ensure a fair distribution of the limited available clothing and textiles. Washington even sent a letter to the Quakers of Pennsylvania requesting that, at the very least, they help with the clothing cause, since they refused to take up arms in the war against Britain.

Figure 3.1 **The Mayflower ship brought Puritans to Plymouth.**
(David Lyons © Dorling Kindersley)

Some colonial families owned or had access to the equipment required for manufacturing fabric, including spinning wheels and looms. If a family did not own the equipment, the family members might borrow the use of a neighbor's wheel or barter yarns and fabrics for other items they could supply. However, the average colonial family was not self-sufficient and spent more than one-fourth of the family budget on imports (Shammas, C., 1982). Colonial families frequently imported British textiles because most families produced insufficient textiles to meet their household needs. Colonists paid for the imported textiles with items they could produce, including tobacco, rice, indigo, wheat, fish, tar, or any other goods with international demand.

Figure 3.2 Antique luggage display at Ellis Island.

Ellis Island Immigrants were encouraged to come to the colonies because significant populations were needed to settle the vast wilderness. Eventually, **Ellis Island**, located off the southern tip of Manhattan, became the official U.S. government site to process newly arrived immigrants. It opened in 1892 and remained a viable entry point until 1954, with officials processing approximately 12 million immigrants. Today, it operates as a museum with an interesting display of immigrants' luggage, suitcases, valises, trunks, and hatboxes used to carry clothing and other necessary belongings as immigrants made their pilgrimage by ship to the United States.

Irish Immigrants The great potato famine that killed potato crops in Ireland from 1845 into the next decade forced many Irish to flee their home country and travel by ship to Canada or New York to begin a new life. The Irish were primarily manual laborers, but some had skills in linen weaving, dressmaking, and sewing. Linen weavers contributed significantly to the Irish economy, particularly in Northern Ireland. So when they moved to the colonies, they brought their skills with them. Colonists appreciated the advanced skills of the weavers, and the reputation of Irish linen grew in importance by the late seventeenth century.

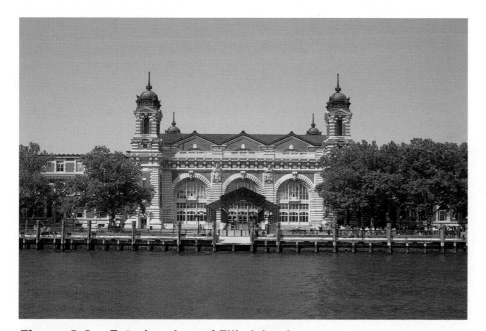

Figure 3.3 Exterior view of Ellis Island.
(Michael Moran © Dorling Kindersley)

Figure 3.4 Irish linens.
(Steve Gorton © Dorling Kindersley)

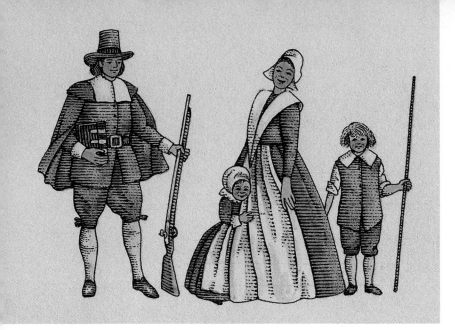

Figure 3.5 Pilgrims in traditional dress.
(Rob Shone © Dorling Kindersley)

Figure 3.6 Leather skins are tanned to make them supple.
(© Dorling Kindersley)

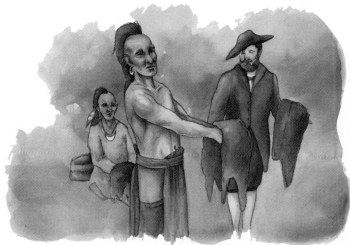

Figure 3.7 Trading with fur pelts.
(EMG Education Management Group)

English Immigrants The English immigrants were some of the first to arrive aboard ships in the New World. Many were deeply religious Puritans who refused to accept the Church of England as a protestant religion. When they immigrated to the colonies, they became known as Pilgrims.

Not all immigrants were Puritans who dressed in simple and austere styles. The more affluent wore fashionable styles imported from the European continent and possessed wardrobes of expensive clothing and fabrics. Other pilgrims barely had enough warm clothing to survive the cold winter months. Regardless of social status, all settlers needed mobility in clothing. A strong work ethic became a necessity for all social classes, and clothing styles allowed for hard work.

Puritans commonly wore brown because the natural dyes were easy to achieve and the clothes were less likely to show dirt. A common misconception exists that the Puritans dressed in black—black hats, black coats, and black or white collars. However, black was reserved for the wealthy colonists rather than the average person, due to the difficulty of obtaining black dyes.

The settlers soon adopted the Indians' notion of making leather clothing because of leather's durability and warmth. The English immigrants were skilled tanners, so quality leather clothing became readily available.

Historically, the British economy relied on the production of textiles, so a great number of immigrants possessed these skills. It was common for the immigrants to set up spinning and weaving operations similar to those back home. In England and most other Western European countries, spinning yarn was the primary task of women, whereas weaving fabric was the primary task of men. With the advent of weaving machines and factory production in the 1800s, chores related to production and management of the household's clothing became the responsibility of the women.

Ruth Henshaw, a young woman from Massachusetts, recorded these experiences in her diary on December 15, 1792. She stated, "This day I am 20 years of age. Spun 3 skains lining [linen]. Wove 3 yards all wool" (Diary of Ruth Henshaw Bascom, 1789–1848). Apparently, even on her birthday, she performed the domestic chore of spinning fibers into yarns and weaving woolen fabric.

Mrs. Martha Stewart Wilson visited Martha Washington at the Mount Vernon plantation and recorded these observations in a letter. "Mrs. Washington told how it had become necessary to make their own domestic cloth, a task at which sixteen spinning wheels were kept constantly busy" (Hinson, 1970, p. 178).

German Immigrants The first large group of German settlers landed in America in 1683 and settled in Germantown, Pennsylvania. German-born immigrant John Jacob Astor became a millionaire and the richest man in America in the early

nineteenth century due to his business acumen and his success with his fur trading company, the American Fur Company.

The early German immigrants brought clothing styles popular in their home country. These styles included the dirndl skirt, aprons, and caps or bonnets that were common styles across Germany. Like other newly transplanted immigrants, the German population tended to retain many of the clothing styles that had been worn in Germany. There is even a German word that refers to maintaining a variety of traditions from the home country. This word, **Heimat**, includes dressing in traditional clothing as an outward expression of one's homeland.

Scottish Immigrants Before relocating to America, Scottish hand weavers were well-known for fine quality linen fabrics made from flax fibers. **Linsey-woolsey** or linsey-homespun was a combination of linen and wool fibers (or sometimes 100 percent wool) that the Scotch Irish immigrants introduced to the colonies. Weavers combined linen warp yarns with wool weft yarns, creating a homespun fabric that was practical and somewhat coarse. The colonists valued these durable and warm fabrics, especially those people living in the colder northern regions.

European Trappers Although the European trappers and fur traders (many of whom were native Frenchmen) did not establish fashions, they provided the supplies that influenced the adoption of fashion in both colonial America and Europe. French fur traders arrived in the sixteenth century in Eastern Canada, and they traveled the St. Lawrence River and across the Great Lakes. They gradually penetrated the northern sections of America and moved westward.

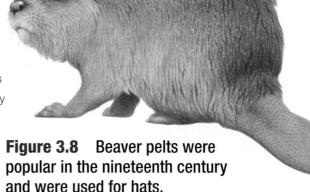

Figure 3.8 Beaver pelts were popular in the nineteenth century and were used for hats.
(Kenneth Lilly © Dorling Kindersley)

Fur traders valued beaver pelts over many other types of fur and commonly obtained the fur by trading with the Native Americans. Trading for beaver pelts became a lucrative and long-term business venture because for almost two hundred years, Western Europeans (and Americans) had insatiable desires to don beaver hats. As trappers and traders depleted beaver populations, they sought new habitats of fur-bearing animals. Historians credit the westward expansion into the Pacific Northwest and along the Oregon Trail in part to these early fur traders. Fortunately for the waning beaver population, the 1840s brought a new fashion to replace beaver hats—silk hats. They soon became the epitome of fashion for men.

In historical accounts, the fur traders discussed some items traded for a fur pelt. These included axe heads; awls; knives; muskets; blankets and fabrics; needles; beads; ammunition; alcohols, such as brandy, rum, and whiskey; and other items previously unavailable to the indigenous people.

The large consumer market demanded all kinds of fur. Consumers desired furs for fashion and warmth, particularly since central heating was unavailable. The uses of fur ranged from entire fur coats for the affluent consumers to small amounts of fur trim on coats or mufflers for consumers of more modest means. In addition to beaver, other useful furs included wolf, marten, mink, lynx, muskrat, raccoon, fox, and later buffalo hides. Southern colonists, in cities such as Charleston, South Carolina, exported deerskin to Europe for textile production.

Figure 3.9 Fur pelts.
(Liz McAulay © Dorling Kindersley)

Figure 3.10 African Adinkra cloth printed with symbolic motifs.

(Andy Crawford © Dorling Kindersley)

Figure 3.11 Navajo blanket with popular red yarns.

(Pearson Education/Modern Curriculum Press/
Pearson Learning)

Figure 3.12 Cowboy Western wear has changed very little in the past two centuries.

(© Dorling Kindersley)

African Immigrant Influences

Enslaved Africans bound for America came from the western regions of Africa and included African people from the countries of Congo, Angola, and Ghana. These people brought their unique African traditions for dyeing and printing textiles. One of their fashion contributions that survived the blending of American cultures is the printed **Adinkra** (ah-DEEN-krah) **cloth** covered with hand-stamped symbols (see Figure 3.10). Artisans originally carved the stamps from chunks of gourd or calabash. This cloth can be identified by bold symbols such as a spiral curl, a geometric shape, or a representation of an animal. Symbols and selected colors have historical, familial, social, political, sacred, and religious meanings. A recent African-American fashion catalog featured several styles of mass-produced, loose-flowing tunics and caftans with Adinkra-style prints. Although the prints and colors have lost their symbolic significance for most Americans, they are popular in a fashion sense.

Native American Influences

In 1540, the Spanish explorer Coronado moved northward from Mexico and explored an area that reached as far north as Kansas. His route made way for Spanish missionaries, fur traders, and military campaigns that exchanged cultural ideas with the indigenous Native Americans. The Spanish brought herds of sheep to the Southwest, and wool weaving quickly became popular among the Native Americans. The Native Americans' cultures greatly appreciated the Spanish red-dyed wools because the new, bright red color contrasted with their muted, natural-colored dyes. They unraveled existing red woolen fabrics, such as soldiers' uniforms or blankets, to obtain the prized yarns for their own uniquely woven rugs and blankets. These items would later become popular items for trade (see Figure 3.11).

Cross-cultural influence in weaving patterns is seen in many of the early American textiles from this region. The Mexican weavers borrowed patterns from the Native Americans, especially in items for export or the tourist trade. The tourists considered the Native American woven textiles as somehow being more authentic than the textiles that used the design elements and color schemes popular in Hispanic weaving.

Influences on American Western Wear

The cowboy duds or western wear so commonly associated with the Great American West is actually a blending of multiple cultures: Spanish, Mexican, and Native American. Synonyms for cowboy include *vaquero*, buckaroo, and drover, depending on the cultural ancestry. Regardless of ancestry, most cattle ranchers and drivers wore ten-gallon hats, kerchiefs, leather vests, chaps, and cowboy boots (see Figure 3.12). The clothing originated as almost entirely functional, but today has evolved into an important fashion trend.

A western hat with a large crown has been called a ten-gallon hat. The name may be derived from an exaggeration of the size of the crown, or it may be derived from the Spanish word *galón,* meaning braid (braiding around the brim). The Spanish word **sombrero** was also a common name for the early cowboy hat. One of the most famous brands of western hats is **Stetson**. John B. Stetson introduced a line of hats after moving westward in the 1860s to produce fur felt hats in a variety of styles.

Cowboy hats function in many ways. A cowboy hat keeps the rain off the cowboy's head, protects his eyes and neck from the sun, keeps his head warm or cool, and could serve as a water bucket for his horse. Mexican cowboys began this practical fashion, and the American cowboys adopted it in the nineteenth century.

Cotton kerchiefs were also practical must-have accessories. Cowboys wore them about the neck to prevent sunburns. Kerchiefs could also be tied over the nose and mouth to filter the air during dusty cattle drives. Dampened kerchiefs could serve as cooling cloths, wash-cloths, or even makeshift bandages.

Leather vests and chaps served as a protection from vegetation while riding horses. Leather is one of the most durable natural textiles. The cowboys wore the leather items over their shirts and pants to protect their bodies and their clothing from scrapes, holes, or tears. Cattlemen obtained soft tanned leather by bartering with the Native Americans. The entertainer Buffalo Bill and his troupe toured with the Wild West Show in the 1880s and created a sensation for fringed leather, beaded fringe, and decorative silver conchos on leather jackets, vests, and chaps.

The leather cowboy boot protected the wearer's calves and guarded against rough terrain and snakebites. It was derived from the classic European riding boot, but the heel was made higher and angled to help the rider's feet stay securely in the stirrups. The decorative stitching on the boot upper secured the lining and prevented the tops from sagging. The German cob-blers who settled in south Texas are credited with designing a functional boot that has changed very little since its inception.

One very important fashion, denim jeans, is truly an American West invention. During the California Gold Rush, **Levi Strauss** transported yards of indigo-dyed cotton fabric to California in 1853 to set up his own wholesale dry goods business. The fabric originated in Nims, France (of Nims or *de Nims*), and soon became the Levi Strauss trademark **denim**. His first man-ufactured work pants were called "waist overalls." One of Strauss' wholesale customers, a tailor named Jacob Davis, developed a technique to place metal rivets in areas that received the greatest stress, such as at the corners of pockets and the lower edge of the button fly. Together, they patented the riveted concept for the clothing that later would be called jeans (Downey, L., 2005).

> Western wear is a style of clothing that is truly American, although its history is adapted from Mexican influences.

From time to time, city dwellers adopt western apparel strictly for a fashion look. It creates a feeling of ruggedness and masculinity for the wearers—unless, of course, it is colorful and embellished with rhinestones! In this case, it serves a simple fashion purpose—adornment.

Figure 3.13 Poster advertising Buffalo Bill's Wild West Show.
(Geoff Brightling © Dorling Kindersley)

The Industrial Revolution Developments

The European Industrial Revolution began as early as the fourteenth century, and the inventions greatly advanced the textile industries. From 1770 to 1830, the technological developments occurred so rapidly that the term *revolution* was completely appropriate. By the early 1800s, the textiles industry had become France's largest industry. In the first twenty years of the nine-teenth century, England doubled its yield of industrial goods. The beginning of the United States coincides with the beginning of the Industrial Revolution. The rapid development of this coun-try can be partially credited to the invention of all kinds of machinery during the developing years of the United States.

Figure 3.14 Denim pants with rivets are a product of the 1849 Gold Rush in California.
(Clive Streeter © Dorling Kindersley)

Key Inventions That Created an Automated Revolution in the Textile and Apparel Industry

1763
Spinning Jenny

1794
Cotton Gin

1846
Sewing Machine

1785
Steam Engine
Spinning Machine
Power Loom

1831
Automated
Knitting Machine

1864
Circular
Knitting Machine

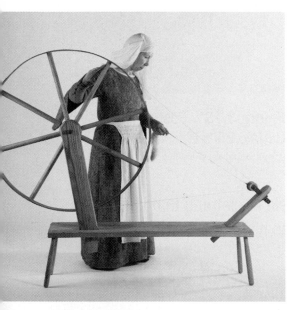

Figure 3.15 Spinning wheel.
(Geoff Brightling © Dorling Kindersley,
Courtesy of the Order of the Black Prince)

Spinning Wheel

The **spinning wheel** was a time-consuming, hand-operated method of creating yarns. Spinning was relegated to the unmarried woman living with her family who performed domestic chores, including spinning yarns and maintaining the family's wardrobes. Her title was **spinster**, which is still used today to refer to an old maid.

Spinning Jenny

Englishman James Hargreaves invented a **spinning jenny** (named after a family member) in 1763. The machine spun cotton fibers into yarns suitable for weaving or knitting fabrics. His wooden machines typically had six or eight spindles, but that number eventually increased to as many as 120 spindles, which greatly increased the yarn output of the operator.

Steam Engine

James Watts of England invented the steam engine in the mid-1780s, and it became an important component of the cotton factories. The steam engine harnessed steam to power machinery. Prior to the invention of the steam engine, owners located factories next to running streams so that the rotating water wheels could turn the machinery parts. Later, invention of the practical steam engine supplied power at locations far from running water.

Spinning Machine

About the same time that James Watt obtained a patent for his steam engine, fellow Englishman Sir Richard Arkwright improved an existing invention—the spinning jenny. The **Arkwright machine** could card, rove, draw, and spin cotton fibers into strong yarns with uniform length. His process allowed for the manufacture of durable yarns that could be woven into very smooth, fine cotton fabrics. Factory workers feared the introduction of machinery such as Arkwright's spinning machine might replace human labor and that their hand skills would no longer be required.

Arkwright and partner quickly noted the mechanical genius of a new apprentice—a young Englishman named **Samuel Slater**. When Slater was in his early twenties, he saw an advertisement for mechanics needed to build an Arkwright machine in America. The protectionist English law forbade the emigration of trained mechanics, but the law allowed farm laborers to

leave the country. Posing as a 21-year-old farmer, Slater defied the law and sailed to New York in 1789. He found financial backers who were willing to pay him one dollar daily and half of the company's net profits for his construction and operation of Arkwright machines. The company, founded in 1793, is considered by some to be the beginning of the U.S. Industrial Revolution. It is interesting to note that Slater's first mill workers were boys and girls, aged seven to twelve. Today, the Slater Mill Museum is located at the original site in Pawtucket, Rhode Island.

Weaving Machine or Power Loom

The powered or hand-operated machine that is used to create fabrics is called a **loom**. A loom is prepared with numerous parallel vertical yarns, called **warp yarns**, which are interlaced with horizontal yarns, called **weft or filling yarns**. This interlacing or **weaving** process forms fabric.

Englishman Edmund Cartwright visited Richard Arkwright and viewed the spinning machine developed by Arkwright. He suggested the creation of an automated weaving machine and proposed some early design ideas that were cumbersome and not well received. Cartwright continued to improve the loom design and obtained patents in 1785 and 1788.

Knitting Machine

The hand-operated knitting machine introduced in 1589 by Englishman William Lee became an automated knitting machine in the late 1700s. In 1864, William Cotton of Leicestershire, England, introduced a **circular knitting machine**. The purpose of a circular knitting machine is to create a seamless tube of fabric that can be used for socks and hosiery, thus eliminating the back seam. William Cotton's patented machine allowed for the full fashioning of the heels and toes of hosiery. **Full fashioning** means knit stitches are dropped to create a tapered and shaped section of the stockings. It eliminates the need for cutting and sewing in these areas.

Mechanical knitting machines were much faster and economical than hand knitting and produced more uniform fabrics. Handmade lace required many hours of hand knotting to make a single accessory, so they were simply too expensive for most consumers. The mechanization of knitted lace caused an increase in production and afforded the average person the opportunity to ornament clothing with beautiful, manufactured laces.

Nottingham, England, became a hub of manufactured laces, textiles, and hosiery during the first part of the nineteenth century. Today, the site of the lace market (and the folklore birthplace of Robin Hood) is in a protected heritage area of Nottingham and is open to tourists.

Cotton Gin

Eli Whitney, a native of Massachusetts and a recent graduate from Yale University, spent a summer in the 1790s on a Georgia plantation. He observed the tedious hand process of separating the cotton lint from the cotton seeds. Since the cotton lint grows out of the seeds, the fibers must be forcibly pulled off the seed. Observing the painstaking work, Whitney noted that each person was only able to clean a single pound of cotton lint each day. He began to envision a hand-cranked machine with curved wires and brushes that could be rotated to pull the seeds away from the lint. The heavier seeds would fall to the bottom of the machine, while the lint would stay on the wires (see Figure 3.16). In ten days, he had designed and named the **cotton gin** (short for *engine*). Using a cotton gin, a person now separated fifty pounds of lint each day!

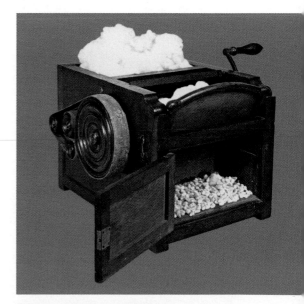

Figure 3.16 Eli Whitney's cotton gin.
(© Bettmann/CORBIS All Rights Reserved)

Whitney patented his cotton gin in 1794, and within ten years, the cotton production in the United States increased from $150,000 to more than $8 million.

Sewing Machine

Prior to the invention of the sewing machine, people sewed by hand. A dressmaker hand-stitched yards and yards of fabric for voluminous skirts and layers of petticoats. Seamstresses engaged in the tedious task of hand-gathering fabric to manage the layers of fullness. Bodices were close-fitting and required many hand-sewn seams. Dressmakers were delighted when they saw the revolutionary sewing machine invention.

A host of inventors attempted to design a sewing machine powered with a hand crank and later with a foot treadle. Elias Howe is credited for patenting the first successful sewing machine in 1846. Isaac Singer quickly added practical improvements to the machine. By 1850, Singer was aggressively marketing the invention on a broad scale. The "Common Sense" machine, as it was sometimes called, became the first home appliance. The home sewer secured the machine with a clamp to a tabletop, and it produced a uniform, straight chain stitch. The results were much nicer than hand sewing, so the machine was well received by the public. In 1853, a Singer sewing machine sold for $100. In 1855, the invention won first place at the World's Fair in Paris, and Singer began international company expansions in France.

Figure 3.17 Early sewing machine patented by Isaac Singer.
(© Dorling Kindersley)

The Growth of the American Textile and Apparel Industry

The Industrial Revolution occurred simultaneously in the United States and England, even though the English government attempted to prevent technological secrets from being exported to the upstart colonies. As late as 1784, the English belatedly recognized that the United States was becoming a major player in textile production. When U.S. merchants shipped a mere eight bales of U.S. cotton to England, the English government seized them on the basis of "fraudulent imports" because England still believed the United States could not produce even as much as eight bales of cotton. In spite of England's initial denial of U.S. cotton production, it soon became obvious that Europe was fast losing its domination of the U.S. textile market. From 1794 to 1810, the cotton mills in the United States increased in number from four to one hundred mills. The 1790 U.S. Census reported the U.S. cotton crop to be 3,000 bales. By 1835, the United States was producing 1,062,000 bales of cotton.

Textile Mills

The movement of production from home to factories characterizes the Industrial Revolution. Historian Victor S. Clark wrote, "The short period between 1810 and 1830 saw the center of gravity of textiles shift from the fireside to the factory" (Clark, 1949, p. 529). Factory owners used machinery powered by alternative sources to operate the factories, including water or steam power, rather than human or animal muscles. Textile producers led the Industrial Revolution in the United States with applications of factory methods. Manufacturers moved cotton ginning, carding, combing, and yarn spinning textile operations to factories. Edmund

Figure 3.18 Textile loom machinery at work for weaving fabric.

(Joe Cornish © Dorling Kindersley)

Cartwright designed a partially powered weaving loom in 1785, resulting in textile weaving mills to spring up in the United States. By 1850, most women no longer produced cloth at home, instead shifting to purchasing yard goods at the store. In spite of the textile mill advancements, home sewing still occupied much of the early American woman's time.

> Textile producers led the Industrial Revolution in the United States with applications of factory methods.

Corporate Codes of Conduct

Among the early groups of concerned citizens and businesses, the 1997 Apparel Industry Partnership issued an industry code of conduct or guideline recommended for use by all

Milan's Ultra-Tech Textiles

In recent years, Milan textile mills have earned the reputation for offering short runs of high-tech and luxurious textiles to designers. High-fashion designers demand small runs of five- to ten-yard lengths of specially created textiles to use in their runway shows. The demand required many of the small and medium Milan textile mills to invest in research and development and upgrade their existing machinery. The opportunity to fill the innovative textiles niche market provides Milan companies with a competitive advantage. The result is beautiful and unique fabrics that are unavailable through mass textile producers, such as those located in China. Recent specialty fabrics include lightweight cottons and silks coated with resins to add body; lightweight wools that transcend seasonal changes; high-quality natural fabrics fused to rubber or nylon; and mohair treated with a transparent film to create a lightweight, vintage-looking fabric.

One other factor in Italy's favor is the country's Made in Italy label which conveys a sense of quality and prestige not associated with the Made in China label. The perceived fashion and styling of textile and apparel products made in Italy may be as important a characteristic as the country's venture into high-tech fabrics.

SOURCE: Meichtry, S. & Passariello, C. (2007, Sep. 29). Milan Fashion Week; Check out the new threads. *Wall Street Journal* (Eastern Edition), p. W1.

the **Business** of **FASHION**

manufacturers and retailers. Two decades later, several organizations now offer retailers and fashion brands the opportunity to adopt codes of conduct. The apparel industry's **corporate code of conduct** is a list of do's and don'ts—necessary human rights policies that all apparel businesses should follow. The topics are based on the International Labor Organization (ILO) core conventions, that include treatment of employees, the right to collective bargaining, minimum age of workers, paying a living wage (money to meet the necessities of life), overtime compensation, safety, and many other important human rights issues. Based primarily on the work developed by the ILO, many apparel companies have adopted codes of conduct or compliance codes to guide their supply chain partners. A manufacturer that consistently fails to comply with the code of conduct should not be a business partner. The U.S. companies have enough leverage in purchasing that they can improve human rights in these global factories.

In poll after poll of consumer opinions, the American people express outrage at violations of human rights in overseas factories. U.S. consumers are particularly sensitive to child labor issues and harassment of female employees. They vow that they would never conduct business with companies that directly or indirectly violate these rights. Yet in the apparel industry, it is difficult, if not impossible, for consumers to know sufficient details about a particular factory in which a garment was produced. First, innumerable factories exist all over the world, and many are quite small in size. A single apparel company may contract with multiple factories to produce a brand of clothing. For example, one global brand of athletic shoes and apparel contracts with more than 700 factories in over 50 countries! Second, the garments may change hands several times (through importers, middlemen, or wholesalers) before being retailed to the ultimate consumer. Third, it is not feasible for consumers to know about all the companies with which their favorite retailer conducts business. After all, a shopper usually just buys fashions because the items are popular, cute, or a good price. The shopper has to trust that the channel members used ethics to guide their production decisions. The responsibility lies with the U.S. apparel companies that source their goods internationally. It is an ethical and expected part of conducting business. The Apparel Industry Partnership operating in conjunction with the U.S. Department of Labor provides several activities for monitoring workplaces once the code of conduct has been set. U.S. businesses can follow these guidelines to reduce the possibilities that they will unknowingly contribute to the activities of a sweatshop. These principles of monitoring are:

1. Establish clear standards.
2. Create an informed workplace.
3. Develop an information database.
4. Establish a program to train company monitors.
5. Conduct periodic visits and audits.
6. Provide employees with opportunities to report noncompliance.
7. Establish relationships with labor, human rights, religious, or other local institutions.
8. Establish means of remediation.

SOURCE: Apparel Industry Partnership's Agreement (1997, Apr. 14). United States Department of Labor.

Today, there are several organizations and associations offering industry codes of conduct. The benefit of these organized groups is their structured system, extensive network, constant vigilance, and increased oversight of international labor rights and working conditions. Apparel companies no longer find it necessary to independently develop and enforce their own codes of conduct; instead, they can take advantage of an association's offerings. Four prominent as-

sociations are the Ethical Trading Initiative (ETI), Fair Labor Association (FLA), Worldwide Responsible Apparel Program (WRAP), and the Global Social Compliance Programme (GSCP). Each of these organizations approaches compliance from a slightly different standpoint and each has a Web site that provides additional information.

Sweatshops

Unsafe or poor working conditions and low pay commonly exist in developing countries with large labor pools. Many of the factories employ children as laborers because they do not require the higher wages expected by the adults, they tend to have better eyesight, and their fingers are more nimble. These **sweatshop** factories tend to consider human rights secondary to production and profit. Sweatshops are common in developing countries because there is limited organized labor and the workers must have jobs to survive. As the world economy continues to expand globally, it becomes increasingly difficult to monitor every factory in every country.

As countries become more developed and as industry increases in these countries, the incidence of sweatshops should decrease. Citizens of these countries become better educated, better organized, and more selective in the types of work they will accept. The early U.S. Industrial Revolution era had its share of sweatshops and similar problems.

The apparel industry has always been an employer of women and immigrants in the United States. Employers have traditionally subjected these two groups to human rights violations during work. A catastrophic fire in a clothing factory occurred at the Triangle Waist (shirtwaist) Factory in New York because of unsafe working conditions. Today, garment workers still lobby for safe working conditions for all people. Figure 3.19 depicts a group of I.L.G.W.U. (International Ladies Garment Workers Union) demonstrators in 1988 carrying a banner that reads "I.L.G.W.U. Proud to defend immigrant rights."

Figure 3.19 1988 garment workers' demonstration march to defend immigrants rights.
(Pearson Education/PH College)

FASHION FACTS: The Catastrophic Triangle Waist Factory Fire of 1911

One of the most widely publicized tragedies in the almost 300-year-old U.S. apparel industry occurred in a New York City building at 23 Washington Place on March 25, 1911. The Asch building housed the Triangle Waist Factory on the top floors. The company sewed blouses, called **shirtwaists**, and employed young immigrant women. Of the 146 people killed in the fire, most were female seamstresses between the ages of 13 and 23. The fire marshal believed the fire started on the eighth floor of the ten-story building. Experts speculated that either a smoldering cigarette thrown into a trash bin or faulty wiring caused the fire. The company managers had placed the sewing machines so close together that the aisles were virtually impassable, and the garments were strung on a clothes line over the top of the machines. The factory became an inferno in a matter of minutes. Witnessed argued that the supervisors locked the exits to prevent the employees from sneaking out before closing time. Some women jumped to their death; others succumbed to smoke inhalation. Many were burned beyond recognition. A few employees escaped, including the owners of the building. The outraged public established a fund to help the victims' families, and a parade of 120,000 people (mostly women) marched through the rain on Fifth Avenue in Manhattan. The police estimate a total of 400,000 people turned out to view or participate in the march.

This event became an important turning point in the U.S. apparel industry. The district attorney charged the owners with two counts of manslaughter due to failure to comply with building safety codes. The charges included having locked exits and unstable fire escapes that ended in mid air. The owners were tried and acquitted of the crimes. This horrific tragedy led to the development of more stringent fire codes for all buildings, including theaters, and the government passed new laws for adequate and safe exits in factories. This event also gave rise to the labor unions that allowed workers to organize for greater benefits and safer conditions.

AUTHOR'S NOTE: For a complete recount of the fire, investigation, and trial, refer to the *New York Times* newspapers, March 26, 1911, through December 29, 1911.

summary

- Many cultures have influenced the clothing of the United States.
- The fashions have evolved over time and merged to form a somewhat homogenous American Look, although many individual aspects of cultures are still seen and worn today.
- Fur traders and trappers were some of the earliest individuals to have contact with the Native Americans, and a blending of these cultures occurred.
- European, African, and Mexican immigrants left their cultural marks on U.S. fashion.
- Western wear is a style of clothing that is truly American, although its history is adapted from Mexican influences.
- The Industrial Revolution in Europe and the United States is responsible for the advancements of mass production.
- Inventions such as the spinning machine, power loom, cotton gin, and sewing machine made fashion affordable to most people.
- Textile production moved from fireside to factories.
- Sweatshops were relatively common during the developmental years of the country and were a source of employment for young women and immigrants.
- Codes of conduct regulate basic human rights in apparel factories and should be a standard part of conducting business.
- The catastrophe in New York City known as the Triangle Shirtwaist Factory Fire resulted in improved conditions in the textile and apparel factories.

terminology for review

Ellis Island 43
Heimat 45
linsey-woolsey 45
Adinkra cloth 46
sombrero 46
Stetson 46
Levi Strauss 47
denim 47

spinning wheel 48
spinster 48
spinning jenny 48
Arkwright machine 48
Samuel Slater 48
loom 49
warp yarns 49
weft or filling yarns 49

weaving 49
circular knitting machine 49
full fashioning 49
cotton gin 49
corporate code of conduct 52
sweatshop 53
shirtwaists 54

questions for discussion

1. What are the textile and apparel contributions of early ethnic settlers arriving in America?

2. Why was the United States a melting pot of cultural dress and fashion?

3. How did fur trappers and traders help promote the fashion industry while settling early America?

4. What was the Industrial Revolution, and what factors impacted the textile and apparel industries?

5. What are some of the major inventions during the Industrial Revolution?

6. How did the invention of the sewing machine benefit the public and the U.S. fashion industry?

7. Why are textile and apparel factories common in the industrialization of developing countries?

8. What are some problems that can occur during development of these countries?

9. What is a code of conduct in the textile and apparel industry?

10. What are some benefits of a code of conduct?

related activities

1. Take a virtual tour of the museum of Ellis Island at http://www.ellisisland.org/photoalbums/ellis_island_photo_album.asp. Look through the photo album at pictures of the immigrants and their countries of origin or evaluate the clothing depicted in any historic photo, such as a great-great grandparent. Write a brief essay and compare the clothing depicted in a photo to the fashionable clothing of that same time period. How are they similar? How are they different? What are some specific styles features of that time period?

2. Choose a specific culture, ethnic group, country, or global region. Identify the cultural dress of the indigenous people. Locate three pictures of various costumes or native dress from the area and write explanatory paragraphs about the clothing. Create a short electronic presentation or slide show to share with the class. Conclude with the complete bibliographic citation for all sources using the American Psychological Association (APA) format.

3. Select a functional work uniform to research and evaluate. Reread the textbook discussion of the functions of Western wear. Develop an explanation of the components of the selected uniform and explain how these uniforms create function for the wearer. Also include a discussion of fiber content. Consider uniforms for hazardous material workers, firefighters, bomb squad personnel, police officers, racecar drivers, surgeons, nurses, machinists, welders, or any other occupation that requires specialty clothing.

4. Using the school library's electronic databases, locate an article that deals with recent sweatshop violations in any country. Summarize the article in a paragraph or two and offer a critique of suggestions on how to prevent or correct this problem. Identify all the parties that might be responsible for the continued violations of the sweatshop and discuss their roles in the problem. Conclude with the complete bibliographic citation using the American Psychological Association (APA) format.

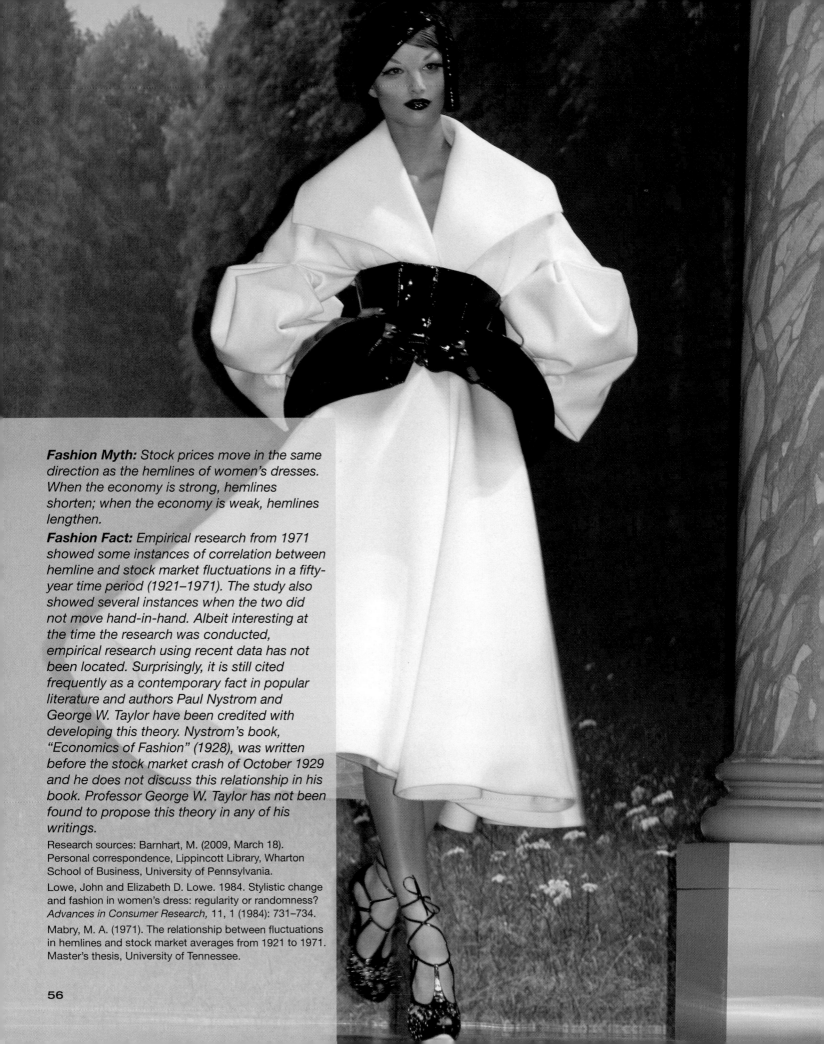

Fashion Myth: *Stock prices move in the same direction as the hemlines of women's dresses. When the economy is strong, hemlines shorten; when the economy is weak, hemlines lengthen.*

Fashion Fact: *Empirical research from 1971 showed some instances of correlation between hemline and stock market fluctuations in a fifty-year time period (1921–1971). The study also showed several instances when the two did not move hand-in-hand. Albeit interesting at the time the research was conducted, empirical research using recent data has not been located. Surprisingly, it is still cited frequently as a contemporary fact in popular literature and authors Paul Nystrom and George W. Taylor have been credited with developing this theory. Nystrom's book, "Economics of Fashion" (1928), was written before the stock market crash of October 1929 and he does not discuss this relationship in his book. Professor George W. Taylor has not been found to propose this theory in any of his writings.*

Research sources: Barnhart, M. (2009, March 18). Personal correspondence, Lippincott Library, Wharton School of Business, University of Pennsylvania.

Lowe, John and Elizabeth D. Lowe. 1984. Stylistic change and fashion in women's dress: regularity or randomness? *Advances in Consumer Research,* 11, 1 (1984): 731–734.

Mabry, M. A. (1971). The relationship between fluctuations in hemlines and stock market averages from 1921 to 1971. Master's thesis, University of Tennessee.

FASHION
RETROSPECTION:
100 + YEARS
of FASHION

LEARNING OBJECTIVES

At the end of the chapter, students will be able to:

- Explain the impact of World War II on the U.S. fashion industry.
- Identify some of the major factors contributing to the rise of the U.S. fashion industry.
- Discuss the role of the Hollywood film industry in helping promote the U.S. fashion industry.
- Explain the cyclical nature of fashion.
- Analyze how past fashions can be used to predicting future fashions.
- Relate the social, economic, and political events of each decade in the twentieth century to the popular styles.

Fewer than one hundred years ago, the U.S. fashion industry carefully followed the biannual design revelations of the Paris couturiers. These couture salons revealed their magnificent fashions and set the fashion tone for every well-dressed woman. *Time Magazine* described the U.S. fashion industry buyers in attendance at these couture showings as "speeding homeward with dearly purchased models, ready to put them in the hands of expert imitators, preparing for the nation's great fall shopping seasons" (Haute Couture, Aug. 13, 1928).

Dress styles were not the only fashion information acquired from Europe. Although domestic hatmakers and milliners set the colors for the U.S. textiles industry, they looked to Germany for dyestuff trends and to Paris for fashion trends. When World War I cut off information from Europe, including its seasonal color information, the U.S. textile industry managers created a new domestic committee of color forecasters to standardize U.S. color cards. This committee included representatives from the wool and silk textile industries; the manufacturers of buttons, threads, and other notions; and garment manufacturers. The Americans began setting their own color standards for popular colors such as the government's Light Olive Drab 80089, a college's Princeton Orange 80070, and a designer's signature color Schiaparelli Pink 80049.

As another important tribute to the U.S. fashion industry, several businesswomen formed the Fashion Group International in 1930 to promote domestic fashions and designers. Founders included Eleanor Roosevelt, Helena Rubenstein, Elizabeth Arden, Edith Head, Claire McCardell, and others.

Just a decade later, the conflict of World War II profoundly impacted the international fashion business by restricting domestic trade with the Western European countries. Many French couture houses closed down during the German occupation of Paris. The need to continue the fashion industry in the United States enhanced the visibility of the available and talented domestic designers. One retailer stated, "The American garment industry is now in a position to show whether it can make a silk dress or whether it will be a sow's ear" (Claire McCardell: The American Look, May 2, 1955). Fashion publicists believed in the U.S. garment industry. Magazines and the *New York Times* newspaper devoted feature article space to U.S. designers. The war forced a belated acceptance of the domestic fashion industry.

After the war, the U.S. fashion brands and designers became widely recognized as equals to European couture houses. Discussing the U.S. fashion industry in the years since 1940, a *New York Times* newspaper article stated, "Yet, until WWII, the people who design and make our country's styles worked in nameless obscurity, snubbed by the fashion press and unknown to the public" (Robertson, July 12, 1956, p. 27). The article further noted that in the years following the war, "Seventh Avenue's big names, and a few in California have been passed on to millions of women shoppers" (Robertson, July 12, 1956, p. 27).

Fashion in Retrospect

Fashion runs its own cyclical course; it does not begin or end at a particular decade. In any year, there are countless fashions worn, and each one is at a particular point on its fashion life cycle. Some are just beginning to become popular, others are at the peak of popularity, and still others are declining in popularity. Popular hemline lengths, colors, silhouettes, and specific details such as collars or neckline treatments may be represented as cycles. Students of fashion can compare these multiple cycles to waves in the ocean—large and small, occurring at irregular intervals. Figure 4.1 shows how a variety of fashion life cycles can be running concurrently

Figure 4.1 Fashion cycles appear like harmonized waves in the ocean.

Important Fashion Silhouettes in Women's Fashions Since 1900

1900s Gibson Girl Look	**1920s** Flapper	**1940s** Military Look	**1960s** Miniskirt and Boots	**1980s** Flowing Midi Skirted Suit with Shoulder Pads	**2000s** Fitted Flat-Front Slacks with Turtleneck Sweater
	1910s Walking Suit	**1930s** Bias-Cut Dress Look	**1950s** New Look	**1970s** Pantsuit	**1990s** L.A. Law Skirted Suit

at any point in time. Like waves in the ocean, some fashion cycles are longer than others (larger waves), some have greater popularity (a higher wave), some recur more frequently (waves closer together), some are fads (peaked waves), and some are classics (long, rolling waves).

It is practical to discuss fashions by each decade, but students of fashion should note that the end of a decade does not necessarily denote the end of a fashion life cycle. For example, the miniskirt fashion often characterizes the decade beginning in 1960 and running through 1969. Hemlines were on the rise but did not achieve the miniskirt status until the mid-1960s, and the miniskirt continued to climb into the early 1970s. Because fashions evolve from one year to the next, popular styles from the final year of one decade will resemble the popular styles of the first year of the subsequent decade. This chapter classifies fashions by decade. The discussion includes fashionable styles and fashion influencers from 1900 to the present. Future editions of this textbook might require subdividing recent decades into two parts in order to accommodate the accelerating fashion life cycles.

The value of studying recent decades of historic fashion is to understand how newer fashions evolve from previous fashions and to evaluate the social, political, and economic factors affecting the fashion looks of a particular era. By considering these issues, fashion marketers can more accurately predict the direction of fashion. They will have a more educated business perspective and will have greater success in several areas. Product developers and designers know to introduce or design new styles adapted from successful current designs. By studying past fashion data, apparel manufacturers and marketers determine which styles to mass-produce, and retail store buyers decide which styles to order or forgo when attending market weeks.

Fashion Emphasis, 1900–1909: Swirls of Curves

The feminine S-curve and sweeping skirts falling from a tiny corseted waist characterized the late nineteenth century and early twentieth-century fashions for women. In order to achieve the feminine S-curve, bodices or waist blouses created the illusion of a protruding **monobosom** (similar to a pigeon's breast), whereas skirts featured multiple gores that widened as they approached the floor-length hemline. When examining the embellishments on the women's clothing, the "more the better" seemed to be the dominant theme by 1900. Any combination of scalloped lace edging and lace panels, horizontal pleating, rosettes, and delicate ruffles were used en mass on a single evening gown. **Art nouveau** was

Figure 4.2 Woman's formal attire, early 1900s.

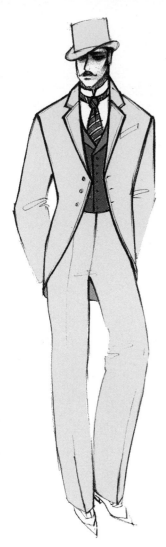

Figure 4.3 Man's formal attire, mid-1900s.

Figure 4.4 Woman's formal attire, late 1900s.

a sinuous or swirling and flowing style of art interpreted into the silhouette and embellishments of the decade's clothing. Daywear was more practical, but the corset remained an important innerwear accessory, and the basic S silhouette remained consistent.

For fanciful dress, women secured their large and heavily decorated hats of considerable weight to pompadour hairstyles with long hat pins. Furs, feathers, silk flowers, and ribbons created fantastic displays on women's heads. Designers recreated panoramic woodland scenes using taxidermied species of birds on the hats. The Audubon Society protested the use and destruction of endangered bird species, and the practice mostly ended.

The Gibson Girl look epitomized the concept of the charming and independent American working girl. The Gibson Girl image, illustrated by Charles Dana Gibson, fostered the demand for the separate skirt and waist (blouse) combination called a **shirtwaist**.

As the decade progressed, sporting activities such as bicycling and tennis became more popular for both genders, and an athletic and lithe body type became fashionable. The public began to view corsets as unhealthy, and corsets lost importance when the silhouette began to straighten: flatter bust, thicker waist, and narrower hips. The skirt maintained the hemline flare and floor-sweeping look. Eventually, women tired of the constrictive and posture-altering fashions and turned toward the emerging columnar silhouette with empire waists. The straighter silhouette also reflected the gradual emancipation of women, both figuratively and literally, since women continued to lobby Congress for the right to vote.

The menswear silhouette of the first decade gradually moved from loose to slender, keeping pace with the changes in the ideal body shape. As time progressed, menswear of the decade allowed for greater freedom of movement for the wearer. The early 1900s featured the lounge or sack suit, with its full and straight upper silhouette, tapering to a narrow hem on the trousers. By the end of the decade, men's suits were a leaner silhouette and might feature a longer jacket over a contrasting color vest and center-creased, cuffed pants.

Men's accessories included walking canes, pocket watches with chains draped across the vest, and a variety of hats. Summer straw boater hats for men and women are icons of the turn of the twentieth century. A silk top hat adorned the head of fashionable gentlemen in formal attire. For a casual appearance, men selected wool felt homburgs, fedoras, soft fabric caps, and straw boater hats.

The increasing popularity of the automobile stimulated interest in outlying sporting facilities, such as golf courses and swimming pools, and vacations at the beaches and amusement parks. Whether people were spectators or participants, the leisure activities encouraged them to choose more casual and less restrictive clothing. Traveling by open-air automobiles required the driver and passengers to adopt motoring coats to protect their clothing from road dirt and dust. Motorists

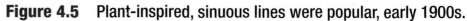

Figure 4.5 Plant-inspired, sinuous lines were popular, early 1900s.

dressed in durable full-length motor coats or dusters made of linen, leather, or fur. Men wore goggles, whereas women wore veils over their hats to protect and secure them while they traveled at the breathtaking speed of twelve to fifteen miles per hour. Blazers and knickerbockers (short pants) became popular spectator and active sportswear apparel for men.

Fashion Emphasis, 1910–1919: The Angular Look

Even before this decade began, the curves of women's fashions had begun to straighten and the constriction at the waist fell to the ankles. Couture designer Paul Poiret introduced his version of the columnar silhouette in 1908, and the fashion pendulum continued to swing toward this slender, vertical look. In 1911, the empire waistline or slightly raised waistline was quite common in women's dresses and contributed to the lean look. By 1912, the tubular silhouette restricted movement so securely that designers incorporated a slit in the hemline to allow for a moderate amount of movement. The *New York Times* referred to this dress style as the hobble skirt in 1912 when it printed, "If you think the skirts of the last two seasons have been narrow, wait until you see the new ones. Some evening gowns are less than a yard wide and slashed in front for at least six inches so that one may move along somehow" (Greenwood & Murphy, 1978, p. 20). The restrictive hobble skirt fad enjoyed only a short life, and skirts were soon sporting slits on the sides and center fronts to create focal points of shoes and hosiery. Skirts also featured multiple layers of varying lengths. In general, women's fashions had far less trim and ornamentation than the preceding ten years.

In keeping with the vertical silhouette, women's hats also became narrower and higher. Less complicated hat designs replaced the overly decorated hats of the previous decade. Simple styles, such as a single plume on a brimless hat or headache band, continued into the 1920s.

In the middle years of the decade, women's fashions reflected a military influence, and skirts became shorter, fuller, and loosely fitted. During World War I (1914–1918), textile shortages somewhat affected the dress silhouette, but in 1919 after the end of the war,

Figure 4.6 Woman's corset, early 1900s.

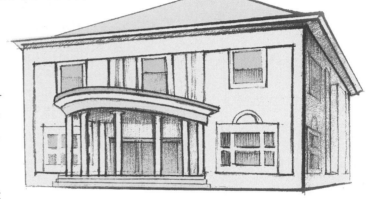

Figure 4.7 Frank Lloyd Wright style of architecture.

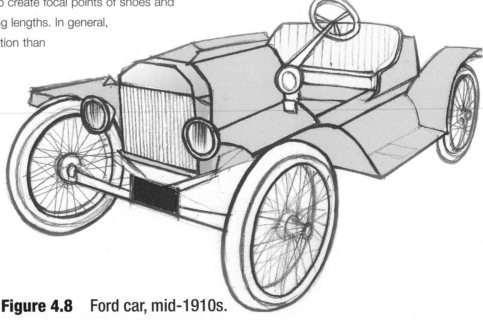

Figure 4.8 Ford car, mid-1910s.

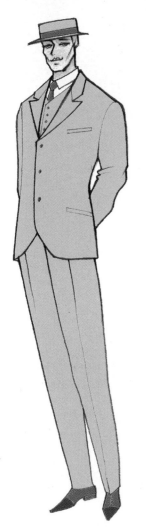

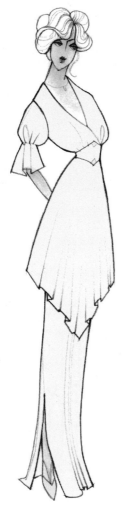

Figure 4.9
Man's suit,
mid-1910s.

Figure 4.10
Woman's evening
dress, early 1910s.

Figure 4.11
Woman's walking suit,
late 1910s.

dress designers lengthened hemlines on a slender, unfitted silhouette called the **chemise** (pronounced shĕ-mēēz). French couturier Paul Poiret designed corset-less dresses before World War I, but the look did not gain widespread acceptance until the 1920s.

Women gained the right to vote in the United States in August 1920 after a hard-fought domestic battle that began decades earlier. The suffrage movement began as early as the 1850s, with women protestors called **suffragettes**. Three contemporaries and associates, Amelia Jenks Bloomer, Elizabeth Cady Stanton, and Susan B. Anthony, gradually affected women's fashions with their public rejection of the restrictive corset and their adoption of Turkish trousers under shorter dresses. One of the popular fashions of this decade was the skirted walking suit that more than slightly resembled the menswear counterpart. Was this just an arbitrary fashion, or was it an outward expression of women's assertion that they were equals to men?

Menswear of this decade changed minimally from the beginning of the decade to the end of the decade. Suit silhouettes continued to narrow, and the columnar effect was present in menswear and women's wear. Jackets shortened as the decade progressed, and some jackets featured an applied waistline. Formal menswear clothing contained a three-piece suit (coat, vest, and slacks) sewn of a subtle fashion fabric, such as solid navy wool serge, pinstripe, or plaid. For accessories, men continued to wear hats, such as panama straw boaters, cloth caps (like newsboy caps), and fedoras. Top hats were limited to formal occasions.

World War I also influenced menswear by emphasizing the military look, even for nonmilitary fashions. The public adopted the convenient wristwatch after the government routinely issued it to military officers. It soon replaced the pocket watch as a staple of a man's wardrobe.

Fashion Emphasis, 1920–1929: The Roaring Twenties!

Slender silhouettes and rising hemlines continued into the early 1920s. Legs remained a fashion focal point, so legwear manufacturers created stockings in fashionable nude tones, in addition to the staple colors of cream and black. These stockings were thigh-high legwear that women attached to garters on a corset or garter belt. The concept of pantyhose hosiery as we know it today was a much later invention of the 1960s.

At the beginning of the decade, women hemmed their skirts above the ankle or near the calf. By the latter years of the decade, women wore skirts just below the knee and often asymmetrical at the edge. The empire and raised waistlines of the previous decade began to drop to below the natural waistline. Generally, the styles for women remained shapeless, creating the

flat-chested look and little definition between the waist and hips. The Paris House of Premet introduced a famous style in 1927 called *La Garçonne* dress (pronounced gair-sewn), making a woman's figure look boyishly preadolescent. Fashions included elongated dress styles with flounces or ruffles at the lower edge. The 1920s term **flapper** described a modern, energetic, young woman with few social inhibitions. The description also encompassed the clothing worn by these liberal women, and today it conjures an image of a sleeveless, tubular, knee-length dress with a fringed lower edge, a knotted string of rope pearls worn around the neck, a bobbed hairstyle, and a cloche hat.

Designers scaled down the size of accessories and ornamentation to reflect the 1920s feminine desire to be uninhibited by conventions or clothing. In spite of most of the French couturiers' collections that featured below-the-knee hemlines (for the Pope and conservative couture customers), young women of the mid-1920s kept shortening their hemlines to at least the knees and rolled down their silk stockings to below the knees. Young women smeared a hint of rouge on their kneecaps to further direct attention to the exposed areas. French designer Coco Chanel also defied the conventions of high fashion by openly claiming that achieving just the right look was more important than a hefty price tag. Chanel advocated the wearing of inexpensive costume or junk jewelry, especially fake or **faux** (pronounced fō) pearls. Fashion sensations included brimless, close-fitting cloche (pronounced clōsh) hats worn over the revolutionary and controversial haircut of short bobbed hair.

During the decade, menswear moved from a fitted upper torso and high waist to a more relaxed fit with padded shoulders. The young males of the 1920s adopted wide-legged trousers called Oxford bags, made popular by Oxford University men in 1925. Men created a casual look by pairing dark-colored blazers, such as a navy, with light-colored slacks. Photographs and illustrations of the era depict bushy, full-length raccoon coats on college men and young adults of the 1920s.

The decade from 1920 to 1929 was a time of considerable prosperity for the American people. The increasing number of roads provided mobility for millions of U.S. drivers, and most urban dwellers enjoyed the modern conveniences of the home, including washing machines, vacuum cleaners, refrigerators, and electricity. The stock market had a few dips during this decade, but each time it swiftly recovered and grew—until September 3, 1929. After reaching an all-time high, the stock market began to flutter and dip, and on October 29, 1929, stock prices dropped

Figure 4.12
Woman's day dress, early 1920s.

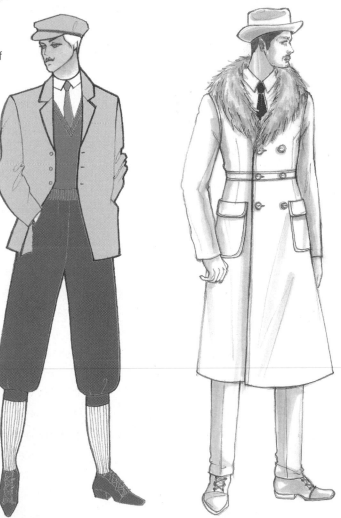

Figure 4.13 **Bobbed hairstyle for women, mid-1920s.**

Figure 4.14
Man's day apparel, mid-1920s.

Figure 4.15 **Man's full-length wool coat, mid-1920s.**

enormously. The stock market did not recover for many years and plunged the United States into the Great Depression. Hemlines lengthened in 1929, but this had been a mission of the French couture for some time. Designer Louise Boulanger created a mid-calf-length chiffon dress with a trailing back hemline that women accepted, and longer lengths soon followed in fashion.

Fashion Emphasis, 1930–1939: Implausible Elegance

Many fashion historians point to the 1930s as a time of bias cut and elegant styling. Couture designer Madeline Vionnet showed the draped bias-cut dress as early as 1919, but it did not gain widespread popularity until the early 1930s. So slinky and form-fitting were the backless, bias-cut dresses that one historian wryly commented that a woman's buttocks became two objects instead of one. Phrases such as cigarette slimness, provocative, hourglass figure, streamlined, body-molding, and figure-revealing apparel all described fashions of this decade. Designers deemed the corset a necessary undergarment to achieve the slenderized look. In 1934, strapless evening gowns and a complementary undergarment, the strapless brassiere, first came into fashion.

The overall silhouette was slender and lean during the 1930s, and trailing trains continued to be a focal point of formal wear during most of the decade. The waistline seam, slightly elevated in the early part of the decade, gradually moved to the natural waist in the mid- to late 1930s. It became an important design element after being absent during much of the 1920s. During the latter years of the 1930s, the dress silhouette began to widen below the waistline into an A-line but remained fitted in the bodice through strategic uses of darts and seaming.

After several seasons of near ankle-length fashions, women began to raise their hemlines. By 1938 and into the 1940s, hemlines were just below the knee. The functional shirtwaist dress with the shorter hemline became a symbol of the working girls (as did denim overalls).

When World War II began in Europe in 1939, women had already begun to wear masculine-tailored suits with squared and padded shoulders and nipped waistlines. Historians credit Italian-born couture designer Elsa Schiaparelli for this broad-shouldered look that continued well into the 1940s.

Hollywood movies significantly influenced fashions of this decade, whereas socialites had influenced

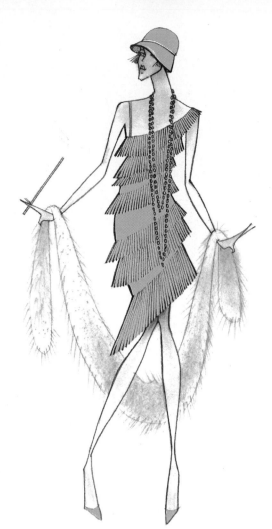

Figure 4.16 Flapper wearing a cloche hat, late 1920s.

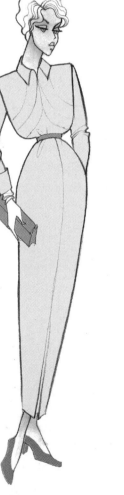

Figure 4.17 Woman's day dress, early 1930s.

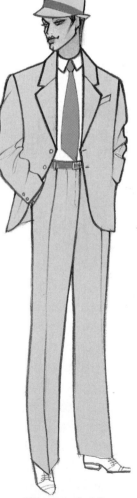

Figure 4.18 Man's suit, mid-1930s.

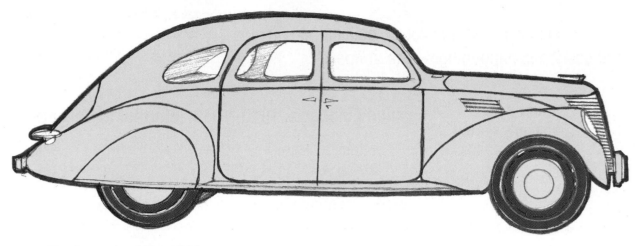

Figure 4.19 Sleek automobile, 1930s.

fashions in past decades. Hollywood designers Travis Banton and Adrian dressed movie stars such as Marlene Dietrich and Greta Garbo in glamorous apparel. Actress Katharine Hepburn looked glamorous in menswear-styled slacks suits. Metro Goldwyn Mayer released the movie *Gone with the Wind* in 1939 and created a sensation for line-for-line copies of the Scarlett O'Hara barbecue dress. In spite of the ability of Hollywood to influence the adoption of fashions, it remained the privilege of the *haute couture* to influence the Hollywood designers. The fashion world still considered Paris the fashion capital.

Menswear during the 1930s included conservative and fitted single-breasted suits with wide-notched lapels on jacket collars and cuffs on full-legged pants. The 1930s actor Gary Cooper epitomized the classic styling in his English drape suit that fitted closely at the natural waist.

A trend toward greater informality in the 1930s improved the market for spectator sportswear, and it grew into a separate fashion industry in California. Increased leisure time, shorter workweeks, and curtailed family budgets created a public desire for mix-and-match separates and casual clothing. Men's sportswear included comfortable and loose-fitting knitted sport shirts and polo shirts. Other popular casual looks included woven plaid madras shirts and Hawaiian prints. Women dressed in an unencumbered style in pants of all lengths.

The stock market improved slowly and steadily after the devastating October 1929 crash. However, during the early 1930s, the United States was still in the throes of the Great Depression. The social relief provided by fashions of the elegant film stars served as a what-to-wear guide for many of the financially stricken consumers. With World War II looming on the horizon, employment opportunities increased for many Americans, and discretionary income improved. Because of the widespread use of

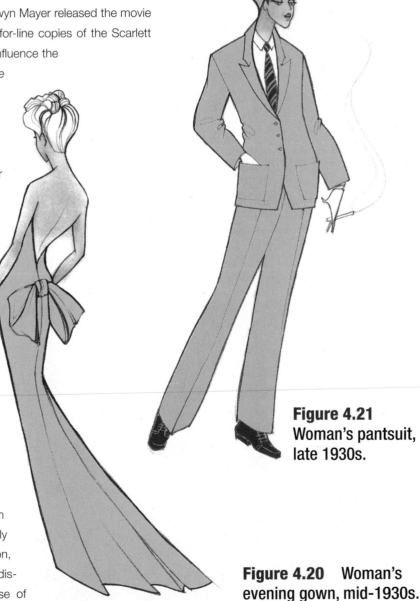

Figure 4.21
Woman's pantsuit,
late 1930s.

Figure 4.20 Woman's
evening gown, mid-1930s.

Fashions reflect the social, political, and economic happenings—the *Zeitgeist*.

rayon in clothing, the price of ready-to-wear dropped to a more affordable level for price-conscious women. DuPont introduced nylon at the 1939 World's Fair, and scientists heralded nylon as a miracle fiber.

Figure 4.22 Woman's skirted suit, mid-1940s.

Fashion Emphasis, 1940–1949: Informal to Delicate

The casual movement gained great impetus in the 1940s. Males and females adopted rolled denim dungarees as the weekend uniform of the teenage and college crowd. With fabrics rationed and clothing supplies limited or too costly to purchase new, teens took to wearing oversized fashions. One 1940s teenager recounted her story of how she robbed her older brother's closet of his fashionable oversized shirts and jackets while he was on active duty in Europe during World War II. The media depicted the icon of Rosie the Riveter in denim coveralls and decidedly masculine attire. The character represented the empowered woman working in a war supply factory. Gender lines had necessarily blurred—at least for women.

Early in the decade, the fashion industry in New York still struggled with the effects of the Great Depression. By 1942, the New York dress trade earned about half of what it earned be-

Figure 4.23 Man in army uniform, mid-1940s.

Figure 4.24 Female teenager in popular fashions, mid-1940s.

Figure 4.25 Male teenager in popular fashions, mid-1940s.

fore the stock market crashed in 1929. To counteract the sluggish sales, over 1,000 dress manufacturers created the New York Dress Institute in 1941 to promote New York City as a world leader in fashion. The war in Europe provided added fuel for the Institute by greatly limiting U.S. industry contact with the couture houses in Paris. Although many Paris couture houses closed, U.S. designers capitalized on the opportunity to promote the creativity of domestic designers. One widely publicized event was the 1943 National Press Week, established to promote the dress industry in New York.

The war in Europe boosted several fashion industries. Suit and coat manufacturers supplemented sales with the production of uniforms for servicemen and servicewomen. The wedding and bridesmaid apparel industry saw large increases in revenues, while the maternity industry reported sales increases of more than 52 percent from 1940 to 1947. The New York fur and perfume industries also benefited from Europe's isolation. Suppliers in Moscow and London could not export furs to the United States, and imported supplies of French perfumes failed to meet domestic demands. Both domestic industries shot ahead during the war years.

War restrictions and rationing progressed as involvement in World War II increased. The U.S. government War Production Board implemented restrictions under the M-388 Textiles for Civilian Items ruling and the L-85 ruling. These restrictions limited the amount of fabric that manufacturers could use for civilian clothing and related items. For example, the government banned two-color shoes, patch pockets, double yokes, sashes, attached hoods, and rolled cuffs. Skirt hem circumferences could not exceed 72 inches. The government rationed shoe purchases; and elastic and nylon were generally unavailable and sorely missed. England's Board of Trade posed even greater restriction on fellow English. In 1943, the British government created the campaign slogan "make do and mend." These wartime restrictions changed women's fashions from the lavish use of fabrics and ornamentation to a much less decorative and more functional style of dressing that lasted through the immediate postwar period. Slacks for women continued to increase in prominence.

Immediately following the end of World War II and the legislated apparel restrictions, designers (led by Christian Dior) provided a revolutionary style referred to as the **New Look**. Although its success was widespread, not all contemporaries endorsed its excess and lack of function. One 1951 historian criticized the New Look by writing, "The silhouette changed . . . with greater jeopardy to women's appearance. It is doubtful whether any amount of legislation could have forced women into such ungainly styles as the unvarnished new look, in which women made up in one overdose for all the fabric pinching of wartime" (Richards, F., p. 30). In 1949, American designer Claire McCardell followed her own creative passions and introduced the popular jersey monastic dress with a crisscross tie spanning the midriff. In spite of McCardell's talents and popularity, it is Dior's New Look that epitomizes the decade.

Fashion Emphasis, 1950–1959: Suburban Style

By 1950, the baby boom was in full swing. Young women, previous employed in factories during World War II, became homemakers with small children. The changing U.S. society valued families and family time. Young families endeavored to own a home in the suburbs. Developers accommodated homebuyers with planned communities located outside of major cities. Suburban dwellers valued parks, recreation centers, swimming pools, sidewalks, and other opportunities for neighborhood residents to mingle. The proliferation of suburban shopping centers added another convenience to these homeowners with families.

Figure 4.26 Woman's New Look dress in 1947.

"With one collection he had achieved an end to which all dress designers aspire, that of, overnight, making every woman wish she were naked with a chequebook" (Ernestine Carter on Dior in Byrd and Garnett, 1994, p. 43).

What was this flowery sensation that swept the female fashion world with long, full skirts, waspish waists, and soft shoulders? The editor of *Harper's Bazaar* magazine dubbed it "The New Look," and it became the subject of much adoration and controversy on both sides of the Atlantic Ocean. Although France's Christian Dior received credit for its introduction by way of his 1947 *Corolla* line of dresses, many designers quickly followed suit, including American designer Claire McCardell. The tiresome masculine wartime fashions rapidly gave way to an elegant style that had been absent throughout most of the war years. Shoulders were rounded and natural; the wartime illusion of broad shoulders created by shoulder pads vanished. Dresses featured cinched waistlines with boning or corseting. Hips were padded or otherwise exaggerated with petticoats to increase the visual distinction between the waist and hips. Hemlines dropped to mid-calf, and the hem circumference increased significantly with waistline gathers or pleats. The popularity of the feminine and sexy New Look continued for ten years, although designers introduced other silhouettes including the trapeze (A-line) silhouette and eventually the tubular silhouette of the chemise.

The overwhelming success of the New Look provides evidence that fashions are a reflection of the current way of life. Women in 1947 were weary of wartime rationing and clothing restrictions. Dior correctly interpreted women's needs for the same femininity that was sorely missing in the wartime fashions. Dior was not a fashion dictator; he served as an interpreter of the fashion barometer. Women were due for a change, and Christian Dior provided them with an important outlet to express their femininity.

Figure 4.27
Women's dress and hat, early 1950s.

Television was the innovation of the decade because it provided instant and consistent national visual exposure. This mass communication tool surpassed all other visual communication tools for disseminating fashion trends, advice, and information to the public. New York's Madison Avenue became a key player in dressing television actors and actresses for programming and commercials. It afforded yet another opportunity for the New York fashion industry to promote American designers, such as Hattie Carnegie, Lilly Daché, Mainbocher, and Pauline Trigère.

The renewed interest in femininity remained important in the early 1950s, but fashions offered a more wearable appeal to women. DuPont introduced Dacron polyester, and the concept of wash-and-wear in 1952. Designers softened the look of women's clothing by introducing a more relaxed bodice fit and slightly padded shoulders. Dress waistlines were still closely fitted and remained so for the first few years of the decade. The 1950 fashion buzzword oblique referred to a popular bias cut that emphasized the diagonal. Women wore semifitted jackets with three-quarter length sleeves over fitted or A-line skirts. In 1954, Chanel made a comeback with her boxy, hip-length jacket with patch pockets and braided trim. Toward the end of the decade, the

Figure 4.28 Man's suit and hat, mid-1950s.

sack style of jackets and dresses came into fashion. This entailed back fullness as extra gathers at the upper edge of a garment. By the conclusion of the decade, the back pouf of the sack dress evolved into a bubble skirt with the entire hem ending in a pouf. Designers reintroduced popular versions of the shapeless chemise. The chemise silhouette rose to prominence in 1957 and during the latter years of the 1950s. The unshaped dress design included the popular A-line, shift, trapeze, and tent styles. Belts did not completely disappear in fashion but significantly waned in popularity during the late 1950s and into the 1960s.

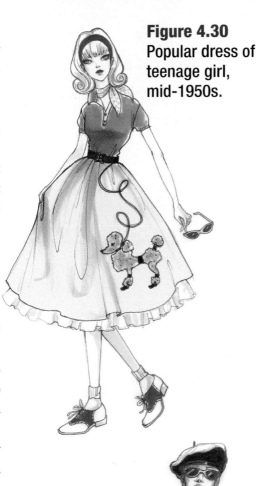

Figure 4.30 Popular dress of teenage girl, mid-1950s.

Gray was one of the predominant neutral colors for much of the decade. Men wore charcoal gray flannel suits with pink shirts, and women wore prints in yellow and gray, turquoise and gray, or pink and gray. The phrase "the man in the gray flannel suit" referred to the successful, corporate moguls of the 1950s that conveyed confidence and prosperity.

Menswear moved toward a more uniform style during this decade. The sack suit of the 1940s gave way to a conservative but easy-to-wear suit. The Ivy League style of menswear had a general slimness that included a narrow-brimmed fedora, natural shoulders, narrow lapels and necktie, and tapered trouser legs. Fashionable men aspired to the Brooks Brothers' look (a fashionable men's clothing store).

The oversized clothing for teenagers of the 1940s gave way to closely fitted denim jeans and leather jackets for males, à la Elvis Presley. **Beatniks** of the mid-1950s had a surprising strong influence on what would later become the hippie movement. These West Coast young men (although women were included, too) epitomized the youth "Beat" counterculture and were characterized by the media as apathetic loafers, in limbo between school and work. The media depicted beatniks as wearing an excess of black clothing, turtlenecks, berets, and facial hair for men. The youth counterculture and the older male establishment viewed each other with disdain. Depending on the perspective, the counterculture was viewed as beatniks and the establishment or dominant culture and its clothing were viewed as "square."

Figure 4.29 Woman's dress, late 1950s.

The market for sportswear separates continued to influence fashion. Young men and women commonly wore contrasting blazers, jackets, or sweater tops with pants or skirts. Sweater blouses, sweater dresses, and Capri pants and flats, popularized by Audrey Hepburn, were especially desired by teenagers and young adults. Poodle skirts, petticoats, and saddle oxford shoes are the icons of the 1950s teenage girls. The introduction of triacetate allowed for permanently pleated skirts to become a fashion mainstay.

Fashion Emphasis, 1960–1969: The Lull and the Storm

The decade of the 1960s is best remembered for its youthful contributions including flower children and hippies, wild psychedelic colors, hip-huggers, and the miniskirt. However, these attributes describe the second half of the 1960s and early years of the 1970s. Common terms

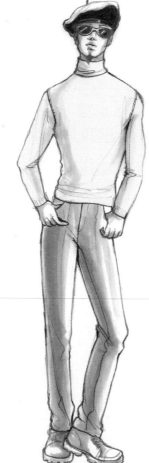

Figure 4.31 Beatnik male, late 1950s.

of the late 1960s included *futuristic, space age, electrifying,* and *mod.* The decade actually began on a more subdued and somewhat architectural note, much like the end of the 1950s.

The decade of the 1960s began with the election of President John F. Kennedy and his fashionable and elegant wife Jacqueline Bouvier Kennedy. The president's loose-cut, two-button suit resembled the conservative suits of other successful American men. The young first lady wore beautifully tailored suits and dresses in sherbet colors. American designer Oleg Cassini created her stunning inaugural gown. The First Lady's style of wearing suits or jacketed dresses quickly caught on with American women. Popular styles included collarless and sleeveless semifitted or fitted dresses or suit jackets with matching knee-length skirts. The pillbox hat made famous by Jackie Kennedy has become a fashion icon of the early 1960s. By the mid-1960s, it had evolved into more of a helmet-style hat.

For the early years of the 1960s, the chemise increased in popularity, and the New Look maintained its popularity. Both styles had shortened hemlines, just below the knees. By 1968, the knees were totally exposed, and the New Look was passé. The A-line dominated the women's fashion silhouette of the mid- and later 1960s. Stores offered the popular separates as fashion options, in the form of dress shorts, slacks, and divided skirts called *culottes* or *scooter skirts.*

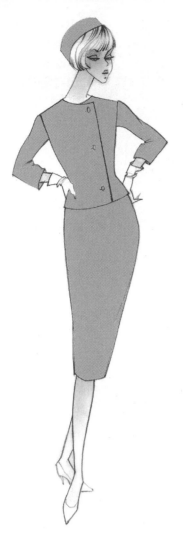

Figure 4.32 1960s outfit popularized by Jackie Kennedy.

Several designers made significant fashion contributions during the decade. The further the 1960s progressed, the more difficult it was to produce fashions with shock value. In 1964, designer André Courrèges introduced his architectural and space age looks and trouser suits for women. He also made famous the combined look of the narrow A-line shift, above-the-knee hemlines, and white go-go boots. The shifting erogenous zone moved to unexplored areas, such as the breasts, midriff, and upper legs. California designer Rudi Gernreich introduced the topless bathing suit and see-through blouses. Couture designer Yves St. Laurent showed his mid-1960s collections with dress cut out areas and large color blocks. British designer Mary Quant introduced her miniskirt in the middle of the decade, and hemlines continued to get shorter as the decade progressed. When the miniskirt became so short as to nearly expose the underwear, the micromini and hot pants were born.

Hosiery companies manufactured pantyhose, an innovative accessory product and logical complement to short skirts. Women needed a hosiery product that would not be visible underneath a short skirt. Prior to the 1960s, hosiery companies offered only thigh-high stockings held up by garters attached to a garter belt. With fashion focusing very much on the exposed legs, manufacturers introduced opaque and patterned hosieries in laces, argyles, stripes, and fishnets.

The look of the decade was the mod look, short for modern. Shiny materials in the form of silver metallic, polyesters, plastics, and patent leathers dominated ready-to-wear apparel and accessories. Fashionable colors and prints preferred by the **hippies** included psychedelic colors, tie-dyes, crazy daisies, and paisley prints. Hippies

Figure 4.33 Hippie, mid-1960s.

were to the 1960s and early 1970s as the beatniks were to the late 1950s and early 1960s. The term *hippie* was derived from the word *hipster* and this group represented a large counterculture.

Menswear became increasingly casual and colorful during the decade. Suits of matching jacket and pant fabrics nearly disappeared for young men. Instead, men wore tunic-style tops or pullover sweaters paired with contrasting-colored pants. The more established men opted for sport coats and slacks. Narrow lapels and neckties marked the beginning of the decade, but they became excessively wide and colorful by the end of the 1960s. President John F. Kennedy's regular hatless appearance from 1960 to 1963 signaled the end of the hat for the average man's wardrobe.

Specific groups influenced various popular looks of the 1960s. The Beatles tremendously influenced the young male's clothing and hairstyle fashions from 1963 through the end of the decade. The music group members wore collarless jackets created by French designer Pierre Cardin. The public emphasis on civil rights and the resulting "Black is beautiful" style popularized ethnic dressing and Afro hairstyles for males and females. The Native American look of moccasins, fringe, and beads influenced popular 1960s fashions. The 1969 Woodstock concert in New York exemplified the counterculture movement, and the clothing worn has become the icon of the 1960s.

Figure 4.34 Teenage girl, late 1960s.

Clothing for teens and preteens consisted of denim jeans for both genders, marking the beginning of the androgynous (genderless) look. Streetwear influenced teenage fashions more so than any couture design. Teens loved the uniform, tattered look that broke down the social class barriers that their parents had so carefully erected. Pant legs in the early 1960s began as close fitting and ended just below the ankle. Pants gradually widened at the hem, and by the late 1960s, bell-bottoms were the universal style of pant for young Americans. Teenage buying power exceeded that of any previous decade, and companies desired and targeted this particular market segment. Denim boutiques offered alternatives to designer salons and other stores where a teenager's mother was likely to shop.

Fashion Emphasis, 1970–1979: Dressing for Success

The early years of the 1970s were an extension of the late 1960s. **Bell-bottom pants** would reach extremely wide proportions early in the 1970s before narrowing again, and hip-huggers

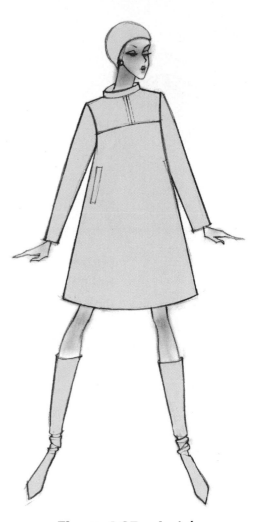

Figure 4.35 André Courrèges A-line dress with go-go boots, mid-1960s.

Figure 4.36 Afro hairstyle and African printed caftan, late 1960s.

would continue the downward trend, requiring the introduction of the bodysuit to prevent indecent exposure. Yet, by the second half of the 1970s, apparel waistlines rose to above the natural waistline.

Author John Molloy wrote the much-heralded book for men, *Dress for Success*, in 1975. With an increasingly competitive job market, young college graduates carefully followed Molloy's book on corporate dressing when selecting interview and career apparel. A common interview outfit for young males included a navy blazer, khaki pants, a white or light blue oxford cloth dress shirt with button-down collar, and a silk tie with a medium to dark red background (Molloy claimed red to be the power color). For female college graduates, nearly all the same items applied to her interview wardrobe, except she wore a khaki A-line skirt and a silk bow around her neck. It was apparent that the fashions for men and women had become more conservative, and this trend continued into the next decade.

Nearly all of the Paris couture designers offered **prêt à porter** lines (ready-to-wear) for consumers. This made good business sense for their struggling design houses, and the retailers and their target customers were eager to have the prestigious merchandise. The designer obsession began during the late 1970s with designer jeans, such as Gloria Vanderbilt, but the craze reached exaggerated proportions in the 1980s.

Two controversial topics in women's wear during the early 1970s were the micro miniskirt and the appropriate occasion for wearing pants. The first controversy involved teenagers and their decision to wear extremely short skirts. Their parents and school officials enacted all sorts of rules to ensure decency among their charges. These dress codes seem quite familiar to today's high school students, but one can image the outrage caused by the first generation of miniskirt wearers. The second controversy involved the wearing of pants to church. With the enormous popularity of pantsuits for women, a natural consequence would be for women to wear pantsuits to the most formal of occasions: church. This outraged some church leaders and congregations, who voted on whether or not to allow women to wear slacks during formal worship services. About the same time as the church-pant controversy, the National Organization for Women pushed for the passage of the Equal Rights Amendment. Ultimately, the amendment did not garner enough votes to become legislation, but women won the pantsuits battle. Both jeans and pants became widely accepted attire for women's everyday dress.

The drastic change in hemlines during the 1970s represents a rare fashion revolution, as did Dior's New Look in 1947. In general, fashions evolve from one year to the next. This includes the lengths of hemlines, gradually moving up or down from year to year. Hemlines had been on the rise from 1947 through the beginning of the 1970s. Once they reached the shortest possible length in 1970 and 1971—crotch skimming—there appeared to be no other direction but downward for hemlines lengths. Fashion designers and manufacturers were tiring of the micro miniskirt and believed a drastic style change might be just the fashion ticket to promote sales. Without sufficient market research, businesses attempted to introduce a radical change—the **midi skirt** (a mid-calf hemline). Unfortunately for business, the consumers were not ready for such a replacement and viewed the new midi with revulsion. It took almost two years and many lost sales before the public adjusted to seeing the new style and began purchasing the midi skirts and dresses.

AUTHOR'S NOTE: For additional reading, see Reynolds and Darden, *Why the Midi Failed*, 1972.

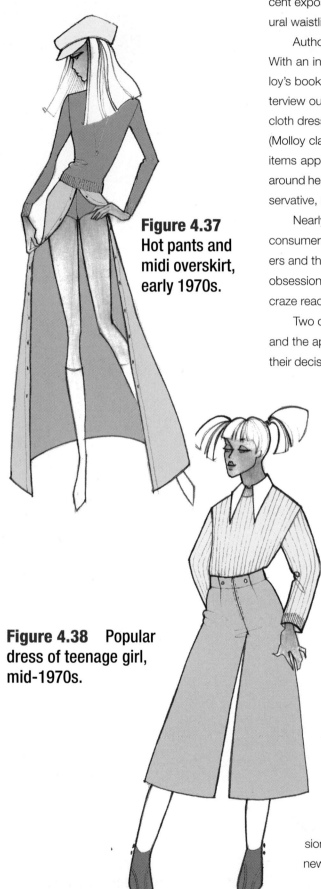

Figure 4.37 Hot pants and midi overskirt, early 1970s.

Figure 4.38 Popular dress of teenage girl, mid-1970s.

The **maxi dress**, a floor-length fashion, coexisted with the micro mini and later with the midi. Its popularity brings up the question: Why did the maxi dress become a fashion during the reign of the miniskirt, while the midi failed? Perhaps there were several reasons. One, a full-length dress would end at the location that the currently fashionable palazzo pants ended, so the appearance was within the comfort zone of the consumer. Two, midi skirts ended at the mid calf, but in the early 1970s, no other fashions ended at mid-calf. It was considered an awkward length. Three, fashion retailers did not promote the maxi as a replacement for miniskirts, while midi skirts were a planned replacement. These reasons and numerous others proposed by Reynolds and Darden (1972) are helpful in understanding the power and decision-making processes of consumers and the widespread adoption or rejection of particular styles.

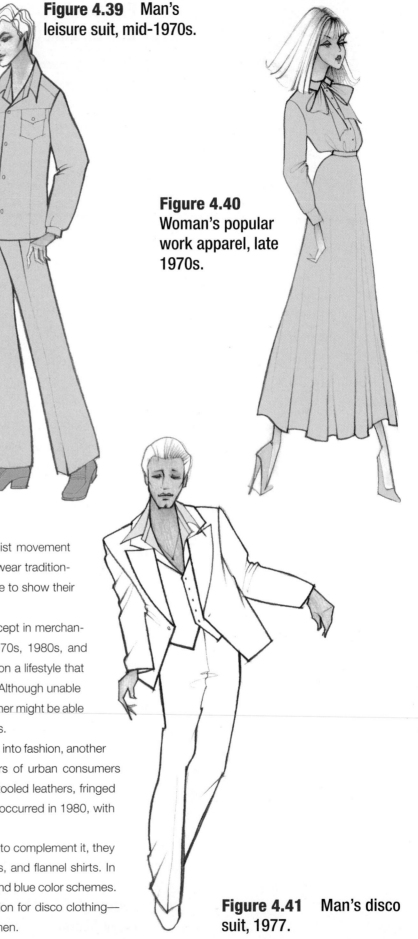

Figure 4.39 Man's leisure suit, mid-1970s.

Figure 4.40 Woman's popular work apparel, late 1970s.

During the early 1970s, menswear continued to become more colorful and effeminate, giving rise to the term the **peacock revolution**. The 1975 polyester leisure suit is the man's fashion icon of the 1970s, although it is now looked upon with amusement.

Manufacturers constructed leisure suits in brightly colored or pastel double knits. The two- or three-piece suits sported patch pockets and wide lapels and were topstitched in contrasting colored threads. This relatively short-lived fashion embodied the 1970s notion of the feminist movement and equality of men and women. Women had earned the right to wear traditionally masculine pants to church or work, and men were given license to show their more feminine side, too.

Menswear designer Ralph Lauren introduced the lifestyle concept in merchandising his collection and continued to refine it throughout the 1970s, 1980s, and 1990s. He understood the value of building a brand image based on a lifestyle that his customers might like to lead, if they had been born into wealth. Although unable to afford all the trappings of conspicuous leisure, the average customer might be able to afford an item or two of clothing that symbolized the leisure class.

While dressing as an upwardly mobile professional was coming into fashion, another fashion was increasing in popularity: Western wear. Both genders of urban consumers donned Western wear that included pearl snaps, Western yokes, tooled leathers, fringed jackets, and cowboy boots. The culmination of the Western craze occurred in 1980, with the release of the film *Urban Cowboy*.

Teenagers still preferred faded denim to any other fashion, but to complement it, they chose patchwork fabrics, printed T-shirts, embroidered work shirts, and flannel shirts. In 1976, the nation's bicentennial year, consumers chose red, white, and blue color schemes. The 1977 blockbuster film *Saturday Night Fever* created a sensation for disco clothing—white suits with vests, gold chains, and platform shoes for young men.

Figure 4.41 Man's disco suit, 1977.

Fashion Emphasis, 1980–1989: Status Symbols and Conspicuous Consumption

Power dressing characterized the attitude of the 1980s fashion consumer. Women continued to enter the executive ranks and needed their clothing to convey an image of competence, strength, and decisiveness. Consequently, the fashion industry provided skirted suits and pantsuits with significant shoulder pads in solid colors, conservative silk blouses and scarves, closed-toed pumps, and other accessories that seemed worthy of boardroom executives. Based on the success of his earlier book, John Molloy authored the *Woman's Dress for Success* in 1977. Women executives looked very much like their male counterparts. Power dressing greatly influenced men's fashions, and navy pinstripe suits became the uniform of the white-collar man.

The 1980s television show *Dynasty* created a power look with enormous shoulder pads on fitted jackets, knee-length fitted skirts, and high heels. Sexy became powerful.

Fashions of this decade exploded with prominently displayed designer labels and prolific designer licensing agreements. Companies marketed all kinds of consumer products with designer names, including jeans, clothing, accessories, eyewear, soups, shoes, pots, pans, bedding, home fashions, and many other product areas. This designer status symbol trend began in the latter 1970s, but it reached exaggerated proportions in the mid-1980s. It seemed no matter what the quality or appearance of a product, a designer-sounding name improved sales. Consumers expected no subtlety; instead they preferred the high visibility of the designer name when they wore, carried, or used the item. Consumers might not be able to afford a genuine couture outfit, but they could wear an Oscar de la Renta scarf or dress their infant in licensed Baby Dior sleepwear.

The fitness craze largely influenced clothing of the 1980s. On November 2, 1981, the cover of *Time Magazine* featured an article entitled "*The Fitness Craze: America Shapes Up*." Also during the 1980s, actress Jane Fonda released her workout videotape, designer Norma Kamali introduced her sweatshirt-fleece separates, and Hollywood released the movie *Flashdance*. Retailers gained substantial profits on workout wear for most every sport. In addition, consumers transitioned their comfortable activewear clothing from the exercise room to the streets for everyday wear. The term **casual athlete** described the person who wore active sportswear clothing for everyday wear. Consumers popularized warm-up suits, jogging suits, wind suits, sweatshirts, and sweatpants for daywear regardless of their level of activity.

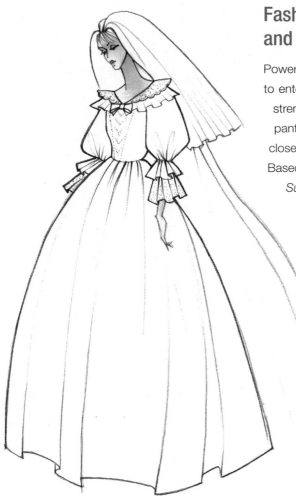

Figure 4.42 Princess Diana's wedding dress, 1981.

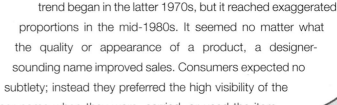

Figure 4.43 Man's workout wear, early 1980s.

Although corporate power dressing was in fashion, so was femininity. England's Lady Diana Spencer wed Prince Charles in 1981 in a spectacular ceremony with an equally spectacular and much-copied wedding dress. For the remainder of the decade, Princess Di was the most photographed woman in the world. Her fashions were feminine and dressy. She influenced the popularity of fanciful hats, ruffles, and dresses.

Conservative, yet powerful clothing with designer names and a focus on staying fit influenced menswear of the decade. Men's clothing was more subdued and easy-fitting than the styles of the 1970s. Lapels and ties were narrow and straight-leg trousers were usually front-pleated. In general, clothing gradually tended toward the traditional, with more muted colors and patterns.

During the late 1970s and early 1980s, the teenage rebellious nature manifested itself in the street style fashions known as **punk**. Designer Vivienne Westwood was influential in creating punk look fashions. The ripped and torn clothing represented the antithesis of power dressing. Association with the punk subculture also represented an affinity for punk music, so punk T-shirts often sported band logos. Among the most recognizable of all punk styles was the spiked hairstyle in purple, green, or blue.

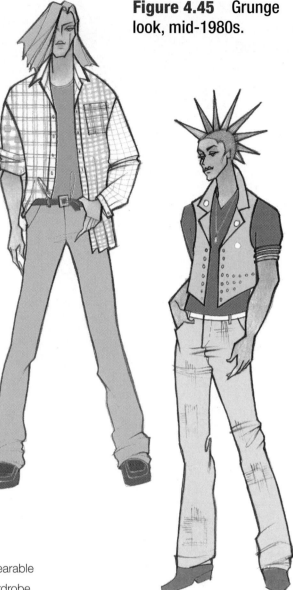

Figure 4.45 Grunge look, mid-1980s.

Figure 4.46 Punk hairstyle, late 1980s.

Figure 4.44 Woman's power suit, mid-1980s.

Fashion Emphasis, 1990–1999: Sporty and Comfy

The early years of the 1990s focused on understated and wearable clothing. The power suits of the 1980s gave way to a more relaxed business fashion wardrobe. Women had broken through the glass ceiling and now were freer to dress in fashions that subtly reflected their assertiveness. As American designer Donna Karan stated women needed "clothes that would travel, interchange and impress." The predominance of fashion versatility grew in importance during this decade. Designers created lifestyle collections with interchangeable pieces that could be dressed up or down, depending on the occasion. Women bought mix and match separates that served multiple purposes and could be combined into any number of outfits. A well-dressed woman could go immediately from work to a night out with just the addition of an accessory or the removal of a jacket. The **casual Friday** concept of wearing casual clothing on Fridays evolved into the **corporate casual** look that entailed dressing casually every workday.

The prevalence of obvious status symbols waned after the explosion of designer names in the previous decade, but branding remained a viable marketing strategy. The blatant designer names and large brand logos became more subtle during the 1990s. Manufacturers replaced designer names with symbols that fashion-savvy customers easily recognized. Branding was taking on a life of its own. Rather than the style or appearance of fashion creating meaning for the wearer, the brand name made the statement. Marketers were discovering that an ordinary T-shirt or ball cap could convey a powerful message by simply displaying a

Figure 4.47 Girls' popular apparel, mid-1990s.

popular brand logo. Through promotions and advertising, marketers positioned the brand in consumers' minds as somehow being a greater value than another brand. This popular 1990s concept became known as **brand equity** or **brand franchise**. As an example, many consumers believe Nike to be a higher-performance product because promotions show professional athletes endorsing Nike. Average and casual athletes choose Nike products, imagining the high-performance power of the brand is somehow transferred through the Nike Swoosh symbol.

The emphasis on exercise and staying fit evolved from an apparel and accessory fad into a permanent way of life that required continuous replenishment of fashionable athletic apparel for the casual athlete. Consumers appreciated the comfort level of athletic apparel and opted to wear it shopping and for relaxing on the weekends, rather than just during exercising. An outgrowth of the explosion in athletic apparel was the addition of spandex to other fabrics not traditionally associated with workout wear. By the mid-1990s, manufacturers included the stretch fiber in a variety of woven street fashions, such as blouses and denim jeans.

The widespread availability of the Internet made it an important information medium, and retailers found e-tailing quite profitable. Most large retailers invested in e-tailing through their online stores to achieve a larger share of the market. Consumers gained confidence ordering fashion merchandise from Internet Web sites. This trend of online shopping continued to grow through the 1990s and into the next decade.

For teens, a looser-fitting, stonewashed, basic five-pocket jean ruled the denim fashions of the early 1990s. The youth adopted extremely wide-legged denim jeans (40 plus inch circumference) as a fad during the early 1990s. In the later 1990s, the denim waistline began to drop and progressed downward each season for the remainder of the decade and into the 2000s. Terms such as *low-rise, low slung, hip-huggers,* or *bumsters* described the extremely low waistlines that reached all-time lows in the 2000s. Female youth paired the low-rise jeans with slightly cropped shirts that showed just a hint of a young woman's midriff. The cropped top fashion became even more pronounced and dominated women's fashions at the end of the decade.

The **grunge** unisex style became mainstream early in 1993 and generally appeared as a dilapidated style. Grunge wearers worked to achieve the appearance of a homeless person whose prime concern was to simply clothe the body from items found at thrift stores. The concept of matching was only an issue in that it was a faux pas for the grunge look. The trickle up effect of the grunge look resulted in mismatched patterns for mainstream fashions. For example, a fashion flannel shirt might have sleeves of two different plaids and a yoke of even a third pattern. Although the grunge look became obsolete by the early 1990s, the general acceptance of mismatched clothing was still significant in mainstream fashion for another decade. As late as 2008, accessories, especially handbags, were not ex-

Figure 4.48 Woman's dress, early 1990s.

Figure 4.49 Casual Friday look, mid-1990s.

pected or recommended to color- or pattern-match the related outfit or the other accessories, such as shoes.

The term **Gothic** gained impetus in the 1990s as a term describing the rebellious young person who preferred antifashion. The **Goth** look included black clothing, wide-legged jeans, liberal use of chains, blue-black dyed hair that contrasted with pale skin, heavy eyeliner, and black fingernail polish.

Some teens adopted the **skateboarder** or **skate thug look** that entailed wearing high-topped canvas tennis shoes, caps with the brims turned backward, large hooded sweatshirts called hoodies, and cargo shorts. A skateboard complemented the skater look, but it was not a requisite of the style of dress.

An ethnic trend that became popular during the mid-1990s was the **hip-hop** style, made fashionable by the rappers from inner cities. Rap musicians Snoop Doggy Dog and Sean "Diddy" Combs were early influencers of the mainstream hip-hop look, although the style had actually begun in the 1970s. The hip-hop fashion took on many different looks, from the 1930s and 1940s gangster and street thug fashions that were called **gangsta** style to streetwear and tough-guy fashions, such as baggy or sagging jeans, large T-shirts, chains, and do-rags or bandanas on the head. A part of this fashion involved the wearing of flashy jewelry and gemstones, referred to as **bling**. The notion of wearing large gemstones in jewelry was popularized with many consumers, regardless of age, ethnicity, or interest in the hip-hop style.

Fashion Emphasis, 2000–Present: You Make the Call!

Identifying the magnitude of fashion trends poses some difficulty if society is currently experiencing the trend. Some trends are visible, but it is much easier to study major fashion trends in retrospect. Styles that are currently in fashion have yet to complete their life cycle, so the degree of popularity or the speed of the cycle cannot be determined. However, since a new fashion usually grows out of a preceding fashion, some generalizations can be made, especially about the earlier years of the twenty-first century.

The terrorist attacks on the World Trade Center towers in New York City on September 11, 2001, and the subsequent military involvement shed fashion light on patriotic colors and camouflage prints. Red, white, and blue color combinations in fashions increased in popularity in the seasons following the attacks. The camouflage prints that had been popular during the mid- to late 1990s were waning in popularity by the end of the twentieth century. The renewed interest in the military after the terrorist attacks also may have renewed the fashion interest in camouflage.

In the early 2000s, fashions became dressier, and the fashion industry heralded the return of the one-piece dress as a new direction in women's wear. Comfort remained an important part of dressing, but people were dressing up more than previous years. The 1970s disco glam look reappeared in the early 2000s and featured glitter and sequin embellishments on clothing and accessories. By the middle of the decade, the 1960s retro fashions emerged in styles that included A-line and tubular silhouettes. Geometric print and mod styles were mid-decade fashions.

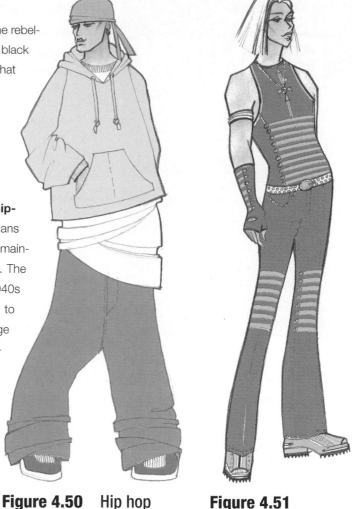

Figure 4.50 Hip hop look, late 1990s.

Figure 4.51 Gothic look, late 1990s.

And the Oscar Goes to . . .

Hollywood celebrities are credited with significantly influencing the global fashion industry. Who is wearing what at the red carpet awards is analyzed in great detail by trade and consumer publications, as well as by popular television programs and their viewers. Movie costume design represents another important part of the Hollywood fashion business. These talented designers also exert influence on popular fashion, although they may be less recognized by the public.

Each year the film industry personnel nominate persons for the Best Costume Design at the annual Motion Picture Academy Awards. Nominees are selected based on their inventive artistry and craft. The most recent winners are:

2008 Michael O'Connor, *The Duchess*
2007 Alexandra Byrne, *Elizabeth: The Golden Age*
2006 Milena Canonero, *Marie Antionette*
2005 Colleen Atwood, *Memoirs of a Geisha*
2004 Sandy Powell, *The Aviator*
2003 Ngila Dickson and Richard Taylor, *The Lord of the Rings: The Return of the King*
2002 Colleen Atwood, *Chicago*
2001 Catherine Martin and Angus Strathie, *Moulin Rouge!*
2000 Janty Yates, *Gladiator*

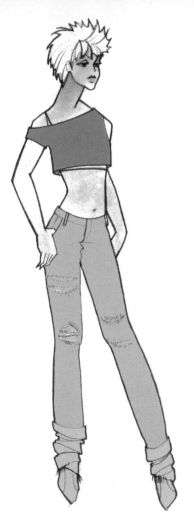

Figure 4.52 Popular teenage fashions, early 2000s.

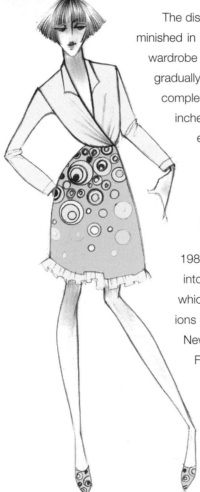

Figure 4.53 Popular woman's fashions, early 2000s.

The distressed jeans look featuring tears, holes, and threadbare patches diminished in popularity although it remained a part of the male and female teen wardrobe beyond the first half of the decade. Darker denims with higher rises gradually replaced the low-rise destroyed and distressed denims. Layered tops complemented the denim fashions. Women's knit tops lengthened to several inches below the waist, replacing the cropped tops of the late 1990s and early years of the 2000s. By the mid-2000s, the tunic-length top was a pervasive fashion trend.

When fashion experts predict the movement of fashion, differences of opinion exist on the emerging trends and the upcoming popular fashions. A perusal of the 2007 fashion editorials identified references to retro fashions from the 1950s, 1960s, 1970s, and 1980s. Although designers may incorporate ideas from all these decades into collections for a particular year, the consumers ultimately decide which styles they adopt. In 2007, the fashion editor predictions and opinions varied on the emerging trends. For example, in February 2007, the New York Fashion Week event showed designer collections for the Fall/Winter 2007–2008 season. The subsequent write-ups by fashion editors represented dichotomous viewpoints. One editor wrote that the designers showed "color, flowing lines and loose cuts." A second editor wrote that the Fall/Winter 2007–2008 season was "all about tighter lines and a closer cut." Could both predictions be correct?

For menswear, the term **metrosexual** defined the fashion-forward male who dressed with care in colorful clothing, hinting at a more feminine side. The more conservative male wore comfortable and colorful sport shirts with neutral colored slacks, jeans, or the wardrobe classic cargo pants or shorts. Popular

neckties prints included bold and colorful patterns, such as repeating stripes (reps) and geometric patterns.

Manufacturers offered conservatively cut suits, featuring moderate-width lapels, single-breasted coats, and straight-legged trousers. As is usually the case, designers concentrated fashion-forward looks in shirts and accessories that could easily be updated each season, rather than in the wardrobe basics, such as men's suits, that often required a higher initial investment.

Variations on the Gothic, hip-hop, gangsta, and skateboarder looks continued well into the first decade of this century, although for the most part they were in the decline stages for mainstream fashions. Until about 2005, retailers featured the distressed or destroyed denim look for adolescent denim fashions, but this look soon moved into the decline stage. By 2007, the preppy look, retro of the 1980s, gained momentum. It included woven button-up shirts, polo knitted shirts, Lacoste alligator logos, wrinkle-free cotton khaki pants, and darker denim jeans. Denim jeans were the item of the decade.

Figure 4.54 Skateboarder, early 2000s.

Figure 4.55 Woman's business attire, mid-2000s.

Figure 4.56 Man's business attire, mid-2000s.

Early Influential American Designers

From Hollywood to New York City, American fashion influencers and designers have gradually defined the recognizable American Look. Among these are the great designers for the early Hollywood stars as well as for the fashion-conscious public. These designers set the tone for the emerging U.S. fashion industry.

American designer names rose to prominence due in part to America's film industry, as well as world events such as World War II. Motion picture designers Howard Greer, Travis Banton, Edith Head, Irene Lentz, and Gilbert Adrian were among the earliest American costume designers recognized for their remarkable craft as well as their role in dressing Hollywood's most glamorous starlets. The Hollywood fashions often established the ready-to-wear trends that trickled down to the general U.S. public that longed to emulate the stars. The following sections discuss influential American fashion designers during the U.S. fashion industry's developmental years (1930s to the 1960s). These designers' careers may have spanned several decades, so they are discussed in a separate section that focuses on their major contributions, rather than a specific decade.

Hattie Carnegie (1889–1956)

Hattie Carnegie, born Henrietta Kanengeiser in Vienna, Austria, has been called either the first American designer or a very successful manufacturing editor. She moved to New York City during her childhood and began her career with a millinery shop in 1909. With limited drawing, sewing, or construction know-how, Hattie built her business with her creative abilities and inspirations from the Paris couture (inspired knockoffs). She hired excellent sewers who could turn her ideas into chic dresses. In 1928, she began a higher-priced ready-to-wear line with Norman Norell as her head designer. Designers Travis Banton and Claire McCardell also worked for Hattie Carnegie's business. During the 1940s, Carnegie's store blossomed into a full-fledged eponymous (under her same name) department store and custom designing shop. She is well-known for her wearable, elegant clothing and her business acumen. Carnegie has been credited with defining the American style. The November 12, 1945, *Life Magazine* referred to her as the "dominant one in her field" (p. 63).

Gilbert Adrian (1903–1959)

Motion picture movie costume designers such as Gilbert Adrian played a dual role of dressing the Hollywood stars, such as Gretta Garbo, Joan Crawford, and Katharine Hepburn, and providing visual cues for the public to interpret in their own wardrobes. The young Hollywood costume designer known simply as Adrian designed for the movie director Cecil B. DeMille and MGM studios in 1928. He continued designing elegant motion picture costumes for over 200 films until the early 1940s. During Adrian's career, major department stores, such as Macy's, regularly knocked off his costume designs. One much-copied design was his costume worn by Joan Crawford in the 1932 movie *Letty Lynton* (see Figure 4.57). Adrian opted to open his own Beverly Hills, California, boutique in 1942 due to his desire to profit from his own creative designs and because the economic depression limited the extravagance of spending for Hollywood costumes.

Figure 4.57 **Evening gown designed by Hollywood designer Adrian.**
(Getty Images Inc./Hulton Archive Photos)

Claire McCardell (1905–1958)

A prominent designer from the 1930s through 1950s, Claire McCardell helped define the American Look with her completely American approach to fashion: youthfulness, flexibility, practicality, and comfort. She is famous for her casual leisurewear designs and has been called the inventor of sportswear. Her design philosophy included a belief that clothing should be simple and easy to wear. McCardell said, "I've always designed things I needed myself. It just turns out that other people need them, too" (Claire McCardell: The American Look, May 2, 1955). This philosophy is apparent in her simplistic designs in denim, seersucker, and ticking. They include the Greek empire dress, tent dress, and diaper fit sportswear. The 1942 popover wrap housedress made McCardell's name a household word (see Figure 4.58). McCardell received the American Designers Coty Award in 1943 and 1956. The May 2, 1955, *Time Magazine* featured McCardell on the front cover.

Edith Head (1907–1981)

Edith Head designed for Paramount Pictures for six decades, beginning in the 1920s. The industry nominated her for 35 Oscars, and she won eight Academy Awards for motion picture costumes. The sarong dress she designed for Dorothy Lamour in the movie *The Hurricane* gained her notoriety among the American public (see Figure 4.59). Her willingness to work with actresses, camouflaging their flaws and enhancing their physical assets, earned her respect in Hollywood circles. She co-authored a biography of her life, called *The Dress Doctor* (1959), which describes her life and many of her famous clients. She also wrote *Fashion as a Career* in 1966.

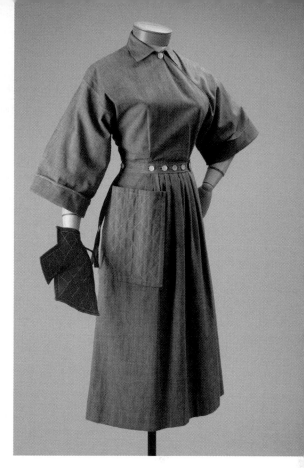

Figure 4.58 Popover dress made famous by Claire McCardell.
(Metropolitan Museum of Art)

Figure 4.59 Sarong dress made famous by Edith Head.
(Second City Style)

summary

- Fashion is a reflection of the way of life at a given time.
- Fashions reflect the social, political, and economic happenings—the *Zeitgeist*.
- Designers, product developers, marketers, and students study recent history for fashion design inspiration or as a way to help them predict the next fashion trends.
- Newer fashions evolve from previous styles, changing only slightly from season to season.
- In every decade, parallels exist between the fashions and the social, political, and economic happenings.
- World events and the emergence of Hollywood costuming propelled the U.S. fashion industry into a contending world fashion leader during the middle decades of the twentieth century.

terminology for review

monobosom 59
art nouveau 59
shirtwaist 60
chemise 62
suffragettes 62
flapper 63
faux 63
New Look 67
beatniks 69
hippies 70

bell-bottom pants 71
prêt à porter 72
midi skirt 72
maxi dress 73
peacock revolution 73
casual athlete 74
punk 75
casual Friday 75
corporate casual 75
brand equity 76

brand franchise 76
grunge 76
Gothic 77
Goth 77
skateboarder 77
skate thug look 77
hip-hop 77
gangsta 77
bling 77
metrosexual 78

questions for discussion

1. What are some specific examples of how the fashions reflected the times in each decade?

2. During any given decade, why are youth fashions often quite different from mainstream fashions?

3. What are some youth fashions that seem to repeat themselves during the decades? Why might this be the case?

4. How are fashions of the end of one decade related to the fashions at the beginning of the subsequent decade?

5. In addition to designers, what are some others sources of inspiration for fashions throughout the decades?

6. What role has Hollywood played in influencing mainstream fashions?

7. Who were some prominent American designers, and what were their contributions?

8. What events influenced the rise of American fashion?

9. How did retail stores influence the development of the U.S. fashion industry?

10. What is meant by the American Look, and how has this evolved over the decades?

related activities

1. Choose a famous American designer from the first half of the twentieth century. Using the library's electronic newspaper database (including the *New York Times*), research the designer in pre-1950 periodicals and create a PowerPoint presentation about the designer's contributions to the U.S. fashion industry. Include substantial information not discussed in this chapter and include a bibliography.

2. Select a decade of the twentieth century and identify several major political, social, economic, or other important events on a timeline (using an electronic timeline template). Research and select corresponding fashions for men and women during the particular decade and describe why these fashions were a reflection of the times. Include substantial information not discussed in this chapter and include a bibliography. Create a presentation for the class.

3. Select a significant event that occurred in any decade of the twentieth century. The class can brainstorm on the list that might include the invention of the automobile, the women's right to vote, the stock market crash, wars, invention of synthetic fibers, Woodstock, the royal marriage, the Ascot races, and so forth. Conduct research on the fashions through library microfiche or historic issues of fashion magazines. Locate electronic articles in popular and trade magazines by using the electronic databases at the college library. Record what fashion editors were saying about the appropriate clothing for the event and how the event influenced popular fashions of the era. Assimilate the findings into a report or presentation and include a bibliography using complete bibliographic citations in the American Psychological Association (APA) format.

4. Type a 350–400 word predictive paper for upcoming fashions for women, men, and teenagers for the next five years. This can include specific details of styles, as well as fabrics, silhouettes, colors, prints, and other general trends. Justify the predictions with some of the principles of fashion discussed in the chapters. Include introductory and concluding paragraphs. Present the paper to the class.

Your Fashion IQ: Case Study
Romancing the Style: Vintage Fashions

Since the 1990s, the craze for vintage fashions has continued to grow. Glamorous women—Kate Moss, Renee Zellweger, and Julia Roberts—all donned vintage dresses on the runway. Smart shoppers can sometimes find vintage fashions in secondhand clothing shops, but enterprising retailers have stepped up the secondhand image and opened stores devoted entirely to vintage clothing and accessories. In Adelaide, Australia, the town has opened dozens of vintage shops featuring a variety of apparel and accessories from past decades. In Los Angeles, the grand dame of vintage Ms. Doris Raymond owns a vintage store called The Way We Wore on La Brea Avenue. Her client list includes designers, such as Zac Posen, Sonia Rykiel,

and Marc Jacobs, and retailers such as Forever 21. Astute thrift shop managers have begun to merchandise their inventory, separating vintage pieces from secondhand clothing. This facilitates shopping for the distinctly different groups of target customers that might patronize a thrift store.

Few ideas are truly new, so vintage research can create a spark of an idea to inspire a collection. Designers and product developers resurrect vintage fashion ideas into marketable looks that appeal to a newer and younger group of customers. According to the "Fashion Secret" article in the *Wall Street Journal* (2007, Apr. 2, p. A1), "designers use many reference points, often starting with their own company archives to see what garments might be recast or updated in the future. Industry houses often shop at vintage stores not just for inspiration, but to find pieces from past collections."

QUESTIONS:

1. What is the psychological appeal of vintage fashions and retro looks for consumers?

2. What sources of inspiration might a designer get from a vintage piece?

3. What might be the benefit of looking in a company's own archives for design ideas?

4. Consider a nearby thrift store in your college town or hometown. Is it merchandised to appeal to a vintage customer?

SOURCES: Harrison, Sky. (2008, Aug. 28). Vintage fashion, new vintage. *The Adelaide Magazine.*

Kang, Stephanie. (2007, Apr. 2). Fashion Secret: Why Big Designers Haunt Vintage Shop. *Wall Street Journal* (Eastern edition), p. A1.

5 Fundamentals of Fashion

6 Fashion Principles, Perspectives, and Theories

7 Marketing Terminology and the 4 Ps of Fashion Marketing

8 Fashion Analysis and Prediction

9 Fashion Branding

The
Uniqueness of
FASHION

5

6

7

8

9

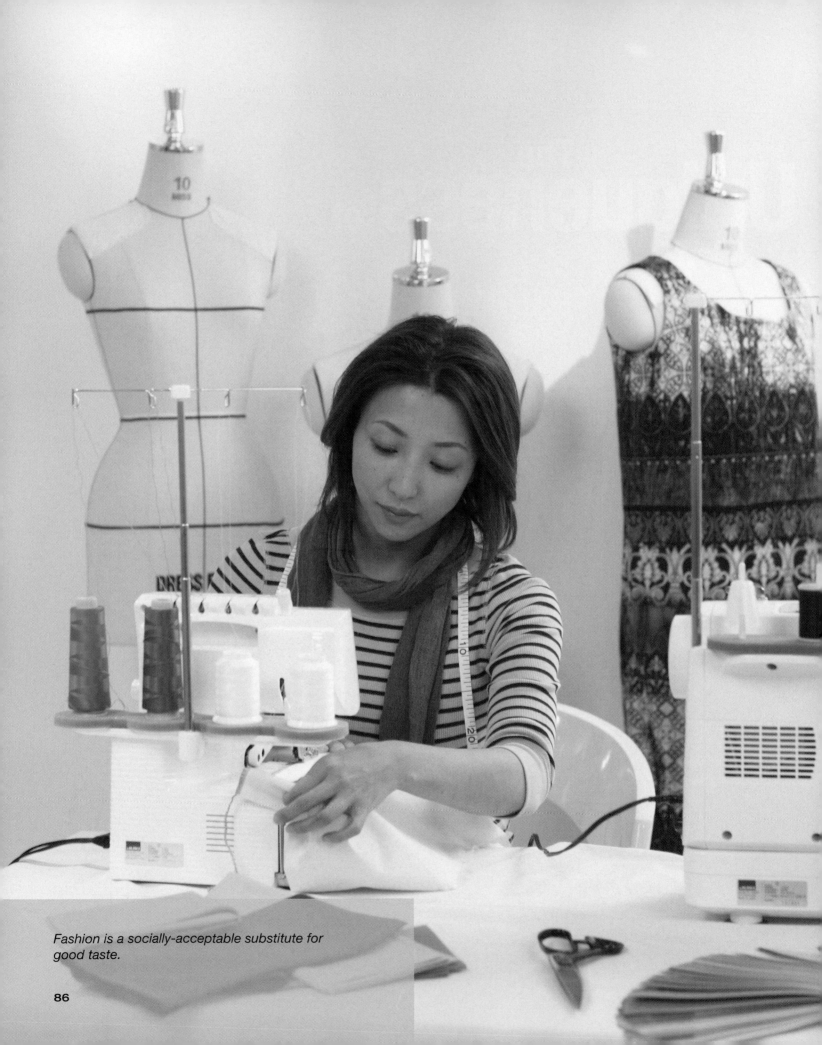

Fashion is a socially-acceptable substitute for good taste.

FUNDAMENTALS of FASHION

LEARNING OBJECTIVES

At the end of the chapter, students will be able to:

- Demonstrate the ability to speak the language of fashion.
- Identify the major categories of women's wear and compare these to menswear and children's wear.
- Classify the size ranges for women's, men's, and children's apparel.
- Describe the different wholesale price zones for women's wear and menswear.
- Distinguish among the various apparel styles.

Students of fashion should learn the basics of the fashion industry so that they can converse with industry professionals on a comparable level. Trade publications use all kinds of industry jargon when reporting fashion news. Effective fashion marketers understand the fundamentals of fashion for menswear, women's wear, and children's wear. Chapter 5 contains important facts and terminology essential to the business of fashion.

The women's apparel and accessory retail industry in the United States is the largest segment of the apparel business. The women's wear retail industry is about four times larger than either the menswear or children's wear retail industries. The U.S. Census Bureau reported 2007 domestic retail sales of more than $40.7 billion for women's wear (NAICS 44812). The Census Bureau reported domestic menswear (NAICS 44811) retail sales over $10.2 billion in 2007, whereas the children's wear (NAICS 44813) retail sales were almost $7.1 billion in 2002. The Census Bureau also reported that domestic retail sales at family clothing stores (NAICS 44814) were $80.3 billion in 2007.

The wholesale apparel and accessory industries are equally impressive in annual sales. The U.S. Census Bureau reported 2007 wholesale merchant sales for apparel, piece goods, and notions (NAICS 4243) to be $128.3 billion. The U.S. Census Bureau reported the sales for the women's, children's, and accessories wholesale industries (NAICS 42433) to be $46.8 billion in 2002. The government agency also reported the value of men's and boy's clothing and accessories wholesale industries (NAICS 42432). The annual sales for this group totaled slightly over $34 billion in 2002.

Women's Wear

Numerous wholesale categories characterize the women's wear and menswear industries. The large sales volume that occurs in the women's wear industry requires more specialized classifications than menswear or children's wear. To illustrate the degree of specialization, a recent wholesale buyer's directory designated the following product categories: outerwear, dresses, suits, sportswear or separates, sweaters/knitwear, denim/jeans, activewear or active sportswear, swimwear, intimates/sleepwear, holiday, maternity, petite, plus size, prom/pageant, special occasion, and accessories. Manufacturers and wholesalers may specialize in one or more related product categories. For example, manufacturers of sweaters and knitwear may also specialize in swimwear, since all are knitted products. A manufacturer of special occasion apparel may create fashions for misses, plus, petites, and maternity, since all of these categories have similar needs for special occasion clothing.

Sizing

Size categories include young junior, junior, junior petite, missy, missy petite, women, and tall. **Young junior** sizes fit adolescent females and are blended sizes: 00, 0/1, 1/2, 3/4, 5/6, 7/8, 9/10, 11/12, and 13/14. These sizes have greater differences between the bust, waist, and hip measurements. **Junior** sizes are odd sizes, 1–15, and fit a more youthful figure, with smaller differences between the bust, waist, and hip measurements. **Junior petite** sizes accommodate females who wear junior sizes and are 5'4" or shorter. **Missy** sizes are even numbers, 2–20, and fit average height women 5'5" to 5'6" with more curves than junior sizes. Females who wear missy sizes have greater differences between the bust, waist, and hip measurements. **Missy petite** sizes fit females who wear missy sizes and are 5'4" or shorter. **Women** sizes fit plus females with a missy figure. These include sizes 34–50 and **women's half** sizes (women's petite) ranging from 12 1/2 to 28 1/2. Retailers may also use 18W, 20W, 22W, 24W, and 26W to indicate women's half sizes. In the 1980s, the fashion industry introduced **plus** sizes 1X through 10X. These were similar to the women's sizes 38–50 but had greater psychological appeal. **Tall** sizes fit females who wear missy sizes and are 5'7" or taller.

In 2003, [TC]² (Textile Clothing Technology Corporation) undertook a data gathering research project called SizeUSA. According to the company Web site, a problem of lost sales occurs when consumers cannot find properly fitting clothing in the stores. "Companies use sales data to get feedback on what sizes are selling and in what proportions—but sales data never captures lost sales" (ww.sizeUSA.com). To combat this problem, [TC]² conducted a national size survey that collected data on 10,000 Americans from both genders, six different age groups, and four ethnicities. Electronic scanners measured their bodies on 200,000 different measurement points. The result was an average of linear measurements and proportions useful to apparel companies when creating standardized sizes.

Jim Lovejoy, the project director, interpreted the data by stating that "the population has grown taller and heavier, but we are growing heavier faster than we are taller. If you look at the grade rules for most manufacturers today, they do not reflect what we are finding in our size survey." Companies such as Victoria's Secret, JCPenney, Lands' End, Jockey, and Lane Bryant have all used body scanning to create more accurate ready-to-wear sizes.

SOURCE: www.SizeUSA.com

Several changes have occurred in the sizing structure of women's wear. In recent years, some have criticized the fashion industry for assigning smaller sizes to larger body measurements. Manufacturers in higher price zones cut their clothing generously to allow a customer to purchase a size smaller than she might normally wear. This practice, called **vanity sizing**, has been noticeable in bridge and designer lines. Chicos Company has its own sizing classifications and uses sizes 0, 1, 2, and 3 to correspond to the range of misses sizes from 4 to 16. Another aspect of sizing has been the increase in measurements for all sizes. Patternmakers designated a misses size 8 in 1955 with a bust, waist, and hip measurement of 32, 27, 35 inches. In the 1980s, a dress pattern in a misses size 8 measured 36, 28, 38 for the bust, waist, and hip inches. This second set of measurements remains the same today.

Wholesale Price Zones

A wholesale price zone is a group designation based on cost and quality of merchandise that will be sold to retail stores. A wholesale amount or cost is about half of the retail selling price, so when students are reading trade publications, they should keep this in mind.

The number of wholesale price zones has increased in recent years, and the distinctions have become somewhat blurred. A single store's merchandise selection may consist of fashions in multiple wholesale price zones. A recent perusal of a fashion industry trade publication identified numerous wholesale price zones for both women's wear and menswear. Those mentioned were mass or budget, moderate, upper moderate, lower better, better, better to bridge, bridge, upper bridge, diffusion, gold range, and designer/signature/couture RTW. The following sections briefly explain each wholesale price zone and provide examples cited in past issues of *Women's Wear Daily*.

Mass/Budget Mass merchandise stores, such as K-Mart and Target, carry apparel and accessories at the mass or budget wholesale price zones. This is the least expensive wholesale price zone in the fashion industry. As an example, a fashion top typically wholesales for less than $5.

Moderate Sears, Kohl's, and JCPenney all carry moderate merchandise. The manufacturer of the brand JH Collectibles classifies it in the moderate wholesale price zone. Alexander McQueen's line of clothes offered at Target would be considered in the moderate wholesale price zone, even though Target is a mass merchandiser. The line called McQ Alexander McQueen for Target features retail prices of up to $129.99.

Upper Moderate/Lower Better The terms *upper moderate* and *lower better* overlap to some degree. These two wholesale price zones are typical of main level merchandise in department stores, such as Macy's and Dillards, and in the mall specialty store J Jill. Various trade resources mention department stores as carrying moderate, upper moderate, and lower better wholesale price zones.

Better Upscale department stores, such as Bloomingdales and Nordstrom, carry merchandise in the better wholesale price zone. The category includes brands such as DKNY Jeans, Lauren by Ralph Lauren, H by Tommy Hilfiger, Claiborne by John Bartlett, and Realities by Liz Claiborne.

> The women's apparel and accessory retail industry is approximately four times larger than the men's and children's apparel and accessories industries.

Better to Bridge Fashion industry trade publications sometimes group these two wholesale price zones together when describing the offerings of a particular store. The Lacoste brand exemplifies merchandise in the better to bridge price zone. Market research from the NPD Group in Port Washington, New York, showed that the better to bridge categories represented over 60 percent of all department store sales for women's apparel.

Bridge/Upper Bridge Wholesale companies created bridge price zones to "bridge" the gap between better and designer merchandise for high-volume U.S. department stores. Since its introduction, bridge lines have dropped to third or fourth place in the wholesale price zone hierarchy. Bridge brands include Juicy Couture, Donna Karan Collection or DKNY, and O Oscar handbags (Oscar de la Renta). Emanuel/Emanuel Ungaro exemplifies an upper bridge brand. Department stores, such as Lord & Taylor, as well as most other major department stores carry bridge lines.

Diffusion Designers reinterpret select pieces from their signature lines for their diffusion lines but maintain the stylistic link to the designer's signature collection. Companies choose to price the diffusion lines lower than the designer lines in order to appeal to a wider market. Wholesale prices are about 30 percent lower than the designer's signature line. Diffusion brands include Ungaro Collections, McQ Alexander McQueen, Valentino Red, Marc by Marc Jacobs, Marc Bouwer Glamit, M Missoni, and BCBG Max Azria. Retailers carrying diffusion lines include Neiman-Marcus, Saks Fifth Avenue, and Bloomingdales.

Gold Range Fashion industry trade publications occasionally mention the gold range merchandise that is above diffusion lines and below the designer signature lines. References to gold range brands include Escada Sport, Max Mara, and some of the merchandise offered at Saks Fifth Avenue.

Designer/Signature/Couture RTW The designer wholesale price zones often bear the signature of the designer, so trade industry publications also refer to this as signature merchandise or couture RTW. This top tier of the wholesale price zones should be creative and unique, creating a perceived value for the customer. Although the bridge, diffusion, and gold range lines of a designer should have some similar elements, designers should ensure that the second- and third-tier lines do not cannibalize the signature line sales. Examples of designer wholesale price zones include the Black Fleece line for Brooks Brothers, Valentino, Marc Bouwer, Badgley-Mischka, and Ungaro's Parallele.

Menswear

The menswear industry is somewhat different from the women's wear industry. First, it is comprised of fewer firms than the women's wear industry. Second, many menswear companies have long histories dating back to the 1800s, such as Hartmarx and Levis. Both of these companies began exclusively as menswear but have since branched into the women's wear industries. In addition to being a smaller and well-established industry, the menswear industry is comprised of vertically integrated firms. **Vertical integration** means a company operates at more than one level of the supply chain by owning the suppliers up the chain and the levels below the suppliers. By owning more than one level, the company has greater control over its supply chain, and it has access to profits at other levels. A company may own its own manufacturing facility as well as a retail store bearing the company name. For example, the Hartmarx company manufacturers men's clothing that are sold in retail stores, such as Nordstrom, but customers can also order directly from the company through its Web site. American Apparel, a vertically integrated sportswear company, also owns its own manufacturing facility and retail stores. The company's Web site states, "American Apparel uses a vertically integrated business model which minimizes the use of sub-contractors and offshore labor" (American Apparel, 2009). The company boasts that its design, knitting, dyeing, cutting, sewing, distribution, and marketing are all housed in the company's factory in Los Angeles, California.

The menswear industry designates men's suits and sport coats as tailored clothing. **Tailored clothing** is identified by the degree of hand workmanship employed during manufacturing. In the 1920s, manufacturers introduced the grading of suits from one to six based on the number of hand operations. A number one suit was almost entirely machine-made, whereas the highest grade, number six, was almost entirely hand-made. Tailors in the United Kingdom use the term **bespoke tailoring**, for the process of custom tailoring a man's clothes to his specific measurements. Today, advanced manufacturing capabilities have resulted in almost complete mechanization of the suit industry, except for a few elite tailor shops.

Classifications

The menswear industry has classifications and wholesale price zones that are similar to the women's wear industry, but tailoring is far more important in menswear. Menswear manufacturers offer matching **suit** sets consisting of jackets, trousers, and sometimes vests when in fashion. Retailers sell these suits as two- or three-piece units. Retailers sell blazers and sport coats as separates, intended to be worn with contrasting slacks. **Blazers** are solid-colored sport coats, often with brass or ornamental buttons. The term **sport coat** encompasses the re-

maining tailored separate jackets. Men's **outerwear** consists of overcoats, raincoats, and jackets. **Causal sportswear** clothing for men includes prehemmed pants, shorts, woven and knit shirts, T-shirts, sweaters, vests, and other apparel purchased as separates. Men's **accessories** or **furnishings** include neckties, pocket squares, jewelry, watches, socks, hosiery (dressy socks), shoes, hats, scarves, and gloves.

Sizing

The American Civil War (1861–1865) required many thousands of uniforms for both the Union and Confederate armies. The beginning of the war marked the first time in U.S. history that uniformmakers collected vast amounts of data on men's clothing measurements. Most states supplied their own soldiers with uniforms made in area factories. The data collected during the years of the war set the standards for future sizing in the menswear industry.

Men purchase suits jackets and sport coats based on their chest measurement and trousers or slacks based on their waist measurements. Suit jacket sizes generally range from 36 to 48 inches, in one- or two-inch increments. Many retailers offer **fringe sizes** on either end of the predominant size range to accommodate a broader market segment. Only small groups of customers desire these sizes, but the sizes often attract an underserved niche market. Men also choose among **shorts**, **regulars**, and **longs**, referring to the overall length of the torso. A short jacket is usually one inch shorter than a regular jacket length, and a long jacket is usually one inch longer than a regular jacket length. In most cases, the jacket should cover the curvature of a man's buttocks, and he should be able to cup his hands on either side of the lower edge of the suit (see Figure 5.1). Retailers measure and hem the trousers to the appropriate length free of charge. Tailors hem trousers with a slight downward angle from center front to center back. Properly-tailored slacks result in a slight fabric bend or horizontal crease, called a **break**, which occurs when the pants rest lightly on the top of the shoe (see Figure 5.2). The waist measurement may require alterations to achieve a comfortable fit, but the center back seam of the trousers facilitates this type of alteration with limited effort. The **drop** is the difference between the suit coat measurement and the trousers waist measurement. For example, a manufacturer might pair a 40-inch regular suit coat with a 33- or 34-inch trouser waist. The normal drop is six or seven inches. Some retailers offer a selection of unhemmed tailored slacks separates intended to be worn with sport coats. Retailers offer free hemming for these slacks. When consumers purchase casual pants as separates, they purchase prehemmed pants based on their waist measurement and the inseam measurement (see Figure 5.3).

Figure 5.1　The best fit is when a man can cup his hands on either side of the lower edge of the suit.

Figure 5.2
A break occurs when the pants rest lightly on the top of the shoe.

Figure 5.3
The inseam designates the length of the pants.

Recognizing Menswear Designers

The menswear fashion industry makes up a small fraction of the total global fashion industry, but fashion centers capitalize on the talents of menswear designers. In the United States, the Council of Fashion Designers of America honors the most talented domestic menswear designer each year. The *Gentleman's Quarterly* (*GQ*) publication also features an annual recognition of America's most influential menswear designers. *Daily News Record* (*DNR*), a trade publication for menswear, offers its own version of the top 100 list of the most powerful people in men's fashion and retail.

Annual fashion weeks also promote menswear designers. The New York Fashion Week designers feature both menswear and women's wear. The London Fashion Week features MAN day on the last day of the fashion week. MAN is an initiative of the British Fashion Council to promote emerging talented menswear designers. Milan, Italy, also has a menswear fashion show during the Milan Fashion Week for well-known Italian menswear designers such as Giorgio Armani and Donatella Versace.

Woven shirts, both dress and sports, have evolved into a status symbol opportunity for the industry and consumers. National brand manufacturers place the small logos prominently on the shirt front. When employers do not require jackets or ties in the workplace, the shirt becomes the prime focal point.

Manufacturers size dress shirts according to the neck circumference and the sleeve length, measured from the nape of the neck to the wrist. Table 5.1 shows common neck sizing conversions. Common sleeve lengths range from 32 inches to 36 inches, in one-inch increments. Table 5.2 shows sleeve lengths for men's dress shirts. As an example, if a man purchases a medium dress shirt, the shirt package might read "15 ½ - 34," meaning the shirt is made for a 15 1/2-inch neck circumference and a 34-inch sleeve length. Customers select from variable neck-sleeve sizing combinations for the best fit.

Table 5.1 Men's Neck Sizes for Woven Shirts

Small	S	14"–14 1/2"
Medium	M	15"–15 1/2"
Large	L	16"–16 1/2"
Extra Large	XL	17"–17 1/2"

Table 5.2 Men's Shirtsleeve Lengths for Sized Woven Shirts

Small	S	33"
Medium	M	34"
Large	L	34"–35"
Extra Large	XL	35"–36"

Children's Wear

The major categories of children's apparel and accessories are preemies, newborns, infants, toddlers, children (boys and girls), and preteens. Boys and girls apparel includes outerwear, dresswear, sleepwear, sportswear, and swimwear.

The children's wear industry is almost as large as the menswear industry and about one-fourth the size of the women's wear industry. Although it may be smaller than the other two categories, children's wear sales rose 7 percent in 2007, compared to the 2.6 percent increase for menswear and 1.9 percent increase for women's wear (Tran, K., 2008, Jan. 18). The steady growth of the children's wear industry during a recession may be attributed to the parents' willingness to shop for their children during difficult economic times. Even if the parents are cutting back on spending in their own fashion wardrobes, they still want to shop for their children. According to Marshal Cohen, apparel analyst for the NPD Group, "Kids' apparel is the last area to get hit when there's a recession and consumers are cutting back" (Ramey, 2008, Feb. 12).

The luxury fashion company Burberry of London has appreciated growth even during difficult economic times. In 2008, the company opened Burberry children's stores in Hong Kong, New York, and California. The loyal Burberry shoppers wanted similar styles created in children's sizes, so the company now offers freestanding stores that feature the company's signature trench coat and baby and children's sportswear and gifts. The company also has children's apparel in a few high-end department stores (Kaplan, 2008, Sept. 29).

Trends

The children's wear industry continues to exert a demand for licensed children's wear. **Licensed apparel** bears the name of a well-known character, person, place, team, event, or other popular icon. Manufacturers or retailers of licensed apparel pay royalties to the company that owns the licensed character or icon. The marketing departments in companies with the popular icons are in charge of launching sought-after products. For example, Mattel licenses Barbie for MP3 player necklaces, screened T-shirts, and many other fashion and nonfashion products. Kohl's department store formed a licensing agreement with Nickelodeon to carry Cover Girl cosmetics and accessories for tweens.

> Manufacturers and retailers have learned that one of the best ways to tap into the tween market is to offer celebrity-licensed brands.

Each June, the Licensing International Expo features more than 6,000 brands, including Barbie, My Little Pony, Pepsi, and Hot Wheels. The Las Vegas, Nevada, show attracts an estimated 25,000 visitors from 82 countries (Kaplan, 2008, June 16). The proliferation of licensed apparel and accessories continues to be a driving force in retail sales.

Marketers understand that children and teens influence the purchase decisions made by their parents. Children's access to more types of mass media has created a marketing opportunity in the fashion industry. The children may not control the family purse strings, but they exert great influence on how the money is spent. Children decide which licensed characters or fashion brands they wear and their favorite stores for spending their parent's money. In addition, when purchasing their own adult clothing, the parents often defer to their teens' sense of fashion and style advice.

Marketers use children and teens as the conduit to in-home marketing of the company's products. The relatively new term **tweens** refers to a consumer group from a marketing standpoint, rather than an actual fashion merchandise classification or a size category. Tweens are adolescents, roughly between the ages of eight and twelve. Some resources cite the age range as eight to ten, whereas others cite eight to thirteen. One of the earliest uses of the term **tweenager** dates back to 1992 in a book entitled *The Seasons of Business: The Marketers Guide to Consumer Behavior* (Waldrop & Mogelonsky, 1992). Tweens or tweenagers represent a formerly underserved market with sizeable spending power. Tween girls, aged eight to twelve, represent about ten million Americans. Add to that the number of tween boys, and the U.S. market serves almost twenty million tweens.

Manufacturers and retailers have learned that one of the best ways to tap into the tween market is to offer celebrity-licensed brands. "When teens and tweens can emotionally connect to a brand they love, they will spend their hard-earned dollars to buy just about anything it offers" (Kaplan, 2008, July 25). The fashion success of Hillary Duff, Hannah Montana, and the Olsen twins provide evidence of this method. As another example, Disney Consumer Products teamed up with the Jonas Brothers franchise to offer a line of tween apparel called Jonas for girls at Wal-Mart, K-Mart, Sears, JCPenney, and other mass retailers in fall 2009 (Kaplan, 2009, Mar 12).

Sizing

Children's wear sizing varies somewhat according to the manufacturer. Weight is the best determinant for babies and toddlers, whereas height is the starting place for determining sizes for children. Table 5.3 shows a general breakdown of the size categories for a typical retail store.

Table 5.3 Children's Wear Sizing

Preemies	• Micro preemie, under four pounds • Regular preemie, under eight pounds
Newborn	Zero to three months Three months Six months Nine months
Infants	12 months 18 months 24 months
Toddler	2T 3T 4T 5T
Boys	3–7 • 3 regular • 4 regular • 5 regular • 6 regular • 7 regular 8–20 (even numbers) • 8–20 regular • 8–20 slim • 8–20 husky
Girls	2–7 • 2 • 3 • 4 • 5 • 6X • 4–6X plus • 7 8–16* (even numbers) • 8–16 regular • 8–16 slim • 8–16 plus *Size 16 is preteen

Basic Terminology

Authors use the terms *fashion, apparel, garments, dress, clothing, style, decoration, adornment,* and *costume* to denote the objects and methods that modify or enhance the human form. In most cases, humans cover or decorate the body as a social communication tool. The following section introduces a common language of fashion communication. Some of these terms reflect the **zeitgeist** or social and political influences of our contemporary culture, whereas others are merely long-standing and widely accepted terms to describe a particular concept. Appendix A includes a pictorial glossary of common styles. Future professionals should learn to fluently speak the language of fashion and recognize basic styles and design details of fashion apparel.

Contemporary Fashion Terminology

Bohemian trend or boho chic. A peasant/gypsy look. Also described as hippie-inspired, folkloric, ethnic, and free-flowing. Includes long, slight ruffled or tiered skirts, flat shoes, and embellished tops.

Bryant Park. The location in Manhattan of the major fashion show held in giant tents where designers show their upcoming lines to fashion buyers, celebrities, and the press.

Catwalk. Refers to a fashion show runway; also refers to the characteristic gait of models on the runway that involves walking an invisible narrow line by putting one foot directly in front of the other foot (like a cat walking along a fence top).

Cross-dressing/Drag. Dressing as the opposite sex; drag refers to men dressing to resemble women.

Disposable fashion. Inexpensive apparel intended to be worn only a few times or for a short duration (such as the summer season) and then discarded.

Emo. Shortened term for emotional. An alternative, counterculture lifestyle expressed through a particular style of appearance and behavior. It is a genderless look, including longish hair worn hanging down over the eyes, black eyeliner, skinny-legged and effeminate jeans for males or females. The emo attitude is a discontented view of life.

Fashion victim. One who adopts a fashion without consideration for its comfort, beauty, price, or value. This may refer to people who religiously follow a particular designer because of his or her famous name rather than the appropriateness, fit, or quality of the goods.

Fashionista. One who is an expert on fashion; a fashion enthusiast; or a dedicated follower of fashion (see also **stylista**).

Fast fashion. Fashion knockoffs of higher-priced items or pervasive trends that are quickly copied, produced, delivered, and sold at low prices (such as merchandise in H&M or Zara).

Global brands. Brands with worldwide appeal, such as Nike and Levi Strauss.

Glocal marketing. To think globally and act locally. Companies sell globally but modify the products to meet the needs of a particular global region.

Goth/Gothic. A unisex, subculture/counterculture style of dressing that includes liberal use of black clothing, chains, and studs. Goths also prefer black-dyed hair and pale makeup, giving them a ghoulish appearance.

Luxe. An adjective meaning luxurious or elegant.

Mass customization. It involves mass-producing basic styles or components from which customers can select or modify to create a customized product that best fits their needs. For example, a men's dress shirt manufacturer might allow customers to custom order the color, fabric, pocket, collar, and cuff styles for a standard-sized shirt.

Metrosexual. A style of dressing (usually menswear) that is fashionable, urban, and unconcerned with gender boundaries; often the style is somewhat effeminate.

Millenial Generation. A group of consumers born after 1982 with significant purchasing power. This group has always been exposed to computers and is sometimes referred to as digital natives.

Power dressing. A method of dressing to enhance one's clout in politics, career, and society. The wearer dresses for success under a more rigid set of rules. Related terms include power suits, power ties, and power colors.

Retro fashion. A current fashion that is reminiscent of an earlier era, such as retro 1970s. For example, hip-hugger, bell-bottom jeans are a retrospective fashion.

Shopaholic. A compulsive shopper with an addictive buying behavior. More often, it refers to any fashion lover who enjoys "shopping 'til she drops."

Street style. A fashion that originates "on the street" following the trickle-up theory of fashion adoption.

Stylista. One who is an expert in style; one who has a great sense of style.

Supermodel. A world famous and highly paid couture model.

Vintage clothing. Any previously used and worn clothing that is at least fifteen years old. Newer clothing should be called contemporary clothing. In high fashion, vintage clothing is widely accepted in the fashion world as appropriate to wear to social functions. Often, an actress is quoted as saying she's "wearing vintage" from a famous designer, such as Armani, although the clothing may not be very many seasons past.

Zeitgeist. A German term, referring to the "spirit of the time." It encompasses the intellectual and moral influences that are reflected in everyday living, including the fashions that are worn.

General Fashion Terminology

Aetelier. This is the French term for the workroom where designers, patternmakers, and sewers create *haute couture* clothing.

Bridge fashions. These are less expensive fashions than designer fashions, but they are more expensive than mass fashions. Bridge fashions "bridge" the price point gap between designer prices and moderate prices.

Chic. (pronounced shēēk) *Chic* is a French term used to describe something very fashionable and stylish.

Classic. This is a fashion with a relatively long life cycle, remaining popular for seasons or even years. Examples of classics are button-down oxford cloth shirts, crewneck sweaters, khaki pants, flip-flops, and the little black dress.

Counterfeit fashion. This is an illegal line-for-line copy that appears to be the authentic item. Counterfeiters copy many luxury items, especially handbags (such as Louis Vuitton or Coach brands).

Couture. This is the French term for sewing. It is also used in reference to high-end apparel made by designers.

Couturier. This is the French term for dressmaker or designer (male).

Couturière. This is the French term for dressmaker or designer (female).

FASHION FACTS: Fashion Defined

Several well-respected authors have published their perspectives of fashion in the past 100+ years in an expansive collection of literature. Each perspective has merit. By studying the collection of writings, students can begin to understand and develop their own meaning of fashion.

George Simmel (1904). "Fashion is a form of imitation and so of social equalization." "Fashion is concerned only with change."

Ferdinand Tönnies (1909). "Fashion is the barrier, continually rebuilt because always repeatedly torn down, through which the prominent circle tries to separate itself from the middle region of society."

Edward Fuchs (1912). "Fashion is a very simple form to distinguish oneself from above and below, and from left or right."

Paul Nystrom (1928). "A fashion is the prevailing style at a given time."

Edward Sapir (1931). "Fashion is a symbol of membership in a particular social class."

James Laver (1945). "Fashion is never at rest; this is a distinction it shares with life itself, of which fashion seems to be some special and significant manifestation."

Dwight Robinson (1961). "Fashion is a mode of symbolic expression."

Mary Ellen Roach Higgins (1981). "A fashion is a form of dress that is . . . spread in use by a high percentage of the "eligible" and aware consumers in the group and is subsequently discarded, and replaced by another form."

Joanne Entwistle (2000). "Fashion is embedded within culture and cannot be isolated as an independent variable."

Progression of Fashion Definitions by Key Fashion Industry Authors

1904	1912	1931	1961	2000
Georg Simmel	Edward Fuchs	Edward Sapir	Dwight Robinson	Joanne Entwistle

1909	1928	1945	1981
Ferdinand Tönnies	Paul Nystrom	James Laver	Mary Ellen Roach Higgins

Design. These are individual interpretations of a style. For example, if two designers create an updated version of an all-weather trench coat, their illustrations might be similar, but each person's *design* would have a customized appearance.

Details. These are small-scale elements giving a distinctive appearance to a garment. For example, details might be the choice of patch or welt pockets, a gathered or flat sleeve cap, and decorative topstitching or no topstitching at all.

Discount fashions. These refer to fashions available at lower price points, such as those sold at off-price and discount stores.

Fad. A fad is a short-lived fashion, characterized by a quick rise to popularity and an even more rapid decline. Fads are usually more extreme than mainstream fashions and rarely last longer than a season. Fads have included neon colors, jelly shoes, and tie-dyed fabrics.

Fashion. A style that is being worn/accepted by a majority of a group.

Fashion fabric. This is the main material selected for an item of apparel that creates the desired aesthetics.

Ford. A ford is a best seller; a hot item that retailers reorder repeatedly.

Haute couture. This term is French for fine sewing. *Haute couture* is the ultimate in beautiful and expensive clothing created on a made-to-order basis for an exclusive group of clients. A single dress often costs thousands of dollars.

High fashion. These are styles or designs popular with a limited group of fashion leaders. High fashion is usually too extreme for the masses.

Knockoff. This is a modified copy of a higher fashion style, usually produced later in the selling season and at a lower price.

Line or collection. A line or collection is a group of related styles featured by a designer or manufacturer for a season. Usually the term collection refers to higher-priced merchandise. For example, one designer offered a cruise collection of sixty pieces in tropical themed prints and coordinating colors. The pieces included bikinis, casual tops and pants, skirts, evening dresses, printed canvas bags, sandals, and sneakers.

Line-for-line copy. This is an exact copy of a high fashion style, including fabric, style, and ornamentation. Line-for-line copies are legal in the United States unless registered trademarks are copied, such as an emblem or logo.

Market. This is a group of consumers who are willing and able to buy a company's product or service. For example, the market can be all the consumers living within a 75-mile radius of a regional shopping center.

Market center. A market center is a geographic area where many manufacturers locate their showrooms. Los Angeles, Chicago, Atlanta, and Dallas have market centers or sections of the city that house many fashion wholesale companies.

Market week or market. This is an organized event for retail store buyers and manufacturers' sales representatives to come together.

Marketing. This umbrella term includes all promotional activities that move a product from the manufacture of raw materials to the ultimate consumer. It is the process a company uses to identify, attract, and maintain customers through a mutually satisfying relationship.

Mart. This is a single building or complex that houses manufacturers' showrooms.

Mass or volume fashions. These are fashions with wide acceptance. Companies produce and sell them in large quantities. Moderate department stores and mass merchandisers or discount stores usually carry mass fashions.

Merchandising. This is a subsegment of marketing that describes the activities of a retail store, from procuring the merchandise to promoting its sale to the ultimate consumers.

Prêt à porter. This is a French term meaning ready to carry. *Prêt à porter* refers to French fashions that are less expensive than haute couture. *Prêt à porter* is a French designer's bridge line.

Ready-to-wear (RTW). This is clothing that is manufactured in standardized sizes and is available through various retail channels, such as stores, catalogs, and the Internet.

Silhouette. This is the overall outline or shape of a garment. In women's dresses, the three main silhouettes are tubular, bell or bouffant, and back fullness.

Style. A specific look, characteristic, or distinctive appearance of a garment. It is a constant design that transcends fashion. A style is always a style, whether or not it is in fashion. Examples of styles include bell-bottom pants, double-breasted blazer, and leg-o'-mutton sleeves.

Style piracy. This refers to copying another manufacturer's design without permission.

Texture. This is the look and feel of the fabric; it is also called the "hand." Texture can be shiny, smooth, dull, matte, nubby, or rough.

To market. This is the process used to satisfactorily move a product or service through the supply chain or channel of distribution until it reaches the ultimate consumer (see also **marketing**).

Trend. This is the direction in which fashion is moving. It is a broad term that usually encompasses several fashions. Past fashion trends included animal prints, bright colors, glam, retro, or bohemian.

Basic Apparel Styles

A complete list of basic apparel styles is exhaustive. Appendix A lists many styles of collars, necklines, sleeves, jackets, tops, coats, dresses, skirts, pants, and details that students will probably see over the course of their fashion careers. Not all of these styles are in fashion at a particular time, but it is likely that eventually a variation of most of these styles will become fashionable. (See Appendix A: Basic Apparel Styles.)

summary

- Employers expect fashion marketing students to know and understand the fundamentals of the industries and basic fashion terminology.

- The women's apparel and accessory retail industry is approximately four times larger than the men's and children's apparel and accessories industries.

- The women's, children's, and accessories wholesale industries are larger than the men's and boy's clothing and accessories industries.

- The wholesale categories in the women's wear industry include outerwear, dresses, suits, sportswear, sweaters/knitwear, denim/jeans, activewear, swimwear, intimates/sleepwear, holiday, maternity, petite, plus size, prom/pageant, special occasion, and accessories.

- The wholesale categories in the menswear industry include tailored clothing, outerwear, casual sportswear, and accessories.

- The wholesale price zones for both women's and menswear include mass or budget, moderate, upper moderate, lower better, better, better to bridge, bridge, upper bridge, diffusion, gold range, and designer/signature/couture.

- The major categories of children's apparel and accessories are preemies, newborns, infants, toddlers, children (boys and girls), and preteens.

- Boys and girls apparel includes outerwear, dresswear, sleepwear, sportswear, and swimwear.

- The children's wear industry has shown steady growth during recent recessionary seasons.

- Trends in the children's wear industry include a proliferation of licensing agreements, an increase in the number of children in the home that influence the family's purchase decisions, and marketing to tweens.

- Fashion marketers seek the business of the tween market, a group of preteens aged eight to twelve. Proportionately, this age group has substantial discretionary income.

terminology for review

young junior 88
junior 88
junior petite 88
missy 88
missy petite 88
women 88
women's half 88
plus 88
tall 88
vanity sizing 89

vertical integration 91
tailored clothing 91
bespoke tailoring 91
suit 91
blazer 91
sport coat 91
outerwear 92
casual sportswear 92
accessories 92
furnishings 92

fringe sizes 92
shorts 92
regulars 92
longs 92
break 92
drop 92
licensed apparel 94
tweens 94
tweenager 94
zeitgeist 95

questions for discussion

1. Why is it important to know fashion terminology?
2. In what ways are the women's, men's, and children's apparel industries different?
3. In what ways are these three industries similar?
4. Why has the fashion industry developed wholesale categories, and how are these useful to industry professionals?
5. What are some problematic sizing issues in the women's wear industry, and what is being done to resolve the problems?
6. What are some trends in the children's wear industry?
7. Why do companies market to children and tweens?
8. What is licensing?
9. Why is it important for students to develop their own perspective of fashion?
10. How can zeitgeist be seen in fashion?

related activities

1. Study the experts' definitions for fashion in this chapter. Visit the college library and peruse published books that cite definitions of fashion (see call numbers TT490–TT 695; HD 9939–9949; and HF 5439.C6). Record at least three different published definitions for the term *fashion* and cite the resources using the correct bibliographic format according to the American Psychological Association style. Compare your findings with the other students.

2. Using fashion magazines, locate pictures for 25 of the terms listed in Appendix A: Basic Apparel Styles. Create a collage to present to the class.

3. Choose one particular style category, such as sleeve treatments, pant styles, dress hem length, or other relatively narrow category (refer to Appendix A). Using mail-order catalogs or fashion magazines, conduct a style analysis of the chosen feature. Locate ten examples of the category and evaluate the findings. Compare and contrast the pictures, and draw conclusions based on the similarities and differences. Write a paragraph explaining the conclusion and present to the class.

4. Create a zeitgeist collage on an 8 1/2 × 11 inch paper. Select fashion and nonfashion pictures that represent the spirit of the times. Incorporate a theme and develop a headline for the collage. Present to the class.

Your Fashion IQ: Case Study
Halston: Faster Than Fast Fashion

American milliner and fashion designer Roy Frowick Halston launched an empire that included designing for First Lady Jacqueline Kennedy. When the famous designer passed away in 1990, his business went into a period of dormancy that lasted for eighteen years. In 2008, the iconic Halston brand was revived by the Weinstein Co. and Hilco Consumer Capital LLC.

The brand owners signed an exclusive deal with the e-tailer Net-a-porter.com to have two of the key runway pieces produced, wrapped, packed, and ready to deliver from New York and London the day after the runway show. The Halston collection was viewed by the media and buyers on February 4, 2008, and the Net-a-porter customers had the opportunity to wear the ready-to-wear dress the very next day.

Natalie Massenet, chairman and founder of Net-a-porter.com, said, "This is offering a luxury brand a lifeline in an age when the high street chain will deliver their product to customers faster" (Karimzadeh, M., 2008, Jan. 29). High-fashion designers are plagued with the fast fashion retailers that can knock off and mass produce the original design more rapidly than the designer can get the style in the store. By designating pieces from the Halston relaunch to Net-a-porter, the Halston company officials see this as an opportunity to combat fast-fashion knockoffs that offer no financial gain for the original designer. According to Massenet, "We are allowing a luxury brand to reclaim the right to sell to the customer first" (Karimzadeh, M., 2008, Jan. 29).

QUESTIONS:

1. How will this initiative and others like it impact copycat manufacturers and fast fashion retailers?

2. Are there disadvantages to offering pieces of a collection the day after the runway show? Explain.

3. What are some risks associated with this type of merchandising?

SOURCE: Edelson, S. & Karimzadeh, M. (2008, Jan. 30). Industry upbeat on Halston plan. *Women's Wear Daily Online*. Retrieved Nov. 23, 2008, from www.wwd.com

Karimzadeh, M. (2008, Jan. 29). Fashion getting faster: Net-A-Porter to deliver Halston day after show. *Women's Wear Daily Online*. Retrieved Nov. 23, 2008, from www.wwd.com

Karimzadeh, M. (2008, July 24). Halston stages global offensive. *Women's Wear Daily Online*. Retrieved Nov. 23, 2008, from www.wwd.com

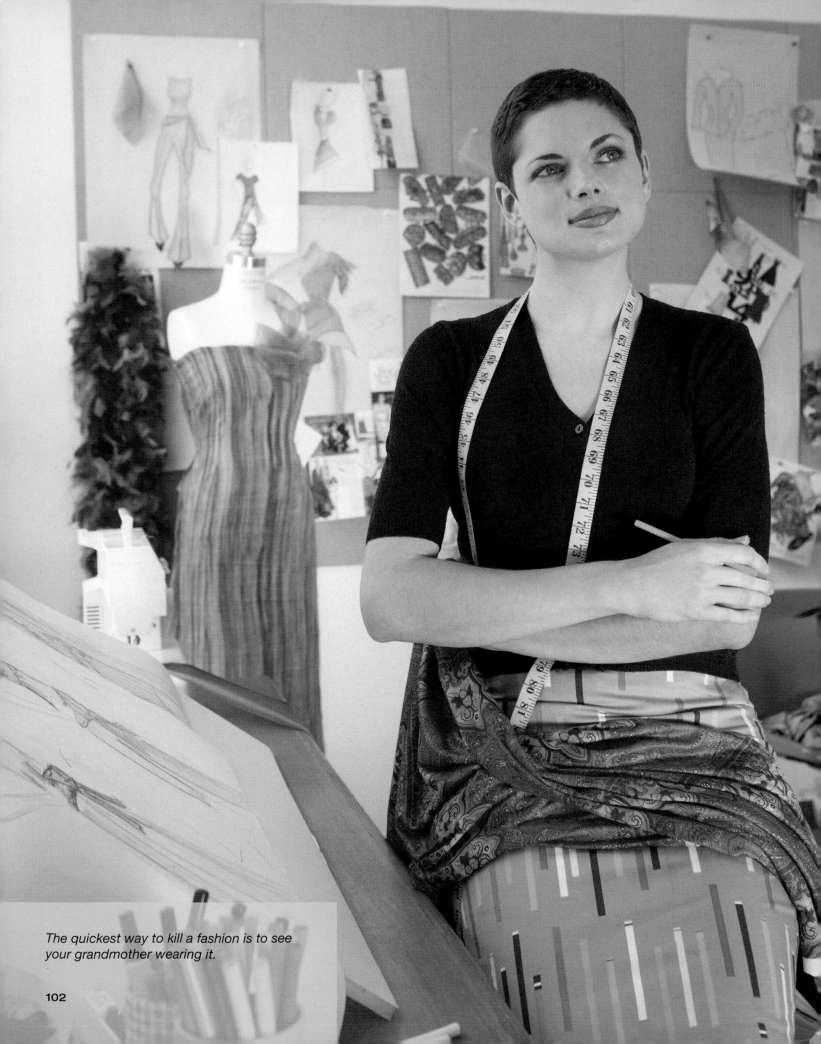

The quickest way to kill a fashion is to see your grandmother wearing it.

FASHION
PRINCIPLES, PERSPECTIVES, and THEORIES

LEARNING OBJECTIVES

At the end of the chapter, students will be able to:

- State and explain the eight principles of fashion.
- Describe at least two examples of historical continuity as it relates to fashion.
- Distinguish among the different theories of fashion innovation and diffusion and state the major premise for each theory.
- Compare characteristics of fashion innovators and fashion followers.
- Explain a style tribe as it relates to fashion adoption.
- Apply Laver's theory on the timeline of acceptability to a variety of past and present fashions.
- Argue the likelihood that James Laver's theory on the shifting erogenous zone is still a part of contemporary fashion.
- Identify the various purposes of fashion in modern Western civilization.

6

Principles of Fashion

Fashion marketers use fashion principles as guides on which to base business decisions. When marketers understand the important principles of fashion, they make educated and profitable decisions. Since crystal balls do not really exist and it is impossible to know what the future holds, fashion forecasters rely on guiding principles to identify the designs most likely to succeed among the targeted consumers. Students of fashion should commit these fashion principles to memory. They are unique to this industry, yet they have a broad application that reaches to just about any product that has an element of fashion. The following section presents a detailed discussion of each principle.

FASHION FACTS: Principles of Fashion

- Fashion is not related to price.
- The consumer is king or queen and decides what will or will not become a fashion.
- Sales promotion cannot reverse the decline in popularity of a fashion.

- All fashions end in excess.
- Fashion requires imitation of style or look.
- Fashion change moves in a cyclical pattern.

- Fashion change is usually evolutionary; it is rarely revolutionary.
- Fashion is a reflection of the way of life at a given time.

Fashion Is Not a Price

Consumers can purchase a similar fashion look at any price point, regardless of their budgets. True fashion is available to persons from most income levels. Being fashionable does not require consumers to spend a great deal of money on clothing. Because of mass media and mass production, consumers can view and purchase similar styles of clothing manufactured at prices to fit their budgets. For example, if a nautical trend is quite fashionable one season, then a navy-and-white color combination will be a featured color combination in most stores that sell fashion apparel, from mass merchandise stores to high-end specialty stores. The same might be true if embossing is the fashionable look for leather goods. Whether a customer purchases PVC shoes at Payless Shoe Source or top grain leather at Steve Madden, the embossed look will likely be available. The instant accessibility of fashion images on the Internet and television creates a large-scale fashion demand for similar looks.

Fashions at all price points can coexist and may appeal to the same consumer. As an example, *Gossip Girl* stylist Eric Daman believes in mixing price zones together for particular fashion looks on the show. When asked whether he tries to make the looks approachable or aspirational, he explained, "I always make sure I mix some of the higher-end looks with something from a less expensive brand. I use stuff from Forever 21 and H&M all the time" (Kaplan, J., 2008, Aug. 22). Daman further explained that it is not uncommon to spot "someone wearing a $5,000 dress with a pair of Nine West shoes. That is how people dress today anyway—they are always mixing high and low" (Kaplan, J., 2008, Aug. 22). This **high-low dressing** trend means that shoppers are looking for trend-right items at fast-fashion or value retailers to complement a more expensive branded piece (Poggi, J., 2007, Jan. 8). First Lady Michelle Obama has often been described by fashion media as looking chic in high-low fashions.

The Consumer Is King or Queen

The runways of Paris, Milan, and New York are often the birth and death of some styles, never to be mass-produced. A runway designer introduces a unique style in the hope that it might become the starting point of a new fashion. But fashion is not a synthetic creation of powerful designers, famous celebrities, or large retailers. They can only introduce it as a worthwhile style, but its ultimate popularity depends on the public's discretion. Unless a majority of a given group wears a style, the style never becomes a fashion; it simply remains a style. Consumers and their pocketbooks have the final say-so in the success or failure of a fashion.

Sales Promotion Cannot Reverse a Fashion's Decline

Once a fashion begins the downward slope of its life cycle, it is soon on its way to obsolescence. Marketers cannot change this direction, no matter how much they advertise, display, mark down, or otherwise promote the fashion. They might be able to extend the life cycle if they add new colors, fabrics, or prints to the line before sales begin to decline. However, the downturn in sales generally signals the ultimate demise of the fashion, and marketers should focus the limited resources of the promotional budget on advertising and promoting newer fashions.

All Fashions End in Excess

This statement made by the famous 1920s Paris couturier Paul Poiret refers to the reason why a fashion declines in popularity and is ultimately discarded by consumers. The term *excess* means overdone, too much or too many, or social saturation. For example, when marketers first introduce skirts above the knee, they are short, but not excessively short. As time progresses, they gradually get shorter. As the fashion gains popularity, the style becomes more extreme—in this case, shorter and shorter, until it is excessively short and the fashion ends due to indecent exposure. Marketers introduce the slightly lower hemlines near the end of the miniskirt life cycle. These skirts gain in popularity as the micromini wanes in popularity.

A second example of eventual excess or overdone fashion is the introduction of embroidery or ornamentation on clothing. The fashion begins with just a little embroidery or ornamentation on an item. As time passes, the designs become increasingly decorated, and the excessive embroidery or ornamentation becomes the focal point of the garment. The excessive applied design gets tiresome, so consumers discard the fashion in favor of a new look—no embroidery and a cleaner, less ornamented look.

A third interpretation of this principle is the notion that when everyone that wants a particular fashion has it, then the market is saturated—that is, an excessive number of people are wearing the fashion. Sproles (1981a, p. 122) refers to this as social saturation. Therefore, the fashion leaders discard the fashion in favor of a newer and more exclusive fashion. All three examples, although slightly different, exemplify the notion of excess. Fashions die when they become excessively short, long, wide, narrow, embellished, plain, and excessively adopted.

Fashion Is a Form of Social Imitation

A style requires group acceptance to become a fashion. According to fashion essayist Georg Simmel (1904), fashion succeeds when followers adopt a style that they have seen others

Figure 6.1 **Retailers clearance merchandise in the decline stage of the product life.**
(Pearson Education/PH College)

> Sales promotion cannot change the decline in popularity of a fashion.

Figure 6.2 **The micro miniskirt represents a hemline at the highest possible point.**
(John Davis © Dorling Kindersley)

Figure 6.3 Advertisements appeal to a person's sense of style.
(PhotoEdit Inc.)

adopt. If one person wears a particular style, such as palazzo (very wide-legged pants), it is still only a style until others in that group adopt that same style. A fashion begins when the fashion leader's style is copied. If imitation does not occur, the style remains a personal style but is not called a fashion. A person with his or her own sense of style may or may not be in fashion (although this is usually meant as a compliment). Astute marketers often feature advertising headlines promoting the store's fashion merchandise and its ability to fulfill the target customer's own personal sense of style. Marketers choose this emotional appeal because it seems more individualistic and is less blatantly a social imitation.

Fashion Is Cyclical

Fashions tend to run in cycles. Consumers gradually popularize a style and continue to wear the fashion for a time, ranging from months to years. As a fashion declines in popularity and slips into obsolescence, it remains in hibernation, until a new generation of consumers or some other renewed interest brings it back into focus. Marketers may not be able to predict the exact date a style or trend will become popular, but a close analysis of previous fashions will give some indication of the likelihood of popularity. Marketers interpret sales data to analyze and predict fashion life cycles. (A significant discussion of the fashion life cycle is presented in Chapter 8.)

The life cycle includes the length of time the style lies dormant before becoming fashionable again. This period of dormancy may last for only a few years, or it may last for decades. For example, tie-dyed T-shirts become fashionable every few years, and retailers regularly offer tie-dye looks in the stores. The target market of elementary school-aged children explains the regular recurrences of tie-dyed fashions. By introducing the fashion every four to six years, marketers can reach a new school-aged consumer that appreciates the bright colors and novelty of tie-dyed T-shirts.

Figure 6.4 Tie-dyed T-shirts recur in popularity every few years.
(Steve Shott © Dorling Kindersley)

Fashion Change Is Evolutionary; It Is Rarely Revolutionary

Economically speaking, consumers simply cannot afford to completely change their wardrobes each season. From a psychological standpoint, although consumers like change each season, they do not like too much change. They prefer something new and slightly different from last seasons' fashions, but not radically different. The gradual change is likened to a slow pendulum swinging. The pendulum represents the changing fashion as it moves toward one direction. When it moves as far as it can to one side, it represents the fashion as an extreme. When this happens, the fashion changes move back toward the middle or a more moderate appearance. As the pendulum swings toward the opposite side, it represents a movement toward a different extreme. Each point on the pendulum swing continuum represents a fashion that is similar to the fashion at the points on either side.

Hemline lengths or waistband locations exemplify how fashions evolve over time. For example, skirt hemlines gradually shorten, and pant waistbands gradually become lower each season. Once the fashion reaches the maximum skimpiness, it begins to reverse directions, just like the pendulum analogy. Waistbands rise a little higher the next season and even higher the second year, continuing to rise until they rise above the waist, like a Hollywood or high-waist style. Designers may attempt to introduce a high-waist pant immediately following the fashion of a hipster pant, but consumers may consider this to be too radical of a change—too revolutionary—to select for their wardrobe. Often only a limited group of fashion innovators will be interested in such a radical style difference; fashion followers need time to make the adjustment.

Even popular colors in fashion tend to evolve from season to season. The Pantone Color System showed spring 2009 colors that were similar variations of the popular colors for the fall 2008 season. According to a *Women's Wear Daily* report, the designers' top choices of palace blue and lavender colors for 2009 were continuations of blue iris and royal lilac colors from the preceding season (Hall, C., 2008, Sept. 4). Although the popular color names changed from season to season, the actual colors exhibit only slight modifications from season to season. After a few seasons of popular purple-blue colors, the fashion will begin to move toward the green-blue colors of the spectrum.

Figure 6.5 Hip-hugger style jeans represent a waistline at the lowest possible point.
(AP Wide World Photos)

The First Lady

Michelle Obama's pragmatic fashion image seems perfectly suited to the tough economic times. She is well-known for her aisle-crossing or high-low dressing, including mixing pieces from J. Crew or White House/Black Market with her favorite American designers, such as Narcisco Rodriguez and Jason Wu.

First ladies of the United States have always been encouraged—although some say expected—to wear all American labels. Both the president and first lady act as ambassadors of the United States in every way, including supporting the domestic fashion industry. American designers appreciate the first lady's support, especially in difficult economic times.

This concept dates back to the very first First Lady of the United States. Martha Washington chose to wear domestic homespun fashions rather than British fashions in the Post-Revolutionary times. Mrs. Washington understood the importance of conveying a message through clothing. She projected an image of an elegant public figure who was decidedly republican. In the early 1930s, First Lady Lou Hoover bolstered the U.S. cotton industry by posing for photographs in cotton apparel. First Lady Jacqueline Kennedy was reported to be an ardent supporter of the domestic fashion industry in the early 1960s. However, one source noted that Mrs. Kennedy was known to circumvent this expectation and occasionally purchase foreign labels. On October 24, 1988, an article in *Time Magazine* criticized First Lady Nancy Reagan for borrowing elegant clothing from U.S. designers. In response, the board of directors of the Council of Fashion Designers of America (CFDA) published a one-page advertisement in *Women's Wear Daily* showing their support for this practice. The notice stated that borrowing fashions was not a new practice and was actually quite beneficial to the fashion industry (CFDA advertisement, 1988, Oct. 20).

SOURCES: Bryan, H. (2002). *Martha Washington: First Lady of Liberty*. NY: Wiley.

Council of Fashion Designers of America. (1988, Oct. 20). Advertisement in *Women's Wear Daily,156* (76), *3*.

Feinberg, B.S. (1998). *America's First Ladies: Changing Expectations*. NY: Franklin Watts.

Magnuson, E. (1988, Oct. 24). Why Mrs. Reagan still looks like a million. *Time, 132*(17), 29–30.

Michelle Obama: A woman of substance. (2009, Jan. 19). *Women's Wear Daily Online*. Retrieved March 6, 2009, from www.wwd.com

Moore, Booth. (2009, Jan 18). Dressing Up D.C.; A National Pasttime. *Los Angeles Times*, Part P, p. 4.

In 1931, essayist Edward Sapir used the term *historical continuity* to explain this evolutionary principle of fashion. In 1969 Herbert Blumer elaborated on the term. **Historical continuity** refers to the notion that new fashions evolve from the most recent fashions. They are most valued if the fashions only slightly vary from the previous mode. Sapir explained that current fashions should fit into a sequential pattern that includes both the recent past fashions and the fashions yet to come. This means that the most current fashion is really just a derivative of the past fashion. Sapir explained the evolution of fashion, "Fashion is emphatically a historical concept. A specific fashion is utterly unintelligible if lifted out of its place in a sequence of forms" (Sapir in Spro1es, 1981b, p. 24).

Fashion Is a Reflection of the Way of Life

Fashion recurs, but never in exactly the same way, because each era has its own unique characteristics. Retrospectively, a student can look at the clothing from a previous decade, and it seems perfectly appropriate for its time. If a designer attempted to exactly re-create the same clothing for contemporary times, the result would probably be unsuccessful because of the dif-

fering environmental conditions between the eras. Successful fashion designers, product developers, and marketers learn to interpret the cultural signals and create fashions that are exclusive to the current era and not a duplication of the bygone eras.

Fashion is an embodiment of the zeitgeist and reflects the environmental factors that shape a culture's current values and beliefs. Students of fashion can identify a fashion mix of colors, prints, fabrics, details, and styles as belonging to a specific era. Even if one or two of the fashion mix variables, such as style and print, are line-for-line copies of a style and print from a previous decade, the other variables in the mix will be more representative of contemporary life.

Figure 6.6 The trickle-down theory of fashion adoption.

Fashion Theories and Theorists

Who starts a fashion, and how does it gain widespread acceptance? Fashion innovators start fashions, and fashion followers soon adopt similar looks. Chapter 8 addresses the various adopter categories in detail, but for now, note that **fashion innovators** start fashions, and **fashion followers** pursue the fashion. The traditional fashion diffusion theories and newer theories on the movement of fashion explain the fashion innovation and adoption processes. These are the trickle-down theory, trickle-up theory, trickle across theory, geographic theory, fashion systems theory, zeitgeist theory, and populist model. Each addresses the origin of the fashion and the process of dissemination to the masses. Students can usually identify fashions that represent the various creation and diffusion theories.

Trickle-Down Theory

Prior to mass production, elite members of society introduced most fashions, and eventually the general population adopted the fashions. The upper class of society expended significant amounts of money on apparel and accessories to be fashionable. The **trickle-down theory** or the class differentiation theory (Blumer, H., 1969) explains that the wealthiest persons (leisure class) or the most public persons, such as political figures and celebrities, introduce the latest style as a means of class differentiation. Then, the consumers of more modest means imitate the style of the wealthy in an attempt to reduce the visible differentiation between the classes. This continual **chase and flight** notion was described by McCracken (1988) when he explained that the lower class chases or imitates the fashions of the upper class and the upper class differentiates or flies toward a newer fashion.

In 1904 in his *Fashion* essay, sociologist Georg Simmel explained that fashion originated with the upper class members and the lower classes copied their style. Thorstein Veblen also advocated this adoption process in his 1899 book, *Theory of the Leisure Class*. This book has been reprinted numerous times since it was originally written. Researchers consider both of these essays to be important historical contributions to the study of fashion movement.

Figure 6.7 Elegantly attired upper-class consumers.
(Slater King © Dorling Kindersley)

Figure 6.8 Teenagers value the importance of clothing as a communication tool and reference group membership.
(Merrill Education)

Georg Simmel In 1904, Georg Simmel wrote a philosophical essay entitled "Fashion." In his essay, he explained that a style requires group acceptance before it can become a fashion. A fashion leader may introduce the newest style, but unless the fashion followers also adopt the style, it cannot be called a fashion. This often-quoted definition of the term fashion appears in his essay: "Fashion is a form of imitation" (p. 130).

Simmel suggested that the success of fashion depends on social imitation or conformity to a particular style of dressing. He further explained that when people follow a fashion, they are not alone in their actions; they are only following what others have already adopted. Thus, fashion becomes a socially unifying force. Fashion allows people to "fit in" to whatever reference group they aspire, but by doing so, the fashion followers also lose some of their identity. The duality of fashion is that humans want to wear clothing that allows them to be a part of a group and fit in, yet they also desire self-expression or to stand out from the crowd.

The clothing behaviors of most junior high and high school students clearly illustrate this concept. Adolescents value the importance of dressing to the precise standards of their group of friends. Social conformity at this age can be so powerful that to dress outside the group norm results in ridicule. The desire to forgo personal individualism for group conformity is a sacrifice willingly made by many of the fashion followers.

The fashion leaders, desiring to look different from the followers, soon abandon the current fashion in favor of a newer look. The fashion followers, aspiring to look like the fashion leaders, soon discard the fashion, so they can imitate the more current looks of the leaders. Consequently, this newer look becomes popular, and the cycle repeats itself.

Thorstein Veblen Economist Thorstein Veblen first wrote *Theory of the Leisure Class* in 1899. Veblen was the premier authority when he included his lengthy and eloquent essay entitled "Dress as an expression of the pecuniary culture" (**pecuniary** meaning having to do with wealth). In many respects, it has some currency to modern fashion adoption, although at the time it was written, women had not even gained the right to vote. Veblen's important premises include:

1. Fashion is a constant social class struggle, wherein the wealthy attempt to set themselves apart from the middle class by adopting fashions not currently worn by those of lesser stations in life.
2. Fashion is an outward expression of a person's wealth (conspicuous consumption).
3. Fashion is a way to demonstrate that a person owns such great wealth that it is not necessary to engage in physical labor (conspicuous leisure).
4. The introduction of newer and more desirable fashions deliberately brings about the demise of the old fashion (artificial obsolescence).

A serious study of fashion brings understanding of the meaning of these challenging words and concepts. **Conspicuous consumption** is the desire to select fashion expenditures that look expensive. Veblen noted that the middle class is quick to adopt the look, so the upper-class consumers react to this problem by continuously changing their styles. Consumers of lesser means find it difficult and costly to follow suit. Fashion requires the expenditure of money to remain in fashion, so it becomes an economic issue. **Conspicuous leisure** is a social communication tool. The affluent person appears idle and without work, yet he or she can somehow afford to enjoy leisure time and seems to have the means to do so (think of heiress Paris Hilton).

Figure 6.9 Paris Hilton exemplifies conspicuous leisure.
(Getty Images, Inc.)

Figure 6.10 England's Princess Diana's wedding dress created a widespread fashion in bridal wear.
(Getty Images)

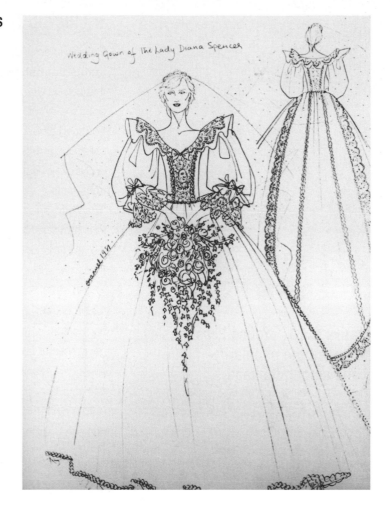

Wedding Gown of The Lady Diana Spencer

Artificial obsolescence refers to the demise of a perfectly service-able item in favor of a newer one that seems more attractive than its predecessor. The newer style might be a different color, style, and/or material. For example, if pointed toes on shoes have been popular for some time, consumers grow tired of the fashion, and so a designer introduces a shoe with rounded toes. The newer style is now desired, and to wear the older style is considered unfashionable. Some argue that artificial obsolescence encourages wastefulness, and this is true. Others could also argue that the introduction of newer fashions increases sales and improves business. Artificial obsolescence is important for the economy and difficult for the environment. The notion of sustainability, such as discussed in the book *Cradle to Cradle* (McDonough and Braungart, 2002), counters the wastefulness of artificial obsolescence and encourages sustainable design and production in all industries. Yet, the fashion industry has worked toward shortening the life cycle of fashions, especially in the fast-fashion industry. The successful fast-fashion retailer Zara, owned by Inditex Group in Spain, has approximately fourteen seasons per year, as opposed to the traditional four or five by more mainstream fashion retailers. This is evidence that fast trends and artificial obsolescence are important concepts in marketing fashions.

Fast-fashion retailers may exemplify the accelerated trickle-down adoption process. Line-for-line copying and infringing on intellectual property rights of high fashion designers are ways that fast-fashion retailers, such as Zara, H&M, Mango, and Sandwich, produce apparel and accessory fashions. These

} **Fashion allows for self-expression or individuality.**

duplicated looks emulate the expensive fashions afforded by the wealthier clients of designers.

Historic examples of the trickle-down fashion adoption process include England's royal wedding in 1981 and the velour track suit associated with Jennifer Lopez in 2002. When preparations were made for the wedding between England's Princess Diana and Prince Charles, the palace officials kept Lady Diana Spencer's wedding gown design a closely guarded secret until the day of the event. Within just a few hours after the televised wedding, dressmaker shops across the country were featuring knockoffs of the royal princess's wedding gown designed by Elizabeth Emanuel. This style continued to be a major fashion influence on popular bridal wear for the next season. Celebrity fashion innovators also exemplify the trickle-down theory. Singer/actress Jennifer Lopez was the leader of the widespread velour tracksuit trend that was going strong by 2003. Although the fashion apparel company Juicy Couture introduced the velour knit pants and zip-up hoodie jacket, Lopez was so enamored with it that she wore it in a video and created her own tracksuit for her J. Lo line in 2002.

Figure 6.11 Jennifer Lopez in a velour track suit she popularized in 2002.
(www.theage.com)

Figure 6.13 Young Elvis Presley hastened the popularity of blue jeans among teenagers.
(Archives du 7eme Art/© Photos 12/Alamy)

Figure 6.14 Retirees today continue to wear the blue jean fashions.
(Pearson Education/ PH College)

Trickle-Up Theory

Fashion experts describe the **trickle-up theory** or the **status float phenomenon** as a fashion life cycle that begins with a subculture, lower class, youth, or on the streets. A comparable theory was introduced by George B. Sproles (1981a). It is called the **subcultural leadership theory**, and it explains that a fashion may originate from various subcultures because of its "creativity, artistic excellence, or relevance to current lifestyles" (p. 120). One of these subcultures or innovator groups introduces the fashion, and then it is diffused upward through the social strata. As a fashion trickles up through the larger society, it evolves and becomes more reflective of popular culture.

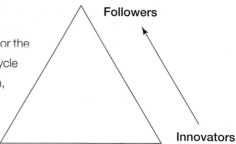

Figure 6.12 The trickle-up theory of fashion adoption.

In 1970, George A. Field wrote the essay, "The status float phenomenon—the upward diffusion of innovation." His argument focused on the notion that some fashions trickle or move up the status pyramid from subcultures to the older and more conventional generations. Field gave several fashion and nonfashion examples from a variety of cultures including African-American, Hispanic, youth, and blue-collar workers. He also included the notion of adopting fashions from the opposite sex as a type of upward diffusion. A later researcher, Polhemus (1994) coined the phrase **bubble-up process**, to describe the trickle-up influence of street style on fashion.

One of the most obvious examples of the trickle-up diffusion of fashion occurred when blue jeans burgeoned in popularity. Prior to World War II, denim pants symbolized the working class and Western wear. By the late 1940s, the youth began to take an interest in denims, especially when pop stars and actors such as Elvis Presley, Marlon Brando, and James Dean adopted the blue jean style (see Figure 6.13). The youth of the 1940s and 1950s continued to wear the denim fashion as they progressed into middle age and later into their retirement years (see Figure 6.14). Today, although all age groups wear jeans, the changes in denim looks still originate with the youth.

As a tribute to the longevity of this fashion trend, research on denim shows that consumers continue to spend an increasing proportion of their discretionary income on blue jeans. Cotton Incorporated's *Lifestyle Monitor* reported that denim represented 12.7 percent of all apparel sales (Jeans on the Rebound, 2006, Dec. 7) and that U.S. consumers own an average of 8.2 pairs of denim jeans (Generations Still Loving Jeans, 2008, Mar. 26). These figures have been increasing for several years.

Other examples of the trickle-up theory of fashion adoption have been demonstrated over the decades by the rise in popularity of beatnik, hippie, biker, punk, grunge, hip-hop, bling, gangsta, skater, and the next generations of antiestablishment and alternative looks. Each of these represents the apparel and accessories manifestations of some counterculture that generally begins with youth or on-the-street looks.

Trickle-Across Theory

The **trickle-across theory** of fashion diffusion implies that fashion innovators at all levels of the social strata introduce a fashion simultaneously.

Fashion information disseminated through the mass media impacts fashion innovators in all social classes. In turn, innovators introduce the fashion to the fashion followers in their particular level of society. The fashions trickle across a particular class from fashion leader to fashion follower, rather than up or down from one class to another.

Charles W. King proposed the trickle-across theory in 1963 in his essay entitled, "Fashion adoption: a rebuttal 'trickle-down' theory." King explained that in the 1960s, fashion democracy was a relatively new concept. He tested this democratic fashion concept with a mass-market theory. His research findings showed that in each socioeconomic strata, certain groups of people tend to be the most influential among their own reference group. These individuals disseminate the values placed on particular fashions. The fashion followers adopt fashions based on the behaviors and recommendations of their reference group leaders.

Democratization of fashion means that fashion has become affordable for most people. The fashion principle "fashion is not a price" exemplifies the democratic nature of fashion apparel. For example, although controversial to some, real fur may be viewed as a status symbol that once was affordable only to the wealthy members of society. The invention of synthetic fibers, such as modacrylic and acrylic, created faux furs manufactured to look like real fur and made the popular look of fur available to most consumers.

Prior to the 1960s, the availability of fashion was limited to the relatively affluent consumers who could afford such luxuries. Several factors have made apparel and accessory fashions relatively inexpensive purchases. These factors include the mass production of apparel in factories; the globalization of the fashion industry, including offshore sourcing; and the popularity of manmade fibers. Global transportation and trade allow apparel companies to hire overseas manufacturers paying low wages because of the availability of large labor pools in their developing countries. In addition, simultaneous exposure of all social classes to the same print and broadcast media and the Internet create a somewhat unified desire for particular fashion looks. Finally, the invention of manmade fibers, such as polyester and nylon, allow for the economical substitution of the more expensive natural fibers, especially silk. These circumstances have created a society in which a desired fashion look can be made available at any price point.

Upper-Class Innovators	⟶	Upper-Class Followers
Middle-Class Innovators	⟶	Middle-Class Followers
Lower-Class Innovators	⟶	Lower-Class Followers

Figure 6.15 The trickle-across theory of fashion adoption.

Figure 6.16 Faux fur is an inexpensive way to look glamorous. (Getty Images)

Geographic Theory

Fashion marketers evaluate the flow of fashion from innovators to followers using the **geographic theory** of fashion adoption. This theory details how fashions begin in heavily populated metropolitan areas where there is considerable emphasis on fashion. Although consumers in Los Angeles and New York are distinctly different in fashion preferences, these cities have long been considered the primary starting points for fashions in the United States. The geographic theory states that fashions begin on the West and East coasts and trickle to the center of the United States. Consumers in the middle portion of the United States prefer a more conservative style that is generally less fashion-forward.

Collective Selection Theory

Herbert Blumer (1969) proposed the **collective selection theory** that explains how fashion change and adoption are a type of social conformity. According to Blumer, Simmel's theory is a misconception of the fashion process. Rather than Simmel's suggestion that fashion is created

when the masses emulate the wealthy, Blumer proposed that a unified fashion arises out of the jumble of diverse tastes of consumers who are participating in modern life. In other words, fashion is created by the collective tastes of a majority. Fashion occupies the role of a socializing agent and is used as a social standard. Fashions change and consumers adopt the new look so that they can conform to the newly formed taste in the society. More recently, theorists proposed that Blumer's theory should be revised as "collective selections" (plural) to explain "the tremendous variance in styles that are simultaneously characterized as fashionable" (Kaiser, Nagasawa, & Hutton, 1995; Lowe & Lowe, 1990). These theorists explain the unlikelihood that a single fashion would be so far-reaching in today's environment as to diffuse across the entire society, as was the case with the New Look in the 1940s and 1950s.

Fashion Systems Theory

The **fashion systems theory** explains how fashion information flows throughout the fashion industry. It works from the premise that the fashion system is a complex entity comprised of a collection of organized parts that are interrelated and form a whole system that is greater than the sum of its parts. The fashion social system includes interdependent parts comprised of institutional, organizational, and market structures, such as textile designers, fabric mills, fashion forecasting services, media, and store buyers. These parts channel and mediate the bidirectional flow of fashion information and the fashion process (Davis, 1992). Fashion designers work within the fashion system and are influenced by the same parts of the whole industry. Thus, the designs that are ultimately made fashionable by consumers have been similarly influenced in the system.

Zeitgeist Theory

Like the fashion system theory, the **zeitgeist theory** also explains how fashion designers are influenced by the same factors. Instead of focusing on how the fashion system influences the designers, the zeitgeist theory explains how the spirit of the times influences the designers and their newest looks. Since designers are exposed to the same trends and fashion expectations of the zeitgeist, their designs may appear similar and a mirrorlike reflection of the times. For example, they may feature hemlines in a narrow range, they may choose a certain color palette, they may use certain types of textiles and materials, and they may feature similar details. The spirit of the times dictates the denim jeans design details, such as wide legs or tapered legs on pants; low-rise or at-the-waist waistbands; and denim treatments, such as dark denim, distressed denim, or overdyed denim.

Both the fashion systems model and the zeitgeist theory partially explain why fashions at any given time can look so similar, even though the creative genius may have been a closely guarded secret and many different companies manufacture them. All designers work within the same fashion business structure or system, and they derive their ideas from a set of time- and context-appropriate rules of fashion.

Populist Model

The **populist model**, an alternative to the systems model, explains how fashions originate from more than one source. In this model, the term **polycentric** means that fashions originate from multiple groups defined by an age range, socioeconomic status, culture, or geographic region. For example, on a college campus, the students might popularize a particular style that is unique

Figure 6.17 The rebellious youth culture may be considered a "styletribe."
(Pearson Education/PH College)

to that campus, or a group of women, aged 65+ years, might popularize the wearing of red hats. The term **styletribes** refers to these unique cultural segments. A styletribe's fashion look is unique to that group and may not have an impact on the larger society.

The explanation of theories in the preceding section is by no means an exhaustive list. Other contemporary thoughts regarding fashion change and consumption exist in the literature, and researchers continue to propose refined and revised models. Behling (1985) cited evidence that the general age of the population determines the upward or downward direction of the fashion process and that a change in disposable income can speed up or slow down the fashion process. Kaiser, Nagasawa, and Hutton (1995) developed the symbolic interactionist theory of fashion to explain the continuous change in appearance styles. Solving human ambivalence created by the variety of fashion images available is said to be the basic motivation to cause changes in individual appearance styles. On the other hand, Kean (1997) argued from the viewpoint of the fashion industry that fashion retailers and manufacturers jointly develop and determine the new styles in the marketplace. In order to survive, small or independent retailers have to be in agreement with large retailers during the design process. Thus, this joint action brings about similar styles in the marketplace at the same time. Other researchers (Cholachatpinyo, *et al.*, 2002) enriched Kaiser's model by integrating specific lifestyles and individual differences into the model. The degree of fashion change depends highly on the combination of social trends, individual needs to conform, and individual pressures from others.

No one theory of fashion is comprehensive, and an analysis of the available fashion theory literature exposes many scholarly disputes over the merits, drawbacks, and precise definitions of each theory. According to researchers, "Fashion theory should not be too totalizing and should initiate individuals into new realms of thought and experience" (Kaiser, Nagasawa, & Hutton, 1997, p. 184). Graduate programs expect students to have some prior exposure to various theories, so the preceding brief mention of several theories in this chapter offers a starting point for an exploration of fashion theories.

Other Fashion Perspectives

Many fashion theories deal with the creation and adoption processes, but others explain perceptions of fashion. Historians John C. Flügel (1930) and James Laver (1945) presented two theories of fashion: the timeline of acceptability and the shifting erogenous zone. Other perspectives exist on the purposes of fashion, including the most common—adornment and acceptance.

Timeline of Acceptability

Noted historian James Laver studied women's perceptions toward fashions, both past and present. He created a list of adjectives that aptly describe a particular style as it is coming into fashion, while it is in fashion, and when it is no longer in fashion. Fashion historians commonly refer to these descriptive terms as the **Laver theory**. This timeline of acceptability describes historic styles that are furthest away from the present as being beautiful or romantic. Laver used distasteful adjectives, such as dowdy and hideous, to describe the recently worn and discarded styles. He described styles that had not yet become fashions as brazen and outlandish. Laver believed that this perception has always been the case and fashion is "a complete delusion" (Laver, 1945, p. 381). The same style, once considered hideous, eventually becomes far enough removed from the modern times that it again becomes appreciated and can be revived as a **retro** (retrospective) fashion.

FASHION FACTS: Laver's Theory

The same style can be described by different adjectives with the passage of time. A style is:

Indecent: Ten years before its time
Shameless: Five years before its time
Outré (daring): One year before its time
Smart: In its time

Dowdy: One year after its time
Hideous: Ten years after its time
Ridiculous: Twenty years after its time
Amusing: Thirty years after its time
Quaint: Fifty years after its time
Charming: Seventy years after its time

Romantic: One hundred years after its time
Beautiful: 150 years after its time

SOURCE: Laver, J. (1945). *Taste and fashion: From the French Revolution to the present day*. London: George G. Harrap and Company, Ltd.

FASHION CHRONICLE

Timeline Representation of the Laver Theory

Indecent: Ten years pre
Outré (daring): One year pre
Dowdy: One year post
Ridiculous: Twenty years post
Quaint: Fifty years post
Romantic: One hundred years post

Shameless: Five years pre
Smart: In its time
Hideous: Ten years post
Amusing: Thirty years post
Charming: Seventy years post
Beautiful: 150 years post

Shifting Erogenous Zone

In 1930, J. C. Flügel proposed the theory of the shifting erogenous zone (see also Laver, 1945). Its applications are only for feminine dress, but it has an important implication for fashion designers and marketers and that is to emphasize one main feature of the body at a given time.

The **theory of the shifting erogenous zone** explains that a woman's body contains several taboo zones. The obvious taboo zones are the breasts, legs, and buttocks, and the less obvious zones include the hands, hip bones, neck, and back. Each of these zones has erotic appeal at a particular time, but the established erogenous zone changes over time. The purpose of fashion is to turn a previously hidden zone into a focal point, creating excitement over the emphasized part. Laver stated, "The aim of fashion . . . has been the exposure of, or the emphasis upon, the various portions of the female body taken in series" (1945, p. 201). Laver argued that man cannot take in all of the erogenous zones at one time, so fashion's objective is to limit the viewer's attention to one particular area. When men begin to lose interest in that one particular segment of a woman's body, the erogenous zone shifts to a different area, creating renewed interest and excitement. Referring to the erogenous zone, Laver explained, " . . . it is the business of fashion to pursue it, without ever actually catching up" (1945, p. 201).

Some scholars dispute the widespread application and erotic basis for this theory, but the notion that fashions need to change in order to continuously attract attention has merit. Fashion enhances the sexual attractiveness and seduction elements of human nature, but fashion can also satisfy numerous other elements of human nature. These include the need to conform or belong to a group, the desire for self-expression, the desire to create a class distinction between persons, and the appreciation for adornment and beauty. The theory of the shifting erogenous zone does not discuss these elements because Laver believed that the attraction principle or the erotic principle was the most fundamental purpose of women's fashions.

The Many Purposes of Fashion in Western Civilization

Consumers choose to adopt fashions for a variety of reasons. One explanation is that fashion succeeds because people want to look attractive. Other, deeper meanings exist below the surface of this simplistic answer. Is attractiveness just physical beauty? Could one argue that power, status, or wealth are included in the notion of attractiveness? Fashion succeeds because it satisfies a host of emotional needs. Experts have identified several purposes of dress and fashion that are explained in the following list.

For decoration or adornment. Most cultures would agree on this widely accepted notion of dress and fashion. Even in civilizations that wear little or no clothing, the people choose to decorate their body with jewelry, tattoos, paints, scarification, or other types of adornment.

To create a sense of identity or belongingness. Fashion allows individuals to be a part of the "in" group or the reference group with which they associate or aspire. For

Figure 6.18 **The back can become an erogenous zone in women's fashions.**
(Getty Images)

Figure 6.19 The Spice Girls' clothing reflected the individuality of the performers' images.
(Getty Images)

example, wearing a college or sorority letters T-shirt forges a bond with others wearing similar shirts.

For self-expression or individuality. Fashion allows the wearer to define himself or herself through the selection of styles. For example, a student that dresses up each day for class will be projecting a somewhat different image than one that regularly wears athletic apparel or jeans and T-shirts to class. To illustrate the notion of self expression, one can look at how each of the five Spice Girls projected distinctly different images in the 1990s.

To gain support from a group that dresses similarly. Group members achieve a certain level of comfort by wearing fashions that are not too different from others in the group. As an example, imagine a teen's junior high school years and note how important it is to "fit in."

To equalize appearances. People sometimes find it difficult to tell the more affluent consumers from the less affluent consumers because the same fashion look is available at many price levels. Consumers consider denim blue jeans an equalizing fashion, and many prefer jeans because the fashion allows them to look just like everyone else.

To demonstrate superiority or power. The power suit and power tie of the white-collar workers exemplify strength and superiority. Power clothing conveys competence and decisiveness, both of which are valuable traits in the business world.

To show affluence or social distinction. A person can demonstrate wealth by choosing fashions that inhibit physical labor, such as high heels or restrictive clothing.

To express one's modern nature. Fashion is forever changing and compels consumers to purchase the newest and most modern styles. Some consumers find it important to keep up to date on the latest fashion trends.

To enhance youthfulness. Fashion is most likely to interest and influence young people, although fashion affects most everyone. By keeping up with the latest fashion, a person shows he has a youthful spirit, if not necessarily a youthful body.

To create interest. Fashion creates interest that keeps consumers continuously shopping for something different for their wardrobe.

To relieve boredom. Consumers with discretionary income tire of the same wardrobe items after an extended time. Fashion helps satisfy the need for excitement. It relieves boredom because shopping for fashion is a social activity, it generates interest when a new outfit is worn, and consumers appreciate the fun of wearing something new.

Figure 6.20 For men, the suit and necktie represent power.
(© Dorling Kindersley)

For erotic appeal. The human form, scantily clad, is far more titillating than a purely nude body. Fashion serves to conceal erotic areas, creating excitement through imagination. A nude body is a form of art; a semiclothed body can be a form of eroticism.

To enhance gender differences. Cultural differences in fashions for men and fashions for women usually exist, although the particular culture influences the degree of gender differences. At times when women are more strongly asserting their independence, the fashions tend to de-emphasize gender differences. This is especially true in career clothing, but gender differences are more likely to be distinct in eveningwear fashions.

summary

- The fashion principles are:
 - Fashion is not a price.
 - The consumer is king or queen and decides what will or will not become a fashion.
 - Sales promotion cannot change the decline in popularity of a fashion.
 - All fashions end in excess.
 - Fashion requires imitation of style or look.
 - Fashion change moves in a cyclical pattern.
 - Fashion change is usually evolutionary and rarely revolutionary.
 - Fashion is a reflection of the way of life at a given time.
- Fashion innovators start fashions.
- Fashion followers follow fashions.
- The trickle-down theory of fashion adoption states that fashions are first introduced by the wealthy and elite members of society and then trickle down to be adopted by the masses.
- The trickle-up theory states that fashions are first introduced by the lower social classes, youth, minorities, or working class and then gain popularity with the more affluent consumers.
- The trickle-across theory states that fashions are introduced simultaneously at all levels of society and move across each social class from fashion innovators to fashion followers.
- The geographic theory states that fashions are first adopted near large metropolitan cities, particularly New York and Los Angeles, and then move inward toward the central United States.

- The fashion systems theory explains that the same environmental factors influence all designers' creations, so there is similarity in what the fashion innovators are offered.
- The populist model explains that fashions originate from multiple and unique groups called styletribes.
- The Laver theory describes a single fashion using different adjectives, depending on how far removed the style is from its fashionable days.
- Flügel and Laver's theory of the shifting erogenous zone addresses the form of the female body and suggests it is divided into a series of sterilized zones that are singularly uncovered to create fashion interest.
- Purposes of fashion:
 - Fashion serves to decorate.
 - Fashion creates a sense of identity or belongingness.
 - Fashion allows for self-expression or individuality.
 - Fashion allows the wearer to gain support from a group that dresses similarly.
 - Fashion equalizes appearances.
 - Fashion demonstrates superiority or power.
 - Fashion shows affluence or social distinction.
 - Fashion expresses a modern nature.
 - Fashion enhances youthfulness.
 - Fashion relieves boredom.
 - Fashion is for erotic appeal.
 - Fashion enhances gender differences.

terminology for review

high-low dressing 104
historical continuity 108
fashion innovators 109
fashion followers 109
trickle-down theory 109
chase and flight 109
pecuniary 110
conspicuous consumption 110
conspicuous leisure 110

artificial obsolescence 111
trickle-up theory 112
status float phenomenon 112
subcultural leadership theory 112
bubble-up process 112
trickle-across theory 112
democratization of fashion 113
geographic theory 113
collective selection theory 113

fashion systems theory 114
zeitgeist theory 114
populist model 114
polycentric 114
styletribes 115
Laver theory 116
retro 116
theory of the shifting erogenous zone 117

questions for discussion

1. What are the principles of fashion, and why is it important to memorize and understand them?

2. What does the term *historical continuity* mean, and why is it useful in describing fashion?

3. What are the major premises for each of the theories of fashion adoption?

4. Why is it important to have multiple theories of fashion?

5. What are fashion innovators, and why are they important to the fashion industry?

6. What are fashion followers, and why are they important to the fashion industry?

7. How are styletribes responsible for fashion adoption within their group?

8. What is Laver's theory on the timeline of acceptability, and how does it relate to past and present fashions?

9. Is James Laver's theory on the shifting erogenous zone still a part of contemporary fashion?

10. Which purposes of fashion are most applicable in modern Western civilization?

related activities

1. Create a table with four quadrants. Label each quadrant with one of the four main theories of fashion adoption (trickle-down, trickle-up, trickle-across, geographic). Create a list of four to six fashions for each of the adoption theories and write them in the appropriate quadrant. Be able to justify your decisions and present to the class.

2. Interview ten young men or women (choose only one gender) in the 16–25 age range. Ask them to describe their sources of fashion advice and how they decide what fashion looks they purchase. Write a 500-word report to analyze the findings.

3. Conduct library research on one of the theorists presented in this chapter. Obtain a copy of the essay or research paper written by the theorist and read it carefully. Summarize the essay, explain your position, and explain the essay's application to modern times.

4. Retrieve electronic copies of the two articles written as dialogue between researchers. Respond to the questions, "Does the globalization of fashion result in greater homogenization of available styles, or does it result in greater heterogeneity, that is, is there a greater diversity of selections? Why?" Type a one-page essay to answer this question and discuss with the class.
 a. Kaiser, S., Nagasawa, R., & Hutton, S. (1997, Jan.). Truth, knowledge, new clothes: Response to Hamilton, Kean, and Pannabecker. *Clothing and Textiles Research Journal, 15*, 184–191. Focus particularly on the "Dialogue with Kean" section.
 b. Kean, R. (1997). The role of the fashion system in fashion change: A response to the Kaiser, Nagasawa and Hutton model. *Clothing and Textiles Research Journal, 15*(3), 172–177.

Your Fashion IQ: Case Study
Much Ado about One-Quarter Inch

Among the slowest-changing fashion items are men's neckties. For years, the width of conservative men's ties has been a constant blade width of three and three quarter inches at the widest point. In 2007, public figures and celebrities such as Robert Kennedy, Jr., soccer star David Beckham, and *American Idol* host Ryan Seacrest were photographed wearing the narrower three and one-half-inch wide neckties.

Some manufacturers and retailers expressed delight that the lagging necktie sales might get a jump-start, since a change in tie width might stimulate men to purchase the newer, narrower ties. In addition to new ties, the consumers might also need to purchase shirts with narrower spreads on collars to balance the narrower ties. They might even need to purchase new suits with narrower lapels to keep the ensemble in proportion because a tie blade should be no more than 1/2 inch wider than the jacket's lapel width.

Other companies preferred not to adjust the width of their standard three and three quarter-inch ties, since they considered the narrowing blade a fad that might not be well received by their customers. According to one image consultant, narrow ties convey a trendy message that might not be desirable in more serious company settings.

Men's suits have gradually slimmed in silhouette during the first decade of the century. According to an article in the *Wall Street Journal*, "men have grown more comfortable showing off their bodies—a result of healthier lifestyles including working out and eating better" (Smith, R., 2007, Oct. 20, p. W5).

QUESTIONS:

1. Fashion changes are sometimes very gradual, and both consumers and manufacturers may be reluctant to change. Does their reluctance mean that change will not happen? Should it happen?

2. Consider these four cause-and-effect statements. Which seems to be the most likely reason for the fashion change? Are there any other possibilities not mentioned?
 a. The shift in necktie widths is an attempt by manufacturers to strengthen sales in the struggling neckwear market.
 b. The shift in necktie widths is a product of social changes, such as healthier lifestyles and that men are more comfortable with their bodies.
 c. The shift in necktie widths is a result of celebrities wearing the new fashion.
 d. The shift in necktie widths is due to boredom from too many years of wider ties.

3. What theories presented in this chapter might support each of the four reasons for change cited in the preceding question?

SOURCE: Smith, Ray. (2007, Oct. 20). Menswear—new neckties go on a diet. *Wall Street Journal*, Eastern Edition, p. W5.

Good Business
By Edgar Guest, 1912

If I possessed a shop or store
I'd drive the grouchers off my floor
I'd never keep a boy or clerk
With mental toothache at his work
Or allow the man who takes my pay
Drive customers of mine away.

I'd treat the man who takes my time
And spends a nickel or a dime
With courtesy, and make him feel
That I was glad to close the deal
For tomorrow who can tell,
He may want things I have to sell.

The reason people pass one door
To patronize another store
Is not because the busier place
Has better gloves or silks or lace
Or cheaper prices, but it lies
In friendly words and smiling eyes.
The only reason I believe
Is in the treatment folks receive.

MARKETING
and the TERMINOLOGY
4 Ps of FASHION
MARKETING

LEARNING OBJECTIVES

At the end of the chapter, students will be able to:

- Identify target customers for a variety of fashion businesses in terms of demographics, psychographics, behavioral characteristics, and geographics.
- Describe ways a single fashion company can target multiple market segments.
- Compare the characteristics of a niche market with a broad market segment.
- Explain how relationship marketing exists in various retail stores.
- Identify the 4 Ps of fashion marketing.
- Define marketing as it relates to a fashion business.
- Apply the different pricing terminology to various retailing scenarios.
- List examples of push and pull marketing.
- Develop a media mix for a fashion company.
- Develop an appropriate integrated marketing communications plan for a fashion business.

Fashion is a business. The most important goal of a fashion business is to make a profit. Without profits, the company fails. According to the Small Business Administration, proper planning is the first step in owning a successful business. Good planning starts with an understanding of the basic marketing terminology, valuing the importance of segmenting a broad market, and ultimately deciding what products and services will best fit the chosen market.

7

Target Market and Market Segmentation

When entrepreneurs prepare to open a fashion business, they choose a company name and determine the kind of merchandise they offer. They decide on a pricing structure. Entrepreneurs choose a location and the interior furnishings. They determine the promotional activities and the number of employees. An entrepreneur must answer many questions, but the one question that drives all the other decisions is: What type of customers will patronize the business? *What customers comprise the target market?* A **target market** is a select group of customers with the ability and desire to purchase a company's products and services and to whom the company has directed its marketing efforts. Target market, **target customers**, and **customer base** are three relatively interchangeable phrases that identify a group of customers selected by a business as the most likely group to purchase the company's goods. The target market preferences drive all business decisions.

No matter what type of business entity (designer, manufacturer, wholesaler, or retailer), the management staff should identify important characteristics of customers that will buy the company's products or services. For example, the target customers of Target Stores are primarily females who are value-conscious, take an interest in fashion, enjoy browsing and shopping, and have families. Compare these customers to the target customer of Wal-Mart. How would the customers be different? They would still be female, value-conscious, and have families. But what would be different?

When describing the target customer of Ralph Lauren, one might first have to specify which of his lines, because each has a slightly different target customer. Is it the description of Polo by Ralph Lauren, Ralph Lauren Purple Label, Ralph Lauren Collection, Black Label, Blue Label, Lauren by Ralph Lauren, RRL, RLX, Rugby, Ralph Lauren Childrenswear, American Living, Chaps, or Club Monaco target customers? In a large company such as Ralph Lauren, the various divisions will have somewhat different target customers, although some target customer characteristics may overlap. The common characteristics may include a preference for elegance, classic styling, and quality clothing, but other consumer characteristics may differ depending on the particular line. A person's income level, lifestyle, or age bracket may influence which of the designer's lines is preferred. For example, Ralph Lauren's Rugby line targets the twenty-something, preppy college consumer. A Rugby customer has a "rebellious irreverent streak and is a much younger brother of Polo" (Karimzadeh, M., 2008, July 31). By contrast, the American Living customer is a more mature and loyal JCPenney shopper. She still appreciates the classic styling of Ralph Lauren fashions but prefers a more affordable price point.

Companies attempt to identify distinctive traits about a group of customers in order to distinguish that group from the larger population. By understanding the customers, the companies can develop precise marketing strategies geared specifically toward a select group. **Segmenting the market** or **market segmentation** means a company focuses on a particular group of customers. For example, a marketer might subdivide a college town into multiple market segments including university employees, college students, retirees, and area families not affiliated with the university. The segment (or segments) a company chooses to attract with its products and services offerings is the target market. In this example, if the company targets the group of college students residing on campus, then the marketing strategies would need to appeal to these students. Discounted prices, campus newspaper coupons, casual athletic apparel, and on-campus convenience would be some of the marketing strategies that would attract this segment of the market (see Figure 7.1).

Fashion marketers segment markets with four main characteristics or variables: demographic, psychographic, behavioral, and geographic. Marketers find it helpful to use all of these segmentation methods when differentiating their target customers from the broader market. For example, marketers for a regional mall may consider everyone residing within a 75-mile radius to be in the mall's market, including teenagers, young families, empty nesters, retirees, and the elderly. Only the groups falling within the defined demographics, psychographics, behaviors, and geographics will become part of the mall's targeted customer base.

Demographic Segmentation

Businesses commonly segment the market based on **demographic variables** or **demographics**, including gender, age, occupation, income, education level, marital status, family life cycle stage (such as newlyweds or empty-nest adults), and many other quantifiable or objective statistics. Table 7.1 shows a comprehensive list of demographic variables. Marketers find demographic segmentation a relatively easy way to define a target market. Survey respondents checking a particular answer box are often providing demographic information. The Census Bureau is the largest collector of personal demographic data in the United States. For example, on a census questionnaire, an individual would check male or female, a specific age range, a specific level of education, and numerous other indicators of personal characteristics. Marketers have access to the most recent census data at www.census.gov.

Psychographic Segmentation

Psychographic variables or psychographics are subjective, psychological statistics about the lifestyles of a population. Psychographics include a combination of personality traits and lifestyle characteristics and may be more difficult to measure than demographics. A target market classified by psychographics segmentation would include consumers with similar values, attitudes, beliefs, opinions, interests, or lifestyles. For example, a marketer might cater to customers who are more liberal-minded or conservative. The targeted customers might enjoy similar types of entertainment, such as extreme sports. The consumers might be somewhat fashion-forward, or they may prefer to purchase fashions well into the acceptance stage. Table 7.2 offers a comprehensive list of psychographic variables. The VALS™ Web site also describes many psychographics. (For additional information and to take your own VALS survey, visit the company Web site at www.strategicbusinessinsights.com/vals/)

Behavioral Segmentation

Behavioral segmentation is closely related to psychographic segmentation, but **behavioral segmentation** classifies customers by similar purchasing intents and behaviors. For example, a cosmetic marketer may use behavioral segmentation to identify potential customers by their heavy product usage or high consumption rate. As another example, marketers for an online retailer could segment the company's online shoppers into heavy users (purchasing at least once a month online), moderate users (purchasing once a quarter online), and light users (making an occasional online purchase). A textile mill can group its trade customers by consumption

Figure 7.1 A typical college town may be divided into multiple distinct segments.

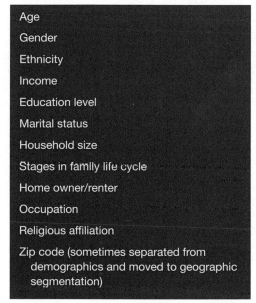

Table 7.1 Demographic Variables

Age
Gender
Ethnicity
Income
Education level
Marital status
Household size
Stages in family life cycle
Home owner/renter
Occupation
Religious affiliation
Zip code (sometimes separated from demographics and moved to geographic segmentation)

Table 7.2 Psychographic Variables

Values
Attitudes
Lifestyles
Opinions
Interests
Hobbies
Beliefs

FASHION FACTS: Nielsen PRIZM (Potential Rating Index for Zip Marketers)

Nielsen, a target marketing information company, offers an analysis of market segments based on zip codes. The subscription-based software, called PRIZM, allows users to generate demographic, psychographic, and behavioral information about the groups of customers living in a particular zip code. This information, called MyBestSegments, provides demographic and psychographic facts about these unique groups of customers. Without a subscription, students can enter their own zip codes and identify the major customer segments in their own places of residence. The information provides catchy names to describe the groups, such as Kid Country, USA; Bedrock America; or Young and Rustic. The information also includes average incomes, lifestyle traits (including major purchases or the types of cars that might be driven), and demographic information, such as ethnic diversity or number of children in a household. For additional information on PRIZM, go to http://www.claritas.com/MyBestSegments/Default.jsp and choose the tab Zip Code Look-Up.

Figure 7.2 Quinceañera party for young Hispanic women from Mexico.
(AP Wide World Photos)

Customers are targeted based on demographic, psychographic, behavioral, and/or geographic characteristics.

rate. They can measure consumption rate by the number of yards of fabric that apparel manufacturers order from the textile mill. Some manufacturing companies purchase more yardage than other companies, so the marketing strategies would differ among trade customers.

Marketers desire to reward their best and most loyal customers (those customers with the greatest usage rates) by offering special quantity discounts or frequent purchaser club accounts. The Victoria's Secret Angel credit card and corresponding Angel V.I.P. status present good examples of segmenting based on buyer behavior and rewarding the most loyal purchasers. Customers that charge the most merchandise to their Victoria's Secret credit cards receive the most benefits from the store in the form of Angel rewards and coupons. The situation is a win-win proposition for the store. Not only does the company benefit from increased sales, but it also earns a 22.8 to 24.99 annual percentage rate (APR) on the consumer purchases. (See Author's Note at bottom of page.)

Another form of behavioral segmentation is by benefits sought or in the case of fashion merchandise, intended end use. This means that different customers have different reasons for purchasing the same merchandise. For example, a manufacturer of special occasion white dresses might sell the same merchandise to retailers across the country with a variety of needs. Stores in the Southwestern United States catering to the Hispanic population might choose the white dresses for *Quinceañeras*, a special event for 15-year-old Latino girls (see Figure 7.2). Other retailers might order the same dresses or even slightly more sophisticated styles for their customers' sweet sixteen parties or debutante events (aged 18).

AUTHOR'S NOTE: Financial planners and the American Association of Family and Consumer Sciences (www.aafcs.org) do not recommend consumers taking advantage of store credit cards because of the extremely high interest rates and the likelihood of consumer overspending with multiple store credit cards.

Geographic Segmentation

When a customer makes a purchase at a store, why might the salesclerk ask for the customer's phone number or zip code? Marketers can collect valuable geographic data at the point of sale. **Geographic segmentation** is the process of dividing the market into groups according to a particular region. Marketers sometime bank on the premise that people or companies residing in a similar region have similar purchasing habits and therefore can be grouped together in a single segment. The geographic region may be as large as several states, such as the Pacific Northwest, or it might a major city and the surrounding suburbs. Generally, fashion buyers for national retailers select merchandise based on consumer regional preferences. For example, a sweater buyer for a national retailer will decide to order wool or cotton sweaters based on the location of the stores. The buyer may order wool sweaters for stores located in Kansas City and cities further north and cotton sweaters for the company stores located in Dallas or other southern cities with relatively warm winter climates. On a much larger scale, global or multinational companies may divide the countries by continent or proximity. For example, a global company such as Nike may group the countries in North America (Canada, United States, and Mexico), Central America (Belize, Costa Rica, El Salvador, Guatemala, Honduras, Nicaragua, and Panama), or the far Western European Union (France, Ireland, Italy, Germany, Portugal, Spain, and United Kingdom).

Targeting Multiple Segments

Large corporations, eager to gain a larger share of the market, sensibly target more than one group of consumers. Serving multiple market segments is a challenge, but it is also a vital part of strategic business planning. Marketers target multiple customer segments by offering fringe sizes to expand market share; by opening new stores to appeal to unique but related segments of the market; and by offering additional merchandise classifications within existing stores that appeal to different genders, ages, or lifestyles. For example, if the Hanes Hosiery Company targets multiple segments, the brand may require a change in fit, color, or denier. Some hosiery must be offered in petite and plus sizes, whereas others customer segments may prefer lighter or darker shades within the mainstream misses sizes. Women with circulation problems, the elderly, or those who stand on their feet for long periods of time may need support hose and will be targeted differently than the mainstream customers. Retail corporations can also increase market share by opening different stores to appeal to variety of ages and lifestyles. American Eagle Outfitters (AEO), known for its guy and girl, 15- to 25-year-old core customers, offers three other types of stores. Aerie is the American Eagle Outfitters counterpart of an intimate apparel and dormitory shop for the core customer. Martin & Osa is the American Eagle Outfitters division for its thirty-something aging customers—those that no longer have the same interests as 15- to 25-year-olds, but loyally shopped at the AEO stores while in high school and college. Another division is 77kids.com by American Eagle Outfitters for children, aged two through ten years.

Figure 7.3 Aéropostale targets teens, whereas P.S. from Aéropostale targets tweens. (PhotoEdit Inc.)

AUTHOR'S NOTE: For additional explanations of segmenting the market, refer to the Small Business Administration Web site at http://www.sba.gov/smallbusinessplanner/manage/marketandprice/ SERV_TARGETMARKETING.html.

> The most important concept to understand is that successful companies do not try to be all things to all people.

> It is true that a store will sell to just about anyone who has the means to purchase, but good business sense dictates that the company must target particular groups. A business only has a limited amount of money to spend on advertising and promotions to attract customer groups. Therefore, companies wisely spend their marketing dollars to entice those consumers who are likely to spend the most money with the company and who have common demographics, psychographics, behaviors, and geographics.

Not all fashion companies cater to multiple market segments. Just because a store offers apparel and accessories for men, women, and children, it may not cater to three different target customers. For example, Old Navy, the big-box fashion store, carries merchandise classifications for women, men, children, and babies. Yet, even with the variety of merchandise offerings, a store such as Old Navy primarily caters to a female, budget-conscious customer, who appreciates the ability to purchase all her family's needs in one store or online. In addition to preferring a one-stop shop atmosphere, this customer is time-poor. She is attracted to the strip shopping center location, rather than having to spend her spare time at the mall going from store to store. This target customer buys Old Navy apparel for her husband, son, and daughter, but she is still just a single market segment. If Old Navy finds that college males are flocking to the stores to purchase the clothing and accessories, then the company may devote additional marketing monies to attracting this consumer segment. The company might make a concerted effort to specifically target young male shoppers by investing resources into radio advertising, Internet, point of sale, and celebrity promotions that appeal to this segment. If this occurs, then Old Navy is targeting another segment of the market.

Niche Markets

A **niche market** is a narrowly defined market segment, but it is not necessarily a small segment. Consumers in this narrow segment seek a distinctive mix of benefits. The niche market may already be quite homogeneous in terms of demographic or psychographic characteristics, but the niche market consumers have an even more defined set of interests. For example, there are many mall-type specialty stores catering to teens and young adults from middle- to upper-middle-income families. These consumers' geographic segmentation is similar; they live and attend school in an area that surrounds the mall. They enjoy meeting their friends at the mall, and the social atmosphere of the mall keeps them returning many weekends during a year. They also have sufficient discretionary income to make apparel, accessory, and entertainment purchases at the mall each time they visit. Yet, this description alone is not a niche market because the defined set of interests is missing. Now consider these same customers but differentiate them into groups of consumers that shop at Pacific Sunwear, those that shop at Hot Topic, and those that shop at Hollister & Company. These companies look for specific interest differences within the larger teen market segment and create stores that cater to these niche markets.

Niche marketing occurs for one of two reasons. First, the company may be small and lack the financial resources to cater to a broad customer base. Second, niche marketing may offer a competitive advantage to the company since there will be few or no other companies offering the highly specialized goods and services. Consider the niche fulfilled by a clothing company that specializes in adaptive clothing and fashionable apparel for physically handicapped and arthritic persons. Imagine a furrier that specializes in restyling and refurbishing out-of-fashion fur

The key to success in any business is to build a lasting relationship with customers, especially those who are likely to spend the most money over an extended period. Think of your favorite place to shop. Do the sales associates call you by name? Do they offer you special incentives because of the frequency of your purchases? Do you have a store credit card that entitles you to advance notices of big sales events? How has this store earned your repeat patronage? How has this store developed a long-lasting relationship with its best customers?

By contrast, think of a store you vowed never to shop again! What went wrong? What (if anything) can they do to earn your business again? Would it have been simpler and more economical for them to keep you as a repeat customer rather than solicit a brand-new customer to replace you? Businesses that realize the critical value of repeat customers are most likely to succeed.

Companies that sell to other companies, or business-to-business (b2b) companies, frequently practice relationship marketing. **Relationship marketing** in the business community is defined as creating lasting and mutually beneficial relationships with key suppliers and customers. This includes fostering strategic alliances with key resources through technology linkups (called electronic data interchange or EDI), creating operations that streamline distribution or reduce production costs, and providing the consumers with the best products for their money. Relationship marketing is simply building a rapport with a company's best and most profitable customers to ensure repeat patronage.

Fashion marketers should go the extra mile and add value to key customer accounts. For example, a store with sizable purchasing power gains quantity discounts from vendors who desire to keep this retailer as a valued client. This same store may be regularly contacted by the manufacturer's sales representative to determine if the merchandise shipment arrived on time and in satisfactory condition. The showroom owner may personally assist the buyer when she visits the apparel mart on scheduled market trips. All of these things—financial incentives and discounts, a simple telephone call, or a personal visit—are easy and effective ways to begin building a marketing relationship with customers. So why not build a relationship with all customers? The answer is "excellent idea!" However, there will always be customer tiers (top spenders, mid-range spenders, and occasional spenders) based on their spending habits with a business. Because a business has finite resources for promotions and incentives, the business manager should allocate marketing expenditures according to customer spending habits. In short, the very best customers should get the best services and incentives.

coats or transforms unwanted fur coats into pillows or throws for the home. Many consumers are familiar with Frederick's of Hollywood, a niche market store that is well-known for its risqué lingerie and sexy costumes. A final example of niche marketing is that of an apparel manufacturer that uses only organically grown cotton in infant's sleepwear. The company's target customers might be educated, upscale, and environmentally conscious grandmothers, mothers, or gift-givers who are willing to pay a premium price. These customers have strong preferences for cotton, grown without herbicides or pesticides, against their babies' delicate skin.

Fashion marketers reap the benefits of niche marketing, but there are also drawbacks of focusing on too narrow of a niche market. If a new market entrant or competitor duplicates the specialty products or services, then sales may suffer. If the narrow segment dwindles in size or the consumers' buying habits change, the sales may also decrease. For example, the once widely popular and very comfortable Classic Crocs shoes still hold some appeal for groups of customers, including a market segment of middle-aged, working adults that spend a great deal of time on their feet and some small children. Even though Classic Crocs have many colors and personalized stickers called Jibbitz for kids of all ages, the basic design of Classic Crocs will pass through the stages of the fashion life cycle, eventually moving into the obsolescence stage. To ensure the continued strength of the company, it has moved into international markets and designed many new shoe styles for the domestic market, such as sandals, platform shoes, wedges, and other popular styles. If a company fails to expand and create new products, sales will decline, and company profits will eventually suffer.

The 4 Ps of Fashion Marketing

What does the term *marketing* mean? **Marketing** is all the activities, from idea conception to ultimate consumer use, that satisfy the objectives of the buyer and seller. The American Marketing Association defines marketing as "an organizational function and a set of processes for creating, communicating, and delivering value to customers and for managing customer relationships in ways that benefit the organization and its stakeholders" (AMA, 2009). Marketing is a mutually beneficial exchange process—a win-win situation for the buyer and the seller.

In an unscientific poll of university students, when they were asked "what is marketing," most students associated it with sales. To an extent, this is true. There is an old saying among retailers—what is bought, must be sold—and this is one of the functions of marketing. However, this selling definition may imply forcing a product on a reluctant consumer, and this is certainly not the intent of a good marketing strategy!

Marketing begins prior to the actual selling stage, at the idea conception stage. Two of the principles of fashion mentioned in Chapter 6 are "the consumer is king/queen" and "sales promotions cannot reverse a fashion's decline." Marketers know it is foolish to ever consider designing any item without first checking with consumers, especially since about 80 percent of all new products fail during introduction. This is a staggering statistic and not one to which a fashion marketer would want to fall victim.

The first step in fashion marketing involves gathering information about the target customers' preferences. It includes finding out what they like and dislike, where they shop, how much they will pay for an item, what colors and print patterns are preferred, how they will use the item, and other pertinent information that will assist in the development of a successful fashion product.

The **4 Ps of fashion marketing** are product, price, place, and promotion. The intended target customer determines the combination of the 4 Ps. The right combination of the 4 Ps, called the **fashion marketing mix**, will be unique for a particular target customer. Although most marketers include timing within the "place" P, it might be worth considering to add a fifth P—precision timing. In the fashion industry, having the merchandise available at just the right time is as critical as the placement and price.

Students of fashion should beware of the person who says "I have a great idea that is sure to sell!" This may be true, but it tends to focus on only one of the four components of marketing—the product component. A successful fashion marketer develops all 4 Ps around the target customer (see Figure 7.4).

The following are questions for consideration when launching a new fashion product.

- Is it similar to a successful style that sold well last season?
- Is there sales data to support this?
- Has style preference testing been conducted on a representative sample of the target customers?
- Do these people have the purchasing power and a desire for the planned item?
- How will the customer be reached?
- How will the item be distributed?
- Is the timing just right?
- Where will the item be sold?
- What prices should be charged for the item?
- Can a profit be made?

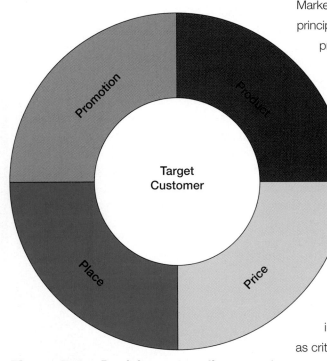

Figure 7.4 Decisions regarding the 4 Ps of fashion marketing are dependent upon the selected target customer.

Product

Fashion marketers must carefully select the products offered by the business. The term **products** refer to a company's goods and services desired by the target customer. **Goods** are tangible items, such as a T-shirt, trench coat, or a pair of khaki slacks. **Services** include intangibles, such as dry cleaning, delivery, layaway, personal shopping, alterations, fur glazing, and cold storage. Companies sell only those products with the greatest appeal to the target customer.

Having the proper quantities also falls under the product P of marketing. Not only do the products have to be "right," but the quantities must be appropriate to ensure a complete sell-through in a timely fashion. Fashion marketers avoid having too many or too few of items on the shelves during peak demand periods. The appropriate numbers differ depending on the other Ps of marketing, including the type of retail stores, prices charged, promotional strategies, and, of course, the target customer.

Price

Price is the determination of a retail value for the product. Marketers base the price on the cost of the product and the willingness of the target customer to purchase the goods or services. The price must be set high enough to cover the wholesale cost of the item, overhead expenses, and a reasonable profit. **Retail price**, price, and **retail** are interchangeable terms that denote the amount the ultimate consumer pays for the item. The customers may be willing to pay full price, but often they will pay only the sale price. For example, one gainfully employed shopper may splurge on a **full-price** ski jacket and pay $150 at the register. The other shopper is a college student on a tight budget and waits (hopes) for the jacket to be marked down to an affordable **sale price** of $99.99.

Wholesale cost, **wholesale**, and **cost** are three interchangeable terms that refer to the amount the store pays for the item. For example, that same ski jacket may cost the store around $75. The store may double the cost and use this as the retail selling price of $150.

The difference between the cost and retail is the **markup**. The markup covers salaries, rent, utilities, advertising, and a host of other expenses and ensures a reasonable profit for the seller. The cost plus the markup will equal the retail price. The following two simple formulas demonstrate ways to determine the retail price of an item. The first method is by approximately (~) doubling the cost price and the second method is by adding the cost and the markup.

$$\text{Cost} \times {\sim}2 = \text{Retail and Cost} + \text{Markup} = \text{Retail}$$

Most businesses do not apply the same markup to each and every item. The retail selling price depends on many factors, including perishability, fashionability, quality, value, store policies, manufacturing costs, competitor's prices, and consumer acceptance.

Place

Place or **distribution** refers to the movement of products through the levels of the fashion marketing channel until the products reach the target customers. The **supply chain**, **channel of distribution**, or **marketing channel** is a representation of all the levels of the fashion industry. It begins with the production of the raw materials used in the making of the fashion merchandise and ends with retailing the apparel or accessories via the Internet, store, or other retail

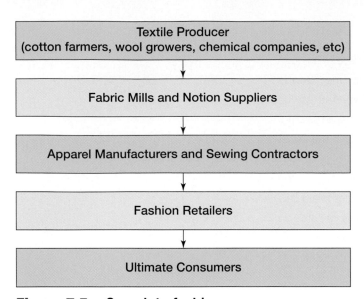

Figure 7.5 Complete fashion marketing channel of distribution or supply chain.

venue (see Figure 7.5). Fashion marketers seek out ways to facilitate moving the fashion goods quickly through the supply chain, bypassing levels when possible. Industry personnel compare selling fashion to selling nearly ripe produce—reduced time or speed-to-market makes all the difference. The faster the products can get into the hands of the ultimate consumers, the better! Extended time spent in the marketing channels can be disastrous. Few customers want to buy a fashion that has passed the peak of the fashion life cycle. With this said, precision timing can be included in the place grouping, or consideration might be given to making it a separate "P" of marketing.

Promotion

Promotion includes all activities that build awareness, interest, traffic, goodwill, and ultimately encourage sales to the target customers. The higher levels in the supply chain promote to the successive levels. Push and pull marketing are two promotional methods commonly used in the fashion industry.

Push marketing involves advertising or promoting to the following levels of the marketing channel. For example, DuPont markets its Lycra spandex to fabric manufacturers, such as knitting mills for swimwear fabrics, encouraging the fabric manufacturers to use Lycra fibers rather than some other brand of spandex in their swimwear fabric. DuPont may also advertise to the Jantzen swimwear manufacturers and Macy's retail store buyers in an attempt to get these companies to demand that the fabric and swimwear they purchase contains the name - brand spandex fiber Lycra. In these examples of the business-to-business (b2b) promotions, DuPont gears its advertising toward three different trade levels in the supply chain. Another common example of push marketing is when a retail store, such as Macy's, advertises a swimwear sale in a local consumer newspaper. Retailers commonly employ this business-to-consumer (b2c) push marketing (see Figure 7.6).

Pull marketing involves promoting further down the marketing channel to encourage consumers to insist on a particular brand. In the past, DuPont has advertised Lycra brand spandex in *Women's Wear Daily*, a trade publication aimed at manufacturers and retailers of fashion. The advertisement cited the high recognition of Lycra spandex among consumers and encouraged retail store buyers to insist that the swimwear they ordered for their departments contained the branded fiber. Another example of pull marketing occurs when manufacturers advertise products and brands in national fashion magazines and then list the retail store outlets where the items are available. This practice is common with formal apparel, such as bridal and prom. The advertisement tagline "ask for it at your favorite retail store" is a common phrase used in pull marketing (see Figure 7.7).

Promotions include the medium choice or media choices as well as the message. The **medium** is a single venue used to send the marketing communication to the target customer, such as radio broadcasts or newspaper print advertisements. The fashion marketers will ask themselves: "Do my customers read the newspaper? Do they prefer to listen to radio station A or B? Would Internet-based marketing appeal to these consumers? Are my customers commuters, and would they view billboards as they passed them each morning on the way to work? Would mall-based promotions and in-store advertising be more appropriate for a hard-to-reach group, such as working mothers?" Whether fashion companies use a single medium heavily, such as newspaper or direct mail, or whether the fashion companies choose a **media**

Figure 7.6 Example of push marketing.

mix (several venues) for maximum exposure, companies base the promotions on the target customers' preferences.

All of the 4 Ps of fashion marketing require strategic planning. Fashion marketers constantly monitor the environment and plan market research so that their company can be successful in a competitive marketplace filled with seemingly fickle consumers.

Positioning and Repositioning

The combination of the 4 Ps (product, price, place, and promotion) creates an image in the minds of the targeted customers. This carefully created image is the **position** the product occupies in the minds of the consumers. In marketing, the term **positioning** refers to a deliberate attempt by a company to make consumers perceive the company and its products as being somehow different from the other companies competing for a similar market. Sometimes the products are similar, the prices are similar, and even the location is similar, but the store interior is different in terms of color scheme, store size, openness of floor plan, types of fixtures, choice of music, and appearance of interior displays. The promotional strategies may be different, and the target customers may be slightly different. Compare the market positioning of Victoria's Secret and Frederick's of Hollywood. How have the parent companies positioned these stores? What image does each of these stores convey? Both may be located in the same mall, and they carry similar basic merchandise at similar prices, yet the choice of store names conveys entirely different images to shoppers. The corporations position each store to appeal to a particular type of target customer. A slightly different example involves positioning of jewelry stores. Many consumers view diamonds as a commodity product, with few (if any) differences other than the carat, cut, clarity, and color. Yet, customers purchasing a diamond from a high-end retailer, such as Tiffany, view the diamond as better than a comparable diamond from a mall store. The difference is really due to positioning.

If a company wants to target a different group of customers than what it has been targeting, it will reposition the brand or company image to attract a different customer group. The term **repositioning** means a company attempts to create a different store image or brand image in the minds of the target customers. In 1980, industry experts referred to JCPenney, Sears, and Montgomery Ward as the Big Three in retailing.[1] They were the largest mass merchandisers in the United States at that time. In an effort to attract a more affluent customer (middle- to upper-middle income) and set itself apart from Sears and Montgomery Ward, the JCPenney company launched a plan in 1983 to reposition itself as a department store. During most of the decade of the 1980s, the JCPenney company continued to work toward a repositioning strategy by modernizing the stores, offering a more fashion-focused and brand-oriented merchandise mix, and changing the advertising methods. The total cost was about $2 billion, but by 1989, the company had "shed its mass merchandise image and was promoting itself as a major fashion department store" (Fisher, C., 1989, July 17, p. R2). It took many years for the company to complete the repositioning process, and the company profits suffered in the 1980s. Today, JCPenney and Sears do not target the same customers with their merchandise offerings, although they are often located within the same mall.

Figure 7.7 Example of pull marketing.

[1]The concept of "The Big Three" in retailing has changed from decade to decade, according to industry publications. In 1980, "The Big Three" chains were Sears, JCPenney, and Montgomery Ward. By 1994, "The Big Three" were mass merchandisers Wal-Mart, K-Mart, and Target. In 2004, "The Big Three" were Wal-Mart, Target, and Costco.

In 2007, the JCPenney company began another repositioning campaign based on the slogan "Every Day Matters." The tagline was intended to convey to consumers that the company could assist them in showing their devotion to friends and family through shopping at JCPenney stores. The purpose of the 2007 repositioning campaign was to "help accelerate growth by helping the company develop an emotional and enduring relationship with current and future customers" (Edelson, S., 2007, Feb. 19). The company planned to attract a more affluent customer with lifestyle advertising, while remaining true to the core JCPenney customer. The marketing campaign was supported by offering better services in the stores and the inclusion of "aspirational brands to attract a higher-spending consumer" (Edelson, S., 2007, Feb. 19).

Unique Selling Proposition

Successful companies strive to be the best at one or more of the 4 Ps. Companies may have a superb design, the best service, the best prices, the best quality, the greatest value (price/quality relationship), the greatest accessibility (such as Internet), excellence in a product line, or the widest selection of merchandise. A company should excel in at least one of the 4 Ps of fashion marketing. This point of distinction is the company's **unique selling proposition (USP)**. Similar terms for the USP are **core competency**, **competitive edge**, and **competitive advantage**. A company should ask the question: "What does our organization do best?" The answer would be the company's unique strengths or competencies that allow it to differentiate itself from the other competitors in the market. By exploiting these special capabilities and ensuring the core business is sound, an organization can become successful.

Integrated Marketing Communications

How can a company ensure that all the marketing communications convey a consistent message to the target customer? The answer is by developing a seamless, integrated marketing

the Business of FASHION

Adding Value

When a company adds extra value and special attention to products and services, it is referred to as "value-added." It may occur at any level of the supply chain, from textile production to apparel manufacturing to retailing. Value-added products and services are a way for a company to carve out a niche in a highly competitive environment, but best of all, value-added products and services help increase sales.

Value-adding can include any type of original design manufacturing of products and services that is unique, functional, and more profitable. Value-added products include innovative textile technologies, such as special core-spun yarns with increased elasticity, and comfort-technology fabrics including wrinkle-free cottons, washable wools and silks, and even oil-repellant shirt fabrics. An example of a value-added service is the apparel manufacturer's efforts to ready the clothing for transition onto the retail store racks. Rather than hanging garments on disposable hangers, covering individual pieces with disposable plastic, and boxing the merchandise for shipment, apparel manufacturing firms can make the merchandise floor-ready. This saves retailers time unboxing and unpacking incoming merchandise and results in greater productivity and profits. Many small and medium-sized businesses have found that adding value to their products and services is an important key to their survival.

communications strategy (IMC). It seems like a complicated term, but it is actually a holistic industry concept that has been used, if not actually named, for a long time. The term **integrated marketing communications** is defined as a strategy for coordinating all of a company's available marketing tools to ensure that the company presents a united front and maximizes its communication impact. In other words, the entire company speaks with one strong voice. The management team bases every marketing decision on how well it conveys a consistent message to the intended audience or target customer. There should be consistency among all the functions of the marketing mix: advertising and promotions; personnel; logos, signage, and color schemes; packaging; visual merchandising; price zones and price endings; and many other facets of the 4 Ps of fashion marketing. For example, if an elegant, upscale retailer of women's career fashions implements an IMC campaign, its target customers should be able to identify with each of the marketing decisions. The main advertising venue might be the local newspaper because the target customer is educated and values keeping up with current events. Since she may commute to work each day, the store might choose to advertise on her favorite radio station during the early morning drive time. Both the newspaper and radio advertisements would convey a similar, sophisticated message to the target audience. The store's logo would appear in each newspaper advertisement and on all exterior and interior signage. The store might host special events, such as a wine and cheese tasting event, and fashion shows during lunch hours or the evening hours to attract affluent, working women. The store's visual team would use sophisticated color schemes for the interior displays, ensure ample room between the fixtures, and provide chairs for her to sit in to relax. The store buyers might limit orders to a maximum of three sizes per style in tasteful, sophisticated designs that mirror the preferences of the target customers. Personal shoppers might be available to preselect styles for her to try on during her lunch break or immediately after work. Once she selects her purchase, the clerk would carefully wrap the items in tissues paper and place them in quality shopping bags (not sacks) printed with the store's logo and in the store's colors. If the customer preferred, she could have the merchandise delivered to her home or work. All of these marketing efforts result in a seamless marketing communication that conveys the primary focus of the store and its services.

summary

- Successful businesses segment the market and select the consumer groups most likely to purchase the goods and services offered by the company.

- The target market is the chosen market segment, and the target customers are the businesses or individual within the group.

- Customers are targeted based on demographic, psychographic, behavioral, and/or geographic characteristics.

- Common demographic variables include age, income, education level, gender, and marital status.

- Common psychographic variables include values, attitudes, beliefs, opinions, interests, and lifestyles.

- Behavioral variables include usage or consumption rates and benefits sought.

- Geographic segmentation variables range from neighborhoods or zip codes to regions of the United States or groups of countries.

- A company may target multiple segments of a market or target a very narrowly defined market segment, called a niche market.

- The greater the number or size of the segments, the broader the products and services offered.

- Fashion marketers create strong relationships with the best customers through relationship marketing, by offering valued product and service packages.

- Relationship marketing helps ensure that the heaviest purchasers remain loyal customers.

- Marketing is a mutually satisfying exchange between a buyer and a seller.

- The marketing mix is subdivided into four unique segments: product, price, place, and promotion.
- Each of the marketing decisions involving the 4 Ps must hold the greatest appeal for the targeted customers.
- Positioning refers to the image the company or brand occupies in the customers' minds in relation to the 4 Ps of marketing.
- Repositioning refers to a deliberate and strategic change in the 4 Ps of marketing to create a different image in the customers' minds.

- The unique selling proposition is the primary strength, competitive edge, competitive advantage, or core competency of a business.
- An integrated marketing communications campaign ensures that all of the company's marketing communications convey a consistent message to the target customer.

terminology for review

target market 124
target customers 124
customer base 124
segmenting the market 124
market segmentation 124
demographic variables or
 demographics 124
psychographic variables or
 psychographics 125
behavioral segmentation 125
geographic segmentation 127
niche market 128
relationship marketing 129
marketing 130
4 Ps of fashion marketing 130
fashion marketing mix 130

products 131
goods 131
services 131
price 131
retail price 131
retail 131
full price 131
sale price 131
wholesale cost 131
wholesale 131
cost 131
markup 131
place 131
distribution 131
supply chain 131

channel of distribution 131
marketing channel 131
promotion 132
push marketing 132
pull marketing 132
medium 132
media mix 132
position 133
positioning 133
repositioning 133
unique selling proposition 134
core competency 134
competitive edge 134
competitive advantage 134
integrated marketing communications 135

questions for discussion

1. What are the 4 Ps of fashion marketing, and how are they different?

2. What is the relationship between a company's target customer and each of the 4 Ps of fashion marketing?

3. Why is the target customer at the center of all business decisions?

4. Why is it important for a company to describe its target customer in terms of demographics, psychographics, behavioral characteristics, and geographics?

5. What are some examples of each of the market segmentation methods (demographic, psychographic, behavioral, and geographic)?

6. Why might large stores have more than one target customer group?

7. What is a supply chain in the fashion industry, and how is each of the levels interrelated?

8. What is meant by the terms *positioning* and *repositioning*, and how are these used by a fashion company?

9. Why do successful companies focus on their unique selling proposition?

10. How can a company ensure that all the marketing communications convey a consistent message to the target customers?

related activities

1. Choose a favorite fashion retail store. Using the student's own knowledge, as well as a brief interview with a store employee (preferably a manager), creatively develop a prototype customer for the store. This should be a detailed demographic and psychographic description of the target market customer. It should also provide information in terms of behavioral characteristics and geographics. Name this prototype customer and describe his or her age, gender, identity, lifestyle, career, and other pertinent information. Most importantly, explain *why* the store caters to this customer. What products and services does the store offer that appeal to the target customer? What makes the store location a favorite shopping location for the customer? Consider adding visuals to enhance the presentation and share the paper and visuals with the class.

2. Develop and maintain a relationship marketing diary of your own service encounters. Post multiple times each week. Make note of the type of encounters you observe or the treatment you receive for the next eight weeks. The diary will probably include both good and bad examples of relationship marketing. In addition, find an electronic article from your library databases on relationship marketing. Incorporate your own findings and the article information into an analysis essay on relationship marketing. Provide the article citation in proper bibliographic format. Present the findings to the class.

3. Choose a favorite retail store located in a particular zip code. Use the PRIZM software to enter the zip code and identify the major customer segments for that zip code. Evaluate all the appropriate demographic, psychographic, and behavioral descriptions from the PRIZM Web site and synthesize them into a single target customer that most accurately describes the customers of the chosen store. Brainstorm with a partner on a six-month integrated marketing communication plan for that store. Be sure to cover all 4 Ps of marketing in the IMC. Present the results to the class as an electronic presentation or a written report. The Nielsen PRIZM Web site is http://www.claritas.com/MyBestSegments/Default.jsp. Choose the Zip Code Look-Up tab to enter the zip code and obtain the information.

4. Choose one of the numerous marketing videos available on the Small Business Administration Web site and watch as a class. Take notes and apply the most important points to successful fashion businesses. Explain how these fashion businesses have applied the suggestions from marketing experts. Online videos can be found at http://www.sba.gov/tools/audiovideo/deliveringsuccess/index.html.

Your Fashion IQ: Case Study
To Buy or Not to Buy

You are the buyer of a small, college town (population 21,000) bridal and prom boutique that enjoys a regional customer base. Because you are the largest prom and bridal shop in the area, your customers range from the more affluent girls in the college town to the lower income families in the rural areas. Your primary target customers are middle to lower-middle income. Most all of them appreciate fashion, regardless of how much they can afford. Your store offers the promise that your customers never have to worry about seeing another girl wearing the same dress at a school prom, if they buy from your store (you keep good records).

This week a sales representative calls on you at the store and brings samples of attractive but unbranded dresses. You have an opportunity to purchase these off-brand prom dresses that are knockoffs of the popular brand Alyssa. As the store buyer, you may opt to buy this line at a lower cost than similar dresses carrying the Alyssa brand. You are concerned that the dresses may lack the consumer recognition that is present with a national brand, such as Alyssa, even though the fashionability and quality seem comparable to the recognizable branded line. You contemplate buying the line and accepting a lower markup on this off-brand, in hope of attracting a similarly fashionable but more price-conscious consumer.

However, you worry that your more affluent customers, in search of a unique dress, may choose another brand not carried by your store if the off-brand looks too similar to the Alyssa brand.

QUESTIONS:

1. Should you buy the line or not?

2. Will it compromise your existing Alyssa brand?

3. What are some considerations that need addressing that are not presented in the case study?

4. Given the information presented, what choice would you make and why?

Fashion is bad news, good news. The bad news: Nothing ever stays in fashion.

The good news: Eventually, it will come back into fashion again.

This simplified, yet intriguing explanation is a caveat of fashion.

FASHION ANALYSIS and PREDICTION

LEARNING OBJECTIVES

At the end of the chapter, students will be able to:

- Explain the different stages of a fashion life cycle.
- Identify the types of consumers at each stage of the fashion life cycle.
- Relate each stage of the fashion life cycle to the 4 Ps of marketing.
- Identify the fundamental steps in research.
- Identify the various types of fashion research.
- Define basic research terminology.
- Create and conduct quantitative research.
- Compare the different types of quantitative research and know when each is most appropriate.
- Discuss the role of technology in fashion marketing research.

Fashion Life Cycle and Adopter Groups

Marketers analyze sales data to make predictions about the remainder of the fashion life cycle. The process for analyzing any style is similar, whether it is a home product, apparel item, accessory, automobile, or hairstyle. Fashions and most other consumer products undergo an introduction, a period of growth, and a period of decline in popularity. The various terms for the succession of stages include: **fashion life cycle**, **product life cycle**, **product diffusion curve**, **fashion curve**, **fashion adoption curve**, or **fashion adoption process**. Although the precise term may vary, the pictorial view is a bell curve. The horizontal or X-axis represents the length of time of the life of the fashion, ranging from a few months to years. The vertical or Y-axis represents the number of people adopting the fashion. Five main segments divide the cyclical life of a fashion. These are:

- Introductory stage
- Rise or growth stage
- Culmination or peak stage
- Decline stage
- Obsolescence stage

The shape of the diffusion curve varies depending on the number of people adopting and the speed of adoption of the fashion. The product life cycle for a standard **fashion** is a bell-shaped distribution curve (see Figure 8.1). A **fad** is characterized by a quick rise to popularity and an even more rapid decline (see Figure 8.2). Tie-dyed T-shirts are usually a one-season fad. A **classic** is a fashion that remains popular over a relatively long period of time (see Figure 8.3). Classic examples include five-pocket blue jeans, animal prints, and a man's navy blazer with a moderate-width lapel.

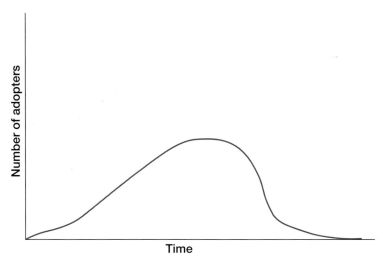

Figure 8.1 A fashion is represented by a bell curve.

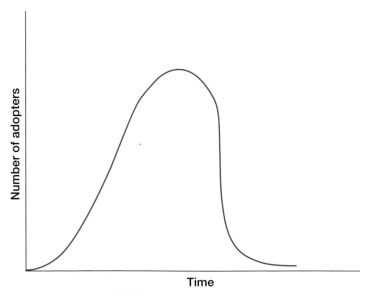

Figure 8.2 A fad has a rapid rise to popularity and an even quicker decline in popularity.

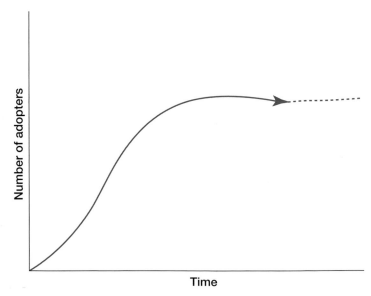

Figure 8.3 A classic life cycle has an extended culmination stage.

Introductory Stage and Fashion Innovators

The **introductory stage** represents the beginning of the fashion life cycle when a group of experimental consumers, called **fashion innovators**, adopt a new look. Fashion innovators comprise only a small percentage of consumers. They will be the first to wear the style, and it becomes a fashion when the innovator's peers and followers imitate the look. The number of adopters increases as time progresses. Fashions at this stage may be expensive, they are different from the existing fashion, and they may be unique to a particular subgroup of the population. Why do fashion innovators begin to wear this new style? Perhaps they desire to be different from others, they enjoy the prestige associated with wearing a new fashion, or they change due to boredom.

Rise Stage and Early Adopters

The **rise or growth stage** occurs when a group of fashion-conscious consumers appreciates and imitates the innovator's new styles. **Early adopters** comprise the second group of consumers who wear the fashion. The early adopters may not desire to be the very first to wear a fashion, but they enjoy wearing the latest fashions.

The following example illustrates the relationship between fashion innovators and early adopters. In the 2000s, low-rise waists on pants and jeans were fashionable for several seasons and progressively descended until modesty prevented designers from lowering them any further. Once the waistline reached the lowest possible point (just before indecency), there was only one direction for the waistband to go—up! Without fashion innovators, waistbands might have hovered at a low rise for even more seasons. However, the same look bored the experimental fashion innovators. They desired a different style to express their individuality. The sexy appeal of the ultra-low-rise jeans abated, and the fashion innovators opted for a new look—higher-waist pants. The early adopters began copying the innovator's new style, and the fashion headed toward the culmination or peak stage.

Culmination Stage and Early Majority

The **culmination or peak stage** is a time when a large percentage of a population is wearing a fashion; everyone who wants the fashion wears it. The **early majority** represents consumers during this stage. The early majority comprises the large group of consumers adopting the fashion before, during, and slightly after the peak of the fashion life cycle. These consumers prefer to wait until numerous others wear a particular style before they desire to wear it themselves.

The culmination stage may occur within a few weeks of the time that innovators first wear the fashion, or it may take one or two years before the fashion gains mass acceptance. Numerous times, various fashionistas have unscientifically stated that when a fashion is shown in Paris (or even New York), it takes one or two years for the fashion to be adopted by the masses in middle America. Is this fact or fiction? A scientific investigation examining several pervasive fashions might determine the speed of fashion adoption to other geographic regions. With most fashion ideas, such as the popularity of ruffles on clothing, it only takes the time needed for manufacturers to view the style on the runway shows and then produce the garments for the stores. This may be as little as three months.

Decline Stage and Late Majority

The **decline stage** occurs when there is a reduction in the number of people buying the fashion. Consumers may still wear the fashion, but declining sales force retailers to reduce prices on the fashion goods that remain in the store. If offered a good price, bargain shoppers may purchase the fashion for the first time, or they may purchase another color or replacement of the same fashion. Consumers at this stage of the fashion life cycle comprise a large segment called the **late majority**. By the decline stage, the fashion innovators have discarded this fashion because they do not want to wear what everyone else is wearing. They choose to be different and begin to look for a different style to adopt.

Obsolescence Stage and Laggards

The **obsolescence stage** represents the final stage in the life of a fashion. The general population rejects the purchase of the merchandise in this stage, and most retailers eliminate it from retail assortments. Stores clearance any remaining merchandise and sell it at sidewalk sales. The innovators and early adopters no longer wear this fashion because the style is noticeably dated. Consumers at this stage of the fashion life cycle belong to the group called **laggards** because they lag behind in adopting and wearing the fashion. The item may hang in the closet for a few more months, but few people wear it. Most people eventually discard the item or donate it to charity. Innovators introduce a new look to replace this obsolete style, and early adopters excitedly adopt the latest fashion. The fashion cycle is well underway for a newer, more fashionable look.

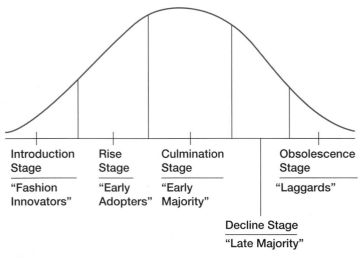

Figure 8.4 A fashion life cycle can be divided into five stages. Each stage has a different group of consumers.

Marketing and the Fashion Life Cycle

The strategies for marketing fashion merchandise differ at each stage of the fashion life cycle. As the same product moves through the diffusion process—from the introductory stage through the obsolescence stage—the price, promotion, and place strategies change. In this next section, the marketing strategies for each of the 4 Ps are described in the stage where they are most often used for a trickle-down fashion. If a fashion follows the trickle-up theory of adoption, as is often the case with streetwear (such as the skater fashion), then the marketing strategies may be different from the information presented in this textbook. Table 8.1 provides a summary of the following information.

Marketing Fashions during the Introductory Stage

Product Consumers may not be familiar with new fashion products, so marketers use the introductory stage to build awareness of the new fashions. The fashion innovations may be a new color, new style, new fabrication, or combination of these things. Fashion-forward stores use introductory stage merchandise to set the fashion image for the stores. The new products get prime selling space, and the visual merchandisers devote displays to the innovations. Designers present the upcoming season's looks to fashion innovators at the trade fashion shows and couture fashion shows on red carpet runways. Consumers gain awareness of the products by viewing these televised events and reading celebrity-spotting pages of fashion

Table 8.1 Marketing Strategies for Fashion Merchandise in the Five Stages of a Product Life Cycle

A fashion life cycle can be divided into five stages. Each stage has a different group of consumers.

	Introductory Stage	Rise Stage	Culmination Stage	Decline Stage	Obsolescence Stage
Pricing Strategies	Generally higher prices due to rarity, to recoup research and development costs, or to cover the risk associated with new product failures	Full prices due to limited competition and rapid rise in sales volume; demand may exceed supply	Slightly reduced prices to attract new buyers in a competitive environment; 20–30% off sales	Half-off sales; end-of-season clearance sales	75% off sales; multiple markdowns; priced to sell; donated to charities
Promotion Strategies	Focus on informing consumers about new product features through personal selling, fashion shows, special events, window displays, and exclusive advertisements; use of cooperative advertising	Persuades consumers to visit the retailer for the best brands; promotes differentiation among brands; increases demand; window displays are used or interior displays are placed near the merchandise in high-traffic areas	Reminds consumers to purchase either for the first time or to buy replacement merchandise (stabilize sales); advertisements focus on complete assortments and competitive prices; interior displays diminish in use; merchandise is moved to center of store or department	Limited marketing except to advertise storewide or department-wide sales; merchandise moved toward the back of the store	Sidewalk sales
Distribution or Place Strategies	Couture salons, exclusive specialty stores, special orders	Specialty stores, some high-end department stores, luxury retail Web sites	Mass merchandisers, department stores, specialty stores, off-price retailers, discount stores, Internet stores, and catalog merchants	Discount stores, off-price retailers, online auctions	Close-out retailers, online auctions, charities

magazines. According to Stacy Bendet, owner/designer for Alice + Olivia, "The biggest effect on business has been from celebrities shot in clothing. It creates a buzz around the brand and it helps to define the image of the brand" (Beckett, W., 2008, June 18).

Price The prices of newly introduced fashion products are usually higher than fashions that have gained widespread consumer acceptance. An exclusive, designer-original dress may carry a price tag of several thousand dollars. The price is a reflection of several factors, including the creative genius, cost of materials, fiber content or textiles used, and amount of hand workmanship. A certain risk of failure exists when introducing a new product, so the price may need to be high enough to cover possible new product failures.

Promotion The goal of promotions at the introductory stage is to inform the consumers of the innovation. The promotions to launch a new product may include designer or celebrity appearances, fashion shows, trunk shows, personal selling, institutional advertisements, exclusive single-item advertisements, and window displays featuring the merchandise. These venues for promotion create a directed focus on the new items or provide face-to-face selling. Having direct contact between a salesperson and a customer is important because new fashions may require explanations or demonstrations on how to wear it. In the

late 1980s when silk scarves were just coming into popularity, some stores had videos in the accessories department to demonstrate the many ways to wear rectangular or square silk scarves. This informative promotion helped sell scarves to customers that were interested in wearing the fashion but did not have confidence or know-how to tie them correctly. When a new fiber is in the introductory stage, as was the case with lyocell (similar to rayon) in the early 1990s, promotions occurred at the trade level to make sure textile producers, apparel manufacturers, and retail store buyers knew about the benefits of the new fiber.

Fiber producers may feature a new product at trade shows or fairs and run advertisements in trade publications. The intent is to provide educational information about a new fiber, encourage textile producers and apparel manufacturers to purchase the raw materials and fabrics, and persuade buyers to order merchandise for their retail stores. The fiber manufacturer may also promote to the ultimate consumers in fashion magazines, encouraging them to ask for the innovative product in their favorite retail store or buy brands that contain the fiber (see pull marketing in Chapter 7). **Cooperative advertisements** are common in the introductory and rise stages. This means the manufacturer and retailer split the cost of the new product advertisement.

> Generally, fashion merchandise is introduced at higher prices and then is reduced as greater numbers of manufacturers produce competing products.

Place Couture salons or exclusive stores sell expensive introductory styles, such as designer goods, during this first stage. Larger specialty stores may open a designer boutique in a section of the store. The store designates the area for a single designer and may have customized floor fixtures to showcase the new merchandise. Neiman-Marcus, a chain of upscale specialty stores, has several designer boutiques on a single floor. Each boutique has different and unique fixtures; the fixtures reflect the image the designer is attempting to convey.

Marketing Fashions during the Rise Stage

Product Fashion marketing efforts target early adopters who desire to emulate styles worn by the innovators. Therefore, the early adopters are responsible for a fashion's rise to popularity. These persons move what has been merely a style to the status of fashion.

Price During the rise stage, some fashions are still relatively pricey, but others are quite affordable. Generally, fashions that follow the trickle-down theory of fashion adoption get less expensive as they progress from the introductory stage to the rise stage. For example, when the Paris *haute couture* introduces a Valentino or Lacroix designer dress, the innovative original may cost $25,000. The same style, knocked off by a copycat designer, may only cost $500 when it is in the rise stage. Fashions that follow the trickle-up theory of fashion adoption may not have price as an issue. If the style originates on the street, such as the grunge or thrift store look, then the price of the fashion during the rise stage is probably not an issue. When fashion marketers incorporate the grunge or thrift look into mainstream fashions, then the retail prices will probably be higher than they were originally.

Promotion The goal of promotions during the early part of the rise stage is to inform the consumers of the prestige of purchasing a new fashion. Later in the rise stage, the goal is to

persuade the consumers to purchase a particular brand. Promotions during the rise stage often involve full-price advertisements featuring the retailer's complete assortment of a branded fashion. Store merchandisers want their customers to know the store carries the fashion and that it has particular brands in a full range of sizes and colors. Visible interior and exterior displays contain merchandise in the rise stage because many consumers are becoming interested, although they may wait to buy until the next stage of the fashion life cycle. Within store interiors, merchandise is placed near the front of the department and adjacent to main aisles. Customers walking through the store may notice the new arrivals and appreciate the fashion-forward look.

Place The types of retail stores most likely to carry fashion in the rise stage are specialty stores of any price range. Many of the specialty stores are higher-priced, but fast-fashion stores, such as Forever 21 and H&M (Hennes & Mauritz), offer early rise stage fashions for low prices. The trendy specialty stores offer clothes intended for wear during a single season before consumers discard the items. These trendy, but inexpensive fashions are **disposable fashions**, **fast-fashions**, or **high street fashions**.

Marketing Fashions during the Culmination Stage

Product The culmination or peak stage represents the largest of the five stages of the fashion life cycle. Fashion companies gear mass-market merchandise to consumers who prefer to purchase a fashion in the culmination stage. A moderate-priced store projects its basic image through an assortment of culmination stage merchandise.

Price Slightly discounted prices dominate the culmination stage to stimulate buying and to get consumers to purchase the fashion at a particular store instead of a competitor's store. Retailers offer small percentages discounts (10 to 25 percent off) during the culmination stage, but the discounts are competitive.

Promotion Prior to the peak of the culmination stage, the goal of promotions is still to persuade the consumers to shop at a particular store. This store may have a better selection, better price, reordered shipments, or some other reason desired by consumers. The goal of promotions after the peak of the fashion life cycle is to remind the consumers to purchase replacement merchandise for a good price from this store. The assortments may be broken— meaning an incomplete range of sizes and colors, so prices may be lower. Promotions include buy one, get one (BOGO) at a percent off and other advertised sales designed to encourage quick sales. Visual merchandisers remove items in the culmination stage from exterior window displays but may still display the merchandise in store interiors near the racks and shelves of the remaining line or collection. Merchandisers relocate the merchandise to the middle or back of the store to make room on the main aisles for newer arrivals.

Place Fashions in the culmination stage are available in most mass merchandise stores. The store buyers have confidence that the style has become a fashion in demand. Certain colors or designs may continue to show an increase in sales or may maintain a certain sales level and become a classic, but most of the fashions in the culmination stage crest and then begin to decline in popularity. Other retailing venues include television home shopping networks, the Internet, and mainstream fashion catalog retailers, such as Lands' End.

Marketing Fashions during the Decline Stage

Product Conservative consumers who purchase a fashion after it begins to decline in popularity may do so for a few reasons. They may be reluctant to call attention to themselves, they may choose to wear items that have a proven record of fashionability, or they may be price-conscious. Marketing efforts still do exist during the decline stage, but marketers greatly reduce efforts and focus on selling the remaining merchandise rather than presenting individual fashions.

Price Stores reduce prices and clearance merchandise in the decline stage. Retailers are not making significant profits on the sale of decline stage merchandise because of reduced retail prices. Instead, they are turning over the inventory and releasing the capital funds so they will have open-to-buy monies for newer merchandise.

Promotion The goal of promotions during the decline stage is to continue to remind consumers to purchase the merchandise. Advertising and promotions would be limited to department or storewide sales events, such as sidewalk sales or end-of-season clearance sales. Stores no longer offer complete assortments of the styles. Merchandisers group decline stage merchandise on a single sale rack by size or color, probably at the back of the department or store, so that the picked-over appearance does not detract from the overall store atmosphere. Department managers should make concerted efforts to keep the sales racks as neat as possible by assigning personnel to regularly scheduled straightening of sales racks.

Place A store will carry decline stage merchandise if it is unsold inventory remaining from the culmination stage. Once merchandise passes its peak, it quickly reaches the decline and obsolescence stage. Retailers do not desire to keep inventory that has reached the decline stage. Most retailers will continue to mark down the items until they sell, even if the final selling price is a small fraction of the original retail price. Department managers should be on guard to ensure unsold inventory does not accumulate in the back stockroom. With few exceptions, fashion inventory should not be stored over a season because it is perishable and will become even more difficult to sell as time progresses.

Marketing Fashions during the Obsolescence Stage

Product Merchandise remaining during this last stage of the fashion life cycle would include out-of-season or out-of-fashion items.

Price Retailers do not expect to earn profits on merchandise in the obsolescence stage. The store personnel prices the merchandise to sell, even if it means the store takes a significant loss on the merchandise. During the obsolescence stage, unsold inventory is far worse than a low selling price.

Promotion Sidewalk sales are common marketing strategies for stores to rid themselves of outdated inventory. Some larger companies have outlet stores that house all of the branch stores' unwanted merchandise. This method helps upscale retailers maintain their elite image by removing unfashionable merchandise from the selling floor and transferring the goods to an off-price location.

Place Independent jobbers may buy a store's excess inventory and resell the items to off-price retailers and bargain basement stores. Stores may try to sell merchandise through other retail venues, such as the Internet. At a recent WWD Magic trade show in Las Vegas, Nevada, retailers were encouraged to visit the eBay kiosk and learn how they could sell clearance merchandise online. For example, a prom and bridal store might sell out-of-season and well-worn rental dresses through eBay or other online auctions. Other stores may cut out the labels and donate the merchandise to charities. Removing labels, red lining labels, or cutting through labels prevents dishonest customers from attempting to return a charitable item for store credit. A store also has the option of destroying the leftover fashions to prevent unwanted returns and requests for merchandise credits.

Database Marketing

Most large fashion companies have access to electronic software that gathers information about target customer demographics and buying habits, peak selling times, preferred methods of payments, and many other data that describe the target customer. As sales occur, the sales data and customer information are stored in data warehouses. **Database marketing** is the process of extracting and interpreting customer data from available electronic information. In a centralized database, companies can keep records of customers' most recent purchases and the frequency and amount of past purchases. These data allow marketers to target specific promotional campaigns to keep the customers satisfied. For example, a click-and-mortar retailer may send out an e-mail containing a $10 gift coupon redeemable online or in the store during the valued customer's birthday month. This coupon is a way of thanking and maintaining the company's best customers—the ones that spend the greatest amount of money in a twelve-month time period.

Fashion Forecasting

The fashion industry has many independent companies that offer fashion forecasting and global trend reporting services. **Fashion forecasting** is predicting the trends in popular colors, prints, styles, fabrications, and general trends. Fashion forecasters base their predictions on sales data; social, political, and economic events; international fashions; pop culture; business trends; and their own knowledge of the fashion industry. Most large fashion companies subscribe to at least one of these services. The benefits of subscribing to a fashion forecasting service is that these services synthesize vast quantities of fashion information into a manageable report. Fashion businesses do not have to spend weeks and weeks gathering the trend data. Fashion forecasting services present only the most important and key trends to subscribers. The next section presents some popular forecasting services.

Color Association of the United States

Since 1915, the Color Association of the United States (CAUS) has been forecasting upcoming colors for apparel and accessory fashions and home fashions. Services of the Color Association of the United States include seasonal color forecasts, bimonthly news reports, color and

pattern archives for research, workshops and presentations, and a color hotline. The Color Association of the United States has a creative internship for students interested in color forecasting. The company's Web site has information on the internship at http://www.colorassociation.com/site/internships.html.

Doneger Group

The Doneger Group, established in 1946, is a large company that includes a buying service as well as a trend and color forecasting service. Located in New York City, the Doneger Group analyzes all segments of the apparel and accessories markets. In addition to forecasting, the company offers complete market coverage, and it shops the U.S. and European retail markets and attends textile and trade fairs. The company has several divisions under the three major categories of merchandising, trend, and consulting services.

Promostyl

Headquartered in Paris, Promostyl is a global trend forecasting, market research, design, and consulting service company. Promostyl's services fall into two major categories: trend books and special projects tailored to the clients' own needs. The trend books offer textile swatches, sketches, and electronic information to assist fashion professionals in identifying important trends. The exclusive projects for clients include market research on brand awareness and consumer behavior, assisting with creating designs and collections, and helping companies with store merchandising.

the Business of FASHION

Trend Analysis

Trend analysts observe and analyze human behaviors in all things social in order to interpret and predict future behaviors of consumers. Most large fashion companies have trend analysts on staff or subscribe to trend forecasting services. Trend forecasting seems glamorous and requires the staff to travel to Asia, Europe, and other major fashion market centers. However, it is more than merely photographing fashions at nightclubs in New York, Los Angeles, London, or Paris and street spotting. It is a business of collecting information. Trend analysts in the field spend days photographing and documenting trends in art, interior design, music, food, and fashion. At the company headquarters, teams of trend analysts pour over the thousands of field photos and notes and interpret them in a context of political, economic, and social climates.

Trend gurus such as New York's David Wolfe of the Doneger Group and Faith Popcorn of BrainReserve or the Dutch trend forecaster Li Edelkoort have made trend analysis their business. These trend forecasters study societal movements and predict consumer preferences. It is not a magical insight bestowed on a few lucky individuals, but it is a highly trained awareness and intellectual curiosity.

Trendstop

Trendstop is an online trend book for global fashion professionals in men's and women's apparel and accessories. The Web site includes daily updates on color and fashion trends in fabrics, accessories, and apparel, from high fashion to street style. The company's researchers are located in London, England, although the company gathers trend information from major fashion cities across the globe. Trendstop features subscription information online at http://www.trendstop.com/main.

World Global Style Network

One of the main functions of the World Global Style Network (WGSN) is to analyze global fashion trends and put them in the perspective of the client's business. WGSN headquarters in London, but has offices in New York, Hong Kong, Seoul, Los Angeles, Melbourne, and Tokyo. The company offers global services, including online research, photo archives, trend analysis, and daily news. The company Web site offers a brief video called *Creative Intelligence* at http://www.wgsn.com/public/html/about-company.htm. The video provides an overview of the major purposes of the company.

Fashion Research

Why is it valuable to conduct research in the fashion industry? Businesspeople rely on the findings from research to make decisions about the firm's current and future business endeavors. **Fashion research** is a systematic method of collecting and analyzing data about a problem and then making a decision based on the findings. For example, an apparel company might consider manufacturing white shirts and blouses to complement an existing line of misses career apparel. Appropriate fashion research might include style testing to see whether the target customers prefer a surplice style, a traditional button-up style, a closely fitted style with spandex, a sleeveless or short-sleeved style, or any other style under consideration. The company can conduct a survey to investigate whether or not it should also expand into the junior market. The company can conduct research on the optimal selling price and determine if adding value, such as embroidery, would allow the company to sell the blouses for a higher markup and profit margin. In a second example, a retailer of career apparel might conduct research to determine what strategies would allow the company to increase market share—should the company consider a Web site? Should it open a branch location in a suburb? In a third example, a fashion company might collect data to determine the best sales promotion activities to reach its trade customers or to determine what factors contribute to customer satisfaction or dissatisfaction.

Researchers collect information in the clothing and textiles industry for purposes other than making contemporary business decisions. Research might be historical—studying and documenting the past. For example, a survey of textiles, fashionable styles, or construction techniques for **extant** (still existing) historic costumes will provide historic data that may be

revisited and evaluated long after the garments and textiles have deteriorated. The U.S. government may employ universities to research high performance textiles or protective clothing suitable for industrial or military applications. The topics for research in the last fifty years are extensive; a perusal of doctoral dissertation titles on the topics of fashion, textiles, clothing, or apparel offered in a dissertation database numbered more than 1,600 titles.

Types of Research and Data

Research can be classified as quantitative or qualitative in nature. **Quantitative research** involves the collecting of relatively small amounts of data on large numbers of persons or things. Data are statistically analyzed to determine averages, frequencies, and other generalizable concepts. For example, during the Civil War, states collected large amounts of sizing data on the soldiers when the governments measured them for uniforms. This provided data that assisted manufacturers in developing standardized sizes for the menswear industry. **Qualitative research** can involve collecting in-depth data on a particular topic or group of people. For example, a research topic might be to analyze the textiles or functions of dress within a subculture of the American society, such as a group of Quakers in Pennsylvania or a group of quilters in Michigan. It is an in-depth study of the small group, rather than an attempt to gather smaller amounts of data on a large group.

Researchers classify data as primary or secondary data. They collect **primary data** or facts to answer a particular marketing research problem. For example, a fashion retailer of prom dresses may conduct a satisfaction survey for a one-month period. Every customer spending at least $150 in the store during the month will have printed on her sales receipt a Web survey address that they can visit, complete an online survey, and be entered into a drawing. The re-

FASHION FACTS: Research Terminology

- **Sample.** The representative group of persons, organizations, or things from a population selected for the research. For example, a sample might be every third one or a random sample of all of the apparel showroom vendors located in a regional fashion mart.
- **Sampling.** The process of selecting the participants for the research project.
- **Population.** The group to be surveyed.
- **Sampling Frame.** The resource used to obtain the sample for the research. A sampling frame might be the local telephone book or the names of showroom vendors published in the directory of a regional fashion mart. The sampling frame provides the sampling group.
- **Simple Random Sample.** Each member of the sample has a random and equal chance of being selected. For example, a research may obtain a random sample from the names listed in a telephone directory. Software programs can generate random samples of these customers' telephone numbers. A substantial random sample is a good representation of the larger population.
- **Convenience Sample.** A group of persons or things selected for the survey because they were available. For example, a convenience sample might be a group of period dresses in the historic costume collection located at a specific university. It also might consist of the customers in a store who are willing to complete a brief survey at the cash register.
- **Judgment Sample.** The group of people or things selected for the survey based upon the researcher's discretion. For example, a researcher might approach mall shoppers that appear to be in a certain age range, that dress a certain way, or have families with them.
- **Sample Size.** The number of the selected persons or things to be surveyed. When conducting quantitative analysis, the larger the sample size, the more representative it is of the population.

tailer collects specific primary data to improve store services. **Secondary data** are previously collected and published facts that answer another's research question. The U.S. government is a collector of demographic census data. Business professionals statistically analyze these external secondary data from the government to answer their own unique research questions. Using the same retailer as an example, the company may refer to available census data for statistics about the population in the company's trading area. The store can extract average salaries, education levels, household size, home ownership, and other external secondary data that might be useful in deciding what services to offer. Perhaps the store might want to consider the service of renting wedding and prom dresses in addition to outright sales, if the consumers in the trading area fall below the national average in income. A business may analyze its own internal secondary data, such as sales records, salesperson performance, reasons for returns, or other potential problems. Generally, secondary data are less expensive to gather than primary data. Trade organizations, commercial databases, and marketing research companies routinely collect data on the marketplace and sell data to companies needing a fast source of external secondary data to complete research projects.

Steps in Conducting Quantitative Research

Researchers use seven major steps when conducting quantitative fashion marketing research. Whether a researcher chooses to conduct a mall survey, Web-based survey, in-store survey, comparative analysis, or evaluation of historic data, the basic steps remain constant. Once the steps are learned, researchers can adapt the steps to meet the unique requirements of their own research.

Step 1: Defining the Research Problem. Most researchers agree that a well-defined research problem is key to the success of any research project. Researchers often pose a problem statement as a question. What is the researcher trying to find out? Examples of problem statements include: Does a relationship exist between two variables, such as sales and marketing efforts? What are the personal characteristics or buying habits of a group of target customers? What is the degree of satisfaction or dissatisfaction with a company's existing services? How can the company increase the effectiveness of its promotional mix? Before designing the research, the marketer should conduct an exploratory investigation to help narrow the research problem and clearly define the scope of the research.

Step 2: Developing Hypotheses. Once the researcher defines the problem, the researcher formulates hypotheses. A **hypothesis** is an educated guess about the relationship between identified variables. It is the researcher's prediction of expected findings based on his or her own knowledge and related literature on the topic. Each hypothesis should relate to the research problem as a subcomponent. Examples of predictive hypotheses include: keeping a store open one hour later during the fourth-quarter holiday season will result in a X% increase in store sales and plus-sized consumers are willing to pay higher prices for a greater fashion selection in apparel. A researcher may formulate more than one hypothesis to test during the research project.

Step 3: Selecting the Sample. Researchers select potential respondents who are appropriate representatives of the target audience. Researchers often desire a random sample, but it is not the only option. If a student conducts a **fashion count** of the popular denim finishes or colors of backpacks carried by males on a college campus, the student researcher would probably count a convenience sample. Every male wearing jeans or carrying a backpack that walks by the researcher during a specified time is analyzed for the particular fashion.

Step 4: Developing the Research Instrument. The research instrument is the method for collecting the data. When the sample involves human subjects, the research instrument is often some type of questionnaire or observation technique. It might be an online or Web-based survey, paper-and-pencil survey, telephone survey, in-store survey,

or any other creative method to gather information about a population. If researchers collect the data in other ways, such as from color photos in select fashion magazines, observations, or running tests (such as textile burn tests), the research instrument should include all probable categories of findings. The researcher will want to administer a small-scale version of the research and work out any potential problems before going to the expense of a full-scale research project.

When administering surveys to human subjects, the researcher should value the respondents' time. Most surveys should be relatively brief, and only the most pertinent questions should be included in the survey. To facilitate quick data analysis, the majority of survey questions are **forced-choice questions**—that is, the respondent chooses the most appropriate response from a predetermined set of responses. Good examples of forced-choice questions are multiple-choice questions on an exam and questions that can be answered with yes or no. **Open-ended questions** require more analysis but can provide the researchers with well-defined data because the respondents develop their own answers. An example of an open-ended question is: "Which of our company services are especially valuable to you?" Sometimes, open-ended questions are converted to forced-choice questions to simplify data analysis. Using the same topic, the researcher can ask the respondent to: "Look over the list of company services and rank the top four services used."

Step 5: Collecting Data. Once the research instrument has been developed and tested, data collection begins. This is simply the process of recording the results. If using in-store surveys, the researcher may collect data at the cash register, or the customers may drop their responses in a locked response box. If researchers mail the surveys, the data collection begins with the mass mailing and ends when the decision is made to close the survey and accept the last returned response. If the data collection process involves analyzing the length of women's hemlines from 1900 to 1999, the researcher will count every visible dress length in selected issues of a fashion magazine for each year, every fifth year, or some other consistent process.

Step 6: Analyzing and Interpreting Data and Drawing Conclusions. This step can range from the simple methods often used by university undergraduate students to the complex statistical procedures used by university statisticians or statistical analyses software programs. Researchers commonly use Microsoft Excel for recording data and then analyzing the data. The researcher often creates charts in Excel to pictorially represent the data. For example, if a student researcher completed a campus count of one hundred college females wearing denim jeans and recorded the dominant washes (dirty washed, dark denim, stonewashed, acid-washed, whisker washed, etc.), he or she could create a pie chart with slices showing the percent of women wearing dark denim, the percent of women wearing dirty washed, and so forth. Based on the findings, the researcher could interpret the data to the population. For example, if 40 percent of the females were wearing dark denim, the researcher might deduce that dark denim fabric is in the peak of the fashion life cycle. If only a couple of females in the sample are wearing whisker-washed denim, the researcher might infer that whisker-washed denim is near-

FASHION CHRONICLE

Linear View of the Order of the Research Stages

Defining the Research Problem		Selecting the Sample		Collecting Data		Reporting Findings
	Developing Hypotheses		Developing the Research Instrument		Analyzing and Interpreting Data and Drawing Conclusions	

ing the obsolescence stage, given the widespread popularity of it in previous seasons. The researcher will re-examine the hypotheses and determine if the data supports or refutes each hypothesis. Researchers draw conclusions based on generalized findings.

Step 7: Reporting Findings. Public researchers, such as university professors, have an obligation to report their findings so that other researchers may expand on previously conducted studies. Businesses prefer to keep findings closely guarded secrets, especially since the intent of the research was probably to collect data that could potentially increase profits.

Common Research Methods Used in the Fashion Industry

Good research is effective at all levels of the fashion industry. It can be as complicated as a Web-based survey sent to millions of consumers in a targeted group, or it can be as easy as having the company's salespeople ask key customers a few simple questions. The method of research selected depends on the problem statement; the type of data to be collected; and the company's available resources: monies, personnel, and time. Each of these data collection methods has unique benefits. Experts divide most research into survey, experimental, or observation research.

Survey Method The survey method involves the asking of questions via questionnaires or personal interviews. Researchers obtain information on consumer demographics, psychographics, and behavioral characteristics with the survey method. The survey questions may be forced-choice or open-ended or a combination of both.

Questionnaire The purpose of a questionnaire is to obtain information directly from the respondents. Questionnaires can be completed face-to-face; or via telephone, post mail, or e-mail; or as a Web-based questionnaire. According to an article on the Small Business Administration Web site, questionnaires are easy to implement and can obtain important information to assist in marketing. The Web site lists five important topics commonly addressed in marketing survey questions:

1. Why do the customers buy from your business?
2. How do they use your product or service?
3. What do they like and dislike about doing business with you?
4. How does your business compare to the competition?
5. What does your business do that annoys, infuriates, or delights them?

SOURCE: 12 high-impact marketing programs you can implement by next Thursday. *Small Business Administration Web site*. www.sba.gov.

Mall Approach Interview In the **mall approach** technique, a research representative approaches a potential respondent who appears to fit the target customer profile. The research representative stops the shopper and begins the interview with a series of demographic questions to ensure the respondent is part of the target market. For example, a woman with a small child in a stroller might be a candidate for the mall approach if the researcher is trying to gain information on opinions about a children's brand or a children's retailer in the mall. However, the research representative may find out the woman pushing the stroller is only the babysitter and may not be a purchaser of children's clothing or a likely shopper at the mall retailer.

Focus Group Interview This research strategy involves bringing a small sample of eight to fifteen individuals together in a comfortable environment. The **focus group** is a semistructured

environment that allows the researcher to gather in-depth information from the respondents on their buying habits, opinions, and attitudes toward the brand or product.

Experimental Method Researchers might conduct experiments that test the sales success of a new product in a small market or compare the buyer behavior of a test group to the behavior of a control group that did not receive the experiment.

Style Testing Style testing is a procedure whereby manufacturers produce a limited quantity of colors or versions of a particular style and test samples in the marketplace before making the decision to manufacture large quantities. Based on consumer feedback, manufacturers decide to promote and mass-produce only the most popular styles. Style testing helps retailers make informed decisions about what to order for their stores. Preseason style testing can greatly reduce end-of-season markdowns.

Market Testing A **market test** realistically gauges consumer responses to the introduction of a new product in a smaller market area, such as one or a few cities, before expanding to a larger regional market or nationwide. For example, if a moderately fashionable discount retailer desires to introduce a new line of private label athletic shoes, the company might test-market the shoes in a city such as Tulsa, Oklahoma. Consumers in the Tulsa market tend to be somewhat conservative and prefer middle-of-the-road looks when it comes to fashions. By testing the success in a city such as Tulsa, the discount retailer can gauge the probable success of introducing the line to its target customers across the nation.

Observation Method The method of research vital to keeping abreast of upcoming fashions is observations. Astute businesspeople observe clothing in the movies, on television, on celebrities on the red carpet runway, on musicians, in fashion magazines, on people on the street, on youth and the subcultures, and on customers. Observations provide a view of only the overt actions of the respondents; the researcher does not typically get involved with the subjects.

summary

- A fashion product life cycle has five stages: introduction, rise, culmination, decline, and obsolescence.

- The corresponding five adopter groups are fashion innovators, early adopters, early majority, late majority, and laggards.

- Marketing strategies for the 4 Ps differ for fashion products during each of the stages of the life cycle.

- Generally, fashion companies introduce fashion merchandise at higher prices and then prices are reduced as greater numbers of manufacturers produce competing products.

- Expenditures for promotional tactics also decrease as the fashion gains popularity.

- The method of distribution changes during the product life cycle, from selling via prestigious companies to selling through discount companies.

- Database marketing involves analyzing existing sales or customer data for trends or problems.

- Quantitative research relies on the gathering of sufficient amounts of data so that the results closely reflect the larger population.

- Qualitative research uses in-depth data-gathering techniques for smaller samples.

- Primary data are facts gathered specifically to answer a research problem.

- Secondary data are useful facts that have been previously gathered for other purposes.

- Fashion research can be broken down into seven separate steps:
 1. Defining the Research Problem
 2. Developing Hypotheses
 3. Selecting the Sample
 4. Developing the Research Instrument
 5. Collecting Data
 6. Analyzing and Interpreting Data and Drawing Conclusions
 7. Reporting the Findings

- The most common research methods used in the fashion industry are the survey, experimental, and observation methods.

terminology for review

fashion life cycle 140
product life cycle 140
product diffusion curve 140
fashion curve 140
fashion adoption curve 140
fashion adoption process 140
fashion 140
fad 140
classic 140
introductory stage 141
fashion innovators 141
rise or growth stage 141
early adopters 141

culmination or peak stage 141
early majority 141
decline stage 142
late majority 142
obsolescence stage 142
laggards 142
cooperative advertisements 144
disposable fashions 145
fast-fashions 145
high street fashions 145
database marketing 147
fashion forecasting 147
fashion research 149

extant 149
quantitative research 150
qualitative research 150
primary data 150
secondary data 151
hypothesis 151
fashion count 151
forced-choice questions 152
open-ended questions 152
mall approach 153
focus group 153
style testing 154
market test 154

questions for review

1. What do the X-axis and Y-axis of the fashion life cycle represent?

2. How and why does the curve appearance differ among a fad, fashion, and classic style?

3. What consumer group is associated with each of the five stages of the fashion life cycle, and what are some characteristics of each group?

4. What are some marketing strategies (price, promotion, and place) associated with products located within each of the stages of the fashion life cycle?

5. What is fashion research, and why is it valuable?

6. How is quantitative research different from qualitative research, and when is each used?

7. What are the advantages and disadvantages of primary and secondary data?

8. How would a researcher choose a sample for research?

9. What are the main steps in conducting research?

10. What are different methods of research that a fashion marketer can use? What might be an appropriate type of research for the following companies and why? Fashion design company? Apparel manufacturing company? Large, multiunit retailer? Single-unit specialty shop?

related activities

1. How important are financial resources and celebrity status in creating a new fashion? Does a fashion innovator need money or fame? Make a list of celebrity fashion innovators and then provide examples of unlikely fashion innovators. Describe the fashion introduced by each celebrity and unlikely fashion innovators.

2. Using the same list developed in the preceding question, explain why each person (or group of persons) on the list is a fashion innovator. Also, explain how these fashion innovators influence the masses or those who look to them for fashion advice. Provide a variety of examples.

3. With a partner, consider your experiences as a customer at your favorite fashion retail store. Pretend that you work for your partner's favorite store and you are in charge of developing a brief survey for the store's customers. Base your survey on the Small Business Administration's common topics for survey questions under this chapter's Questionnaire subheading. Each partner should respond to the other's survey about their favorite retail store. Compare the responses and discuss the similarities and differences.

4. Individually or as a class, choose a fashion in the introductory or rise stage of the fashion life cycle on the college campus. Develop a list of five questions, both forced choice and open-ended, to test the awareness of the fashion and the likelihood of its continued adoption. Using a convenience or judgment sample, each class member should survey ten persons on campus and record their responses. Analyze the findings and present to the class.

Your Fashion IQ: Case Study

Barneys and Target Coop: Confusing to Customers?

Note: Before discussing this case study, obtain a copy of the article "Barneys Loves Target: Retailing's Odd Couple Takes Marketing Leap" (see complete citation following).

In May 2008, Barneys and Target announced a design project that would furnish merchandise to both the high-end Barneys stores and the mass merchandise Target stores. Barneys introduced the eco-friendly line Rogan at the New York and Los Angeles stores for just a few days, and then the line was moved to the Target stores. Designer Rogan Gregory designed high-end merchandise for Barneys but branched into a more affordable line for the Target stores. The brief strategic marketing move had industry officials shaking their heads in consternation.

QUESTIONS:

1. Why was this high-low strategy used?

2. After reading the *Women's Wear Daily* article, what is your impression of the likelihood for success and a repeat of this venture?

3. In what ways did Barneys benefit from this strategy?

4. In what ways did the Target stores benefit from this strategy?

5. Do you predict that other high-end/low-end co-ops might begin to occur?

6. Locate updated information on the co-op and discuss your opinion of the outcome.

SOURCE: Edelson, S. (2008, May 7). Barneys loves Target: Retailing's odd couple takes marketing leap. *Women's Wear Daily*, pp. 1, 14.

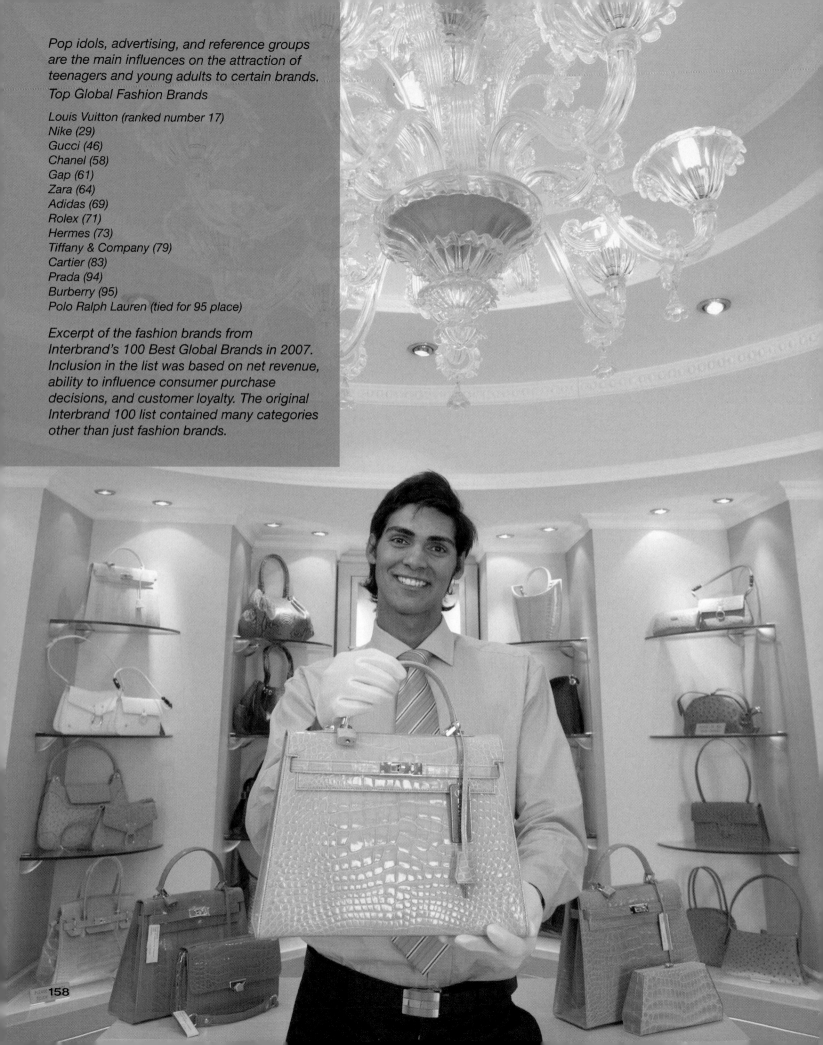

Pop idols, advertising, and reference groups are the main influences on the attraction of teenagers and young adults to certain brands.

Top Global Fashion Brands

Louis Vuitton (ranked number 17)
Nike (29)
Gucci (46)
Chanel (58)
Gap (61)
Zara (64)
Adidas (69)
Rolex (71)
Hermes (73)
Tiffany & Company (79)
Cartier (83)
Prada (94)
Burberry (95)
Polo Ralph Lauren (tied for 95 place)

Excerpt of the fashion brands from Interbrand's 100 Best Global Brands in 2007. Inclusion in the list was based on net revenue, ability to influence consumer purchase decisions, and customer loyalty. The original Interbrand 100 list contained many categories other than just fashion brands.

FASHION
BRANDING

LEARNING OBJECTIVES

At the end of the chapter, students will be able to:

- Explain the value of branding and creating brand equity in fashion products.
- Compare the concepts of positioning, repositioning, and brand reinvention and apply them to actual brands.
- Compare and contrast the benefits of private label and nationally branded merchandise.
- Recognize the different types of brands and identify examples of each.
- Explain how both the licensee and licensors benefit from licensing agreements.
- Explain how intellectual property rights affect the fashion industry.
- Describe the differences and recognize the relationships among the terms *knockoff, style piracy, intellectual property rights,* and *counterfeiting.*

Branding is building a distinctive image—an image that companies attempt to differentiate from a sea of similar products. Companies strive for fashion branding with many fashion products, including store or company names, designer labels, and merchandise lines. Branding provides a way to demonstrate to the target customer that the product has a superior attribute. These attributes include high fashion at discounted prices, outstanding quality, an inviting store atmosphere, convenience, a wide variety of merchandise assortments, or great styling. Think of the brand images that are conjured by names such

as Nike, Ralph Lauren, Target, and Tiffany. These brands have built a distinctive image in the minds of the targeted customers, and every company activity deliberately and carefully represents the brand to the shoppers.

The Value of Branding

How important is it to build a strong brand image in the fashion industry? The answer is very important, but first it is necessary to explain that a brand does not necessarily refer to a label sewn into an item of apparel, although this is one component. According to the American Marketing Association (Ailawadi & Keller, 2004), a **brand** is a word or symbol that identifies the source of goods or services and differentiates it from the competitor's goods or services. Fashion students recognize an abundance of brands such as the GAP, Burberry, Hot Topic, Victoria's Secret, Fossil, Nine West, Hanes, George, Eddie Bauer, Diane Von Furstenberg, and Vera Wang, among numerous others. Some of these brands represent both a store name and a label bearing the store name sewn into the apparel (for example, GAP). At other times, a brand can represent merchandise items found in a variety of competing retailers (for example, Hanes) or merchandise brands owned by a particular store (George labels owned by Wal-Mart). The brands may also represent fashions designed by and bearing the name of a particular person (for example, Vera Wang). These are all considered brands, but branding does not automatically occur. Marketers must make a concerted effort to create a positive brand image that is customer-relevant. **Branding** refers to the way a store, label, or designer impresses customers and influences their perceptions of the brand. Branding is an intangible asset of the company that encourages shoppers to patronize a store or buy a brand and become loyal customers.

> Stores, companies, designers, and manufacturers use branding to demonstrate superior attributes to target customers.

Figure 9.1 Abercrombie and Fitch is positioned as a sexy teenage retailer, as evidenced by nudity in advertising.
(David Young-Wolff/PhotoEdit, Inc.)

Positioning, Repositioning, Rebranding, and Reinventing Brands

The ideas of positioning, repositioning, rebranding, and reinventing brands are about the company's efforts to create or update a brand image and bring in additional customers. As explained in Chapter 7, the concept of positioning a brand refers to placing the brand in the consumers' minds so that they perceive it in a particular way. Repositioning refers to an attempt to change the customers' perceptions of the brand from a previously held belief about the brand to a slightly different view. Many business authorities use the terms *positioning, repositioning, rebranding,* and *reinventing* brands somewhat interchangeably, although a completely new product, brand, or company could only be positioned, not repositioned, rebranded, or reinvented.

A brand repositioning, rebranding, or reinvention campaign generally requires changes in all of the 4 Ps: product, price, place, and promotion. The most obvious way to convey a new position is to implement a new advertising and promotions campaign, but this must also be backed with a strong execution in the remaining areas—product, price, and place. New lines or brands may be introduced, higher or lower price points may be required, and a redi-

rected emphasis on marketing channels may be needed, such as greater focus on e-commerce.

In addition to the repositioning discussion of JCPenney in Chapter 7, other companies have been successful at repositioning, rebranding, or reinventing brands. Wilsons Leather is an example of an accessories company that underwent a repositioning or rebranding strategy. It changed the image of its leather goods stores from basic stores lacking products with fashion appeal to a more stylish and spacious store interior with an edited line of more fashion-forward leather accessories. The century-old Samsonite Corporation, well-respected for functional and sturdy luggage, hired the famous couture designer Alexander McQueen to design a new line of high-end travel bags, luggage, and travel accessories. McQueen, considered the bad boy of fashion with his outlandish designs, created an eleven-piece, licensed collection bearing his signature thumbprint on the zipper. To create added excitement, the designer used a human rib cage as the shape basis for one of the luggage pieces. He also selected polyvinylchloride (PVC) plastic embossed like alligator skin for the exterior material. The luxury line launched in 2007 and retailed in Samsonite's upscale specialty stores, called Black Label. The company's goal was to reach a younger target customer—a world traveler who enjoyed new and trendy fashions.

Figure 9.2 High-end luggage for Samsonite.
(Jennifer Graylock/AP Wide World Photos)

The concept of **rebranding** or **brand reinvention** is similar to repositioning, but it usually involves resurrecting a brand that has been dormant or obsolete for quite some time. An existing brand name, even if it is no longer popular, may have a certain amount of name recognition among consumers from the time when it was popular. Company executives may choose to channel marketing funds into the dormant existing brand, rather than create an entirely new brand. The new target customers may have similar demographics and psychographics as the original target customers, but they may not have experience with or have purchased the original brand. Because consumers prefer the familiar and may have difficulties accepting unfamiliar brands, brand reinvention may be a good opportunity, especially if the brand was strong during its original launch.

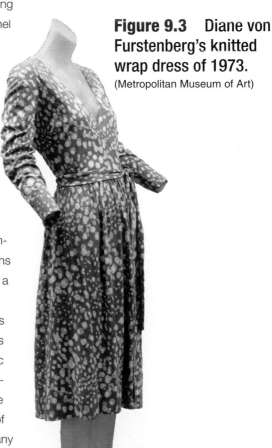

Figure 9.3 Diane von Furstenberg's knitted wrap dress of 1973.
(Metropolitan Museum of Art)

Brand Equity

Brand equity or **brand franchise** refers to the intangible, positive feelings that consumers associate with a brand. It is the added value and trust that have built up over time in consumers' minds about a particular brand. Think of a brand of athletic shoes, handbags, or jeans that a large number of the population considers best in class. These brands have achieved a highly desired state of brand equity.

Many students recognize the familiar tan, black, white, and red plaid of the famous Burberry line, known as the Burberry Check. This decades-old English brand—once famous for raincoats—has achieved a strong brand equity based on the high quality and classic styling of the Burberry collection. In the early 2000s, the company also produced a line of under $50 items using the same plaid fabric, such as soft hats and scarves. The inexpensive products featuring the plaid fabrics created overexposure, undermined the luxury status of the brand, and were easy to counterfeit. To counteract this watered-down effect, the company opted to focus on a new luxury line called Icons that only showed hints of the recognizable

Sixty-something-year-old Diane von Furstenberg wears many hats. She is well-known as a powerful fashion designer and guest judge on *Project Runway*, an often-copied designer by fast-fashion retail stores, a promoter of intellectual property rights, and the president of the Council of Fashion Designers of America. Baby boomers will remember her as the Belgium-born baroness who gained celebrity status overnight as the signature designer of the versatile knit wrap dress of 1973. Her 1973 slogan was: "Feel like a woman; wear a dress." Her famous Tatiana fragrance and cosmetic lines from the early part of her career were sold to other companies and eventually faded into obscurity.

After twenty years of a relatively dormant brand identity, Diane von Furstenberg made her comeback on the television shopping channel QVC. The timing was right to reintroduce an updated version of her signature knit wrap dress featuring bold colors and prints and varying lengths. Her revitalized business allowed her to expand into the luxury jewelry business, and she has plans to move forward in cosmetics, fragrances, and home. Her dresses are sold in 56 countries; she has her own freestanding boutiques throughout the world; she has a Web site, www.dvf.com; and her versatile designs are appreciated by young, as well as old.

Part of the reinvention of the DVF brand involves moving the label from her own elegant, iconic image from 1970s to that of promoting the brand without her image. "I want to differentiate the person from the brand," said Von Furstenberg (Karimzadeh, M., 2008, Jan. 23, p. 8). She now promotes the legacy of the brand with the goal of expanding into brand extensions, such as home and beauty.

In 2008, as a tribute to the service to the U.S. fashion industry, Diane von Furstenberg's and Liz Claiborne's names were both added to the Seventh Avenue Fashion Walk of Fame in the New York City Garment District. Other Walk of Fame names include Calvin Klein, Marc Jacobs, Bill Blass, and Claire McCardell.

SOURCES: Feitelberg, Rosemary. (2008, May 15). Claiborne, DVF to be honored on SA Walk of Fame. *Women's Wear Daily, 195*(104), 6.

Karimzadeh, Marc. (2008, Jan. 23). Separating brand from designer. *Women's Wear Daily, 195*(16), 8.

McKay, Alistair. (2007, Sept. 17). Yes, you can have a man's life in a woman's body. *The Evening Standard, London.* Retrieved September 1, 2008 from LexisNexis database.

Medina, Marcy. (2008, Apr. 16). Von Furstenberg, Karan address luxe. *Women's Wear Daily, 195*(82), 16.

Burberry plaid. The efforts paid off by attracting the more devoted Burberry shopper who prefers more subtle ways of showing brand loyalty. The more upscale Burberry products only hinted at iconic clues, rather than offer blatant and highly recognizable designs (such as large sections of the plaid). The result strengthened the brand equity among the elite consumers who were most likely to buy the up-scale Burberry lines.

Types of Fashion Brands

As mentioned previously in the chapter, a brand is a company's way of identifying products. A name, symbol, or other identifying icon can distinguish a company's products. Marketers classify brands as private label brands, national brands, multinational and global brands, designer brands, and luxury brands. Some overlap exists among these classifications. But each has some distinct characteristics, and each has its own value.

Figure 9.4 Burberry's recognizable plaid is a fashion icon.
(Tim Ridley © Dorling Kindersley, Courtesy of Burberry's of London)

Private Label Brands

Retailers own **private label brands**, and these brands are exclusive to the store. Competing stores may not carry them, so customers know that they must shop at a particular store in order to purchase a private label brand. Most often, private labels are similar in appearance to popular branded merchandise, with style piracy and knockoffs common practices. In other instances, private labels may be original creations by a designer employed exclusively by the retail corporation. Examples of private labels are Payless Shoe Source's American Eagle brand shoes (not to be confused with American Eagle Outfitters store's private label accessories); Hollister brand clothing that may only be purchased at Hollister stores; and I.N.C. International Concepts, the private label owned by Macy's. In a unique private label crossover strategy in 2008, the Limited Corporation began selling its Victoria's Secret Pink fragrance line in its Bath & Body Works stores.

Private labels offer several advantages for retailers. Stores often choose to develop private labels in the hope of gaining customer loyalty. Since these brands are not available anywhere but in the parent company stores, the company benefits from repeat business, season after season. With private label merchandise, brand loyalty translates into store loyalty. Another advantage for retailers is that the profit margins are usually higher for private labels than for national brands. By eliminating the higher markups or national advertising required by branded companies, the retailers can pass along some of the savings to the customers and still earn higher margins on the merchandise. Retailers also benefit from merchandise made precisely to the company's specifications. The store's product developers may desire a certain look that is available to the junior market, but have it manufactured to fit the store's more mature target customer.

Disadvantages of private labels also exist, and these are frequently the advantages of carrying national brands (see the next section). Unless a store's own brand gains notoriety, it lacks the strong brand name recognition of national brands. Retailers who carry only private labels do not benefit from national advertising by the branded label manufacturers, such as Levi Strauss denim advertisements run in the back to school issues of teen fashion magazines. A store such as JCPenney that carries a competing Arizona denim line for teens must pay for their own advertising of the private label line. By contrast, some national brand companies offer cooperative advertising monies to help defray the store's advertising costs when they run advertisements featuring a particular national brand.

In spite of the strong advantages of private label merchandise, some stores prefer to carry a selection of well-respected, branded merchandise that is available in competing stores across the nation or the world. **National brands** refer to brands owned by manufacturing companies and sold in a variety of retail stores. National brands have extensive distribution and recognition within a country. Examples of national brands are Hanes, Nine West, Playtex, Jantzen, and Danskin.

National brands offer several advantages for retailers. The most obvious is the widespread brand recognition by consumers. Some national brands have built brand equity over the years, and the stores that carry these brands benefit from transference of a well-known brand image to the retailer's own store image. Department stores have traditionally carried respectable national brands such as Gold Toe socks for men. A market researcher for NPD Fashionworld estimated that on average, department stores carried 52 percent national brands, compared to 35 percent private labels. The remaining 13 percent was divided between designer goods and other types of goods (Lockwood, L, 2003, Sept. 17). By comparison, Dillard Department Stores have a merchandise selection that is only about 20 percent private label (Lee, G., 2008,

Figure 9.5 National brands enjoy significant advertising to ensure that customers ask for the brand by name.

(Chen Chao © Dorling Kindersley)

Feb. 20). Mass merchandise or discount stores carry national brands because consumers know that they are getting a proven brand name, even though it may be for a lower price. In recent years, the private labels have eroded some market share from the national brands, but many customers still appreciate the longstanding valued associated with a national brand. Manufacturers spend significant resources advertising national brands, and retailers benefit from these promotions.

Multinational and Global Brands

Multinational brands or **global brands** span geographic boundaries and may be available at stores throughout the world. They have similar advantages to national brand merchandise but are distributed on a much broader scale. Guess, Baby Phat, Diesel, and Burberry branded products are considered multinational or global brands with global appeal.

Designer Brands

Similar to national or multinational brands, **designer brands** bear the name of the original designer, have widespread appeal, and may be available in a variety of competing stores. Designer brands may have regional, national, or global distribution. These particular brands represent a designer's philosophy and may range from a narrow group of products to a variety of product lines. For example, Manolo Blahnik, designer of high-end shoes, offers collections in stores such as Neiman Marcus and Bergdorf Goodman. Ralph Lauren is also a designer who oversees the creation of an extensive product mix bearing variations of the Ralph Lauren name. His collections range from home fashions to ready-to-wear.

Some designers create specialty lines for branded companies. As noted previously, couturier Alexander McQueen created an exclusive designer line for Samsonite luggage. The partnership provides additional exposure and diversification for the designer and serves to establish the national or multinational brand as a fashion leader.

Luxury Brands

Although few can afford luxury brands, they are often the most interesting and most discussed of all types of brands. In the fashion industry, **luxury brands** are high-end or expensive brands afforded only by customers with significant amounts of discretionary income, or at least those who aspire to be affluent. As a person's income increases, the demand for luxury goods increases more than proportionally. Customers in the highest income brackets are relatively isolated from price concerns on luxury fashion items, but the demand for luxury items by aspirational customers is somewhat affected by higher prices of the expensive fashions.

Marketing luxury goods may require adding more value to the item than merely the brand image and a high quality product. For example, with the current consumer interest in sustainability, it might behoove a luxury brand to advertise "green" practices used in the manufacture of the luxury goods. For example, a luxury designer of handbags, such as Chanel or Louis Vuitton, might advertise that the leather was tanned using environmentally safe tanning methods without the harmful effluence that often comes with tanning practices. They might also add a hidden pocket containing a lightweight polyester tote made from recycled two-liter plastic soft drink bottles (with the designer's names prominently printed on the tote). When grocery shopping, the customer no longer needs the wasteful plastic or paper bags offered by the grocer. Instead, she can feel good about her "green" contributions to the environment and demonstrate her status with a designer tote. These marketing practices might appeal to the environmentally conscious consumers that want both luxury and socially responsible companies.

Luxury brands are high-status and sold in high-profile locations. They may feature cutting-edge or conservative styles, and consumers that buy the luxury brands consider them to be prestigious. A luxury brand may bear the name of the original designer, such as Prada or Chanel, or it may bear the name of the retailer or company such as Tiffany or Rolex. Most luxury brands are sold in storefronts with high visibility in order to position them as premier fashion items.

Even during economic slowdowns, luxury goods often sell quite well. One perspective is that consumers with the means to purchase luxury merchandise need to spend hundreds or thousands of dollars for luxury fashion items so they can feel good about the purchase. For example, in 2007, Neiman-Marcus offered a limited edition, crocodile Chanel handbag for $25,000 to celebrate the centennial of the Neiman-Marcus company. All 25 pieces had a rapid sell-through, providing evidence that a market exists for just the right luxury item.

Figure 9.6 Louis Vuitton is one of the most recognizable luxury brands in the world.
(PhotoEdit Inc.)

Branding and Legal Issues

The U.S. fashion industry is built on the interpretation of others' designs and knockoffs of popular styles. When taken a step too far in copying design details and registered trademarks from other designers, the result can be a lawsuit filed for infringement of intellectual property rights. The most extreme type of copying, that is counterfeiting, is illegal and costs the U.S. economy over $200 billion each year (Casabona, L., 2007, July 23).

Licensing Agreements

Licensing occurs when designers or celebrities sell the rights to use their names on products manufactured by another company. A **licensing agreement** in the fashion industry is a legal contract between the licensor and the licensee that grants permission or gives the rights to use the licensor's name or other symbol on fashion goods made by the licensee. The licensor may have limited or considerable creative input into the design, production, or marketing of the fashion products. For example, music artists Brittney Spears, Madonna, and Gwen Stefani license their names to fragrances; the Playboy company licenses the Playboy name to a line of T-shirts and other casual wear; Warner Brothers licenses the Tweety canary cartoon character to apparel lines; and celebrity Paris Hilton provided her vision for a line of licensed sportswear, watches, handbags, footwear, and fragrances. Well-known designers or fashion companies often team up with other apparel and accessory manufacturers to offer licensed fashion merchandise. This merchandise appeals to a variety of consumer segments and promotes brand growth. For example, the Karl Lagerfeld and Ralph Lauren brands have licensing divisions that ensure an expanded, but controlled, reach for the designers' reputations. The Guess company licenses the brand to a European manufacturer of watches and jewelry and sells the accessories under the Guess name.

Celebrities and singers are usually not the designers of the lines of clothing bearing their names, although they may claim the apparel embodies their own inspirations for clothing. According to *Women's Wear Daily*, "most of them are just signing apparel deals for the cash and publicity to pump up their record sales or films" (Feitelberg, R. & Kaplan, J., 2008, Oct. 2). Celebrities-as-designers include Matthew McConaughey, Mary-Kate and Ashley Olsen, Beyonce Knowles, and Gwen Stefani.

Figure 9.7 Licensing a celebrity's name to a fragrance is a common practice in the fashion industry.
(© Dorling Kindersley)

Intellectual Property Rights

Editors of apparel and accessories trade periodicals publish many articles about infringements on intellectual property rights (IPR). Designers and design companies struggle to protect their designs. In the U.S. fashion industry, domestic patents protect specific ornamentation and creative details, whereas copyrights and registered trademarks protect symbols, logos, and brand names. However, entire apparel designs are not protected by law. Even though domestic laws protect some fashion specifics, trademarks in the United States may not have the same legal rights in other countries.

Celebrity Brands or Celeb-brands

The cultural obsession with celebrities has given rise to celebrity clothing lines. Marketers know that famous faces and the celebrity factor sell products, so they use the iconic status of the stars to launch fashion lines. Much of the demand comes from the celebrities' biggest fans. Well-known celebrities, from sports, acting, music, or modeling, make a tremendous financial impact on the fashion industry. A few from the extensive list include David and Victoria Beckham, Mary-Kate and Ashley Olsen, Sean Combs, Jennifer Lopez, Eva Mendes, Gwen Stephani, Janet Jackson, Elle Macpherson, and Kate Moss.

Where do aspiring celebrity designers get their design inspiration? Most likely, they gain inspiration from their own wardrobes. The phrase *celebrity designer* is somewhat misleading. Although they may inspire pieces, they do not actually sketch the designs or engage in the preproduction processes. However, in defense of the celebrities, they may have developed a heightened sense of fashion because of years of extensive wardrobing for films, music, and runway appearances. To the general public, it may seem a logical transition from wearing great fashions to inspiring them. Yet, celebrity status does not guarantee the success of the fashion. According to David Wolfe, creative director at Doneger Group, it takes reasonable prices and an accurate reflection of the celebrity's own image to sell the clothing.

SOURCES: Frock Stars. (2009, Feb. 4). *South China Morning Post*, Feature Section, p. 6.

Wells, R. (2007, Apr. 8). Can't sew, so what? *Sunday Age* (Melbourne, Australia), Section M; Upfront, p. 10.

The term **intellectual property rights** refers to the protection of a person's or company's creative ideas for a certain period of time. A significant problem in global trade is that not all countries agree on what constitutes intellectual property rights. The World Trade Organization is working toward a common global definition, but numerous grievances are filed annually by the United States and European countries claiming that China is infringing on intellectual property rights. According to the World Trade Organization Web site (www.wto.org), "Intellectual property rights are the rights given to persons over the creations of their minds." It is a concept used in all product areas, from the pharmaceutical and entertainment industries to the fashion industry.

Knockoffs and Style Piracy

The terms *knockoff* and *style piracy* are similar concepts, although a *knockoff* is a noun and refers to a copied idea, whereas *style piracy* is a verb and refers to an action of copying. A **knockoff** ranges from a loose adaptation to a very similar adaptation of another design. Although legal, knockoffs can be frustrating for the original designer. For more than forty years, an American copycat designer, Victor Costa, made his fortune through the creation of affordable knockoffs of couture designs. Now, stores such as H&M, Forever 21, and Zara have made the knockoff business their modus operandi.

Style piracy refers to the process of the line-for-line copying of design ideas from other designers or companies. The illegal form of style piracy is counterfeiting. Style piracy is a common source of frustration for designers, as well as a widespread practice among fast-fashion stores. The Council of Fashion Designers of America backed a bill called the Design Piracy Prohibition Act. The purpose of the bill was to implement protection for apparel and certain accessories (handbags, footwear, belts, and eyeglass frames). The proposal requested that fashion designs be protected under copyrights that last up to three years, as is the case in France and

Figure 9.8 Hennes & Mauritz is a fast-growing fast-fashion retailer that specializes in knocking off runway designs.

(Tim Knox © Dorling Kindersley)

Figure 9.9 Counterfeiters may smuggle illegal fashion merchandise past customs agents and sell it in large cities.

(PhotoEdit Inc.)

Italy. Proposed fines would be a total of $250,000 or $5 per copied item. Proponents of the bill introduced it in 2006, but the bill stalled in Congress.

According to the lawyer for the Council of Fashion Designers of America, "We know and recognize that the creation of fashion designs is a matter of inspiration . . . but we are really going after plagiarism, which is very different. If it's original and identifiable, with elements of novelty and originality, it should be protected" (Karimzadeh, M., 2006, Mar. 10).

In February 2008, designers and vendors battled in a congressional hearing over the ethics and legalities of style piracy. Designer proponents of additional legislation argued that copied styles infringe on the creator's profits and dilute a brand's image. Apparel vendor opponents argued against any additional legal restrictions such as the proposed bill. They believed the courts would be filled with frivolous lawsuits that create difficulty for many small apparel manufacturing companies (Ellis, K., 2008, Feb. 15 and http://www.stopfashionpiracy.com).

Counterfeiting Brands

Counterfeits are fakes that are intended to look like authentic originals. In the fashion industry, **counterfeiting** is the practice of creating replica merchandise of any quality to resemble the genuine brands. Counterfeits are illegal in the United States if falsely represented as authentic merchandise or if they infringe on registered trademarks, copyrights, or patented details. The U.S. Chamber of Commerce estimates that overall counterfeiting and piracy removes more than $200 billion from the total U.S. economy each year (Clark, E., 2007, Oct. 24). The same government agency estimated a loss of $12 billion dollars in 2006 revenues because of counterfeiting apparel and fashion goods (Brown, R, 2008, May 7). The U.S. Trade Representative estimated that more than 80 percent of the illegally copied goods seized by the Customs and Border Protection officials were from China, and a statement from the European Union esti-

FASHION FACTS: Counterfeiting on Canal Street in Chinatown

Fashion marketing students visiting New York almost always plan for a visit to Chinatown—one of the most congested and exciting places to shop in the entire United States. Taking the subway downtown, tourists and college students ride the line down to Canal Street, the most common subway stop for Chinatown shoppers. Canal Street and the intersecting side streets house little storefronts and vendors offering merchandise from fresh fish and produce to fashion accessories, apparel, and fragrances. The vast variety of fashion merchandise is displayed floor to ceiling in these hundreds of small shops, and the goods spill out the shop doors onto the crowded sidewalks. Chinatown is a fun experience in sights, sounds, and cultures, and most visiting students would appreciate scheduling an entire afternoon to devote to shopping in bustling Chinatown.

There is a darker side to Chinatown, too—namely the hidden counterfeit merchandise also available for sale in an area called Counterfeit Triangle. Tourists, shoppers, and curious college students who arrive at the underground subway stop climb a series of steps to emerge in the heart of Chinatown. Almost as soon as the travelers step onto the sidewalk, they are bombarded by female counterfeit runners who whisper key words in their ears, such as Chanel, Prada, Louis, or Coach. If the tourist acknowledges the runner, then he or she is motioned to follow the runner to a shop (sometimes several blocks away), appearing like any of the other shops lining Canal Street. Counterfeit shops may have illegal merchandise stashed in black trash bags under the counters, or they have a secret entrance to a back room. The entrance is frequently a door behind hanging waterfalled merchandise, invisible to casual shoppers. Often it requires navigating a narrow staircase that leads up or down to a storage room filled with counterfeit handbags, sunglasses, scarves, hats, and any other merchandise with a high demand. Once customers make their selections, the buyer and seller haggle over the price; then the exchange takes place (cash only). Because counterfeiting is an illegal activity, the merchant detains the shopper in the storage room until the store is clear before emerging from the counterfeit merchandise room. If the police or customs officials happen to be close by, the shopper must wait in the crowded back room for several minutes.

Chinatown is not the only location in New York City that offers counterfeit merchandise, but it is the most concentrated source of illegal fashion goods in the city. Chinatown is a wonderful opportunity that all visitors should experience, but students should consider the ethical and legal issues and beware of the purchase of counterfeits.

[Note: For online information about style piracy and counterfeiting, visit the Web site www.stopfashionpiracy.com and complete Related Activity number three at the end of the chapter.]

mated that 86 percent of its counterfeits were from China (Ellis, K. 2007, May 1). Additionally, six other countries (Canada, Japan, South Korea, Mexico, New Zealand, and Switzerland) joined forces with the United States and the European Union and proposed an anticounterfeiting trade agreement. These countries claimed that China "provided a safe haven for product piracy and counterfeiting" (World Business Briefing, 2007, Sept. 26).

Some of the most common counterfeited brands seized in the United States include Baby Phat, Burberry, Cartier, Chanel, Chloé, Coach, Dolce and Gabbana, Fendi, Fubu, Gucci, Lacoste, Levi Strauss, Louis Vuitton, Nike, National Football League, The North Face, Polo Ralph Lauren, Rocawear, Rolex, Seven for All Mankind, and Tiffany. Most government officials and fashion industry experts agree that counterfeit merchandise is harmful to brands because of oversaturation of products and the degeneration of the brand's claim to rarity. However, one industry expert claimed that a label's proliferation on counterfeit goods also serves the purpose of stoking the brand's image.

Figure 9.10 Chinatown is a prime location for counterfeit merchandise.

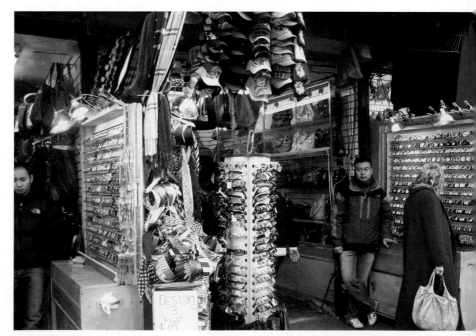

summary

- Branding creates a unique and distinct image in the minds of consumers.

- Stores, companies, designers, and manufacturers use branding to demonstrate superior attributes to target customers.

- Branding persuades customers to patronize a store or regularly buy a brand.

- Positioning is placing the brand in the consumers' minds so that they perceive it in a particular way.

- Repositioning is when marketers change the customers' perceptions of the brand from a previously held belief to a different view.

- Extensive efforts are required to change the brand image or resurrect a dormant brand.

- Brand equity or brand franchise encompasses the positive feelings and added value that consumers associate with a brand.

- Types of brands include private label, national, multinational or global, designer, and luxury.

- Private label brands are a store's own brand.

- Manufacturers own national brands, and they are available in competing stores across the nation.

- Multinational or global brands are retailed and recognized in countries around the globe.

- Designer brands usually bear the name of the designer.

- Luxury brands are prestigious, costly, and require significant discretionary income to purchase them.

- Licensing is a contractual agreement between a licensor and a licensee. The licensor sells the rights to use its name on merchandise produced by the licensee.

- Celebrities and designers license their names to related or unrelated product lines, or cartoon or movie characters may be licensed to apparel producers.

- Intellectual property rights (IPR) are original creative ideas.

- Knockoff goods are considered a normal and acceptable means of doing business, whereas style piracy is considered plagiarizing others' designs.

- Copyrights and registered trademarks protect symbols, logos, and brand names.

- Counterfeits are replicas and fake merchandise disguised as authentic originals, and the practice is illegal.

terminology for review

brand 160

branding 160

rebranding 161

brand reinvention 161

brand equity 161

brand franchise 161

private label brands 163

national brands 163

multinational brands 164

global brands 164

designer brands 164

luxury brands 165

licensing agreement 166

intellectual property rights 167

knockoff 167

style piracy 167

counterfeits 168

counterfeiting 168

questions for discussion

1. What are fashion brands, and why are they important in the fashion industry?

2. Choose a well-known and well-respected fashion brand. Why are customers loyal to this brand, and what are the qualities of the brand that have created brand equity in the customers' minds?

3. What is meant by the concepts *rebranding* and *brand reinvention*?

4. What are some of the advantages and disadvantages of private label brands and national brands?

5. What is the relationship between designer brands and luxury brands?

6. What is a licensing agreement in the fashion industry, and what are some examples of licensing agreements not already listed in this chapter?

7. How do businesses benefit from the contractual agreement of licensing?

8. What are knockoffs, and what are the similarities and differences between creating knockoffs and style piracy?

9. What is meant by the term *intellectual property rights,* and how does the concept relate to the fashion industry?

10. What are several reasons why consumers should not purchase counterfeit merchandise?

related activities

1. With a partner, choose a fashion brand that caters to target customers with wants and needs similar to your own wants and needs. How would you reposition the branded product to appeal to a different target customer? Explain how you would change each of the 4 Ps of fashion marketing to reposition the product and describe the new target customer group. Be prepared to present to the class.

2. Think of a brand that was popular when you were in elementary school but has run its life cycle course. It can be currently dormant or may still be sold in mass merchandise or discount stores, but it has lost its fashion appeal. What promotional techniques might you employ to reinvent the brand to appeal to the same demographic customer group that the brand targeted over a decade ago? Be prepared to present your brand reinvention promotional strategy to the class.

3. Go shopping online at a fast-fashion retailer, online auction, or mass merchandise store. Locate a picture of any fashion accessory or apparel item (questionably legal or suspected counterfeit) and find a similar one by a designer or an exclusive brand. Prepare a brief presentation showing both fashions and explain how the concepts of knockoff, style piracy, and intellectual property rights are evident. Explain the ethical considerations involved.

4. As a class, visit the stopfashionpiracy.com Web site and watch the online video. Then, debate the topic of intellectual property rights and style piracy in the fashion industry. Respond to the question: How closely should the United States protect fashion designs? Assign sides to debate—in favor of passing the proposed legislation described in this chapter's Your Fashion IQ or satisfied with current legislation. Find an electronic article from one of your library's database subscriptions to support your position. Be sure to justify your position with a credible resource. Follow the debate guidelines suggested at http://712educators.about.com/cs/lessonsss/ht/htdebate.htm.

The following proposed piece of legislation was based on another act that protects the original design of vessel hulls for ten years. As written, this bill would require a three-year copyright on original fashion designs. Although introduced in March 2006, it failed to reach Congress for a vote and was not passed as legislation. It would have extended copyright protection to designers of fashions and accessories.

The Bill

HR 2203 and HR 5055 [109th]: The proposed bill called the Design Piracy Prohibition Act

To amend title 17, United States Code, to provide protection for fashion design.

Be it enacted by the Senate and House of Representatives of the United States of America in Congress assembled,

SECTION 1. SHORT TITLE.

This Act may be cited as the 'Design Piracy Prohibition Act.'

SEC. 2. PROTECTION FOR FASHION DESIGN.

- (a) Designs Protected- Section 1301 of title 17, United States Code, is amended—
 - (1) in subsection (a), by adding at the end the following:
 - (3) FASHION DESIGN- A fashion design is subject to protection under this chapter.'; and
 - (2) in subsection (b)—
 - (A) in paragraph (2), by inserting 'or an article of apparel,' after 'plug or mold,'; and
 - (B) by adding at the end the following new paragraphs:
 - (7) A 'fashion design' is the appearance as a whole of an article of apparel, including its ornamentation.
 - (8) The term 'design' includes fashion design, except to the extent expressly limited to the design of a vessel.
 - (9) The term 'apparel' means—
 - (A) an article of men's, women's, or children's clothing, including undergarments, outerwear, gloves, footwear, and headgear;
 - (B) handbags, purses, and tote bags;
 - (C) belts; and
 - (D) eyeglass frames.'.
- (b) Designs Not Subject to Protection- Section 1302 of title 17, United States Code, is amended in paragraph (5)—
 - (1) by striking '(5)' and inserting '(5)(A) in the case of a design of a vessel hull,';
 - (2) by striking the period and inserting '; or'; and
 - (3) by adding at the end the following:
 - (B) in the case of a fashion design, embodied in a useful article that was made public by the designer or owner in the United States or a foreign country more than 3 months before the date of the application for registration under this chapter.'.
- (c) Term of Protection- Section 1305(a) of title 17, United States Code, is amended to read as follows:
 - (a) In General- Subject to subsection (b), the protection provided under this chapter—
 - (1) for a design of a vessel hull shall continue for a term of 10 years beginning on the date of the commencement of protection under section 1304; and
 - (2) for a fashion design shall continue for a term of 3 years beginning on the date of the commencement of protection under section 1304.'.
- (d) Infringement- Section 1309 of title 17, United States Code, is amended—
 - (1) in subsection (c), by striking 'that a design was protected' and inserting 'or reasonable grounds to know that protection for the design is claimed';
 - (2) in subsection (e), by inserting 'or from an image thereof,' after 'copied from a design protected under this chapter,'; and
 - (3) by adding at the end the following new subsection:
- (h) Secondary Liability- The doctrines of secondary infringement and secondary liability that are applied in actions under chapter 5 of this title apply to the same extent to actions under this chapter. Any person who is liable under either such doctrine under this chapter is subject to all the remedies provided under this chapter, including those attributable to any underlying or resulting infringement.'.
- (e) Application for Registration- Section 1310 of title 17, United States Code, is amended—
 - (1) in subsection (a), by striking the text and inserting the following:
 - (1) VESSEL HULL DESIGN- In the case of a design of a vessel

hull, protection under this chapter shall be lost if application for registration of the design is not made within 2 years after the date on which the design is first made public.

- (2) FASHION DESIGN- In the case of a fashion design, protection under this chapter shall be lost if application for registration of the design is not made within 3 months after the date on which the design is first made public.'; and
 - (2) in subsection (b), by striking 'for sale' and inserting 'for individual or public sale'.
- (f) Examination of Application and Issue or Refusal of Registration- Section 1313(a) of title 17, United States Code, is amended by striking 'subject to protection under this chapter' and inserting 'within the subject matter protected under this chapter'.
- (g) Recovery for Infringement- Section 1323(a) of title 17, United States Code, is amended by striking '$50,000 or $1 per copy' and inserting '$250,000 or $5 per copy'.
- (h) Other Rights Not Affected- Section 1330 of title 17, United States Code, is amended—

- (1) in paragraph (1), by striking 'or' after the semicolon;
- (2) in paragraph (2), by striking the period and inserting '; or'; and
- (3) by adding at the end the following:
- (3) any rights that may exist under provisions of this title other than this chapter (Retrieved Oct. 4, 2008, from http://www.govtrack.us/congress/billtext.xpd?bill=h109-5055)

Proponents of the bill, including many well-known designers such as Diane Von Furstenberg, Nicole Miller, Zac Posen, and Oscar de la Renta, believed it was the only way to stop the piracy of original designs. The Council of Fashion Designers of America (CFDA) cited other countries with similar laws protecting fashion designers. They explained that American designers spend tens of thousands of dollars before they get wholesale orders on the merchandise. They must invest in the creation of originals, that is, prints, patterns, and samples, and pay for the high costs of creating a runway show. Finally, proponents of the bill claimed that original design innovation is vital to a free U.S. economy and that style piracy is equivalent to counterfeiting without the label.

Opponents of the bill, such as the American Footwear and Apparel Association (AFAA), claimed the protectionist measures of the bill would increase costs and prevent many consumers from having access to lower-priced fashions with the same fashion look. The association stated that this "misguided fashion police" act would "stifle creativity and innovation in the development of fashion designs" (American Apparel and Footwear Association Web site, 2008). Opponents also argued that the exposure from pirated designs may actually benefit designers by providing recognition, rather than harming them.

QUESTIONS:

1. Is designer apparel "useful articles" or "works of art"?

2. What other arguments might be made for and against the bill?

3. What do you think about the clarity of the bill and the use of legislation from vessel hulls?

4. Do you think this might come for a vote in the near future? What changes would you suggest?

SOURCES: AAFA on the issues: Intellectual property rights. (2008). American Apparel and Footwear Association Web site. Retrieved Oct. 1, 2008, from http://www.apparelandfootwear.org/LegislativeTradeNews/default.asp

Coblence, Alain. (2007, Aug. 24–30). Design Piracy Prohibition Act: The proponents' view. *California Apparel News*, p. 12. Retrieved Oct. 1, 2008, from http://www.stopfashionpiracy.com/pdf/sfp_news_1.pdf

Stop fashion piracy: About the bill. (2008). Stop Fashion Piracy Web site. Retrieved October 1, 2008, from http://www.stopfashionpiracy.com/about.php#Bill_Summary.

10 Textile Producers and Suppliers

11 Designers, Product Developers, and Fashion Manufacturers

12 Fashion Market Centers, Wholesalers, and Intermediaries

13 Textile and Apparel Legislation

14 Fashion Retailing Formats

FASHION
Marketing
Supply Chain

 10

 11

 12

 13

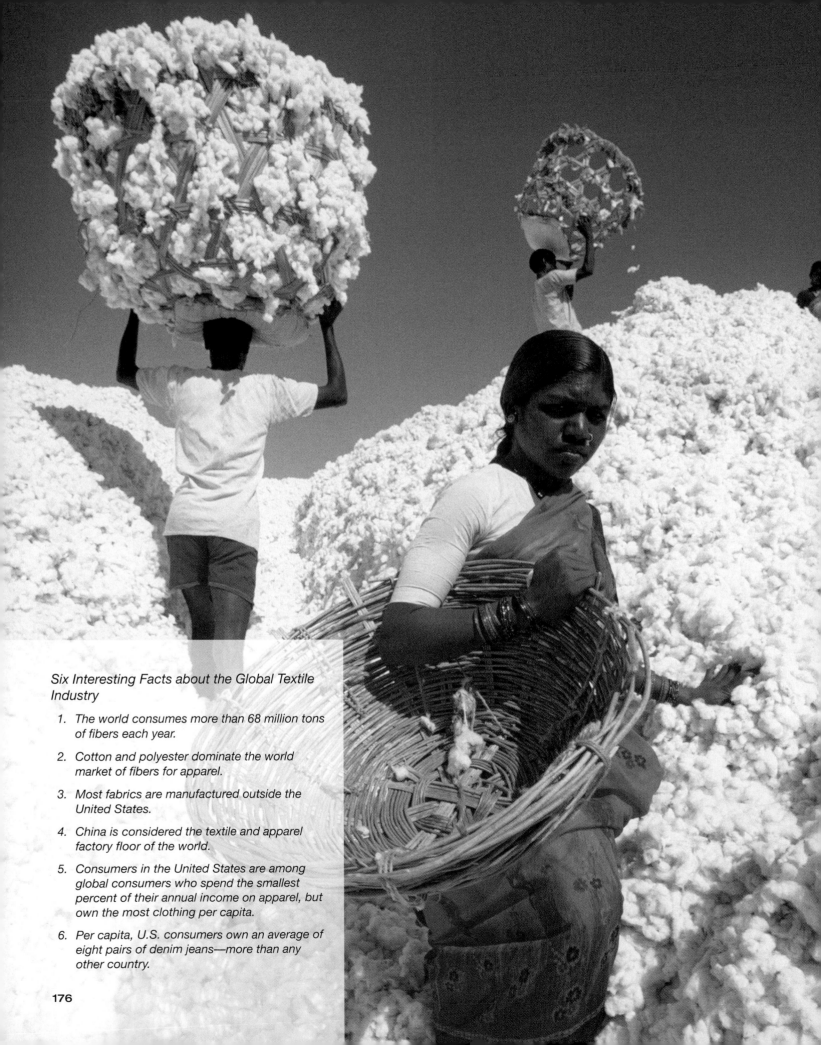

Six Interesting Facts about the Global Textile Industry

1. The world consumes more than 68 million tons of fibers each year.

2. Cotton and polyester dominate the world market of fibers for apparel.

3. Most fabrics are manufactured outside the United States.

4. China is considered the textile and apparel factory floor of the world.

5. Consumers in the United States are among global consumers who spend the smallest percent of their annual income on apparel, but own the most clothing per capita.

6. Per capita, U.S. consumers own an average of eight pairs of denim jeans—more than any other country.

TEXTILE
PRODUCERS
and
SUPPLIERS

LEARNING OBJECTIVES

At the end of the chapter, students will be able to:

- Assess the global impact of the textile and apparel industries.
- Identify important social, economic, and political factors that affect the global textile and apparel industries.
- Identify the differences between natural cellulose and natural protein fibers, and compare these to man-made fibers.
- Explain the important trends in sustainability in the textile and apparel industries.
- Explain the role and value of leather and fur to the fashion industry.
- Describe some of the major marketing activities of the textile and apparel industries.

The term **textiles** encompasses the entire fabric industry, including the fibers, yarns, and manufacturing of the fabrics. It is derived from the Latin term *texere* which translates into "to weave." In simplified terms, a textile is created from loose fibers that are processed and spun together into yarns. Then, the yarn manufacturers weave or knit the yarns into fabrics. The terms *fabrics* and *textiles* are often used interchangeably in the fashion industry.

10

Textile manufacturing is usually a global process. At any phase during the production of textiles, the materials can be transported from country to country. The fibers may be grown or manufactured in one country, shipped to another country for yarn spinning and weaving, and marketed as fabrics and fashions in multiple countries across the world. For example, pima cotton may be grown in the southern United States (Step 1), shipped to a Central American country for spinning into yarns (Step 2), shipped to Mexico to be knitted into T-shirts and screen printed with college logos (Step 3), and finally returned to the United States and Canada to be sold to ultimate consumers (Step 4). The T-shirt would be labeled Made in Mexico and sold at retail for about $25 in the university's bookstore (see Figure 10.1).

Fiber producers, yarn manufacturers, and fabric mills comprise the trade levels in the textile industry supply chain. They function to move a textile product from its production to its consumption. Some companies are **vertically integrated**, meaning they engage in several levels of production within a single company. For example, Pendleton Woolen Mills in Washington and Oregon controls much of the wool manufacturing for its Pendleton products. Pendleton representatives hand select premium quality wool from wool growers and then oversee the processing of the wool fibers, including cleaning and scouring, twisting the fibers into yarns, weaving the famous Pendleton plaids and fabrics, and finally cutting and sewing the Pendleton apparel and home fashions.

Figure 10.1 A T-shirt can cross the borders of several countries during production.

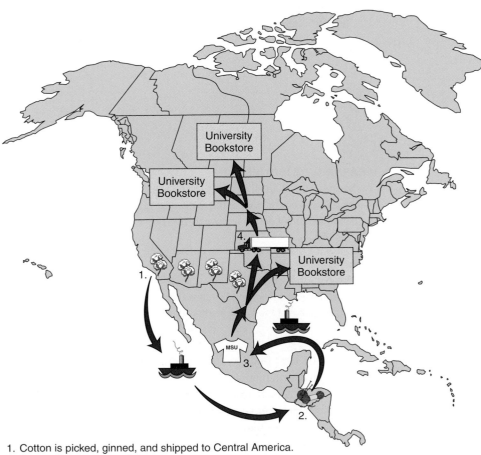

1. Cotton is picked, ginned, and shipped to Central America.
2 Cotton fibers are spun into yarns.
3. Yarns are knitted into T-shirts and screen printed with college logos.
4. T-shirts are trucked to retail outlets and bookstores in the United States and Canada.

Textile Industry: Scope and Trends

The textile industry is a multibillion-dollar industry worldwide, and per capita, citizens of the United States consume the most apparel. Sales of apparel are more than $2.1 billion annually. Most of the textiles consumed in the United States are imported from other countries, where labor costs are much lower. Table 10.1 shows the top trading countries and the value of their textiles, textile products, and apparel supplied to the United States in 2008.

Multiple government agencies in the United States monitor the global textile industry. The U.S. Census Bureau offers some industrial statistics on textile production, but most information can be obtained from two other important government agencies. The U.S. Department of Agriculture (USDA) monitors data related to textile and apparel legislation and cotton fiber production through its Foreign Agricultural Service (FAS). The purpose of the Foreign Agricultural Service is to "improve foreign market access for U.S. products, build new markets, and improve the competitive position of U.S. agriculture in the global marketplace" (About FAS, Foreign Agriculture Service, 2008). The U.S. Department of Commerce International Trade Administration tracks imported and exported textile fibers, yarns, fabrics, apparel, and home fashion soft goods through the Office of Textiles and Apparel (OTEXA). Both agencies classify textile commodities with ten-digit codes specified under the Harmonized Tariff System (HTSUSA or HTS). For example, men's and boys, trousers and shorts in blue denim fabric are classified as Harmonized Tariff System code 6203424013. The World Customs Organization maintains the first six digits of the code, called the *Harmonized System (HS)*. About 130 countries participate in the Harmonized System.

The fluctuating price of oil has affected the entire textile industry. One concern has been the higher cost of petroleum in the manufacture of oil-based synthetic fibers, such as polyester and nylon. Another concern has been the increased costs of transporting the textiles from factories and mills to ports and onto boats or airplanes. According to an article in *Women's Wear Daily*, "The high price of oil has meant higher expenses for moving the goods throughout the product development life cycle, from a dye facility to weaving mills" (Tucker, Sept. 4, 2007). In 2007, trucking and other transportation fees had almost doubled over the previous five years.

Fashion influences the textile industry, just as it does the apparel industry. Textiles are used to follow fashion trends and create specific looks in fashionable apparel. For example, in the denim jeans category, fabric treatments are used to differentiate relatively similar styles. Unique fabric developments, from fiber content to yarn combinations to fabric finishes, become new opportunities for designers to re-create a target customer's favorite pair of jeans with an updated look. Called **trend-based fibers or trend-based textiles**, the suppliers offer fibers, yarns, and fabrics that evolve to meet market demand. Denim manufacturers may choose organically grown cotton for denim or mix cotton fibers grown in two different regions of the world. Denim manufacturers sometimes include the addition of spandex or the removal of spandex from the fabric. Differing warp and weft yarns may be combined to create fabrics that are thinner or thicker, of varying durability and texture. The fabric finishes may include acid-washing, stonewashing, embellishing, distressing, destroying, or dark dyeing.

Raw Materials in the Fashion Industry

The first level of the textile supply chain is the production of raw materials called *fibers*. **Raw materials** are unfinished natural or man-made products that are consumed by a manufacturer and used in the manufacture of finished goods, such as apparel or accessory merchandise.

Table 10.1 U.S. Imports of Textiles, Textile Products, and Apparel (NAICS Codes 313, 314, and 315) from Top Suppliers, 2008

Country	Value in Thousands of Dollars
China	34,803,800
India	5,520,400
Mexico	5,383,700
Vietnam	5,339,500
Indonesia	4,228,100
Bangladesh	3,564,400
Pakistan	3,981,000
Honduras	2,688,900
Cambodia	2,386,700
Italy	2,342,600

SOURCE: Imports of Textiles, Textile Products, and Apparel from Top Trading Partners. (2008). *Foreign Trade Statistics, U.S. Census Bureau*. Retrieved July 30, 2009 from http://www.census.gov/foreign-trade/statistics/country/sreport/textile.html.

Raw materials may be grown naturally from plant or animal sources, or they may be manufactured, such as those from petroleum. In the fashion industry, raw materials include wool shorn from sheep, cotton fibers grown in bolls in the fields, petroleum used for polyester, seashells used for jewelry, straw used for summer hats, and any other material that undergoes a transformation to create a fashionable product. The raw materials used in the accessories industries are quite varied and include the shells and straw previously mentioned as well as fibers, leather, PVC (polyvinyl chloride, a simulated leather), felt, fur, metals, stones, and many other unique raw materials. Raw materials used in the apparel industry are usually fibers spun into yarns, woven or knitted into textiles, and finally fashioned into garments. Therefore, a substantial discussion of fibers is necessary when discussing apparel and accessory fashions.

Apparel programs teach students about textile raw materials and how they are used in the production of apparel or soft goods. **Soft goods** may be defined as apparel or home fashion items that are made of textiles, soft to the touch, and nondurable (meaning they are not intended to be kept for too many years). Most of the fashion merchandise available to consumers is classified as soft goods (fine jewelry and fine watches would be exceptions). The study of textiles is so important to understanding apparel that it warrants a substantial section in this textbook and a separate textiles class at many colleges and universities.

Textile Fiber Classifications

Two major categories of textile fibers supply the apparel industry: natural and man-made fibers. **Natural fibers** grow from a plant source or are produced by a living animal. Cotton and flax (linen) grow from plants and are called **cellulose fibers**. Wool and silk are **protein fibers** produced by animals. Wool grows as the coat of a living animal, such as sheep, and silk is obtained from the cocoon of silkworms. Other specialty natural fibers exist, but cotton, flax (linen), wool, and silk are the four primary natural fibers. **Man-made or manufactured fibers** include the synthetic or petroleum-based fibers, such as polyester, nylon, acrylic, and olefin. Rayon, acetate, and lyocell are also man-made fibers but are manufactured from regenerated cellulose, so their performance more closely resembles cotton. The two major categories and the important fibers within each category will be discussed in the following sections. Figure 10.2 shows the estimated global textile usage of the most widely used natural and man-made fibers in the fashion industry.

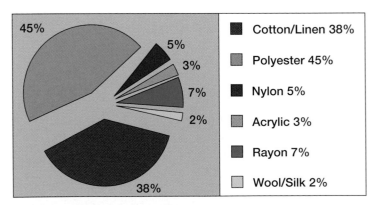

Figure 10.2 Estimated global textile usage for 2007.

SOURCE: Worldwide chemical fiber production in 2007. (2008). *Japan Chemical Fiber Association.* Retrieved September 28, 2008, from www.jcfa.gr.jp/english/what_data/worldwide-production2007.pdf

Natural Fibers

Most top fashion designers prefer using natural fibers because of the beauty, drape, and elegance associated with these fibers. Linen, wool, and silk fabrics are especially prized in high fashion designs. They require extra effort for care and are available in limited quantities, since they must be grown and cannot be quickly manufactured to meet demand. Rarely do high fashion designers use anything but natural fibers in their elegant designs—thus creating a certain "snob appeal" with natural fibers.

Natural Cellulose Fibers Cotton and flax plants supply most of the natural cellulose fibers used in the fashion industry, whereas ramie, jute, and hemp are used in smaller quantities in apparel and accessories. Natural fibers require climates conducive for growth and production.

For example, cotton requires a long, hot growing season, so cotton farms are located in regions with plenty of sunlight and extended summers. The southern one-third of the United States, called the cotton belt, is a large geographic region that contributes a significant supply of raw cotton to the world market. By contrast, flax (linen fibers) plants require a more temperate climate with significant rainfall during the growing season. Much of Europe, as well as parts of China, receives sufficient rainfall and moderate temperatures to grow most of the world's supply of flax fibers, which are woven into linen fabrics.

Cellulose fibers come from a variety of plants, yet have many similar behavioral characteristics, as follows:

- Low resilience (easily wrinkled)
- Garment shrinkage may be a problem if fabrics are not preshrunk
- Ease of creasing and pleating
- Relatively low flexibility (repeated creasing in the same place may cause fibers to break)
- High absorbency (including perspiration and water-based stains)
- High heat tolerance (can be pressed with a hot steam iron to remove wrinkles)
- High tolerance for most laundry chemicals

Cotton Cotton grows on leggy plants and is a cousin of okra and hibiscus plants. The actual cotton fibers grow out of seeds contained within a pod called a **cotton boll**. When mature, the one-plus-inch, creamy white cotton fibers, called **lint**, are collected from the bolls and then separated from the seeds. The process of separating the seeds from the lint is called **ginning** and is performed by the cotton gin machine.

From denim jeans and T-shirts to towels and sheets, cotton is the primary choice for fashions because of its comfort.

Cotton varies in quality from the lustrous American pima and Egyptian cotton to the less refined, coarser, and shorter fibers used in cotton muslin. For example, a set of bed sheets labeled 100 percent pima or Egyptian cotton command higher prices than cotton muslin sheets which are typically coarser.

Of all available fibers in the world, cotton is the most important textile fiber. Globally, almost 80 percent of all natural fibers used are cotton. The remaining 20 percent is divided among wool, silk, linen flax, and a few other natural textile fibers. The U.S. cotton production (20 percent) is second only to that of China (24 percent). Consumer demand for cotton products has grown significantly since the end of the 1990s, both in the United States and abroad. According to the Economic Research Center of the U.S. Department of Agriculture, the cotton industry in the United States contributed over $25 billion in products and services in 2009 and annually generates more than 400,000 jobs—from farming to textile mills. Cotton accounts for close to 40 percent of the world's fiber production, making it the most important textile crop (Cotton, U.S. Department of Agriculture, 2009). In 2007, China, India, and the United States produced over half the world's cotton supply, although overall cotton production occurs in approximately eighty countries worldwide (Cotton: World Markets and Trade, 2007).

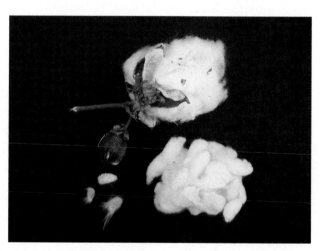

Figure 10.3 Cotton fibers grow out of seeds in a cotton boll.

{ Natural fibers include plant and animal fibers, such as cotton, flax, wool, and silk.

AUTHOR'S NOTE: Visit www.cottoninc.org for more information.

Figure 10.4 **Flax fibers grow within the stem of the flax plant.**

Linen Flax Flax is the plant from which linen fabrics originate. The fabric called **linen** is woven from a variety of flax, called **fibre flax or linen flax**. This section of the chapter focuses on linen flax. There are different varieties of flax grown for many commercial uses, including food, fuel, paper, geotextiles, and fabrics. Some seeds are edible; the oil is useful; the fibers can be made into fuel, substituting for coal; the flax fibers can improve the quality of recycled paper; and the stalks can be used to prevent soil erosion.

Flax fibers grow in long bundles within the woody stalk of the flax plant. The longer the flax fiber, the better, so flax plants are grown close together in order to cause competition for sunlight and result in taller plants. Flax fibers are encased in a woody outer layer that must be removed during processing. When removed from the plant, they look very much like a hank of long, dishwater-blonde hair. In fact, in fairy tales, the princess has been referred to as a "flaxen-haired beauty." The average length of flax fibers is about eighteen inches. Flax fibers have less flexibility than cotton fibers and repeated creasing of linen textiles may cause the fabric to eventually split along the crease. Linen fabrics are widely known for excessive wrinkling, but these are considered "status wrinkles." Some manufacturers may combine flax fibers with more resilient fibers such as silk to lessen the problem of wrinkling.

Most of the flax fibers used in the making of linen fabrics are grown in China, France, the Russian Federation, and Belarus, a country west of Russia (Flax Fibre and Tow, 2005). Globally, the United States is the largest per capita consumer of flax fibers.

Ramie Ramie, or China grass, is a cousin to the nettle plant and has greater strength and more luster than flax. Ramie has a low flexibility, so it may be knitted in sweaters or combined with more resilient fibers to reduce yarn breakage due to creasing.

Jute and Hemp These fibers are rough and reedy natural fibers. Jute is the fabric of burlap gunnysacks and sandbags. It is strong but not too suitable for wearing apparel because it is itchy. Hemp is the controversial fiber that is a distant cousin to the marijuana plant, although it does not have the same hallucinogenic qualities. According to a representative for the company Enviro Textiles, "There's a major difference between marijuana and hemp. It's like jalapeño peppers and bell peppers; one's hot, the other's not" (Williams, C., 2007). Because they look similar when growing in the field, it is illegal to grow hemp in the United States. The fashion industry uses imported hemp for macramé and inexpensive necklaces and bracelets. Hemp cordage is also braided and used to decorate the sole and heel of shoes.

Figure 10.5 **Hemp fibers and yarns are often used in accessories.**

FASHION FACTS: Eco-craze: Sustainable and Green Textiles

What do all these terms mean: *green-friendly, enviro-friendly, eco-friendly, eco-sustainable, eco-influenced, eco-conscious, renewable, recycled, reused, reclaimed, organic,* and *green textiles*? The conundrum of applied terms has consumers and industry experts confused by fashion labels and logos. Are consumers becoming immune to the increasing almost cliché use of these terms? Are they really willing to spend the extra time to decipher the meanings on the labels? Most importantly, are they willing to spend the extra money on eco-friendly textiles? According to a 2007 Cotton Incorporated survey, 29 percent of female respondents reported that environmental friendliness was an important consideration when buying apparel. This same question received only 23 percent in 2006. Yet, the Director of Global Development and Marketing for Bagir Group Limited, a tailored apparel manufacturer, commented, "We believe that eco-sensitive products should not come at a premium and that companies should improve their processes and supply eco-sensitive garments at equal prices" (Saving Green While Going Green, 2008).

Although some consumers are interested in ecology, they experience confusion with the plethora of terms in retail stores and the mixed messages in labeling. For example, if an item is labeled "organic," it can mean the item is 100 percent organic, or it can mean it only has a small percentage of organic fiber. Is it made from renewable fibers (such as cotton grown each year)? Is it made from recycled fibers, such as recycled wool (which is generally considered inferior quality wool)? Is it from a sustainable source, such as bamboo (which grows very rapidly)? Even a single fiber category, such as wool, has the potential to be labeled with all sorts of confusing terms: organic, recycled, reused, sustainable, virgin, renewable, and all of the other enviro and eco words.

The U.S. National Organic Standards Board under the direction of the U.S. Department of Agriculture attempted to eliminate misconceptions of the concept of organically grown crops, such as cotton. The Web site reported research that stated, "Organic agriculture is an ecological production management system that promotes and enhances biodiversity, biological cycles and soil biological activity. It is based on minimal use of off-farm inputs and on management practices that restore, maintain and enhance ecological harmony" (McWilliams, *et al*, 2007). However, if a cotton garment manufacturer purchases organic cotton to manufacturer apparel or home fashions, the notion of organic is not passed on to the manufactured clothing. The manufacturing company must apply for its own license.

Overall, the green movement shows no signs of slowing down in the textiles and fashion industry. The eco-friendly fashion movement emphasizes nature and well-being of the individual and the global environment. Recently, numerous trade shows have touted seminars dealing with environmental awareness issues and the use of sustainable materials in the fashion industry. References to trade organizations, manufacturers, and designers using these concepts include ideas from complex to simple:

- Polylactide fibers, such as the trademarked Ingeo PLA fibers by NatureWorks, are different from other natural fibers because the fabrics perform similar to synthetic materials, such as petroleum-based polyester. Polylactide fibers can be produced from corn or any starchy vegetable containing sugar. The liquid sugar (dextrose) is fermented into a yogurt-like polymer that is transformed into the high-performance (especially ultraviolet protection) fibers that cost only slightly more than cotton fibers.
- Bamboo textiles are popular because they are soft and inhibit bacteria growth, and bamboo is one of the fastest-growing renewable resources on earth. Bamboo fabrics are used in active sportswear, such as yoga, aerobics, and running apparel.
- The company Ideal Earth has created recycled polyester zipper tapes. The company estimates that zippers for 500 garments conserves about one gallon of gasoline.
- Designers are using recycled fabrics or remnants from fabric manufacturers for fashions from T-shirts to cashmere cardigans.
- Some fashion design courses offer classes in sustainable development and ecology, including hosting student contests to design fashions from sustainable materials, such as hemp, that merge style with social conscience.
- The Designers and Agents Trade Show in New York sponsored The Green Room, which showcased sustainable collections in an art gallery setting.
- On a more simplified scale, fresh flowers were left uncut in vases for fashion shows, so they could be replanted in a garden after the show.

For an example of an interesting college effort aimed at recycling denim jeans and helping Habitat for Humanity, visit the Cotton Incorporated Web site and view the brief television media clips "Cotton. From Blue to Green™" at http://www.cottoninc.com/CottonFromBlueToGreenFlashVideos.

SOURCES: Cotton. From blue to green. (2008). Cotton Incorporated Web site. Retrieved July 20, 2008, from http://www.cottoninc.com/CottonFromBlueToGreenFlashVideos.

Going green. (2006, Sept. 26). *Women's Wear Daily Online*. Retrieved September 4, 2007, from www.wwd.com.

Karimzadeh, M. (2007, May 17). D&A emphasizes power of green. *Women's Wear Daily Online*. Retrieved September 17, 2006, from www.wwd.com.

Saving green while going green. (2008, Jan. 31). *Cotton Incorporated Lifestyle Monitor Womenswear Article*. Retrieved March 17, 2008, from http://www.cottoninc.com/lsmarticles/?articleID=572&pub=Womenswear.

Natural Protein Fibers
Natural Protein Fibers This category of fibers includes hair fibers, such as sheep's wool, camel hair, goat hair (such as mohair), and even rabbit hair (angora). Natural protein fibers also include silk fibers that are extrusions from silkworms when cocoons are created. Wool and silk are important raw materials in the fashion industry, and they are raised in regions appropriate to their growth and production.

Natural protein fibers have many characteristics in common, and the most important are listed following:

- Good resilience (wrinkles tend to fall out)
- Ease of creasing and pleating with steam iron
- Low tolerance for harsh laundry chemicals; dry cleaning may be required
- Lower heat tolerance than natural cellulose fibers
- Breathable and comfortable (coarse wool may irritate the skin)
- Prestigious

Wool Wool is grown naturally as the coat of hair on sheep. Sheep are sheared once or twice yearly, and the wool is cleaned and processed. The **lanolin** or sheep's natural hair grease is purified and used in many cosmetics. Just like with human hair, different varieties of sheep produce wool that ranges from very coarse and rough to fine and silky. The coarser the wool fibers, the greater the itch factor, so many woolens are lined to improve comfort. Merino wool comes from a desirable breed of sheep because Merino sheep have longer and finer hair than many other varieties.

Protein fibers can come from any furbearing animal, including cashmere goats, angora goats (mohair), camels, llamas, alpacas, and rabbits (angora). If the fibers are removed from a living animal, the term used is **wool**. If the individual fibers are removed from the pelt of the animal (such as with rabbits and beavers), the term used is **fur fibers**.

Wool is grown naturally as the coat of a living animal. Sheep are the primary source of wool, but goats, vicuñas, llamas, camels, and other wool-bearing animals can be used to grow wool. The average sheep fleece weighs slightly over seven pounds when shorn. Lanolin oil or grease is a by-product of wool, and manufacturers use it extensively in the cosmetic industry.

Figure 10.6 Wool fibers come from sheep and other wool-bearing animals, such as goats, camels, and llamas.

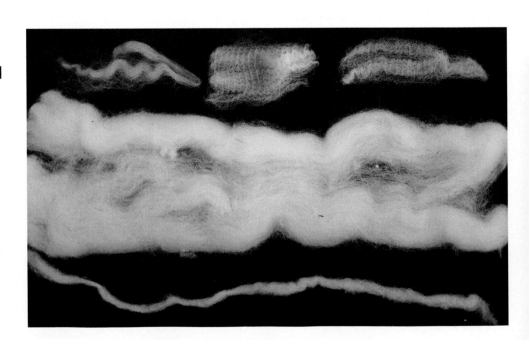

Australia produces the world's finer wool fibers. Although China and New Zealand produce large quantities of wool, it is somewhat coarse (Wool, Greasy, 2005). The United States imports most of its wool from Australia, the United Kingdom, and Italy because these countries can supply the finer quality wool used in apparel. Some wool is produced in the United States, but supplies are limited.

Cashmere is one of the most luxurious wool fibers. From the underhair of the silky-haired Kashmir or Cashmere goat, cashmere wool fibers must be separated from the coarser guard hairs of the goat. Cashmere fabrics cost several hundred dollars per yard. It is also used in the expensive pashmina scarves and shawls.

Vicuñas are Peruvian, camel-like animals that once faced near extinction due to the high demand for their soft wool. Through careful breeding and government intervention, vicuñas are once again available for luxury woolens. Luxury woolen company Loro Piana works closely with the Peruvian government to shear the vicuña herds in a controlled setting.

Silk Since its discovery, silk is regally known as the "queen of fibers" and is a rare and prized fabric. The process of converting caterpillar cocoon extrusions into silk fabrics is credited to the ancient Chinese, and it was a closely guarded secret. Enterprising smugglers stole the secret, and silk became so important to commerce that the trade route across China was labeled the Silk Road. China is still the primary producer of silk (Silk and Silk Business in Iran, 2003).

Consumers desire both raw silk and pure silk, but in the past, the dry cleaning procedures required to care for silk garments prohibited widespread fashion use. In recent years, machine washable silk was developed, and the popularity of silk in mass fashions skyrocketed. Even small percentages of silk will add value to fashion apparel. For example, a mostly cotton sweater combined with 15 percent silk will be appreciated by consumers, particularly if the sweater can still be machine washed.

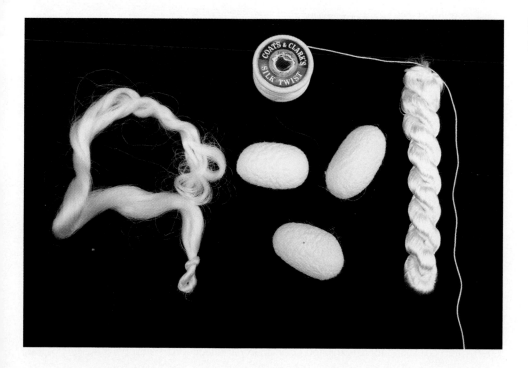

Figure 10.7 Silk cocoons are unraveled to obtain silk fibers.

AUTHOR'S NOTE: For an interesting video on vicuñas, see the Loro Piana Web site at http://www .loropiana.com/eng/tessuti/vicuna_01.php.

The rarity of silk has always been a factor in the price of silk textiles. Cultivated silk is not produced in the United States due to the intense labor required in the production of silk. Silkworms secrete a gelatinous substance called **sericin** that coats silk fibers. Silk fibers still covered with sericin are called **raw silk**. Raw silk has more of a knobby or rough **hand** (feel to the touch) and has a low luster. Fabrics made from silk fibers with the sericin removed are **pure silk**. Pure silk is much lighter in weight and is shiny and lustrous. **Sericulture** is the processing of silk cocoons into thread suitable for weaving or knitting.

Man-made or Manufactured Fibers

Natural fibers have always been available to humans, but man-made fibers are a relatively new invention. Fiber companies derived the earliest manufactured fibers (rayon and acetate) from cellulose, such as cotton and wood pulp. Beginning with nylon in 1939, the chemical companies derived synthetic fibers (nylon, polyester, acrylic, etc.) from petroleum. The production of man-made fibers is not dependent on weather conditions, but it is affected by the price of oil and the availability of technology, such as machinery and developments in chemistry.

Fibers not grown naturally are considered man-made or manufactured, but the petroleum-based man-made fibers are considered **synthetic fibers**. To help students maintain the difference between the two major categories of man-made fibers—regenerated cellulose and synthetic—the most important qualities of each category will be discussed in two separate lists.

Regenerated Cellulose Fibers The properties of regenerated cellulose fibers include:

- Comfort similar to cotton
- Lower durability than cotton
- Moisture absorbent
- Wrinkles
- Soft hand with good drapability
- Luster ranges from slightly to very shiny
- Can be manufactured in any length, depending on the desired end use
 - Short fibers resembling cotton are called **staple fibers**
 - Long fibers resembling silk are called **filament fibers**
- May require special care procedures
 - Rayon may be machine washable or dry cleaned
 - Acetate is usually dry clean only

Rayon In the late 1800s, the American Celanese Corporation manufactured the first man-made fiber with comfort properties similar to cotton, but with a somewhat shiny appearance. Marketers called it *artificial silk* and gave it the name rayon. The "ray" referred to the silk-like sheen of the fabric, and "on" referred to the cotton source. Rayon is made from cotton linters (short cotton fibers) and wood pulp that have been liquefied by adding a chemical to dissolve the cellulose and then are regenerated into rayon fibers. The processing involves extruding the liquid fiber through a showerhead-like device called a **spinneret**. The manufacturing process solidifies the extruded rayon filament in air or a liquid bath to create a rayon fiber. The first regenerated cellulose fabrics exhibited poor quality and lacked dimensional stability, but they have become popular in recent years for mass fashion dresses and blouses.

Lyocell In the 1990s, the Federal Trade Commission recognized another generic fiber category called *lyocell*. It is subcategorized under rayon and has improved wet strength, wrinkle resistance, a soft hand, and good absorbency. Textile producers can manufacture lyocell with a suede-like nap that resembles the fuzzy texture of peach skin. Lyocell is most often manufactured by the Lenzing Corporation under the trade name Tencel®. Like rayon, lyocell is made from regenerated cellulose (wood pulp), but it uses an organic solvent in the manufacturing process. It can be blended with cotton, rayon, linen, and silk or may be used alone. For further information, visit the Federal Trade Commision Web site (http://wwww.ftc.gov/os/statutes/textile/alerts/ lyocell.shtm) to see an interesting textile industry alert on the mislabeling of lyocell garments.

Acetate After the success of rayon, manufacturers produced a shinier and slipperier man-made fabric called *acetate rayon*. Later, acetate became its own generic category, and the inclusion of the term *rayon* was dropped. Apparel manufacturers commonly use acetate in coat linings because the slippery fabric allows a person to slide easily into the confines of a coat. Textile manufacturers use it for formal fabrics, such as taffetas, because it has a beautiful luster that rivals the appearance of silk. The lustrous yarns lack durability and tend to slip and unravel, preventing acetate from widespread everyday use.

Synthetic Fibers The properties of synthetic fibers include:

- Low moisture absorbency
 - Water-based spills clean easily
 - Quick drying
 - Lacks breathability
- Absorbs oil-based stains
- High strength or tenacity
- Little or no fading after repeated washing
- Little or no shrinkage
- High resiliency (does not wrinkle or pack down)

Nylon The invention of nylon just before World War II began a new chapter in textile history. It was so important that it earned a spot at the 1939 World's Fair, alongside other high-tech inventions that included an igloo experience in conditioned air, a ten-foot tall robot that could talk and sing, and a remote-control car. Nylon stockings became very scarce during the war, and a poll of women showed that nylon was the most desired wartime commodity, outranking men by a two to one vote (Bruns, R., 1988).

DuPont's team of research scientists created the unnamed fiber 66 over a period of several years. The struggle to decide on a name evolved through a brainstorming session in which the team considered numerous options for names, such as *no-run* (referring to hosiery) and *duparooh*, an acronym for Du Pont pulls a rabbit out of hat (Bruns, R., 1988).

Nylon is significantly different from the regenerated cellulose fibers of rayon and acetate. Manufacturers melt and extrude petroleum-based polymer chips (millimeter-sized plastic beads) through the spinneret. The process draws and stretches the fibers until they become very thin and pliable. Nylon fibers lack the absorbency of cellulose fibers, such as cotton or flax, but nylon has significant strength and resiliency. Additionally, nylon fibers possess an important wicking

quality that move moisture away from the body to the outside of the garment where it evaporates, keeping the wearer dry. Apparel manufacturers make hosiery, lingerie, jogging pants, windbreakers, swimwear, handbags, and shoes from durable nylon. Interior carpeting represents the single largest end use of nylon because of nylon's inherent abrasion resistance.

China is the top producing country of nylon. The United States, Western Europe, and Taiwan also produce nylon (Worldwide Chemical Fiber Production, 2007).

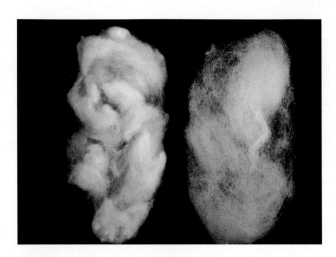

Figure 10.8 Polyester fibers are much more resilient and a much brighter white than creamy cotton fibers (cotton on left; polyester on right).

Polyester In 1952, DuPont invented its second synthetic fiber, and the company marketed the polyester fibers with the slogan "wash and wear." Polyester combines easily with cotton, and manufacturers frequently use them together in sportswear, T-shirts, and durable press fabrics. The advantages of cotton and polyester blend clothing are the merging of the comfort factor provided by cotton and the resiliency provided by polyester. Apparel manufacturers offer durable press men's dress shirts of 65 percent cotton and 35 percent polyester. Usually, cotton comprises the greatest percent because the comfort factor is critical in apparel and cotton has the greater comfort.

Like all man-made fibers, polyester has the flexibility to be cut in short staple lengths to resemble cotton fibers or left in long filament lengths that resemble silk. With the invention of **microfibers** (very fine, man-made filaments), both nylon and polyester have found wider consumer markets for products that once required silk to achieve such supple appearances. For example, men's polyester microfiber neckties are quite close in appearance to 100 percent silk neckties, although they lack the status associated with pure silk.

Polyester has earned almost 70 percent of the man-made chemical fiber market share. It is highly desired as a global textile fiber because it is relatively inexpensive to produce compared to other chemical fibers; it is suitable for varied end uses; and polyester fibers are easy-care, durable, and can be manufactured from recycled plastics. For example, some companies recycle discarded plastic beverage bottles into polyester products, including sweaters, shirts, upholstery, and fiberfill for stuffing and padding. In 2008, the Federal Trade Commission opened a discussion on the revision of the polyester generic definition to include a modified polyester fiber, referred to as PPT. It is slightly different than the conventional polyester used in carpets and clothing, referred to as PET.

Polyester fibers are produced in many countries. China, India, and several countries in Southeast Asia (ASEAN nations) produce polyester fibers (Worldwide Chemical Fiber Production, 2007).

Acrylic Manufacturers invented the third synthetic fiber as a substitute for wool. Marketers advertised the lofty acrylic with the explanatory slogan "warmth without weight." The introduction of acrylic to substitute for wool was a tremendous success in winter clothing, such as coats and sweaters, and also in home fashions, such as blankets.

Other Synthetics and Special Use Fibers Textile companies have developed numerous man-made fibers since the advent of nylon—the first truly synthetic fiber. Each new fiber possesses similar general properties (see preceding bulleted list for synthetics), but it usually excels in a particular quality. The next section presents a brief list of some of the remaining man-made fibers, including high-performance fibers.

FASHION FACTS: Speedo's Olympic Gold

Most students will remember the 2008 Summer Olympics in Beijing, China, when the USA swimmer Michael Phelps earned eight gold medals in the sport of swimming. Phelps passed Mark Spitz's world record of seven gold medals in the 1972 Summer Olympics in Munich, Germany. During the events, Phelps repeatedly set world records. Was it his adrenaline, his rigorous training, his extra long arms, the ten-foot deep pool, or his high-tech swimsuit? Did Speedo's promise of a $1 million bonus upon winning that eighth gold medal improve Phelps' determination? Speedo claimed Michael Phelps' success was due in part to the NASA-engineered, corset-like swimsuit named the LZR Racer. According to the Speedo Web site, the world's fastest, space-age LZR Racer is "made from an ultra lightweight, chlorine resistant, water repellent, and fast-drying fabric." The uniqueness of the competition swimsuit is attributed to its ultrasonically welded (rather than stitched) seams that feel invisible and reduce skin friction drag in the water. Laser-cut, polyurethane panels are laminated onto the base fabric and change the shape of the athlete's body, compressing extra curves and facilitating muscle contraction.

Some controversy arose over a perceived violation of the International Swimming Federation's (FINA) regulation. The regulation states: "No swimmer shall be permitted to use or wear any device that may aid speed, buoyancy or endurance during a competition" (Longman & Kolata, 2008). Critics believed the high-tech textile unfairly shaved time off previous world records. However, most athletes agreed that the sport should keep up with the technology. Most all Olympic competition teams wore some form of this type of suit.

In the 1972 Olympics, American gold medal swimmer, Mark Spitz wore a skimpy red, white, and blue bikini swimsuit and a fashionable mustache. In the 2008 Olympics, Michael Phelps wore the high-tech, full-body suit that took as much as thirty minutes to don. Speedo hired the design house Comme des Garçons to develop a unique look for Phelps and Team USA, still with the American flag theme. Speedo marketed the high-performance racing swimsuit on its Web site prior to the actual release of the item in October 2008. For $550, swimmers could preorder the product and await their opportunity to set swimming records.

SOURCES: LZR Racer, behind the technology. (2008). Speedo home page. Retrieved July 30, 2009, from http://www.speedousa.com/technology/index.jsp

Longman, J. & Kolata, G. (2008, Aug. 12). As swimming records fall, technology muddies the water. *New York Times*. Retrieved August 17, 2008, from NewsBank database.

FASHION CHRONICLE

The Generic Categories of Man-made Fibers and Their Approximate Date of Introduction
Exact dates may differ due to varying sources. Microfibers are also included in the timeline because of their value to the fashion industry.

1885 Rayon	1913 Polyvinylchloride (PVC)	1937–1942 Polyurethane	1944 Acrylic	1959 Spandex	1972 Aramid	1996 Lyocell
	1900 Acetate	1939 Nylon / 1943–1952 Polyester		1949 Modacrylic	1965 Olefin	1990 Microfibers

- **Modacrylic**—After the success of acrylic, textile companies developed modacrylic for improved heat resistance. Manufacturers of children's sleepwear commonly use modacrylic fibers.
- **Olefin/Polypropylene/Polyethylene**—Very lightweight and strong fibers; olefins are also moisture and sun resistant and used for outdoor textiles.
- **Spandex**—The synthetic substitute for rubber, spandex is used in small quantities to add comfort or power stretch to garments ranging from denim jeans to swimwear.

- **Metallic**—A sheet of nontarnishing metal (such as aluminum) is colored and coated with plastic and cut into thin slivers. It can simulate expensive metals, such as silver or gold threads, but coated metallics do not tarnish like real silver threads.
- **Polyvinylchloride (PVC)**—Considered a film rather than a fiber, PVC is a leather simulant and is used frequently in fashion accessories, such as handbags and shoes.
- **Aramid**—These are high-performance fibers, closely related to nylon, which are very strong, impact and chemical resistant, and lightweight. Manufacturers use them for protective vests and helmets, industrial clothing, airline upholstery, and sporting goods. The aramid fibers include Kevlar® and Nomex®, both produced by DuPont.

Leather and Fur as Textiles

To a lesser degree, leather and fur are important materials in the fashion industry. Leather is a natural material used in the manufacture of apparel, such as leather coats, jackets, skirts, and pants, and accessories, including footwear, handbags, small personal and flat leather goods, belts, and luggage.

Bovine (cattle) leather is a by-product of the meat-packing industry and comprises the largest category of leather. The United States produces some of the best quality cattle leather in the world because of the high standards for animal husbandry in the beef industry. Leather categories also include goats, sheep, swine, deer, reptiles, and aquatic animals.

The United States consumes far more leather and fur than it produces. Leather imports are approximately twice the number of leather exports, and fur imports are more than ten times higher than fur exports. The United States exports its leather to Mexico, Japan, Canada, China, and Italy (Exports of NAICS 3161, 2007), whereas it imports its tanned leather from Mexico, Italy, Brazil, Argentina, and China (Imports of NAICS 3161, 2007). The United States exports its fur to Japan, Canada, Italy, China, and Germany (Exports of HS 4303, 2007), whereas it imports primarily from China, Canada, and Italy (Imports of HS 4303, 2007).

Not all fashion consumers desire leather and fur products, so designers and manufacturers offer fashions in faux or imitation leather, suede, and fur. Many of these synthetic alternatives are attractive and less expensive substitutes (a fraction of the cost), including polyvinylchloride (PVC), a leather simulant; polyester suede cloth; and acrylic and modacrylic as faux (fake) fur. Although some consumers express concern over animal rights, others express concern over the choice of nonsustainable materials such as PVC. Whether natural or fake materials are used, the fashion look is generally the same, and consumers have a choice. Designer Stella McCartney takes an animal-

Figure 10.9 Faux fur jacket.
(Getty Images Inc./Stone Allstock)

Figure 10.10 Real fur jacket.
(© Nancy Kaszerman/CORBIS All Rights Reserved)

Beautifully Canadian Brand Initiative

The Canadian fur industry is represented by the Fur Council of Canada organization. In 2007, it launched the "Beautifully Canadian" labeling campaign to enhance the focus on the Canadian industry's exceptional workmanship and high-end creativity in the fur industry. The label also represents the Canadian fur industry's centuries-old heritage, its quality animal husbandry standards employed, and its species sustainability through carefully monitored trapping and fur farming processes. The brand initiative is a competitive advantage over the low-cost fur imports from China.

The Canadian fur industry is well established, beginning with the Hudson Bay Trading Company in the late seventeenth century. Canada features the North American Fur and Fashion Exposition (NAFFEM), which is the largest apparel show in Canada. About 80 percent of the country's fur manufacturing occurs in Montreal, and most are characterized as small cottage industries. Furs are sold at Canadian fur auctions, and when the supply is gone, no additional Canadian furs are available until the next year.

SOURCES: Friede, E. (2008, Jan. 29). Fur industry seeks to trap a green image; Launches campaign in newspapers, magazines. *The Gazette (Montreal)*, p. D2.
Fur Council of Canada Home Page. (2009). *Fur Council of Canada*. Retrieved March 11, 2009, from www .furcouncil.com

friendly stance in her designs by not using fur or leather. By contrast, Karl Lagerfeld has served as creative director for years with the House of Fendi, well known for its luxurious furs.

Yarns

Fibers are tightly twisted or **spun** into **yarns** to provide the strength needed to make fabrics. The **spinning** process involves taking a group of aligned fibers and imparting twist to create a yarn.

Fabrication

The process of creating textiles from yarns is fabrication. Two major methods of fabrication are weaving and knitting. **Woven fabrics** are characterized by the interlacing of yarns at right angles. They are created on a machine called a **loom**. Blue jeans and bath towels are examples of woven fabrics. Unless spandex is added for stretch, most woven fabrics have very little stretch. **Knitted fabrics** are made by creating interlocking loops in the yarn. Crocheting and hand knitting with needles are examples of textiles manufactured with interlocking loops. One can completely unravel a knitted fabric such as these. Most apparel knits are made on knitting machines that create either flat or circular fabrics. Generally, knits are characterized by a greater degree of stretch than woven fabrics. T-shirts and socks are knitted items of apparel.

Marketing Textiles

The promoting and selling of textiles occur at all levels of the industry, by private textile businesses, governments, trade associations, and at sponsored events. Most often, the marketing of textiles occurs as a trade promotion (business to business, B2B), such as a chemical

AUTHOR'S NOTE: For several demonstrations of spinning fibers into yarns, visit www.youtube.com and search the site for "spinning fibers."

company promoting its water-resistant leather to a footwear manufacturing company. Occasionally, a business at the trade level will market directly to ultimate consumers as well as the trade level. For example, Cotton Incorporated frequently advertises the excellent wearing properties of cotton in consumer fashion magazines (see **pull marketing**, Chapter 7). It also publishes research in its *Lifestyle Monitor* trade publication, showing businesses how important cotton is to American and global consumers (see **push marketing**, Chapter 7). As an auxiliary service provider in the textile industry, Cotton Incorporated can ensure the greatest reach of its promotional messages by targeting the ultimate consumers and the textile businesses.

> Marketing occurs at all levels of the industry, by private textile businesses, governments, trade associations, and textile trade shows.

Trade Shows

The most innovative fibers, yarns, and fabrics can be viewed at textile trade shows all over the world. Each year, dozens of these events are hosted by governments, industry trade organizations, or private businesses promoting a country's primary textile industries. The United States, Japan, Italy, France, China, Turkey, Mexico, and many other textile countries

FASHION FACTS: Material World Trade Show

Boasting the slogan "from design to delivery," the Material World & Technology Solutions events in Los Angeles, California, and Miami Beach, Florida, are fabric sourcing and apparel production trade shows. They are sponsored primarily by the American Apparel and Footwear Association (AAFA). Industry personnel from all over the world are invited to attend the California (spring and fall) or Florida (spring) events that feature representatives from all levels of the supply chain. Important topics from previous events included the Americas' competitiveness, supplier relationship management, textile developments, supply chain and sourcing, trend seminars, fashion forecasting, fashion shows, display ideas, and socially responsible marketing/sustainability. The focus areas were:

- **Eco-Friendly**—The show featured fabrics made from alternative or renewable resources, such as organic cotton, bamboo, soy, and corn fiber. In addition, fabrics manufactured using eco-friendly and environmentally sound processes were highlighted during the shows.
- **Textile Performance**—The show featured the latest developments in moisture management, ultraviolet (UV) protection, antimicrobial protection, thermoregulation, and water or wind resistance.
- **Product Lifecycle Management (PLM)**—The show offered software demonstrations of the product lifecycle management (PLM) strategy and explained the PLM benefits of accelerated speed-to-market production and supply chain collaboration.
- **Brand Management**—A panel of experts discussed brand management issues they face every day, including merchandising, sourcing, fit, customer retention, gross margin, markdowns, and closeouts.
- **Design and Merchandising Solutions**—The show offered resources for all phases of product development, including line planning, trend and color forecasting, technical and 3-D design, creating samples, and visual merchandising.
- **Home Furnishings Fabrics**—The show featured a section for home fashions, including representatives of fabric mills, converters, and leather and trimming manufacturers. These suppliers showcased products from home textiles with special finishes such as chintzes and flocked fabrics, leather, sheeting, jacquards and tapestries, bed/bath, and other home furnishings fabrics.

SOURCES: Going green. (2006, Sept. 26). *Women's Wear Daily Online*. Retrieved September 4, 2007, from www.wwd.com

Kleinman, Rebecca. (2007, Apr. 17). Material World Miami readies for three-in-one show. *Women's Wear Daily Online*. Retrieved August 31, 2007, from www.wwd.com

Material World & Technology Solutions Web site. (2008). American Apparel and Footwear Association (AAFA). Retrieved July 1, 2008, from www.material-world.com

host trade shows that last for several days and attract people from many levels of the supply chain. **Trade shows** are scheduled events that provide opportunities for members of the trade to make industry contacts, network, create awareness, view trends, show innovative products (from fibers to machinery), and ultimately to do business in the future. Trade shows have become a one-stop shop for sourcing textiles from many countries. Since the World Trade Organization dropped most of the apparel and textile quotas in the world in January 2005, global trade has increased substantially, and many countries are vying for a larger global market share.

Table 10.2 shows some important international trade shows in the global textile industry. Many of the trade shows listed, as well as other smaller trade shows not listed in the table, are described in greater detail at the following Web site: http://www.biztradeshows.com/textiles-fabrics.

Figure 10.11 Material World & Technology Solutions Trade Show in Miami, Florida.
(Amy Dufour)

Table 10.2 International Textile Trade Shows

Trade Show	Location
China International Sewing Machinery & Accessories Show (CISMA)	Shanghai, China
Expofil Yarn Fair	Paris, France
Fashion Week	Tokyo, Japan
Federal Fair-Textillegprom	Moscow, Russia
Indigo Paris	Paris, France
Indonesian Textile & Apparel Fair	Jakarta, Indonesia
International Textile Machinery Association (ITMA Munich)	Munich, Germany
Intertex Milano	Milan, Italy
Japan Yarn Fair	Tokyo, Japan
Material World & Technology Solutions	Miami Beach, FL, and Los Angeles, CA
Los Angeles International Textile Show www.californiamarketcenter.com/markets	Los Angeles, CA
Milano Unica (five separate shows)	Milan, Italy
Mod-Amont Trimmings Show	Paris, France
Modacalzado Leather Goods Trade Fair	Madrid, Spain
NAFFEM Fur Luxury Outerwear Show	Montreal, Canada
PremièreVision Textile Show	Paris, France
Printsource New York	New York, NY
Textilmoda	Madrid, Spain
Texworld	Paris, France
Yarn Expo www.fibre2fashion.com/tradefairs	Beijing, China

Trade Associations

Trade associations organized by interested stakeholders support most major industries. A **trade association** is an organization that represents a particular industry and lobbies and promotes the industry on behalf of its members. Involvement in these associations entitles the members to the activities supported by the association, including maintaining an informational Web site, supporting research, publishing articles and press releases, engaging in forecasting, lobbying in Congress, supporting and promoting consumer education, coordinating global activities, assisting with self-regulation of members, acting as a liaison between different levels of the industry, and, in general, increasing demand for the industry's products and services. For example, Cotton Incorporated is an important trade association in the textile industry. Headquartered in Cary, North Carolina, it also has offices in Mexico, Japan, Singapore, and China. Its purpose is to promote and ensure cotton continues to be widely used in the soft goods industry.

Table 10.3 lists many of the textile trade associations that support and promote the textile industry.

Table 10.3 Several Important Textile Trade Associations

Association	Purpose
American Fiber Manufacturers Association, Inc. fibersource.com	Represents U.S. manufacturers of synthetic and cellulosic fibers
Fashion Business Inc. www.fashionbizinc.org	Promotes the fashion business in Los Angeles and San Francisco, CA
Fur Council of Canada www.furcouncil.com	Sponsors the NAFFEM trade show, represents all levels of the fur industry, and promotes the fur industry in Canada
Fur Information Council of America www.fur.org	Serves all facets of the U.S. fur industry, from farming to retailing
International Fur Trade Federation www.iftf.com	Sets industry standards through self-regulation and promotes the fur industry
International Textile and Apparel Association www.itaaonline.org	Scholarly organization comprised of teachers and researchers of textiles and apparel from production to customer satisfaction with products
Leather Industries of America www.leatherusa.com	Represents the American industry tanners and suppliers
National Council of Textile Organizations www.ncto.org	Represents all levels of the U.S. textile industry and lobbies in Congress
Organic Trade Association www.ota.com	Promotes and protects the organic trade in North America
Synthetic Fiber and Yarn Association www.thesfya.org	Promotes the production and improvement of synthetic yarns and fibers
United States Association of Importers of Textiles and Apparel www.usaita.com	Represents the interests of the textile and apparel importing community to the government and its agencies, the business community, and the public

summary

- The term *textiles* encompasses fibers, yarns, fabrics, and products.

- The textile industry is comprised of fiber producers, yarn manufacturers, and fabric mills.

- Governing agencies include the U.S. Census Bureau; the Foreign Agricultural Service, U.S. Department of Agriculture; and the Office of Textiles and Apparel, International Trade Administration, U.S. Department of Commerce.

- The textile supply chain begins with the production of raw materials called *fibers*.

- Two major categories of textile fibers are natural and man-made textile fibers.

- Natural fibers include plant and animal fibers, such as cotton, flax, wool, and silk.

- Man-made fibers may be made from regenerated cellulose (wood pulp) or petroleum.

- Man-made fibers include rayon, acetate, and lyocell (regenerated cellulose) and nylon, polyester, acrylic, and modacrylic (petroleum-based or synthetic fibers).

- Leather and fur are important textiles in the fashion industry and may be real or simulated.

- Marketing occurs at all levels of the industry, by private textile businesses, governments, trade associations, and textile trade shows.

- Trade shows have become a global, one-stop shop for sourcing.

- A trade association promotes and lobbies the industry on behalf of its members.

terminology for review

textiles 177
vertically integrated 178
trend-based fibers or trend-based
 textiles 179
raw materials 179
soft goods 180
natural fibers 180
cellulose fibers 180
protein fibers 180
man-made or manufactured fibers 180
cotton boll 181
lint 181
ginning 181
linen 182

fibre flax or linen flax 182
lanolin 184
wool 184
fur fibers 184
cashmere 185
vicuñas 185
sericin 186
raw silk 186
hand 186
pure silk 186
sericulture 186
synthetic fibers 186
staple fibers 186

filament fibers 186
spinneret 186
microfibers 188
spun 191
yarns 191
spinning 191
woven fabrics 191
loom 191
knitted fabrics 191
pull marketing 192
push marketing 192
trade shows 193
trade association 194

questions for discussion

1. What are textiles?

2. What is meant by the term *vertical integration*? How might it be beneficial in the textiles industry?

3. What is the Harmonized System?

4. How has the fluctuating cost of petroleum affected the textiles industry?

5. What are some properties common to all natural cellulosic fibers?

6. What are some properties common to all natural protein fibers?

7. How are leather and fur used in the fashion industry?

8. How do textiles businesses promote their products and services to other textiles businesses in the supply chain?

9. What are some of the major purposes of trade associations?

10. What are the functions of trade shows?

related activities

1. Choose a particular country that has a substantial textiles industry. Research the country's contribution to the global economy. Prepare 15 to 20 PowerPoint slides with a map of the country in relation to its continent, general information about the country, textiles industry statistics, textiles trade shows and trade associations, and any other relevant information. Present the PowerPoint slides to the class.

2. Conduct a search using the university library's database of electronic journals to find an article about textiles that are eco-friendly, sustainable, green, or any other related topic. Type a summary of the article and present a critique addressing the following questions: Was the article informative? Why or why not? How can this information be used by fashion marketers? What are some of the uses of the textile? What is the long-term forecast for this type of textile?

Cite the reference using the correct bibliographic format. Present the findings to the class.

3. Choose either two textiles trade associations or two textiles trade shows and develop a one-page report about them. Identify the purposes of the trade associations or shows, and then compare and contrast them. Present the paper to the class.

4. Schedule a class field trip or teleconference with a wholesale showroom representative at a nearby market center. Develop a list of questions to ask before visiting with the representative. Ask the showroom representative to explain how he or she obtains merchandise to offer store buyers. Have the representative explain the supply chain in terms of his or her own organization.

Your Fashion IQ: Case Study
Buying Green Fashions: Is This Fundamentally Wasteful?

If you think about it, being a green consumer requires the act of purchasing a product and then consuming it. One could argue that purchasing a pair of organic cotton denim jeans is still wasteful consumption, especially since American women own an average of eight pairs of jeans. According to the article, "The myth of green marketing: tending our goats at the edge of apocalypse (Smith, 1999), being a green consumer determines the types of products that will be produced, and green consumers can demand environmentally benign products. Although this may be true, is there a problem with being a green consumer? Does "adopting the green consumer style create the illusion that a contribution to the solution is being made while it actually serves to perpetuate the problem" (Smith, 1999, p. 105)?

QUESTIONS:

1. How does one reconcile the desire to be a green fashion consumer to the notion of reduce, reuse, and recycle, rather than consume, consume, and consume?

2 What is an argument that explains why the promoting of green products in order to sell more products is an unethical practice?

3. What is a counterargument to Question 2? How can fashion marketers ethically justify the promoting of green consumerism in order to sell more merchandise?

SOURCES: Kilbourne, W. (2001, June). The myth of green marketing. *Journal of Macromarketing*, 20(1), 103–106.

Smith, T. M. (1999). *The myth of green marketing: tending our goats at the edge of apocalypse*. Toronto, Canada: University of Toronto Press.

"Forget the 'trickle down' time from runway to the store; it's Niagara Falls."

Robin Lewis, Fashion Consultant, regarding fast-fashions.
Source: Beckett, W. (2007, March 21). Lag time closes in between runway and better department. Women's Wear Daily, www.wwd.com.

DESIGNERS, PRODUCT DEVELOPERS, and FASHION MANUFACTURERS

LEARNING OBJECTIVES

At the end of the chapter, students will be able to:

- Recognize the differences between fashion designers and product developers and explain why each is important to the fashion industry.
- Identify sources of design inspiration.
- Compare the differences between legal knockoffs and infringement on intellectual property rights.
- Discuss the stages of the production process for fashion merchandise.
- Explain the importance of and relationship between speed-to-market and just-in-time production concepts.
- Identify several benefits of mass customization.
- Demonstrate an understanding of outsourcing and its related terminology.
- Compare the outsourcing of apparel manufacturing to developing countries with domestic apparel manufacturing.

Many people at the designing, product developing, and manufacturing level of the fashion industry possess a great deal of creativity. In most cases, original creativity is not the primary focus of these careers; instead, it is interpretive creativity. A great designer is one who can take the zeitgeist (spirit of the times) and create a fashion that expresses the contemporary world. Marc Jacobs, an American designer, carefully explained his own source of fashion inspiration.

11

I'm a designer living In this world who loves fashion . . . I'm attentive to what's going on in fashion. . .I'm influenced by fashion . . . I have never insisted on my own creativity . . . I have my interpretation of ideas . . . Anybody who's aware of what life is in a contemporary world is influenced by other designers." (Karimzadeh and Foley, B., 2007, Sept. 13, p. 2.)

The same political, economic, and social elements—and other industry personnel—influence members of the fashion industry. Some designers may have unique interpretations of these elements, whereas other industry personnel prefer to knock off popular existing designs or even create line-for-line copies. The fashion industry is built on the notion of borrowing bits and pieces of ideas from other resources and then combining them into new looks and new fashions. Designers understand that consumers want change, but they do not want too radical of a change. However, occasionally the "borrowed" ideas obviously duplicate copyrighted items, such as logos, fabric prints, symbols, or other distinctive features. This infringes on another company's intellectual property rights (IPR), and legal battles ensue. The controversial topics of intellectual property rights and counterfeiting are discussed in Chapters 9 and 13.

Designing and Developing Fashion

Generally, fashion marketing students have a greater awareness than other students on the topics: what's in fashion, what will sell, what looks good on a person, what items "go together," how to mix and match pieces from their wardrobes, whether or not colors match, and many other fashion-related topics. However, only some of the fashion students master the specialized skills required to become fashion designers. These skills include drawing a fashion sketch (by hand and using computer-aided design), understanding garment construction processes, and sewing a garment. The question becomes: How can nontechnical fashion marketing students use their fashion knowledge to get a job in the fashion industry? The answer is in product development. A **designer** creates ideas, whereas a **product developer** becomes a master at identifying and adapting previously successful concepts into marketable products.

Stages in Product Development and Manufacturing

Fashion marketers choose to market original designs, or they create knockoffs from already popular fashions. At the mass fashion level, the **product development process** may involve the creation of original ideas that will appeal to the company's target customer, or the process may involve private label knockoffs of branded designs. Private label retailers knock off popular branded items, such as Donna Karan designs, Dockers apparel, or Sketchers shoes. For example, the mass merchandise store's team of product developers might visit an upscale retailer and purchase a Donna Karan ready-to-wear printed skirt. They analyze the branded product and create a similar design with a slightly different fabric and print (usually changing the original design by about 25 percent). This knockoff becomes a private label skirt retailing for less than half of the price of the original Donna Karan product. A similar process might occur when product developers plan for a pair of men's khaki slacks that are based on a popular style of Levis Dockers khaki slacks. The product developers may purchase a pair of Dockers and

Creations by Texas designer Michael Faircloth rival the creative genius of most any Paris couturier. Notable clients include Laura Bush, wife of President George W. Bush; Sarah Perot, wife of businessman and former presidential candidate, Ross Perot; Nancy Brinker, founder of the Susan G. Komen Foundation; and Mrs. Thomas Borer, wife of the Swiss ambassador to Germany. Faircloth designed many of Laura Bush's inaugural outfits, including her widely anticipated inaugural suit and evening gown for President Bush's 2004 inauguration ceremonies.

Faircloth earned his bachelor of fine arts degree in fashion design from the University of North Texas. During his college career, he entered the Dallas Fashion Group competition for garment design during college, but he did not place in the competition. Unwilling to forgo his dream to become a successful fashion designer, Faircloth continued to take art, sewing, and drawing classes. His part-time job at Neiman-Marcus provided opportunities for him to meet famous couture designers and closely examine couture garment construction.

Upon graduation, Faircloth opened his fashion business in Dallas, employing a patternmaker and seamstresses. His first client (she's still a client after a quarter of a century) asked him to design a dress for the symphony ball and later referred him to a friend. His business continued to grow, and he decided to remain in Dallas. Eventually, he received a $10,000 loan from a friend to create a ready-to-wear collection which he took to the Drake Hotel in New York City.

The hotel regularly scheduled a ready-to-wear showing for buyers of boutiques to visit and place orders with new designers. Later, Faircloth showed his collection at the Waldorf Astoria Hotel where one floor served as a temporary showroom during Fashion Week.

In 1992, Faircloth worked as an in-house designer for the Escada Boutique. He met many of the boutique's clients, and he worked to create special orders for those clients who did not see what they liked in the boutique.

Laura Bush contacted the Dallas designer when her husband George W. Bush was campaigning for governor. Later, when her husband was on the presidential campaign trail, Mrs. Bush ordered clothing for herself and her daughters, including her inaugural ball dress. Faircloth believes in designing clothing that helps his client "speak." In the case of Laura Bush, she needed modest clothing that covered her body, but possessed a wonderful sparkle that celebrated the first day of her husband's presidency. The red inaugural ball gown designed for First Lady Laura Bush conveyed the confidence and reverence associated with such an important position. The gown is now on permanent exhibit at the Smithsonian Museum in Washington, D.C.

Faircloth's designing strengths are his ability to interpret his clients' wants, his elegant creations in luxurious fabrics, and his careful attention to details. When showing his clients possible design ideas, Faircloth creates very detailed sketches, including seam lines, shoulder lines, and accessories, so that the clients understand the intent of the designs. He is willing to make some concessions to accommodate his clients' needs, but he believes a designer should be true to himself or herself. He loves natural fibers, including mohair, wool, cotton, and silk and makes efforts to support Texas-grown fibers. Faircloth is truly an American couturier.

Figure 11.1 First Lady Laura Bush in inaugural gown designed by Michael Faircloth.
(Getty Images, Inc./Liaison)

cut a swatch of fabric from the pants to send to fabric mills for an accurate textile match. A nearly line-for-line copy of the branded khakis can be created, altering the product sizing to meet the store's target customers. The knockoff product retails for considerably less, and the private label store earns a higher profit on the private label merchandise. In a third example, a large company may purchase a pair of popular Sketchers shoes for girls. The product developers for the mass merchandise retailer change the design at least 25 percent and legally market the new shoe under a Wal-Mart private label.

In each of these examples, product developers took care to prevent excessive infringement on the intellectual property rights of the designer or national brands. Although product developers consult with attorneys to minimize the risks of legal action, many lawsuits are filed every year for perceived intellectual property rights infringements. In 2007, at least twenty copyright lawsuits were filed against Forever 21 for illegally copying fabric prints and other parts of the designs of Anna Sui, Diane von Furstenberg, Tokidoki, Bebe, Anthropologie, and Gwen Stefani's Harajuku Lovers line (Casabona, L., 2007, July 23).

Apparel manufacturing involves preproduction and production steps, which are outlined in the following section. Once managers decide to mass-produce a style, the complicated process requires constant monitoring to ensure the product is sewn to specifications and to ensure quality control.

A point of contention between fashion designers and fast-fashion retailers is the speed at which a designer's original ideas are knocked off and mass-produced for fast-fashion stores.

Preproduction and Production Steps

Designers and product developers go through similar processes for creating apparel and accessories. The steps involved in producing fashion merchandise are complex, but they have been classified into ten separate stages. In the fashion industry, some steps are automated, and some are completed by hand. Figure 11.2 represents an abbreviated version of the steps discussed following.

Market Research The preproduction process begins when a fashion marketer identifies a market opportunity by conducting formal or informal research, such as evaluating previous sales figures, talking to the company's target customers, surveying currently popular styles, or any other methods of interpreting data to identify trends. It is vital to first determine the target customers' needs and wants and then produce a product that satisfies these desires.

Idea Conception After consumer input is obtained or after the current top sellers are evaluated, designers or product developers begin to formulate ideas. They get their design ideas from a variety of sources, including art; other designers' creations; following celebrity fashions; watching people on the street; reading trade periodicals, such as *Women's Wear Daily* or *Daily News Record*; perusing fashion magazines, fashion catalogs, and the Internet; and watching television and movies.

The first two steps of market research and idea conception are closely related. Sometimes they occur simultaneously or evolve as a back-and-forth process between the two steps. For example, an accessory designer may get the idea for creating colorful enameled jewelry after reading an article in a trade publication about an Italian designer who has also used enameling techniques. The designer may try out a few sample pieces and test-market the idea, refine the look based on customer feedback, and then conduct more market research on the revised ideas.

Step 1: Market Research → Conduct research to determine target customers' needs and wants.

Step 2: Idea Conception → Get design ideas from: Art, other designers, celebrities, people on the street, trade periodicals, fashion magazines, television, movies, fashion catalogs, and the Internet.

Step 3: Garment Design → Conceptualize the design through fashion sketching or computer-aided design.

Step 4: Budget Concerns → Determine the feasibility of the design production, including how much will be spent per unit on fabric, buttons, labor, lining, etc.

Step 5: Patternmaking → Design is sent to the patternmaker, who creates a cardboard pattern and sample by working from the designer's sketch.

Step 6: Grading → The pattern is graded, meaning the master pattern is increased or decreased to larger or smaller sizes.

Step 7: Marking → The pattern pieces are carefully laid out on the computer screen or directly on the fabric to ensure the least amount of wasted fabric during cutting

Step 8: Cutting → Once the pattern pieces are laid out on the fabric, the layers of fabric arecut with a blade or laser, then bundled and sent to the sewing factory

Step 9: Assembly → Sewing or garment assembly is when substantial transformation occurs; the product goes from flat fashion fabric to a three-dimensional garme

Step 10: Finishing and Inspecting → After the last sewing operation is performed, the garment undergoes a final finish and inspection to make the apparel ready to be shipped to the retail stores or warehouses.

Figure 11.2 Stages of fashion production.

Garment Design The design process involves conceptualizing the idea through fashion sketching of a proportioned garment with construction details or computer-aided design programs, such as Adobe's Illustrator. A two-dimensional figure is drawn by hand (front and back), or a computer illustration is created (see Figure 11.3). Computer-aided designs can be detailed, technical, and present a three-dimensional figure viewed from several angles.

Costing Fashion marketers complete an exercise called **costing out a garment**. This means the production team decides the total cost of producing the garment--that is, how much will be spent per unit on the fashion fabric and lining, findings (such as buttons, threads, or zippers), labor, overhead, packaging, and any other required costs. The production team must also ensure that the company realizes a profit on the garment. Design teams make sure a style is economically feasible to manufacture before moving forward with production. If the team agrees on the feasibility of the design, it sets a final dollar for which the garment can be produced. This is the **wholesale cost**, which is about half of the retail prices charged in the stores.

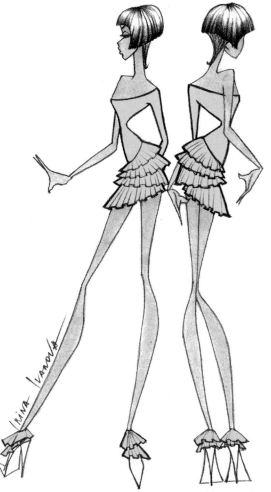

Figure 11.3 A fashion sketch of an outfit, complete with croquis.

Sustainability

According to the United Kingdom's Centre for Sustainable Design (www.cfsd.org/uk), there are four components of sustainability: refine, redesign, repair, and rethink. Traditionally, fashion businesses have been strongly criticized for their disregard for sustainable practices. Some have unfounded fears that eco-friendly and fashion are not compatible concepts. Today's businesses should refine their production and manufacturing processes to make them even more streamlined and earth-friendly. Fashion companies should redesign products to incorporate organic and recyclable materials as well as reusable components. Consumers should consider ways to reuse products and repair existing apparel and consider apparel donations rather than discarding unwanted items. Sustainability requires all of us to rethink our current mode of operation. Can we recycle things, including newspapers, aluminum, glass, cardboard, and plastics? Can we be less wasteful by using fewer resources, whether gasoline, electricity, water, or natural gas?

Many opportunities exist in the fashion industry to implement sustainable practices. As an example, the London Fashion Week includes an "Esthetica" program showcasing ethical designer fashions that focus on one of three principles: organic, fair trade, or recycled. The program, established in 2006, has become part of sustainable fashion design in the industry.

Patternmaking During this stage of production, the design is sent to the patternmaker, who creates a first sample working from the designer's sketch or the computer-aided design (CAD) drawing. The pattern is made from paper or tagboard (like flimsy poster board). A **first sample** is a rough draft or prototype in fashion fabric in a common size, such as size 8 or 10. A fit model with precise body measurements may try on the sample to ensure comfort and proper fit during wearing.

Grading If approved, the pattern is **graded**, meaning the master pattern is increased or decreased to larger or smaller sizes. A pattern grader in a larger company may use a computer for sizing the patterns, but in smaller manufacturing firms, patterns may be hand-graded. The sizing measurements are not standardized in women's wear, and each company establishes its own measurements for a particular size. In some higher-priced lines, the sizes may be cut more generously to appeal to the customers who appreciate being able to wear smaller sizes. **Vanity sizing** is discussed in Chapter 5.

Marking Once the pattern pieces are properly scaled for a particular size, the pattern is marked. A **marker** is a long paper cutting guide generated by a printer or plotter that ensures the best possible material yields (least amount of wasted fabric). When the marking operation is performed by hand, the person in charge of marking lays the individual pattern pieces in a way that follows the proper grain and wastes the least amount of fabric. If the marking operation is performed on a computer, a paper pattern may not be necessary since the computer can control the exact location of the cutting blade or laser. Each pattern piece is laid on the layers of fabric according to the grain line, and the individual pieces are placed as close as possible to the other pattern pieces. According to the Web site of Gerber Technologies, a leader in apparel manufacturing equipment, a computerized marking machine can save as much as two to four cents per garment in wasted fabric, adding up to several thousand dollars on large manufacturing runs.

Cutting The fashion fabric is hand- or machine-spread on a long cutting table. Once the pattern pieces are properly laid out on the spread fabric, they are cut with a blade or laser. The fashion fabric may be a single layer, or the fabric may have multiple layers stacked, resulting in a stack that is a few inches thick. In expensive fabrics, leathers, and furs, there is only one layer of the fashion textile. The person who performs the cutting operation is the **cutter**. The cut pattern pieces are bundled and sent to the sewing factory for assembly.

Assembling Sewing or garment assembly is generally considered the point at which substantial transformation occurs, thereby designating the sewing country as the country of origin. **Substantial transformation** means the product undergoes significant change, such as from flat fashion fabric to a three-dimensional garment. **Country of origin** refers to the geographic location where the substantial transformation, garment assembly, or sewing occurs.

Two main types of assembly processes are used in the fashion industry. The first method of garment construction is called **modular manufacturing** and is characterized by a small team of garment workers making a garment from start to finish. The second method is called **piecework**, in which one person performs a single function of garment assembly. For example, in piecework, one machine operator spends the entire day sewing the sleeves into the bodice armscyes. Then, the stack of bodices with the sewn-in sleeves is passed to the next sewing machine operator, who may only attach the collars and cuffs. The number of individuals and separate steps involved in the piecework of assembling a garment depends on the complexity of the design. The assembly of a garment may require fewer than ten separate steps (such as a T-shirt), or it may require over one hundred steps (such as a man's tailored suit jacket).

Finishing and Inspecting After the last sewing operation is performed, the garment undergoes a final **finish and inspection** to make the apparel ready to be shipped to retail stores or warehouses. This may include pressing the seams, clipping extra threads, buttoning the buttons, steaming the garment, inserting hangers, attaching sensors, tagging the merchandise, and any other finishing steps to ready the apparel for shipments to retail stores or warehouses.

AUTHOR'S NOTE: It is helpful to view a video on apparel manufacturing. Cotton Incorporated developed several helpful CDs on various types of apparel manufacturing, including *The Art of Garment Manufacturing*, *The Art of Denim Manufacturing*, and *The Art of Sweater Manufacturing*. These and several other CD-ROMs are available from the organization's Web site at http://www.cottoninc.com/TextileBasicsCDs.

Easy, accurate inputting of patterns into your Gerber CAD system

You can quickly and efficiently input pattern pieces into your AccuMark™ system in several ways: through Silhouette™, Pattern Design™, or by digitizing. The digitizer workstation consists of a digitizing table with menu, and a cursor. The digitizer allows you to enter information that describes a pattern piece.

Using a predefined grade rule table as a reference, an entire range of sizes can be graded from a single base size pattern during digitizing.

Here are some of the types of information you can enter into the system:
• Grading information and data
• Piece outline and internals, such as stripe and plaid lines, and drill locations
• Piece identification
• Notch type and location, up to five different kinds per piece
• Piece labels and special point information, such as instructions for the GERBERcutter® system

You can use special digitizing techniques for a variety of pattern requirements, such as nested, copied, or mirrored pieces. All of the information entered into the AccuMark system, where it is then ready for pattern modification and the marker making process.

GERBER TECHNOLOGY
Expect More.

Figure 11.4 Gerber Technology AccuMark marker for pattern piece placement.
(Gerber Technology)

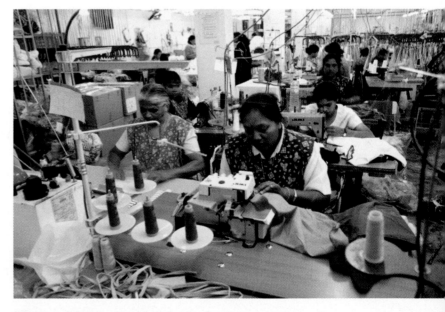

Figure 11.5 Sewing factories are common in developing countries.
(The Image Works)

Speed-to-Market Production

Each year, the major players in the fashion industry convene for a variety of conferences, seminars, and summits, during which company leaders discuss important trade issues. For the past several years, one of the top issues has been speed-to-market production, especially in the junior market, because trends cycle more quickly in fashions for teens and young adult females. **Speed-to-market** means shrinking the time required for the entire production process—from design through production and then to delivery to retail stores. Start to finish production can occur in as little as three to six weeks, rather than the traditional time frame of three months generally required when items are manufactured overseas. The goal of fast-fashion retailers is to achieve **just-in-time (JIT) production**, which means the goods are produced and delivered to the stores just in time for the selling season. In this way, the investment capital is not tied up in inventory for the weeks or even months leading up to the actual selling season. For example, the fast-fashion retailers H&M and Zara are market leaders in manufacturing and delivering small shipments of new and trendy fashion merchandise to the company stores in as little as three weeks. Using product life cycle management software systems, the fashion merchandise is speedily shipped directly to the stores, bypassing the distribution facilities and saving time and money. As much as two weeks of the supply chain can be eliminated when distribution facilities are bypassed. This strategy requires careful collaboration between key suppliers and the retailer, especially in packing the merchandise and labeling the cartons in the country of origin. With careful planning, the strategy can work with fashion coordinates or staple merchandise.

Both retailers and manufacturers are concerned about reducing production time and saving money on shipping costs, yet the green factor is also an issue. Fashion marketers can reduce the size of the carbon footprint by eliminating the additional miles needed to transport the goods to and from the distribution centers.

The benefits of speed-to-market trickle down to the customers of all kinds of retailers, from department stores to fast-fashion stores. Department store customers get better merchandise assortments, competitive prices, and can shop the selling floor for the latest fashions several days earlier each season. Customers patronizing fast-fashion stores, such as H&M and Zara, can view the latest runway trends from couture shows and expect that these companies will have lower-priced knockoffs in the store within the month.

> Just-in-time manufacturing refers to producing goods and delivering them to the stores just in time for the selling season.

In addition to hastening the merchandise into the store, fast-fashion retailers limit the quantities received. The sell-through is quick and markdowns are reduced. Fast-fashion retailers often will not reorder on the same items because the generally held belief is that faster production and leaner inventories improve profits. Production batches are kept small to control the supply and create immediate demand for the fashion goods. Consumers learn that they must buy the item at full price, at that moment, or risk not getting it at all.

Apparel Manufacturing in Developing Countries

Students can visit just about any fashion retailer in the United States, peruse the racks of garments in the stores, and find that the vast majority (an estimated 96 percent) are manufactured outside of the borders of the United States (Field, May 28, 2007a). The main reason for the out-

Mass customization is a cross between mass production and custom manufacturing. Defined, **mass customization** is a marketing strategy that provides for some degree of customer design input into what is normally a mass-produced item. In the fashion industry, mass customization continues to grow in popularity because it offers more opportunities to niche markets.

The mass customization concept has been popular for many years with higher-priced items, such as fine jewelry and bridal wear. In the jewelry industry, mother's rings are a good example of a basic multistone ring setting for which the customers can choose the particular gemstones (based on the children's birthstones). In bridal wear, the brides typically have been able to choose colors and applied designs from a basic selection of styles. The cost of customization had been factored into the retail selling price, which was already hundreds or thousands of dollars.

More recently, mass customization has gained popularity with fashion items under $100. For example, Paul Fredrick Menstyle, a menswear online and catalog retailer, sells basic men's dress shirts in standardized sizes. The company provides its customers opportunities to choose specific details to customize the shirts to their own personal preferences. Customers can choose among a host of options, including monogramming, nine collar styles, six cuff styles, a dozen different fabrics, and a multitude of colors and patterns. The customized shirts are delivered to the customer's home in seven to eight weeks. Another example of mass customization is the Nike.com offering of customized athletic shoes with the NikeId® program. Athletes can choose the colors of almost all of the components (base, secondary, lining, lace, plate, accent, Shox®, Swoosh®, and Swoosh® border) and can further personalize the shoes with a ten-character tag (such as the athlete's last name) on each shoe. Customized shoes, such as the Shox®, are manufactured and delivered to the customer's door in four weeks. A third, less technical example is the opportunity for online shoppers to visit a customized handbag Web site and choose from a predetermined selection of fashion fabrics, lining fabrics, and handbag styles. Once the order is processed, the Web site states that the custom bags can be manufactured and delivered in only two weeks.

sourcing of labor is due to the competitive advantage of low labor costs in developing countries. Garment production is an industry that requires considerable handwork, including sewing seams, applying notions, and other types of detail work that must be hand-sewn. Between 30 and 65 percent of the retail prices of fashion products are due to the garment labor costs. In labor-intensive industries, such as the fashion industry, it is difficult for the United States to compete with developing countries whose hourly wages are so much lower. Table 11.1 shows a comparison of some of the average apparel factory wages for various countries.

Because labor costs are much lower in these developing countries, they have become among the top textile and apparel trading partners with the United States. China is the key supplier of textile and apparel items to the United States. In 2008, the United States imported from China more than six times the textile and apparel items imported from its second- or third-highest trading partners—India and Mexico. The top ten suppliers to the United States of textiles, textile products, and apparel are identified by the Foreign Trade Division of the Census Bureau and are listed in Table 11.2.

Canada and Italy are considered industrialized or developed nations and have apparel manufacturing wages comparable to the United States. Canada's hourly rate for clothing manufacturing is $15.17 per hour (*Earning, Average Hourly*, 2006), and Italy's hourly rate for clothing manufacturing is comparable. Yet they are still within the group of top suppliers (Italy ranks 10th and Canada ranks 11th). Canada's convenient geographic proximity fosters trade with the United States in the fashion industry. Italy provides the United States with high-end fashion apparel, knitwear, and leather goods. It should be noted that Italy may outsource a part of its apparel manufacturing to developing countries to take advantage of low labor costs, too.

Table 11.1 Documented Hourly Wages for Apparel Workers in Select Countries

Country	Hourly Wage in U.S. $
United States	17.99
Bangladesh	.26
Canada	18.92
China, Mainland	.40–.53
China, Coastal	.60–.70
Costa Rica	1.11–2.38
Dominican Republic	1.62
El Salvador	1.38
Guatemala	.90–1.12
Haiti	.49
Honduras	.82–1.31
Indonesia	.34
Mexico	2.04
Nicaragua	.76
Vietnam	.26

SOURCES: International Labor Comparison. (2009). U.S. Bureau of Labor Statistics. Retrieved August 3, 2009, from www.bls.gov/fls/flshcaeindnaics.htm
Powell, B. & Skarbeck, D. (2004, Sept. 27). Sweatshops and third world living standards: Are the jobs worth the sweat? Independent Institute Working Paper Number 53, *The Independent Institute.* Retrieved August 3, 2009, from http://www.independent.org/pdf/working_papers/53_sweatshop.pdf

Table 11.2 U.S. Imports of Textiles, Textile Products, and Apparel, Top Trading Partners in 2008

Ranking	Country
1	China
2	India
3	Mexico
4	Vietnam
5	Indonesia
6	Bangladesh
7	Pakistan
8	Honduras
9	Cambodia
10	Italy
11	Canada

SOURCE: Imports of Textiles, Textile Products, and Apparel from Top Trading Partners. (2008). *Foreign Trade Statistics, U.S. Census Bureau.* Retrieved July 30, 2009, from http://www.census.gov/foreign-trade/statistics/country/sreport/textile.html

Sourcing

When discussing global trade, it is necessary to explain the various concepts related to sourcing. **Sourcing** refers to the apparel company's decision to buy certain component parts and materials from vendors in other parts of the world. Sourcing also refers to the decision about where the cutting and sewing will be performed. An overseas source may supply the necessary fashion fabric, whereas the notions (zippers, thread, buttons, etc.) may be sourced from a different country. The assembly of a garment is usually outsourced to independently-owned factories in developing countries. The terms **source**, **sourced**, **outsourced**, and **sourcing** refer to the notion of contracting with another business or resource (often outside the country) to provide a product or service used in the production of fashion merchandise. The country selection is based on the country's ability to produce the job at a more appealing and lower cost. For example, "sourcing fabric" means finding a textile mill somewhere on the globe that can supply adequate yardage of a particular type of fabric at an acceptable price. The fabric supplier is the "source." In another example, "labor sourcing" is used to represent the instance when a brand, such as Levi Strauss, contracts with a factory in Mexico to assemble the components in denim jeans for a fair price. Therefore, the labor is "outsourced" to Mexico because this offshore production can take place at a lower cost to the company.

In order to remain price competitive, apparel companies usually decide to send their production work offshore. Once the decision has been made to outsource the labor, the company must determine where the factories will be located. Lowest labor costs are not always the pri-

mary determinant for factory location, although they are important. Other considerations include existing industry contacts and relationships, speed of production, speed of delivery, and production expertise of the factories.

Consumers have benefited from falling apparel prices for the last several years. The Consumer Price Index, reported by the Bureau of Labor Statistics, shows a decline for all of the years 2000–2008, except the year from 2005 to 2006, when the index was zero, rather than a negative number (http://www.bls.gov/cpi). The **Consumer Price Index (CPI)** is a measure of the average change over time in the prices paid by urban consumers for certain apparel items. It allows for comparison of the same apparel items from month to month and year to year. The regular annual decreases in the Consumer Price Index indicate that apparel companies are increasingly outsourcing for the lowest labor costs and are offering items at lower retail prices.

Working Conditions in Developing Countries

A primary concern among corporations, consumer groups, and industry watchdogs, such as the Apparel Industry Partnership organization, is the working conditions in the foreign apparel factories with which U.S. corporations conduct business. For more than a decade, some multinational corporations and large retailers have been criticized in media blitzes that exposed a variety of human rights violations in fashion apparel factories located in developing countries. Well-known names such as Nike, Gap, Wal-Mart's Kathie Lee Gifford and Mary Kate and Ashley lines, Levis, and many other companies were lambasted for "exploiting" workers in factories. Industry watchdogs criticized the use of underage laborers, such as young children sewing throughout long production days. Other criticisms were aimed at unsafe and unsanitary working conditions in factories called sweatshops. **Sweatshops** are places of employment that have low wages, poor working conditions (crowded, inadequate ventilation, sexual harassment, filth, etc.), and long hours. The workers are compelled to stay in these sweatshop facilities out of fear because they are owed back wages and sometimes because the job is one of the few that is available. In the worst circumstances, the workers may be enslaved or indentured.

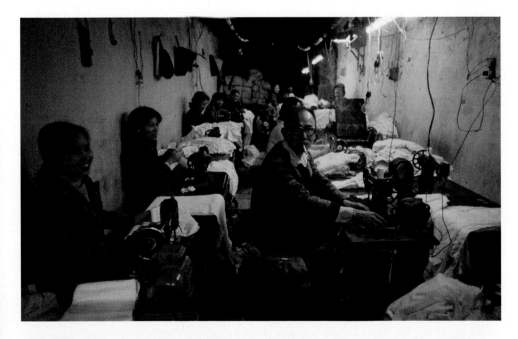

Figure 11.6 Eliminating sweatshop conditions is difficult in poor developing nations such as Cambodia.
(CORBIS)

AUTHOR'S NOTE: Visit the Under Armour Web site to view a good example of an athletic apparel company's corporate code of conduct for suppliers. Go to http://www.uabiz.com/corpResponsibility.cfm.

Codes of Conduct in the Apparel Industry

Many companies, especially those that were heavily criticized by the public, now regularly inspect the partnering factories. These multinational corporations employ factory compliance officers to ensure obedience and require their factory partners to adhere to written codes of conduct. **Codes of conduct** are policies that define ethical standards for companies, and they are usually made available to the public, such as posting them on the company Web site. They typically address several important human rights topics, including minimum wages, minimum ages, working conditions, employee treatment, and workers' rights. One of the problems with monitoring compliance is the sheer number of factories that might be contracted to work for a multinational corporation. Apparel companies may conduct business with dozens to hundreds of small factories around the globe, so enforcement is difficult and often limited. Even though large corporations may have controls in place to enforce compliance in contracting factories, many small retail companies are far down the supply chain and may know very little about the working conditions in offshore manufacturing facilities. In spite of these limitations, all retailers should ask questions of their wholesalers and suppliers and insist on information about the factories that supply their apparel.

Domestic Apparel Manufacturing

Although the majority of apparel companies choose outsourcing for the labor-intensive production steps, some apparel companies prefer to use domestic manufacturing facilities. The primary advantage of keeping the manufacturing steps close to home is the quick turnaround time. By using sewing factories that are located near the retail stores, the merchandise can be designed, produced, and placed on the selling floor in far less time than what is required for outsourced apparel. For example, Zara, a fast-fashion retailer, uses sewing factories located near its retail stores in Spain. The goods are delivered quickly, and transportation costs, a significant expense, are reduced.

Other advantages of domestic manufacturing are greater control over the quality of merchandise and the quality of the manufacturing facility. Relationship marketing is more likely to occur with domestically owned companies. Frequent communications, a common language, and other cultural similarities between the levels of the supply chain help ensure more careful attention to the production specifications. In addition, the concern of conducting business with factories that exhibit sweatshop-type conditions can be monitored when factories are nearby. Some incidences of poor working conditions have been found in factories in large cities, such as Los Angeles and New York City. However, these are not usually the extreme cases that are often reported in the poor developing countries. Heavy fines and penalties are assessed for domestic facilities that are below standards.

Domestic manufacturing is most commonly used for fashions that sell at higher retail prices. The cost of production can be absorbed more easily into the designer, bridge, and better retail selling prices. The target customers of these fashions are not so price-conscious, instead preferring higher-quality goods and a greater emphasis on customer services at the retail level.

Some industry officials predict a renewed interest in domestic textile production because of the high cost of outsourcing transportation (oil costs) and because textile production is far less labor intensive than apparel manufacturing. Labor costs are only about 10 percent of textile prices. These two factors combined with greater quality control and domestic relationship marketing bode well for domestic textile mills.

summary

- Designers are creative individuals who develop new ideas and gain inspiration from things around them, such as art, cultures, other designers, Hollywood and celebrities, streetwear, and fashion periodicals.
- Product developers take popular styles and create knockoffs or adaptations that have marketability.
- The stages of fashion preproduction and production are:
 - Conducting market research to determine the target customers' needs and wants
 - Idea conception or the formulation of potential designs
 - Garment design, drawn by hand or performed on a computer
 - Costing, which means the production team determines the financial feasibility of producing the garment
 - Patternmaking and creating the first sample
 - Grading the pattern into various sizes
 - Marking or determining the most efficient placement of the pattern pieces for cutting
 - Cutting the pattern pieces from the fashion fabric by hand or with a machine
- Assembling or sewing the cut pieces
- Finishing and inspecting the finished garments to make them ready for shipment to the stores
- The entire production process should be streamlined so that the production time is minimized.
- Speed-to-market means reducing the time required to design, produce, and deliver goods.
- Just-in-time manufacturing refers to producing goods and delivering them to the stores just in time for the selling season.
- Apparel manufacturing may be outsourced to other countries where labor costs are much lower, or it can occur near the retail outlets.
- Lower shipping costs, higher quality, greater quality control, and relationship marketing are offered as advantages of domestic production.
- Foreign sweatshops are issues of concern in the apparel manufacturing industry because the further removed a retailer is from its supply chain, the less control the retail firms have over the manufacturing facilities.

terminology for review

designer 200
product developer 200
product development process 200
costing out a garment 203
wholesale cost 203
first sample 204
graded 204
vanity sizing 204
marker 204
cutter 205

substantial transformation 205
country of origin 205
modular manufacturing 205
piecework 205
finish and inspection 205
speed-to-market 206
just-in-time (JIT) production 206

mass customization 207
sourcing 208
source 208
outsourced 208
Consumer Price Index (CPI) 209
sweatshop 209
codes of conduct 210

questions for discussion

1. Where do designers get their inspiration when they are creating styles for the upcoming season?

2. How does a fashion designer differ from a product developer?

3. What are the major production steps for fashion merchandise?

4. What is the relationship between the terms *substantial transformation* and *country of origin*?

5. What are the two main types of assembly processes used in the fashion industry, and when would each be appropriate?

6. What is meant by the term *speed-to-market,* and why is it critical in the fashion industry?

7. Why does mass customization provide fashion marketers with a competitive advantage?

8. Why do sweatshops exist in the fashion industry, and what can businesses and consumers do to correct the problem?

9. What are the advantages and disadvantages of overseas and domestic production?

10. How does the decision to outsource production overseas affect the profits of the apparel company?

related activities

1. Bring fashion magazines or mail order catalogs to class and study the fashions. Identify the sources of design inspiration (such as celebrities, other designers, nature, streetwear, subcultures, historical fashions, etc.) for the styles featured in the magazines or catalog.

2. Visit a nearby design studio or manufacturing facility. Make a detailed outline of the steps involved in production within this particular business. Compare the production steps to those listed in the textbook. How are they similar? How are they different?

3. Using the university library databases, locate five articles on the topic of textile and apparel factory working conditions overseas. Conduct a survey among other students. Develop some survey questions to ask regarding awareness of working conditions in developing countries, the other students' degree of interest in the topics, their willingness to pay more for non-sweatshop-certified apparel, and any other questions related to production in overseas factories. Write a 500-word paper that reviews the five articles and reports and analyzes the findings. Include a reference page with correct bibliographic citations.

4. Develop a debate topic and hold a class debate on outsourcing production work in the fashion industry (or choose a different debate topic, such as copying designs/counterfeiting). Each student should bring an article to support his or her assigned position. Follow the debate guidelines suggested at http://712educators.about.com/cs/lessonsss/ht/htdebate.htm.

Your Fashion IQ: Case Study
Proximity Pays: The Case for Domestic Production

Labels bearing the phrases "Made in the U.S.A." and "Made in Canada" are becoming increasingly scarce during a time when apparel margins are squeezed and consumers insist on value pricing. Yet, some companies are able to successfully own and operate production facilities in the United States and Canada. Two Canadian apparel manufacturers, Joseph Ribkoff International of Montreal and Oceanic Sportswear of Vancouver, are two successful manufacturers. Both have felt the tug of low-cost foreign factories but have resisted the urge to become importers rather than manufacturers. Ribkoff manufactures mid- to high-end women's apparel, whereas Oceanic manufactures better quality active sportswear, including yogawear.

The benefits of manufacturing domestically include numerous requests from Canadian retailers for the "Made in Canada" label and greater control over the company's own destiny. Joseph Ribkoff International has used foreign factories in the past but found that the wait time for the manufacturing goods in Asia was simply too long. These domestic manufacturers benefit from "quick turnarounds, smaller runs and better customer service" (Dunn, B., 2008, Mar. 18). The Oceanic manufacturing company currently manufacturers about 70 percent of its apparel in Canada and 30 percent overseas. The margins are lower for domestically-produced goods (15 percent versus 25 percent for foreign-made goods), but Oceanic's owner, Simpson Ma stresses that customer service is his company's competitive edge.

QUESTIONS:

1. Do these higher manufacturing price zones have some impact on the companies' success?

2. What is meant by the key terms *quick turnarounds* and smaller runs?

3. Why can quick turnarounds, smaller runs, and customer service become competitive advantages?

4. In your opinion, is there sufficient customer demand for labels that say "Made in the USA" or "Made in Canada"?

SOURCE: Dunn, Brian. (2008, Mar. 18). Proximity pays for Canadian manufacturers. *Women's Wear Daily Online*. Retrieved October 20, 2008, from www.wwd.com

"There is a new circumspect consumer who is more thoughtful and price-conscious. No one wants to pay retail; everyone wants to get or think they are getting a deal."

POGGI, J. (2007, Nov. 8). Off-price could be sweet spot for holiday. Women's Wear Daily Online, www.wwd.com.

CRAIG JOHNSON, Customer Growth Partners

214

FASHION
MARKET CENTERS,
WHOLESALERS, and
INTERMEDIARIES

LEARNING OBJECTIVES

At the end of the chapter, students will be able to:

- Explain the basic marketing activities that occur in a fashion market center and compare to the activities that occur during a scheduled market week.
- Identify the major contributions of the domestic market weeks held across the nation.
- Explain the value of off-price merchandise to both retailers and consumers.
- Describe the concept of "going to market."
- Explain China's role in the global fashion production market.
- Compare the advantages and disadvantages of China's global apparel manufacturing presence.
- Identify the pros and cons of sourcing apparel outside the United States.
- List the benefits of conducting business with each of the major foreign trading countries for textiles and apparel.
- Differentiate among types of wholesalers and intermediaries.
- Explain the variations in quality of merchandise acquired by a jobber.
- Describe the services offered by independent resident buying offices.
- Compare the advantages and disadvantages of mergers that result in ownership groups.

What is a **fashion market center**? As the name implies, it is a geographic center—a hub of fashion activity that includes a high concentration of manufacturing companies, fashion company headquarters, and permanent wholesale showrooms. A fashion market center is a city or location in a city that houses fashion wholesale businesses that sell to fashion retail businesses. For example, in the United States, Manhattan (New York City) is considered the largest and most important fashion market center. In France, Paris is the fashion market center, and in Italy, Milan has this distinction. Usually, market centers are located in one of the largest cities in a country.

The term **market** refers to an event, such as a market week or a wholesale market, when retail store buyers and wholesale sales representatives (sellers) converge. New York City and Los Angeles are market centers that host numerous market weeks throughout the year. A market week is an intense, three- to five-day event for the purpose of attracting retail store buyers to place orders for merchandise to be carried in their stores. Las Vegas, Nevada, hosts several enormous wholesale markets each year, but the city is not a fashion market center. It lacks the permanency of a true fashion market center. The climate, facilities, and centralized location of Las Vegas make it appealing as a temporary site for market weeks, but few fashion trade businesses are permanently located in the city.

United States Market Event Locations

Market weeks (usually 3 to 5 days) are held in major market centers and large cities throughout the world. A perusal of an international fashion calendar published by *Women's Wear Daily* showed a total of 171 foreign fashion markets occurring worldwide in a four-month time frame. The domestic fashion calendar published by *Women's Wear Daily* showed a total of 159 domestic fashion markets in 25 states occurring in the United States in a six-month time frame. Calculating an average of 69 domestic and international events per month, the annual world total exceeds 800 fashion market events. Market events may be specialized, such as textiles, couture, bridal, accessories, leather, and fur, or they may be more general, featuring women's, children's, or men's apparel. Table 12.1 lists many of the countries that hold a fashion market for industry representatives and store buyers. Figure 12.1 shows a sample calendar of countries hosting fashion events during the month of March.

New York, New York

New York City has long been the fashion capital of the United States and is widely known for its creative fashion talent. Along Seventh Avenue, renamed Fashion Avenue (see Figure 12.2), the Fashion Walk of Fame displays commemorative plaques for the honored designers who have made New York a world-renown fashion capital. The city boasts over 5,000 fashion showrooms,

Table 12.1 Numerous Countries Hosting Market Weeks

Amsterdam	Italy
Australia	Japan
Belgium	Malaysia
Brazil	Poland
Canada	Russia
China	South Korea
England	Spain
France	Turkey
Germany	United States
Hong Kong	

March

Global Fashion Weeks

Note: Multiple shows may occur in a country during a designated time period

Mon	Tue	Wed	Thu	Fri	Sat	Sun
			1	2	3	4
			Russia China	Russia China France	Russia China France Austria	Canada China France Austria
5	6	7	8	9	10	11
Canada China France Austria Australia Germany England	Canada Hong Kong France Australia Germany England	Canada Hong Kong France Brazil Japan Germany England	Canada Hong Kong Germany Brazil Japan	Canada Hong Kong Germany Brazil Japan	Canada Germany Japan	Canada Germany
12	13	14	15	16	17	18
Canada Australia Germany	Canada Australia China	Canada Australia China	Canada England China S. Korea Japan Italy	Canada England Turkey S. Korea Japan Italy	Canada Turkey S. Korea Japan Italy	Canada Turkey Italy
19	20	21	22	23	24	25
Canada England Germany	Canada England Germany	Canada Germany	Canada Hong Kong	Canada Hong Kong Spain	Canada Hong Kong Spain Malaysia	Canada Germany Spain Malaysia
26	27	28	29	30	31	
Canada Germany Malaysia	Canada Germany Malaysia	Canada Hong Kong China	Canada Hong Kong China Italy	Canada Hong Kong China Italy	Canada Hong Kong China	

Figure 12.1 Calendar of countries hosting market weeks.

Figure 12.2 Street sign of Seventh Avenue/Fashion Avenue.

(Nelson Hancock © Rough Guides).

is home to eight fashion-dedicated schools (including the Fashion Institute of Technology—F.I.T.), and generates approximately 100,000 fashion-related jobs.

Near the center of the city is the irregular-shaped geographic area of the garment center, commonly called the **garment district,** giving credence to New York as a vital market center

in the United States. The approximate area extends from 35th Street to 41st Street and from 5th Avenue to 9th Avenue (see Figure 12.3).

An interesting and attractive kiosk at the corner of Seventh Avenue and 39th Street provides business-to-business (B2B) information to fashion industry visitors who might need assistance when visiting the city. The recognizable button logo is found on sites throughout the garment district (see Figure 12.4).

Larger-than-life bronze sculptures decorate city streets and honor the contributions of the city's garment workers, who were often first generation immigrants (see Figure 12.5). Today, immigrants constitute more than three-fourths of the fashion industry workforce. Each workday, hundreds of workers mill along the streets of the fashion district, pushing rolling racks laden with fabrics and clothing, unloading delivery trucks, displaying goods, visiting showrooms, and engaging in the necessary and exciting operations of the fashion industry.

Students should be encouraged to visit the exciting city to see firsthand the economic impact of the fashion industry. The city is committed to a focus on fashion; this commitment is in evidence all over the city. There exists an elevated sense of fashion, museums of costume, wonderful shopping opportunities in flagship stores, global fashion business headquarters, and opportunities for internships. Not only is New York one of the most important fashion cities in the world, but it also provides an excellent cultural opportunity for visitors.

Figure 12.3 **Map of New York City Garment District.**
(NYC Fashion Center)

Figure 12.4 **The Fashion Center Information Kiosk in New York City.**
(NYC Fashion Center)

New York Fashion Week in the Big Apple

Manhattan's New York Fashion Week is one of the primary venues featuring American fashion collections by top designers during February and September. Designers able to show at the event in Bryant Park have a competitive advantage in the global fashion industry. Designers participating in the 2009 show included almost all the big-name designers, including Marc Jacobs, Narcisco Rodriguez, Diane von Furstenberg, Michael Kors, Carolina Herrera, Betsey Johnson, and Vera Wang.

Originally, the show was called **Seventh on Sixth** and was created in 1993 by IMG Fashion. The name was derived from two locations in New York City: Seventh Avenue (or Fashion Avenue) because it is the hub of the fashion center in New York and Sixth Avenue, the location of Bryant Park in Manhattan. Today, the show bears the name of the sponsors—Mercedes-Benz Fashion Week. There is some speculation that the location will move to Damrosch Park in Lincoln Center in September 2010 and that a competing venue for the fashion shows may develop with Mac Cosmetics at the Milk Photography Studios in Manhattan.

The show producers boast state-of-the-art production and it is housed in the superstructure tents used during the event. The velvet-roped tents contain numerous show spaces that become fashion showrooms for approximately sixty runway shows. In February 2009, about 100 designers participated in the New York Fashion Week. This included three Project Runway finalists who showed their collection on the last day of the New York Fashion Week.

The Bryant Park fountain stands as a focal point within the lobby of the main tent. The luxurious lobby provides a central meeting area with sponsored lounges for invited guests. Over 100,000 people attended the event in 2008, although that number declined in February 2009 due to the recession. Attendees included fashion buyers, celebrities, supermodels, political and social VIPs, and media representatives from all over the world. The shows are intended to be a commercial enterprise and general public tickets can be purchased for about $900.

the Business of FASHION

Figure 12.5 Bronze statue of sewer in the New York City Garment District.

Los Angeles, California

Whereas New York is known as the designer fashion market, Los Angeles is known as the denim, street, and contemporary fashion market. The Hollywood influence is also a large part of the Los Angeles market and holds significant appeal for international buyers. In 2005, Los Angeles designers implemented the first annual Los Angeles Fashion Awards ceremony as a way to increase the visibility of the city as a fashion epicenter. The fall evening event honors designers and tastemakers and features runway presentations.

The California Market Center (CMC) is located in three connected wings, with thirteen stories each. It has nearly three million square feet for the more than 1,000 showrooms and 10,000 product lines. The CMC features five fashion markets, two textile markets, and four gift and home markets. Like the Atlanta Merchandise Mart, the California Market Center features a wide array of products, including apparel, accessories, textiles, gifts, and home furnishings. "This merchandising shift was implemented to mirror current times, where the most successful retailers, designers and manufacturers are regularly crossing product categories to communicate a lifestyle vision" (Building Overview, 2006, www.californiamarketcenter.com).

The CMC wholesale apparel mart was established in 1963, but has undergone several expansions and renovations. The most recent renovation involved the construction of additional private showrooms, an exhibition hall, new flooring and fixtures, and the uncovering of an enormous picture window that provides a panoramic view of Los Angeles.

Las Vegas, Nevada

Las Vegas, Nevada, is a relatively recent location for fashion trade shows. Events are hosted at the Las Vegas Convention Center and the Sands Expo and Convention Center. The MAGIC, WWIN, WWDMAGIC, and Off-Price Specialty Shows have been successful in recent years due to conveniently serving the midwestern United States. The **MAGIC** International Show, sponsored by the Men's Apparel Guild in California (M.A.G.I.C.), features a menswear and MAGIC Kids Apparel Market (layette to teens). Running concurrently (at the same time) or contiguously (just before or after) the MAGIC shows is the WWDMAGIC International Trade Show. It features several merchandise categories in all wholesale price zones, including women's activewear, intimate apparel, swimwear, resortwear, contemporary, juniors, denim, and better, bridge, and designer apparel and accessories. The Women's Wear in Nevada (WWIN) trade show also runs concurrently with the WWDMAGIC.

A list of some of the numerous Las Vegas market venues for apparel buyers and executives is featured in Table 12.2.

Atlanta, Georgia

The fashion market center of Atlanta is geographically located near textile production facilities in the United States. In 1957, John Portman built the Atlanta Merchandise Mart to serve the textile and apparel wholesale trade industry in the southeastern United States. Since then, it has been renamed the Americasmart-Atlanta. The developers expanded the facility to three high-rise buildings (15 to 23 stories) with more than 4.2 million square feet devoted to exhibit space. Aerial walkways connect the buildings named Americasmart 1, Americasmart 2, and Americasmart 3. The buildings house permanent showroom space, exhibit halls, and convention and meeting room spaces. The second floor of the main registration building was recently

Table 12.2 Las Vegas Market Venues for Apparel Buyers and Executives

Trade Shows	Descriptions
Off-Price Specialist Show www.offpriceshow.com	Features off-price merchandise for jobbers (resellers). The show offers closeout and irregular merchandise and manufacturer's overruns.
Women's Wear in Nevada (WWIN)	Features upscale plus sizes and accessories
Sourcing at MAGIC	Offers opportunities for large-scale buyers to foster relations with textiles and apparel contractors worldwide.
Apparel Sourcing Association Pavilion Global Sourcing Show (ASAP) www.asapshow.com	Boasts a one-stop marketplace for sourcing apparel overseas; features hundreds of manufacturers of men's, women's, and children's apparel, textiles, and leather from over 35 countries.
POOL Trade Show	Features creative merchandise from emerging designers, artistic T-shirts, fashion-forward streetwear, and denim
International Swimwear and Activewear Market Event (ISAM) www.isamla.com	Offers swimwear, beachwear, and resortwear
World Shoes and Accessories Show www.WSAshow.com	Features 1,600 exhibitors of footwear and related accessories from 30 countries
MAGIC Kids www.magiconline.com	Offers boys and girls apparel and accessories, including layette, infant, toddler, tween, footwear, private label, accessories, uniforms, licensed products, juvenile products, toys, and gifts
MAGIC Marketplace	The Marketplace includes Premium at Magic Street, Sourcing at Magic, WWD Magic, FN Platform, Menswear at Magic, S.L.A.T.E., Ecollection at Magic and MAGIC Kids

redefined to house the Premiere upper-end product lines. Premiere offers an upscale, contemporary ambience, with amenities such as a live disc jockey, fresh flowers, Internet connections, wine, and other specialty foods.

Americasmart-Atlanta is a leading international market for many consumer goods, including apparel, accessories, gifts, home furnishings, textiles, and rugs. It hosts seventeen wholesale markets featuring 11,000 apparel and accessory lines and six Market Wednesdays that annually attract more than 303,000 industry representatives from all 50 states and more than 72 countries. The Atlanta International Gift and Home Furnishings Market held in January and July are the largest markets in the Americasmart.

Chicago, Illinois

Two major apparel, accessories, gift, and home fashion centers in Chicago are the Chicago Apparel Center and the Chicago Merchandise Mart. The Apparel Center is the smaller and newer (built in 1977) of the two adjacent buildings and houses more than 250 wholesale showrooms and a business class Holiday Inn hotel. The larger of the two buildings (spanning two city blocks) was built in the 1930s as a wholesale building for Marshall Fields and Company. Called the Chicago Merchandise Mart, it has 25 stories and its own city zip code. Several trade shows are held in the Chicago Apparel Center and the Chicago Merchandise Mart, including the Women's and Children's show, the Men's Wear Collective show, the National Bridal Market, Pulse, and STYLEMAX.

> A market refers to a trade event that is held in a city with the purpose of bringing together wholesale sellers and retail buyers.

FASHION FACTS: The Off-Price Specialist Show

What does off-price mean?

Off-price refers to apparel (or any merchandise) that is usually discounted 20 to 70 percent below the usual retail selling price. It is merchandise that features high profit margin potential for retailers and low prices for consumers.

Where does off-price merchandise originate?

Many of the merchandise lines are actually first season goods, but manufactured as a budget run—that is, the production costs are kept very low with the intent of offering it as off-price merchandise. Other off-price merchandise comes from closeouts and manufacturers' overruns (excess inventory that is produced and is above what is ordered by traditional retailers).

What is the appeal of the Off-Price Specialist Show to a fashion retailer?

These shows allow for face-to-face contact and the building of relationships between retailers and the suppliers that offer the heavily discounted merchandise. Store buyers can choose from vast quantities of deeply discounted, off-price merchandise that they can sell in their stores for a competitive price while still getting higher profit margins for the store. The merchandise can be offered as a special buy at a promotional price in order to stimulate store traffic and improve the store's competitive edge. Customers are attracted by a great sale and often a nicer quality garment at a lower price. Carrying off-price apparel allows retailers to remain profitable while providing attractive prices and good values. Traditional retailers may choose to replenish inventory with an occasional off-price grouping, or off-price stores may focus entirely on offering off-price goods. Most off-price goods are available for immediate delivery to the stores.

What is the history of the show?

In 1995, two off-price executives organized the first off-price event in Las Vegas, Nevada. Prior to this time, many jobbers rented area hotel space during regular market weeks, but adequate space became a problem as the number of off-price vendors increased. Eventually, the Off-Price Specialist Show was created and is now hosted twice annually at the Las Vegas Sands Expo & Convention Center and the Venetian Grand Ballrooms. These are cost-efficient shows designed for serious off-price buyers. As many as 12,000 visitors and 450 exhibitors attend the shows. The show primarily targets big-box discount retailers, military surplus liquidators, and dollar stores, but in recent years it has gained popularity with traditional fashion stores because of the show's increased offering of branded merchandise.

SOURCES: Off-Price Specialist Show Web site. (2009). Retrieved August 4, 2009, from www .offpriceshow.com

Thomas, Brenner. (2009, Feb. 10). Recession lifts Off-Price Specialist Show. *Women's Wear Daily Online.* Retrieved August 4, 2009, from www.wwd.com

Dallas, Texas

The Fashion Center Dallas marketplace is a fashion wholesale location for approximately 14,000 product lines, on the top four floors (twelve through fifteen) of the World Trade Center. The fashion wholesale showrooms are located in the same building as the gift and home fashion showrooms (floors one through eleven). The World Trade Center is the central building in a connected triplex (with a fourth building across the road), collectively referred to as the Dallas Market Center, encompassing a 100-acre trading area near downtown Dallas. The Dallas Market Center consists of the World Trade Center, the Trade Mart, the International Floral and Gift Center, and the nearby Market Hall, which usually operates as a consumer exhibit hall (see Figure 12.6).

Within the Fashion Center Dallas, the temporary showrooms are located on the twelfth floor, and a buyers' lounge, accessory showrooms, and edited or juried temporaries are located on the thirteenth floor named SCENE. The women's apparel showrooms and the Kim Dawson

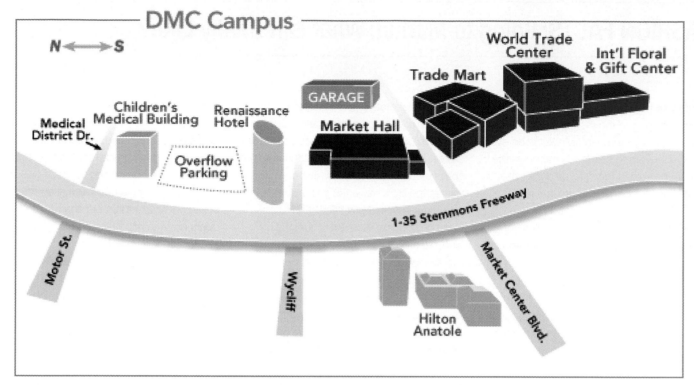

Figure 12.6 Campus map of the Dallas Market Center.
(Dallas Market Center)

Runway Café are located on the fourteenth floor. In the Runway Café, buyers can enjoy lunch and view informal modeling. Bridge and contemporary showrooms are located on the fifteenth floor. The first floor contains the Hall of Nations, featuring flag displays from around the world, and an International Buyers' Lounge. Many of the menswear showrooms are located on the seventh floor. The floors have small lobbies where buyers can relax and watch broadcasted fashion shows, such as the Bryant Park shows in New York.

Founded in 1957, the Dallas Market Center is one of the world's largest wholesale merchandise marts. It hosts 50 markets annually that are attended by more than 200,000 retail buyers from all over the United States and 84 countries. According to the company Web site, "it was the first permanent facility to unite regional wholesalers under one roof" (DMC Overview, 2006, www.dallasmarketcenter.com).

Denim, casual, and Western wear are a large part of the Texas fashion industry. In addition, the large Hispanic market has resulted in niche marketing toward Hispanics, including complimentary translation services in Spanish in the International Buyer's Lounge and specialized apparel for the Hispanic market. This also includes the marketing of Quinceañera apparel for the teen's fifteenth birthday (similar to the debutante or "sweet sixteen" party apparel sold in the United States).

FASHION FACTS: Going to Market: What Is It Really Like?

"Going to market" is a common phrase used by buyers in the fashion industry. But what does it really mean? Market is an event for store buyers to select the merchandise that will be sold in their stores during the upcoming season. This event is usually housed in a facility large enough to accommodate booths or showrooms of hundreds of vendors who represent and sell for manufacturers of apparel and accessories. Buyers and sellers come together to discuss the business of fashion and place/receive orders of fashion goods. Both parties are in the business to make a profit, so mutually satisfying agreements must be reached.

Jana is the owner/buyer for a chain of specialty stores in Oklahoma. She attends the five major markets each year at the Fashion Center Dallas in Texas. Because she carries off-price merchandise, she also visits the Off-Price Specialty Show in Las Vegas, Nevada. While at market, Jana always schedules appointments with her key vendors, such as Sharon Young and French Dressing Jeans. She may spend over an hour in a single showroom discussing the merchandise lines with the sales representative, jotting notes on the line sheets, evaluating samples, and placing orders for just the right goods to sell in her stores. Often, she selects merchandise with specific customers in mind. Once, while visiting the Berek sweater showroom, she ordered a novelty New Year's Eve sweater that one of her customers requested. She also selected three football-themed sweaters that she hoped would be best sellers during the back-to-school season. Although she realized these sweaters would have to retail for significantly more than her usual off-price points, she felt the attractive appearance would appeal to football moms, coaches' wives, and school teachers—all three are her target customers—who might be willing to splurge on the item. She knew that she should only sell one sweater per town, because in the three small towns where her stores are located, the sweater purchaser would *not* want to see another woman sporting the same sweater at a Friday night football game!

Jana carefully plans how much money she will encumber while at market. She works from a detailed buying plan for her regular price merchandise orders. She must determine how much to spend on certain accessories and how many tops, bottoms, and sizes of each she needs to round out her regular price assortment in the store. Sometimes when buying off-price goods, she does not get a complete assortment of sizes, but the bargain-basement wholesale costs are a terrific buy, and her customers appreciate a bargain!

Meeting with jobbers at area warehouses are a big part of Jana's market trip. It is not glamorous to sort through the warehoused racks of overstocked goods or sit on the floor and dig through boxes of discarded samples, but the digging and hunting often turn up some great deals that will keep her customers coming back to see the newest arrivals.

Combining traditional merchandise buying and off-price buying is one of the keys to the success of her three stores. Jana knows her target customers and realizes that they use different standards for shopping, even on the same trip. They love cheap prices and impulse items but are willing to pay much higher prices for fashion merchandise that they "love and can't live without."

Sourcing Worldwide and Labor-Intensive Regions

The United States conducts textile and apparel trade with many countries in the world. About 96 percent of all apparel products sold in the United States is imported (Field, May 28, 2007a). The benefit of this large influx of goods is that Americans are enjoying inexpensive apparel at the retail level. The disadvantage is that lower prices on imports keep domestic wages down and may result in a long-term decline in apparel and textile manufacturing jobs.

Several important trade terms are discussed in the following section and in Chapter 13. Table 12.3 lists and defines these terms.

The focus of this section is to highlight five of the U.S. top textile and apparel trading partners. These important trading partners include China, Mexico, India, Indonesia, and Vietnam (for a complete list, see Table 10.1 in Chapter 10). Of the five listed, only Mexico is located in North America, adjacent to the United States. The other four countries are located on the continent of Asia. Asia is the largest of the seven continents and has approximately 60 percent of the world's

Table 12.3 International Trade Terminology

Dumping	Pricing goods for sale in another country below the cost of manufacturing or below market price in the country of origin
Duty-free	No taxes are imposed on the importer or exporter; tax-free
Duty or import duty	A tax that must be paid to the domestic government on foreign goods imported into the country to protect domestic production of competing goods. It is a percent of the declared value of the goods being imported. The amounts can range from 0 percent to 100 percent, depending on the type of goods.
Embargoes	Refusals of goods when quota limits have been reached
Exports	Goods shipped out of the producing country
Imports	Goods brought into a receiving country
Quotas	Quantity limits on the amount of goods that can be imported into a country in order to protect the domestic manufacturing industry and give other developing countries opportunities to trade
Safeguard quotas	Limit import quantities in order to safeguard the competing domestic industry
Tariff	A tax or assessment charged on imported goods from a country to make the goods more expensive in the foreign market to discourage consumers from buying the foreign goods. It is a protectionist measure or trade barrier to curb the supply of imports.
Transshipping	An illegal activity in which countries that approach quota limits continue to produce the goods and ship them by way of another country not restricted by quotas

population, although most people live in southern and eastern Asia. The continent has a tremendous number of workers in the labor force, willing to work for very low wages.

China

The People's Republic of China has great appeal as a textile producing and apparel manufacturing country. In fact, many economists refer to China as the "world's factory." It is the largest country in the world and has about 21 percent of the global population, which translates into an enormous labor pool that will work for low wages. It is estimated that China supplies about 80 percent of all consumer goods to the United States (U.S. textile and apparel trade, 2009, Feb. 5). To put the size of China in perspective, the country has more than 120 cities with populations of over one million, whereas the United States has only nine such cities.

By the end of the first decade, the country is expected to have over a 50 percent share of the world textile trade. In 2008, China accounted for over one-third of U.S. textile and apparel imports (Clark, E., 2008, Feb. 21). The relatively low cost of setup of textile mills and apparel manufacturing facilities, combined with government subsidies and a large supply of unskilled laborers, make China an important global trading partner for retailers and manufacturers. In years past, it was viewed as a source of low-cost goods, but it is becoming a sophisticated manufacturing center. The Shanghai Mart advertises in the buyer's directories for domestic markets, such as the Dallas Market Center directory. The advertisements encourage U.S. buyers to take advantage of trade events and special services that provide them with efficient access to the Chinese manufacturers.

China is increasingly viewed as a tremendous selling opportunity for retailers and global brands. Currently, the Chinese consumers have a limited number of global brands available to them, yet their disposable income is increasing. Because of the untapped potential in some parts of China, Wal-Mart and Simon Properties partnered for expansion into a new mall development in Hangzhou, China, a two-hour drive south of Shanghai. In addition, Saks Fifth Avenue is making plans to open a licensed store in Shanghai, China.

China is not without its share of controversy, however. Many developing countries and the manufacturing sector in the United States consider the qualities that make China desirable to retailers and importers an unfair competitive advantage. Extremely low labor costs benefit U.S. consumers and retailers, but this also means that most domestic manufacturers cannot produce goods as cheaply as the Chinese. A large number of U.S. companies have been forced to close their manufacturing facilities. Internationally, a country can limit the number of textile or apparel items that can enter its borders by either charging high tariffs or imposing quotas. **Quotas** are quantitative restrictions on the number of items that can enter a country. A domestic country imposes quotas to limit the amount of goods that can be imported. This protects the domestic manufacturing industries and gives other developing countries opportunities to trade with the domestic country.

Once quotas have been reached for a period, no more of that type of product may enter the country's borders. For example, in July 2007, China declared that it had met its imported wool quota for the calendar year. Wool growers in Australia and New Zealand had wool ready to be shipped to China when the country made the declaration. The wool growers had to make alternative plans for the wool they produced (Tucker & Huntington, 2007, Aug. 7).

The owner of the goods may decide to export the goods to a different destination, have the goods destroyed, pay an additional tax or **tariff** to the importing country, or hold them until the beginning of the next quota period. A tariff, **duty,** or **import duty** refers to an import tax or an additional charge levied on imports.

On January 1, 2005, U.S. quota restrictions on most textile and apparel goods were lifted. This caused an increase in the influx of Chinese goods coming into the U.S. market, which resulted in an increased U.S. trade deficit with China. China's exports to the United States increased 61 percent in the nine months following the removal of quotas on January 1, 2005 (Zarocostas, A., 2006, Jan. 3). To protect certain vulnerable domestic manufacturing industries, the U.S. government imposed some safeguard quotas. The safeguarded goods ranged from knit fabric and polyester filaments to cotton trousers and sweaters.

The United States and China have been working toward quota-free trade. This would mean that Chinese textile and apparel imports to the United States would be unrestricted. Many U.S. fashion retailers and importers see this as an opportunity, whereas many domestic textile and apparel manufacturers have cause for concern. Other trade safeguards have been implemented, such as China self-regulations, global trade talks via the World Trade Organization (WTO), and individual petitions to restrict import growth. These individual petitions have resulted in safeguard quotas. **Safeguard quotas** limit import quantities in order to safeguard the competing domestic industry.

Two additional terms, *exports* and *imports,* are fundamental to understanding international trade. **Exports** (n.) refer to goods shipped out of the producing country. **Imports** (n.) refer to goods brought into a receiving country. As an example, it is appropriate to say: "China exports (v.) sweaters to the United States. The terms export and import may also be used as verbs. There may be limits on the number of Chinese sweaters that can be imported (v.) into the United States."

The U.S. government has historically imposed quotas on the number of Chinese goods (such as low-cost sweaters) that can be brought into the United States from China. In order to circumvent U.S. customs laws that regulate the shipments, some companies engage in the illegal activity of transshipping. **Transshipping** "is when a garment is produced in one country but shipped to its final destination with labels that say it comes from a third nation" (Ellis, K., 2004, June 15). This means that countries approaching quota limits (such as China) continue to produce the goods and ship them by way of another country not restricted by quotas (such as Australia). Labels might be sewn in the garments that falsely read "Made in Australia," and then the garments are shipped to the United States. Transshipping is a way for a country to send its goods **duty-free** (tax-free) to the United States when **embargoes** (refusal of goods when quota limits have been reached) have been imposed. U.S. Customs officials continually monitor the activities and detain shipments of goods that are suspected of transshipping. For example, in late 2006, U.S. Customs and Border Protection officials seized shipment containers of mislabeled shirts and sports jerseys in an alleged scheme to circumvent U.S. custom quotas. The exporting company and the sewn-in labels indicated the goods were made in another country.

Even though China has a fair share of trade problems, the Chinese fashion industry is working toward a global awareness of the country's fashion talent. Since 2001, China has televised an award ceremony that recognizes important fashion contributors. The event, called the China Fashion Awards, serves as a promotional activity for China's fashion industry. The televised show honors top designers, models, and artists who have contributed to the notoriety of the country. Bridal designer Vera Wang, who is of Chinese descent, was honored in 2005 with the international fashion designer of the year award. The show airs on Channel Young, China's fashion channel. Channel Young boasts 400 million viewers and features apparel fashion brands, celebrities, entertainment, and other nonapparel products.

Mexico

The close proximity to the United States has made Mexico an important trading partner and a source of apparel and textiles. In 1994, Congress began implementation of the **North American Free Trade Agreement (NAFTA)** to improve trade relations between the United States, Mexico, and Canada. This agreement affects most agricultural products and is especially beneficial for U.S. exporters of food products, such as red meats, poultry, dairy products, grains, fruits, vegetables, and nuts. Cotton growers in the United States also export to Mexican textile mills, and the finished apparel goods are returned to the United States for retail sales. Conducting business with Mexico creates fast deliveries, lower transportation costs, and ease of accessibility for service and technical issues. Because of the North American Free Trade Agreement, the United States imports a substantial amount of textiles and apparel from Mexico. (A discussion of NAFTA as it relates to textiles and apparel is discussed in Chapter 13.)

Most textile and apparel production facilities in Mexico are located in the central and northeastern regions of the country, particularly Monterrey, Mexico. Textile industry production plants have become more modern in past years due to investments in modernization and expansion.

Retailing and marketing techniques in Mexico are similar to those in the United States. The Mexican consumer products market is dominated by small retailers and family-owned stores, using the common practices of price-leader merchandising and self-selection shopping.

Figure 12.7 Map of Asia.

(CIA, The World Factbook)

Scale 1:48,000,000

Azimuthal Equal-Area Projection

0 800 Kilometers

0 800 Miles

Boundary representation is
not necessarily authoritative.

803364AI (R02105) 6-08

India

India is the second-largest apparel manufacturing country in the world, second only to China (See Figure 12.7.) The country has undertaken a technology platform for the Indian apparel industry. Long-term plans for the country's textile and apparel industry include making the country fully automated with state-of-the-art manufacturing and training the numerous domestic workers to become highly skilled textile employees.

Indian officials see the abolition of world quotas as a growth opportunity, but subject to international competition (particularly from China) for the Indian textile and apparel industry. Nine months after the quota restrictions were lifted in 2005, India posted a 26 percent growth in exports of textiles and apparel to the United States and the European Union markets. According to Mr. Premal Udani, the president of the Clothing Manufacturers Association of India (CMAI), a competitive edge is needed by the Indian manufacturers. He explained, "Technology will be the driver helping the Indian apparel industry to graduate in its quest for value-added productivity and quality" (Think Technology, 2006, www.apparelreview.com).

In January 2006, India held its first apparel machinery exposition featuring high-tech machines for sewing, knitting, laundry, and finishing. Other trade shows in India include the India knit fair called Knit Tex in Tirupur, which is the knitwear capital of India; the National Garment Fair in Mumbai; and Tex Styles India, in New Delhi.

The Fashion Design Council of India produces an India Fashion Week featuring 45 to 50 fashion designers. As a next step in the growth of India's fashion industry, the Lakme cosmetic company and IMG (global fashion events planner) have created a more selective event for recognizing international fashion designers. This event, called the Lakme Fashion Week, is held at Mumbai's National Center for Performing Arts.

Indonesia

Indonesia is a member country of the Association of Southeast Asian Nations, called the ASEAN region. In recent years, Indonesia has become a leading supplier of textiles and textile products to the United States. The success of the Indonesian textile and textile products industry can be attributed to the large and relatively cheap labor force; its vertical integration, including polyester fiber production facilities; and its ability to produce mid- to high-level quality products. Indonesia has also benefited from the U.S. and European Union's trade restrictions and safeguard quotas imposed on some Chinese-made fashion goods.

Second only to petroleum in earnings, the Indonesian manufacturing sector of textiles, textile products, and footwear employs a workforce of 1.2 million people in more than 4,500 factories. These factories are vertically integrated and may encompass operations in all stages of textile and textile products development. Indonesia has approximately eighteen companies that produce petrochemicals, such as polyester fibers.

Vietnam

Like Indonesia, Vietnam is also a member country of the Association of Southeast Asian Nations (ASEAN). In January 2007, Vietnam became a member of the World Trade Organization, providing it with a privileged trade status with the other World Trade Organization member countries. In 2007, the United States was Vietnam's largest trading partner, purchasing 55 percent of Vietnam's exports.

Vietnam is building its domestic textile industry and encouraging other Asian countries, such as Taiwan and South Korea, to invest in Vietnam's industry. The country's strategy is to improve its competitive advantage by promoting spinning, knitting, and weaving industries within the country's borders. This strategy allows the country to avoid the higher costs of importing textiles.

Vietnam is organizing the collective members of its fashion industry and offering them textile and apparel fashion and trade centers. One association that is a forerunner in organizing is the Ho Chi Minh City Garment & Textile, Embroidery and Knitting Association. Ho Chi Minh City has short-term plans to open a fashion center by 2012 and at least three trading centers. Vietnamese fashion designers will be featured at the fashion center, and the trade centers will promote the textiles and apparel commerce.

In 2007, Vietnam was criticized by U.S. textile producers for allegations of dumping. **Dumping** is the practice of "selling goods in another country below the cost of manufacturing or below market price in the country of origin" (Barrett, J., 2007, July 31, *Women's Wear Daily Online*). A foreign government is often behind the practice of dumping because it may subsidize the manufacturing. In turn, the U.S. government may impose higher duties to offset the negative impact of dumped imports. Other domestic industries suffer from dumping issues, including the steel industry. The Vietnamese textile industry was scrutinized by the Commerce Department, but there was little or no evidence to formally accuse the country of dumping. The U.S. producers of textiles and apparel were supportive of the Commerce Department investigation because much of the members' livelihoods depend on curbing the import of fashion goods. By contrast, the U.S. Association of Importers of Textile and Apparel (USA-ITA) criticized the allegations of dumping because much of these members' livelihoods depend on Vietnamese imports.

Wholesalers and Other Intermediaries

The terms *wholesalers, wholesale buying offices, intermediaries, middlemen, importers, exporters, jobbers,* and *brokers* refer to companies located in the mid levels of the supply chain or channel of distribution. These companies do not participate in production and therefore do not alter the merchandise in any way. Instead they focus on the trade functions of making the merchandise readily available and selling the finished products to retail store buyers. This may or may not require taking ownership of the goods.

Wholesaling

Wholesaling is one of the middle trade levels of the fashion merchandise supply chain and is considered a business-to-business (B2B) operation. A wholesaler is a company that sells products and services to retailers that will then resell the merchandise to the ultimate consumer. Merchandise does not undergo transformation in the hands of a wholesaler, but this level of the industry does perform several important functions. The main function is to show and sell manufacturers' goods to trade buyers. A wholesaler must provide a location, called a wholesale showroom, or some other venue (such as the Internet or direct mail) for the trade buyer to view samples of a manufacturer's line. Wholesalers provide related services, such as order placement and delivery, and market trend information that helps retail store buyers decide which lines to order for their stores. Some wholesalers assume title and ownership of the goods for

a short period of time. Other wholesalers may not assume title (own outright) or carry inventory; they may simply have a showroom that carries samples from which retail store buyers can place orders.

There is some concern that the Internet has created competitive problems for wholesalers. The availability of price lists on the Internet provides businesses with opportunities to shop around and ensure they are getting the lowest prices from their wholesale suppliers. Some businesses are bypassing the wholesalers and negotiating directly with the manufacturers, even those manufacturers that are located overseas. The Internet allows the retail store buyers to contact the manufacturer through its Web site and save on the wholesale costs.

Manufacturer-Owned and Independently Wholesalers

In the fashion industry, wholesale sales representatives act as liaisons for manufacturers and retail store buyers. A **manufacturer-owned wholesale showroom** represents only one manufacturer, while the **independently-owned wholesale showroom** may represent several noncompeting manufacturers' lines. These companies earn a percentage on what they sell. For example, in the Dallas Market Center Showroom Directory, a listing exists for a Jessica McClintock showroom. The wholesale sales representative is employed by the Jessica McClintock Company and shows all of the Jessica McClintock lines, including Jessica McClintock Bridal, Jessica McClintock Designer, Jessica McClintock Girls, Jessica McClintock Juniors, Jessica McClintock Collection, and Scott McClintock Missy. Indepently wholesale showrooms representing multiple manufacturers' lines are an alternative to manufacturer-owned wholesale showrooms. This type of wholesale sales representative is self-employed and chooses to represent the manufacturers' lines he or she thinks best fit the needs of his or her target customer. One independent showroom mentioned in the Dallas Market Center Directory lists the 33 different accessories lines that are represented, including Betsy Johnson Sunglasses, Ralph Lauren Scarves, Echo Scarves, Jessica McClintock Handbags, Olivia Rosetal Shoes, and Hyde Belts.

Import or Export Agents

Wholesalers that bring together buyers and sellers from different countries are import and export agents. These persons specialize in international trade and are beneficial because they have an understanding of the cultures of both countries involved in the marketing exchange. If the agent resides in the United States and sources goods from other countries to bring to the United States, the agent would be considered an **import agent**. If the agent is located in a foreign country, such as China, and assimilates Chinese goods to be shipped to the United States for resale, the individual would be considered an **export agent**.

Jobbers

Jobbers also perform the basic wholesaling function, but the available merchandise may be odd-lot assortments, manufacturers' overruns or last season's fashions, manufacturers' samples, goods that are considered irregulars or seconds, or damaged goods, such as those damaged by smoke or water. **Jobbers** are middlemen merchants who purchase and warehouse off-price merchandise for reselling to the retail trade. The advantages of purchasing from jobbers are that the goods are usually available for immediate delivery and a retailer can use them to fill in inventory as needed. The merchandise is available at a fraction of a cost of regular season merchandise, and the savings can be passed on to the consumer or used to offset other low-margin inventory items. A disadvantage is that the merchandise may not reflect the image of the store and the available assortments may not be appropriate for the

preferences and needs of the target customers. Off-price retail outlets are significant trade purchasers of odd-lot assortments. **Odd-lot assortments** are less-than complete assortments of styles, colors, or sizes. **Manufacturer's overruns** are extra inventory that was manufactured in a sewing factory but was not sold to the company's regular retail store buyers. For example, an independent sewing factory in Bangladesh may fill a chain department store order for 95,000 pairs of jeans. Because of the economies of scale, the factory produces an extra 5,000 pairs that it can sell to jobbers at a cut rate. The jobbers may break the 5,000 jeans into assortments of a few dozen and sell to small specialty stores across the country. The retail shops receive a complete assortment of sizes and styles, but at a reduced wholesale cost. In addition to purchasing **first quality merchandise** as manufacturer's overruns, jobbers also purchase merchandise irregulars and seconds. **Irregular quality merchandise** is merchandise with a slight manufacturing defect, but the wearability or usability is not affected. For example, a toddler's corduroy jumper may have the dress front pattern piece cut with the nap going one direction and the dress back pattern piece cut with the nap going the opposite direction. The lighter appearance on the front and a darker appearance on the back result in the jumper being considered an irregular. **Second quality merchandise** has obvious damaged areas, such as stains, holes, or tears, and may not be desired by the majority of customers. The wearability is affected, and the item would need to be deeply discounted to sell at retail.

Brokers This type of intermediary performs the short-term wholesaling function of bringing trade buyers and sellers together. The broker's income is derived from a commission paid by either the buyer or the seller, depending on the agreement.

Independent Resident Buying Offices

Independent **resident buying offices** (RBOs) represent member stores in the fashion marketplace. They serve member retailers by assimilating external fashion and marketplace information, forecasting and reporting on trends, buying for member stores, obtaining quantity discounts, and generally acting as the eyes and ears of the retailers. The resident buying offices are usually located in major market centers, such as New York. Often a retail store buyer's first stop when attending market week is to visit the offices of the resident buyers. Their services range from merely assisting retail store buyers in planning and streamlining individual market trips to handling all the merchandise buying for the store. Most retail store buyers prefer to attend market weeks, but it is possible for a retail store buyer to order all merchandise for the store through a resident buying office and never attend the major markets. Resident buying offices work with store personnel to ensure a successful buying season.

In addition to the actual buying option, retail store owners may take advantage of many other services offered by resident buying offices. Weekly and monthly trend reports and newsletters are sent to member stores. Special buys of off-price goods are offered to member stores so that they can increase their store traffic with promotional sales. Resident buying offices host informative sessions during market weeks that retail store buyers can attend. A resident buying office can offer private label designs to its noncompeting member stores so that they can entice customers to shop at their particular retail stores. Style and ordering information is offered online to simplify the retail store buyer's efforts.

One of the largest resident buying offices is the Doneger Group, with offices located in Manhattan. This enormous resident buying office has been in business since the end of World War II and has many specialized divisions, such as children, men, fringe sizes, and home. The company's various Web sites include **www.doneger.com** **www.donegermarketplace.com** and **www.donegerconsulting.com**.

Consolidation, Mergers, and Ownership Groups

Retail and vendor ownership groups continue to increase in importance and magnitude. These are usually loosely to closely related companies that merge into much larger corporations. A **retail ownership group** is a consolidation of multiple retailers, often with similar core customers. The benefits of buyouts and mergers are significant to a retail corporation. The sheer size of the retail ownership group allows for greater leverage when dealing with vendors, greater buying power and economies of scale, instant globalization, and greater efficiencies in overhead costs, such as accounting, real estate, and systems.

Ownership groups in the fashion industry gained momentum in the late 1980s and early 1990s, when powerful retail organizations merged and reconfigured the company store structure. Among the most widely publicized retail mergers was the 1994 merger of Federated Department Stores and Macy's. In 2006, Federated Department Stores bought the May Department Store Company (including Filene's, Lord & Taylor, and Marshall Field's), and in 2006, all the May department stores were renamed Macy's. In 2007, Federated underwent a name change to Macy's Group Incorporated. Each chronological change provided greater economies of scale for the large retail conglomerate.

Another type of ownership group emerged after the success of retail ownership groups. **Vendor ownership groups** are mergers of resources higher up in the supply chain, such as large design firms acquiring other design firms, textile producers acquiring other producers, and large brands merging together. The benefits are similar to those of a retail ownership group. In vendor ownership groups, a company may own two or more large brands, and it becomes a more important source to the retailers. It is a way to increase market share for the suppliers. For example, in 2008 in the fashion eyewear industry, the giant Luxottica Group SpA (which includes Ray-Ban) merged with the California-based Oakley, Incorporated. The giant conglomerate also owns the licensing rights to Chanel, Dolce & Gabbana, Prada, Versace, and Stella McCartney's eyewear. By absorbing all these similar brands, the company gains a larger slice of the market share (Roberts, A., 2008, Apr. 25).

In spite of the tremendous benefits of mergers, not all prove to be panaceas for a struggling retail market. Astute fashion business executives understand the value of local relevance and differentiation at the local level. Consumers desire merchandise that is local and holds authentic value. Macy's Group Incorporated implemented a My Macy's localization program that tailored the merchandise assortment by districts, comprised of about ten stores per district. The program focused on providing appropriate brands, styles, colors, and sizes for the stores in a particular region. Other components of the My Macy's program aimed to get merchandise exclusives for the district stores and enhance the authority of local managers.

Figure 12.8 Macy's is an example of a retail ownership group.
(Picture Partners/Alamy)

summary

- Fashion market centers are geographic regions that have a high concentration of fashion trade businesses.
- New York City, Los Angeles, Chicago, Dallas, and Atlanta are important fashion market centers in the United States.
- Milan, Italy, and Paris, France, possess the distinction as important European fashion market centers.
- A market refers to a trade event that is held in a city with the purpose of bringing together wholesale sellers and retail buyers.
- Overall, there are more than 800 market events held globally each year.
- The United States imports about 96 percent of all apparel consumed in the country, especially from Asian countries where labor costs are lowest.
- China, Mexico, India, Indonesia, and Vietnam are important trading partners of the United States. China supplies over one-third of textiles and apparel imported into the United States.
- Domestic manufacturers are concerned with China's dominance in world textile and apparel production, whereas domestic importers and retailers appreciate the lower apparel costs of garments manufactured in China.
- Safeguard quotas are imposed on the importing of some Chinese goods that can also be produced in the United States.
- Preferential trading between the United States and Mexico is encouraged due to the North American Free Trade Agreement.
- India, Indonesia, and Vietnam are also key suppliers of U.S. textiles and apparel, and they are working to create strong trade relations with the United States.
- Quotas are limits on the amount of goods that can be imported into a country.

- Tariffs and duties are taxes imposed on imported goods.
- Imports are goods brought into a receiving country.
- Exports are goods shipped out of a producing country.
- Transshipping is an illegal activity in which goods that are restricted by quotas for the producing country are shipped to a nearby country that is not restricted by quotas.
- Duty-free means tax-free imports.
- Embargo means a refusal of goods when quota limits have been reached.
- The middle levels of the supply chain may be described by many terms such as *wholesalers, wholesale buying offices, intermediaries, middlemen, importers, exporters, jobbers,* and *brokers.*
- A manufacturer-owned wholesale showroom sells only one brand of goods because it is owned by the branding company.
- An independently owned wholesale showroom may represent several noncompeting manufacturers' lines and is paid by each represented manufacturer based on a percentage of what they sell.
- Wholesalers may sell any combination of odd-lot assortments, overruns, out-of-season fashions, first quality merchandise, irregular quality merchandise, and second quality merchandise.
- Resident buying offices are mid-level fashion businesses located in a major market center and act as the eyes and ears of the retail store buyers.
- When two or more related companies merge to form a larger corporation, the resulting company is called an ownership group.

terminology for review

fashion market center 215

market 216

garment district 217

Seventh on Sixth 219

MAGIC 220

off-price 222

going to market 224

quotas 226

tariff 226

duty or import duty 226

safeguard quotas 226

exports 226

imports 226

transshipping 227

duty-free 227

embargo 227

North American Free Trade Agreement (NAFTA) 227

dumping 230

wholesaling 230

manufacturer-owned wholesale showroom 231

independently owned wholesale showroom 231

import agent 231

export agent 231

jobbers 231

odd-lot assortment 232

manufacturer's overrun 232

first quality merchandise 232

irregular quality merchandise 232

second quality merchandise 232

resident buying office 232

retail ownership group 233

vendor ownership group 233

questions for discussion

1. How is a fashion market center unique?

2. Why has off-price merchandise become increasingly popular in the United States?

3. What is the purpose of a market week or market event?

4. Why is China both a concern and an opportunity for domestic fashion businesses?

5. What are some of the competitive edges that other Asian countries use to compete with the export ability of China?

6. Why is it important for the United States to build trade relations with Canada, Mexico, and Latin America?

7. What are some benefits and disadvantages of trading with other countries, including India, Indonesia, and Vietnam?

8. What are the different terms used to describe businesses engaged in the wholesale level of trade?

9. What is the difference between first quality merchandise, irregulars, and seconds?

10. What are the primary services offered by a resident buying office, and why would a small retailer choose to take advantage of these services?

related activities

1. Visit Web sites and conduct Internet research for two different fashion market centers in the United States. Compare the market centers on the following criteria: history, size, number and types of annual markets, number buyers/vendors participating, number of designated buildings/showrooms, special services offered, quality and clarity of Web site information, and other pertinent information. Develop a sales poster for one of the market centers.

2. Choose a foreign country that promotes the fashion industry (see Table 12.1 for a list of possible countries). Begin your research by visiting the Web site https://www.cia.gov/library/publications/the-world-factbook/index.html. Use other resources to gather information about the country's contribution to the fashion industry and develop a paper or poster for presentation to the class.

3. Hold a class debate on the merits and problems of the free trade agreements. Each student group can take the position of an interest group, such as fiber growers, textile and fabric mills, apparel manufacturers, apparel importers, and retailers. Locate articles to support a particular position. Follow the debate guidelines suggested at http://712educators.about.com/cs/lessonsss/ht/htdebate.htm.

4. Interview a businessperson engaged in the wholesale trade level or research a particular wholesale trade career. Develop a list of questions and write a 500-word report based on the findings to present to the class.

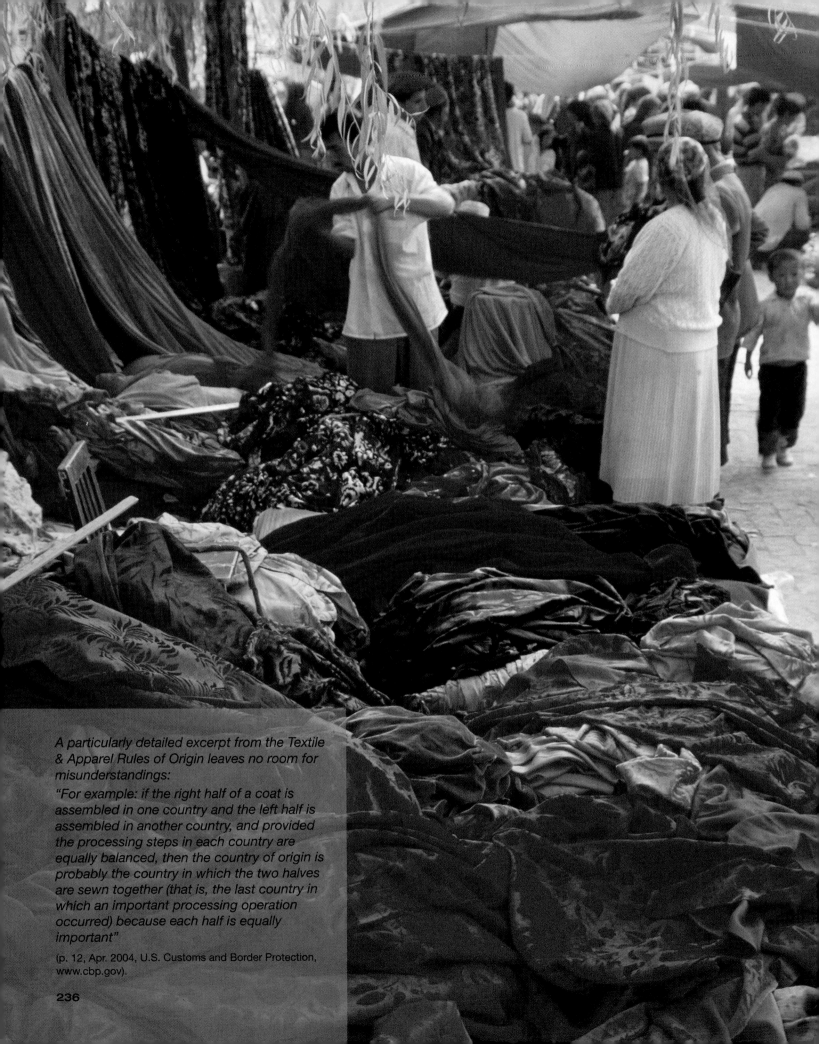

A particularly detailed excerpt from the Textile & Apparel Rules of Origin leaves no room for misunderstandings:

"For example: if the right half of a coat is assembled in one country and the left half is assembled in another country, and provided the processing steps in each country are equally balanced, then the country of origin is probably the country in which the two halves are sewn together (that is, the last country in which an important processing operation occurred) because each half is equally important"

(p. 12, Apr. 2004, U.S. Customs and Border Protection, www.cbp.gov).

TEXTILE and APPAREL LEGISLATION

LEARNING OBJECTIVES

At the end of the chapter, students will be able to:

- Identify the various governmental acts and agencies and explain their roles in the textiles and apparel industries.
- State the purposes and benefits of free trade agreements.
- Recognize the concerns over protecting intellectual property rights.
- Identify problems and propose solutions for global trade.
- Describe the core labor standards deserved by all workers.
- Evaluate ways to prevent human rights violations against workers in the garment manufacturing industry, regardless of the country.

Numerous government agencies monitor the import and export of textiles and textile products. Legislators design laws to protect and inform consumers, promote the domestic industry, ensure fair trade, and build partnerships with other countries. Many interest groups exist in the textiles and apparel industries, and they are vying for scarce resources, greater import or export opportunities, and trade regulations that benefit their particular position. Since January 1, 2005, the elimination of textile quotas or quantitative restrictions has greatly impacted the textiles and apparel industries in the United States and other regions of the world.

Regulating Organizations

The Federal Trade Commission, Department of Commerce, and Department of Homeland Security are three major agencies that regulate the textiles and apparel industries in the United States. On a global scale, the World Trade Organization works to ensure the more than 150 member countries participate fairly in trade.

Federal Trade Commission

The **Federal Trade Commission (FTC)** was established in 1914. It protects U.S. consumers and ensures fair trade in a competitive environment. The Federal Trade Commission directs several laws related to the textiles and apparel industries and amends rules and regulations.

Consumer Products Safety Commission

The **Consumer Products Safety Commission** is an independent federal regulatory agency created in 1972 under the Consumer Products Safety Act. The agency protects consumers from unsafe products, including textiles and apparel that may seriously harm their families. The important Flammable Fabrics Act is enforced by the Consumer Products Safety Commission.

The Consumer Products Safety Commission has the ability to enforce compliance on a variety of textile and apparel safety issues. As an example, a New York-based apparel importer, Liberty Apparel Company, Inc., imported more than 12,000 defective Jewel girls hooded sweatshirts with drawstrings on the hoods in August 2007. The sweatshirts were sold to various retail stores, although they had not been approved for sale by the Consumer Products Safety Commission. The Commission previously ruled that no hooded sweatshirts (sizes 2 to 12) can feature a drawstring because of the risk of strangulation (from being caught in cribs, bus doors, etc.). In December 2007, the Consumer Products Safety Commission reached a settlement with Liberty Apparel Company, Inc. The company recalled the sweatshirts and was required to pay a civil penalty of $35,000 (Consumer Products Safety Commission, 2008, Aug. 8).

Office of Textiles and Apparel

The **Office of Textiles and Apparel (OTEXA)** operates under the International Trade Administration within the U.S. Department of Commerce. The goal of OTEXA is to improve the global competitiveness of the U.S. fiber, textiles, and apparel industries. Helpful trade data and detailed information on trade agreements is available on the Office of Textiles and Apparel Web site (www.otexa.ita.doc.gov).

U.S. Customs and Border Protection

> The U.S. Customs and Border Protection falls under the Department of Homeland Security, and its duty is to inspect imported goods.

The **U.S. Customs and Border Protection** agency, under the U.S. Department of Homeland Security, inspects goods entering the United States through the more than 300 land, air, and sea ports of entry. U.S. Customs and Border Protection agents and officers are charged with confiscating counterfeit or smuggled goods and prohibiting these illegal goods from entering the United States.

Inspection officers are trained to watch for unusual appearances, patterns, and trends in goods that are shipped to the U.S. borders. In November 2007, a counterfeiter was caught shipping fake Louis Vuitton handbags that were sewn into unlabeled, generic tote bags. The inspecting officer noted the ugliness of the generic totes and cut open the tote. He discovered fake Louis Vuitton bags sewn into the yellow and pink linings (Casabona, L., 2007, Nov. 12).

Office of the United States Trade Representative

The agency known as the **Office of the United States Trade Representative** was organized in 1962. Its general mission has been to open global trade. More specifically, its purposes include negotiating with other governments to create trade agreements, resolving trade disputes, and maintaining a high level of involvement and visibility in global trade organizations, including the World Trade Organization. The agency is a key force in ensuring the protection of intellectual property rights—an issue that constantly plagues luxury goods manufacturers, such as those found in the fashion industry. The agency has offices in Washington, D.C., Geneva, Switzerland, and Brussels, Belgium.

Figure 13.1 U.S. Customs agent inspecting a container of fashion merchandise at a port of entry.
(U.S. Customs and Border Protection)

World Trade Organization

The **World Trade Organization (WTO)**, headquartered in Geneva, Switzerland, is an international multilateral trading system that works toward liberalizing trade and has established rules of trade for its 153 member countries. The World Trade Organization serves as a forum for governments to negotiate trade agreements. It is a place for them to settle trade disputes. It operates a system of trade rules. The governments of member countries are expected to enter into binding contracts with governments of other countries and follow the legal ground rules set forth by the World Trade Organization.

Negotiated membership in the World Trade Organization is granted to observing countries with a willingness to open their markets and follow the guidelines established by the member countries. In 2009, 29 observing countries were awaiting membership in the World Trade Organization.

Member countries established the World Trade Organization on the premise that free trade among nations promotes great economic and social benefits. The organization advocates international trade based on the economic principle of **comparative advantage**, meaning that each country (no matter how small) can make money by producing and trading something with other countries in the world. The principle of comparative advantage is explained by the World Trade Organization as "countries prosper first by taking advantage of their assets in order to concentrate on what they can produce best, and then by trading these products for products that other countries produce best" (The Case for Open Trade, 2007).

The World Trade Organization was created on January 1, 1995, as the successor to the previous international organization known as the General Agreement on Tariffs and Trade (GATT). The General Agreement on Tariffs and Trade (GATT) replaced the International Trade

Organization (ITO) that began in 1948, just after World War II. Although the General Agreement on Tariffs and Trade was replaced by the World Trade Organization, its policies currently exist as the World Trade Organization's umbrella treaty for trade in goods. On January 1, 2005, the textiles and apparel trade ceased to be subject to special trade provisions. The textile and apparel industries became governed by the general rules and disciplines that the World Trade Organization set forth for all industries.

One of the World Trade Organization's primary responsibilities is trade dispute settlement between countries. Most disputes arise when one or more countries consider another country's trade activity to be breaking the multilateral trade agreements or the complainants consider the country to have broken its promise of trade obligations. Member countries of the World Trade Organization have agreed to follow the dispute resolution processes of the multilateral trading system, rather than taking action unilaterally. Those countries involved in the dispute are expected to attempt their own resolution. If they require World Trade Organization judgment, they must respect the judgment and abide by the agreed procedures (Settling Disputes, n.d.).

In 2004, Brazil lodged a complaint against the United States for unfairly subsidizing cotton exports. After hearings, the panel reviewed the case and ruled that the United States had "failed to bring its measures into conformity with the Agreement on Agriculture and has failed 'to withdraw the subsidy without delay'" (Dispute Settlement DS267, 2007). In 2006, the United States enacted new legislation to remove specific subsidies, but Brazil argued that the new legislation was insufficient. Both countries appealed, and in late 2007, the panel found that the United States continued to act inconsistently with its obligations (see Note at bottom of page).

Legislation and Government Involvement

Legislative acts involving the textiles and apparel industries are not static. After the government implements an act, new issues arise that require amendments to the existing act, the passage of concurrent acts, or new acts to supersede the original act. Each legislative act described in this chapter is closely related to the textiles and apparel industry, although the list is not all-inclusive. The various acts described involve protecting consumers and ensuring economic development. Free trade agreements are created between the United States and numerous other countries that enjoy preferred nation status with the United States. **Free trade agreements (FTA)** are pacts between two or more countries to expand trade opportunities for the nations and grow their economies. The main benefits of U.S. free trade agreements with other countries are to open foreign markets and promote fair competition for the United States. Most of the 17 U.S. free trade agreements are with countries in North America, Latin America, Asia, the Middle East, and Africa. Since the beginning of active free trade agreements, the U.S. exports to partnering countries have grown more than twice as fast as exports to other countries in the world. Free trade agreements increase the size of the existing export market, improve the market for U.S. consumers, and enhance the leadership stature of the United States in the global economy (Trade Delivers, 2006). Textile, apparel, and fashion marketers receive the benefits of knowing that the countries with whom they do business engage in fair labor practices and that the governments of these countries support these partnerships. The U.S. raw cotton and yarn manufacturing industries have benefitted from these free trade agreements. Fashion marketers

NOTE: For additional information, visit the World Trade Organization Dispute Settlement and review the summary of the multifaceted dispute at **http://www.wto.org/english/tratop_e/dispu_e/cases_e/ds267_e.htm.**

Made in the USA: Does This Label Work?

Which do most consumers prefer: low prices or a display of economic nationalism? Although national pride and the "Made in USA" label hold some appeal, the enticing lower prices have become the primary criteria for mass fashion shoppers. Consumers choose apparel based on color, style, fit, price, fashion trend, and the occasion for which they are buying. Few consumers, except those who are socially hypersensitive, would place the country of origin near the top of their list.

In spite of the lure of low production costs, some companies continue to make products domestically. Brooks Brothers hopes to appeal to its customers with a new manufacturing facility in Haverhill, Massachusetts. American Apparel still struggles to produce most of its apparel in California. Environmentalist-designer, skateboarder, and founder of Sole Technology, Inc., Pierre Senizergues offers high-end, USA-made, sustainable apparel. His products include a $2,400 blanket blazer, $280 recycled oxford shirt, and $170 tie made from cassette tapes.

According to a report issued by Trendwatching.com, "In a world ruled by globalization and mass production, a growing number of consumers are seeking the local, and thereby the authentic" (Silverman, 2009, May 13). Other trendwatchers agree that local merchandise is preferred, but suggest the "Made in the USA" brand is too broad and lacks an emotional attraction. Marc Gobé, president of Emotional Branding.com, offers a suggestion for Brooks Brothers. Instead of relying on "Made in the USA" to attract consumers, the company might consider a "Made in New England" label, since this region of the United States, is associated with fine workmanship.

If the "Made in USA" label has lost its strength as a brand, perhaps domestic manufacturers can label by regions or states. Consider a garment bearing the label, "Made in the Deep South," "Made in the Wild, Wild West," "Made in the Great Pacific Northwest," or "Made in Big Sky Country." Price is important to many, if not most consumers, but a domestic authenticity, combined with great styling, fit, and color are competitive advantages.

SOURCES: Protectionist winds stir in fashion world. (2009, Mar. 30). *Women's Wear Daily Online*. Retrieved August 5, 2009, from www.wwd.com

Silverman, D. (2009, May 13). Is 'Made in the USA' enough? *Women's Wear Daily Online*. Retrieved August 5, 2009, from www.wwd.com

the Business of FASHION

must also consider that it may not be the least expensive sourcing opportunity, but it is one that is encouraged and supported by the U.S. government.

The most widely known free trade agreements are the agreement between Canada, the United States, and Mexico, called the North American Free Trade Agreement (NAFTA), and the Central American Free Trade Agreement (CAFTA-DR) between the United States, Dominican Republic, and five Central American countries. On a smaller scale, special free trade agreements exist between the United States and several additional nations, including Australia, Bahrain, Chile, Jordan, Morocco, and Singapore. The goods traded include textiles and apparel, agricultural products, digital products, and services. At least a dozen other countries are negotiating with the United States toward similar free trade agreements.

Wool Products Labeling Act

The intent of the 1939 **Wool Products Labeling Act** (also called the Wool Act) is to define basic wool terminology and explain the variations in wool qualities. It also protects consumers and reputable businesses from deception and misbranding of wool products. Wool was a primary

Figure 13.2 Woolmark symbol.
(The Woolmark Company)

textile fiber during the early 1900s, and this Act represents the first regulation for a textile product under the Federal Trade Commission.

In 1999, eight manufacturers or retailers of clothing and other textile products were found to have violated the Wool Act and its statutes. The companies were charged with failure to provide sufficient product information on wool products offered for sale, either in print catalogs or on the companies' Web sites. They were also charged with violations of the Textile Products Identification Act because they failed to state the precise country of origin information (see Note at bottom of page).

Fur Products Labeling Act

Fur apparel, accessories, and trim became more carefully regulated due to the **Fur Products Labeling Act** established by the Federal Trade Commission in 1952. Overall, the Act establishes standardized definitions to be used in the industry, requires the country of origin and true English name of the animal, and regulates branding and advertising. The Act puts a damper on unscrupulous retailers, such as one who might falsely advertise a coat made of skunk fur as a civet cat fur to confuse buyers.

Flammable Fabrics Act

The Federal Trade Commission enforced the Flammable Fabrics Act, enacted in 1953, for two decades, until the Consumer Products Safety Commission was established in 1972. At this time, enforcement authority of the Flammable Fabrics Act moved to the Consumer Products Safety Commission.

The purpose of the **Flammable Fabrics Act** is to protect consumers from the manufacture and sale of highly flammable or torch-like fabrics. It requires rigorous testing procedures before any articles of wearing apparel and home fashions, such as carpets, rugs, mattress pads, and mattresses, can be sold. Establishing protective measures for children's sleepwear is also an important component of this Act.

Textile Fiber Products Identification Act

Among the most important of all acts that regulate the textile and textile products industries is the Textile Fiber Products Identification Act (TFPIA), enforced by the Federal Trade Commis-

NOTE: For a list of the company names and additional information on these violations, visit the FTC Web site at **http://www.ftc.gov/opa/1999/03/musatex.shtm**.

sion. The Act has been amended several times since its inception in 1960. The basic premise of the **Textile Fiber Products Identification Act** (also called the Textile Act) is that sellers of specific textile products (including apparel) provide consumers with an affixed label showing the fiber content, country of origin, and the manufacturer's identity. The manufacturer may identity itself by either the company name or a Registered Identification Number (RN) issued to the company by the Federal Trade Commission. According to the FTC Web site, any U.S. business involved in the "manufacturing, importing, or distributing of products covered by the Textile, Wool and Fur Acts can use this number on their labels in lieu of their company name" (**http://www.ftc.gov/os/statutes/textile/faq.shtm**).

In 1999, the FTC alleged that a California women's apparel manufacturer and seller of sportswear violated the Textile Act by removing the "Made in China" labels from T-shirts and replacing them with "Made in USA" labels. According to the Federal Trade Commission news release, some of the "Made in USA" labels were affixed to T-shirts without removing the foreign country-of-origin labels (Wal-Mart, Burlington Coat Factory, 1999, Mar. 16).

Figure 13.3 Permanently affixed care label.

Care Labeling Rule

In 1971, the Federal Trade Commission established (and later amended) the **Care Labeling Rule** to standardize care requirements for garments and ensure that consumers are able to properly care for their clothing with the least expensive appropriate method. Manufacturers or importers must permanently affix care labels with full instructions for cleaning or a statement indicating the garment cannot be cleaned. In 2003, the rule was amended to allow for permanent and legible screen printed labels on knit tops, rather than a sewn-in label.

Made in the U.S.A.

Before marketing products as "**Made in the USA**," the companies must be able to verify and substantiate the claim that the goods were substantially transformed in the United States or face legal actions by the Federal Trade Commission. Manufacturers of U.S.A.-made goods are not required by law to market the products as "Made in the U.S.A.," but this is an option. The country-of-origin laws still apply under other acts, such as the Wool Products Labeling Act, Fur Products Labeling Act, and Textile Fiber Products Identification Act.

Figure 13.4 Screenprinted care label in the back of a knit top.

North American Free Trade Agreement

The **North American Free Trade Agreement (NAFTA)** entered into force in January 1994, linking Canada, the United States, and Mexico by encouraging multilateral trade liberalization. The agreement created the largest free trade area in the world and opened the doors to economic growth for all three countries. The three countries were able to significantly reduce or eliminate tariffs for trade on most items, including textiles and apparel. The success of NAFTA persuaded U.S. lawmakers to reach a similar agreement with Dominican Republic and five Central American countries, called the Central American Free Trade Agreement (CAFTA).

NOTE: NAFTA is also briefly discussed in Chapter 12 under the Mexico section.

AUTHOR'S NOTE: For more information on registered numbers and labeling, see the online publications by the Federal Trade Commission "Threading Your Way Through the Labeling Requirements Under the Textile and Wool Acts" at **http://www.ftc.gov/bcp/edu/pubs/business/textile/bus21.shtm** and "Registered Number: Frequently Asked Questions" at **http://www.ftc.gov/bcp/rn/rnfaq.shtm**.

Caribbean Basin Trade Partnership Act

The **Caribbean Basin Trade Partnership Act,** enacted in 2000, is part of the collective programs of the **Caribbean Basin Initiative**, which provided approximately two dozen countries or territories in Central America with an opportunity to more fairly compete with Mexico in supplying goods to the United States. Because of the North American Free Trade Agreement, Mexico had an advantage over its neighbors to the south. The Caribbean Basin Initiative was a trade preference program that offered reduced duties or duty-free status to participating countries in Central America.

The Caribbean Basin Trade Partnership Act originally included the CAFTA countries, but when the countries ratified the Central American Free Trade Agreement, they were no longer included in the Caribbean Basin Initiative. The Caribbean Basin Initiative benefits the Caribbean Basin apparel manufacturers and employees and provides benefits to the U.S. textile and yarn manufacturers. Much of the yarns, fabrics, and thread used in the Caribbean Basin apparel manufacturing plants originate in the United States. The Caribbean Basin Trade Partnership Act remains in effect until September 30, 2010, or until the proposed Free Trade Agreement of the Americas (FTAA) supplants it. The Free Trade Agreement of the Americas (North America and South America) is still in the negotiation stages, with Brazil and the United States key leaders in the proposal.

Table 13.1 shows the Central American countries that have participated with the United States in the Caribbean Basin Initiative.

Nineteen countries, including those eight listed in the Caribbean Basin Trade Partnership Act (CBTPA) are beneficiaries of a 1983 trade agreement under the Caribbean Basin Economic Recovery Act (CBERA). It is is a precursor to the U.S.-Caribbean Basin Trade Partnership Act (CBTPA).

Central American Free Trade Agreement

The 2004 **Central America Free Trade Agreement Dominican Republic** is a multicountry partnership designed to benefit the domestic industries (including textiles and apparel) in the United States, Dominican Republic, and five Central American countries: El Salvador, Guatemala, Honduras, Nicaragua, and Costa Rica. They are part of an export zone created by two separate legislative acts: The Caribbean Basin Trade Partnership Act of 2000 (CBTPA) and the Central America Free Trade Agreement (CAFTA-DR), which includes the Dominican Republic (DR). It created a trade zone that is the U.S. third-largest export market in Latin America, behind Mexico and Brazil.

Lawmakers purposely created this extensive free trade zone to help the domestic textile industry compete with imports from Asia. When originally written, CAFTA-DR contained a special textile safeguard which allowed the United States to reimpose tariffs on textiles and apparel if imports surged. The purpose of this safeguard was to ensure that illegal transshipments from Asia did not occur through the Central American countries. The free trade agreement CAFTA-DR had many general provisions, but this was the only product-specific safeguard in the agreement. After implementation of the Act, Mexico and the United States realized the benefits to

Table 13.1 Central American Countries Participating in the Caribbean Basin Economic Recovery Act*

Antigua and Barbuda
Aruba
Bahamas
Barbados
Belize
British Virgin Islands
Dominica
Grenada
Guyana
Haiti
Jamaica
Montserrat
Netherlands Antilles
Panama
St. Kitts and Nevis
St. Lucia
St. Vincent and the Grenadines
Trinidad
Tobago

SOURCE: Caribbean Basin Initiative. (2009). Office of the United States Trade Representative. Retrieved August 5, 2009, from http://www.ustr.gov/trade-topics/trade-development/preference-programs/caribbean-basin-initiative-cbi

*Note: The list does not include the six countries participating in CAFTA-DR.

NOTE: For more information on the Caribbean Basin Initiative, see the online publication of the Office of the United States Trade Representative Web site at **http://www.ustr.gov/trade-topics/trade-development/preference-programs/caribbean-basin-initiative-cbi.**

Important Rules and Legislation for Global Textiles and Apparel Industries

1939	1953	1971	1995	2004
Wool Products Labeling Act	Flammable Fabrics Act	Care Label Ruling	World Trade Organization	Central American Free Trade Agreement

1952	1960	1994	2000	2005
Fur Products Labeling Act	Textile Products Identification Act	North American Free Trade Agreement	Caribbean Trade Partnership Act	Textile and Apparel Quotas Lifted

each economy. The two countries agreed on a less stringent customs cooperation agreement for 2007. This allowed for Central American apparel made from fabrics produced in Mexico to qualify for duty preferences when exported to the United States.

African Growth and Opportunity Act

The **African Growth and Opportunity Act** (AGOA) is part of the larger Trade and Development Act of 2000. It established duty-free trade for many of the 48 sub-Saharan African countries and the United States. The benefits of the African Growth and Opportunity Act included two-way trade and investment opportunities in African countries. Duty-free trade of textiles and apparel is a primary focus of AGOA.

Multifiber Agreement and Agreement on Clothing and Textiles

The **Multifiber Agreement (MFA)** was implemented in 1974 as a framework agreement that ruled world trade in textiles and clothing. It allowed for quotas on specific textiles and apparel. In 1995, the **Agreement on Clothing and Textiles (ACT)** was implemented to begin the phasing out of MFA quotas on textiles and apparel over a ten-year period. This phase-out was completed in 2005, and most of the quota restrictions were lifted. Some safeguard quotas were left in place to continue to protect domestic industries. For example, the quotas imposed on Chinese cotton, wool, and man-made fiber socks have been implemented to protect the domestic sock manufacturers.

Contemporary Global Issues

As global trade increases, the controversial issues also increase. Are countries accepting imported goods with the same willingness as those goods they are exporting? Are any countries trying to dominate the market with exports? Do other countries respect the ownership of creative ideas? Do countries respect the lives of workers? Each of these questions has been at the forefront of contemporary trade issues and will be addressed in the next section.

NOTE: See Chapter 12 for definition of safeguard quotas.

FASHION FACTS: Green Businesses

Among the most important of all global issues are business sustainability and going green. Business owners are concerned with the carbon footprint they make on the Earth, but they are also drawn toward the cost savings that result from reducing the amount of energy used. A **carbon footprint** represents the measure of carbon dioxide emissions from personal or business use of heating, cooling, lighting, and transportation.

The choices made by companies or individuals affect the size of their carbon footprints. The goal is to reduce the size of the carbon footprint by making wise choices about consumption patterns, including transportation, purchases, and waste. Going green makes the world a better place. It also has other benefits, including greater energy efficiency, decreased expenses, financial incentives for energy upgrades, and financial and technical assistance from state and local government partnership programs. One of the first energy conservation programs began in 1992 as a joint effort between the U.S. Environmental Protection Agency and the U.S. Department of Energy. The program, called ENERGY STAR, is a voluntary labeling program of energy efficient power machines. Its purpose is to encourage the use of energy-efficient products and practices to help U.S. businesses save money and protect the environment. The program was first used on computers and monitors but has expanded into more than 50 product categories, including some home fashion products such as doors, windows, appliances, and light fixtures. Another partnership program is the Carpet America Recovery Effort to encourage reuse and recycling of postconsumer carpeting in order to reduce carpeting in landfills. There are dozens of Partnership Programs listed on the EPA Web site and each targets a particular aspect of a carbon footprint. Individuals can calculate their personal carbon footprint at the United States Environmental Protection Agency Web site at **http://www.epa.gov/climatechange/ emissions/ind_calculator2.html#c= theBasics&p=reduceOnTheRoad&m= calc_instructions**.

Going green is the right thing to do, whether starting a new business or making changes to an existing business. It can be as simple as reducing paper usage, choosing compact fluorescent lamps (lightbulbs), or conserving water. Suggestions for improvement and a list of fashion businesses that are ENERGY STAR partners can be found on the following two Web sites: **http:// www.business.gov/guides/environment/ energy-efficiency** and **http://www. energystar.gov/index.cfm?c=small_ business.sb_index**.

NOTE: Information on ethical issues of green marketing follows at the end of this chapter in the Your Fashion IQ: Case Study.

Intellectual Property Rights

Although the discussion of proprietary rights or protecting intellectual property rights is mentioned in Chapters 9 and 11, it is a global issue that has created widespread concern in the fashion industry. **Intellectual property rights** are ownership of original expressions of ideas or a creative individual's entitlements for an invention, a name, or specific design feature. The World Trade Organization rules on issues involving infringement of intellectual property rights. For example, in 2007, the United States, the European Union, and Japan filed formal complaints with the World Trade Organization because of intellectual property rights violations. These countries claimed that China failed to sufficiently protect foreign-owned patents and trademarks and did not sufficiently enforce intellectual property rights.

> Counterfeits and knockoff merchandise often infringe on intellectual property rights.

Dumping

Dumping occurs when an exporting country sells goods abroad at a price that is lower than the normal value of the goods in the country of origin. It also refers to a situation in which the exporting country attempts to sell the goods at a price lower than what it costs the importing

NOTE: For a detailed discussion of the law in Congress to protect intellectual property rights in the domestic fashion industry, refer to the "Knockoff and Style Piracy" section in Chapter 9.

country to produce the same goods. It is a very complex issue, hotly contested by proponents and opponents. Dumping is also discussed in Chapter 12 in relation to Vietnam.

Antidumping legislation refers to laws enacted to protect against the problem of dumped goods. In recent years, the most common problems occurred with trade of base metals, chemicals, and textile yarns and fabrics. In 2008, China was the most frequent subject of the new investigations registered with the World Trade Organization, whereas India accounted for the largest number of antidumping initiatives, meaning the country imposed measures, such as dumping tariffs, to combat exporting countries' low prices.

The United States also uses antidumping measures to protect its domestic textile industry from low-cost fibers being sold in the United States by foreign countries. For example, in recent years, the United States imposed additional duties on polyester fiberfill from China, South Korea, and Taiwan that stuffed ski jackets, sleeping bags, and similar products. The foreign governments were accused of attempting to sell the polyester fiberfill in the United States at prices below the established fair market value, so the U.S. government imposed a punishment of additional duties on the fibers to help ensure fair competition. Some opponents of antidumping measures cite the notion of comparative advantage and argue that consumers should be able to benefit from the lowest cost products, no matter where they originate. Opponents also argue that antidumping measures are trade barriers.

Bilateral and Multilateral Free Trade Agreements

When two countries enter into an agreement to engage in trading goods and services based on predetermined rules, it is called a **bilateral agreement**. The countries agree to give preferential trade treatment by reducing or eliminating trade barriers such as tariffs. It becomes a **multilateral agreement** when more than two countries are involved, such as with the World Trade Organization. In a multilateral agreement, the participating countries do not necessarily make up a single region. The North American Free Trade Agreement is considered a **regional agreement** because the countries involved do make up a single region of a defined geographic area.

Fair Labor Standards and Human Rights Issues

Some textile and apparel manufacturing facilities are located within the borders of the United States, and these employers are governed by the **Fair Labor Standards Act**, enforced by the Department of Labor. In the instance of garment homeworkers, these persons may still be protected by the Fair Labor Standards Act, if the homeworkers are certified. Seven specific industries are protected by homeworker certifications: women's apparel, jewelry manufacturing, knitted outerwear, gloves and mittens, button and buckle manufacturing, handkerchief manufacturing, and embroideries. Homeworkers are entitled to the same federal minimum wage and overtime compensation, and employment records must be kept on these individuals (Fact Sheet #24, July 2008).

While the Department of Labor regulates working conditions in the United States, the global body that sets standards for working conditions is the International Labor Organization (www.ilo.org). The World Trade Organization has given authority to the **International Labor Organization** to set and judge fair labor standards in all types of trade.

Textiles and apparel factories are prevalent in developing countries where labor costs are much lower and the workers are reasonably skilled in textile production. Sometimes, with lower labor costs comes substandard working conditions and unfair treatment of workers (see

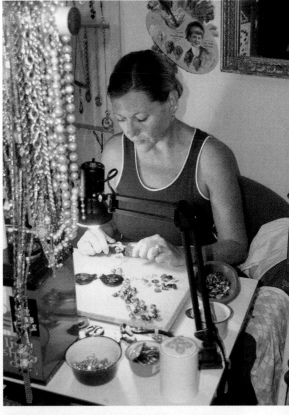

Figure 13.5 **Homeworker in the United States making jewelry.**
(Lorelie Kay Designs)

Chapter 3 for a discussion of sweatshops and Chapter 11 for a discussion of working conditions in developing countries). In 2006, the south Asian country of Bangladesh was reported to have over 3,800 occupational accidents that resulted in injuries or death. Close to half of these accidents (44.5 percent) involved workers in the garment industry (Zarocostas, J., 2007, Sept. 25). During the year ending June 2008, over 75 percent of the exports from Bangladesh were apparel. The United States is the leading purchaser of the country's exports (Ahmed, J., 2009, July 17).

Bangladesh and Cambodian textile and apparel labor leaders and workers have also been subjected to deliberate human rights violations, including beatings, torturing, and killing. Other countries, such as Pakistan, India, China, Jordan, Madagascar, Kenya, Mauritius, the Philippines, Mexico, and some Central American countries, have been similarly criticized for harming trade unionists and workers who advocated workers' rights to organize and collectively bargain.

In 2009, the International Labor Organization published a 96-page conference paper entitled, "The Cost of Coercion." It addresses global forced labor issues ranging from opportunity costs to enforcement and prosecution. The entire document is located on the International Labour Organization Web site.

When factories are accused of human rights violations, the domestic companies that contract with these factories are publicly scrutinized and denounced. The general consensus is that any domestic company that contracts with foreign factories is responsible for the treatment of the workers in those factories. Although it is recognized that legal and cultural standards may vary between countries and sometimes within the boundaries of a single country, the U.S. companies conducting business in a foreign country expect that the workers will be treated humanely and fairly. Table 13.2 is a representative list of employment issues and essential rights that all global workers should enjoy.

Table 13.2 Core Human Rights Issues in Apparel Factories, Regardless of Global Location

Human Rights Issue	Description
Freedom from Forced Labor or Labor Coercion	Prohibition of involuntary labor, including imprisoned, indentured, or debt-bonded
Freedom from Underage Labor	Minimum age legal requirement, often 14 or 15
Freedom from Harassment or Abuse	Includes all types of corporal punishment and physical, sexual, psychological, or verbal abuse
Nondiscrimination	Employment decisions based on ability to do the job, not gender, race, color, religion, disability, sexual orientation, nationality, political opinion, marital status, or ethnic origin
The Right to Health and Safety in the Workplace	Provision for clean and safe working conditions, including sufficient ventilation and lighting, fire and risk protection, and structural safety; emergency measures are in place
Freedom of Association and Collective Bargaining	Workers' right to join associations of their choice and organize or unionize to improve conditions of the workplace environment
Fair Wages and Benefits	Comply with legal minimum wage or local industry standards and legally mandated benefits
Reasonable Hours of Work	Maximum of 48 hours per week and 12 hours of overtime on a regular basis; minimum of one day off per week
Overtime Compensation	Overtime compensation is higher than regular work hour rates; workers can refuse overtime without threat of dismissal

Imagine sewing twelve- to fifteen-hour days in a poorly lit and ventilated workroom and sitting elbow to elbow at a long table with dozens of other workers. Visualize the rows of unfinished garments hanging on overhead racks, further blocking the limited natural sunlight. What if bathroom breaks were only allowed during lunchtime, and the drinking water was filthy? What if the exit doors were locked to prevent employees from sneaking out of the building? Imagine the manager verbally harassing or physically beating the employees for either not meeting the day's quota of piecework or trying to lobby for better working conditions. What if the weekly wages were withheld to ensure that the workers returned to work the next week? What if workers were forced to work overtime? If this scenario sounds comparable to the Triangle Waist Factory

working conditions in 1911, it is because it is quite similar, but it is about 100 years after the catastrophic Triangle Waist Factory fire in New York City (discussed in Chapter 3 Fashion Facts).

Substandard or **sweatshop** factory conditions are most likely to exist in developing countries, such as those in Asia, Central America, and South America. The preceding scenario was created from recent newspaper accounts of global sweatshops since 2000.

What can be done? Are consumers willing to pay more for the assurance that the fashions they purchase did not come from sweatshops? Would consumers support an antisweatshop tax on fashion merchandise? Would they be willing to spend an extra 5 percent to ensure that the goods were not made in a sweatshop? Would they avoid

shopping at a store that sold goods produced under sweatshop conditions? Would consumers support a legislative ban on goods that were deemed to be made in overseas sweatshops? Would consumers support trade negotiations that offered preferred vendor status to those factories that complied with or improved upon the international labor standards? Each of these methods has been proposed by interest groups in order to eliminate sweatshops.

Regardless of the proposal, antisweatshop activists seek and encourage involvement from a variety of sources: legislators, human rights activists, religious organizations, the media, and even university student groups. Why are each of these groups considered key to the successful implementation of an antisweatshop movement?

summary

- Most textile or apparel trade involving the United States is regulated by the Federal Trade Commission, the Department of Commerce, or the Department of Homeland Security.

- The Federal Trade Commission oversees the Consumer Products Safety Commission, deals with the protection of U.S. consumers, and ensures fair trade in a competitive environment.

- The Department of Commerce oversees the Office of Textiles and Apparel (OTEXA), and OTEXA's mission is to improve the global competitiveness of the U.S. fiber, textiles, and apparel industries.

- The U.S. Customs and Border Protection falls under the Department of Homeland Security, and its duty is to inspect imported goods.

- The Office of the United States Trade Representative is a domestic agency with the mission of increasing global trade through the creation of trade agreements and participation in the World Trade Organization.

- On an international scale, the World Trade Organization resolves many types of trade disputes among member countries.

- Comparative advantage means that countries prosper first by taking advantage of their assets in order to concentrate

on what they can produce best and then by trading these products for products that other countries produce best.

- Major legislative acts about textiles and apparel include the Wool Products Labeling Act, Fur Products Labeling Act, Flammable Fabrics Act, Textile Fiber Products Identification Act, Care Labeling Rule, and Made in the U.S.A.

- Recent trade agreements for the United States include the North American Free Trade Agreement between Canada, the United States, and Mexico; the Caribbean Basin Trade Partnership Act and the Central American Free Trade Agreement, both of which cover countries in Central America; and the African Growth and Opportunity Act.

- The Multifiber Agreement and the Agreement on Clothing and Textiles were historic trade agreements that limited certain textile and apparel imports into the United States.

- Counterfeits and knockoff merchandise often infringe on intellectual property rights.

- Dumping involves an exporting country selling goods abroad at a price that is lower than the normal value of the goods in the country of origin, and dumping is also when the exporting country attempts to sell the goods at a price lower

13

than what it costs the importing country to produce the same goods.

- Bilateral agreements are trade agreements between two countries, and multilateral agreements are trade agreements between more than two countries.

- Regional trade agreements involve countries within a certain geographic region.

- Fair labor standards, such as safety and freedom, are the human rights that workers deserve, regardless of the global location.

- The International Labor Organization sets global fair labor standards, wheras the U.S. Department of Labor sets fair labor standards for domestic businesses.

- Sweatshops are substandard working conditions in factories that include a lack of sanitation, unsafe working conditions, poor ventilation or lighting, and excessive hours of work.

terminology for review

Federal Trade Commission (FTC) 238

Consumer Products Safety Commission 238

Office of Textiles and Apparel (OTEXA) 238

U.S. Customs and Border Protection 238

Office of the United States Trade Representative 239

World Trade Organization (WTO) 239

comparative advantage 239

free trade agreement (FTA) 240

Wool Products Labeling Act 241

Fur Products Labeling Act 242

Flammable Fabrics Act 242

Textile Fiber Products Identification Act 243

Care Labeling Rule 243

Made in the U.S.A. 243

North American Free Trade Agreement (NAFTA) 243

Caribbean Basin Trade Partnership Act 244

Caribbean Basin Initiative 244

Central American Free Trade Agreement Dominican Republic (CAFTA-DR) 244

African Growth and Opportunity Act 245

Multifiber Agreement (MFA) 245

Agreement on Clothing and Textiles (ACT) 245

carbon footprint 246

intellectual property rights 246

dumping 246

antidumping legislation 247

bilateral agreement 247

multilateral agreement 247

regional agreement 247

Fair Labor Standards Act 247

International Labor Organization 247

sweatshop 249

questions for discussion

1. Why are the textiles and apparel industries regulated by such a variety of government agencies? Is this necessary? Why or why not?

2. What event occurred on January 1, 2005, and how did it affect global textile and apparel trade?

3. What are the main acts and responsibilities of the Federal Trade Commission as they relate to textiles and apparel?

4. How does the World Trade Organization enforce its rules?

5. Why is it important to create free trade agreements with selected countries?

6. In what ways are businesses protecting their intellectual property rights in the fashion industry?

7. What is dumping, and how are countries combating this problem?

8. What are the core human rights that all workers should expect, regardless of country of origin?

9. Why are sweatshops prevalent in the garment manufacturing industry?

10. What organizations protect garment factory workers' rights?

related activities

1. Hold a class debate on some aspect the topic "Free trade versus fair trade in the textiles and apparel industries." Find an electronic journal article from the library's databases to support a selected point of view on this topic. Follow the guidelines for a debate as suggested at http://712educators.about.com/cs/lessonsss/ht/htdebate.htm.

2. Using the university library's electronic databases, locate an anecdotal article on a modern-day textile or apparel factory sweatshop. Compare the conditions in the sweatshop to the list of core human rights from Table 13.2. In what ways have these workers' rights been violated? What can be done to correct the problem? Type a brief summary and critique of the article and present to the class.

3. Using online information from government agencies, such as the Office of Textiles and Apparel (http://otexa.ita.doc.gov/) or the Office of the United States Trade Representative (www.ustr.gov), research a free trade agreement for textiles or apparel between the United States and one other developing country that enjoys a preferred nation status with the United States. Explain the agreement, its date of inception, the products covered, and any other pertinent information. Present the findings to the class.

4. Choose one of the legislative acts affecting the textile and soft goods industries. Research the act online and locate information on the specific features of each act. Explain why this law was enacted. Prepare a PowerPoint presentation for the class.

Your Fashion IQ: Case Study
Greenwashing in Green Marketing

Legitimate "green" companies are concerned about the prevalence of unethical claims in the marketing of green goods. The term *greenwashing* is defined as "the act of misleading consumers regarding the environmental practices of a company or the environmental benefits of a product or service" (The Six Sins of Greenwashing, 2007, Nov.).

The marketing firm TerraChoice Environmental Marketing conducted research in North America on marketing practices for more than 1,000 consumer goods advertised as eco-friendly. Almost all of the goods were found to have some degree of unfounded "green" claims, ranging from misleading customers or blatant deception. Based on the findings of the study, the firm categorized the deceptive or unethical marketing claims into The Six Sins of Greenwashing (The Six Sins of Greenwashing, 2007, Nov.). The six sins are:

- Sin of the Hidden Trade-Off
- Sin of No Proof
- Sin of Vagueness
- Sin of Irrelevance
- Sin of Fibbing
- Sin of Lesser of Two Evils

The U.S. government is also concerned with unfair claims regarding green or enviro-friendly products. The Federal Trade Commission regulates advertising and marketing practices and protects consumers from unfair or deceptive acts. It requires truthful and substantiated claims in all consumer products, including those considered to be "green" products. Due to the increasing interest in marketing green products, the Federal Trade Commission issued the Guides for the Use of Environmental Marketing Claims in 1992 to help marketers avoid making unlawful environmental claims that are unfair or deceptive. The publication, referred to simply as the "Green Guides," was updated in 1998 and again in 2008 when the FTC held conferences to further refine them.

Read the online Green Guides posed by the Federal Trade Commission and the online paper "The Six Sins of Greenwashing." Consider the Recommendations for Marketers posed by TerraChoice in light of fashion apparel products.

QUESTIONS

1. Might the TerraChoice Recommendations for Marketers be useful ways to substantiate green marketing claims?

2. Do you agree with the TerraChoice statement in the Recommendations for Marketers that there is no such thing as a perfectly green product?

3. Which of the listed six sins is most likely to be used in fashion marketing? Why?

4. After reading the online Federal Trade Commission Green Guides, do you think the FTC should provide more stringent guidelines for green marketing? Why or why not?

5. In your opinion, is there a problem with unethical claims in marketing fashion apparel, accessories, or home fashions as green? Should the various terms (*green, eco-friendly, enviro-friendly,* etc.) be defined by the Federal Trade Commission?

SOURCES: Guides for the use of environmental marketing claims, Part 260. (1998). *Federal Trade Commission Web site.* Retrieved October 25, 2008, from **http://www.ftc.gov/bcp/grnrule/guides980427.htm**

The six sins of greenwashing. (2007, Nov.) *TerraChoice Environmental Marketing, Inc.* Retrieved October 25, 2008, from **http://www.terrachoice.com/files/6_sins.pdf**

Black Friday, the day after Thanksgiving, has traditionally been the largest in-store shopping day of the year. For most retailers, it represents the beginning of the very profitable fourth-quarter holiday shopping season. The word "black" refers to being in the black or turning a profit. **Cyber Monday** is the virtual version of Black Friday, referring to one of the most important and often the largest online shopping day of the year. On the Monday after the Thanksgiving holiday, office employees return to work and sneak in a little Web time shopping online from their office computers.

252

FASHION RETAILING FORMATS

LEARNING OBJECTIVES

At the end of the chapter, students will be able to:

- Discuss the benefits of retailing.
- Describe the origins of retailing in the United States.
- Compare department stores and discount department stores.
- Identify some marketing strategies used by department stores to improve profits.
- Compare specialty stores and limited line specialty stores.
- Explain the concept of lifestyle retailing and lifestyle merchandising.
- Compare merchandise selections in discount stores with those in off-price retail stores.
- Identify the different types of shopping centers and explain their purposes.
- Discuss the major trends in shopping center development.
- Evaluate the benefits of electronic retailing and other forms of nonstore retailing.

Retailing is an ever-changing method of selling to consumers, yet good retailing has some basic tenants that do not change with the decades. Retailing is all about creating value for customers. It is about optimizing the retailer's relationship with its targeted customers. Retailing has always involved treating customers the way the company employees would like to be treated. Retailing involves striving to be the best at whatever the company determines to be its core competency.

14

The state of retailing today is highly competitive, and retailers have difficulty differentiating from competing companies. To better compete, retailers have expanded into **multichannel retailing**, which is using multiple venues to reach customers. These include brick-and-mortar stores, Internet Web sites, mobile devices, and catalogs. Retailers strive to increase market share, and this often translates into catering to a big middle market. Retailers employ **scrambled merchandising** methods, such as offering seemingly unrelated items that might also appeal to the same target customer. For example, a traditional apparel store might also offer gourmet candy, candles, or travel planning within the store. These strategies used by retailers provide competitive advantages that are useful in being successful in a highly competitive environment.

Fashion Retailing Formats

The term **retailing** refers to the function of selling products or services to ultimate consumers. Retailing is the last level of the supply chain. Fashion goods may be retailed through traditional formats, such as stores or mail-order catalogs, or goods may be sold through the Internet, a television home shopping network, door-to-door, home parties, or any other format that involves marketing goods or services to ultimate consumers for their personal use. As a benefit, the retailing function provides fashion manufacturers with convenient access to the end users of apparel, accessories, or home fashions. For example, a fashion company such as Levis is primarily in the business of making jeans. Levis contracts with manufacturing facilities in Mexico and other parts of the world to produce hundreds of thousands of Levis blue jeans. When a small retail store buyer places an order for four dozen of the jeans to sell in the store, a consumer is able to visit the conveniently located store and purchase a single pair of Levis in his or her size. It is because of the retailing function and the retailers that the ultimate consumers easily acquire the jeans for their personal use.

Benefits of Retailing

Retailing offers numerous benefits to consumers. These include breaking bulk, taking ownership of the goods, providing a one-stop shopping experience, creating convenience, offering services, guaranteeing the products, and linking the customers to the manufacturers. Without the function of retailing, manufacturers would have difficulty selling to ultimate consumers from coast to coast and around the world.

Breaking Bulk

Retailers buy merchandise in bulk or large quantities, from dozen to millions, in order to obtain quantity discounts. For example, a small mom-and-pop specialty store may only purchase six pieces of a style for a particular season. By contrast, a mass merchandiser the size of Wal-Mart may require millions of a single style, since a retailer of that magnitude can easily sell two or three million pieces of one style in a single week. No matter what size the retailer, it is willing to sell a much smaller quantities to an ultimate consumer who needs only one pair of shoes or a three-pack of trouser socks.

Recessionary Buying

During a recession, people want fun accessories that make them feel good without spending a lot of money. This might include big belts, colorful hair accessories, wrist cuffs, dangling earrings, oversized necklaces, or other decorative items. Designers and manufacturers capitalize on consumer spending cutbacks by offering unique collections using less expensive materials, such as silver, leather splits, and semiprecious stones. Creative retailers work with manufacturers to bring their customers a better value, such as offering a similar look at 15 to 20 percent lower retail prices.

Recessionistas are comfortable shopping in their own closets but are still tempted by attractive and innovative accessory designs. The social activity known as shopping or fashion retail therapy still occurs, but consumers may not be spending as much money on accessories as they did in past seasons.

Taking Ownership of Goods

Retailers generally assume ownership of the goods. That is, they buy the goods outright at the wholesale cost, they own title to the merchandise, and they assume the risk for the merchandise. Because of ownership, retailers charge the retail prices that consumers are willing to pay. If an item is not selling well, the retailer is allowed to determine an appropriate markdown to encourage consumer purchasing (see Figure 14.1).

Providing One-Stop Shopping Experiences

A retail store procures merchandise from across the globe and brings it all together in a single location. A customer can visit a store and select an ensemble comprised of products from numerous countries. It would not be possible for the customer to track down all the manufacturers and purchase individual pieces from each manufacturer.

Creating Convenience

In addition to a one-stop shopping experience, consumers can visit retail outlets near their homes or workplaces. Stores are conveniently located near the target customers. Many retailers offer nonstore retailing formats, such as Internet, mobile commerce, and catalog sales to further provide convenience for customers.

Offering Services

Retailers offer specialized services desired by the target customers. For example, if the target customers are elderly, the retailer may provide home delivery for a nominal fee. Gift wrap, special orders, and alterations are value-adding services that can be offered by retailers. Generally, the level of service depends on the type of retailer and the retail prices charged. Retailers desiring to keep prices extremely low may eliminate basic services, such as accepting credit cards or providing private dressing rooms. Customers assume that the nicer the store, the better the services and the higher the prices.

Figure 14.1 Stores use large interior sale signs to stimulate customer purchasing.
(Pearson Education/PH College)

Guaranteeing the Products

Retailers stand behind the products they sell in the stores. When consumers purchase defective items, they expect to be able to return it to the retailer for a replacement or a refund. Most retailers will try very hard to work within the store's policy to ensure customer satisfaction. Retail return policies usually range from offers of a money-back guarantee, if the customer is not completely satisfied, to offers of replacement merchandise or gift cards. Reasonable and fair product guarantees are one of the best ways to build relationships with customers and gain their loyalty. However, retailers are not required to refund the purchase price of merchandise that is not defective, if the consumer simply changes his or her mind.

Linking Manufacturers to Consumers

"Nothing happens until the cash register rings." This adage means that a store is the fashion industry's direct link to the ultimate consumer. The retail establishment is the final stop for fashion merchandise before it ends up in the closets of the ultimate consumers. Because of the importance of retailing, many fashion companies require months of retail experience before college graduates can become fashion buyers, product developers, wholesale sales representatives, or work in other corporate-level positions. Educators and corporate recruiters stress the importance of gaining retail experience while students are enrolled in college. It teaches students how to understand and interpret the needs of consumers and provides opportunities to gain practical learning for a well-rounded college education.

Origins of Retailing

Trading posts, mercantile stores, or general merchandise stores, dry goods stores, mail-order catalogs, five-and-dime stores, and traveling peddlers were some of the earliest forms of retailers. In populated areas, a mercantile storefront (often the front room of the family residence) was opened for selling merchandise and was staffed by the male or female head of the household. Nearby townspeople benefited from the convenience of having an assortment of necessary goods all located under one roof. The store offered an array of staple and fashion goods—set on the floor, displayed on shelves and counters, and hanging from the ceiling. Customers paid the storekeeper in cash or bartered for other goods and services. Figure 14.2 represents a typical general store in early American history, and the following paragraph explains a typical retailing transaction in early America adapted from a storekeeper's account ledger.

On November 25, 1874, Mrs. Fannie McElroy visited McAlester's General Store and purchased three yards of flannel for $1.87, eight yards of calico for $1.00, and three yards of jean (denim) for $1.75. In addition to the fabric, she bought coffee, sugar, tobacco, and a pair of shoes from the store for a total bill of $12.02. Other customers purchased lace, ribbon, hooks and eyes, thread, ready-made flannel work shirts, socks, slippers, hats, and handkerchiefs (English, L., 2002).

In isolated areas or farming communities, peddlers loaded the goods onto wagons pulled by mule teams and transported the merchandise to outlying homes. Rural consumers purchased commodities, textiles, and

Figure 14.2 Museum replica of the interior of a California general store during the Gold Rush.
(Andrew McKinney © Dorling Kindersley)

clothing to meet their families' needs. Like their town-dwelling counterparts, rural dwellers often bartered with the peddler for items from his wagon. According to one account, "Bolts of cloth, needles, spools of thread, forks, knives, spoons, a grinding stone that could sharpen anything, staples, nails, mule harnesses, and a thousand other things filled the inside of the peddler's wagon" (Jones, L., 2000, May, p. 297). Farmers bargained eggs, grain, and canned fruits or vegetables for textiles and other items they were unable to produce on the farm.

Some of the large retailers today began as general dry goods stores. In 1902, James Cash Penney opened a dry goods store called The Gold Rule Store that was later changed to JCPenney. Aaron Montgomery Ward began selling merchandise in 1872 through his mail-order catalog, and Sears, Roebuck and Company began as a partnership selling mail-order watches and jewelry in 1893. Sam Walton began his Wal-Mart empire in 1950 with a single unit five-and-dime shop in Bentonville, Arkansas.

Successful mercantile stores evolved into family-owned department stores in larger cities. Stores such as Lord & Taylor (est. 1826), Lazarus (est. 1851), I. Magnin (est. 1876), Filene's (est. 1881), and Bonwit Teller (est. 1897) began as single-unit department stores owned by a local family in a metropolitan city. Over time, mergers, acquisitions, and bankruptcy affected each of these historic stores, and many were sold to another corporation, such as Federated Department Stores. Those that still exist today try to maintain their historical identity.

Department Stores

Fashion department stores may be classified as department stores or discount department stores. They may be either single-unit stores or chain stores. According to the U.S. Census Bureau and the North American Industry Classification System (NAICS) definitions, **department stores** are stores "with separate departments for various merchandise lines, such as apparel, jewelry, home furnishings, and linens, each with separate cash registers and sales associates. Department stores in this industry generally do not have central customer checkout and cash register facilities" (NAICS Definitions, 452111, 2002). Discount department stores also have separate departments but "have central customer checkout areas, generally in the front of the store, and may have additional cash registers located in one or more individual departments. Department stores in this industry sell a wide range of general merchandise (except fresh and perishable foods)" (NAICS Definitions, 452112, 2002). Department stores include Macy's, Gottschalks, Kohl's Corporation, Dillard Department Store, and Stage Stores.

In the last two decades, much has been written about the demise of the department store or the department store dinosaur. In 2006, a study by Unity Marketing showed that retail sales in traditional department stores have decreased by 13 percent since 2000. Part of the problem has been that traditional, enclosed shopping malls (with two to five anchoring department stores) have been losing market share to other shopping center formats, such as lifestyle centers, value-oriented malls, and off-mall formats. These locations are less costly to operate than traditional mall-based department stores and offer consumers convenience with one-stop shopping. Another problem is the department store mergers that have reduced the number of possible tenants in a mall. For example, the consolidation of Burdines or Foleys into Macy's reduced the number of potential stores in a mall, since they are all owned by Macy's.

A 2008 study showed value-priced department stores in a slightly better light. According to the Consumer Sentiment Index research conducted by AlixPartners, value-priced department stores featuring designer merchandise were gaining a competitive edge over specialty

stores. The examples given by the research group included value-priced department stores Belk and Kohl's compared to private label specialty retailers, such as GAP. A trend toward a more promotional climate in retailing has propelled value-priced retailers of all kinds toward improved sales (Clark, E., 2008, Mar. 4).

In spite of the somewhat mixed predictions, existing department stores continue to implement new merchandising strategies designed to improve profits. The turnaround strategies are usually centered on either improving the shopping experience or reinvigorating the merchandising concept. The changes undertaken by department stores include mergers, Internet offerings, modified merchandise assortments, evolution into specialty department stores, shoppertainment (shopper entertainment), and lifestyle services. Table 14.1 lists some common strategies department store retailers have used to improve their bottom line. These are not necessarily unique to department stores, since other retailing formats have also found success using these methods.

Table 14.1 Profitable Merchandising Strategies Used by Retail Stores

Strategy: Build a strong relationship with core customers and offer attractive incentives for the store's most profitable customers.

Details: Offer store credit cards, implement frequent buyer programs, schedule VIP events, offer advance notices of sales, and maintain customer profiles in the company database.

Strategy: Create a shopper-friendly environment through proper signage.

Details: Make sure signs are in sign holders, signed prices match the merchandise, clutter is eliminated, and only the signed merchandise is located on the corresponding fixture.

Strategy: Implement self-service elements.

Details: Convert to centralized checkout stations, offer point-of-purchase merchandise displays (manufacturer-supplied fixtures and graphics), and increase signage.

Strategy: Offer more distinctive assortments with added value.

Details: Study competitors' offerings, seek out new resources, schedule personal visits from upcoming designers, focus on attractive packaging or enhancing the giftability of items, offer fringe sizes for niche markets, customize promotions and marketing programs, and offer embellishments and novelty styles.

Strategy: Eliminate unnecessary duplications of merchandise assortments.

Details: Work toward more sales volume with less inventory, continue to offer consumers fashion selections, but reduce excessive inventory.

Strategy: Offer fashion-relevancy.

Details: Study consumer buying habits, such as style and color preferences; limit number of resources of supplying basics; plan stock and colors around key trend items; invest in brand-right merchandise; and offer special events.

Strategy: Implement lifestyle merchandising and marketing strategies.

Details: Bring together several classifications of related merchandise, such as offering cosmetics in the junior department; create social areas in key departments; expand direct mail campaigns to key customers; and implement less focus on vendor shops.

Strategy: Develop partnerships with noncompeting retailers and explore multichannel retailing.

Details: Include subretailers within departments, such as a travel agency in the luggage department or a gourmet coffee shop in the housewares department. Consider nontraditional retail formats to complement the store's current retail format.

Strategy: Differentiate merchandise offerings with the store's private labels or negotiate for exclusives of national brands.

Details: Private labels usually generate higher margins and can be tailored to customer preferences through corporate product development. Exclusives provide a compelling reason for customers to return to the store, since the goods are not available elsewhere.

Strategy: Create changeable themed areas within departments.

Details: Revitalize visual merchandising with vendor shops, create focal points, install destination points in stores, continually remerchandise departments, and tie together the synergies of a variety of products.

Strategy: Focus on high-margin areas and increase the space allocated to strong merchandise categories.

Details: Implement suggestive selling of high-margin items, cull slow sellers from inventory, and add floor space to best-selling categories.

Specialty Stores and Limited Line Specialty Stores

Specialty stores may specialize in menswear, women's wear, children's wear, and accessories. A **specialty store** can be defined as a retail store that offers a relatively narrow product assortment compared to that which is offered at a department store. A **limited line specialty store** is a subcategory of a specialty store that specializes in a very narrow product assortment. For example, an apparel store such as Aéropostale Inc. is considered a specialty store, whereas a narrowly focused accessory store such as Sunglass Hut is considered a limited line specialty store because the store's merchandise assortment is limited to sunglasses. Although a store such as Sunglass Hut has a narrow breadth in its merchandise assortment, it has depth within the product line of sunglasses. There are many choices of brands, colors, materials, and styles.

Specialty stores come in all sizes. Traditional specialty stores include American Eagle Outfitters, Limited, Footlocker, and Bed, Bath & Beyond. Large, anchor-type fashion specialty stores include Nordstrom, Neiman-Marcus, and Saks Fifth Avenue. These upscale larger stores are technically not considered department stores since they do not carry furniture, toys, sporting goods, appliances, or luggage.

Specialty stores may be chains, or they may be single-unit stores. The U.S. Census Bureau does not specifically define specialty stores, but it does define clothing stores for women, men, and children. They are defined as "establishments primarily engaged in retailing a general line of clothing (men's, women's or children's) and these establishments may provide basic alterations" (NAICS definitions, 448110, 448120, 448130, 2002).

Some specialty stores carry national brand merchandise, whereas others carry only private labels. Specialty stores can carry both national brands and private labels. When the specialty store carries a private label bearing the store's own name, it is called a **monobrand**. For example, GAP stores carry the GAP monobrand, and Express stores carry the Express monobrand.

Specialty stores have varying levels of customer service and prices. As explained previously, the price points in the store are a guide to the level of customer service. Generally, the lower the prices, the fewer the services. Stores such as Shoe Carnival or Payless Shoe Source are self-service stores that focus on customer convenience and speed and offer low prices. All the available sizes are placed directly on the selling floor, with little or no back stock. By contrast, higher-priced stores such as Ann Taylor or Nordstrom offer greater numbers of customer services. Customers may receive personalized assistance from commissioned salespeople, who start dressing rooms for the clients, assist with wardrobing, walk around the front of the cash register to present the sack to the customer (rather than handing it over the counter), and send thank-you notes to purchasing customers. All these services add value to the sale, but they usually add to the selling price of the merchandise as well.

Lifestyle concepts have increased within specialty stores, just as they have in shopping center designs. **Lifestyle merchandising** in specialty stores is the creation of smaller, more intimate settings with narrowly focused offerings to attract customers. The Polo Ralph Lauren store is a good example of a retail store that is merchandised by lifestyle. Department stores often carry a Polo Ralph Lauren department featuring customized fixtures in the men's section of the department store. Yet, this department lacks the degree of intimacy that customers experience when they shop in the freestanding Polo Ralph Lauren stores. These intimate shops

implement cross merchandising to present a lifestyle concept. For example, the bedding, linens, draperies, and dishes are presented as a total look display and may also include a nearby body form outfitted in the Polo apparel.

The lifestyle merchandising approach has evolved from the boutique merchandising approach. **Boutique** is the French word for "little shop." It has been a common method of merchandising in small specialty stores, but not in large specialty stores and department stores. In the 1970s, large department stores, losing customers in the "sea of floor racks," opted for the boutique approach within the store. Rather than merchandising all pants together or all coats together, regardless of brand, important brands or **power brands** were given exclusive spaces. The brand's entire line of apparel of pants, jackets, blouses, and accessories were brought together in one area with specialized visual merchandising and specially created stock-holding fixtures unique to the brand.

Pop-Up Stores

Temporary specialty shops or boutiques that carry a small, but specialized category of merchandise are called **pop-up stores**. These shops open in high-traffic locations for a time duration that ranges from just a few days to a few months. They may exist as a collaborative effort between the parent store or brand and a local designer or store. Because of the short time of operation, marketing of pop-up stores is most often conducted by using the local press and word-of-mouth advertising. The merchandise carried in a pop-up store may be more unique or edgy, theme-based, or for a special occasion, such as resortwear. For example, Levis briefly opened a pop-up store in a dorm room, and GAP housed a pop-up boutique called Colette from Paris within its Manhattan store. Other pop-up stores have appeared in Southampton, New York, during the summer vacation season, at ski resorts during the snow ski season, in Manhattan's Grand Central Station during the six weeks before Christmas, and for the duration of the Sundance Film Festival in Park City, Utah.

Mass Merchandise or Discount Stores

There exists some confusion over the multiple names used to describe mass merchandise stores. They have been called mass merchandisers, discount mass merchandise stores, discount general merchandise stores, discount stores, and discounters. The retail formats are similar, although one store may emphasize trends and fashion, whereas another store may emphasize low prices. Regardless of the descriptive term used, a **mass merchandise or discount store** generally has four common characteristics: It is a large retail store with a high sales volume; it carries a broad merchandise assortment; it emphasizes self-service; and it offers bargain pricing. These stores may offer weekly price promotions to entice customers into the stores, or they may advertise everyday low prices, with few significant price reductions each week. Mass merchandise stores include Target, Wal-Mart, and K-Mart.

In the apparel departments of these mass merchandise stores, products range from basic merchandise to trendy items. Recently, mass merchandisers experimented with short-run designer projects. Target has been noted for its "limited-edition alliances with trendy designers" (Bower, 2007) that are effective methods of increasing the foot traffic within the fashion departments. Rather than selling tremendous volumes of a select style, Target has been successful at its attempts to create fashion interest with trendier styles and smaller production runs. The featured designer's brand is prominently placed on coordinate fixtures within the department in order to increase visi-

The mall-based Hot Topic stores have been successful for many years. They have catered to the music-inspired and concert-going Gothic teenagers with remarkable success. In the late 1990s, Hot Topic sales showed the plus sizes were flying off the shelves before the other sizes. Strategic data mining showed a sizeable niche market of underserved, plus-sized teens to 30-year-olds. The company data showed that 25 to 30 percent of the female youth market was wearing sizes 14 to 26 (plus sizes). The California-based retail chain began in-store and Web site testing of plus sizes after numerous requests were written on in-store comment cards. They found that many of their potential customers either chose to wear men's clothing or make their own clothing so that they could get the proper fit.

Market researchers asked the target customers what they wanted in a plus-sized store. One requirement was to open a female-only store, and the other requirement was that the store had to be cool. Betsy McLaughlin, Torrid CEO and president during the planning of the Torrid stores, cited specific comments by the teenage shoppers about store expectations: "If they saw linoleum floors and aluminum racks, they'd keep walking" (Reda, 2002).

The culmination of this market research evolved into a spin-off store from Hot Topic called Torrid, carrying apparel sizes 14 to 26. The first Torrid store opened at the Brea Mall in Brea, California, in 2001. To date, the company has opened more than 159 stores in 36 states.

Torrid store merchandise is somewhat different from the merchandise found in Hot Topic stores. Hot Topic stores' main focus is on music-inspired clothing and accessories. Torrid sells moderately priced edgy and trendy apparel, accessories, and lingerie. About half of the Torrid merchandise assortment features the Torrid private label, whereas the other half includes well-known fashion brands, such as Apple Bottoms, Booty Parlor, Betsey Johnson, Dickies, Ed Hardy, LA Ink, Spanx, and Z. Cavaricci. Torrid has been described as multicultural, loud, colorful, exotic, funky, and over-the-top, especially compared to traditional plus-sized clothing stores.

The Torrid Web site features an annual model search contest that attracted the attention of an *American Idol* contestant and eventual winner in 2007. Before her *American Idol* win, Jordin Sparks entered and won a modeling gig for Torrid, as well as appearing in a Torrid advertisement for *Seventeen* magazine.

Ironically, after Torrid opened its doors for business, the number one request on in-store customer comment cards was that the stores carry sizes smaller than 14. In response to that request, Torrid stores now carry size 12.

SOURCES: Reda, S. (2002, August). Customer focus helps Hot Topic launch Torrid concept. *Stores, 84*(8), 33–34.

Torrid.com company Web site.

Wilson, M. (2001, July). Torrid: Hot fashion for plus-size teens. *Chain Store Age, 77*(7), 130–131.

bility and encourage wardrobing. Since 2007, Target has featured Erin Fetherston, Jovovich-Hawk, Rogan, Richard Chai, Jonathan Saunders, Thakoon, Tracy Feith, and the Rodarte line.

Other mass merchandise stores have strategized to create cheap chic clothing within the broader scope of the store's inexpensive basic apparel. The target customers of some mass merchandise stores are widely accepting of low-priced basics to fill in their fashion wardrobe, but some customers are reluctant to buy fashion merchandise in the same store that they buy their groceries. Wal-Mart has struggled with a way to entice its target customer into the fashion departments. The concern has been that the more affluent customer is willing to buy food and sundries at Wal-Mart, but she pushes her shopping cart right past the higher-margin apparel departments. The introduction of branded fashion merchandise and designer names has improved sales.

The following information is an example of how mass merchandise stores can differ in target customer demographics. The available data from a 2006 study, ShopperScape by Retail Forward, indicated the subtle demographic differences between Target and Wal-Mart menswear shoppers. Target male shoppers are slightly younger and more affluent than the average Wal-Mart male shopper. Fifty-eight percent of the Target menswear shoppers are under the age of 44, whereas only 41 percent of the Wal-Mart menswear shoppers are under the age of 44. Forty-one percent of Target menswear shoppers have household incomes of over $75,000, whereas only 19 percent of the comparable Wal-Mart customers are in households earning $75,000 or more (Bower, 2007). These different demographics help merchandisers determine existing customer preferences and identify potential markets that are not currently being served, but might be served in the future.

Off-Price Stores

The key ingredients to fashions found in off-price retail stores are branded merchandise, a good style, and reasonable prices. In recession-like conditions, few customers want to pay full retail price for items, unless it is a must-have item or unless they know it will not be there when they return. Customers are increasingly price-conscious, and they prefer to think they are getting a good deal with each purchase. Customers are accustomed to low prices from mass merchandise stores, and it has infiltrated the other types of retail stores.

Off-price retail stores are varied in their merchandise offerings and therefore varied in the definitions. In general, **off-price stores** carry brand- or designer-name merchandise and offer it at a 20 to 70 percent lower price than the manufacturers' suggested retail prices. The merchandise consists of in-season **manufacturers' overruns** (extra merchandise manufactured, but not needed by the full-price stores), in-season merchandise obtained from cancelled orders, or last season's goods obtained directly from the department stores or jobbers.

More upscale off-price retailers carry in-season, high-quality designer or better merchandise that is found in traditional department or specialty boutiques and offer it at discounted prices. Yet they are not considered mass merchandise or discount stores (refer to the preceding "Mass Merchandise or Discount Stores" section for a definition of mass merchandise or discount stores). These off-price merchants have agreements with the vendors not to use the brand or designer's name in the store's off-price marketing efforts, such as print advertisements, Web sites, or television commercials. Merchandise in these stores may have the brand labels removed (cut out) or the labels may be slashed or redlined to prevent return at a competing full-price retail store. Examples of off-price stores include Loehmann's, a national, upscale, off-price specialty retailer in business since 1921; TJ Maxx, with more than 800 stores nationwide; and Ross Stores, Stein Mart, Marshalls, and Gordmans, which are all off-price department stores. Bluefly.com began in 1998 as an off-price e-tailer that offers 20 to 40 percent discounts on designer goods, including high-fashion apparel and designer accessories.

Better off-price retailers typically carry first quality, in-season merchandise. Their assortments are complete with all size ranges and colors. The services and amenities are limited so that the savings can be passed on to consumers, but the merchandise is often the same as that found in moderate to upscale stores that appeal to moderate to upscale shoppers.

On the opposite end of the off-price spectrum are off-price stores that carry odds and ends type merchandise. The merchandise assortments consist of closeouts, last season's merchandise, odd-lots assortments, manufacturer's overruns, seconds and irregulars, and even fire-damaged goods. Merchandise is heaped on tables and in bins or poorly hung on available straight or circular racks with shoulder-out views. These stores cater to lower- and middle-income consumers, with greater emphasis on low, low prices and less emphasis on fashion. Half of Half Name Brand Clothing is an example of a low-end off-price retail chain. Because little money is invested in the facilities, these types of stores may exist in larger cities, or they may be a single-unit, mom-and-pop store.

One of the most famous of all off-price fashion stores is the century-old, legendary Filene's Basement in Boston, giving rise to the term *bargain basement prices.* The Filene's department store has since closed, but the Filene's Basement still operates in the basement of the original building. With 65,000 square feet, hand-lettered signs, and clothing piled on tables, Filene's Basement is a thriving institution among shoppers in Boston. A second, but more upscale off-price Filene's Basement location opened in 2006 on Boylston Street in Boston, but the mer-

chandising concept is quite different. A doorman greets shoppers and plasma screen televisions are located within the two-story, 38,000-square-foot store.

The success of off-price retailing is spurred by recession-like conditions in the economy. Bargain lovers and savvy shoppers brag about how much they saved on an outfit rather than how much they spent on the outfit. The bargain-loving sentiment was measured in Cotton Incorporated's fourth-quarter 2007 *Lifestyle Monitor* (Saving green while going green, 2008, Jan. 31). When asked what information was important to them when purchasing clothing, nine out of ten female respondents cited price. Shoppers choose to save money on their clothing purchases so that they can use their discretionary income in other areas, such as travel and entertainment.

Shopping Centers and Malls

Shopping centers are defined by the U.S. Census Bureau as "a group of architecturally unified commercial establishments built on a site that is planned, developed, owned, and managed as an operating unit related in its location, size, and type of shops to the trade area that the unit serves" (Shopping Centers, Table 1030, Wholesale & Retail Trade, 2008). Adequate on-site parking is also a part of the census definition of multiretail shopping centers. The International Council of Shopping Centers provides an abbreviated definition of a shopping center as a "group of retail and other commercial establishments that is planned, developed, owned and managed as a single property, with on-site parking provided" (ICSC Shopping Center Definitions, 2004).

The design of shopping centers and malls continues to evolve into creative and hybrid concepts. In the 1980s, the factory outlet malls, with their off-price and value-oriented merchandise excited hoards of shoppers from coast to coast. Power shopping centers of the next decade offered large anchor stores with highly competitive retail prices typically found in discount department stores, off-price stores, warehouse clubs, and big-box stores. One of the most recent hybrids of shopping centers is the lifestyle center that offers multipurpose pursuits to the nearby upscale customers. In addition to including conventional or specialty fashion stores, a lifestyle center includes restaurants, entertainment, and other design elements, such as fountains and street furniture to encourage leisure activities and casual browsing. According to the International Council of Shopping Centers, the shopping center industry will continue to change as developers seek out new ways to differentiate their shopping centers and reach unique segments of consumer groups.

Shopping centers are divided into two separate categories: open-air centers and malls. **Open-air centers** do not have enclosed commons areas or walkways lining the stores, although storefronts may have connecting canopies. Parking is located on-site, usually in front of the stores. **Malls** are generally enclosed shopping centers with a central walkway and ample parking around the perimeter of the mall. The climate-controlled atmosphere of a mall is conducive to leisurely shopping and has additional appeal during inclement weather. Within each of these categories are multiple shopping center descriptions that are subcategorized

Figure 14.3 **The Mall of America in Minnesota.**
(PhotoEdit Inc.)

FASHION FACTS: Shoppertainment at the Mall of America and the Dubai Mall

Multiuse malls act as shopping centers, business conference facilities, tourist attractions, and destination points for vacationers. The Mall of America in Bloomington, Minnesota, is the largest of all destination malls in the United States and is a first-class example of experiential marketing. Built in 1992 on the site of the former Metropolitan Stadium for the professional sports teams, the Minnesota Vikings and the Twins, it meshes a retail shopping mall with an entertainment experience suitable for the whole family. It contains the world's largest underground aquarium, an enchanted forest theme park, a NASCAR silicon motor speedway racecar simulation, a 14-screen movie theater, an 18-hole miniature golf course, a play center filled with thousands of LEGOS® for creative building, a day spa, hourly child care, a recreational oxygen bar, a souvenir shop, a wedding chapel, 50 restaurants, and 520 enclosed stores.

More than 40 million customers visit the growing Mall of America each year, and most have shopping in mind. The mall has been a tremendous boost for Minnesota's economy, generating more than $1.8 billion in sales each year. The expansion phase of the Mall of America includes an additional 5.6 million square feet of mixed-use space devoted to more structured parking and retail, office, hotel, residential, and entertainment venues. Best of all, there is no sales tax on apparel in Minnesota. (See Figure 14.3)!

In Dubai, the largest city in the United Arab Emirates, a megamall called the Dubai Mall opened in November 2008 after four years of planning and construction. It moved into first place as the largest mall in the world with 5.6 million square feet of space. To add the wow factor, the mall stands next to the tallest building in the world—a 200-story building built on top of a hotel. The Dubai Mall resembles an ocean liner from the outside and houses more than 1,200 stores and 160 food outlets. The mall format incorporates ten mini malls within the megamall. The main attractions include an aquarium and ice skating rink; a four-story, indoor waterfall; KidZania, a children's edutainment activity center; a SEGA Republic theme park; and a 22-screen movie theater.

SOURCES: Briefing: Mall of America, a strategic public investment. (2007, Feb.). *City of Bloomington, Minnesota.* Retrieved February 13, 2008, from http://www.mallofamericaphase2.com/downloads/Briefing%20MallofAmerica-AStrategicPublicInvestment.pdf

Mall of America. (2008). *Mall of America Web site.* Retrieved February 13, 2008, from www.mallofamerica.com

Upadhyay, R. (2008, Nov. 4). World's largest mall takes center stage in Dubai. *Women's Wear Daily Online.* Retrieved November 4, 2008, from www.wwd.com

Zargani, L. & Moin, D. (2008, Mar. 10). Heading to the desert? Bloomingdale's store in Dubai said in works. *Women's Wear Daily Online.* Retrieved November 4, 2008, from www.wwd.com

Figure 14.4 Mixed-use centers often have retail spaces on the ground level and second-floor residential lofts.
(The District at Green Valley Ranch)

based on size or square footage, merchandise orientation, number of anchor stores, and other factors. To further segment shopping centers, developers are creating **hybrid shopping centers** that combine elements from two or more classifications and **mixed-use centers** that combine retail space with other revenue-producing uses, such as office space, entertainment, hotel space, and sports facilities. Some of the newer mixed-use and lifestyle centers offer first-level retail space and second-story residential condominiums (see Figure 14.4). Generally, these shopping centers have a main street format and are considered a walkable community, which means that all the components, such retail, restaurant, and lodging, are located within walking distance and the development's layout encourages strolling.

The following sections provide a summary of open-air shopping centers and their subcategories and mall shopping centers and their subcategories. The section describes the distinguishing characteristics of

each type of shopping center. Much of the information in the next section is derived from the publication by the International Council of Shopping Centers (2004).

Open-Air Centers

Neighborhood Shopping Centers Some shopping centers boast convenience for customers by locating within close proximity (up to three miles) of the area residents they serve. Known as **neighborhood shopping centers** or **convenience centers**, they usually contain retailers that provide for day-to-day needs, such as a supermarket or grocery store, a convenience store or mini mart, and perhaps a bakery, dry cleaner, or other service provider. The stores are frequently linear in configuration (hence the name, strip shopping centers), but they may have other shapes, such as L, U, Z, or a clustered form. Generally, the rent for the commercial spaces is relatively low in a neighborhood shopping center, so some mom-and-pop clothing establishments may be located in these centers.

Community Shopping Centers The merchandise orientation for a **community shopping center** is usually broader in scope than the neighborhood shopping center, and the size is larger. In addition to the supermarket, these centers also may have a discount department store or other big-box apparel or home improvement retailer. Specialty stores commonly occupy community shopping centers, and the center may only have one or two anchor stores. Convenience and a general merchandise selection characterize these centers.

Power Shopping Centers Anchor stores dominate the retail makeup of power shopping centers, with only a few specialty tenants filling in the small spaces. **Power shopping centers** contain numerous value-priced large stores, such as discount department stores, off-price stores, and big-box stores. Power anchors include stores such as Home Depot, Staples, and Super Target.

Theme/Festival Shopping Centers The unifying elements in this type of shopping center may be architectural, historic, and possibly even the type of merchandise carried in the stores. Often tourist attractions, the shops in **theme or festival shopping centers,** may include restaurants or movie theaters that anchor the shopping center. Shoppertainment for tourists or locals characterizes these shopping centers. In Boston, Massachusetts, the historic Faneuil Hall Marketplace has been a retail haven for more than 250 years. In Dallas, Texas, the West End historic district, developed in the early 1900s, has been converted to a mixed-use tourist attraction with retail shopping, cultural activities, and nightlife entertainment.

In Shanghai, China, Metro-Goldwyn-Mayer Studios (MGM) has signed a licensing agreement with an entertainment company and a mixed-use center developer to create the MGM Studio World in 2010. The

Figure 14.5 Lotte World in Seoul, South Korea.
(Omni-Photo Communications, Inc.)

Hollywood-themed, indoor center will contain retail shops, restaurants, nightlife venues, and entertainment.

Outlet Shopping Centers Off-price stores and other value-oriented retailers comprise the tenants of **outlet shopping centers**. Rather than anchor stores, popular off-price fashion stores selling name-brand merchandise may serve as retail magnets to draw in customers. The configuration of an outlet shopping center may be some variation of a strip or L-shaped mall, or it may take the form of a village cluster, such as the sizeable Belz Factory Outlet Centre near Orlando, Florida. The center features several magnet tenants, including the Polo Ralph Lauren factory store, the Ann Taylor factory store, and OFF 5th – Saks Fifth Avenue Outlet (see Figure 14.6).

Figure 14.6 The Belz Factory Outlet Centre near Orlando, Florida.

(Heidi Targee © Dorling Kindersley)

Lifestyle Shopping Centers Lifestyle malls are among the newest type of retailing formats. When shopping center developers are able to tailor the center's design to the style, architecture, and retail needs of individual communities, they are said to have created a **lifestyle shopping center**.

Lifestyle centers cater to a specific (often upscale) customer base looking for fashion and convenience. The stores within the lifestyle shopping center provide the targeted customers with a condensed variety of products and services. Shoppers appreciate the convenience of these shopping centers, although they may choose a regional or superregional mall when they prefer to browse a large selection. According to lifestyle center developer Brian Sciera, a goal is to offer a variety of retailers that will bring customers to the center multiple times each week. He explained, "If customers are in the habit of coming to your project for groceries or coffee, they'll come for jeans and a book" (Everything's Coming Up Lifestyle, 2007, Mar).

The intent of lifestyle centers is to offer not only fashion retailers, but also necessity retailers, such as a bakery, coffee shop, liquor store, bank, barbershop, and beauty shop. Lifestyle centers emphasize leisure time activities, including restaurants and entertainment venues. Common lifestyle tenants include Talbots, Chicos, Coldwater Creek, J. Jill, Barnes & Noble, Cheesecake Factory, Starbucks, JoS. A. Bank, and Ann Taylor Loft. A lifestyle center may also feature power anchor stores, such as Hobby Lobby, Super Target, Cost Plus World Market, and DSW.

Regional Malls

One of the largest types of shopping centers is a **regional mall**. These are usually enclosed shopping centers with inward-facing stores, a common walk-

Figure 14.7 Storefronts line the waterway in the Canal Shoppes area of the Venetian Hotel, Las Vegas, Nevada.

(Demetrio Carrasco © Dorling Kindersley)

way, and a large perimeter parking lot. A regional mall offers depth and variety in fashion products and services for more than one target customer. Most regional malls cater to women with families, since they tend to purchase apparel and accessories for most of the family members. The main attractions are the recognizable anchor stores, ranging from traditional department stores to mass merchandise stores. Numerous specialty stores fill in the spaces between the anchor stores.

Superregional Malls

The largest of all enclosed shopping centers are classified as **superregional malls**. These are similar in nature to regional malls, but they have a larger selection of products and services, feature more anchor stores, are often multilevel, may have structured perimeter parking, and are usually larger in size. The general size range of superregional malls exceeds 800,000 square feet, although some are much larger. The Mall of Georgia at Mill Creek is a 1.7 million square foot superregional mall on the outskirts of Atlanta, whereas the supperregional Mall of America in Minnesota has 2.5 million square feet of leased space.

E-Tailing, E-Commerce, and M-Commerce

Internet shopping for fashion merchandise has steadily grown each year. In 1998, during a retailing seminar on Internet retailing, the retail executive participants were asked how many were wearing something they had purchased online. Only 1 out of the 450 persons present raised a hand. In 1996, only 7 percent of women used the Internet to browse for apparel. By 2000, the amount had grown to 24 percent, and by 2007, 52 percent of women had used the Internet to browse for apparel (The Bionic Consumer, 2008, Jan. 23).

E-tailing, an important form of nonstore retailing, is also known as Internet retailing and falls under the headings of electronic commerce and e-commerce. **E-tailing** is defined as electronic retailing using the Internet as the medium to display the merchandise, provide product information, receive customer orders, process payments, and arrange for delivery. Quite simply, it is retailing over the Internet.

Many retail executives believe that e-tailing has the greatest potential for growth among all the retailing channels. The National Retail Federation data show that since 2006, apparel sales occupy the top spot in Internet retail sales. Prior to this time, online computer hardware and software sales occupied the top spot (excluding travel sales). Apparel, accessories, and footwear sales have gradually been creeping upward in the rankings since Internet sales began in the late 1990s. In 1999, women's wear occupied eighth place, whereas menswear and children's wear tied for twelfth place. In 2010, Internet retailing accounted for about 15 percent of all retail purchases.

In the past, retailers expressed concerns over selling apparel online. Most often, the concerns included the inability to actually try on the garment to check for fit (improper fit ranks among the top reasons for returns) and the lack of touch and feel of the fabric. Retailers have addressed these concerns by offering additional details on the Web site and liberal and convenient return policies to lessen the impact of the fit problem. Detailed fit guides allow customers to get a better impression of how the garment fits. Three-hundred-sixty-degree image rotation allows customers to see all angles of the merchandise. Rich imaging and close-up photographs of fabric swatches provide greater visibility, and some stores provide customer service representatives

with access to the merchandise so they can further clarify colors and textures that are not clearly indicated on Web sites. Available live chats with customer service representatives are also ways to improve online selling.

Brick-and-mortar stores that become click-and-mortar stores should offer a seamless integration of services, regardless of the retail venue. Customers often want to first research a product online and then find it at a nearby store to try it on for fit and sizing. After further researching the product online, if the customer decides to buy, she wants the merchandise available for ordering on the retailer's Web site. If the customer changes her mind when the merchandise arrives, she expects to be able to return it directly to the nearest store on her next shopping visit. Essentially, the Internet site becomes an extension of the brick-and-mortar store in the eyes of the customer. It should come as no surprise that retailers who take special measures to ensure customer satisfaction with Web sites will benefit from repeat customer patronage and customer recommendations. Overall, the focus in e-tailing is to maximize the customer's experience and increase customer retention. Successful e-marketers can capitalize on customers' willingness to buy via the Internet, if the shopping experiences are personalized and if the customer service is exemplary.

In the early 2000s, large well-established retailers, such as JCPenney and Nordstrom, were among the first to offer Web site shopping. Years later, small specialty online boutiques created strong Web presences. Some are exclusive online boutiques, whereas others are click and mortar. These fashion boutiques offer high-end fashions and bring awareness to emerging and established designers. Popular online boutiques include Net-a-Porter, Couture Candy, Shopbop, and Bluefly. Each of these online boutiques specializes in a slightly different apparel niche and price point. Bluefly opened a holiday shop in Manhattan in order to capitalize on the heavy foot traffic of the city during the holidays, but its primary retailing venue is online.

Online selling is a unique breed of traditional retailing, yet it has many of the same requirements for success as face-to-face selling. Convenience is one of the top benefits and expectations of online retailing. Online retailing will not replace in-store retailing in the near future, but it does change the way consumers do business, and convenience is at the top of customers' shopping lists. Table 14.2 summarizes keys to success for managing online retailing.

Table 14.2 Ten Keys to Success When Managing an Online Store

Know that customers expect high-quality service, the right products, and an easy-to-navigate Web site—all 24/7. They can easily shop elsewhere.

Provide complete product, pricing, and shipping information to the customers. Be up front about all charges, especially shipping.

Manage fewer products very well, rather than trying to market something for everyone.

Offer something unique to gain customer loyalty.

Incorporate suggestive selling to sell accessories and other high-margin merchandise.

Keep a lean inventory. Plan more turnovers per year than a brick-and-mortar store.

Study the competition and implement tactics to build relationships with the best customers.

Provide financial and personnel resources to ensure a successful Web presence. Continually improve and invest in the Web site.

Collect and analyze data on customers' preferences and buying habits. Database marketing and tracking technology will help predict future consumer behavior.

Make improvements based on data analysis to increase sales and profits.

SOURCES: Corcoran, C. (2007, May 14). Apparel now no. 1 online. *Women's Wear Daily Online*, www.wwd.com.
Five steps for minding the sophisticated online store. (2007). *E-tailing Group* Web site, www.e-tailing.com.

Lindstrom, M. (2001). E-tailing's critical success factors, *ClickZ Network*, http://www.clickz.com/showPage.html?page=841931.

An offshoot of e-tailing is **m-commerce**, or mobile commerce. M-commerce incorporates technology that reaches the customer through his or her mobile technology, such as personal data assistants and cellular phones. It includes sales texts or e-mails sent to customers, options for payments, managing gift cards, and rewards balances. The banking industry has been a leader in m-commerce, but some fashion retailers are capitalizing on the concept. In 2008, Polo by Ralph Lauren, Estée Lauder Cos. Inc., and Adidas introduced scannable codes (somewhat like a digitized image or bar code) on the company print and electronic advertisements, e-mails, in-store shelves or posters, direct mail pieces, the side of a bus or train compartment, and even television advertisements. The image can be embedded in any media, and when a consumer takes a cell phone picture of the image it automatically links that customer to the company's Web site. The link provides access to products and services, such as video downloads, contests, coupons, promotions, voting, social networking communities, and style advice. As with Internet shopping, customers still need to type in their credit card information and billing and shipping addresses. Some of the leaders in mobile image recognition technology are SnapTell, SpyderLynk, and MyClick Media.

Social networking communities or social media is another e-commerce opportunity for retailers. The purpose of retail social networking communities is to give voice to the customers and provide the retailer with a way to monitor and catalog customer comments. For example, Wet Seal provides a social networking opportunity for teens on the company's Web site. Teens can fill their virtual closet with outfits selected from Wet Seal inventory, share outfit suggestions, vote on favorites, and purchase outfits online or in a local store. In the first four months of operation, the social networkers created 1.2 million outfits, and the site realized a 10 percent increase in sales (Corcoran, C., 2008, Aug. 13).

Many other retailers maintain contact with their customers on social networking sites, such as Facebook, Twitter, LinkedIn, and MySpace. The stores maintain a relationship with these consumers even when they are not buying. This free strategy is especially appealing to retailers on limited advertising budgets. They use these sites to promote their merchandise and encourage customers to visit the store to see new arrivals or take advantage of special sales. With

Figure 14.8 Online retailing must be convenient for customers.
(CORBIS NY)

Many fashion marketing and merchandising majors claim they have a handbag fetish (meaning they love and collect handbags). What if an enterprising student rented her collection of handbags to her friends on a nightly basis, just like a video store rents DVDs nightly? Fashion entrepreneurs who know how much women appreciate expensive designer handbags have created several online versions of a rent-a-bag Web site.

For a nominal sign-up fee, shipping, insurance, and a bag rental of around 10 percent of the average retail price, bag fashionistas can order their favorite luxury handbags. Renters are usually allowed to keep the bags for a week to a month before returning the merchandise to the e-tailer.

Different levels of bags are available for rent. The luxury bags may retail anywhere from a few hundred dollars to as much as $2,500 for top-of-the-line bags. The rental price ranges from $40 to $200 per month, depending on the popularity of the brand. Well-known brands include Prada, Dolce and Gabbana, Coach, and Louis Vuitton. Rare vintage bags such as a Hermès vintage Kelly bag in crocodile leather can rent for as much as $2,500 for a month, but this might be considered a bargain, since a new leather Hermès Kelly bag (in the customer's color choice) retails for around $9,000.

The concept of renting a one-size-fits-all fashion item has extended from luxury handbags to shoes and jewelry. Although the idea originated in the United States, both American and Japanese consumers have access to their own countries' versions of online bag and accessory rentals. This entrepreneurial spirit is within many college students, and creative thinking like this should be encouraged.

larger retailers, the social networking site usually encourages the visitor to go directly to the company's Web site where the merchandise is available for purchase.

Direct Marketing and Other Nonstore Retailing

Direct marketing is a promotional tactic used by retailers to directly contact potential customers. When the direct marketing takes place without requesting customers to take action within a physical facility, such as a store, it is considered **nonstore retailing**. The U.S. Census Bureau provides examples of nonstore retailing, such as "the broadcasting of infomercials, the broadcasting and publishing of direct-response advertising, the publishing of paper and electronic catalogs, door-to-door solicitation, in-home demonstrations, selling from portable stalls, and distributing through vending machines" (2007 NAICS Definitions, 2007).

According to the Direct Marketing Association of Washington Web site (www.dmaw. org), **direct marketing** is "direct communication to a consumer or business recipient that is designed to generate a response." That response includes making a purchase, visiting a store, ordering from a Web site, or simply requesting more information. A slightly different definition is provided by the Direct Marketing magazine: "Direct marketing is an interactive system of marketing that uses one or more advertising media to affect a measurable response and/or transaction at any location, with this activity stored on a database" (About Direct Marketing, 2007).

The purpose of direct marketing through nonstore retailers is to get the customers to take action. Examples of direct marketing in the fashion industry might be home shopping networks, such as QVC that hires spokespersons to sell apparel and accessories to television viewers, or a Mary Kay or Avon consultant who sells cosmetics, accessories, and gifts to other women in the office. Direct marketing involves a persuasive seller or selling tool that encourages a customer to take action—an action that usually results in the purchase of the merchandise.

summary

- Retailing is the function of selling products or services to ultimate consumers.

- Fashion goods are retailed through retail stores, direct marketing, or electronic formats.

- Retailing provides manufacturers with an outlet for reaching the consumers.

- Retailers take ownership of goods, break bulk for consumers, provide a one-stop shopping experience, create convenience, offer services, and guarantee products.

- The earliest forms of retailers were trading posts, mercantile stores, general merchandise stores, dry goods stores, mail-order catalogs, five-and-dime stores, and traveling peddlers.

- Open-air shopping centers include neighborhood shopping centers, community shopping centers, power shopping centers, theme/festival shopping centers, outlet shopping centers, and lifestyle shopping centers.

- Malls include regional malls and superregional malls.

- Department stores have separate departments for merchandise lines, including apparel, jewelry, home furnishings, and linens.

- Department stores have struggled to compete in recent years but are implementing new merchandising strategies to improve profits.

- Specialty stores offer a relatively narrow product assortment of menswear, women's wear, children's wear, and accessories.

- Pop-up stores are temporary stores in high-traffic locations.

- A limited line specialty store specializes in a very narrow product assortment.

- Mass merchandise or discount stores are large retail stores with high sales volumes, broad merchandise assortments, self-service, and low pricing.

- Off-price stores carry brand- or designer-name merchandise and offer it at a lower price than the manufacturer suggested retail price (MSRP).

- Internet retailing or e-tailing sales of fashion merchandise has grown steadily each year since its inception and now is the most frequently purchased online product.

- Customers expect a seamless integration of services from retailers who have both a brick-and-mortar store and a Web site, and they expect convenience from all e-tail Web sites.

- Mobile commerce or m-commerce is growing in popularity as a way to allow shoppers to access product information virtually anywhere via their cell phones.

- Direct marketing is direct communication that is designed to generate a response and includes home shopping networks, door-to-door sales, and catalog mailers.

terminology for review

Black Friday 252
Cyber Monday 252
multichannel retailing 254
scrambled merchandising 254
retailing 254
department store 257
specialty store 259
limited line specialty store 259
monobrand 259
lifestyle merchandising 259
boutique 260
power brand 260

pop-up store 260
mass merchandise or discount store 260
off-price store 262
manufacturer's overrun 262
open-air center 263
mall 263
hybrid shopping center 264
mixed-use center 264
neighborhood shopping centers 265
convenience centers 265
community shopping center 265
power shopping centers 265

theme or festival shopping center 265
outlet shopping center 266
lifestyle shopping center 266
regional mall 266
superregional mall 267
e-tailing 267
m-commerce 269
social networking community 269
nonstore retailing 270
direct marketing 270

questions for discussion

1. Why is retailing a necessary element of the fashion industry?

2. How have fashion retailers evolved over time?

3. What are mixed-use and hybrid shopping centers?

4. What are some of the trends of lifestyle shopping centers, and why has there been a surge in the popularity of lifestyle shopping centers and lifestyle stores?

5. What are some predictions for the future of malls?

6. How do the stores within a mall define the target customer of the mall?

7. How are department and specialty stores changing to meet the needs of customers today?

8. What defines a mass merchandise or discount store?

9. What type of merchandise is offered in off-price stores?

10. What are some similarities and differences between traditional in-store retailing and e-tailing?

related activities

1. Visit a mall or a lifestyle shopping center, either in-person or on a shopping center Web site. Study and evaluate the layout of the center and the businesses housed in the shopping center. Evaluate the success of the shopping center based on criteria developed by the class. This might include the number and type of competing and noncompeting stores, number of anchor stores, proximity of complementary stores, walkability, parking, amenities, and any other important evaluative criteria. Write a 500-word critical thinking paper on the potential success of this shopping center. Present the paper to the class.

2. Choose two online apparel retailers. Study and compare the two Web sites based on the ease of navigation of the Web site, convenience of the services, comprehensiveness of the fit information, presence of suggestive selling, any amenities, checkout process, shipping and handling fees, and any other noteworthy issues. Write a 500-word comparative analysis on these two apparel e-tailers. Present the paper to the class.

3. Visit one rent-a-handbag Web site and one online retailer who sells luxury handbags. Locate three to five similar styles and brands that are carried by both Web sites. Calculate the rental percent of the full retail price. In other words, for what percent of the total retail price does a luxury handbag rent? Compare all the findings across the class.

4. View a 30-minute episode of a home shopping television program. Evaluate the intended target customer of the program. Identify demographic, psychographic, and behavioral characteristics of this target customer. Type a 500-word explanation and justification on why the home shopping program caters to this customer. Use critical thinking to analyze the program in terms of the four Ps of fashion marketing. Present your paper to the class.

Your Fashion IQ: Case Study
Tough Times in 2008

- In October 2008, company officials announced the layoff of dozens of executives in the Lord & Taylor Company. Over 100 employees in the central offices in Lord & Taylor's Fifth Avenue flagship store in Manhattan and at branch stores lost their jobs in the layoff. The economic slowdown and soft sales were blamed for the layoffs.

- In May 2008, Linens 'N Things filed Chapter 11 for bankruptcy court protection.

- In June 2008, Goody's Family Clothing Inc. filed Chapter 11 for bankruptcy court protection.

- In July 2008, the moderately priced department store Mervyns Stores of California filed for bankruptcy, citing a challenging retail environment.

- In July 2008, Steve & Barry's University Sportswear filed a voluntary Chapter 11 petition. The company cited a cash flow crunch, tight credit, and a slowdown in consumer spending.

- In August 2008, Boscov's, a 97-year-old Pennsylvania retailer, filed a voluntary Chapter 11 petition for bankruptcy. The bankruptcy was blamed on tightening credit terms from suppliers and a recent slowdown in consumer spending.

These bankruptcy petitions were evidence of many months of difficulties for retail companies of all kinds. The company failures stemmed from a combination of lack of customer spending, mismanagement, insufficient cash flow, and lack of economies of scale or buying power with suppliers. Mergers and acquisitions are ways that retailers can strengthen the company during difficult economic times because they typically improve company performance and shareholder value over time. A company that merges with another company can experience improved economies of scale, generate increased sales revenue, improve market share, and increase tax efficiency. According to retail analyst Marc Cooper, managing director and partner at Peter J. Solomon Company, "If you want to be one of the survivors, if you want to be one of the growers, you're going to have to consolidate. You're going to have to either acquire or merge" (Clark, E., 2008, Oct. 13).

QUESTIONS:

1. Retrieve several of the articles in the following source list. Make a list of the cited reasons for the bankruptcies.

2. Are these financial difficulties primarily due to reduced consumer spending or might other factors be involved? Besides the ones listed in this case study, what do you believe are some other factors contributing to bankruptcy during a recession?

3. Is it necessary to "acquire or merge" to remain viable in today's retail environment? Why or why not? What are some other options?

SOURCES: Clark, Evan. (2008, Oct. 13). Financial meltdown might shrink fashion. *Women's Wear Daily Online*. Retrieved October 17, 2008, from www.wwd.com

Edelson, Sharon. (2008, Oct. 17). A big retailer falls: $2.5 billion Mervyns plans to liquidate. *Women's Wear Daily Online*. Retrieved October 17, 2008, from www.wwd.com

Layoffs seen at Lord & Taylor. (2008, Oct. 17). *Women's Wear Daily Online*. Retrieved October 24, 2008, from www.wwd.com

Moin, David. (2008, May 5). The pressure is on: retail anxiety builds as economy weakens. *Women's Wear Daily Online*. Retrieved October 17, 2008, from www.wwd.com

Young, Vicki M. (2008, June 11). Bad times for Goody's: retailer files Chap. 11 as economy takes toll. *Women's Wear Daily Online*. Retrieved October 17, 2008, from www.wwd.com

Young, V. (2008, June 11). Goody's financing scrutinized. *Women's Wear Daily Online*. Retrieved October 17, 2008, from www.wwd.com

Young, V. (2008, July 8). Steve & Barry's squeeze: without white knight, liquidation a possibility. *Women's Wear Daily Online*. Retrieved October 17, 2008, from www.wwd.com

Young, V. (2008, July 29). Mervyns files Chapter 11. *Women's Wear Daily Online*. Retrieved October 17, 2008, from www.wwd.com

Young, V. (2008, Aug. 5). Boscov's files for Chapter 11; chain said to put itself up for sale. *Women's Wear Daily Online*. Retrieved October 17, 2008, from www.wwd.com

Young, V. (2008, Aug. 18). Mervyns, Boscov's to close stores. *Women's Wear Daily Online*. Retrieved October 17, 2008, from www.wwd.com

15 Creative Fashion Careers and Enrichment Opportunities

CAREERS and Opportunities

15

"Starting a business is not easy. Entrepreneurs must be willing to take risks others won't. They must work around the clock if necessary, often acting not only as the CEO of their company, but the head of sales, head of finance, and whatever else it takes to get the job done.

It's hard work. In fact, I often say small business owners match every dollar of equity with $10 of sweat equity. But that's also why they're successful where others are not. America as an economy that regenerates, is flexible, and adapts to opportunity in large part because our entrepreneurial culture has taught us to dream, to see possibilities, and to act on these possibilities."

STEVEN PRESTON, FORMER ADMINISTRATOR, Small Business Administration

CREATIVE
FASHION
CAREERS and
ENRICHMENT
OPPORTUNITIES

LEARNING OBJECTIVES

At the end of the chapter, students will be able to:

- Describe various educational enrichment opportunities and identify ways to participate in these activities during college.
- Locate available careers in the fashion industry and understand their relationship to the various levels of the industry.
- Understand the value of resources available to fashion entrepreneurs and know the types of business ownership.
- Explain the benefits of gaining work experience through internships or part-time work experiences in the industry.
- Assess the numerous extracurricular opportunities and organizations available to textiles, apparel, and fashion students.

What can college students do to find out about fashion careers? They can study abroad for a semester, apply for an internship, job shadow for a day, enter a merchandising or design competition at a regional career day, work part-time in the fashion industry, take a study tour trip to a major market center, and join the student chapter of a professional organization and attend its annual conference. It is the student's responsibility to seek out enrichment opportunities to complement his or her college career. It may require moving out of one's comfort zone, spending time researching opportunities on the Internet, completing application after application,

15

Figure 15.1 New York City is a major fashion market center in the U.S.

(Omni-Photo Communications, Inc.)

and scheduling informational appointments with academic advisors. Most but not all enrichment opportunities require varying levels of funding. A four-day trip to New York can cost well over $1,000, and that is if the student is willing to share a hotel room with three other students! Students must plan ahead and begin budgeting for these enrichment activities. Most educational institutions plan conferences and trips semesters or years in advance. Large companies may begin accepting summer internship applications as early as October. Students should consider which extracurricular opportunities will be of greatest value to them early in their college career, so they can budget money each month for the planned enrichment event. These types of activities can be as important as taking a class in one's major.

Fashion Careers

The ensuing section discusses a variety of creative fashion career opportunities at many levels of the fashion industry, beginning with preproduction careers and moving toward retail careers. Most require a college degree and some require several years of work experience. Other careers are available to entry-level college graduates, or the title of "assistant" might be added to the position, making the work experience requirements less stringent. For example, many college students say they want to become buyers when they graduate. In reality, a corporate buyer position would require several years of working as an assistant buyer or an assistant to the buyer. However, it is important to provide college students with ideas of exciting future opportunities in the field of fashion.

Fashion Trend Analyst

This creative career requires several years of prior fashion industry work experience in the textile or apparel design fields, although some college internships do exist. Trend analysts work about eighteen months to two years in advance of the selling season to identify fashion trends for a company that will fit within the lifestyles of the company's target customers. Major trends might include particular color stories; world events, such as the Olympics; the green movement; or a trend toward more masculine dressing.

Fashion analysts are information processors. They collect information from trend subscription services, such as Doneger or the World Global Style Network (WGSN), or color subscription services, such as Pantone. They glean ideas from fashion trend Web sites, such as style.com or ny.com. They view designers' collections, keep tabs on starlets, and study clothing styles on the street. One of the more exciting parts of this career includes global travel to Paris, Milan, and other domestic and world fashion centers. Paris, France, hosts a Premiere Vision trade show, and New York hosts a Print Source show that provide valuable upcoming fashion trend ideas.

As an example, a moderately priced department store chain recently created a trend team to start the design process for the retailer's own private labels. This team works closely with the fabric team and the product development team. The trend team determines the most marketable trends to follow and ensures that the selected trends meet the needs of the retailer's target customer. The trend team avoids "crazy trends" and tempers the fashion trends to the more conservative customer.

Textile Specialist

A recent college graduate would need a few years of experience assisting a textile specialist before moving into this position. Textile specialists work closely with sourcing specialists, designers, and overseas offices to research appropriate fabric qualities and identify new textile

trends. They meet with fabric mills and suppliers to review available fabric collections and attend seasonal fabric shows to gain trend knowledge for the upcoming season. They are responsible for communicating with the design and production team to select appropriate fabric colors and patterns. Like designers and product developers, textiles specialists also shop stores on a regular basis for unique fabrics and emerging trends ideas.

An assistant to a textile specialist might be responsible for maintaining a fabric library. This career requires in-depth knowledge of fibers and fabrics and a keen eye for color. A significant amount of an assistant's time consists of communicating with sources, as well as monitoring and tracking fabric orders. Fabric specialists know that consistent communication with textile mills encourages on-time deliveries of orders, so this becomes an important task of the assistants.

Designer

A designer, technical designer, or entry-level assistant designer is responsible for creating garment designs reflective of the company and brand concepts. Designers may work as freelancers to sell their own unique designs (Ralph Lauren began his career selling his own wide ties when skinny neckties were popular), or they may work many years for another company before branching out on their own (Donna Karan worked for more than a decade as a designer at Anne Klein).

Designers translate the design concept from a flat sketch into a sample product that includes the preparation of technical packs (or tech pack) for overseas factories. A tech pack contains all measurements and product specifications and ensures that all details are commercially feasible and cost-effective. They must fully understand patternmaking, garment construction, and fitting. Business and negotiation skills are increasingly important. Desired technical skills include knowledge of software programs, such as Adobe Illustrator and Gerber Web PDM.

Designers obtain trend inspiration from many resources including museums, costume collections and libraries, flea markets, vintage stores, and retail stores. Once an idea is generated and sketched, a designer creates a precise technical illustration. Designers must follow through with the design by preparing colored sketches and storyboards for specific categories and attending all fittings of the first sample until the fit is approved. Buyers may be involved in selecting fabrics, notions, trims, and linings. All of these activities occur according to a fast-paced schedule.

Patternmaker

A career as a patternmaker requires several technical skills, including experience with computer-aided design (CAD) systems (such as Tukatech, PAD, Lectra, or Gerber), sewing construction techniques, flat pattern design, and draping. This person (called a **first-through-production patternmaker**) must be able to create first sample patterns to production patterns for styles based off designer sketches. Patternmakers interact with the design staff in order to create complete style packages. They work with designers to ensure the proper fitting of the first prototype on a fit model.

Patternmakers must understand proper pattern grading techniques and generate graded specifications (specs) and production construction information. They communicate this information to domestic and overseas vendors.

A career as a patternmaker requires an extensive knowledge of construction and fabrics. Large companies expect employees to have substantial experience with computer-aided design (CAD), Microsoft Excel, and Adobe Illustrator. Some smaller apparel companies expect the patternmaker to be able to draft patterns by hand.

Sourcing Specialist

A career as a sourcing specialist involves seeking out dependable international resources that can supply the components needed to create marketable fashion products. For example, a costume jewelry sourcing specialist might travel to India or China to find suppliers of jewelry components

WHAT iS SNAPFASHUN?

SnapFashun Design Contest
CLICK HERE

- EDU Home
- What is SnapFashun?
- Instructors' Lounge
- Recent Articles
- Students' Lounge
- TECH Corner
- Mailing List

1 Select an item

2 Ungroup it

3 Clean it up

4 Select a new detail from another sketch

5 Paste new detail and lengthen the leg

6 Add pattern & color

SnapFashun is a computerized "pictionary" of women's, men's, and kid's apparel. Thousands of sketches including:

- **Details**: cuffs, pockets, waistbands, collars, plackets, lapels, sleeves, and
- **Items**: jackets, vests, blouses, jumpers, pants, shorts, dresses, and more.

Using Adobe Illustrator or Micrografx Designer you can "snap" the sketches together (see above) in an infinite number of ways. You can alter, resize, and simplify every line. Of course, you can draw your own sketches!

Yes, there are CAD programs that you can buy off the shelf that give you the tools to draw, but they still require lengthy and valuable time to create a sketch from scratch. Now, **SnapFashun**, coupled with Illustrator or Designer, provides an easy, quick, and fun way for everyone to create and design.

To continue, students click here, instructors click here.
For a more detailed view of SnapFashun, visit our home page by clicking here.

Edu Home | What is SF? | Instructors' Lounge | Recent Articles | Student Lounge | Tech Corner | Mailing List

Figure 15.3
SnapFashun is an easy-to-use software program for computer-aided design.
(SnapFashun)

or costume jewelry products. A sourcing specialist should possess retail math skills and have extensive product knowledge, from design to finished product. It is important to be able to articulate fashion concepts and interpret trends. In addition to dealing with domestic agents, a sourcing specialist also deals with suppliers in developing countries, so this person must monitor social compliance standards in the foreign factories. Significant overseas travel is required, so this individual should possess high energy and a willingness to work long hours during travel.

Product Developer

A career in product development provides wonderful opportunities for creative individuals with an eye for trends who might lack formal fashion design training. This is the position that takes designs from other popular national brands and creates a look that is right for a store's target

customer. Product developers must research trends and shop the market to get ideas from best-selling branded merchandise that can be translated into the company's own successful designs. They maintain fashion awareness through research, reading, and shopping. These individuals work with designers and merchandisers to create marketable product ideas based on successful products already on the market.

Some employers require extensive clothing construction skills, whereas other employers require garment industry experience, but not necessarily technical sewing skills. If sewing is not required, these positions may require the employee to have knowledge of fabrics and trims used in sample-making and production. A product development job may entail ordering and organizing fabrics and trims and organizing and reviewing samples for accuracy. They closely track the development process and manage their time and deadlines.

Product development careers are increasingly important for offering fashionable merchandise at a good value. Express, GAP, Dillards, Wal-Mart. and most every other large national retailer have product development departments at the corporate level. For example, a product developer for private label fashion athletic shoes might select a national brand such as Sketchers for inspiration. The product development team then modifies the design by at least 25 percent, sends it to the legal department for approval, and ultimately has the redesigned shoes manufactured under the store's own private label.

Account Executive

An account executive needs a bachelor's degree, sales and negotiation abilities, and advanced retail math skills. An account executive is an employee of an apparel company, such as DKNY, Ralph Lauren, or Juicy Couture. This person's primary job responsibility is to sell the division's line of products and services to established primary accounts, such as department store buyers. Each day, an account executive communicates with the client store buyers, analyzes sales, and helps the store buyers manage their open-to-buy (OTB). This career requires sales forecasting and assortment planning on a weekly and monthly basis. An account executive must keep abreast of competitor's offerings and be able to react to immediate opportunities. Because an account executive is a salesperson, compensation for this type of job involves some commissioned pay. The company may pay a base salary and provide benefits to the account executive, since he or she is an employee of the company. Before landing a position as an account executive for a major apparel company, a graduate is expected to have three to five years of sales or buying experience and have experience working with department stores. An account executive manager may manage a team of independent representatives that also sell the company's lines.

Independent Wholesale Sales Representative

A wholesale sales representative has job duties similar to an account executive, except this person may work for an independent showroom located in an apparel mart or market center. A wholesale sales representative is responsible for selling wholesale merchandise to retail store buyers. An independent showroom salesperson represents or **reps** several different and mostly noncompeting manufacturers' lines. For example, an independent showroom may represent ten different children's wear companies, each offering a different category of children's wear. The retail store buyers make appointments during market week and visit the showroom to look at the different lines. The wholesale sales representative shows the buyer the best-

selling lines and those that can meet the needs of the retailer's target customer. The wholesale sales representative receives a commission from the manufacturers whose lines are ordered.

When market weeks are not in session, wholesale sales representatives go on the road, calling on buyer clients who may not have made it to the showroom during market. During market weeks, the hours are long and arduous. After markets, the representatives may opt to take a few days vacation to recover from the intensity of the wholesale market. Some showrooms will hire college students as temporary help (gofers) to fill in wherever needed in the showroom. Fashion merchandising students located near an apparel mart can apply for these coveted positions in the weeks prior to the five-day markets.

Figure 15.4 Buyers and merchandise planners determine merchandise assortments to be shipped to the stores.
(PhotoEdit Inc.)

Merchandise Planner

This highly analytical career involves developing store assortment plans and creating an inventory mix for the store. The merchandise planner presents detailed information to the buyer, so that the buyer can purchase merchandise for resale in the store. The merchandise planner uses past sales data and trend analysis to determine appropriate classifications, assortments, price points, quantities, styles, sizes, and any other stockkeeping unit (SKU) information. This detailed information is passed on to the buying department. Both the merchandise planner and the buyer collaborate to establish seasonal budgets and flow by month. Merchandise planners are expected to achieve company objectives within budget parameters.

Merchandise planners get involved before the goods are ordered for the store, and they stay involved until sell-through. They are responsible for analyzing actual sales and comparing them against the planned sales and last year's sales. They also develop and execute markdowns and in-store promotional strategies to improve sales. Merchandise planners collaborate with the distribution analysts to ensure the proper distribution of key items and in general determine how the merchandise is divided among the stores in the company.

College graduates would begin in an entry-level position in allocation or as an assistant merchandise planner. Most merchandise planners are required to have at least three years of prior experience and be proficient in Microsoft Word and Excel. Strong analytical skills and retail math skills are vital to career advancement.

E-Commerce Merchandise Planner

A professional in this career is responsible for the merchandise planning, reporting, and development of online assortments for the online portion of a business. E-commerce merchandise planners must use Web analytics to make merchandising decisions. They determine product rankings and merchandise layouts on the Web site pages to maximize sales. Just like the merchandise planners, e-commerce merchandise planners will prepare sales forecasts with different marketing efforts, including sales promotion and e-mail marketing. They report daily and weekly on inventory availability.

E-commerce merchandise planners should have some experience with Internet marketing and have worked as an assistant to a merchandise planner. These careers require experience in Microsoft Word and Excel and an understanding of software programs for planning and allocation, content management, and Web analytic tools (tracking Web site visitor behavior,

search engines used, online sales, and marketing campaigns). As expected, a keen understanding of technology and a desire to try new ideas are job requirements.

Buyer

A buyer's primary responsibilities are to identify, select, and purchase wholesale merchandise for resale in the store. Buyers are given an **open-to-buy**, which is the amount of money allotted for merchandise ordered from vendors at market. Buyers work from an assortment plan, which means they must select certain categories of merchandise, in styles and sizes desired by the target customer. They locate resources all over the world that can supply their retail company with merchandise that meets the needs of the target customer.

Although it seems ideal to "shop" for a living, a buyer's job requires lots of data analysis and number crunching. For example, buyers read computer-generated reports each day to perform item analysis on individual styles or particular lines. A buyer may generate an exception report that identifies unusually slow or fast sellers. Exception reports allow the buyer to make price adjustments to the slow sellers or reorder on the fast sellers. Understanding retail mathematic concepts such as planning and analyzing sales, stock-to-sales ratios, stock turnover, gross margins, markups, and markdowns are necessary skills for buyers.

In addition to procurement responsibilities, buyers identify and quickly react to upcoming fashion trends. This means discovering trends early and then ordering the right merchandise to have in the stores when the trend becomes an in-demand fashion. Buyers continually research merchandise lines and shop the competition to identify new opportunities. They may work with preferred vendors, or they may seek out new vendors to fill in the assortment with unique merchandise. They may even work with vendors to develop new items that are exclusive to their store. Building partnerships with vendors allows buyers leverage when negotiating for lowest costs, delivery charges, and promotional monies.

Buyers work with other managers to ensure a coordinated marketing plan for the retail company. They work with merchandise planners and in some cases designers, product developers, and sourcing specialists when selecting private label merchandise. They partner with divisional merchandise managers (DMM) to identify promotional and key item opportunities each season. They assist brand managers with executing appropriate brand strategies. Buyers are in contact with advertising managers to develop promotional strategies that support sales goals and profit margin objectives. It is critical for the managers to work within the company guidelines and follow the goals and objectives established for the year.

The general experience needed to become a corporate buyer is usually a college degree. Some companies will allow for equivalent work experience, but most often, buyers are managers with four-year degrees. Buyers usually begin as assistant buyers or assistants to the buyer and work their way up to the level of buyer after a few years and a proven success rate. Some companies require several years experience in retail management, retail distribution, or buying offices. Technical skills include proficiency with spreadsheets (particularly Microsoft Excel), knowledge of retail tracking systems, and advanced retail math skills. Employers require buyers to have strong verbal and written communication and negotiation skills to successfully manage business deals.

Buyers travel extensively to domestic and international markets and trade shows. For example, an upscale women's single-unit specialty store buyer may travel as much as two weeks out of a month. During her time in the store, the buyer meets with sales representatives, motivates her department managers, and catches up on the mounds of paperwork, pricing strate-

gies, and data analysis. If a buyer is responsible for a single-unit store, the buyer may wear more hats than the buyer in a large retail chain. The single-unit store buyer probably buys across more categories of merchandise, although he or she would buy fewer pieces within each line, since only one store is stocked. The buyer is ultimately responsible for the sale of the merchandise that he or she has ordered.

Fashion Copywriter

A student interested in pursuing a career as a fashion copywriter might consider a double major or major/minor in fashion merchandising and a journalism area, such as mass communications or advertising. Professionals in this field are fastidious about their English and well versed in the fashion industry. They follow fashion and popular cultural trends and keep abreast of all types of fashion media.

The main job of a copywriter is to create engaging headlines and text, whether it is for newspapers, magazines, catalogs, promotional literature, or the Internet. Copywriters ensure that the copy content matches the tone of the brand or organization and enhances its image. Copywriters for retailers are careful to include only factual copy, so they should have significant product knowledge and be able to turn features into benefits. Accuracy and original style are goals of copywriters. Good copy should stimulate sales and minimize returned merchandise.

Copywriters work closely with buyers and brand managers to present an imaginative approach and develop strategic selling tactics. They must work as a team on a tight schedule and make sure they stay within the budget for the project.

Merchandise Coordinator

A **merchandise coordinator** may work internally for a manufacturer or may work for an outsourcing company as an external merchandise coordinator. Both positions are responsible for the merchandising of branded products to ensure visual or brand standards are upheld within the retail store. These persons act as a brand advocate for the national company.

An **internal merchandise coordinator** is employed by the national brand, such as Ralph Lauren. This person travels between stores, training and building relationships with store personnel. The merchandise coordinator's customers are the store's buyers and departmental salespersons. The internal merchandise coordinator trains the salespeople on features and benefits of the brand, ensures that the racks are properly merchandised, negotiates with the store management on space and location within the department store, and reports sales and market conditions back to the brand company.

A similar position is a **client services coordinator** who works for an outsourcing company, such as Davaco, BDS Marketing, or Winston Retail Solutions. A client services coordinator may be in charge of communicating daily with five or six key brand accounts such as national or designer brands carried by retailers across the country. This employee is responsible for coordinating the part-time merchandisers (also confusingly called merchandise coordinators) working out in the client retail stores or the "field." The part-time merchandisers travel from store to store within an area, visually merchandising a particular brand, such as Kenneth Cole or Nautica in a retail department store such as Macy's or Dillards. The outsourcing company's coordinators work for the national brand as a brand advocate to ensure maintenance of the brand image and integrity.

Figure 15.5 Merchandise coordinators ensure that brands are properly displayed.
(Frances Roberts/Alamy)

Client services coordinators keep track of the merchandise coordinators' schedules and their recaps and photos from each of their visits made to the stores. Additional documentation of the completed work includes before and after photos of the newly merchandised departments within the store.

Special Events Coordinator

Most large fashion companies employ full-time special events coordinators to plan large companywide promotions. The primary purpose of special events is to generate traffic and ultimately sales for the store, although other purposes include creating goodwill, sponsoring charities, and fashion leadership. Special events can include seasonal fashion shows, trunk shows, designer visits, special exhibits, or VIP (very important persons) parties.

Strong creative skills, organizational skills, and a keen attention to details are important qualities that events coordinators should possess. Some events coordinators have a team of assistants working with them. The days and hours leading up to a special event can be stressful and lengthy, but usually compensation time is given after the event's fruition.

The Neiman-Marcus flagship store in downtown Dallas, Texas, is a leader among retailers in offering creative special events. In spring 2008, the store's creative special events coordinator teamed up with the American Film Institute of Dallas and presented a unique two-week special events exhibit entitled Through the Lens Clearly. Displays of costumes from famous movies included an exact replica of Scarlett O'Hara's green curtain dress from *Gone with the Wind,* Robert De Niro's green jacket from the 1976 movie *Taxi Driver,* and original costumes and accessories from *Road to Morocco* and *An Affair to Remember*. Each of the six floors featured dress forms with elegant 1940s and 1950s Hollywood costumes (see Figure 15.6).

Figure 15.6 **Exact replica of Scarlett O'Hara's green curtain dress from the MGM movie *Gone with the Wind*.** (Courtesy of Harry Ransom Humanities Research Center, The University of Texas at Austin)

Executive Training Program Trainee

An executive trainee is a temporary position in a retail company that leads to permanent employment in a particular area, such as the buying office or within a store. A retail executive trainee typically spends three to six months learning all facets of the company business. This person may spend some time on the selling floor, rotating through the various departments in order to better understand merchandising methods. The trainee may also spend a week in loss prevention, a week with the visual merchandising team, a week in shipping and receiving, a week in the credit department, and time with any other key areas of operation. After the trainee has gained a thorough knowledge of the workings of one or more stores, the trainee is ready to move to a more permanent position, possibly as an assistant store manager, a merchandise manager, or even into the buying office.

Store Manager

This career is among the most lucrative of fashion careers because the store manager often earns annual bonuses based on store performance. A store manager must be driven to suc-

ceed and be able to motivate the selling staff in order to reach store sales goals and earn the bonuses. Training employees, ensuring excellent customer service, maintaining store presentation, and supervising interior merchandising are a few of the varied duties of a store manager. Travel requirements are limited with store management positions, although annual training sessions at company headquarters are common. Retail stores are located in every town, so many fashion merchandising majors choose retail careers such as store management, especially if family commitments prevent them from relocating after graduation.

Visual Merchandiser

A creative college graduate might be interested in the fast-paced and physically demanding career as an in-store visual merchandiser. Most large stores have a team of five or six visual merchandisers led by a visual manager. The purposes of visual merchandising in a store are to improve the layout and presentation of the store merchandise and to increase customer traffic and sales. Primary responsibilities of a visual merchandiser include creating compelling merchandise presentations on a weekly or biweekly basis, including interior displays and window displays. Visual merchandisers have specific tasks, such as redressing and relocating mannequins, moving fixtures in the department, creatively showing merchandise to its best advantage, selecting and locating props, creating signage, and ensuring proper lighting techniques. In addition to working with displays, they participate in major floor set visual activities to create an exciting and ever-changing in-store shopping experience for customers.

Visual merchandising positions also exist at the corporate level. These store planners and designers may set the standards for all the stores in the chain. For example, merchandise and fixture planograms and floor sets may be created at the corporate level, photographed, and then sent to the stores. Store visual teams are expected to follow the corporate recommendations as closely as possible.

A unique example of a visual merchandising position is one that has been recently created at the Wal-Mart corporate headquarters. The new corporate-level department is called

Figure 15.7 Classic interior display at an upscale department store.

the customer experience team. The **project managers** in this department are responsible for the in-store presentation in a particular area of the Wal-Mart store, such as home fashions. The company still has its corporate visual merchandising team that creates the modulars or planograms used at the store level, but this new team works closely with the corporate visual merchandisers and the home fashion buyers to enhance the in-store presentation. The customer experience team is responsible for updating the merchandise guidelines used in the home fashion department, and the team also participates heavily in brand launches.

Skills needed for visual merchandising careers include a keen eye for details and a strong fashion sense. They are expected to develop innovative merchandising concepts and strategies within the store's guidelines for merchandise presentation. Although creativity is a must, the visual merchandiser's creative ideas must support the stores' goals, as well as be compelling and flawlessly executed.

Most visual merchandising positions require a bachelor's degree in fashion merchandising, art, or design. Visual merchandise managers must have three to five years visual merchandising and presentation experience.

Entrepreneurship

Simply stated, **entrepreneurship** is the risky venture of owning one's own business in order to make a profit. A fashion business entrepreneur offers innovative products and services to satisfy unmet needs in the fashion industry. Many college graduates are excited by the prospect of being their own boss and filling a business niche with their own ideas. Experts recommend that graduates gain valuable work experience in their chosen field before launching a business of their own. Most college advisors suggest that the students "make their mistakes on someone else's money," meaning that the students should learn from direct work experience with other companies before venturing out on their own.

Why Start a Business?

The obvious answer is because the owner can be his or her own boss, making almost all decisions for the company. Entrepreneurs also expect financial gain and the ability to grow equity in the company. An intrinsic reward of starting a business is the ability to be involved in all aspects of the product or service development, from the beginning to the end of the project. Many entrepreneurs enjoy the varied tasks of creating, promoting, and selling. The prestige of being a business owner or president is another enticement of entrepreneurship. Seasoned workers may be frustrated by lack of advancement in the corporate world, where rewards might be based on seniority or office politics rather than individual accomplishments. Entrepreneurship offers a solution to workers who might be laid off from their corporate careers, and it is a way to support the community. Small businesses offer stable employment for others. The Ewing Marion Kauffman Foundation Web site explains that entrepreneurship should be viewed as social responsibility. Entrepreneurs make products, practices, and institutions better. Their ideas are transformed into enterprises that give value and security to other people (2009). Most likely, the choice to become an entrepreneur is a combination of some of the previously mentioned reasons. It requires determination, good business sense, financial backing, and a solid business plan.

Business Types

After making the decision to start a business, the type of business must be determined. The three most common business types are sole proprietorship, partnership, and corporation. Each has advantages and disadvantages which are discussed in the following section.

A **sole proprietorship** (or simply **proprietorship**) includes between 75 and 85 percent of all small businesses in the United States. It is a business managed by a single owner and is the easiest type of business to start. This type of business ownership entitles the owner to all profits from the business and allows the sole proprietor to make all business decisions. The risks of a proprietorship include unlimited personal liability for the business debts and losses and complete responsibility for the success of the business.

A partnership is a business managed by two or more owners. According to the Small Business Administration Web site glossary of terms, a **partnership** is "a legal relationship existing between two or more persons contractually associated as joint principals in a business" (http://web.sba.gov/glossary/). They share all assets, liabilities, and profits of the business. The benefits of a partnership include shared decision-making responsibilities and the opportunities to focus on each partner's personal and business strengths, such as sales, creativity, or business skills. Another benefit of partnerships is that banks are more apt to loan money to partners rather than sole proprietors because the failure rate is lower. This fact alone may cinch the decision to create a partnership. Partners sometimes have difficulty agreeing on the appropriate business strategy, and since business decisions are jointly determined, they must work through these conflicts. In a partnership, the owners are still liable for the business debts.

After a business grows to sufficient size, sole proprietors and partners may choose to incorporate, or become a corporation. The purpose of incorporating is to protect the personal property of the company founders. According to the Small Business Administration glossary of terms, a **corporation** is "a group of persons granted a state charter legally recognizing them as a separate entity having its own rights, privileges, and liabilities distinct from those of its members" (http://web.sba.gov/glossary/). By incorporating, the liability is limited to the corporate entity's assets. It has a life separate from the entrepreneurs. The assets of the founders are no longer used as collateral. The previous owners become the new officers, such as president, vice president, or secretary, and they no longer own the company. Shares or stocks are created and divided among the officers and other selected shareholders.

Economic Impact of Entrepreneurship

Successful entrepreneurship leads to economic growth, a reduction in poverty, the strengthening of the middle class, and economic stability. According to the Small Business Administration, the annual revenues of sole proprietorships in 2006 amounted to $102 billion. The SBA also reports that small businesses represent 99.7 percent of all U.S. employers (http://web.sba.gov/faqs/faqindex.cfm?arealD=24).

Many garage-type businesses are started with as little as $5,000. At the 2008 Dallas Fashion Group Career Day, a featured presentation by three successful entrepreneurs revealed that each of the speakers had invested a minimal amount of money in their new business. The first speaker sold stocks from his previous employer's investments and used the $20,000 to start his own design company. The second presenter invested her $10,000 from savings to begin her jewelry production and design company, whereas the third speaker invested only $1,500 as start-up capital in her handbag production company. However, many

FASHION FACTS: Want an Entrepreneurship Loan? First, Write a Business Plan

Entrepreneurs rely on the Small Business Administration as a primary resource for getting a fledgling business off the ground. It should be the starting place for planning an entrepreneurial venture and writing a business plan. A **business plan** is a written document containing a description of the business, the marketing and management of the business, and the financial data for the business. Entrepreneurs must also submit tax returns and financial information on the principals, as well as other supporting documents. Bankers and loan officers require the submission of a business plan before extending credit to the principals. Writing a business plan might seem daunting at first, but upon reviewing samples of real business plans, a general writing formula becomes evident. Before writing a business plan, entrepreneurs should examine several related sample business plans linked to the Small Business Administration Web site (http://www.sba .gov/smallbusinessplanner/plan/ writeabusinessplan/SERV_ WRRITINGBUSPLAN.html). The more than one hundred sample plans provide a helpful overview and a formula from which to write a new business plan. The Internet link includes an extensive collection of sample business plans, including an online clothing retailer, a drapery company, and a wedding consultant company.

The Small Business Administration Web site also offers a small business start-up guide containing information on a variety of topics. It also offers a virtual campus with many online courses available for enrollment through the Small Business Training Network (SBTN). The purpose of the Small Business Training Network is to provide helpful and specific online training to respond to the needs of persons considering opening their own business. Free online courses include Small Business Primer: Guide to Starting a Business; How to Start a Business on a Shoestring Budget; and Accounting 101: The Fundamentals. Each of these free courses may be taken online in approximately thirty minutes.

Before deciding to proceed with the exciting idea of opening a fashion business, potential entrepreneurs should complete the small business readiness assessment tool Are You Ready to Start a Business? (http://web.sba.gov/sbtn/sbat/index.cfm? Tool=4). This allows businesspeople to evaluate their skills, personal characteristics, and work experiences in relation to the type of business they desire to open.

Figure 15.8 Small Business Administration Web site home page.
(Small Business Administration)

Securing an Internship

It is never too early to start preparing for the job market. Some companies begin the summer internship hiring process as early as October, so that the company can make internship offers early in January. Judicious students work during their sophomore years to prepare themselves for early junior year interviewing. The formal internship labor market has become increasingly competitive, and employers may be cutting back on numbers of summer internship openings in order to reduce costs. Securing the most desirable internship is important business, and the process starts well before a student's senior year.

Students seeking internships must learn to fine-tune their business skills, including polishing résumés, participating in mock interviews, and attending business etiquette seminars offered by their university. Most university placement services offer résumé doctor workshops presented by industry personnel. Students may already have a decent résumé, but industry professionals can offer valuable tips and help make an average résumé become a best-selling résumé. Placement services offer mock interview sessions, either in-person with placement personnel or as a video streaming interview that students can play back and critique. Future interns who attend business etiquette seminars learn the importance of eye contact, a firm handshake, and many other details that an applicant might forget during a stressful interview. A university has a vested interest in helping its students secure the very best internships, so students should take advantage of these services and greatly improve their chances of success.

other business owners take substantial loans, and the failure rate is high. The risks should be carefully considered.

College Opportunities

Take opportunities and make opportunities. College students are advised to take their education outside the walls of the classroom in order to gain valuable fashion experiences. Ambitious students might consider internships, job shadowing, studying abroad, attending career days, entering student competitions, traveling to fashion market centers, joining student organizations, and most of all, gaining related work experience. Each of these opportunities is résumé-worthy and makes for a well-rounded education.

Internship

Employers of all sizes may offer apparel and fashion career opportunities to students so that they can obtain real-life experiences prior to graduation. Internships provide valuable work experience in a student's chosen field. An **internship** is defined as a "meaningful work or service learning experience in which a student has intentional learning goals and is carefully monitored to enhance a positive learning environment" (AgCareers.com, May 2006, 12).

Internships offer numerous benefits for the companies. They allow employers to sample the students for a few weeks or months, without having to make a permanent commitment. It provides employers with a cost-effective way to recruit and evaluate potential employees. Interns are an economical workforce that can perform essential day-to-day duties, relieving full-time employees of these basic tasks. Another benefit of interns is that they offer a fresh perspective on the business.

Internships benefit the students, too. They provide students with a glimpse of the industry and help the students to decide on career directions. When students work at a retailer or company during college, they make excellent contacts with the managers who will consider hiring them after graduation. The interns learn of internal job openings of which non employees may not be aware. Another benefit of completing an internship is the increased ability to negotiate for a higher salary on a first job. According to a 2005 internship survey conducted by MarketSense, a marketing consulting firm in Manor, Pennsylvania, more than 70 percent of the 1,000 students surveyed believed that internships should be required for graduation. Interns may receive a minimal stipend to cover expenses, such as travel, or they may receive a fraction of the starting salary of a full-time person in this position.

> College students are advised to take their education outside the walls of the classroom in order to gain valuable fashion experiences.

Job Shadow

Job shadowing offers opportunities for college students to briefly observe and explore an occupation at a particular business. College students who spend a day or two at a fashion business job shadowing with a practicing professional learn how a business operates and observe the day-to-day activities of this position. While job shadowing, students observe, ask questions, apply people skills, and make valuable industry contacts. The student may want to bring a résumé and ask the professional to critique the résumé and offer suggestions for improvement. These significant short-term interactions may lead to subsequent internships or future career opportunities.

Study Abroad

The distinction of having studied abroad is an exciting addition to a student's personal and professional life and résumé. Because of the global scope of the fashion business, companies seek employees who are able to communicate and work with others from different cultural backgrounds. A study abroad experience adds a competitive advantage for that student. A session, semester, or year is the usual range of time for a study abroad program. Colleges may participate in joint exchange programs with overseas universities. Larger universities provide on-campus offices to facilitate the preparations for the study abroad process. Smaller universities that lack specific offices should have key faculty members designated as study abroad resources. One advantage of study abroad programs is that the student remains continuously enrolled and receives college credit for the experience. Participants earning college credit may be required to develop a research paper prior to or during the program. Students can also enroll in full degree programs through an intercontinental university, such as the American Intercontinental University. If possible, students should combine an international internship with the study abroad educational experience. Work experience in a foreign country provides another competitive edge on a student's résumé.

Attend Career Days, Career Fairs, and Enter Competitions

Various fashion groups across the country sponsor college career days and design competitions for students interested in fashion-related and interior design careers. One major annual

University Home

Home
About Us
Courses
News & Events
Showcase
Research
Contact Us
International
Open Days
Business
Alumni

Figure 15.9 The London College of Fashion website—
www.fashion.arts.ac.uk/
(Courtesy of University of the Art London/London College of Fashion)

University of the Arts London
London College of Fashion

Develop your own fashion label

Unlocking the Look: From Hair Cut to Hair Couture

Pigeons & Peacocks

MA_STERS
MA SHOW
LONDON COLLEGE OF FASHION

Browse the MA_10 blog

Vox-pops from the MA shows

NEW Flexible learning courses

Site Search

▶ Go

University Links
Prospective Students
Fees and Money

University Site Map Accessibility Prospectus? Contact Us Find Us e-bulletin

© 2010 University of the Arts London All Rights Reserved.

career day occurs at the World Trade Center in Dallas, Texas, and an important student design competition occurs at the St. Charles Convention Center in St. Charles, Missouri.

Career days may offer students and employers a career resources exhibition. This is an exhibit of companies and organizations offering information, internships, and career opportunities for student participants. Career days usually begin early in the morning with a keynote speaker, such as a well-known designer or fashion industry leader. During the day, students attend three or four educational workshops on topics of their choice, including computer-aided design, product development, portfolio presentation, projecting a professional image, digital merchandising, trend forecasting, and visual merchandising. Students may use the preceding school year to prepare for competitions that include variations on a retail merchandising competition, a design competition with a fully staged runway, a trend board competition, and a cause-related competition. The cause-related competition at the Dallas Career Day is a DIFFA (Design Industries Foundation Fighting AIDS) denim jacket design competition allowing students to embellish or reconstruct denim jackets into wearable art that is sold or auctioned to benefit patients with AIDS (see figure 15.10). The Dallas Career Day sponsor is the Dallas Chapter of the Fashion Group International. The Emerging Young Designer of the Year Fashion Competition in St. Charles, Missouri, is sponsored by the Sewing Dealers Trade Association/Round Bobbin. Career days and the sponsored competitions provide students with experiential learning and networking opportunities. Universities with strong apparel or fashion programs typically attend the closest career day or competition each year.

Figure 15.10 Career Day event for college students pursuing fashion careers.

The trade publication, *Women's Wear Daily,* and talent recruitment agency, 24 Seven, sponsored two career fairs for professionals in New York and Los Angeles in the fall of 2008. The Web site advertisement boasted that it is the "apparel world's premier hiring event" (www .fashioncareers.com). Only current industry professionals were allowed and only if they had a four-year degree and two years of fashion industry experience; a two-year degree and four years of fashion industry experience; or five years of fashion industry work experience.

Visit Fashion Market Centers

A fashion market center is a major metropolitan city that has a concentration of fashion businesses and becomes a converging place for representatives of manufacturers, wholesalers, and retailers. Larger university programs sponsor annual or biannual study tour trips to major market centers such as Los Angeles or New York City. Attendees spend several days touring area fashion businesses and marts. Faculty often arrange for students to meet with industry contacts, especially alumni of the college's textile, apparel, and fashion programs. Students who have attended these school-sponsored study tours have found them to be one of the most comprehensive and memorable learning experiences of their college careers. Whether students are visiting a city known for its fashion businesses or a trade show event such as MAGIC, setting aside time and money to attend one of these study tours are well worth the benefits received.

Join Student and Professional Organizations

Universities support student organizations for the majors on campus. Active participation in a campus club provides students with opportunities to make a difference, develop new skills, network, and meet others with similar career interests. An online perusal of a few campus club names listed for textiles, apparel, and fashion majors across the country include the Fashion Association; Fashionista Club; Fashion Group; Fashion Focus Club; Fashion Unlimited; Fashion Design Club; Merchandising and Design Association; Design Council; Textile Entrepreneurs Club; and the Fiber, Apparel and Design Club (FAD).

Faculty members are also encouraged to join and support professional organizations, such as the widely recognized International Textile and Apparel Association (ITAA). Some inter-

Figure 15.11 Student organization club picture.

Table 15.1 Apparel Organizations with Student Memberships

American Association of Family and Consumer Sciences (AAFCS)	www.aafcs.org	AAFCS Student Unit and state-level chapters.
American Association of Textile Chemists and Colorists (AATCC)	www.aatcc.org	Apply for student chapters with ten or more students and an advisor.
American Marketing Association (AMA)	www.marketingpower.com	Apply for collegiate chapters with ten or more students and an advisor.
Association for Operations Management (APICS)	www.apics.org	Student chapters are affiliated with parent chapters.
Fashion Group International (FGI)	www.fgi.org	No national student memberships. Some chapters have student membership groups, and others offer different educational events, such as career days and scholarships.
The Fiber Society	www.fibersociety.org	Membership is by faculty nomination and is limited to graduate students.
International Textile and Apparel Association (ITAA)	www.itaaonline.org	Graduate and undergraduate student affiliations with ITAA member sponsor.
Textile Institute (United Kingdom)	www.textileinstitute.org	Student members may sign up for three special interest groups.

national and national organizations sponsor student membership sections or chapters for a reduced membership fee. Organizations may offer scholarship opportunities and schedule student chapter activities during the national meetings. Table 15.1 lists prominent professional organizations with collegiate student memberships.

Gain Industry Work Experience

A college degree and directly related work experience are joint keys to successfully landing a dream job upon graduation. Internships are not always available or feasible for college students, but directly related work experience is the next best thing. Whether a student has completed a formal college internship or has worked part-time in the industry during college, employers look for an applicant with experience. A well-rounded individual is one who understands the basic workings of the industry and possesses a bachelor's degree. On-the-job training and formal education are complementary in developing and strengthening applicants' critical-thinking skills. Students should understand that although employers are attracted to applicants with high academic skills, the employers also expect candidates to have industry awareness, good communication skills, and related work experience. Students who possess formal knowledge and practical work experience are often successful at negotiating for higher salaries.

Working part-time as a sales associate at a local apparel store is among the most practical of work experiences because it is the direct link to the ultimate consumer. College students learn skills that will be of value, no matter which level of the industry they ultimately gain employment. Customer service skills are at the top of the important learning experiences. Sales associates learn how to deal with irate customers, gain sales and negotiation skills, and discover the true meaning of "the customer is always right." Students also gain basic understanding of pricing and promotion strategies, markdowns, floor merchandising, and merchandise presentation. Store personnel gear all the activities that happen at the retail level toward the store's particular target customer, and a retail employee learns the significance of knowing precisely how to reach this group of customers.

Recommended Activities for Fashion Marketing and Merchandising Students

Sophomore Year
Fall Semester 3: Job shadow
industry professional
Spring Semester 4: Update résumé;
join fashion club
Summer Semester: Visit major market
center on study tour

Pre College
Gain fashion industry
work experience

Summer Semester:
Internship

Freshman Year
Fall Semester 1: Work
part-time in retailing
Spring Semester 2: Enroll
in introductory fashion class

Junior Year
Fall Semester 5: Run
for club office; prepare for
competition
Spring Semester 6: Attend
regional career day and
enter competition; attend
job fair and résumé/business
etiquette workshops

Senior Year
Fall Semester 7: Study abroad
Spring Semester 8: Interview;
prepare to be hired

Students need a professional résumé to present their qualifications in the best light. The following résumé is a sample of one that might be useful to a fashion marketing student with a limited amount of fashion retail experience during high school or college. For additional résumés, cover letters, and a list of sample interview questions, refer to Appendix D.

Fashion Marketing Student

Street Address • City, State, Zip Code • e-mail address • (area code) XXX-XXXX

Career Objective
To obtain a position as a visual merchandiser and fashion specialist.

Education

Your University	2008–present	City, ST
Bachelor of Science in Family and Consumer Sciences		
Major: Fashion Marketing; Minor: Business Marketing		
Expected Graduation Date: Summer 201X		
Community College (36 hours)	2006–2008	City, ST

Relevant Courses
- Fashion Accessories
- Visual Merchandising
- Introduction ot Faashion
- Fashion Study Tour
- Profitable Merchandising
- Fashion Buying

Relevant Work Experience

Visual Merchandiser **Department Store** Aug 2007–Jan 2008 City, ST
- Changing fashions on mannequins
- Monitoring store's visual standards and décor
- Installing and trimming windows

Wardrobe Hostess **Walt Disney World**
WDW College Program Jan 2007–June 2007 City, ST
- Preset costumes for performes and characters
- Assisted performers before show times
- Assisted cast members with costuming needs

Extracurricular Activities
- Fashion Asssociation (2008–present)
- University Entertainers (2008–present)
- Fashion Show Model (2008)
- University Chorus (2008–present)
- Volunteer Fashion Stylist (2006–2007)
- Student Government Rep (2006–2007)
- TRIO Success (2006)
- University study tour to NYC (2006)

Honors
- Regent's Fee Wavier Scholorship
- Academic Achievement
- Dean's Honor Roll (four semesters)
- Trend Board Competition

References available upon request

summary

- To learn about the fashion industry, students study abroad, secure an internship, job shadow, enter a competition at a regional career day, take a study tour trip, join a professional organization, and work part-time in the fashion industry.

- Creative fashion careers opportunities for college graduates are available at all levels of the fashion industry regardless of the years of previous work experience.

- Entry-level or assistant-type positions are available for students with limited work experience.

- Fashion careers include fashion trend analyst, textile specialists, designer, patternmaker, sourcing specialists, product developer, account executive, independent wholesale sales representative, buyer, merchandise coordinator, special events coordinator, store manager, visual merchandiser, and entrepreneur.

- Entrepreneurship refers to owning one's own business.

- Benefits of entrepreneurship include being one's own boss, making decisions about the company, financial gain and equity growth, involvement in the varied tasks of the project from start to finish, prestige, and recognition for hard work.

- A sole proprietor is the most common type of business ownership, and the owner is responsible for all company debts.

- In a partnership, the ownership responsibilities are shared among partners, and the strengths of each partner are utilized.

- A corporation is a type of business ownership in which the officers no longer actually own the business, so they are no longer financially liable for any business debts.

- The Small Business Administration supports entrepreneurs from the planning process throughout business ownership by offering advice on writing a business plan, getting a loan, starting a business, and maintaining a successful business.

- Professional organizations include the American Association of Family and Consumer Sciences, American Association of Textile Chemists and Colorists, American Marketing Association, Association for Operations Management, Fashion Group International, Fiber Society, International Textile and Apparel Association, and Textile Institute.

terminology for review

first-through-production patternmaker 280
rep 282
open-to-buy 284
merchandise coordinator 285
internal merchandise coordinator 285

client services coordinator 285
project manager 288
entrepreneurship 288
sole proprietorship 289
proprietorship 289

partnership 289
corporation 289
business plan 290
internship 291

questions for discussion

1. What resources are available to college students interested in pursuing extracurricular and enrichment opportunities?

2. Why is it important for students to participate in extracurricular and enrichment opportunities?

3. What are some entry-level jobs for graduates of a textiles, apparel, or fashion program?

4. What are some advanced-level jobs for graduates of a textiles, apparel, or fashion program?

5. What is a fashion entrepreneur?

6. What are some of the primary benefits of becoming an entrepreneur?

7. How does owning a business benefit others in a community?

8. What are the three forms of business ownership, and how are they different?

9. What are the major extracurricular college opportunities?

10. How can joining professional organizations benefit college students?

related activities

1. Take the short Small Business Administration entrepreneurship readiness assessment Are You Ready to Start a Business? at http://web.sba.gov/sbtn/sbat/index.cfm?Tool=4. Based on the results, write a self-analysis of strengths and weaknesses. Outline a possible plan of action during college that strengthens apparent weaknesses.

2. Research at least one additional fashion career (not described in Chapter 15) that might be of interest. Locate four online vacancy announcements for each career and assimilate information on the various job descriptions, skills, and required training. Prepare a PowerPoint presentation that combines all the information into a unified format. Cite the resources used at the end of the presentation.

3. Conduct online research about an extracurricular activity. It can be a study abroad program, design or merchandising competition, career day, professional organization, or some other extracurricular opportunity of interest. Create a table or outline that includes time frames and deadlines, fees, rules of entry, requirements, benefits, and other important information. Orally present the findings to the class.

4. Visit the Small Business Administration Web site and select a podcast on beginning or owning a small business. Take notes and submit for credit. Podcasts can be found at http://www.sba.gov/tools/audiovideo/Podcasts/index.html.

Basic Apparel Styles

Collars

Ascot—A rectangular scarf tied around the neck in a half knot, with both long ends overlapping at the center front.

Bertha—Wide, shoulder-covering collar.

Button-down—Collar points are buttoned to the shirtfront.

Convertible—Common collar for dress shirts with a stand and a fall of near equal length.

Jabot—Ruffled neckline treatment that extends down a narrow section of the shirtfront.

Mandarin or Chinese— Similar to a Nehru stand-up collar with an asymmetrical closure.

Nehru—Made famous by prime minister of India; a collar stand, no fall, and a center front opening.

Notched—Offset section or notch where the collar and lapel are sewn together.

Peter Pan—Small, fold-over collar with rounded points.

Platter or Puritan—Large collar that extends to shoulder seams, with opening at the center front.

Polo—Knit collar attached to a buttoned placket at the center front.

Portrait—Wide, shawl collar that frames the face on a lowered neckline.

Rever or lapel—Bodice is folded back on either side of the center front seam.

Ruff or ruffled—Soft or stiff ruffles around the neckline.

Sailor—Large rectangular collar on the shirt back that tapers to a V at the shirtfront.

Shawl—Collar with a center back seam line that drapes to a curved V neckline.

Necklines

Boat or bateau (Fr.)—Wide, horizontal neck opening with limited curvature.

Cowl—Draped neckline with extra fullness that creates a scrunched effect.

Crew—Ribbed, close-fitting neckline that sits at the base of the throat.

DOcolletO—Plunging neckline that shows cleavage.

Funnel—The fitted neckline rises slightly up the base of the neck.

Halter—A cutaway sleeveless style with a neckline that ties at the nape of the neck.

Jewel or plain—A style that exposes just the base of the throat (so a short string of pearls will be visible).

Keyhole or peek-a-boo—Teardrop opening at the base of the neck.

Mock turtleneck—Similar to a turtleneck, but the fabric does not fold down.

Scalloped—Created by repeating small arcs across a scoop neckline.

Scoop—A low, rounded neckline.

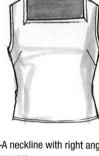

Square—A neckline with right angles that resemble a square.

Surplice—A crossover V neckline created when the right and left sides of a bodice cross over one another.

Sweetheart—A heart-shaped neckline.

Turtleneck—Fitted tubular extension that extends up to the chin, but may be folded down half way.

U—Curved neckline that resembles the letter U.

V—Comes to a point in the center front and resembles the letter V.

Sleeves

Angel—Widens to the wrist and ends in a diagonal flare that falls under the hand.

Bell—Fits closely at the natural shoulder, flaring and hanging loosely at the elbow or wrist.

Bishop—Fits closely at the natural shoulder and widens as it extends down the arm where it is heavily gathered onto a wrist cuff.

Butterfly or flutter—Short or long length; large expanse of fabric that drapes in loose folds.

Cap—Tiny sleeve that covers only the top of the shoulder.

Dolman or batwing—Extra fullness from wrist to waist, wing-like.

Juliet—Puff sleeve near the shoulder, but closely fitted below the upper arm.

Kimono—Of Japanese origin; long, full sleeves are rectangular shape.

Lantern—Short, puffed sleeve with extra fullness gathered at banded lower edge.

Leg-o'-mutton—Gathered fullness above the elbow and tightly fitted from elbow to wrist.

Petal—Resembles flower petals; two-piece short sleeve with front section overlapping back section.

Puff or melon—Short with extra fullness that resembles a round melon.

Raglan or baseball—Armseye seams extend to neckline; often sleeve color contrasts with the top body.

Three quarter, 3/4, or bracelet—Sleeve hem ends midway between elbow and wrist.

Jackets and Tops

Battle or Eisenhower—Waist length with banded lower edge; shoulder epaulets, volume sleeves gathered onto cuffs, and patch flap pockets; worn by General Dwight D. Eisenhower.

Blazer—Traditional jacket with two or three buttons; sold separately from slacks and usually in a contrasting fabric.

Blouson—Top with extra fullness at lower edge of top, creating a bloused effect.

Bolero—Unstructured, above-the-waist jacket with rounded edges at hemline.

Bomber—Popularized by WWII pilots; cropped leather jacket with collar and multiple zippers.

Camisole—Originally a lingerie item; fitted, pullover top with narrow or spaghetti straps.

Cardigan—A sweater that buttons up the center front and usually has patch pockets.

Chanel—Made famous by designer Coco Chanel; short, boxy, simple design with braided trim.

Cossack—Origins in Russia; belted tunic with long sleeves, asymmetrical front closure, and collar stand.

Double-breasted—Two rows of buttons used as closure on overlapping front sections.

Henley—Collarless, pullover top with center front button placket; short or long sleeves.

Middy—Sleeveless, tunic top with sailor collar.

Peasant—Blouson top with raglan puff sleeves and scoop neck.

Safari—Belted at the waist in varying styles with multiple cargo pockets and center front buttons.

Shell— Sleeveless, collarless close-fitting top worn under cardigans.

Shrug or chubby—Small stole with armscyes.

Stole or stolla—Large rectangular scarf worn around the shoulders and draped over the arms; materials vary from fur to fabric.

Tunic—Unfitted top that hangs at hip length.

Tuxedo or cutaway—Any jacket that resembles a formal tuxedo, with or without tails.

Vest—Originally for menswear; sleeveless, close-fitting top due to bust and waist darts; center front buttons.

Western—Western wear; fitted shirt or jacket with collar, cuffs, and a front placket, scalloped shoulder yokes in front and back; may have fringe at yoke, sleeve seams, or hem.

Coats

Balmacaan—Overcoat with raglan sleeves and center front closure.

Cape—Knee to ankle length, semicircular garment that hangs freely from the shoulder and opens in the center front; usually one size fits all.

Capelet—Similar to cape, except shorter.

Car coat—Hip length coat without excess fabric that allows wearer to easily slide into a car.

Chesterfield or box—Square shaped with set-in collar and sleeves, center front closure, and pockets.

Coachman or A-line—Double breasted, mid-calf length coat; wide revers, fitted bodice, and flared from the waist to the hem.

Cocoon—Voluminous folds of fabric creating a fluffy wrap with batwing sleeves; envelops the wearer like a cocoon; length varies from hip to below-the-knee.

Cutaway—Single button coat that tapers to long tail in the back.

Inverness—Coat with shoulder capelet overlay; mid-calf length.

Parka—Originally worn by Eskimos; hip-length and hooded, usually with fluffy fur trim at the hood, down the center front, across the pocket openings, and on the cuffs.

Pea coat, pea jacket, or reefer—Originally a sailor's coat; double-breasted wool jacket with wide revers or lapels and princess seam lines with inseam pockets.

Poncho—Similar to a cape except it pulls over the head and extends to a point in the center front and back; may have minimally defined sleeves.

Princess—Fitted silhouette created with extra seaming; similar to coachman coat, but single breasted.

Redingote—A dress coat worn as part of an ensemble; matching dress and coat.

Trench coat or all-weather coat—
Common name for many styles of collared and belted, mid-calf length coats in water resistant fabric, such as poplin; may have removable, insulated lining.

Dresses

Caftan—Long, loose-fitting pullover dress with full sleeves in three-quarter length.

Chemise (pronounced shəmēēz´), shift, or sack—French word for a tubular and close-fitting dress.

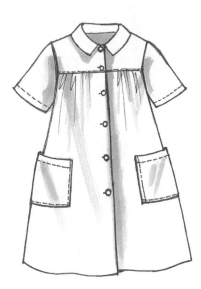

Duster or housecoat—A-line, loose-fitting short-sleeved dress with center front snaps.

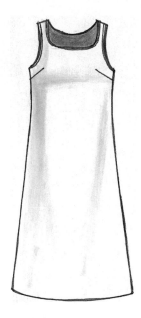

Jumper—No fitted waistline seam, hanging loosely from shoulders to hemline, possibly with fitting darts to loosely follow the body contours. Usually worn with shirt or top underneath.

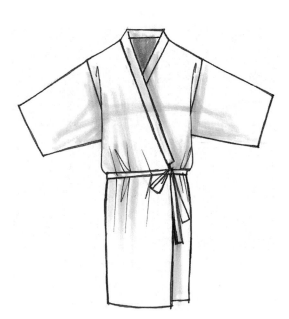

Kimono—Origins in Japan; rectangular wrap robe with three-quarter or full length kimono sleeves.

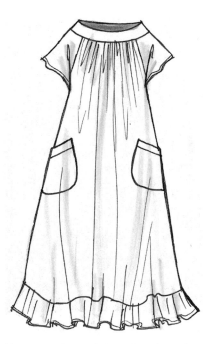

Muumuu—Full length, loose-fitting dress with flounce at hem.

Peasant—Bouffant style dress with cinched waist and full skirt, full puffed sleeves, and gathered, scooped neckline.

Pinafore—Similar to an apron with front and back pieces; bib bodice attached to a gathered A-line skirt.

Princess—Bodice has vertical front seams that cross the bust point; skirt is usually slightly flared; especially flattering style.

Sheath—Tubular dress with fitting darts to enhance body contours.

Shirtwaist—A fitted shirt-style top attached to a skirt with a close-fitting waistline seam; buttons up the front.

Trapeze or tent—Dress is fitted across the shoulders and bust and hangs fully and freely at lower edge.

Wedge—Broad at the shoulders, tapering to a narrow hem; like an inverted triangle.

Skirts

A-line—Flares slightly from waist to hemline.

Bouffant—Full, flared skirt with tightly gathered waist.

Broomstick—Long cotton skirt with extensive vertical wrinkling achieved by tying the damp skirt around the length of a broomstick and letting it air-dry.

Circular—360° fabric circle with hole in center for waistline.

Dirndl—German origins; large rectangle of fabric is gathered onto a waistband.

Gauchos or divided skirt—Originally worn by female horseback riders; divided skirt that hangs below the knees.

Handkerchief—Bias cut skirt with asymmetrical hemline resembling handkerchief corners.

Kilt—Scottish origins; A-line, woolen (often plaid) skirt with fringed side front opening and ornamental safety pin closure.

Maxi—Hemline extends to the floor.

Midi—Hemline ends at mid calf.

Mini—Hemline ends above mid thigh.

Peg top—Full gathers at waistline; fullness tapering to a narrow hem.

Pencil—Extremely narrow silhouette, longer length.

Pleated—Vertical folds at equal intervals, from waistline to hemline; includes knife, accordion, inverted, and box pleats.

Sarong or wrap—Large, rectangular piece of fabric with two upper corners tied at the side waist.

Straight—Comfortably-fitted, with very little flare.

Tiered—Gathered layers that get progressively fuller as the skirt extends to the hem; skirt length is determined by the number of tiers, such as two-tiered or three-tiered.

Tulip or trumpet—Fitted at waist and hips by use of multiple gores; hemline flare.

Pants

Baggies—Pleated or gathered at the waist and full through the legs.

Bell-bottoms—Wide flare below the knee.

Capris, pedal pushers, or clam diggers—Mid calf or below-the-knee tight fitting pants.

Cropped or ankle—Slightly longer than capris, ending just above the ankle.

Flared—Any pant that increases in width as it approaches the hem.

Harem—Yoke waistline with full pant legs created by significant gathering below the yoke and at the ankles.

Hip-hugger or low-rise—Refers to the location of the waist, several inches below the natural waistline.

Leggings—Tight-fitting stretch pants often worn by dancers.

Palazzo—Silky fabric; very full legs that appear to be a skirt when the wearer is standing still.

Stovepipe or slim-jims—Tubular, fairly close-fitting long legs.

Trousers or slacks—General term that refers to tailored woven pants with waistband, zipper, and optional front pleats.

Tuxedo—Formal trousers with satin stripes extending down side seams.

Details

Armseye or Armscye—Armhole in the bodice into which the sleeve is sewn.

Asymmetrical—Off center; unequal or informal balance.

Bifurcated—Two pieces, such as pants or a divided skirt.

Cuff, barrel—Traditional shirt cuff, two or three buttons.

Cuff, French—Extra long cuff is folded back on itself and secured with cuff links.

Cuff, extended—Extra long cuff that extends over the hand.

Facing—Narrow fabric in the same shape as the garment opening; sewn to the opening with the purpose of concealing its raw edges.

Godet (pronounced go-day)—Triangular insert that serves to expand a section; located under the arm or at the hemline.

Gore—A panel piece that extends the length of the garment, such as a six-gore skirt (three front panels and three back panels).

Hollywood waist—Seamless, raised natural waist; cut in one with the pants or skirt, rather than a separate waistband.

Interfacing—Extra layer of fabric sewn between the facing and the fashion fabric to add stiffness or body.

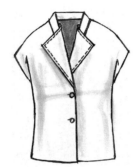

Lapel—Folded back center front section of a shirt, coat, or jacket that is part of the collar.

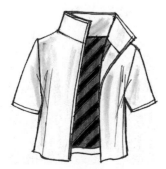

Lining—Contrasting under fabric that adds additional weight and body to the fashion fabric.

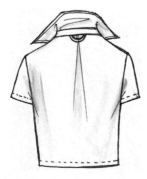

Locker loop—Narrow fabric sewn at top of back box pleat on a dress shirt; useful for hanging the shirt in confined spaces.

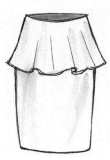

Peplum—Decorative fullness created by short puff or ruffle sewn into the waist of a skirt, falling around the hip area.

Placket—Reinforced center strip of fabric to ensure stability around buttons and buttonholes.

Pleat—Vertical fold that facilitates movement without obvious extra fullness (see Skirt-Pleated on page 320).

Pocket, besom, or welt—Tailoring term for a slashed pocket opening bound with a narrow piece of fabric.

Pocket, patch—Entire pocket is visible and sewn onto the garment.

Rever—Extra wide lapel. See Collars: Rever or Lape on page 302l.

Self belt—Belt is made of the same fabric as the garment.

Smocking— Embroidery technique on pleats to gather the fabric and impart stretch.

Sleeve cap—Uppermost part of the sleeve pattern piece covering the shoulder top.

Waistline, dropped—Below the natural waist.

Waistline, empire (pronounced ahm peer)—Under the bustline.

Waistline, natural—Below the rib cage, at the narrowest part of the torso.

Yoke—Inset panel of fabric used to create a fitted appearance; located at shoulders, waistline, or hipline.

Yoke, western—Scalloped edge to a shoulder yoke.

Small Business Fashion Marketing Plan

The purpose of the small business fashion marketing plan is to furnish students with many of the skills needed to write a business plan based on the Small Business Administration format. Each team will plan the opening of a brick-and-mortar fictional fashion retail business. Throughout the course of the semester, the team will write and revise eight related business plan components describing the fictional business. A complete packet will be due at the semester's conclusion. This small business fashion marketing plan precisely defines the business; identifies its goals, products, services, target customers, competitive edge, and marketing strategies and, in general, serves as the company's résumé. The eight separate components are:

1. Executive Summary
2. Objectives
3. Mission Statement and Keys to Success
4. Company Information
5. Target Market and Market Segmentation
6. Products and Services
7. Main Competitors and Competitive Edge
8. Marketing and Merchandising Strategies

To get started, the team should first visit the Small Business Administration Web site at www.sba.gov. Click on the Small Business Planner tab; then Plan Your Business > Write a Business Plan; then click on Writing the Business Plan link. Scroll to the bottom of the page and click on the link, Review examples of real business plans. These links will direct the team to the page of free sample business plans where students can scroll down and choose "All Categories: to locate business plans similar to their fictional business idea.

This particular marketing business plan is modified to accommodate the knowledge and skills of most students enrolled in an introductory fashion marketing course. The financial component is not included, since some students have not completed a basic accounting course. Teams should use the textbook as a resource.

The team will write all components as though they will be submitted to a loan officer for loan approval. The information should be written in the future tense, since the team is only planning for a business. An example of appropriate wording is: "We will offer personalized services . . ." or "Our business will be located at. . . ." Avoid writing as though the reader is the customer. Do not use the words "you" or "your." Instead, use the phrase "our customers" or some other descriptive term.

Component One: Executive Summary

The assigned teams should plan and write as a group. The executive summary will include a description of the company, the unique selling proposition, and the sources of sales revenue.

Description of the company. Develop a couple of paragraphs describing the fictional fashion retailer. This includes the company name, location, general products and services, and an overview of the target customers, so that the reader knows who will patronize this business. A more detailed description of products, services, and target customers will follow in subsequent components.

Unique Selling Proposition (USP). This is what differentiates the team's company from the competitors who have already entered the market. It is also called a **competitive advantage** or **competitive edge.** For example, the Bass Pro Shop has a creative store interior design that includes a pond, waterfall, indoor woods, and taxidermied animals. The store's décor is distinctly different from other sporting goods shops. Other examples of unique selling propositions include special services that the store offers; specialty items (private label items, unique brands, or fringe sizes) that can only be purchased at this store; highly-trained staff; all-inclusive nature of the business; absolute lowest prices; decor; theme; entertainment; size of establishment; location of establishment; hours of operation; or serving a niche market not currently being served. Choose only the most unique competitive advantage(s) and discuss these in depth. The team should not try to be the best at everything.

Sources of Sales Revenue. What products and services will the store be selling? Subdivide the fictional business into different profit centers or strategic business units (SBUs) and explain how each SBU will generate income. For example, a bridal salon could have three profit centers: bridal gown and accessories sales, tuxedo rentals, and wedding planning services. A menswear store also might have three strategic business units: merchandise sales, tailoring services, and Internet sales. A company has diversified strategic business units to ensure a steady income year-round.

The team needs to include an introductory paragraph and a concluding paragraph. Limit the paper to one concept per paragraph (just like essays for an English class). Each paper submitted by the team will need a heading that includes the company name, component name and number, and all of the team members' names. Remember, each of these components is to be a team effort. Every team member should share equally in the responsibility.

Component Two: Objectives

The objectives are usually in the form of a bulleted list. Each bullet is one or a few sentences. Peruse sample business plan objectives from the Small Business Administration Web site. Do not copy the sample objectives—only use them as guidelines. For this project, each of the team's objectives should be quantifiable (give numbers, dollars, or percents for each objective). Six to ten broad objectives are sufficient for this component. Some of the broader objectives may have subobjectives.

The first objective should discuss time frame for the grand opening. Other objectives may include the projected average dollar sales per customer and the average number of customers served per day, week, month, and annually. Discuss sales goals for each strategic business unit (such as product sales, service sales, Internet sales, etc). The team may want to create an easy to read format, whether a table, chart, or columnar listing. Discuss the dollar sales goals as weekly or monthly figures and as annual figures. To obtain daily, weekly, or monthly sales figures, calculate the average number of customers for the time period x the average sale. Discuss the break-even date when the store starts showing a profit rather than a loss. Discuss plans for expansion and if so, when the branch stores will be opened. If not, just mention that there are no expansion

plans at this time. Discuss market share percent. Calculate how many stores are competing for the same customer base. Calculate what percentage of the customer group (market) the team hopes to gain. Even if the store has no direct competition, there may be similar types of businesses competing for the same dollar. For example, if the planned store is a menswear suit retailer, a tailoring shop or a wedding boutique may have part of the total market share. Considering the competitors, what size slice of the market share pie can the team's fictional business expect? Discuss expected profit as a percent of annual net sales. See what comparable businesses on the SBA Web site are projecting and use a similar figure. Profit is usually 4 to 10 percent of net sales.

Objectives should be quantifiable (numbers, percentages, dollars, or specific dates), so try to make each objective written in a way that it can be measured. Always spell-check and grammar-check the team's paper. Use the same heading format as the one used for Component One.

Component Three: Mission Statement and Keys to Success

Mission Statement. Develop a brief mission statement for the team's fictional company. A mission statement is the essential purpose that differentiates a company from other companies. It provides the overall organizational goals and scope and provides operational guidelines for future management actions. The mission statement should be three to six sentences in length. Visit the Small Business Administration sample business plans Web site for mission statement ideas.

Keys to Success. Develop a list of keys to success for the team's fictional company. Suggestions are listed following. Only list the five to seven most important keys to success and explain each one in a brief paragraph. The following list is just a sample of ideas. Visit the Small Business Administration sample business plans Web site for other ideas.

Always spell-check and grammar-check the team's paper. Use the same heading format as the one used for Component One.

Component Four: Company Information

This component describes the company in greater detail than the Executive Summary component. It is acceptable (and normal) to repeat some information across components due to overlaps. If some repetition occurs, the team will need to write it in a slightly different way and should always include new information.

▶ Ideas for Keys to Success

Products consistent in quality
Product innovation or development
Niche market
Low expenses or overhead; economies of scale
Adequate or network of suppliers
Effective communication
Packaging
Reliability
Financial management
Exclusivity

Company Location. Where is the company located (provide an address, even if fictional). Is it one location or branch locations? Why did the team choose this/these locations? Justify the decision based on real data, such as community size, type of residents, demographics, parking, major intersection, close to something else, and so forth. Teams may want to access the U.S. Census Bureau Web site to retrieve specific demographic information about a partiuclar zip code or find helpful information on the Claritas Web site at http://www.claritas.com/MyBestSegments/Default.jsp?ID=20.

Facilities. What kinds of facilities are needed? Will it consist of an existing building, or will a building need to be built? Why? What is the square footage? What is the number of patrons that can be accommodated? How many dressing rooms, chairs, and so forth? Provide extensive details about the interior décor and ambiance.

Major Products and Services. What products or services does the company offer? (Only briefly mention here because a detailed description will be the sixth component.)

Type of Ownership. Is the company a sole proprietorship, partnership, or corporation? How is the ownership divided (for example, among three partners, the stakes might be 40%, 40%, and 20%)? List the names of the owners. Is there any history associated with the company?

Work Experiences of Owners. What work/management/educational experiences does each team member have that makes him or her suitable to begin a business like this? Make each student's paragraph substantial because these experiences are indicators of the likelihood to succeed. Each team member must write his or her own experiences paragraph. Do not write paragraphs for nonparticipating group members.

Component Five: Target Market and Market Segmentation

This component describes the primary target customer segment and the secondary target customer segment. These groups will be described in terms of demographics, psychographics, and behavioral characteristics. A **primary target customer segment** is the homogeneous group of customers that are most like to buy from this store and who will spend the most money in the store. This is the core group of customers. The **secondary target customer segment** is a slightly different group of customers that will also spend significantly in the store, although they are not the biggest spenders. Ideas for demographic, psychographic, and behavioral variables may be found in the textbook.

Primary Target Customers. What primary market does the fictional company target? What are the demographic, psychographic, and behavioral characteristics of this group of consumers? How will the team's fictional store meet these customers' needs?

Secondary Target Customers. What secondary market does the fictional retailer serve? What are the demographic, psychographic, and behavioral characteristics of this group of consumers? How will the team's fictional store meet these customers' needs?

For additional information about describing target markets, both of these Web sites are helpful: http://sbinfocanada.about.com/cs/marketing/a/targetmarket_2.htm and http://www.sba.gov/smallbusinessplanner/manage/marketandprice/SERV_TARGETMARKETING.html.

Be very professional and formal when writing the team's papers. With minimal modifications, the team could realistically submit the fictional marketing plan to a loan officer when it is completed at the semester's end. Continue to improve and make corrections to the components as they are returned from the professor. This serves two purposes: the team will be

required to submit a complete, corrected plan at the semester's conclusion and the team's marketing plan will be as professional as any real-life plan. If a student would like to open his or her own business one day, the student will have a well-written marketing plan to use or adapt as needed.

Use the same heading format as the one used for Component One. This is a team project, and all team members should contribute equally to the effort. Please let the instructor know if a partner is not participating as a team player.

Component Six: Products and Services

Please discuss the following five areas, using subheadings and paragraph format. This will be one of the longer sections of the fashion marketing business plan.

Products. What major product lines does the company sell? List and describe the major merchandise classifications. Provide some general prices or price ranges from several of the major merchandise classifications, such as the average price for a pair of jeans is $X or the average price for a man's dress shirt is $Y. Discuss the importance of branding in the store and list some important brands. In the future, after the company becomes established, what products might be considered to expand the store's offering? Why choose this? Explain.

Services. List and provide a substantial description of each major service offered and relative prices. After the company becomes established, what services might be considered to expand the store's service offering and why?

Personnel. Who is responsible for selling/managing these products or services? Include the names and titles of key personnel, types and numbers of employees needed (cashiers, stockers, etc.), and describe how many are part-time/full-time. The name of each active group member should show up here. Do not add the name of a nonparticipating group member.

Technology. How will the company use technology in doing business? Describe specifics.

Sourcing. From what resources will the company obtain the products for the store? Will the store representative order from domestic suppliers or importers (which countries) and why? What is the competitive advantage of buying from/using these resources? How often will merchandise be ordered?

Component Seven: Main Competitors and Competitive Edge

Begin this paper with an introductory paragraph, explaining the purpose of this component. For example, list the main competitors, and explain that this paper contains explanations of how the company is different from its competitors and how it will succeed. This introductory paragraph does not have to be long; just give the reader an overview.

Who are the store's main competitors (each team member must describe a minium of one competitor)? Provide information on the store name, locations, and why each company is a competitor. Be specific, and use an entire paragraph to explain what they offer and how that might infringe on the team's company profits. Explain the competitive edge of the fictional business over these competitors. The team should give specific comparisons to illustrate the advantages. Make sure that for every competitor offering, the team's fictional company has an offering that is somehow better than the competitor. In other words, objectively describe the competitors but make sure the team's ideas are even better! The competitor may offer some-

thing that the fictional company cannot precisely duplicate, but the company should offer a suitable alternative. Sell the company!

Component Eight: Marketing and Merchandising Strategies

This assignment looks at the team's promotional activities at the local/store level and state/national/international level (if applicable). Component eight should include a discussion of the grand opening and promotions throughout the year.

Your discussion of the company's promotional activities should include:

Grand Opening Special Event. Describe in detail the dates, activities, events (minimum of two), food, incentives, and special decorating that will be part of the grand opening. What forms of advertising will best reach the primary and secondary target customer segments?

Promotional Activities throughout the Year. After the grand opening, how will the store personnel disseminate information about its products and services? What will entice customers into the store? Choose at least two mass media for advertising and explain the value of these media. That is, what arte the adantages of these forms of media over the other available media? Why are they best for reaching your target customers? Will personal selling or self selection be important in the store and why? What other promotions will be used on a regular basis to sell the store's products and services? Make this a substantial paragraph and justify each decision.

Conclusion. The team should write a substantial concluding paragraph that summarizes the likelihood of success of the business based on this entire marketing plan (all eight components). After each component is graded, the team should correct the errors and resubmit a revised packet with title page at the semester's conclusion.

Note to Instructors Regarding Grading:

Each of the eight components may be valued at 20 points each (160 total points). The final packet of the eight revised components and cover sheets may be valued at 10 points. It is recommended that the instructor assign points for team peer evaluations at the end of the semester. The peer evaluation may be worth 20 points. The entire assignment may be valued at 190 points.

Fashion Retail Promotional Plan

The purpose of the promotional campaign assignment is to introduce students to the process of planning a lengthy promotional event at the store level. With an assigned group, develop a proposal for a four- to six-week promotional campaign that benefits a fashion store and a charity. The team project must include a fashion show and one other special event. The following information will be included in the assignment: synopsis of the promotional activities, calendar of events, budget, theme, description of the target market, retailer and charity, key personnel, advertising media, giveaways and prizes, fashion show and runway sketch, sample commentary cards, and descriptions of other promotions. A written report and an electronic presentation are required.

Write each section in third person, avoiding the use of the words "you" or "your." The promotional plan is not for the store's target customers to read. Imagine that this presentation will be evaluated by the store officials who make the decision whether or not to fund the planned promotional activities. The instructor may ask teams to submit each section as it is written, so he or she can check for comprehensive content and make suggestions for revisions. Teams will submit one final copy for grading.

The following section is an explanation of the required contents for the promotional plan:

1. Cover page with catchy title of theme, graphic, and team members' names.
2. Selling synopsis. Write this last. It is a summary sheet of the entire promotion. Weave together one or two key sentences or concepts from each of the components.
3. Five measurable objectives. This may include a percent increase in sales during the promotional period, increase in store traffic by X%, increase in credit applications (give percent or numeric increase), number of items sold, number of attendees at the special event, party bookings, gift registries, money raised at the charitable event, number of people signed up for a drawing or any other important measurable improvement. Include numbers, quantities, percentages, or some other quantifiable figure in each objective. For example, the objective of the promotional plan is to increase store sales by X%, increase store traffic by Y%, book Z parties during the month, and so forth.
4. One- to two-month calendar. The calendars are template pages of all important dates, times, advertising schedule, and events. Include fashion show date and time, commentator's arrival and length of his or her stay, dress rehearsal date and time, model fittings, date and time of second special event, employee training schedule, advertisement break date and length of run, in-store display dates, and any other dates and times of importance.
5. Expense budget. Categorize budget items for ease of reading, such as decorations, print advertisements, broadcast advertisements, facilities (banquet hall or arena/concert hall) expenses, food expenses, and so forth. For example, the team might group several subtopics (such as catering fee, servers' salaries, number of hors d'oeuvres trays, etc.) under the heading Food Expenses. Ideas for budget items include commentator's fee, facility and equipment rental, carpentry, food, advertisements, flyers, printing fees, gifts and giveaways, music/band, models' fees, dry-cleaning, and so forth. If

an item is at no charge, it should still be included in the budget, with the amount listed as no charge or n/c.

6. Theme. Why did the group choose this theme? Explain the title of the promotion and why this is a nice fit for the store and charity. Why does it represent the selected target customer and charity? What will be the contribution to the charity? It might be a percentage of sales, proceeds from an event, merchandise donations, or some other in-kind payment. Explain. How will the funds be raised? Will there be cosponsors, such as other stores or companies, such as airlines?

7. Target customer. Describe the demographics and psychographics of the target customer segment. Use several demographic and psychographic terms to describe the target customer. Is this the same as the store customers, or will the promotion be reaching a different/broader audience? Explain.

8. Retailer and charity. Explain the decision behind choosing the particular charity for this promotional campaign. Why does the selection of the retailer fit well with the selected charity? Is there a history of a relationship between the store and the charity? How will the retailer benefit from the association? Does this charity commonly benefit from these types of fund-raisers? How does the charity usually get its funding? Peruse the charity's Web site to see about its annual donations. How important is this event's anticipated contribution to the charity?

9. Personnel. What key people will be participating in this campaign, and what are their roles? This might include a celebrity, commentator news personalities, store manager, buyer, department manager, salespeople, and models. List each important role and explain that person's responsibilities.

10. Location, date, and time of important events. This is not a separate section but make sure these are incorporated into at least one of the other parts.

11. Advertising. What media will be used and why? Discuss both the in-store and mass media advertising and visuals. Will there be special displays or store signage? What are the dates of the advertising? Advertising dates and visual display setup dates will also be located on the calendar.

12. Promotional items. This section discusses the giveaways and prizes. Describe any items to be given away or auctioned. Describe discounts or other incentives the store will offer to increase store sales. Justify these decisions. If the store has negotiated for cooperative funds, explain this, too. For example, an airline might donate a trip for two, or a travel store may donate a luggage set. Cross-check the promotional items from this section with the budget and calendar. Make sure the items appear on both.

13. Fashion show setup (room and runway layout). Include chair or audience locations, speaker podium, entrance and exit traffic flow arrows, and so forth. This can be developed on the computer, or the team may locate a good runway picture on the Internet and use it.

14. Fashion show description. Where will the fashion show be held, and why did the team choose this location? Justify the choice of commentators. What is the type of music? (The team may list a few songs or artists) Are there door prizes, and how will these be given away? The giveaways are probably addressed in an earlier section but need to be mentioned at least briefly. How long will the fashion show last? How many outfits (estimate thirty seconds per outfit)? What decorations will be used and why? Describe these in detail.

15. Two commentaries for the fashion show. Creatively write two commentaries with a minimum of six sentences per commentary, describing the model's outfit, features and benefits, brand name, and so forth (see following sample commentary). It is not necessary to write commentaries for every outfit.

16. Second special event description. Explain another major special event to be featured during the promotional campaign and justify why the team chose this promotion. Examples of other special events include artisans, craftsmen, exhibits, celebrity appearances, grand prize giveaway, workshops, demonstrations, tasting party, VIP event, after-hours activity, sponsorship of dance/concert/ballet and so forth, or any other creative activity that meets the team's objectives.

▶ Fashion Show Commentary Tips

When writing a fashion show script, use concise, interesting, and informative descriptions of the merchandise. Refer to specific details as they relate to current fashion. Keep sentences short and consider using incomplete sentences when appropriate. The commentary should be no less than six lines in length and no more than eight lines in length. It should be neatly typed within a three- by five-inch rectangle that can be attached to a note card.

The cards will be attached to each outfit prior to the show, and the model will carry the card to the runway where he or she may hand it to the commentator. Always bring extra blank commentary cards on the day of the show, just in case a garment is changed or the model loses the card. Be prepared!

An ideal source of key phrases is current fashion magazines and mail-order catalogs. Usually, these materials contain contemporary wording and fashion descriptions. The commentary may also suggest a use for the garment, such as an interview suit, versatile, day-to-evening dressing, and so forth. Mention the retailer's name at the beginning and the end of the commentary and the model's first name near the beginning of the commentary.

Mention points that are not obvious to the audience. For example, a commentary should mention that turquoise is the most popular color of the season or that turquoise enhances the wearer's coloring. These are benefits rather than features. A feature would be merely mentioning that the dress is turquoise.

Sample commentary 1. Jennifer Smith looks like a homecoming queen in this ensemble from the Bookstore. Perfect to wear with her favorite jeans, this cotton tee sports the fashionable university logo. Jenny has paired the tee with a lightweight windbreaker for the evening football game. Expecting rain? No problem. The water repellent nylon microfibers will keep her dry, and the concealed hood can be used in an emergency. There's even a hidden pocket for her student ID and extra cash! Thank you, Jennifer.

Sample commentary 2. Imagine yourself—a graduate with a professional résumé and this power suit! The job is a cinch! Where to find this suit coat and slacks? The Dillard Department Store in the mall. John Jones, a Marketing senior, models this European-styled outfit in a wool/polyester blend. It has just enough polyester to resist wrinkles, but an ample amount of lightweight wool to be fashionable. Christian Dior suits like this can be found at Dillard's. Good luck, John!

17. Electronic slide presentation that highlights only the important information. The team should not try to recreate the calendar, advertisements, or every budgeted item. The team will present an overview of the most interesting concepts. Limit the number of words per slide to fewer than 25. Do not exceed 40 slides total. Pictures, charts, and limited words are best on a slide show. Dress professionally on the team's presentation date and make sure each team member has an equal part in the presentation.

18. Use the peer evaluation to assign grades to the other group members. Please wait until after the oral presentation to peer evaluate.

Promotional Plan and Electronic Presentation Grading Sheet for the Instructor

Names_____ and Presentation _____

Oral Report and Electronic Presentation	Possible Points
Professionalism of group members	5 _____
Visibility of slide information	5 _____
Slides discussed, not read word for word	5 _____
Number and content of slides are adequate/appropriate	5 _____
Pictures/illustrations	5 _____
Written Report	**Possible Points**
Selling synopsis	5 _____
Objectives	5 _____
Calendar	5 _____
Budget	5 _____
Theme	5 _____
Target customer	5 _____
Retailer and charity description	5 _____
Charity description	5 _____
Personnel	5 _____
Location, date, time	5 _____
Promotional items	5 _____
Advertising	5 _____
Fashion show room and runway sketch	5 _____
Fashion show description	5 _____
Sample commentaries	5 _____
Special event description	5 _____
Total	100 _____

Confidential Peer Evaluation for Promotional Plan and Electronic Presentation*

If you were an instructor, what percent grade (0–100%) would you give your partners who helped write your promotional plan and electronic slide presentation? (It can be any whole number, such as 74%, 87%, or 95%). Please justify your decision. (You may want to evaluate the student's strengths and weaknesses)

*No students will see this (not even your partners), so be honest in your evaluation. List each partner, the grade percent he or she deserves, and a justification or explanation.

Sample Résumés, Cover Letters, and Interview Questions

<div style="border: 1px solid black;">

Name
Address

Objective:	To obtain a career in the fashion apparel industry	
Education:	Northeastern State University	City, State
	Bachelor of Science in Human Environmental Sciences	
	Expected date of graduation: May 2010	
	Major: Fashion Marketing	
	Minor: Mass Communication	
Honors:	President's Honor Roll	2008–2009
	Dean's Honor Roll	2006–2008
	Freshmen Scholarship Recipient	2006

Related Course Work:

- Interior Design
- Fashion Buying
- Visual Merchandising
- Fashion Marketing
- Fashion Accessories
- Textiles
- Clothing Fundamentals

Experience:	Sales Associate	
6/09 – present	American Eagle Outfitters	City, State

- Operate a cash register
- Assist with customer service
- Manage inventory control

5/07 – 5/09	Sales Associate	
	Wal-Mart Inc.	City, State

- Merchandise the men's clothing department
- Assisted with customer service

Skills:	Microsoft Word, Excel, PowerPoint	
Affiliations:	Phi Sigma Kappa Fraternity	2007–2010
	• President	2008–2009
	Intrafraternity Council	2008–2009
Activities:	NSU Fashion Association	2007–2010
	NSU Young Democrats	2006–2008
	Northeastern Student Government Association	2006–2008
	Rookie Bridge Camp Volunteer	2007
References:	Provided Upon Request	

</div>

Sample Student Résumé #1

ADDRESS • PHONE • E-MAIL

NAME

EDUCATION

Northeastern State University City, ST
Bachelor of Science, Family and Consumer Sciences
To be conferred May 2010
Major: Fashion Marketing
Minor: Marketing

WORK EXPERIENCE

Dillard's Inc. City, ST
Sales Associate October 2008–Present
• Open/Close register, assist customers, merchandise area, and work with vendor representatives.

Frederick's of Hollywood City, ST
Store Assistant Manager June 2007–August 2008
Sales Associate Manager September 2006–June 2007
• Opened/closed store, merchandised floor, and received shipment.

Smith Electric, Inc July 2004–August 2006 City, ST
Office Assistant
• Payroll, Accounts Receivable, and Accounts Payable.

HONORS AND ACTIVITIES

• Fashion Association—President	2008–2009
• Career Day Student Competition: Trend Board	2008
• Attended International Apparel Mart Career Day	2008
• Student Activity Award—NSU	2007
• Set Committee, NSU Fashion Show	2007
• Attended New York City Cultural Trip	2007
• Student Representative for the Business & Technology Strategic Planning Committee	2006–2007

REFERENCES AVAILABLE UPON REQUEST

Sample Student Résumé #2

Name
Address

1300 N. Jones Ave., Apt. 4, City, ST Zip Code (XXX) XXX-XXXX e-mail

Objective:	To obtain an entry-level position as an interior design assistant with the goal of becoming a professional interior designer		

Education:
Northeastern State University City, ST 2008–2010
- Major: Interior Design Minor: Art
- Major GPA 3.5

Junior College City, ST 2006–2008
- Associates of Arts
- GPA 3.4

Honors:
Dean's Honor Roll – two semesters
Who's Who Among American High School Students – three years

Experience:
11/09–Present

<u>Office Assistant</u>
Northeastern State University, Art Department City, ST
- Maintain academic records
- Entrusted with confidentially
- Organize laboratory procedures

Summer 08
Summer 07
Summer 06

<u>Beach Captain</u>, <u>Snack Shop Lead</u>, and <u>Operations Hand</u>
Canoe Rental Resorts City, ST
- Assisted hundreds of people daily • Handled large sums of cash
- Balanced cash registers • Managed inventory

December 05

<u>Sales Associate</u>
Stage Stores City, ST
- Personal assistant • Customer service
- Visual merchandising • Closed the store

Lifetime

<u>Decorator</u>
- Decorated new home
- Assisting friends with decorating tips
- Following latest home fashion trends

Relevant Coursework:
- CAD for Interior Design • Textiles
- Interior Design • Profitable Merchandising

Skills:
- Microsoft Word • Microsoft Excel

Affiliations:
- General Hospital Volunteer (decorating for holidays), 2005–2007
- Northeastern State University Softball Team, 2008–2010
- Junior College Softball Team, 2006–2007

References provided upon request

Sample Student Résumé #3

<div style="border: 1px solid black;">

Name
Address

1300 N. Jones Ave., Apt. 4, City, ST Zip Code (XXX) XXX-XXXX e-mail

Dr. Jill Smith, Associate Professor of Marketing
 Department of Business Administration
 Main Hall 203
 Street Address
 Northeastern State University
 City, ST Zip Code
 (XXX) XXX-XXXX

Ms. Jane Doe, Hall Manager
 Department of University Housing
 South Hall 101
 Street Address
 Northeastern State University
 City, ST Zip Code
 (XXX) XXX-XXXX

Mr. John Jones, Assistant to the Dean of Student Affairs
 Department of Student Affairs
 Administration Bldg. 204
 Street Address
 Northeastern State University
 City, ST Zip Code
 (XXX) XXX-XXXX

</div>

Sample Student Reference List

Date

Your Name
Address
City, State, Zip Code
(XXX) XXX-XXXX

Mrs. Mary Smith, Owner
Fashionable Stylist Enterprises
Address
New York, NY 10001

Dear Mrs. Smith:

I am writing in regard to the intern position at Fashionable Stylist Enterprises. I heard about this position through a magazine article that I read in *Vibe Magazine.* I feel that I can offer the skills of diversity, creativity, and great public relations, which are vital to a successful company.

Recently, I have partnered to organize a small volunteer stylist company, called PB Stylist and Company. In the past few months, we have created campus gigs to share our fashion tips with the Mr. Fraternity Pageant and the Miss Northeastern State University Pageant. We are currently working on building our portfolio with a diverse group of fellow students on campus. This internship will sharpen my creativity and provide insight to owning and operating a stylist company. I can offer you a hardworking individual with the drive to succeed. I am willing to work most days to gain knowledge of the industry.

As you can see by the enclosed résumé, my previous education and work experiences are a good fit with your company. I am excited about this position and look forward to meeting with you. I will call you next week to discuss the possibility of an interview and answer any questions you might have. Thank you for your time.

Sincerely,

Your Signature in black ink

Your Name

Enclosure

Sample Cover Letter #1

March 24, 20XX

Your Name
Address
City, State, Zip Code
(XXX) XXX-XXXX

Mrs. Mary Smith, Marketing Manager
Galleria Mall
Address
City, State, Zip Code

Dear Mrs. Smith:

Please accept the enclosed résumé as my application for the Events Coordinator internship. I am confident my experience in public relations and my training in fashion marketing can benefit the Galleria's marketing and promotional goals.

Club participation has made up a large portion of my college experience. Elected by my fellow peers, I have held several leadership positions over the years. My favorite experience has been participating in the annual student fashion show. As chairperson for the merchandise committee, I took the initiative to contact the stores featured in our show. After permission was granted to feature the merchandise, we picked up the items and took full responsibility for their safe return. The show was fantastic! We modeled the merchandise, wrote commentary cards to identify the apparel, and made sure everything was returned to the proper stores by the next day.

I pride myself on managing my time in an organized fashion. I completed college in 3½ years and maintained a high GPA. In addition, I became involved in many clubs and college events. During part of my college career, I actually had to work two jobs, while maintaining 16 or more hours in school. Holding leadership positions in clubs also requires much organization on my part. As secretary/treasurer of the Fashion Association, I was required to keep accurate records of all meetings and was responsible for keeping track of money collected and making deposits.

As you can see from my enclosed résumé, I have many valuable qualities to bring to this position. I look forward to hearing from you and will contact your office to schedule an interview within the week.

Sincerely,

Your Signature in black ink

Your Name

Enclosure

Sample Cover Letter #2

Sample Interview Questions

1. What are your short-term goals?

2. How are you preparing yourself to achieve these goals?

3. What are your long-term goals?

4. If you could do anything, what would you choose as a career?

5. Why did you choose your field of study?

6. Why did you select your college or university?

7. What were your favorite and least favorite courses in college? Why?

8. Tell me about your time management skills and your success at meeting deadlines.

9. What college activity was most rewarding?

10. Tell me about your participation in extracurricular activities.

11. If you could make any change at your university, what would it be?

12. What percent of your college expenses did you pay?

13. What do you expect to learn at our company?

14. What will you contribute to our company?

15. Can you give me an example of when you worked as a successful member of a team? What problems did you encounter?

16. What starting salary do you require and how much do you expect to be earning in five years?

17. Why did you choose to apply with our company?

18. What are your strengths and weaknesses?

19. How might an employer or professor describe you?

20. What motivates you to put forth your greatest efforts?

21. Why should I hire you?

22. Convince me that I should hire you over the other candidates.

23. Do you have experience managing people? Tell me about your management style.

24. What might make you leave this job?

25. What are qualities of a successful manager?

26. Have you ever had problems with a manager in the past?

27. What have you learned from your mistakes?

28. Describe the ideal relationship between a supervisor and subordinates.

29. What are two or three personal qualities or accomplishments that you would want others to know?

30. If you were hiring a graduate for this position, what qualities would you look for?

31. What might you offer our company?

32. How do you feel about travel/relocation?

33. Do you think that your grades are a good indication of your academic success?

34. How do you handle pressure at work and at home?

35. Describe the ideal job.

Accessories—Men's neckties, pocket squares, jewelry, watches, socks, hosiery (dressy socks), shoes, hats, scarves, and gloves.

Adinkra cloth—An African printed fabric covered with hand-stamped symbols. This cloth can be identified by bold symbols such as a spiral curl, a geometric shape, or a representation of an animal.

African Growth and Opportunity Act—Part of the larger Trade and Development Act of 2000, it established duty-free trade for many of the forty-eight sub-Saharan African countries and the United States. The benefits of the African Growth and Opportunity Act included two-way trade and investment opportunities in African countries.

Agreement on Clothing and Textiles (ACT)—Implemented to begin the phasing out of MFA quotas on textiles and apparel over a ten-year period.

American Look—A style of casual simplicity that evolved after World War II when U.S. retailers collaborated with Italian fashion design.

Antidumping Legislation—Laws enacted to protect against the problem of dumped goods.

Arkwright machine—Textile machinery that could card, rove, draw, and spin cotton fibers into strong yarns with uniform length.

Art nouveau—A sinuous or swirling and flowing style of art interpreted into the silhouette and embellishments of early twentieth century clothing.

Artificial obsolescence—Refers to the demise of a perfectly serviceable item in favor of a newer one that seems more attractive than its predecessor.

Ateliers—A sewing workroom.

Beatniks—A term which gained popularity in the 1960s for people of the late 1950s and early 1960s who rejected or avoided conventional behavior, dress, etc.

Behavioral segmentation—The classifying of customers by similar purchasing intents and behaviors.

Bell-bottom pants—A style of flare-legged blue jeans which gained popularity in the 1960s and 1970s. Also the uniform pant style of the Navy, during both World Wars.

Bespoke tailoring—A British term for the process of custom tailoring a man's clothes to his specific measurements.

Bilateral agreement—When two countries enter into an agreement to engage in trading goods and services based on predetermined rules.

Black Friday—The day after Thanksgiving; traditionally the largest in-store shopping day of the year.

Blazer—A solid-colored sport coat, often with brass or ornamental buttons.

Bling—Large, flashy jewelry and gemstones worn as part of the "gangsta" style.

Boutique—French word for "little shop."

Brand—A word or symbol that identifies the source of goods or services and differentiates it from the competitor's goods or services.

Brand equity—The end result of a company using advertising and promotions to convince consumers that their brand is somehow of greater value than others.

Brand franchise—Another term for brand equity.

Brand reinvention—Similar to repositioning but it usually involves resurrecting a brand that has been dormant or obsolete for quite some time.

Branding—The way a store, label, or designer impresses customers and influences their perceptions of the brand.

Break—A slight crease that occurs when pants rest lightly on the top of the shoe.

Bubble-up process—A term coined by Polhemus to describe the trickle-up influence of street style on fashion.

Business plan—A written document containing a description of the business, the marketing and management of the business, and the financial data for the business.

Bustle—A structural "dress improver" made of stiff horsehair ruffles or wires shaped to create back fullness.

Caged crinoline—A bell of bouffant-shaped skirt undergarment made of graduated sizes of lightweight steel hoops held together by narrow cotton tape.

Carbon footprint—A measure of carbon dioxide or greenhouse gas emissions from business or personal use.

Care Labeling Rule—Standardized care requirements for garments to ensure that consumers are able to properly care for their clothing with the least expensive appropriate method.

Caribbean Basin Initiative—A broad term for Caribbean Basin Trade Partnership Act.

Caribbean Basin Trade Partnership Act—Provided approximately two dozen countries or territories in Central America with an opportunity to more fairly compete with Mexico in supplying goods to the United States.

Cashmere—One of the most luxurious wool fibers, made from the underhair of the silky-haired Kashmir or Cashmere goat.

Casual athlete—A person who chooses active sportswear clothing for everyday wear.

Casual Friday—The loosening of office dress codes on Friday to raise employee morale.

Casual sportswear—Clothing for men including prehemmed pants, shorts, woven and knit shirts, T-shirts, sweaters, vests, and other apparel purchased as separates.

Cellulose fibers—Fibers derived from plant material such as cotton or flax.

Central American Free Trade Agreement (CAFTA-DR)—A multicountry partnership designed to benefit the domestic industries (including textiles and apparel) in the United States, Dominican Republic and five Central American countries: Dominican Republic, El Salvador, Guatemala, Honduras, Nicaragua, and Costa Rica.

Chambre Syndicale de la Couture Parisienne—The French association that manages the Paris haute couture and protects the culture industry.

Channel of distribution—The process of moving fashion merchandise from its conception to the ultimate consumer through the supply chain.

Chase and flight—The lower class chases or imitates the fashions of the upper class, and the upper class differentiates or flies toward a newer fashion.

Chemise—A slender, tubular, and unfitted dress silhouette.

Chic—Clothing that is attractive and fashionable.

Circular knitting machine—A device which creates a seamless tube of fabric that can be used for socks and hosiery, thus eliminating the back seam.

Classic—A fashion that remains popular over a relatively long period of time.

Client services coordinator—One who works for an outsourcing company and is responsible for coordinating part-time merchandisers working out in the client retail stores.

Codes of conduct—Written policies to define ethical standards for companies. See also corporate code of conduct.

Collective selection theory—Proposed by Herbert Blumer, it explains how fashion change and adoption are a type of social conformity. That is, fashion is created by the collective tastes of a majority.

Community shopping center—Broader in size and scope than a neighborhood shopping center. Convenience and a general merchandise selection characterize these centers.

Comparative advantage—The principle that each country (no matter how small) can make money by producing and trading something with other countries in the world.

Competitive advantage—Another term for unique selling position (USP).

Competitive edge—Another term for unique selling position (USP).

Conspicuous consumption—The desire to select fashion expenditures that look expensive.

Conspicuous leisure—The affluent person appears idle and without work, yet he or she can somehow afford to enjoy leisure time and seems to have the means to do so.

Consumer Price Index (CPI)—A measure of the average change over time in the prices paid by urban consumers for certain apparel items.

Consumer Products Safety Commission—An independent federal regulatory agency created in 1972 under the Consumer Products Safety Act. The agency protects consumers from unsafe products, including textiles and apparel that may seriously harm their families.

Convenience center—A shopping center containing retailers that provide for day-to-day needs, such as a supermarket or grocery store, a convenience store or mini mart, and perhaps a bakery, dry cleaner, or other service providers.

Cooperative advertisements—Common in the introductory and rise stages; the manufacturer and retailer split the cost of the new product advertisement.

Core competency—Another term for unique selling position (USP).

Corporate casual—The idea that it is acceptable for office employees to dress casually for work on a daily basis.

Corporate code of conduct—A list of do's and don'ts; necessary human rights policies that all apparel businesses should follow. See also codes of conduct.

Corporation—A group of persons granted a state charter legally recognizing their company as a separate

entity having its own rights, privileges, and liabilities distinct from those of its members.

Cost—The amount a retail store pays for the merchandise it offers for sale in the store.

Costing out a garment—The process in which a production team factors in every cost involved in making a piece of apparel. The final number is the "wholesale cost."

Cotton boll—The pod of a cotton plant that contains the seed from which cotton fibers grow.

Cotton gin—A machine that separates the seeds, seed hulls, and other small objects from the fibers of cotton.

Counterfeiting—The illegal practice of creating replica merchandise of any quality to resemble the genuine brands.

Counterfeits—Illegal fakes that are intended to look like authentic originals.

Country of origin—The geographic location where the substantial transformation, garment assembly, or sewing occurs.

Couturières—Female fashion designers.

Couturiers—Male fashion designers.

Culmination or peak stage—A time when a large percentage of a population is wearing a fashion; everyone who wants the fashion wears it.

Customer base—Another term for a store's target customers.

Cutter—The person responsible for trimming fabric around the pattern pieces that have been laid on the fashion fabric, which continue on to the assembly stage.

Cyber Monday—The virtual version of Black Friday, often the largest online shopping day of the year. On the Monday after the Thanksgiving holiday, office employees return to work and sneak in a little Web time shopping online from their office computers.

Dandy—A word originally used to describe George Bryan "Beau" Brummell, who set many standards for fashion and style in eighteenth century England.

Dandyism—The condition of a man who is overly concerned with his clothing, appearance, and wearing the latest fashions.

Database marketing—The process of extracting and interpreting customer data from available electronic information in order to target specific promotional campaigns to keep the customers satisfied.

Decline stage—Occurs when there is a reduction in the number of people buying the fashion. Consumers may still wear the fashion, but declining sales force retailers to reduce prices on the fashion goods that remain in the store.

Democratization of fashion—The development of fashion becoming affordable for most people. The fashion principle "fashion is not a price" exemplifies the democratic nature of fashion apparel.

Demographic variables or demographics—Criteria used for market segmentation, including gender, age, occupation, income, education level, marital status, and many other quantifiable or objective statistics.

Denim—A fabric which originated in Nims, France; popularized by Levi Strauss during the California Gold Rush.

Department store—Store with separate departments for various merchandise lines, such as apparel, jewelry, home furnishings, and linens, each with separate cash registers and sales associates.

Designer—One who creates fashion ideas.

Designer brands—Similar to national or multinational brands, they bear the name of the original designer, have widespread appeal, and may be available in a variety of competing stores. Designer brands may have regional, national, or global distribution.

Direct marketing—Communication to a consumer or business recipient that is designed to generate a response.

That response includes making a purchase, visiting a store, ordering from a Web site, or simply requesting more information.

Disposable fashions—Trendy, inexpensive fashion items that are meant to be worn for a single season and then discarded.

Distribution—One of the 4 Ps of marketing; another term for place. Refers to the channels through which goods are distributed, including vending machines, retail stores, and Internet.

Drop—The difference between the suit coat chest measurement and the trousers waist measurement.

Dumping—The practice of selling goods in another country below the cost of manufacturing or below market price in the country of origin.

Duty or import duty—A tax that must be paid to the domestic government on foreign goods imported into the country to protect domestic production of competing goods. It is a percent of the declared value of the goods being imported.

Duty-free—A tax-free import.

Early adopters—Comprises the second group of consumers who wear the fashion. The early adopters may not desire to be the very first to wear a fashion, but they enjoy wearing the very latest fashions.

Early majority—The large group of consumers who adopt a fashion before, during, and slightly after the peak of the fashion life cycle.

Ellis Island—Located off the southern tip of Manhattan, it became the official U.S. government site to process newly arrived immigrants.

Embargo—Refusal of goods when quota limits have been reached.

Emotives—"Emotional motives"; tool used in a marketing campaign to convince consumers to purchase a certain fashion.

Entrepreneurship—The venture of owning one's own business in order to make a profit.

E-tailing—Electronic retailing using the Internet as the medium to display the merchandise, provide product information, receive customer orders, process payments, and arrange for delivery.

Export Advantage—An informational resource staffed by trade specialists that assists domestic producers and manufacturers with exporting U.S. textiles and apparel products.

Export agent—A wholesaler who arranges the transfer of goods from his or her home country to a foreign nation.

Exports—Goods shipped out of the producing country.

Extant—Still existing.

Fabrics—Material created from loose fibers that are processed and spun together into yarns. Yarn manufacturers then weave or knit the yarns into fabrics.

Fad—A fashion characterized by a quick rise to popularity and an even more rapid decline.

Fair Labor Standards Act—A U.S. federal law that applies to employees engaged in interstate commerce or employed by an enterprise engaged in commerce or in the production of goods for commerce.

Fashion—An item that is accepted and worn by the majority of a group.

Fashion adoption curve—Depicts the process by which a fashion undergoes the stages of introduction, a period of growth, and a period of decline in popularity.

Fashion adoption process—Refers to the process in which a fashion undergoes the stages of introduction, a period of growth, and a period of decline in popularity.

Fashion count—A research method of determining how many persons are wearing a particular fashion at a certain time and place.

Fashion curve—Another term for fashion adoption curve or fashion life cycle.

Fashion dolls (jointed babies, mannequins)—Historic wood-carved, anatomically correct figures historically dressed as precise miniature replicas of French couture fashions, complete with necessary accessories and real hair styled in the latest colonial fashion.

Fashion followers—People who pursue the fashions and trends started by fashion innovators.

Fashion innovators—People who start fashions and trends.

Fashion life cycle—Another term for fashion curve.

Fashion market center—A geographic hub of fashion activity that includes a high concentration of manufacturing companies, fashion company headquarters, and permanent wholesale showrooms.

Fashion marketing mix—The correct combination of the "4 Ps" of marketing: Product, price, place, and promotion which is uniquely based on the store's target customers' preferences.

Fashion plates—Two-dimensional engravings of fashion designs that were used to inform fashion customers in remote regions of the popular styles.

Fashion research—A systematic method of collecting and analyzing data about a problem and then making a decision based on the findings. Appropriate fashion research might include style testing to see whether the target customers prefer a traditional button-up style, a sleeveless or short-sleeved style, or any other style under consideration.

Fashion systems theory—Explains how fashion information flows throughout the fashion industry. It works from the premise that the fashion system is a complex entity comprised of a collection of organized parts that are interrelated and form a whole system that is greater than the sum of its parts.

Fast-fashions—Trendy, inexpensive fashion items that are meant to be worn for a single season and then discarded. Also know as disposable fashions.

Faux—A French word meaning "fake." Wearing *faux* pearls and other fake jewelry was encouraged by Coco Chanel.

Federal Trade Commission (FTC)—Established in 1914 to protect U.S. consumers and ensure fair trade in a competitive environment. The Federal Trade Commission directs several laws related to the textiles and apparel industries and amends rules and regulations.

Fibre flax or linen flax—One of many varieties of the flax plant. Fibers are spun into yarns and woven together to produce linen fabrics.

Filament fibers—Long fibers resembling silk.

Finish and inspection—A final check of a garment to ensure it is ready to be shipped to a retailer. This may include pressing the seams, clipping extra threads, buttoning the buttons, steaming the garment, inserting hangers, attaching sensors, tagging the merchandise, and any other finishing steps to ready the apparel for shipments to retail stores or warehouses.

First quality merchandise—Normal merchandise with no significant defects.

First sample—A rough draft or prototype in fashion fabric in a common size, such as size 8 or 10.

First-through-production patternmaker—One who creates the very first sample pattern based off of the designer's sketch and sees its progress through to the finished pattern used in mass production.

Flammable Fabrics Act—A law that protects consumers from the manufacture and sale of highly flammable or torch-like fabrics. It requires rigorous testing procedures before any articles of wearing apparel and

home fashions, such as carpets, rugs, mattress pads, and mattresses, can be sold.

Flapper—A 1920s term for a modern, energetic, young woman with few social inhibitions.

Focus group—A semistructured environment that allows the researcher to gather in-depth information from the respondents on their buying habits, opinions, and attitudes toward the brand or product.

Forced-choice questions—A survey format in which the respondent chooses the most appropriate response from a predetermined set of responses.

4 Ps of fashion marketing—Product, price, place (distribution), and promotion. The intended target customer determines the combination of the 4 Ps.

Free trade agreement (FTA)—A bilateral or multilateral pact with one or more nations to pen markets and expand opportunities to compete in the global economy.

Fringe sizes—Sizes on either end of the predominant size range; sold to accommodate a broader market segment.

Full fashioning—The process in which knit stitches are dropped to create a tapered and shaped section of stockings; eliminates the need for cutting and sewing in these areas.

Full price—The circumstance in which the initial markup is equal to the maintained markup. The item sold at the original price without a markdown.

Fur fibers—Term used for the individual fibers removed from the pelt of an animal (such as with rabbits and beavers).

Fur Products Labeling Act—Established by the Federal Trade Commission; overall, the Act establishes standardized definitions to be used in the industry, requires the country of origin and true English name of the animal, and regulates branding, the disclosure of fur treatments, and advertising.

Furnishings—Neckties, pocket squares, jewelry, watches, socks, hosiery (dressy socks), shoes, hats, scarves, and gloves. Another term for men's accessories.

Gangsta—A branch of hip-hop style including streetwear and tough-guy fashions, such as baggy or sagging jeans, large T-shirts, chains, and do-rags or bandanas on the head.

Garment district—An irregular-shaped geographic area near the center of New York City that gives credence to New York as a vital market center in the United States. The approximate area extends from 35th Street to 41st Street and from 5th Avenue to 9th Avenue.

Geographic segmentation—The process of dividing the market into groups according to a particular region. People or companies residing in a similar region often have similar purchasing habits and therefore can be grouped together in a single segment.

Geographic theory—States that fashions begin in heavily populated metropolitan areas where there is considerable emphasis on fashion.

Ginning—The process of separating seeds from the lint during cotton production.

Global brands—Span geographic boundaries and may be available at stores throughout the world.

Going to market—An event for store buyers to select the merchandise that will be sold in their stores during the upcoming season. This event is usually housed in a facility large enough to accommodate booths or showrooms of hundreds of vendors who represent and sell for manufacturers of apparel and accessories.

Goods—Tangible items, such as a T-shirt, trench coat, or a pair of khaki slacks.

Goth—A look that includes black clothing, wide-legged jeans, liberal use of chains, blue-black dyed hair that contrasts with pale skin, heavy eyeliner, and black fingernail polish.

Gothic—A term which gained popularity in the 1990s and described a rebellious young person who preferred antifashion.

Graded—The process whereby a master pattern is increased or decreased to larger or smaller sizes.

Grunge—A unisex style that became mainstream early in the 1990s and generally appeared as a dilapidated style that had its origins at thrift stores.

Hand—The feel of a textile to touch.

Haute couture—The most exquisite and finely-crafted high fashion clothing.

Heimat—A German word that refers to maintaining a variety of traditions from the home country, including dressing in traditional clothing as an outward expression of one's homeland.

High street fashions—Trendy, inexpensive fashion items that are meant to be worn for a single season and then discarded.

High-low—Completing an ensemble made from expensive fashions as well as inexpensive fashions.

Hip hop—An ethnic trend made popular by rappers from the inner cities in the 1990s.

Hippies—Large counterculture of the late 1960s and early 1970s. The term was derived from the word, hipster.

Historical continuity—Refers to the notion that new fashions evolve from the most recent fashions. They are most valued if the fashions only slightly vary from the previous mode.

Hybrid shopping center—Combines elements from two or more classifications, such as a mall or open-air center.

Hypothesis—An educated guess about the relationship between identified variables. It is a researcher's prediction of expected findings based on his or her own knowledge and related literature on the topic.

Import agent—An individual who arranges the transfer of goods from a foreign nation into a receiving country.

Imports—Goods brought into a receiving country.

Independently-owned wholesale showroom—May represent several noncompeting manufacturers' lines. The showroom representatives earn a percentage on what they sell to retailers.

Integrated marketing communications—A strategy for coordinating all of a company's available marketing tools to ensure that the company presents a united front and maximizes its communication impact.

Intellectual property rights—The protection of a person's or company's creative ideas for a certain period of time.

Internal merchandise coordinator—This person travels between stores, training and building relationships with store buyers and salespersons.

International Labor Organization—A global group given authority by the World Trade Organization to set and judge fair labor standards in all types of trade.

Internship—A meaningful work or service learning experience in which a student has intentional learning goals and is carefully monitored to enhance a positive learning environment.

Introductory stage—The beginning of the fashion life cycle when a group of experimental consumers adopt a new look.

Irregular quality merchandise—Merchandise with a slight manufacturing defect, but the wearability or usability is not affected.

Jobbers—Middlemen merchants who purchase and warehouse off-price merchandise for reselling to the retail trade.

Junior—A category for odd sizes, 1-15, and fit a more youthful figure, with smaller differences between the bust, waist, and hip measurements.

Junior petite—A size that accommodates females who wear junior sizes and are 5'4" or shorter.

Just-in-time (JIT) production—When goods are produced and delivered to stores immediately before the selling season.

Knitted fabrics—Made by creating interlocking loops in the yarn.

Knockoff—Anything ranging from a loose adaptation to a very similar adaptation of another design. Although legal, knockoffs can be frustrating for the original designer.

Laggards—The group of consumers who still wear a given fashion during the obsolescence stage.

Lanolin—A sheep's natural hair grease.

Late majority—The group of consumers who adopt a new fashion when it reaches the late culmination or decline stage.

Laver theory—A list of adjectives that aptly describe a particular style as it is coming into fashion, while it is in fashion, and when it is no longer in fashion.

Levi Strauss—A man who, during the California Gold Rush, transported yards of indigo-dyed cotton fabric to California and made them into work pants.

Licensed apparel—Clothing that bears the name of a well-known character, person, place, team, event, or other popular icon.

Licensing agreement—A legal agreement between the licensor and licensee.

Lifestyle merchandising—The creation of smaller, more intimate settings with narrowly focused offerings to attract customers who aspire to the lifestyle portrayed in the setting.

Lifestyle shopping center—A shopping center whose design is tailored to the style, architecture, and retail needs of individual communities.

Limited line specialty store—A subcategory of a specialty store that specializes in a very narrow product assortment.

Linen—A fabric woven from fibers obtained from a variety of the flax plant.

Linsey-woolsey—A combination of linen and wool fibers (or sometimes 100% wool) that the Scotch Irish immigrants introduced to the colonies.

Lint—Fibers collected from cotton bolls and then separated from the cotton seeds.

Long—A man's jacket whose length is usually one inch longer than regular.

Loom—A powered or hand-operated machine that is used to weave fabrics.

Loyalty programs—A system of rewarding a store's best customers—the people who spend the most and shop the most in that store.

Luxury brands—High-end or expensive brands afforded only by customers with significant amounts of discretionary income, or at least those who aspire to be affluent.

Made in the U.S.A.—In order to label an item "Made in the U.S.A.," companies must be able to verify and substantiate the claim that the goods were substantially transformed in the United States.

MAGIC—An acronym for the Men's Apparel Guild in California. MAGIC hosts several annual trade shows, including the MAGIC International Show.

Mall—A generally enclosed shopping center with a central walkway and ample parking around the perimeter.

Mall approach—A method for administering a questionnaire in which a research representative approaches a potential respondent who appears to fit the target customer profile. The research representative stops the shopper and begins the interview with a series of demographic questions to ensure the respondent is part of the target market.

Man-made or manufactured fibers—Fibers that are created from petroleum, such as polyester, nylon, and acrylic, or created from regenerated cellulose, such as rayon, lyocell, and acetate.

Manufacturer-owned wholesale showroom—A liaison for manufacturers and retail store buyers that represents only one manufacturer.

Manufacturer's overrun—Extra inventory that was manufactured in a sewing factory but was not sold to the company's regular retail store buyers.

Marker—A long paper cutting guide generated by a printer or plotter that ensures the best possible material yields (least amount of wasted fabric).

Market—A trade area from which target customers are segmented.

Market segmentation—The decision of a company to focus on a particular group of customers within a trade area or market.

Market test—A method for realistically gauging consumer response to the introduction of a new product in a smaller market area before expanding to a larger regional market or nationwide.

Marketing—All the activities, from idea conception to ultimate consumer use, that satisfy the objectives of the buyer and seller.

Marketing channel—A representation of all the levels of the fashion industry. It begins with the production of the raw materials used in the making of the fashion merchandise and ends with retailing the apparel or accessories.

Markup—The difference between the cost to the store and the retail price.

Mass customization—A marketing strategy that provides for some degree of customer design input into what is normally a mass-produced item.

Mass merchandise or discount store—Generally has four common characteristics: It is a large retail store with a high sales volume; it carries a broad merchandise assortment; it emphasizes self-service; and it offers bargain pricing.

Maxi dress—A floor-length dress popular at the same time as midi and mini skirts in the 1970s.

M-commerce—Marketing to the customer through his or her mobile technology, such as personal data assistants and cellular phones.

Media mix—The use of several advertising venues to reach the largest possible audience.

Medium—A single venue used to send the marketing communication to the target customer, such as radio broadcasts or newspaper print advertisements.

Merchandise coordinator—One who merchandises branded products to ensure visual or brand standards are upheld within the retail store.

Merchandising—Providing the right goods, at the right time, in the right quantities, and at prices consumers are willing to pay.

Metrosexual—A fashion-forward male who dresses with care in colorful clothing, hinting at a more feminine side.

Microfibers—Very fine, man-made filaments such as nylon and polyester.

Midi skirt—A dress with a mid-calf hemline.

Missy—Sizes of even numbers, 2–20, that fit average height women 5'5" to 5'6" with more curves than junior sizes.

Missy petite—Sizes that fit females who wear missy sizes and are 5'4" or shorter.

Mixed-use center—Combines retail space with other revenue-producing uses, such as office space, entertainment, hotel space, and sports facilities.

Modular manufacturing—A method of garment manufacturing where a small team of garment workers make a garment from start to finish.

Monobosom—A blouse style in which the bust area is extended from neckline to waistline, creating a pigeon-breasted look.

Monobrand—When a specialty store carries only one private label brand that bears the store's own name, such as GAP stores.

Multichannel retailing—Using multiple venues to reach customers; these include brick-and-mortar stores, Internet Web sites, mobile devices, and catalogs.

Multifiber Agreement (MFA)—Implemented in 1974 as a framework agreement that ruled world trade in textiles and clothing with quotas on specific items.

Multilateral agreement—When more than two countries enter into an agreement to engage in trading goods and services based on predetermined rules.

Multinational—A company that operates in one or more foreign countries.

Multinational brands—Span geographic boundaries and may be available at stores in several nations.

National brands—Brands owned by manufacturing companies and sold in a variety of retail stores. National brands have extensive distribution and recognition within a country.

Natural fibers—Fibers that grow from a plant source or are produced by a living animal.

Neighborhood shopping centers—Another term for convenience center.

New Look—A fashion movement (led by Christian Dior) in reaction to the apparel restrictions of World War II.

Niche market—A narrowly defined market segment, but not necessarily a small segment.

Niche marketing—Focusing on a narrow target customer base.

Nonstore retailing—When direct marketing takes place without requesting customers to take action within a physical facility, such as a store.

North American Free Trade Agreement (NAFTA)—An Act passed by Congress in 1994 that was designed to improve trade relations among the United States, Mexico, and Canada.

Obsolescence stage—The final stage in the life of a fashion. The general population rejects the purchase of the merchandise in this stage, and most retailers eliminate it from retail assortments.

Odd lot assortment—Less-than-complete assortment of styles, colors, or sizes.

Office of Textiles and Apparel (OTEXA)—Operates under the International Trade Administration within the U.S. Department of Commerce. The goal of OTEXA is to improve the global competitiveness of the U.S. fiber, textiles, and apparel industries.

Office of the United States Trade Representative—Organized in 1962, its purposes include negotiating with other governments to create trade agreements, resolving trade disputes, and maintaining a high level of involvement and visibility in global trade organizations, including the World Trade Organization.

Off-price—Apparel (or any merchandise) that is usually discounted 20 to 70 percent below the manufacturer's

suggested retail price. It is merchandise that features high profit margin potential for retailers and low prices for consumers.

Off-price store—Carries brand- or designer-name merchandise and offers it at a lower price than the manufacturers' suggested retail prices.

Open-air center—A shopping center without enclosed commons areas or walkways lining the stores, although storefronts may have connecting canopies.

Open-ended questions—A survey format that requires more analysis but can provide the researchers with well-defined data because the respondents develop their own answers.

Open-to-buy—The amount of money a buyer is allotted for ordering merchandise from vendors at market.

Out of fashion—The condition of aging styles, prints, colors, and fabrics after new trends are established.

Outerwear—Overcoats, raincoats, and jackets.

Outlet shopping center—Comprised of off-price stores and other value-oriented retailers. Rather than anchor stores, popular off-price fashion stores selling name brand merchandise may serve as retail magnets to draw in customers.

Outsourced—Contracting with another business or resource (often outside the country) to provide a product or service used in the production of fashion merchandise.

Partnership—A legal relationship existing between two or more persons contractually associated as joint principals in a business.

Peacock revolution—A period during the 1970s when men's fashion became more colorful and effeminate.

Pecuniary—Having to do with wealth.

Piecework—A method of garment construction in which one person performs a single function of garment assembly.

Planned obsolescence—The continual introduction of new styles, prints, colors, and fabrics to keep up with the changing tastes of consumers. This makes the older styles, prints, colors and fabrics no longer desirable by consumers.

Plus—Sizes 1X through 10X. These are similar to the women's sizes 38–50 but have greater psychological appeal.

Polycentric—The idea that fashions originate from multiple groups defined by an age range, socioeconomic status, culture, or geographic region.

Populist model—An alternative to the systems model, it explains how fashions originate from more than one source.

Pop-up store—A temporary specialty shop or boutique that carries a small, but specialized category of merchandise.

Power brand—An important brand that is given exclusive space by a retailer.

Power shopping center—A shopping center containing numerous value-priced large stores, such as discount department stores, off-price stores, and big box stores.

Place—Another term for distribution; one of the 4 Ps of marketing.

Position—The image of a company's product in the mind of a consumer as determined by the combination of the "4 Ps."

Positioning—A deliberate attempt by a company to make consumers perceive the company and its products as being somehow different from the other companies competing for a similar market.

Prêt à porter—"Ready-to-wear," mass-produced lines of clothing offered by prestigious design houses in France.

Price—The determination of the retail value for a product.

Primary data—Statistical facts to answer a particular marketing research problem.

Primary target customer segment—The homogeneous group of customers that are most likely to buy from this store and who will spend the most money in the store. This is the core group of customers.

Private label brands—The store owns the brand. No other company can carry the brand without the store's permission.

Product developer—One who identifies and adapts previously successful concepts into marketable products.

Product development process—Involves the creation of marketable ideas that will appeal to the company's target customer, or the process may involve private label knockoffs of branded designs.

Product diffusion curve—Refers to a pictorial diagram of the process in which a fashion undergoes the stages of introduction, a period of growth, and a period of decline in popularity; another term for fashion life cycle or product life cycle.

Product life cycle—Another term for product diffusion curve.

Products—A company's goods and services desired by the target customer.

Project manager—Responsible for the overall image of a department, the project manager's team works closely with the corporate visual merchandisers and the fashion buyers to enhance the in-store presentation.

Promotion—Includes all activities that build awareness, interest, traffic, goodwill, and ultimately encourage sales to the target customers; one of the 4 Ps of marketing.

Proprietorship—A business managed by a single owner, it is the easiest type of business to start. This type of business ownership entitles the owner to all profits from the business and allows the sole proprietor to make all business decisions.

Protein fibers—Fibers such as wool and silk that are produced by animals; wool grows as the coat of a living animal, such as sheep, and silk is obtained from the cocoon of silkworms.

Psychographic variables or psychographics—Subjective, psychological statistics about the lifestyles of a population. Psychographics include a combination of personality traits and lifestyle characteristics.

Pull marketing—Promoting further down the marketing channel to encourage consumers to visit their favorite retailer and insist on a particular brand.

Punk—A manifestation of 1970s and 1980s teen rebellion in street style and fashions.

Pure silk—Fabrics made from silk fibers with the sericin removed.

Push marketing—Advertising or promoting to the following levels of the marketing channel.

Qualitative research—The collecting of in-depth data on a particular topic or group of people.

Quantitative research—The collecting of relatively small amounts of data on large numbers of persons or things. Data are statistically analyzed to determine averages, frequencies, and other generalizable concepts.

Quotas—Limits set on the amount of goods that can be imported; done to protect the domestic manufacturing industries and give other developing countries opportunities to trade with the domestic country.

Raw materials—Used for producing and manufacturing materials; such as cotton is used in the production of cotton yarns and fabrics.

Raw silk—Silk fibers covered with a substance called sericin. Fabrics are nubby and have slub yarns.

Rebranding—Similar to repositioning but it usually involves resurrecting a brand that has been dormant or obsolete for quite some time.

Regional agreement—A bilateral or multilateral trade deal among a group of nations who comprise a single geographic region.

Regional mall—Usually an enclosed shopping center with inward-facing stores, a common walkway, and a large perimeter parking lot.

Regular—The standard length cut for men's jackets.

Relationship marketing—Creating lasting and mutually-beneficial relationships with key suppliers and customers. This includes fostering strategic alliances with key resources through technology linkups (called electronic data interchange or EDI), creating operations that streamline distribution or reduce production costs, and providing the consumers with the best products for their money.

Rep—Abbreviated term for representative; has job duties similar to an account executive, except this person may work for an independent showroom located in an apparel mart or market center.

Retail—The sale of products or services to ultimate consumers or the ultimate amount the consumer pays for the item.

Retail ownership group—A consolidation of multiple retailers, often with similar core customers.

Retail price—Another term for retail.

Retailing—The function of selling products or services to ultimate consumers.

Repositioning—A company's attempt to create a different store image or brand image in the minds of the target customers.

Resident buying office—A type of broker that represents member stores in the fashion marketplace. They serve member retailers by assimilating external fashion and marketplace information, forecasting and reporting on trends, buying for member stores, obtaining quantity discounts, and generally acting as the eyes and ears of the retailers.

Retro—A phenomenon that occurs when the same style, eventually becomes far enough removed from its original time that it again becomes appreciated and can be revived.

Rise or growth stage—Occurs when a group of fashion-conscious consumers appreciates and imitates an innovator's new styles.

Safeguard quotas—Limits on import quantities in order to safeguard the competing domestic industry.

Sale price—When the original retail selling price is reduced or marked down to a new, lower retail selling price to encourage customers to buy.

Samuel Slater—An English mechanic who immigrated to the United States to manufacture spinning machines.

Scrambled merchandising—Retailers offering seemingly unrelated items that might also appeal to the same target customer.

Second quality merchandise—Merchandise with obvious damaged areas, such as stains, holes, or tears, which may not be desired by the majority of customers. The wearability is affected, and the item would need to be deeply discounted to sell at retail.

Secondary data—Previously collected and published facts that answer another's research question.

Secondary target customer segment—A group of customers that is the second most important customer group for retailers. This segement spends less than the primary target customer segment, but it is still a notable amount.

Segmenting the market—The decision of a company to focus on a particular group of customers.

Seventh on Sixth—A fashion show created in 1993 by IMG Fashion that boasted state-of-the-art production and show facilities in New York City. It has since been renamed Mercedes-Benz Fashion Week.

Sericin—A gelatinous substance produced by silkworms which coats silk fibers. *See* raw silk definition.

Sericulture—The processing of silk cocoons into thread suitable for weaving or knitting.

Services—Include intangibles, such as dry cleaning, delivery, layaway, personal shopping, alterations, fur glazing, and cold storage.

Shirtwaists—An old-fashioned term for blouses, such as those produced by the Triangle Waist Factory.

Shoppertainment—A merchandising philosophy that combines the shopping experience with entertainment opportunities.

Short—man's jacket whose length is usually one inch shorter than regular.

Shortened inventory cycles—When retailers stock the floors with merchandise closer to the wearing season and tend to keep the merchandise in the store for shorter periods of time.

Silk Road—An extensive and established pattern of commercial trade that spanned the entire country of China, Central Asia, and ended in the Mediterranean region.

Skate thug look—Another term for skateboarder.

Skateboarder—A look that entails wearing high-topped canvas tennis shoes, caps with the brims turned backward, large hooded sweatshirts called hoodies, and cargo shorts.

Social networking community—Another e-commerce opportunity for retailers. The purpose of a retail social networking community is to give voice to the customers and provide the retailer with a way to maintain constant contact with customers.

Soft goods—Apparel or home fashion items that are made of textiles, soft to the touch, and nondurable (meaning they are not intended to be kept for too many years).

Sole proprietorship—Another term for proprietorship.

Sombrero—A common Spanish name for the early cowboy hat.

Source—The vendor from which retailers obtain the merchandise. Usually refers to the level of the supply chain which supplies products or services to the level below.

Sourcing—The apparel company's decision to buy certain component parts and materials from vendors in other parts of the world. Sourcing also refers to the decision about where the cutting and sewing (labor decisions) will be performed.

Specialty store—A retail store that offers a relatively narrow product assortment compared to that which is offered at a department store.

Speed to market—Moving fashion merchandise through the fewest possible levels of the supply chain in the shortest period of time.

Spinneret—A showerhead-like device used for extruding liquid fibers during the fiber manufacturing process.

Spinning—Process involving taking a group of aligned fibers and imparting twist to create a yarn.

Spinning jenny—A machine invented by James Hargreaves, which spun cotton fibers into yarns suitable for weaving or knitting fabrics.

Spinning wheel—A time-consuming, hand-operated machine that creates yarns by twisting loose fibers into strands.

Spinster—A woman who worked a spinning wheel; still used today to refer to an old maid.

Sport coat—A tailored jacket sold separately and meant to be worn with contrasting slacks.

Spun—How yarns are created by twisting staple fibers together.

Staple fibers—Short fiber lengths measured in inches, such as cotton or wool.

Status float phenomenon—Another term for the trickle-up theory.

Stetson—A line of hats introduced by John B. Stetson after moving westward in the 1860s to produce fur felt hats in a variety of styles.

Studied creativity—The process of acquiring an elevated taste level and aptitude for crafting fashionable looks.

Style piracy—The process of the line-for-line copying of design ideas from other designers or companies. This process is legal in the U.S.

Style testing—A market testing procedure whereby manufacturers produce a limited quantity of colors or versions of a particular style and test samples in the marketplace before making the decision to manufacture large quantities.

Styletribes—Refers to a unique cultural segment whose fashion look is unique to that group and may not have an impact on the larger society.

Subcultural leadership theory—Explains that a fashion may originate from various subcultures because of its creativity, artistic excellence, or relevance to current lifestyles.

Substantial transformation—When a product undergoes significant change, such as from flat fashion fabric to a three-dimensional garment.

Suffragettes—Female protestors who crusaded for equal rights for women in the early 1900s.

Suit—Set of clothes, often sold together, consisting of jackets, trousers, and sometimes vests when in fashion.

Sumptuary law—A law that restricts or regulates clothing for economic, religious, or political reasons.

Superregional mall—Similar in nature to a regional mall, but they have a larger selection of products and services, feature more anchor stores, are often multilevel, may have structured perimeter parking, and the size usually exceeds 800,000 square feet.

Supply chain—Group consisting of several trade levels of business with each one selling and distributing to the following level.

Sweatshop—A factory that tends to consider human rights secondary to production and profit; common in developing countries because there is limited organized labor and the workers must have jobs to survive.

Synthetic fibers—Petroleum-based man-made fibers.

Tailored clothing—A clothing designation that identifies the degree of hand workmanship employed during manufacturing.

Tall—Sizes that fit females who wear missy sizes and are 5'7" or taller.

Target customers—A select group of customers with the ability and desire to purchase a company's products and services and to whom the company has directed its marketing efforts.

Target market—The segment (or segments) of consumers a company chooses to attract with its products and services offerings.

Tariff—A tax or assessment charged on imported goods from a country to make the goods more expensive in the market to discourage consumers from buying the foreign goods. It is a protectionist measure or trade barrier to curb the supply of imports.

Textile Fiber Products Identification Act—Also called the Textile Act, it requires that sellers of specific textile products (including apparel) provide consumers with an affixed label showing the fiber content, country of origin, and the manufacturer's identity.

Textiles—Material created from loose fibers that are processed and spun together into yarns. Yarn manufacturers then weave or knit the yarns into textiles.

Theme or festival shopping center—Often tourist attractions, the unifying elements in this type of shopping center may be architectural, historic, or type of merchandise carried in the stores and may include restaurants or movie theaters that anchor the shopping center.

Theory of the shifting erogenous zone—Explains that a woman's body contains several taboo zones. Each of these zones has erotic appeal at a particular time, but the established erogenous zone changes over time.

Trade shows—Scheduled events that provide opportunities for members of the trade to make industry contacts, network, create awareness, view trends, show innovative products (from fibers to machinery), and ultimately to do business in the future.

Transshipping—An illegal practice when a garment is produced in one country but shipped to its final destination with labels that say it comes from a third nation. It is illegal because no tranformation occurred in the third nation, yet the shipper deceptively labels the garments as though transformation did occur.

Trend-based fibers or trend-based textiles— Textiles created based on what is popular at a particular time.

Trickle-across theory—A fashion diffusion theory which implies that fashion innovators at all levels of the social strata introduce a fashion simultaneously.

Trickle-down theory—States that the wealthiest persons (leisure class) or the most public persons, such as political figures and celebrities, introduce the latest style as a means of class differentiation.

Trickle-up theory—A fashion life cycle that begins with a subculture, lower class, youth, or on the streets.

Tweenager—Adolescents roughly between the ages of eight and twelve. The term refers to a marketing category rather than an actual fashion merchandising classification or size category.

Tweens—Another term for tweenager.

Unique selling proposition—The area of the "4 Ps of Marketing" where a company excels. This distinguishes them from their competition.

U.S. Customs and Border Protection— Government agency that inspects goods entering the United States through ports of entry and prohibits illegal goods from entering.

Vanity sizing—A practice used by higher-end clothing manufacturers, where sizes are cut generously to allow a customer to purchase a size smaller than she might normally wear.

Vendor ownership group—Mergers of resources higher up in the supply chain, such as large design firms acquiring other design firms, textile producers acquiring other producers, and large brands merging together. The benefits are similar to those of a retail ownership group.

Vertical integration—When a company operates at more than one level of the supply chain by owning the suppliers up the chain and the levels below the suppliers. By owning more than one level, the company has greater control over its supply chain, and it has access to profits at other levels.

Vicuñas—Peruvian, camel-like animals that once faced near extinction due to the high demand for their soft wool. Through careful breeding and government intervention, vicuñas are once again available for luxury woolens.

Warp yarns—Parallel vertical yarns used in a loom. These create the grainline of the fabric.

Weaving—The interlacing of yarns at right angles on a loom to produce fabric.

Weft or filling yarns—Horizontal yarns that are interlaced with warp yarns in a loom.

Wholesale—Another term for wholesale cost.

Wholesale cost—The amount a retail store pays for the merchandise it offers for sale to the customers.

Wholesaling—One of the middle trade levels of the fashion merchandise supply chain; considered a business to business (B2B) operation.

Women—Sizes that fit plus females with a missy figure. This includes sizes 34–50.

Women's half—Sizes ranging from 12½ to 28½. Retailers may also use 18W, 20W, 22W, 24W, and 26W to indicate women's half sizes.

Wool—Term used for hair fibers removed from a living animal.

Wool Products Labeling Act—Also called the Wool Act, it was enacted to define basic wool terminology and explain the variations in wool qualities. It also protects consumers and reputable businesses from deception and misbranding of wool products.

World Trade Organization (WTO)—Headquartered in Geneva, Switzerland, it is an international multilateral trading system that works toward liberalizing trade and has established rules of trade for its 153 member countries.

Woven fabrics—Fabrics created by interlacing yarns at right angles.

Yarns—A continuous strand of twisted fibers of natural or synthetic material, such as wool or nylon, used in weaving or knitting.

Young junior—A fit for adolescent females with blended sizes: 00, 0/1, 1/2, 3/4, 5/6, 7/8, 9/10, 11/12, and 13/14. These sizes have greater differences between the bust, waist, and hip measurements.

Zeitgeist—A German term referring to the "spirit of the time." It encompasses the intellectual and moral influences that are reflected in everyday living, including the fashions that are worn.

Zeitgeist theory—Explains how the spirit of the times influences designers and their newest looks. Because designers are exposed to the same trends and fashion expectations of the zeitgeist, their designs may appear similar and a mirrorlike reflection of the times.

bibliography

AAFA on the issues: Intellectual property rights. (2008). *American Apparel and Footwear Association* Web site. Retrieved Oct. 1, 2008 from http://www.apparelandfootwear.org/LegislativeTradeNews/default.asp

About direct marketing. (2007). Direct Marketing Association of Washington Web site. Retrieved March 18, 2008 from www.dmaw.org

About Export Advantage. (2001). Office of Textiles and Apparel. Retrieved December 28, 2006 from http://web.ita.doc.gov/tacgi/eamain.nsf/b6575252c552e8e28525645000577bdd/5fe750ce3168a06385256ebc004a2a80?openDocument

About FAS. (2008, June). Foreign Agriculture Service, United States Department of Agriculture. Retrieved September 28, 2008 from www.fas.usda.gov/aboutfas.asp

About fur. (2004). FICA: Fur Information Council of America. Retrieved November 8, 2006 from http://www.fur.org

About textiles and fibers. (2006). About.com Web site. Retrieved December 21, 2006 from http://retailindustry.about.com/cs/manmadefibers/

About the Fashion Center Business Improvement District. (2005). The Fashion Center BID Web site. Retrieved November 30, 2005 from www.fashioncenter.com

About us. (2006). California Market Center Web site. Retrieved January 4, 2006 from http://californiamarketcenter.com

Acker, Mary. (2000). *My dearest Anna, Letters of the Richmond family, 1836–1898.* Chicago: Adams Press.

Acts and resolves public and private of the Province of the Massachusetts Bay, 21 vols. (1869–1922). Boston, MA.

After consolidation comes localization. (2008, Feb. 11). *Retailing Today Weekly Retail Fix.* Retrieved July 14, 2008 from OCLC FirstSearch, number 5804548.

Ahmed, J. (2009, July 17). Bangladesh recovering from labor unrest. *Women's Wear Daily Online.* Retrieved August 5, 2009 from www.wwd.com

AgCareers.com. (2006, May). Tips for hosting an intern. *Agri Marketing, 44*(4), 12.

Ailawadi, Kusum, & Keller, Kevin. (2004, Sept. 27). Understanding retail branding: Conceptual insights and research priorities. *Journal of Retailing, 80*(4), 331–342.

AltaRomAltaModa. (2005). AltaRomAltaModa Web site. Retrieved October 27, 2006 from http://www.altaroma.it/English/Partecipazione.htm

American Apparel vertical integration. (2009). *American Apparel* home page. Retrieved July 17, 2009 from www.americanapparel.net/contact/vertical.html

Americasmart-Atlanta. (2003). Americasmart-Atlanta Web site. Retrieved January 4, 2006 from www.americasmart.com

Anderson, Kim. (2005). Nonwoven fabrics in fashion apparel. *Bi-Weekly Technology Communicator.* Retrieved August 3, 2007 from http://www.techexchange.com/thelibrary/nonwovenfabrics.html

Andinkra cloth. (2006). Akan Andinkra Cloths. Retrieved November 13, 2006 from http://www.marshall.edu/akanart/akanclothintro.html

Apparel Industry Partnership's Agreement. (1997, Apr. 14). United States Department of Labor. Available from http://www.itcilo.it/english/actrav/telearn/global/ilo/guide/apparell.htm

Arnaud, Jean-Louis. (1996, Mar.). *When Paris sets the tone.* Label France Online. Retrieved February 20, 2006 from http://www.diplomatie.gouv.fr/label_France/ENGLISH/INDEX/i23.html

The artistry of Adrian: Hollywood's celebrated design innovator. (2001). Kent State University Museum Web site. Retrieved June 6, 2008 from http://dept.kent.edu/museum/exhibit/adrian/adrian.htm

Audiat, Louis. (1903). *Un poète: abbè Jacques Delille, 1738–1813.* Paris: A. Savaète.

Barnhart, M. (2009, March 18). Personal Correspondence. *Lippincott Library,* Wharton School of Business, University of Pennsylvania.

Barrett, J. (2007, July 31). U.S. monitoring leads Vietnam to seek alternatives. *Women's Wear Daily Online.* Retrieved November 30, 2007 from www.wwd.com

Beau Brummell. (2006). *Wikipedia encyclopedia.* Retrieved February 16, 2006 from http://en.wikipedia.org/wiki/Beau_Brummell

Beckett, W. (2007, March 21). Lag time closes in between runway and better department. *Women's Wear Daily Online.* Retrieved July 30, 2009 from www.wwd.com

Beckett, Whitney. (2008, June 18). Brands: Layering on the exposure. *Women's Wear Daily Online.* Retrieved August 23, 2008 from www.wwd.com

Behling, D. (1985). Fashion change and demographics: A model. *Clothing and Textiles Research Journal, 4,* 18–24.

Benberry, Cuesta. (1992). *Always there: The African-American presence in American quilts.* Louisville, KY: The Kentucky Quilt Project.

Benefits of NAFTA. (2005, May). Foreign Agricultural Services, FAS Online. U.S. Department of Agriculture. Retrieved January 30, 2006 from www.fas.usda.gov

The bionic consumer: retailers have the formula and technology. (2008, Jan. 23). *Women's Wear Daily Online.* Retrieved August 5, 2009 from www.wwd.com

Blumer, Herbert. (1969). Fashion: From class differentiation to collective selection. *The Sociological Quarterly, 10*(3), 275–291.

Bohemian looks, white denim are spring's home runs. (2005, May 16). *Women's Wear Daily Online.* Retrieved May 21, 2005 from www.wwd.com

Boone, L., & Kurtz, D. (2004). *Contemporary marketing.* Mason, OH: South-Western.

Bower, K. (2007, Feb. 5). Mass market demotes uniforms. *Daily News Record,* 16.

Brannon, Evelyn. (2005). *Fashion forecasting.* New York: Fairchild.

Bricker, Charles. (1987, Apr.). Looking back at the New Look. *Connoisseur,* 137–143.

Briefing: Mall of America, a strategic public investment. (2007, Feb.). City of Bloomington, Minnesota. Retrieved February 13, 2008 from http://www.mallofamericaphase2.com/downloads/Briefing%20MallofAmerica-AStrategicPublicInvestment.pdf

Brown, Rachel. (2008, May 7). Vendors, designers persist in copyright proposal rift. *Women's Wear Daily Online.* Retrieved October 5, 2008 from www.wwd.com

Bruns, Roger. (1988, Dec.). Of miracles and molecules: The story of nylon. *American History Illustrated, 23*(8), 24–29, 48.

Bryan, H. (2002). *Martha Washington: First Lady of Liberty.* NY: Wiley.

Building overview. (2006). California Market Center Web site. Retrieved January 4, 2006 from http://www.californiamarketcenter.com

Byrd, Penelope, & Oliver Garnett. (1994). *The Museum of Costume & Assembly Rooms, Bath: The official guide.* Bath, England: England's National Trust and the Bath City Council, Museum and Historic Buildings Section.

CAFTA gets tough on illegal transshipments. (2005, July). CAFTA Facts: CAFTA policy brief. Office of the United States Trade Representative Web site. Retrieved January 10, 2008 from http://www.ustr.gov/assets/Trade_Agreements/Regional/CAFTA/Briefing_Book/asset_upload_file768_7870.pdf?ht=

CAFTA-DR facts. (2007, July). Office of the United States Trade Representative Web site. Retrieved January 4, 2008 from http://www.ustr.gov/assets/Trade_Agreements/Regional/CAFTA/Briefing_Book/asset_upload_file216_7186.pdf

CAFTA-DR final text. (2006). Office of the United States Trade Representative. Retrieved December 27, 2006 from http://www.ustr.gov/Trade_Agreements/Bilateral/CAFTA/CAFTA-DR_Final_Texts/Section_Index.html

Camera Nazionale della Moda Italiana history. (2006). CNMI Web site. Retrieved October 27, 2006 from http://www.cameramoda.it/eng/

Cameron, E. H. (1955, May). The genius of Samuel Slater. Bulletin reprinted from Massachusetts Institute of Technology, *The Technology Review, 57*(7).

Caribbean Basin Initiative. (2007). U.S. Trade Representative. Retrieved January 4, 2008 from http://www.ustr.gov/Trade_Development/Preference_Programs/CBI/Section_Index.html?ht=

Casabona, Liza. (2007, Dec. 6). Pirated products are big business. *Women's Wear Daily Online.* Retrieved December 28, 2007 from www.wwd.com

Casabona, L. (2007, July 23). Retailer Forever 21 facing a slew of design lawsuits. *Women's Wear Daily Online.* Retrieved October 1, 2007 from www.wwd.com

Casabona, L. (2007, Nov. 12). Joint efforts key to tackling counterfeits. *Women's Wear Daily Online.* Retrieved October 23, 2008 from www.wwd.com

The case for open trade. (2007). *World Trade Organization* Web site. Retrieved August 4, 2009 from http://www.wto.org/english/thewto_e/whatis_e/tif_e/fact3_e.htm

CBTPA information. (2006, Jan. 31). Office of Textiles and Apparel, U.S. Department of Commerce, International Trade Administration. Retrieved January 31, 2006 from http://web.ita.doc.gov/tacgi/overseas.nsf/

Charles Frederick Worth. (2006). *Wikipedia encyclopedia.* Retrieved February 16, 2006 from http://en.wikipedia.org/wiki/Charles_Worth

Chemical fiber production in 1,000 tons. (2007). Japan Chemical Fiber Association. Retrieved June 30, 2008 from http://www.jcfa.gr.jp/english/what_data/worldwide-production2007.pdf

Chénier, André. (2003). *Jacques Delille et la poésie descriptive (22).* Paris: Société des amis des poètes.

China domestic market potential. (2005). ASAP Show. Retrieved January 10, 2006 from www.fashionforchina.com/whychina.html

The China factor. (2005, Nov.). *Industry Week, 254*(11), 27–30.

Chirls, Stuart. (1998, Feb. 10). The urge to merge. *Women's Wear Daily, 175*(25), 10.

Choi, A. S. (2005, July 26). Wal-Mart to anchor Simon's China malls. *Women's Wear Daily Online.* Retrieved January 17, 2006 from www.wwd.com

Cholachatpinyo, A., Padgett, I., & Crocker, M. (2002). A conceptual model of the fashion process: Part 1. *Journal of Fashion Marketing and Management, 6*(1), 11–23.

Claire McCardell: The American look. (1955, May 2). *Time Magazine.* Retrieved June 13, 2008 from http://www.time.com/time/covers/0,16641,19550502,00.html

Clark, Evan. (2007, Jan. 1). U.S. imposes duties on polyester staple; new antidumping tariffs on fiber from China are in addition to regular 4.3 percent duties already on product. *Daily News Record,* 10.

Clark, E. (2007, Sept. 18). Taking stock of Vietnam. *Women's Wear Daily Online.* Retrieved November 30, 2007 from www.wwd.com

Clark, E. (2007, Oct. 24). Anti-counterfeit trade deal sought. *Women's Wear Daily Online.* Retrieved December 30, 2007 from www.wwd.com

Clark, E. (2007, Oct. 29). U.S. puts antidumping case against Vietnam on hold. *Women's Wear Daily Online.* Retrieved November 30, 2007 from www.wwd.com

Clark, E. (2007, Nov. 12). Apparel imports down in Sept. *Women's Wear Daily Online.* Retrieved November 30, 2007 from www.wwd.com

Clark, E. (2008, Feb. 21). Women's apparel prices see 3rd straight rise. *Women's Wear Daily Online.* Retrieved October 22, 2008 from www.wwd.com

Clark, E. (2008, Mar. 4). Survey finds price top factor for shoppers. *Women's Wear Daily Online.* Retrieved March 5, 2008 from www.wwd.com

Clark, E. (2008, Oct. 13). Financial meltdown might shrink fashion. *Women's Wear Daily Online.* Retrieved October 17, 2008 from www.wwd.com

Clark, E. (2008, Oct. 17). Mervyns to liquidate. *Women's Wear Daily Online.* Retrieved October 17, 2008 from www.wwd.com

Clark, E., & Zarocostas, J. (2006, Jan. 13). China continues import dominance. *Women's Wear Daily Online.* Retrieved January 17, 2006 from www.wwd.com

Clark, Victor. (1949). *History of manufactures in the United States, Vol. I, 1607–1860.* New York: Peter Smith.

Code of Vendor Compliance. (2000). Tarrant Apparel Group Web site. Retrieved January 11, 2008 from http://www.tags.com/VendorCompliance/CodeofVendorCompliance.pdf

Coblence, Alain. (2007, Aug. 24 -30). Design Piracy Prohibition Act: The proponents' view. *California Apparel News,* p. 12. Retrieved Oct. 1, 2008 from http://www.stopfashionpiracy.com/pdf/sfp_news_1.pdf

Collins, J. P. (2006, Summer). Native Americans in the census. *National Archives Prologue, 38*(2). Retrieved November 1, 2006 from http://www.archives.gov/publications/prologue/2006/summer/indian-census.html

Complying with the Made in the USA standard. (2006). Facts for Business, Federal Trade Commission Web site. Retrieved January 3, 2008 from http://www.ftc.gov/bcp/conline/pubs/buspubs/madeusa.shtm

Consumer Products Safety Commission. (2008, Aug. 8). *Federal Register, 73*(156), 46879–46880. Retrieved October 24, 2008 from http://www.cpsc.gov/BUSINFO/frnotices/fr08/liberty.pdf

Conti, Samantha. (2007, Feb. 14). H & M's new collection a step upmarket. *Women's Wear Daily Online.* Retrieved June 3, 2007 from www.wwd.com

Corcoran, Cate T. (2006, Dec. 28). Small boutiques grow online. *Women's Wear Daily Online.* Retrieved March 18, 2008 from www.wwd.com

Corcoran, C. T. (2007, May 14). Apparel now no. 1 online. *Women's Wear Daily Online.* Retrieved March 18, 2008 from www.wwd.com

Corcoran, C. T. (2008, Apr. 2). My Click hopes marketing idea clicks in the U.S. *Women's Wear Daily Online.* Retrieved October 16, 2008 from www.wwd.com

Corcoran, C. T. (2008, Aug. 13). Tech forum focuses on customer. *Women's Wear Daily Online.* Retrieved October 15, 2008 from www.wwd.com

Cotton. (2007, June 13). U.S.D.A. Briefing Room. Economic Research Service, U.S. Department of Agriculture. Retrieved August 6, 2007 from http://www.ers.usda.gov/Briefing/Cotton

Cotton. (2009, June 25). *U.S.D.A. Briefing Room.* Economic Research Service, United States Department of Agriculture. Retrieved July 29, 2009 from http://www.ers.usda.gov/Briefing/Cotton/

Cotton. From blue to green. (2008). Cotton Incorporated Web site. Retrieved July 20, 2008 from http://www.cottoninc.com/CottonFromBlueToGreenFlashVideos

Cotton, review of the world situation. (2004, Nov.–Dec.). *International Cotton Advisory Committee, 58*(2), 11. Retrieved August 3, 2007 from http://www.cotton.org/issues/2005/cappealletter.cfm

Cotton: The perennial patriot. (1987, Aug.). Brochure published by the National Cotton Council of America.

Cotton world supply, use, and trade. (2007).Cotton: World markets and trade, Foreign Agricultural Services, USDA. Retrieved January 5, 2008 from http://www.fas.usda.gov/cotton/circular/2007/December/cotton1207.pdf

Council of Fashion Designers of America. (1988, Oct. 20). Advertisement in *Women's Wear Daily, 156*(76), p. 3.

Council of Fashion Designers of America & Charlie Scheips. (2007). *American fashion.* New York: Assouline.

Crivellin, Lorenzo. (2004). *Madame Pompadour.* Retrieved February 14, 2006 from http://www.madamedepompadour.com/_eng_pomp/home.htm

Crowston, Clare H. (2002, Apr.). The queen and her Minister of Fashion: Gender, credit and politics in pre-revolutionary France. *Gender and History, 14*(1), 92–116.

Dallas Market Center buyers' guide. (2005, Oct.). Fashion Center Dallas Directory. Published by the Dallas Market Center Co., Ltd.

Davenport, Millia. (1948). *The book of costume,* Vol. II. New York: Crown Publishers.

Daves, Jessica (Ed.). (1967–1968). *1947–1967 Fashion Group French Shows: Twenty years of French fashions as shown by the New York Fashion Group.* New York: The Fashion Group.

Davis, Doris. (2006, Summer). Destiny world. *African Arts, 39*(2), 36–87.

Davis, Fred. (1992). *Fashion, culture, and identity.* Chicago: University of Chicago Press.

DeJean, Joan. (2005). *The essence of style: How the French invented high fashion, fine food, chic cafés, style, sophistication, and glamour.* New York: Free Press.

Diary of Ruth Henshaw. (1983). Diary of Ruth Henshaw Bascom, in Ruth Henshaw Bascom papers, (1789–1848). American Antiquarian Society, Worcester, MA., microfilm edition, American Women's Diaries: New England: From the collection of the American Antiquarian Society, New Canaan, CT 1983, reel I.

Dispute Settlement DS267. (2007). United States—Subsidies on upland cotton. World Trade Organization Web site. Retrieved October 25, 2008 from http://www.wto.org/english/tratop_e/dispu_e/cases_e/ds267_e.htm

DMC Overview. (2006). *Dallas Market Center* Web site. Retrieved August 4, 2007 from www.dallasmarketcenter.com

Dodes, Rachel. (2006, Apr. 1). Pursuits; Style—shopping: The new web exclusives. *Wall Street Journal* (Eastern edition), New York, 3.

Downey, Lynn. (2005). *Levi Strauss: A short biography.* Levi Strauss & Company. Retrieved November 13, 2006 from http://www.levistrauss.com/Downloads/History_Levi_Strauss_Biography.pdf

Dunn, Brian. (2008, Mar. 18). Proximity pays for Canadian manufacturers. *Women's Wear Daily Online.* Retrieved October 20, 2008 from www.wwd.com

Earning, Average hourly for hourly paid employees, clothing manufacturing. (2006). *Statistics Canada.* Retrieved October 31, 2007 from http://www40.statcan.ca/l01/cst01/labr74e.htm

Economic profile 2005. (2005). The Fashion Center New York City Web site. Retrieved January 3, 2006 from http://www.fashioncenter.com/EconomicProfile2005/EPIntroduction.html

Edelson, Sharon. (2007, Feb. 19). J. C. Penney reveals new brand positioning; company's updated tagline to be "Every Day Matters." *Daily News Record.*

Edelson, Sharon. (2008, May 7). Barneys loves Target: Retailing's odd couple takes marketing leap. *Women's Wear Daily,* p. 1, 14.

Edelson, Sharon. (2008, Oct. 17). A big retailer falls: $2.5 billion Mervyns plans to liquidate. *Women's Wear Daily Online.* Retrieved October 17, 2008 from www.wwd.com

Edelson, S. (2008, Nov. 18). McQueen on Target. *Women's Wear Daily Online.* Retrieved November 20, 2008 from www.wwd.com

Edelson, S. (2009, August 5). Rodarte a 'Go' with Target. *Women's Wear Daily Online.* Retrieved August 5, 2009 from www.wwd.com

Ellis Island timeline. (2000). The Statue of Liberty-Ellis Island Foundation, Inc. Retrieved November 3, 2006 from http:// ellisisland.org/genealogy/ellis_island_timeline.asp

Ellis, Kristi. (2004, June 15). Customs in sweater crackdown. *Women's Wear Daily Online.* Retrieved December 19, 2008 from www.wwd.com

Ellis, K. (2006, July 28). Senate considers changes to put CAFTA back on track. *Women's Wear Daily Online.* Retrieved January 4, 2008 from www.wwd.com

Ellis, K. (2007, May 1). Report sees China counterfeiting worsen. *Women's Wear Daily Online.* Retrieved December 30, 2007 from www.wwd.com

Ellis, K. (2008, Feb. 15). Designer vs. vendor: Battle over copyright issue hits Congress. *Women's Wear Daily Online.* Retrieved December 30, 2007 from www.wwd.com; also available online at http://www.stopfashionpiracy.com/pdf/sfp_news_6.pdf

English, Linda. (2002, Spring/Summer). Revealing accounts: Women's lives and general stores. *Historian, 64*(3/4), 567–586.

Entrepreneurship. (2009). *Ewing Marion Kauffman Foundation* Web site. Retrieved August 6, 2009 from http://www.kauffman.org/Section.aspx?id=Entrepreneurship

Estimates of monthly retail and food services sales by kind of business, NAICS 444811 and 444812. (2007). Service Sector Statistics, U.S. Census Bureau. Retrieved June 21, 2008 from http://www.census.gov/mrts/www/data/html/nsal07.html

Eugénie de Montijo. (2006). *Wikipedia encyclopedia.* Retrieved February 16, 2006 from http://en.wikipedia.org/wiki/Empress_Eugenie

Everything's coming up lifestyle: Extending the wildly successful lifestyle center concept. (2007, March). *Chain Store Age, 83*(3), 130.

Exhibitor information/participation: Off-price show eligibility guidelines. (1996–2004). The Off-price Specialty Show Web site. Retrieved December 30, 2005 from www.offpriceshow.com

Exports of HS 4303. (2007). Trade Stats Express, National Trade Data. Retrieved July 1, 2008 from http://tse.export.gov/MapFrameset.aspx?MapPage=NTDMapDisplay

.aspx&UniqueURL=dl5qfkjgpn5vqw3wme5c3a45-2008-7-1-9-9-0

Exports of NAICS 3161. (2007).Trade Stats Express, National Trade Data. Retrieved June 30, 2008 from http://tse.export.gov/MapFrameset.aspx?MapPage=NTD MapDisplay.aspx&UniqueURL=dl5qfkjgpn5vqw3wme5c3 a45-2008-7-1-9-33-56

Fact Sheet #24: Homeworkers under the Fair Labor Standards Act. (2007, Nov.). Wage and Hour Division, United States Department of Labor Web site. Retrieved January 11, 2008 from http://www.dol.gov/esa/regs/compliance/whd/whdfs24.pdf

Fact Sheet #24: Homeworkers under the Fair Labor Standards Act. (2008, July). *Wage and Hour Division, United States Department of Labor website.* Retrieved August 5, 2009 from http://www.dol.gov/esa/regs/compliance/whd/whdfs24.pdf

Fashion Center Dallas. (2006). Dallas Market Center Web site. Retrieved January 19, 2006 from www.dallasmarket center.com

The fashion industry and New York City. (1996–2001). Garment Industry Development Corporation Web site. Retrieved November 30, 2005 from http://www.gidc.org/industry .html

Federation activities. (2006). Federation Française de la Couture. Retrieved October 13, 2006 from http://www .modeaparis.com/va/toutsavoir/index.html

Feinberg, B. S. (1998). *America's First Ladies: Changing Expectations.* NY: Franklin Watts.

Feitelberg, Rosemary. (2007, Aug. 9). Schumer touts plan to fight design theft.*Women's Wear Daily Online.* Retrieved December 30, 2008 from www.wwd.com

Feitelberg, R. (2007, Sept. 11).To hype or not to hype: Designer divide grows over role of N.Y. shows. *Women's Wear Daily Online.* Retrieved November 26, 2007 from www.wwd .com

Feitelberg, R. (2008, May 15). Claiborne, DVF to be honored on SA Walk of Fame. *Women's Wear Daily, 195*(104), 6.

Feitelberg, R., & Kaplan, J. (2008, Oct. 2). The celebrity clothing game. *Women's Wear Daily Online.* Retrieved October 5, 2008 from www.wwd.com

Felgner, Bruce. (2006, Jan. 2). No "sure thing" in global retail. *Home Textiles Today,* 27(15), 2.

Field, Alan. (2007, May 28a). A tale of 2 regions. *Journal of Commerce,* 1.

Field, Alan M. (2007, May 28b). Vietnam's textile exports threatened by Commerce program. *Pacific Shipper, 82*(14), 91.

Field, George A. (1970, Aug.). The status float phenomenon— The upward diffusion of innovation. School of Business at Indiana University, *Business Horizons,* 8, 45–52.

Fischer, D. (1989). *Albion's seed: Four British folkways in America.* New York: Oxford University Press.

Fisher, C. (1989, July 17). Strategies: Refashioned Penney's struggles to sway shoppers. *Advertising Age, 60*(31), R2.

Five steps for minding the sophisticated online store. (2007). The E-tailing Group Web site. Retrieved March 18, 2008 from www.e-tailing.com

Flammable Fabrics Act. (2007). Consumer Products Safety Commission Web site. Retrieved January 3, 2008 from www.cpsc.gov

Flax fibre and tow; Major food and agricultural commodities and producers. (2005). The Statistics Division, Economic and Social Department, Food and Agricultural Organization of the United States. Retrieved August 2, 2007 from http:// fao.org/es/ess/top/commodity.html

Flügel, J. C. (1930). *The psychology of clothes.* London: Hogarth Press.

Flusser, A. (1996). *Style and the man.* New York: HarperStyle.

Foley, B. (2007, Sept. 13).

Foulk, J. A., Akin, D., & Dodd, R. (2003, Jan. 24). *Fiber flax farming practices in the southeastern United States.* Crop

Management Online. Retrieved August 7, 2007 from http://www.plantmanagementnetwork.org/pub/cm/management/2003/flax/

Frequently asked questions. (2009). *Small Business Administration* Web site. Retrieved August 6, 2009 from http://web.sba.gov/faqs/faqindex.cfm?areaID=24

Friede, E. (2008, Jan. 29). Fur industry seeks to trap a green image; Launches campaign in newspapers, magazines. *The Gazette (Montreal),* p. D2.

Friede, E. (2008, Jan. 29). Fur industry seeks to trap a green image; launches campaign in newspapers, magazines. *The Gazette* (Montreal), p. D2.

Fulton, Joan. (2004, July/Aug.). Serving multiple market segments effectively. *Agri-Marketing,* 42(6), 34, 36.

Fur Council of Canada Home Page. (2009). Fur Council of Canada. Retrieved March 11, 2009 from www.furcouncil.com

Fusich, Monica. (2005, Dec.). *History of fashion plates.* California State University. Retrieved February 17, 2006 from http:// zimmer.csufresno/~monicaf/histfashplates.htm

Garment District main map. (2005). The Fashion Center New York City Web site. Retrieved November 30, 2005 from http://www.fashioncenter.com/Mapzone3.html

Generations still loving jeans, sneakers and tees. (2008, Mar. 26). *Women's Wear Daily Online.* Retrieved October 12, 2008 from www.wwd.com

The Gibson Girl. (2001). EyeWitness to History Web site. Retrieved December 1, 2006 from www.eyewitnesstohistory.com

Gilbert, Daniela. (2006, May 25). Denim destinations. *Women's Wear Daily Online.* Retrieved September 4, 2007 from www.wwd.com

Gillon, Jr., Edmund V. (1969). *The Gibson Girl and her America: The best drawings of Charles Dana Gibson.* New York: Dover.

Giraudias, Étienne. (1910). *Étude Historique sur les Lois Somptuaires.* Poitiers, France:Oudin. Société Française d'imprimerie et de librairie.

Global silk production. (2005, Oct. 9). *Silk & Silk Business in Iran.* Irano-British Chamber of Commerce, Industries and Mines. Retrieved August 14, 2007 from www.ibchamber .org/Magazine%2018/4.htm. Data adapted from the Food and Agricultural Organization of the United Nations.

Glossary of terms. (2009). *Small Business Administration* Web site. Retrieved August 6, 2009 from http://web.sba.gov/glossary/

Going green. (2006, Sept. 26). *Women's Wear Daily Online.* Retrieved September 4, 2007 from www.wwd.com

The grand French Haute Couture houses. (2001). Elegant-Lifestyle.com Web site. Retrieved February 14, 2006 from http://www.elegant-lifestyle.com/haute_couture.htm

Green, Penelope. (1999, July 4). Mirror, mirror; how stylish people don't describe themselves. *New York Times Sunday,* Late Edition.

Greenberg, Hope. (2001). *Godey's Lady's Book* Publication History Web site. Retrieved November 20, 2006 from http://www.uvm.edu/~hag/godey/glbpub.html

Greenwood, Kathryn, & Murphy, M. (1978). *Fashion innovation and marketing.* New York: Macmillan.

Growing flax. (2006). Flax Council of Canada Web site. Retrieved August 7, 2007 from www.flaxcouncil.ca

Growth of off-price home goods creates need for second show, set for May in Las Vegas. (2005, Feb. 15). The Off-price Specialty Show Web site. Retrieved December 30, 2005 from http://www.offpriceshow.com

Guest, Edgar A. (1912). Good business. In *Selected Poems, 1940.*

Guides for the use of environmental marketing claims, Part 260. (1998). Federal Trade Commission Web site. Retrieved October 25, 2008 from http://www.ftc.gov/bcp/grnrule/guides980427.htm

Haber, Holly. (2004, Mar. 26). Dallas' new venue off to strong start. *Women's Wear Daily Online.* Retrieved January 19, 2006 from www.wwd.com

Haber, H. (2008, July 1). Distribution centers being skipped for speed, savings. *Women's Wear Daily Online.* Retrieved July 15, 2008 from www.wwd.com

Hall, Carolyn. (1983). *The twenties in Vogue.* New York: Harmony.

Hall, Cecily. (2008, Sept. 4). Pantone's top ten colors for spring. *Women's Wear Daily Online.* Retrieve September 8, 2008 from www.wwd.com

Harmonized System news. (2007). World Customs Organization. Retrieved August 6, 2007 from www.wcoomd.org/ie/en/topics_issues/harmonizedsystem/harmonizedsystem.htm

Hattie Carnegie. (1945, Nov. 12). *Life Magazine,* p. 63. Retrieved June 13, 2008 from http://www.life-magazines.com/?gclid=CM3qrlaF8pMCFRcOIgodiBlHWg

Haute couture (1928, Aug. 13). *Time Magazine.* Retrieved June 14, 2008 from http://www.time.com/time/magazine/article/0,9171,928838,00.html

Haute couture. (2006). Ministry of Foreign Affairs and Label France magazine Web site. Retrieved February 20, 2006 from http://www.diplomatie.gouv.fr/label_France/ENGLISH/DOSSIER/MODE/MOD.html

Heineman, Karl. (2005, Nov. 22). *California Market Center unveils extensive plans to renovate penthouse floor.* California Market Center Web site press release. Retrieved January 4, 2006 from www .californiamarketcenter.com

Hickey, Thomas E. (2006, Nov./Dec.). Fashion thinks global: The Pat Riley effect. *Textile World, 156*(6), 32+.

Hinson, Dolores. (1970). *Quilting manual: New! Designer's boutique.* New York: Hearthside Press.

Home textiles finding shelf space online. (2005, Nov. 28). *Home Textiles Today,* 27(11), 1.

Hood, Adrienne. (1997). Industrial opportunism: From handweaving to mill production, 1700–1830. In *Textiles in early New England: Design, production, and consumption.* Annual proceedings of the Dublin Seminar for New England Folklife, June 1997. Boston: Boston University, pp. 135–151.

Hood, Adrienne. (2003). *The weaver's craft: Cloth commerce and industry in early Pennsylvania.* Philadelphia: University of Pennsylvania Press.

Hoover, Gary. (2005, Sept.). A plea to look at history. *Chain Store Age, 81*(9), 85–86.

Horton, Laurel, ed. (1994). *Quiltmaking in America: Beyond the myths: Selected writings from the American Quilt Study Group.* Nashville, TN: Rutledge Hill Press.

Hyde, Nina. (1988, May). Fabric history of wool. *National Geographic, 173*(5), 552–591.

ICSC shopping center definitions. (2004). Publication from the International Council of Shopping Centers, New York, NY.

Imports of HS 4303. (2007). Trade Stats Express, National Trade Data. Retrieved July 1, 2008 from http://tse.export.gov/MapFrameset.aspx?MapPage=NTDMapDisplay.aspx&UniqueURL=dl5qfkjgpn5vqw3wme5c3a45-2008-7-1-9-37-45

Imports of NAICS 3161. (2007). Trade Stats Express, National Trade Data. Retrieved June 30, 2008 from http://tse. export.gov/MapFrameset.aspx?MapPage=NTDMapDisplay.aspx&UniqueURL=dl5qfkjgpn5vqw3wme5c3a45-2008-7-1-9-27-6.

Imports of Textiles, Textile Products, and Apparel from Top Trading Partners. (2008). *Foreign Trade Statistics, U.S. Census Bureau.* Retrieved July 30, 2009 from http://www.census.gov/foreign-trade/statistics/country/sreport/textile

In brief: AEO sues Payless. (2007, April 23). *Women's Wear Daily Online.* Retrieved December 19, 2007 from www.wwd .com

In brief: Fur trouble. (2008, Aug. 11). *Women's Wear Daily Online.* Retrieved September 28, 2008 from www.wwd.com

Industry statistics sampler, NAICS 448110 men's clothing stores. (2002). U.S. Census Bureau. Retrieved June 17, 2008 from http://www.census.gov/econ/census02/data/industry/E448110.HTM

Industry statistics sampler, NAICS 448120 women's clothing stores. (2002). U.S. Census Bureau. Retrieved June 17,

2008 from http://www.census.gov/econ/census02/data/industry/E448120.HTM

Industry statistics sampler, NAICS 448130 children's clothing stores. (2002). U.S. Census Bureau. Retrieved June 17, 2008 from http://www.census.gov/econ/census02/data/industry/E448130.HTM

Irish linen history. (2006). Irish Linen Guild Web site. Retrieved November 3, 2006 from http://www.irishlinen.co.uk/history/index.asp

The J. C. Penney customer. (1998). Educational materials from J.C. Penney Company, Plano, TX.

Jarvis, Steve. (2000, Oct.). Schools need to fortify intern programs. *Marketing News, 34*(21), 9.

Jeans on the rebound. (2006, Dec. 7). *Women's Wear Daily Online.* Retrieved March 6, 2007 from www.wwd.com

Jobber profile: Julie Ann Apparel—A friend to the small retailer. (2005, Dec. 10). The Off-Price Specialty Show Web site. Retrieved December 30, 2005 from http://www.offpriceshow. com/scripts/publish/headlines.asp?code=ARF&eventid=1

Jones, Lu Ann. (2000, May). Gender, race, and itinerant commerce in the rural new South. *Journal of Southern History, 66*(2), 297–320.

Jones, N. (2006, Nov. 9). McQueen's human touch for Samsonite. *Women's Wear Daily Online.* Retrieved December 23, 2007 from www.wwd.com.

Kaiser, S., Nagasawa, R., & Hutton, S. (1995). Construction of an SI theory of fashion: Part 1, ambivalence and change. *Clothing and Textiles Research Journal, 13*, 172–183.

Kaiser, S., Nagasawa, R., & Hutton, S. (1997, Jan.). Truth, knowledge, new clothes: Response to Hamilton, Kean, and Pannabecker. *Clothing and Textiles Research Journal, 15*, 184–191.

Kaplan, Julie. (2008, June 16). From Barbie to Pepsi: The next generation of deals. *Women's Wear Daily Online.* Retrieved June 22, 2008 from www.wwd.com

Kaplan, J. (2008, July 25). *The top 10 youth/contemporary: The kids are alright.* Retrieved November 22, 2008 from www.wwd.com

Kaplan, J. (2008, Aug. 22). Dressing the *Gossip Girls. Women's Wear Daily Online.* Retrieved August 23, 2008 from www.wwd.com

Kaplan, J. (2008, Sept. 29). Burberry to open children's stores in U.S. *Women's Wear Daily Online.* Retrieved November 22, 2008 from www.wwd.com

Kaplan, J. (2009, Mar. 12). Jonas Brothers add tween apparel to brand. *Women's Wear Daily Online.* Retrieved July 17, 2009 from www.wwd.com

Karimzadeh, M. (2005, Dec. 1). IMG, Lakme create new fashion week in India. *Women's Wear Daily Online.* Retrieved January 17, 2006 from www.wwd.com

Karimzadeh, M. (2006, Mar. 10). CFDA takes piracy issue to Washington. *Women's Wear Daily Online.* Retrieved December 28, 2007 from www.wwd.com

Karimzadeh, M. (2007, May 17). D&A emphasizes power of green. *Women's Wear Daily Online.* Retrieved September 17, 2006 from www.wwd.com

Karimzadeh, M. (2008, Jan. 23). Separating brand from designer. *Women's Wear Daily, 195*(16), 8.

Karimzadeh, M. (2008, July 31). Rugby to launch e-commerce website. *Women's Wear Daily Online.* Retrieved November 30, 2008 from www.wwd.com

Karimzadeh, M. (2008, Aug. 14). Polo to launch mobile commerce. *Women's Wear Daily Online.* Retrieved October 15, 2008 from www.wwd.com

Karimzadeh, M. & Foley, B. (2007, Sept. 13). Jacobs blasts back: designer tells critics shut up or stay home. *Women's Wear Daily, 194* (56), p.2.

Kean, R. (1997). The role of fashion system in fashion change: A response to the Kasier, Nagasawa and Hutton model. *Clothing and Textiles Research Journal, 5*(3), 8–15.

Kean, R. (1997). The role of the fashion system in fashion change: A response to the Kaiser, Nagasawa and Hutton model. *Clothing and Textiles Research Journal, 15*(3), 172–177.

Kellogg, A., Peterson, A., Bay, S., & Swindell, N. (2002). *In an influential fashion.* Westport, CT: Greenwood Press.

Kendzulak, S. (2005, Sept. 1). Fashion icon Vivienne Westwood turns up in Taipei. *The Taipei Times Online.* Retrieved January 30, 2006 from www.taipeitimes.com

Kercheval, M. (2004, May). Here to stay. *Chain Store Age*, 80(5), 110.

Kerin, R., Hartley, S., Berkowitz, E., & Rudelius, W. (2006). *Marketing,* 8th ed. New York: McGraw-Hill/Irwin.

Kidwell, Claudia, & Steele, V. (1989). *Men and women: Dressing the part.* Washington, DC: Smithsonian Institute Press.

Kilbourne, W. (2001, June). The myth of green marketing. *Journal of Macromarketing, 20*(1), 103–106.

Kiley, Daniel. (2007, Aug. 6). Best global brands. *BusinessWeek Online.* Retrieved December 23, 2007 from http://www.businessweek.com/magazine/content/07_32/b4045401.htm

King, Charles W. (1963). Fashion adoption: A rebuttal to the "trickle down" theory. *Toward scientific marketing,* Stephen A. Greyser, (Ed.), *Proceedings of the American Marketing Association,* 108–125.

King, C. W. (1963). Fashion adoption: a rebuttal to the "trickle down" theory. In Sproles, G. B. (Ed.), *Perspectives of fashion.* Minneapolis, MN: Burgess Publishing Company, 31–39.

Kippen, Cameron. (2004). *The history of footwear: Sumptuary laws.* Curtin University of Technology, Perth, WA. Retrieved October 19, 2006 from http://podiatry.curtin.edu.au/sump.html#vd

Kleinman, Rebecca. (2006, July 24). Sign of the times; sunglass branding is appealing to the fashion insider. *Women's Wear Daily Online.* Retrieved December 19, 2007 from www.wwd.com

Kleinman, Rebecca. (2007, Aug. 17). Material World Miami readies for three-in-one show. *Women's Wear Daily Online.* Retrieved August 31, 2007 from www.wwd.com

Klepaki, L. (2005, Aug. 29). Looking good: Strong sales continue to drive the better and bridge sportswear business. *Women's Wear Daily,* 30B.

Korea-South: Local industry and market. (2005, Mar. 8). Office of Textiles and Apparel, U.S. Department of Commerce, International Trade Administration. Retrieved January 31, 2006 from http://web.ita.doc.gov/tacgi/overseas.nsf/

Kurt Salmon Associates. (2008). White paper: Outlook from the WWD/DNR Retail/Apparel CEO Summit. *Women's Wear Daily Online.* Retrieved May 19, 2008 from www.wwd.com

La Mode en Chiffres. (2005). Ministère de l'Économie des Finances et de l'Industrie. Retrieved October 13, 2006 from http://www.industrie.gouv.fr/cgi-bin/industrie/recherche.pl

Laver, James. (1945). *Taste and fashion: From the French Revolution to the present day.* London: George G. Harrap and Company, Inc.

Law, K., Zhang, Z., & Leung, C. (2004). Academic paper: Fashion change and fashion consumption: The chaotic perspective. *Journal of Fashion Marketing and Merchandising, 8*(4), 362.

Layoffs seen at Lord & Taylor. (2008, Oct. 17). *Women's Wear Daily Online.* Retrieved October 17, 2008 from www.wwd.com

Leaders: Trouble at till; Global Retailing. (2006, Nov. 4). *The Economist,* London, *381*(8502), 18.

Lee, Georgia. (2005, Dec. 7). Movement at the mart. *Women's Wear Daily Online.* Retrieved January 4, 2006 from www.wwd.com

Lee, G. (2008, Feb. 20). Makeover at Dillard's; Store moving upscale, adding more fashion. *Women's Wear Daily Online.* Retrieved September 1, 2008 from www.wwd.com

Less risk seen in purchasing clothes online. (2007, May 14). *New York Times,* National Edition, C1.

Lewis & Clark and the revealing of America. (2005, July 7). Library of Congress online exhibition. Retrieved November 1, 2006 from http://www.loc.gov/exhibits/lewisandclark/lewis-before.html

Lindsay, Marsha. (2007, June 4). Today's niche marketing is about narrow, not small. *Advertising Age,* Midwest Region Edition, 78(23), 30, 32.

Lindstrom, M. (2001). *E-tailing's Critical Success Factors.* ClickZ Network, http://www.clickz.com/showPage.html?page=841931

Lippert, B. (2007, Nov. 12). Target's holo promise. *Adweek,* 48(41), 22.

Lockwood, Lisa. (2003, Sept. 17). Fashion's move to the middle. *Women's Wear Daily Online.* Retrieved July 28, 2009 from www.wwd.com

Longman, J., & Kolata, G. (2008, Aug. 12). As swimming records fall, technology muddies the water. *New York Times.* Retrieved August 17, 2008 from NewsBank database.

Lowe, E. D., & Lowe, J. W. G. (1990). Velocity of the fashion process, 1789–1980. *Clothing and Textiles Research Journal, 9*(1), 50–58.

Lynch, Matthew. (2008, Sept. 22). Industry, government cooperation urged to beat back the bogus. *Women's Wear Daily Online.* Retrieved September 28, 2008 from www.wwd.com

LZR Racer high neck bodyskin. (2008). Speedo home page. Retrieved August 17, 2008 from http://www.speedousa.com/product/index.jsp?productId=3106216&cp=3124322.3124333.3132091h

LZR Racer, behind the technology. (2008). *Speedo* Web page. Retrieved July 30, 2009 from http://www.speedousa.com/technology/index.jsp

Mabry, Mary Ann. (1971). *The relationship between fluctuations in hemlines and stock market averages from 1921 to 1971.* Master's thesis, University of Tennessee.

Madame de Pompadour. (2006). Chateau de Versailles Web site. Retrieved February 14, 2006 from http://www.chateauversailles.fr/en/230_madame_de_Pompadour.php

Magnuson, E. (1988, Oct. 24). Why Mrs. Reagan still looks like a million. *Time, 132*(17), 29–30.

Mall of America. (2008). Mall of America Web site. Retrieved February 13, 2008 from www.mallofamerica.com

Malone, S. (2005, March 8). South Koreans differentiate to compete. *Women's Wear Daily Online.* Retrieved January 23, 2006 from www.wwd.com

Mariani, M. (1998, Summer). Job shadowing for college students. *Occupational Outlook Quarterly, 42*(2), 46–49.

Marketing definition. (2005). American Marketing Association. Retrieved May 25, 2005 from www.marketingpower.com

Marketing definition. (2009). American Marketing Association Web site. Retrieved July 23, 2009 from http://www.marketingpower.com/_layouts/Dictionary.aspx?dLetter=M

Material World Web site. (2008). American Apparel and Footwear Association (AAFA). Retrieved July 1, 2008 from www.materialworld.com.

McCracken, G. (1988a). Consumer goods, gender construction, and a rehabilitated trickle-down theory. *Culture and Consumption*, 83–103.

McDonough, W. & Braungart, M. (2002). *Cradle to Cradle: Remaking the Way We Make Things.* NY: North Point Press.

McKay, Alistair. (2007, Sept. 17). Yes, you can have a man's life in a woman's body. *The Evening Standard, London.* Retrieved September 1, 2008 from LexisNexis database.

McWilliams, D., Wakelyn, P., & Hughs, S. (2007, Jan. 11). *Ginning and processing research to enhance quality, profitability and textile utility of western cottons.* Proceedings at the National Cotton Council Beltwide Cotton Conference in New Orleans, LA. Retrieved September 28, 2008 from http://www.ars.usda.gov/research/publications/publications.htm?seq_no_115=207732

Medina, Marcy. (2008, Apr. 16). Von Furstenberg, Karan address luxe. *Women's Wear Daily, 195*(82), 16.

Merchant wholesalers—Summary: 2000 to 2007, Table 1006. (2009). U.S. Census Bureau. Retrieved July 17, 2009 from http://www.census.gov/compendia/statab/tables/09s1006.pdf

Merriam-Webster online search. (2006). *Merriam-Webster Online Dictionary.* Retrieved December 30, 2006 from www.m-w.com

Mexico: Local industry and market. (2006, Jan. 10). Office of Textiles and Apparel, U.S. Department of Commerce, International Trade Administration. Retrieved January 31, 2006 from http://web.ita.doc.gov/tacgi/overseas.nsf/

Meyer, L., MacDonald, S., & Skinner, R. (2006, Dec. 12). Foreign cotton consumption expansion continues. *Cotton and wool outlook, electronic outlook report* from the Economic Research Service. U.S. Department of Agriculture. Retrieved December 28, 2006 from http:// usda.mannlib.cornell.edu/usda/current/CWS/CWS-12-12-2006.pdf

Meyer, L., MacDonald, S., & Skinner, R. (2007, July 13). World consumption overtakes new supplies of cotton. *Cotton and wool outlook, electronic outlook report* from the Economic Research Service. U.S. Department of Agriculture. Retrieved August 6, 2007 from http://usda.mannlib.cornell.edu/usda/current/CWS/CWS-7-13-2007.pdf

MGM Studio World' Lifestyle Center unveiled in Shanghai. (2007, May 21). *Wireless News.* Retrieved February 28, 2008 from http://newfirstsearch.oclc.org/WebZ/FTFETCH?sessionid=fsapp7-57127-fd7pim0z-8jigyq:entitypagenum=8:0:rule=990:fetchtype=fulltext:dbname=BusIndustry_FT:recno=2:resultset=1:ftformat=ASCII:format=T:isbillable=TRUE:numrecs=1:isdirectarticle=FALSE:entityemailfullrecno=2:entityemailfullresultset=1:entityemailftfrom=BusIndustry_FT:

Miley, Patti. (2007, June 7). *Who owns whom: The structure of U.S. department store ownership groups.* Arkansas Association of Family and Consumer Sciences Web site. Retrieved July 20, 2008 from www.arafcs.com/article-2007-06-store_ownership.php

Mills, Betty J. (1985). *Calico chronicles: Texas women and their fashions.* Lubbock, TX: Texas Tech Press.

Moin, D. (2006, Jan. 19). Growing in the East: Saks, Gap sign deals to open Asian stores. *Women's Wear Daily Online.* Retrieved January 19, 2006 from www.wwd.com

Moin, David. (2008, May 5). The pressure is on: Retail anxiety builds as economy weakens. *Women's Wear Daily Online.* Retrieved October 17, 2008 from www.wwd.com

Molloy, John. (1975). *Dress for success.* New York: P. H. Wyden.

Molloy, J. (1977). *The women's dress for success book.* Chicago: Follet Publications.

Moltmann, Günter. (1995). *When people migrate, they carry their selves along* (keynote address). Emigration and Settlement Patterns of German Communities in North America, conference proceedings held in New Harmony, IN, Sept. 28–Oct. 1, 1989. Indianapolis: Max Kade German-American Center, Indiana University–Purdue University at Indianapolis, pp. xvii–xxxii.

Moore, Booth. (2009, Jan 18). Dressing Up D.C.; A National Pasttime. *Los Angeles Times,* Part P, p. 4.

More space and more style. (2007, Apr.). *Chain Store Age,* 83(4), 76.

Movius, Lisa. (2007, Nov. 20). Intertextile Shanghai plans expansion. *Women's Wear Daily Online.* Retrieved November 30, 2007 from www.wwd.com

Mulvey, K., & Richards, M. (1998). *Decades of beauty: The changing image of women, 1890s–1990s.* New York: Facts on File.

Murphy, A. (1999). *Mexico fields U.S. cotton exports.* Foreign Agricultural Services, FAS online. U.S. Department of Agriculture. Retrieved January 30, 2006 from www.fas.usda.gov

Murphy, R. (2008, Mar. 27). Levi's blue popping up. *Women's Wear Daily Online.* Retrieved October 31, 2008 from www.wwd.com

Murphy, R. (2008, June 25). Colette popping up at Gap in Manhattan. *Women's Wear Daily Online.* Retrieved October 31, 2008 from www.wwd.com

Murray, Maggie P. (1989). *Changing styles in fashion: Who, what, why.* New York: Fairchild.

Myres, Sandra L. (1982). *Westering women and the frontier experience, 1800–1915,* Albuquerque, 242.

NAICS definitions, 452111. (2002). U.S. Census Bureau. Retrieved August 5, 2009 from http://www.census.gov/epcd/naics02/def/ND452111.HTM

NAICS definitions, 452112. (2002). U.S. Census Bureau. Retrieved August 5, 2009 from http://www.census.gov/epcd/naics02/def/ND452112.HTM

NAICS definitions, 448110, 448120, 448130. (2002). U.S. Census Bureau. Retrieved August 5, 2009 from http://www.census.gov/epcd/naics02/def/ND448110.HTM

National occupational employment and wage estimates, United States. (May 2006). Bureau of Labor Statistics, Occupational Employment Statistics. Retrieved October 31, 2007 from www.bls.gov/oes/

A new knot in textile trade. (2004, Dec. 18). *Economist, 373*(8406). Retrieved January 2, 2006 from Academic Search Premiere.

The new off-price specialist markets—Bringing the vendors to the retailers. (2005, Sept. 5). The Off-Price Specialty Show Web site. Retrieved December 30, 2005 from http://www.offpriceshow.com/scripts/publish/headlines.asp?code=ARF&eventid=1

Off-Price Specialist Show Web site. (2009). Retrieved August 4, 2009 from www.offpriceshow.com

Ogg, C. K. (1988, Oct.). The decision to move. *Retail Control, 56*(8), 32+.

Olympus Fashion Week. (2006). Retrieved January 3, 2006 from http://www.olympusfashionweek.com/spring2006/event_info/rel001.html

Onlins, A. (2009, Jan. 27). Haute Couture houses profit from an influx of new money. *The Times* (London), Edition 1, p. 9.

Palmieri, J. (2006, Aug. 28). Bloomies beefs up clothing for fall; department store also adds new vendors, shops and lifestyle merchandising in anticipation of strong season. *Daily News Record,* 11.

Palmieri, J. (2006, Sept. 18). Filene's basement. *Daily News Record,* 6.

Palmieri, J. (2006, Nov. 15). American Eagle team spirit. *Women's Wear Daily Online.* Retrieved July 11, 2007 from www.wwd.com

Palmieri, J., & Pallay, J. (2006, Jan. 23). Retail sales expected to slow in 2006. *Daily News Record,* 17.

Paris Haute Couture Fall 2009. (2009, July 6). *Women's Wear Daily Online.* Retrieved July 14, 2009 from www.wwd.com

The peopling of America. (2000). The Statue of Liberty-Ellis Island Foundation, Inc. Web site. Retrieved October 31, 2006 from http://www.ellisisland.org/immexp/wseix_4_3.asp?

Poggi, Jeanine. (2007, Nov. 8). Off-price could be sweet spot for holiday. *Women's Wear Daily Online.* Retrieved November 26, 2007 from www.wwd.com

Poggi, J. (2007, Jan. 8). The big picture: What it takes to grow in 2007. *Women's Wear Daily Online.* Retrieved September 1, 2008 from www.wwd.com

Polhemus, T. (1973). Fashion anti-fashion and the body image. *New Society, 11,* 73–76.

Polhemus, T. (1994). *Streetstyle: From sidewalk to catwalk.* London: Thames and Hudson.

Powell, B. & Skarbeck, D. (2004, Sept. 27). Sweatshops and third world living standards: Are the jobs worth the sweat? Independent Institute Working Paper Number 53, *The Independent Institute.* Retrieved August 3, 2009 from http://www.independent.org/pdf/working_papers/53_sweatshop.pdf

Powers, Denise. (2006, June 14). E-tailers try video, analytics. *Women's Wear Daily Online.* Retrieved March 18, 2008 from www.wwd.com

Preston, Steven. (2007, Feb./Mar.). The importance of entrepreneurship in America. *The Rippon Forum, 41*(1). Retrieved April 21, 2008 from http://www.sba.gov/idc/groups/public/documents/sba_homepage/news_release_ripon_v41-no1.pdf

Preview in Daegu '07 spring and summer international textile fair. (2006). Preview in Daegu Web site. Retrieved January 23, 2006 from www.previewin.com

Preview in Seoul 2006. (2006). Preview in Seoul Web site. Retrieved January 23, 2006 from www.previewinseoul.com

Ramey, J. (2008, Feb. 12). Positive signs. *Women's Wear Daily Online.* Retrieved June 22, 2008 from www.wwd.com

Reda, S. (2002, Aug.). Customer focus helps Hot Topic launch Torrid concept. *Stores, 84*(8), 33–34.

Reeves, Don. (2006). American Cowboy Gallery. National Cowboy and Western Heritage Museum. Oklahoma City, OK. Retrieved November 13, 2006 from http://www.nationalcowboymuseum.org/g_cowb_info.html

Reichmann, Ruth. (1996, Fall). Native dress, costume or fashion? *Indiana German Heritage Society Newsletter, 12*(4). Retrieved November 3, 2006 from http://www.serve.com/shea/germusa/trachten.htm

Retail trade and food services—estimates per capita sales by selected kinds of business: 1995 to 2005. (2007). *United States Census Bureau, Statistical Abstract of the United States: 2007.* Retrieved December 30, 2006 from http://www.census.gov/prod/2006pubs/07statab/domtrade.pdf

Retail trade and food services—Sales by kind of business: Summary 2000 to 2007, Table 1009. (2009). *U.S. Census Bureau.* Retrieved July 17, 2009 from http://www.census.gov/prod/2008pubs/09statab/domtrade.pdf

Reynolds, Fred, & Darden, William. (1972, Aug.). Why the midi failed. *Journal of Advertising Research, 12,* 39–44.

Ribeiro, A. (1986). *Dress and morality.* New York: Holmes and Meier.

Richards, Florence. (1951). *The ready-to-wear industry.* New York: Fairchild.

Roach-Higgins, M., & Eicher, J. (1992). Dress and identity. *Clothing and Textiles Research Journal, 10*(4), 1–8.

Roberts, A. (2008, Apr. 25). U.S. market drags down Luxottica net. *Women's Wear Daily Online.* Retrieved July 14, 2008 from www.wwd.com

Robertson, Nan. (1956, July 12). Now millions of shoppers seek U.S. name designers. *New York Times,* p. 27.

Rothrock, V. (2004, Oct. 26). Interstoff firms set for quota end. *Women's Wear Daily Online.* Retrieved January 23, 2006 from www.wwd.com

Rules and regulations under the Textile Fiber Products Identification Act. (2005). Federal Trade Commission Web site. Retrieved January 3, 2008 from www.ftc.gov

Sabharwal, Binny. (2006, Oct. 18). Wrapped up in India textiles; some view low tech industry as a solid long-term opportunity. *Wall Street Journal* (Eastern edition), C-12.

Salem witch trials. (2004). CBS.com Web site. Retrieved November 3, 2006 from http://www.cbs.com/specials/salem_witch_trials/behind/clothing.shtml

Samsonite raises its profile through McQueen collection. (2006, July 15). *Duty-Free News International, 20*(13), 19.

Sands floorplan. (1996–2004). The Off-price Specialty Show Web site. Retrieved December 30, 2005 from http://www.offpriceshow.com/scripts/publish/information.asp?code=SFP

Sapir, E. (1931, 1959). Fashion. In Seligman, R. (Ed.), *Encyclopedia of the Social Sciences, 6,* 139–144.

Saving green while going green. (2008, Jan. 31). *Cotton Incorporated Lifestyle Monitor Women's Wear Article*. Retrieved March 17, 2008 from http://www.cottoninc.com/lsmarticles/?articleID=572&pub=Womenswear

Schulz, D. (2004, Nov.). Who shops where—and why? *Stores, 86*(11), 104, 106. scotchirish.net

Schwab signs textile customs cooperation agreement with Mexico. (2007, Jan. 26). Press release, Office of U.S. Trade Representative. Retrieved September 14, 2008 from http://www.ustr.gov/Document_Library/Press_Releases/2007/January/Schwab_Signs_Textile_Customs_Cooperation_Agreement_with_Mexico.html

Seckler, V. (2000, Jan. 19). Net apparel shoppers more than double in '99. *Women's Wear Daily Online*. Retrieved March 18, 2008 from www.wwd.com

Seckler, V. (2007, July 27). Vuitton top-ranked among fashion brands. *Women's Wear Daily Online*. Retrieved December 19, 2007 from www.wwd.com

Secondary collections can't seem to make a French connection. (1997, Oct. 15). *Women's Wear Daily, 174*(74), 1+.

Settembrini, L. (1994). From haute couture to prêt-à-porter, in Celant, Germano, (Ed.), *Italian Metamorphosis 1943–68*, New York: Guggenheim, 485.

Settling disputes. (n.d.). Understanding the World Trade Organization. World Trade Organization Web site. Retrieved October 25, 2008 from http://www.wto.org/english/thewto_e/whatis_e/tif_e/disp1_e.htm

Shammas, C. (1982, Winter). Consumer behavior in colonial America. *Social Science History*, 6, 62–86. Reprinted in Peter Charles Hoffer (Ed.), *American Patterns of Life*. Garland Publishing, 1987.

Shammas, Carole. (1982, Autumn). How self-sufficient was colonial America? *Journal of Interdisciplinary History*, 13, 247–272.

Shopping Centers, Table 1030, Wholesale and Retail Trade. (2008). *Statistical abstract of the United States, U.S. Census Bureau*. Retrieved February 11, 2008 from http://www.census.gov/prod/2007pubs/08statab/domtrade.pdf

Show history. (1996–2004). The Off-price Specialty Show Web site. Retrieved December 30, 2005 from www.offpriceshow.com

Silk and silk business in Iran. (2003). Irano-British Chamber of Commerce. Retrieved September 28, 2008 from http://www.ibchamber.org/Magazine%2018/4.htm

Simmel, Georg. (1904, Oct.). Fashion. *International Quarterly*, 10, 130–155.

Singer history. (2003–2006). Singer at home worldwide. Singer Company Web site. Retrieved November 16, 2006 from http://www.singerco.com/company/history.html

The six sins of greenwashing. (2007, Nov.). TerraChoice Environmental Marketing, Inc. Retrieved October 25, 2008 from http://www.terrachoice.com/files/6_sins.pdf

Skrebneski, V., & Jacobs, L. (1995). *The art of haute couture*. New York: Abbeville Press.

Slave trade and textile production. (1995). H-Africa Web site. Retrieved November 10, 2006 from http://www.h-net.msu.edu/~africa/threads/slaverytextiles.html

Smith, Ray. (2007, Oct. 20). Menswear—new neckties go on a diet. *The Wall Street Journal,* Eastern Edition, p. W5.

Smith, T. M. (1999). *The myth of green marketing: Tending our goats at the edge of Apocalypse*. Toronto, Canada: University of Toronto Press.

Socah, M., Mascetta, K., & Foreman, K. (2009, July 6). Couture rides the economic storm. *Women's Wear Daily Online*. Retrieved July 14, 2009 from www.wwd.com

Socha, Miles. (2005, Dec. 13). Ungaro said close to naming new designer. *Women's Wear Daily Online*. Retrieved October 11, 2006 from www.wwd.com

Socha, Miles. (2006, Oct. 11). Chloe appoints Paulo Melim Andersson to chief designer. *Women's Wear Daily Online*. Retrieved October 11, 2006 from www.wwd.com

Sproles, George B. (1979). *Consumer behaviour towards dress*. Minneapolis, MN: Burgess Publishing Company, p. 244.

Sproles, G. B. (1981a). Analyzing fashion life cycles—Principles and perspectives. *Journal of Marketing, 45*(4), 116–124.

Sproles, G.B. (1981b). *Perspectives of Fashion*. Minneapolis, Minnesota: Burgess Publishing Co.

Sproles, G. B. (1982). *Perspectives of fashion*. Minneapolis, MN: Burgess Publishing.

The Statistics Division, Food and Agricultural Organization of the United Nations, 2005 Stop fashion piracy: About the bill. (2008). *Stop Fashion Piracy* Web site. Retrieved October 1, 2008 from http://www.stopfashionpiracy.com/about.php#Bill_Summary

Steele, Valerie (Ed.). (2005). *Encyclopedia of clothing and fashion*, Vol. 2. Farmington Hills, MI: Charles Scribner's Sons.

Steele, Valerie. (2000). *Fifty years of fashion: New Look to now*. New Haven, CT: Yale University Press.

Stegymeyer, Anne. (2004). *Who's who in fashion*, 4th ed. New York: Fairchild.

Steidtmann, C. (2005, Mar. 22). The case for deconsolidation. *Retail Merchandiser, 45*(3).

Stern, R. M., & Terrell, K. (2003, Aug.). *Labor standards and the World Trade Organization: A position paper*. World Trade Organization Web site. Retrieved November 1, 2007 from http://www.wto.org/english/info_e/search_results_e.asp?SearchItem=sweatshop

Stone, Elaine, & Samples, J. (1985). *Fashion merchandising: An introduction,* 4th ed. New York: McGraw-Hill.

Stop fashion piracy video. (2008). Available online at www.stopfashionpiracy.com

Storm, Penny. (1987). *Functions of dress: Tools of culture and the individual*. NJ: Prentice-Hall.

Strategy targeting organized piracy (STOP!). (2005, Nov. 2). United States Patent and Trademark Office. Retrieved January 31, 2006 from http://www.uspto.gov/main/profiles/stopfakes.htm

Strugatz, Rachel. (2007, May 2). Designers push eco-friendly fabrics. *Women's Wear Daily Online*. Retrieved September 16, 2007 from www.wwd.com

Study: Department store sector losing business. (2006, Aug. 1). *National Jeweler,* 100(15), 14.

Sustainability. (2008). U.S. Environmental Protection Agency Web site. Retrieved November 15, 2008 from www.epa.gov/sustainability

Tait, Tricia. (2003). Madame de Pompadour Web site. Retrieved February 14, 2006 from http://departments.kings.edu/womens_history/pompadou.html

Taiwan: Local industry and market. (2005, Aug. 22). Office of Textiles and Apparel, U.S. Department of Commerce, International Trade Administration. Retrieved January 31, 2006 from http://web.ita.doc.gov/tacgi/overseas.nsf/

Textile companies may have new trade tactic. (2006, Nov./Dec.). *Textile World*, 156(6), 16.

Textile industry alert: Lyocell is a generic fiber name; Tencel® is not. (2001, Mar.). Federal Trade Commission. Retrieved September 28, 2008 from http://www.ftc.gov/os/statutes/textile/alerts/lyocell.shtm

Textile Korea: Annual report. (2005). Korea Federation of Textile Industries. Retrieved January 17, 2006 from www.kofoti.or/.kr/eng/index.php

Textiles of the North American Southwest. (2006). Smithsonian Center for Education and Museum Studies, Smithsonian Institution. Retrieved November 10, 2006 from http://www.smithsonianeducation.org/idealabs/textiles/english/gallery/index.htm

Think technology. (2006). The Clothier's Digest of the Clothing Manufacturer's Association of India. Retrieved January 18, 2006 from www.apparelreview.com

Thinkquest: Arkwright, Richard. (2006). Oracle Thinkquest Educational Foundation. Retrieved September 29, 2006 from http://library.thinkquest.org/16541/eng/learn/library/content/arkwright.htm

Thomas, Brenner. (2009, Feb. 10). Recession lifts Off-Price Specialist Show. *Women's Wear Daily Online*. Retrieved August 4, 2009 from www.wwd.com

Thomas, Pauline Weston. (2006). *Chambre Syndicale fashion history*. Fashion-Era. Retrieved February 15, 2006 from www.fashion-era.com/chambre_syndicale.htm

Tierney, Tom. (1985). *Great fashion designs of the fifties*. Mineola, NY: Dover Publications.

Tierney, Tom. (1987). *Great fashion designs of the forties*. Mineola, NY: Dover Publications.

Tierney, Tom. (1983). *Great fashion designs of the twenties*. Mineola, NY: Dover Publications.

Tierney, Tom. (1987). *Great fashion designs of the Victorian era*. Mineola, NY: Dover Publications.

Top 100 specialty retailers. (2005, Aug.). Supplement to *Stores, 87*(8), S2–S14.

Torntore, Susan J. (Ed.) (2001). *Nigerian textiles: Global perspective*. St. Paul, MN: The Goldstein Museum of Design, University of Minnesota.

Trade delivers. (2006, July). Office of the United States Trade Representative. Retrieved September 14, 2008 from http://www.ustr.gov/assets/Document_Library/Fact_Sheets/2006/asset_upload_file920_9647.pdf

Tran, Khanh. (2005, Dec. 7). Movers and shakers. *Women's Wear Daily Online*. Retrieved January 4, 2006 from www.wwd.com

Tran, K. (2008, Jan. 18) American Eagle launching children's concept 77kids. *Women's Wear Daily Online*. Retrieved July 17, 2009 from www.wwd.com.

Trappers, fur traders, frontiers & mountain men. (2006). Multnomah County Library. Retrieved November 8, 2006 from http://www.multcolib.org/homework/biohc.html#trap

Tucker, Ross. (2007, Apr. 10). Sprouting issues. *Women's Wear Daily Online*. Retrieved September 16, 2007 from www.wwd.com

Tucker, R. (2007, Sept. 4). Textiles face price pressure. *Women's Wear Daily Online*. Retrieved September 4, 2007 from www.wwd.com

Tucker, R. (2007, Sept. 18). Import prices: Nowhere to go but up. *Women's Wear Daily Online*. Retrieved November 30, 2007 from www.wwd.com

Tucker, R., & Huntington, P. (2007, Aug. 7). China quota call shakes up global wool industry. *Women's Wear Daily Online*. Retrieved January 17, 2008 from www.wwd.com

Tutelian, Louise. (2006, Nov. 17). In Minnesota, a mall as big as all indoors. *New York Times*. Retrieved February 13, 2008 from http://www.mallofamericaphase2.com/downloads/NYTimes.pdf

12 high-impact marketing programs you can implement by next Thursday. (1998, Feb. 26). Small Business Administration Web site. Retrieved June 6, 2007 from http://www.sba.gov/gopher/Business-Development/Success-Series/Vol9/12highim.txt

2007 NAICS definitions. (2007). United States Census Bureau. Retrieved February 7, 2008 from http://www.census.gov/naics/2007

Ulrich, Laurel T. (1998, Jan.). Wheels, looms, and the gender division of labor in eighteenth-century New England. *William & Mary Quarterly*, 3rd Series, 55(1), 3–38.

University of Houston news release. (1994, Apr. 19). *Celebrated fashion designer Victor Costa to receive first merchandising Star Award by UH College of Technology*. University of Houston Web site. Retrieved June 3, 2007 from http://www.uh.edu/admin/media/nr/2004/04apr/041904costaawd.html

U.S.-Dominican Republic-Central American Free Trade Agreement. (2004). Trade Information Center, Export.gov. Retrieved January 31, 2006 from http://www.ita.doc.gov/td/tic/fta/CAFTA/index.htm

U.S. imports of textiles, textile products and apparel, top trading partners. (2007). U.S. Department of Commerce, Census Bureau, Foreign Trade Division. Retrieved October 31, 2007 from http://www.census.gov/foreign-trade/statistics/country/index.html

U.S. population milestones. (2006, Oct. 3). CBS News Web site. Retrieved November 3, 2006 from http://www.cbsnews.com/elements/2006/10/03/sunday/timeline2058523_0_main.html

U.S. retail trade sales—total and e-commerce: 2004 and 2003. (2006, May 25). *2004 e-commerce multi-sector report.* United States Census Bureau E-stats. Retrieved December 30, 2006 from http://www.census.gov/eos/www/2004tables.html

U.S. textile and apparel trade programs in a post-quota world. (2009, Feb. 5). *Office of Textiles and Apparel* webinar. Retrieved August 4, 2009 from http://web.ita.doc.gov/tacgi/eamain.nsf/6e1600e39721316c852570ab0056f719/475c76712aaecfc185257527006f967a?OpenDocument

Upadhyay, R. (2008, Nov. 4). World's largest mall takes center stage in Dubai. *Women's Wear Daily Online.* Retrieved November 4, 2008 from www.wwd.com

Value of exports, general imports, and imports for consumption by SITC commodity grouping (2651). U.S. Census Bureau online. Retrieved August 7, 2007 from http://www.census.gov/prod/1/ftd/ft925/f925125b.pdf

Veblen, Thorstein. (1912). *Theory of the leisure class.* New York: Macmillan.

Veblen, T. (1994). *Theory of the Leisure Class.* NY: Penguin Books.

Waldrop, Judith, & Mogelonsky, Marcia. (1992). *Seasons of business: The marketer's guide to consumer behavior.* Ithaca, NY: American Demographics.

Wal-Mart, Burlington Coat Factory, Bugle Boy, Delia's and others settle charges of violating Textile, Wool Acts in on-line catalogs. (1999, Mar. 16).Federal Trade Commission Web site. Retrieved October 25, 2008 from http://www.ftc.gov/opa/1999/03/musatex.shtm

Warlick, A. (2007, Oct.). Take advantage of study abroad experiences. *Agri Marketing supplement,* 14–15.

Warren, Alice F. (1927). *Sumptuary legislation in the thirteen colonies from 1620 to 1760.* Unpublished master's thesis, University of Wisconsin.

Weinstein, Jeff. (2002, July 24).Exhibit profiles work of Hollywood fashion designer Adrian. *The Philadelphia Inquirer.* Retrieved June 9, 2008 from EBSCOhost, accession number 2W73639521300.

Weitzman, J. (2001, June 28). Sister store concepts offer strong potential for youth retailers. *Women's Wear Daily Online.* Retrieved March 10, 2008 from www.wwd.com

Welcome to the Lace Market. (2006, May). Lace Market Web site. Retrieved September 29, 2006 from www.lacemarket.com

Wells, R. (2007, Apr. 8). Can't sew, so what? *Sunday Age* (Melbourne, Australia), Section M; Upfront, p. 10.

What about the name? (2004). ScotchIrish Web site. Retrieved November 6, 2006 from http://www.scotchirish.net/What%20about%20the%20name.php4

What are intellectual property rights? (2007). TRIPS Council of the World Trade Organization Web site. Retrieved December 28, 2007 from http://www.wto.org/english/tratop_e/trips_e/intel1_e.htm

What every member of the trade community should know about: Textile & apparel rules of origin. (2004, Apr.). United States Customs and Border Control Web site. Retrieved January 2, 2008 from www.cbp.gov

What is a fashion? (2006). *On2: History of Fashion.* Public Broadcasting Service online. Retrieved February 14, 2006 from http://www.pbs.org/newshour/infocus/fashion/whatisfashion.html

What is a quota? (2001, Mar. 22). Foreign Trade Division of the United States Census Bureau. Retrieved January 7, 2008 from http://www.census.gov/foreign-trade/faq/reg/reg0034.html

What is a tariff? (2001, Mar. 22). Foreign Trade Division of the United States Census Bureau. Retrieved January 7, 2008 from http://www.census.gov/foreign-trade/faq/reg/reg0033.html

What is the World Trade Organization? (2007). World Trade Organization Web site. Retrieved January 3, 2008 from www.wto.org

White, N. (2000). *Reconstructing Italian fashion: America and the development of the Italian fashion industry.* Oxford: Berg.

Whitfield, M. B. (2002, Aug.). Department stores: A bet on turnaround strategies. *Chain Store Age, 78*(8), 18A–19A.

Who's who. (2006). Vogue.com Web site. Retrieved October 11, 2006 from http://www.vogue.co.uk/whos_who/

Wild, Oliver. (1992). *The Silk Road.* Retrieved February 18, 2006 from http://www.ess.uci.edu/~oliver/silk.html#2

Williams, Court. (2007, Apr. 10). Second nature. *Women's Wear Daily Online.* Retrieved September 16, 2007 from www.wwd.com

Wilson, Eric. (2007, Nov. 1). Is this it for the it bag? *New York Times* (Late Edition, East Coast), G10.

Wilson, M. (2001, July). Torrid: Hot fashion for plus-size teens. *Chain Store Age, 77*(7), 130–131.

Women's Wear Daily. (1963). *Sixty years of fashion.* New York: Fairchild.

Wool, Greasy; Major Food and Agricultural Commodities and Producers. (2005). The Statistics Division, Economic and Social Department, Food and Agricultural Organization of the United Nations. Retrieved October 3, 2007 from http://www.fao.org/es/ess/top/commodity.html

World business briefing; W.T.O. opens piracy case. (2007, Sept. 26). *The New York Times.* Retrieved December 29, 2007 from http://query.nytimes.com/gst/fullpage.html?res=9F07E3DB1430F935A1575AC0A9619C8B63

Worldwide chemical fiber production in 2007. (2008). Japan Chemical Fiber Association. Retrieved September 28, 2008 from www.jcfa.gr.jp/english/what_data/worldwide-production2007.pdf

Young, Vicki M. (2008, June 11). Bad times for Goody's: Retailer files Chap. 11 as economy takes toll. *Women's Wear Daily Online.* Retrieved October 17, 2008 from www.wwd.com

Young, V. (2008, June 11). Goody's financing scrutinized. *Women's Wear Daily Online.* Retrieved October 17, 2008 from www.wwd.com

Young, V. (2008, July 8). Steve & Barry's squeeze: Without white knight, liquidation a possibility. *Women's Wear Daily Online.* Retrieved October 17, 2008 from www.wwd.com

Young, V. (2008, July 29). Mervyns files Chapter 11. *Women's Wear Daily Online.* Retrieved October 17, 2008 from www.wwd.com

Young, Vicki M. (2008, Aug. 5). Boscov's files for Chapter 11; chain said to put itself up for sale. *Women's Wear Daily Online.* Retrieved October 17, 2008 from www.wwd.com

Zargani, L., & Moin, D. (2008, Mar. 10). Heading to the desert? Bloomingdale's store in Dubai said in works. *Women's Wear Daily Online.* Retrieved November 4, 2008 from www.wwd.com

Zarocostas, John. (2006, Jan. 3). China, India top exporter list. *Women's Wear Daily Online.* Retrieved January 19, 2006 from www.wwd.com

Zarocostas, J. (2007, June 19). Textiles top dumping cases. *Women's Wear Daily Online.* Retrieved January 7, 2008 from www.wwd.com

Zarocostas, J. (2007, July 10). China restrictions aid Indonesia. *Women's Wear Daily Online.* Retrieved November 30, 2007 from www.wwd.com

Zarocostas, J. (2007, Sept. 25). Group calls for crackdown on labor abuse practices. *Women's Wear Daily Online.* Retrieved January 12, 2008 from www.wwd.com

Zarocostas, J. (2007, Oct. 26). Most counterfeits said to come from China. *Women's Wear Daily Online.* Retrieved December 30, 2007 from www.wwd.com

Accessories, men's, 92
Account executive, 282
Acetate, 187
Acrylic, 188
Adidas, 269
Adinkra cloth, 46
Adrian, Gilbert, 65, 80
Aéropostale Inc., 259
Affair to Remember, 286
African Growth and Opportunity Act (AGOA), 245
African immigrants, 46
Agreement on Clothing and Textiles (ACT), 245
Alexander McQueen, 90, 161, 164
Alice + Olivia, 143
A-line silhouette, 70, 71
AlixPartners, 257
Alta moda, 26
Alyssa brand, 137
American Apparel and Footwear Association (AAFA), 192
American Celanese Corporation, 186
American Eagle Outfitters (AEO), 127
American Idol, 261
American Look, 25
American western wear, 46–47
Angular look, 61–62
Anne Klein, 280
Ann Taylor, 259
Anthony, Susan B., 62
Antidumping legislation, 247
Antoinette, Marie, 28, 37
Apparel Industry Partnership, 52
Apparel manufacturing, in developing countries, 206–210
Apple Bottoms, 261
Aramid, 190
Arden, Elizabeth, 58
Arkwright machine, 48
Artificial obsolescence, 111
Art nouveau, 59–60
Assembling, 203, 205
Association of Southeast Asian Nations (ASEAN), 229
Astor, John Jacob, 44–45
Ateliers, 34
Athletic apparel, 76
Atlanta, GA, 220–221

Baby Phat, 261
Bagir Group Limited, 183
Bamboo textiles, 183
Bankruptcy, 273
Banton, Travis, 65, 80

Barneys, 157
Beall's, 269
The Beatles, 71
Beatniks, 69
Beckham, David, 121
Behavioral segmentation, 125–126
Belk, 258
Bell, John, 37
Bell-bottom pants, 71
Belz Factory Outlet Centre, 266
Bendet, Stacy, 143
Bertin, Rose, 28
Bespoke tailoring, 91
Betsy Johnson, 261
Better pricing, 90
Better to bridge pricing, 90
Bias cut, 64
Bilateral agreements, 247
Black Friday, 252
Blass, Bill, 162
Blazers, men's, 91
Bling, 77
Bloomer, Amelia Jenks, 62
Bluefly.com, 262, 268
Blue jeans, 112
Blumer, Herbert, 108, 113
Bobbed hairstyle, 63
Bodysuit, 72
Bonaparte, Napoleon, 28–29
Bonwit Teller, 257
Borer, Thomas, 201
Boscov's, 273
Boulanger, Louise, 64
Boutique, 260
Brand equity, 76, 161–162
Brand franchise, 76, 161–162
Branding, 75–76
 defined, 160
 legal issues and, 166–169
 types of fashion brands, 162–165
 value of, 160–162
Brando, Marlon, 112
Brand reinventions, 161
Brands
 celebrity, 167
 counterfeits, 168–169
 defined, 160
 designer, 164
 global, 164
 luxury, 165
 multinational, 164
 positioning, 160–161
 private label, 163–164

 rebranding, 160–161
 reinventing, 160–161
 repositioning, 160–161
Break, 92
Breaking bulk, 254
Bridge pricing, 90
Brinker, Nancy, 201
Brokers, 232
Brummell, George Bryan "Beau", 29
Bubble skirt, 69
Bubble-up process, 112
Budget concerns, 203–204
Budget pricing, 89
Burberry of London, 93, 161–162
Burdines, 257
Bush, George W., 201
Bush, Laura, 201
Business plan, 290
Business types, 289
Bustle, 31
Buyers, 284–285

Caged crinoline, 30
Calculating, 18
California Market Center (CMC), 220
Camouflage prints, 77
Carbon footprint, 246
Cardin, Pierre, 71
Career days/fairs, 292–294
Careers, 278–288
Care Labeling Rule, 243, 245
Caribbean Basin Initiative, 244
Caribbean Basin Trade Partnership Act, 244, 245
Carnegie, Hattie, 68, 80
Carter, Ernestine, 32–33
Cartwright, Edmund, 49, 50
Cashmere, 185
Cassini, Oleg, 70
Casual athlete, 74
Casual Friday, 75, 76
Casual movement, 66
Casual sportswear, men's, 92
Celebrity brands, 167
Cellulose fibers, 180–184, 186–187
Central American Free Trade Agreement (CAFTA), 243
Central American Free Trade Agreement-Dominican Republic (CAFTA-DR), 14, 244–245
Chambre Syndicale de la Couture Parisienne, 34
Chanel, Coco, 31–32, 63, 68

Channel of distribution, 11–12, 131–132
Charisma, 17–18
Charles, Prince of Wales, 75, 111
Chase and flight, 109
Chemise, 62, 68, 70
Chic, 36
Chicago, IL, 221
Chicos Company, 89
Children's wear, 93–94, 95
China, 225–227
China grass, 182
Chinatown, NY, 169
Circular knitting machine, 49
Claiborne, Liz, 162
Claritas PRIZM, 126
Clark, Victor S., 50
Class differentiation theory, 109
Classic, 140
Client services coordinator, 285–286
Cloche hats, 63, 64
Clothing Manufacturers Association of India
 (CMAI), 229
Coach, 270
Codes of conduct, 210
Cohen, Marshall, 93
Collective selection theory, 113–114
College opportunities, 291–297
Color Association of the United States
 (CAUS), 147–148
Columnar silhouette, 60, 61
Combs, Sean "Diddy", 77
Community shopping centers, 265
Comparative advantage, 239
Competitions, 292–294
Competitive advantage, 134
Competitive edge, 134
Conspicuous consumption, 74–75, 110
Conspicuous leisure, 110
Consumer Price Index (CPI), 209
Consumer Products Safety Commission, 238
Consumer Sentiment Index, 257
Convenience centers, 265
Cooper, Gary, 65
Cooper, Marc, 273
Cooperative advertisements, 144
Copywriter, 285
Core competency, 134
Corporate buying office positions, 8
Corporate casual, 75
Corporate code of conduct, 51–53
Corporation, 289
Corsets, 60
Cost, 131
Costa, Victor, 167
Costing out a garment, 203–204
Cotton, William, 49
Cotton boll, 181
Cotton gin, 49–50
Cotton Incorporated, 112, 183, 192, 194
Council of Fashion Designers of America
 (CFDA), 93, 108, 162, 167–168
Counterfeiting, 168–169
Counterfeits, 168–169
Country of origin, 205

Courrèges, André, 70, 71
Couture RTW pricing, 91
Couturières, 34
Couturiers, 34
Crawford, Joan, 80
Creativity, 17
Critical thinking, 16
The Crusades, 22
Culmination stage, 141, 145
Curvy looks, 59–61
Customer base, 124
Cutting, 203, 205
Cyber Monday, 252
Cycles, of fashions, 106

Daché, Lilly, 68
Dacron polyester, 68
Daily News Record (DNR), 93
Dallas, TX, 222–223
Daman, Eric, 104
Dandy, 29
Dandyism, 29
Data analysis positions, 8
Database marketing, 147
David, Jules, 38
Davis, Jacob, 47
Dean, James, 112
Decline stage, 142, 146
DeMille, Cecil B., 80
Democratization of fashion, 113
Demographics, 125
Demographic variables, 125
Denim, 47, 112
Department stores, 257–258
Designer, 200, 280
Designer brands, 164
Designer pricing, 91
Design Piracy Prohibition Act, 167–168,
 172–173
Developing countries, manufacturing in,
 206–210
Diana, Princess of Wales, 74, 75, 111
Dickies, 261
Dietrich, Marlene, 65
Diffusion pricing, 90
Dillard Department Store, 257
Dior, Christian, 32–33, 67, 68
Direct marketing, 270
Direct Marketing Association of
 Washington, 270
Disco clothing, 73
Discount stores, 260–261
Disposable fashion, 145
Distressed look, 78
Distribution, 131–132
Divisional merchandise managers (DMM), 284
Dolce and Gabbana, 270
Domestic production, 210, 213
Doneger Group, 148, 233, 278
D'Orsay, Count, 29
Dress, 7
Dress codes, 72
Dress Doctor (Head), 81
Dress for Success (Molloy), 72

Drop, 92
Dubai Mall, 264
Dumping, 230, 246–247
Duty, 226
Duty-free, 227
DVF brand, 162
Dynasty, 74

Early adopters, 141
Early majority, 141
E-commerce merchandise planner, 283–284
Eicher, Joanne, 7
Ellis Island, 43
Emanuel, Elizabeth, 111
Embargoes, 227
Emotives, 11
Empire waists, 60, 61
Employment, 7–9
English immigrants, 44
Entrepreneurship, 288–291
Entwistle, Joanne, 97, 98
Equal Rights Amendment, 72
Erin Fetherston, 260–261
Estée Lauder Cos. Inc., 269
E-tailing, 76, 267–268
Ethical Trading Initiative (ETI), 53
Ethnic dressing, 71
Ethnic influences, 42–47
Europe, 23–26
European immigrant influences, 42–45
European trappers, 45
Ewing Marion Kauffman Foundation, 288
Excess, 105
Executive training program trainee, 286
Experimental method, 154
Export Advantage, 15
Export agent, 231
Exports, 226
Extant, 149–150

Fad, 140
Faircloth, Michael, 201
Fair Labor Association (FLA), 53
Fair Labor Standards Act, 247
Fashion
 authors' definitions of, 97
 defined, 5
 life cycle, 140–142
 primary consideration for, 7
 principles of, 104–109
 purposes of, 117–119
Fashion adoption curve, 140
Fashion adoption process, 140
Fashion as a Career (Head), 81
Fashion count, 151
Fashion curve, 140
Fashion Design Council of India, 229
Fashion dolls, 36–37
Fashion followers, 109
Fashion forecasting, 147–149
Fashion Group International, 58
Fashion icons, 162
Fashion innovators, 109, 141
Fashion life cycle, 140

Fashion market center, 215–223, 294
Fashion marketing mix, 130
Fashion plates, 37–38
Fashion research, 149–154
Fashion (Simmel), 109, 110
Fashion systems theory, 114
Fashion trend analyst, 278
Fast-fashion retailers, 111
Fast-fashions, 145, 206
Faux, 63
Faux fur, 113
Federal Trade Commission (FTC), 238
Federated Department Stores, 257
Festival shopping centers, 265–266
Fibers
 acetate, 187
 acrylic, 188
 cellulose, 180–184, 186–187
 cotton, 181
 filament, 186
 hemp, 182
 jute, 182
 linen flax, 182
 lyocell, 187
 man-made or manufactured, 180,
 186–190
 natural, 180–186
 nylon, 187–188
 polyactide, 183
 polyester, 188
 protein, 180, 184–186
 ramie, 182
 rayon, 186
 silk, 185–186
 staple, 186
 synthetic, 187–190
 wool, 184–185
 yarns, 191
Fibre flax, 182
Field, George A., 112
Filament fibers, 186
Filene's Basement, 257, 262–263
Filling yarns, 49
Film industry, 80
Finishing, 203, 205
First quality merchandise, 232
First sample, 204
First-through-production patternmaker, 280
Fitness craze, 74
Flammable Fabrics Act, 242, 245
Flapper, 63, 64
Flashdance, 74
Flax, 182
Flügel, J. C., 117
Focus groups, 153–154
Foleys, 257
Fonda, Jane, 74
Forced-choice questions, 152
Foreign Agricultural Service (FAS), 179
4 Ps of fashion marketing, 130–135
France, 24
Free Trade Agreement of the Americas
 (FTAA), 244

Free trade agreements (FTA), 240
Fringe sizes, 92
Fuchs, Edward, 97, 98
Full fashioning, 49
Full-price, 131
Fur, 113, 190–191
Fur Council of Canada, 191
Fur fibers, 184
Furnishings, men's, 92
Fur Products Labeling Act, 242, 245
Fur traders, 45

Gabriel, Alfred Guillaume, 29
Gangsta, 77
Gap, 258, 260
Garbo, Greta, 65, 80
Garment design, 203
Garment district, 217
General Agreement on Tariffs and Trade
 (GATT), 239–240
Genoni, Rosa, 25
Gentleman's Quarterly (GQ), 93
Geographic segmentation, 127
Geographic theory, 113
George IV, King of England, 29
German immigrants, 44–45
Gernreich, Rudi, 70
Gibson, Charles Dana, 60
Gibson Girl look, 60
Ginning, 181
Giorgini, Giovan, 25, 33
Global brands, 158, 164
Global issues, 245–249
Globalization, 16
Global Social Compliance Programme
 (GSCP), 53
Gloria Vanderbilt, 72
Go-go boots, 70, 71
Going to market, 224
Gold range pricing, 90
Gone with the Wind, 65, 286
Goods, 131
Goody's Family Clothing Inc., 273
Gordmans, 262
Gossip Girl, 104
Gothic look, 77
Goth look, 77
Gottschalks, 257
Grading, 203, 204
Great Depression, 63–64, 65, 66–67
Green businesses, 246
Green consumer, 197
Green marketing, 251
Green textiles, 183
Greer, Howard, 80
Gregory, Rogan, 157
Group acceptance, 11
Growth stage, 141
Grunge, 76

H&M, 206
Halston, Roy Frowick, 101
Hand, 186

Harmonized Tariff System (HTSUSA or HTS), 179
Harris, James, 37
Haute couture, 28, 34–36
Head, Edith, 58, 80, 81
Heimat, 45
Hemp, 182
Henry IV, King of France, 36
Henshaw, Ruth, 44
Hepburn, Audrey, 69
Hepburn, Katharine, 65, 80
Hermès, 270
Hickey, Thomas E., 4
Higgins, Mary Ellen Roach, 97, 98
High-low dressing, 104
High street fashions, 145
Hip-hop, 77
Hippies, 70–71
Historical continuity, 107–108
History
 1900-1909, 59–61
 1910-1919, 61–62
 1920-1929, 62–64
 1930-1939, 64–66
 1940-1949, 66–67
 1950-1959, 67–69
 1960-1969, 69–71
 1970-1979, 71–73
 1980-1989, 74–75
 1990-1999, 75–77
 2000-present, 77–79
Hobble skirt, 61
Hollywood glamour, 64–65, 78, 80
Home Depot, 265
Hoover, Lou, 108
Hosiery, 70
Hot pants, 70
Hot Topic, 261
House of Fendi, 191
Howe, Elias, 50
Human rights, 247–248
The Hurricane, 81
Hybrid shopping centers, 264
Hypothesis, 151

Idea conception, 202–203
I.L.G.W.U. (International Ladies Garment
 Workers Union), 53
I. Magnin, 257
Imitation, 105–106
Import agent, 231
Import duty, 226
Imports, 226
Independently-owned wholesale
 showroom, 231
Independent wholesale sales representative,
 282–283
India, 229
Indonesia, 229
Industrial Revolution, 47–50
Inspecting, 203, 205
Integrated marketing communications (IMC),
 134–135
Intellectual property rights, 166–167, 246

Interbrand, 158
Internal merchandise coordinator, 285
International Council of Shopping
 Centers, 263
International Labor Organization (ILO), 52,
 247–248
International trade terminology, 225
Internet retailing, 15, 76
Internships, 291–292
Introductory stage, 141, 142–144
Irish immigrants, 43
Irregular quality merchandise, 232
Italy, 25–26

Jacobs, Marc, 83, 162, 199–200
JCPenney, 133–134, 257, 268
JH Collectibles, 90
Jobbers, 231–232
Job shadowing, 292
Jointed babies, 36
Jonathan Saunders, 261
Joseph Ribkoff International, 213
Journal des Dames et des Modes, 37
Jovovich-Hawk, 261
Juicy Couture, 111
Junior petite sizes, 88
Junior sizes, 88
Just-in-time (JIT) production, 206
Jute, 182

Kamali, Norma, 74
Karan, Donna, 75, 280
Kennedy, Jacqueline, 70, 101, 108
Kennedy, John F., 70, 71
Kennedy, Robert Jr., 121
King, Charles W., 113
Klein, Calvin, 162
K-Mart, 260
Knitted fabrics, 191
Knitting machine, 49
Knockoffs, 111, 167–168, 200, 202
Kohls Corporation, 257, 258

La Belle Assemblée, 37
Labor-intensive regions, 224–230
La Garçonne dress, 63
Lagerfield, Karl, 191
Laggards, 142
Lamour, Dorothy, 81
Lanolin, 184
Las Vegas, NV, 220, 221
Late majority, 142
Lauren, Ralph, 280
Laver, James, 97, 98
Laver theory, 116
Lazarus, 257
Leather, 190–191
Lee, William, 49
Legal issues
 African Growth and Opportunity Act, 245
 Agreement on Clothing and Textiles, 245
 bilateral agreements, 247
 branding and, 166–169

Care Labeling Rule, 243, 245
Caribbean Basin Trade Partnership Act,
 244, 245
Central American Free Trade Agreement,
 244–245
dumping, 246–247
Fair Labor Standards Act, 247–248
Flammable Fabrics Act, 242, 245
Fur Products Labeling Act, 242, 245
human rights, 247–248
intellectual property rights, 246
Made in the U.S.A., 243, 245
Multifiber Agreement, 245
multilateral agreements, 247
NAFTA, 243, 245
regional agreements, 247
regulating organizations, 238–240, 245
Textile Fiber Products Identification Act,
 242–243, 245
Wool Products Labeling Act,
 241–242, 245
l.e.i., 261
Leisure suit, 73
Le Moniteur de la Mode, 37–38
Lentz, Irene, 80
Letty Lynton, 80
Levi Strauss, 47, 254, 260
Licensed apparel, 94
Licensing agreements, 166
Licensing International Expo, 94
Lifestyle merchandising, 259–260
Lifestyle Monitor, 112
Lifestyle shopping center, 266
Liguoro, Lydia De, 25
Limited line specialty stores, 259–260
Linen, 182
Linen flax, 182
Linens 'N Things, 273
Linsey-woolsey, 45
Lint, 181
Loehmann's, 262
Longs, men's sizing, 92
Loom, 49, 191
Lopez, Jennifer, 111
Lord & Taylor, 257, 273
Los Angeles, CA, 220
Louis Vuitton, 270
Louis XIV, King of France, 24, 27
Lovejoy, Jim, 89
Lower better pricing, 90
Loyalty programs, 15
Luxury brands, 165
Lycra spandex, 132
Lyocell, 187
LZR Racer, 189

Macy's, 257
Made in the U.S.A., 241, 243
MAGIC (Men's Apparel Guild in California),
 220
Mainbocher, 68
Mall approach, 153
Mall of America, 264

Malls, 263–267
Man-made/manufactured fibers, 180,
 186–190
Mannequins, 36
Manufacturer-owned wholesale
 showroom, 231
Manufacturer's overruns, 232, 262
Manufacturing, in developing countries,
 206–210
Market, 216
Marketing
 4 Ps of, 130–135
 database, 147
 fashion life cycle and, 142–147
 market segmentation, 124–128
 niche markets, 128–129
 positions in, 9
 relationship marketing, 129
 target market, 124
 textiles, 190–194
 use of term, 130
Marketing channel, 131–132
Market research, 202, 203
Market segmentation, 124–128
Market test, 154
Marking, 203, 204–205
Markup, 131
Marshalls, 262
Mass customization, 207
Massenet, Natalie, 101
Mass merchandise stores, 260–261
Mass pricing, 89
Material World Trade Show, 192
Maxi dress, 73
McCardell, Claire, 58, 67, 68, 80, 81, 162
McCartney, Stella, 190–191
McLaughlin, Betsy, 261
M-commerce, 269
McQueen, Alexander, 90, 161, 164
Media mix, 132–133
Medici, Maria de, 36
Medium, 132
Menswear, 91–93
Merchandise coordinator, 285–286
Merchandise planner, 283
Merchandising, 7
Mervyns Stores, 273
Metallic, 190
Metro-Goldwyn-Mayer Studios (MGM), 65,
 265–266
Metrosexual, 78–79
Mexico, 227
Microfibers, 188
Micromini, 70
Micro miniskirt, 72
Midi skirt, 72–73
Miniskirt, 70
Missy petite sizes, 88
Missy sizes, 88
Mixed-use centers, 264
Modacrylic, 189
Moderate pricing, 90
Mod look, 70

Modular manufacturing, 205
Molloy, John, 72, 74
Monobosom, 59
Monobrand, 259
Montijo, Empress Eugénie de, 30
Moss, Kate, 83
Multichannel retailing, 15, 254
Multifiber Agreement (MFA), 245
Multilateral agreements, 247
Multinational brands, 164
Multinational companies, 16

National brands, 163
National Chamber for Italian Fashion, 26
National Organization for Women, 72
National Press Week (1943), 67
National Retail Federation, 267
Native American influences, 46
Native Americans, 71
Natural fibers, 180–186
Neckties, 121
Neighborhood shopping centers, 265
Neiman-Marcus, 286
Net-a-porter.com, 101
New Look, 67, 68, 70
New York, NY, 216–219
New York Dress Institute, 67
Niche marketing, 15
Niche markets, 128–129
Nike, 207
Nonstore retailing, 270
Nordstrom, 259, 268
Norrell, Norman, 80
North American Free Trade Agreement
 (NAFTA), 14, 227, 243, 245
North American Fur and Fashion Exposition
 (NAFFEM), 191
North American Industry Classification
 System (NAICS), 257
NPD Group, 93
Nylon, 66, 187–188
Nystrom, Paul, 56, 97, 98

Obama, Michelle, 104, 108
Oblique, 68
Observation method, 154
Obsolescence stage, 142, 146–147
Oceanic Sportswear, 213
Odd lot assortments, 232
Office of Textiles and Apparel (OTEXA), 14,
 179, 238
Office of the United States Trade
 Representative, 239
Off-price, 222
Off-price stores, 262–263
Offshore sourcing, 13
Old Navy, 128
Olefin, 189
Online shopping, 76
Open-air centers, 263
Open-air shopping centers, 265–266
Open-ended questions, 152
Open-to-buy, 284

Opinion leaders, 26, 27
Opportunities, college, 291–297
Organic, 183
Outerwear, men's, 92
Outlet shopping centers, 266
Out of fashion, 11
Outsourcing, 206–210
Ownership groups, 233
Oxford bags, 63

P3 Program, 10
Pantone, 278
Pants, 72
Pantyhose, 70
Partnership, 289
Patriotic colors, 77
Patternmaker, 280
Patternmaking, 203, 204
Paul Fredrick Menstyle, 207
Payless Shoe Source, 259
Peacock revolution, 73
Peak stage, 141
Pecuniary, 110
Pendleton Woolen Mills, 178
Penney, James Cash, 257
Periodicals, 37–38
Perot, Ross, 201
Perot, Sarah, 201
Peter J. Solomon Company, 273
Phelps, Michael, 189
Piecework, 205
Pierre Cardin, 71
Pilgrims, 44
Place, 131–132
Planned obsolescence, 11
Plus sizes, 88
Poiret, Paul, 61, 62, 105
Poisson, Jeanne-Antoinette, 28
Polo by Ralph Lauren, 269
Polo Ralph Lauren, 259–260
Polyactide fibers, 183
Polycentric, 114
Polyester, 188
Polyester leisure suit, 73
Polyethylene, 189
Polypropylene, 189
Polyvinylchloride (PVC), 190
Pompadour, Madame de, 28
Popcorn, Faith, 148
Popover dress, 81
Populist model, 114–115
Pop-up stores, 260
Portman, John, 220
Posen, Zac, 83
Position, 133
Positioning, 133–134
Power brands, 260
Power dressing, 74–75
Power shopping centers, 265
Prada, 270
Preproduction stages, 202–205
Presley, Elvis, 69, 112
Prêt à porter, 72

Price, 131
Pricing, women's wear, 89–91
Primary data, 150–151
Private label brands, 163–164
PRIZM (Potential Rating Index for Zip
 Marketers), 126
Product developer, 200, 281–282
Product development process, 200–206
Product diffusion curve, 140
Production positions, 8
Production stages, 202–205
Product life cycle, 140
Products, 131
Professional organizations, 294–295
Project managers, 288
Promostyl, 148
Promotion, 132–133
Proprietorship, 289
Protein fibers, 180, 184–186
Psychographics, 125
Psychographic variables, 125
Pucci, Emilio, 25
Pull marketing, 132, 192
Punk, 75
Pure silk, 186
Puritans, 44
Push marketing, 132, 192

Qualitative research, 150
Quant, Mary, 70
Quantitative research, 150, 151–153
Questionnaires, 153
Quotas, 226–227

Raccoon coats, 63
Ralph Lauren, 73
Ramie, 182
Raw materials, 179–180
Raw silk, 186
Raymond, Doric, 83
Rayon, 186
Ready-to-wear, 72
Reagan, Nancy, 108
Rebranding, 161
Recessionary buying, 255
Regional agreements, 247
Regional malls, 266–267
Regulars, men's sizing, 92
Regulating organizations, 238–240
Relationship marketing, 129
Rent-a-bag online, 270
Repositioning, 133–134
Reps, 282–283
Resident buying offices (RBO), 232–233
Résumé, 297
Retail, 131
Retailing
 benefits of, 254–256
 defined, 254
 department stores, 257–258
 direct marketing, 270
 e-tailing, e-commerce, and m-commerce,
 267–270

fashion formats, 254
mass merchandise or discount stores,
260–261
multichannel, 254
nonstore, 270
off-price stores, 262–263
origins of, 256–257
shopping centers and malls, 263–267
specialty stores, 259–260
Retail ownership group, 233
Retail price, 131
Retail store positions, 9
Retro fashions, 77, 116
Richard Chai, 261
Rise stage, 141, 144–145
Road to Morocco, 286
Roberts, Julia, 83
Robinson, Dwight, 97, 98
Rodarte, 261
Rogan, 261
Roosevelt, Eleanor, 58
Ross Stores, 262
Rubenstein, Helena, 58
Rykiel, Sonia, 83

Sack style, 69
Safeguard quotas, 226
Sale price, 131
Samsonite Corporation, 161, 164
Sapir, Edward, 97, 98, 108
Sarong dress, 81
Saturation, 105
Saturday Night Fever, 73
Schiaparelli, Elsa, 64
Sciera, Brian, 266
Scottish immigrants, 45
Scrambled merchandising, 254
S-curve, 59–60
Seacrest, Ryan, 121
Sears, Roebuck and Company, 257
Secondary data, 151
Second quality merchandise, 232
Segmenting the market, 124–128
September 11, 2001, 77
Sericin, 186
Sericulture, 186
Services, 131
Seventh on Sixth, 219
Sewing machine, 50
Shifting erogenous zone theory, 117
Shirtwaists, 54, 60
Shoe Carnival, 259
ShopperScape by Retail Forward, 261
Shoppertainment, 15, 264
Shopping centers, 263–267
Shortened inventory cycles, 15
Shorts, men's sizing, 92
Signature pricing, 91
Silhouettes, history of, 59
Silk, 185–186
Silk Road, 22
Simmel, Georg, 97, 98, 105–106, 109, 110
Singer, Isaac, 50

SizeUSA, 89
Sizing
children's wear, 94, 95
menswear, 92–93
women's wear, 88–89
Skateboarder look, 77, 79
Skate thug look, 77
Slater, Samuel, 48–49
Small Business Administration, 289, 290
Small Business Training Network (SBTN), 290
Snoop Doggy Dog, 77
Social imitation, 105–106
Social networking communities, 269–270
Soft goods, 180
Sole proprietorship, 289
Sombrero, 46
Source, 208
Sourced, 208
Sourcing, 208–209, 224–230
Sourcing specialist, 280–281
Spandex, 76, 189
Spanx, 261
Sparks, Jordin, 261
Special events coordinator, 286
Specialty stores, 259–260
Spectator sportswear, 65
Speedo, 189
Speed to market, 12
Speed-to-market, 206
Spencer, Diana, 74, 75, 111
Spice Girls, 118
Spinneret, 186
Spinning, 191
Spinning jenny, 48
Spinning machine, 48–49
Spinning wheel, 48
Spinster, 48
Spitz, Mark, 189
Sport coat, 91–92
Sproles, George B., 112
Spun, 191
Stage Stores, 257
Stanton, Elizabeth Cady, 62
Staple fibers, 186
Staples, 265
Status float phenomenon, 112
Status symbols, 74–75
Steam engine, 48
Stein Mart, 262
Stetson, 46
Steve & Barry's University Sportswear, 273
St. Laurent, Yves, 33, 70
Store manager, 286–287
Strapless gowns, 64
Streamlining, 6
Student organizations, 294–295
Studied creativity, 17
Study abroad, 292
Style piracy, 167–168
Style testing, 154
Styletribes, 115
Subcultural leadership theory, 112
Substantial transformation, 205

Suburban style, 67–69
Suffragettes, 62
Suit, men's, 91
Sumptuary law, 23
Sunglass Hut, 259
Superregional malls, 267
Super Target, 265
Supply chain, 11–12, 131–132
Survey methods, 153–154
Susan G. Komen Foundation, 201
Sustainability, 10, 111, 204
Sustainable textiles, 183
Sweatshops, 53, 209, 249
Synthetic fibers, 186

Tailored clothing, 91
Tall sizes, 88
Target customers, 124
Target market, 124
Target stores, 157, 260–261
Tariffs, 226
Taxi Driver, 286
Taylor, George W., 56
Terminology
basic, 95–99
international trade, 225
research, 150
TerraChoice Environmental Marketing, 251
Textile Clothing Technology Corporation, 89
Textile Fiber Products Identification Act
(TFPIA), 242–243, 245
Textiles
defined, 177
estimated global usage, 180
fiber classifications, 180–191
fur as, 190–191
green, 183
international trade shows, 193, 194
leather as, 190–191
marketing, 191–194
Material World Trade Show, 192
mills, 50–51
overview, 178–179
raw materials, 179–180
sustainable, 183
trend-based, 179
Textile specialist, 278–280
Thakoon, 261
Theme shopping centers, 265–266
Theory of the Leisure Class (Veblen),
109, 110
Theory of the shifting erogenous zone, 117
TJ Maxx, 262
Tobaccowala, Rishad, 11
Tobē, 148
Tönnies, Ferdinand, 97, 98
Torrid, 261
Tracy Feith, 261
Trade associations, 194
Trade shows, 193
Transshipping, 227
Trapeze silhouette, 68
Trappers, 45

Trend analysis, 148
Trend-based fibers, 179
Trend-based textiles, 179
Trendstop, 149
Triacetate, 69
Triangle Waist Factory, 54
Trickle-across theory, 112–113
Trickle-down theory, 109–111
Trickle-up theory, 112
Trigère, Pauline, 68
Tubular silhouette, 61, 68
Tunic top, 78
Tweenager, 94
Tweens, 94

Udani, Premal, 229
Unique selling proposition (USP), 134
Upper bridge pricing, 90
Upper moderate pricing, 90
Urban Cowboy, 73
U.S. Customs and Border Protection,
 238–239
U.S. Department of Agriculture (USDA), 179
U.S. Environmental Protection Agency
 (EPA), 10
U.S. National Organic Standards Board, 183

VALS™, 125
Value-added, 134
Vanderbilt, Gloria, 72
Vanity sizing, 89, 204
Veblen, Thorstein, 109, 110

Vendor ownership groups, 233
Vertical integration, 91, 178
Vicuñas, 185
Vietnam, 229–230
Vintage fashions, 83
Vionnet, Madeline, 64
Visual merchandiser, 287–288
von Furstenberg, Diane, 162

Waistline seams, 64
Wal-Mart, 257, 260, 261, 287–288
Walton, Sam, 257
Ward, Aaron Montgomery, 257
Warp yarns, 49
Wash-and-wear, 68
Washington, Martha, 44, 108
Watts, James, 48
Weaving, 49
Weft yarns, 49
Western wear, 73
Westwood, Vivienne, 75
Wet Seal, 269
Whitney, Eli, 49–50
Wholesale, 131
Wholesale cost, 131, 204
Wholesale price zones, 89–91
Wholesale sales positions, 9
Wholesaling, 230–232
Wilson, Martha Stewart, 44
Wilsons Leather, 161
Wolfe, David, 148

Woman's Dress for Success (Molloy), 74
Women's half sizes, 88
Women sizes, 88
Women's wear, 88–91
Woodstock, 71
Wool, 184–185
Wool Products Labeling Act, 241–242, 245
Word of Mouth Marketing Association
 (WOMMA), 26
Work experience, 295
World Global Style Network (WGSN), 149,
 278, 279
World Trade Organization (WTO),
 239–240, 245
World War I, 61–62
World War II, 64, 66–67
Worldwide Responsible Apparel Program
 (WRAP), 53
Worth, Charles Frédéric, 30–31, 34
Worth, Gaston, 34
Woven fabrics, 191
Wrap dress, 162

Yarns, 191
Young junior sizes, 88

Zara, 206
Z. Cavaricci, 261
Zeitgeist, 95
Zeitgeist theory, 114
Zellweger, Renee, 83